Rock 'N' Film

Rock 'N' Film

CINEMA'S DANCE WITH POPULAR MUSIC

David E. James

OXFORD
UNIVERSITY PRESS

OXFORD
UNIVERSITY PRESS

Oxford University Press is a department of the University of
Oxford. It furthers the University's objective of excellence in research,
scholarship, and education by publishing worldwide.
Oxford is a registered trade mark of Oxford University Press in the UK
and in certain other countries

Published in the United States of America by
Oxford University Press
198 Madison Avenue, New York, NY 10016, United States of America

Library of Congress Cataloging-in-Publication Data
James, David E., 1945–
Rock 'n' film : cinema's dance with popular music / David E. James.
pages cm
Includes bibliographical references and index.
ISBN 978–0–19–938759–5 (cloth) — ISBN 978–0–19–938761–8 (updf) —
ISBN 978–0–19–938762–5 (epub) 1. Rock films—History and criticism.
2. Motion pictures and rock music. I. Title. II. Title: Rock and film.
PN1995.9.M86J37 2015
791.43'6578—dc23
2015013936

1 3 5 7 9 8 6 4 2
Printed in the United States of America
on acid-free paper

For Joann

{ CONTENTS }

{ ACKNOWLEDGMENTS }

Like film and music, cinema historiography is a collective activity, and I have been extraordinarily privileged in the many friends and colleagues who have contributed to this project. I am especially indebted to Derek Nystrom and other university press editors and readers who encouraged, enriched, and guided it from its beginnings. Johanna Gosse, Adam Hyman, Jonathan Kahana, Tom Kemper, Dana Polan, Sophia Serrano-Wagner, and Dean Wilson all read the manuscript, helping me enormously and saving me from many errors. I am additionally grateful for many kinds of assistance from Nicole Brenez, Drew Caspar, John Ganim, Alan Golding, Rick Jewell, Harvey Kubernik, Earl Rath, Paul N. Reinsche, Paige Rozanski, and Jeff Sconce.

I have been aided by the School of Cinematic Arts at the University of Southern California, and by two awards: an Academy Film Scholarship from the Academy of Motion Picture Arts and Sciences, Beverly Hills, in 2007, and the Ailsa Mellon Bruce Senior Fellowship at the Center for Advanced Studies in the Visual Arts, National Gallery of Art, Washington, D.C., for the academic year, 2011–2012. My gratitude for the assistance and pleasure they gave me is unbounded.

For permission to reproduce the Sprod cartoon, I gratefully acknowledge Punch Limited, www.punch.co.uk; and for the Midnight Movies calendar, Presidio Theater, San Francisco, Fall 1977 (detail), I gratefully acknowledge Mike Getz.

Notes: This project attempts a scholarly treatment of a topic that so far has received primarily journalistic attention. Hoping to make it useful for popular as well as academic readers, I have relegated the scholarly apparatus to the footnotes, and developed the theoretical and methodological principles all together in the first chapter. This may be postponed by any reader preferring to move directly to the historical account.

Almost all the illustrations are drawn from the films themselves, which now exist in a variety of formats. To ensure some consistency, the frames have been edited, though as little as possible. Nevertheless, all should be considered as details rather than full frames. Specifications of images in the composites read left to right, top to bottom.

Rock 'N' Film

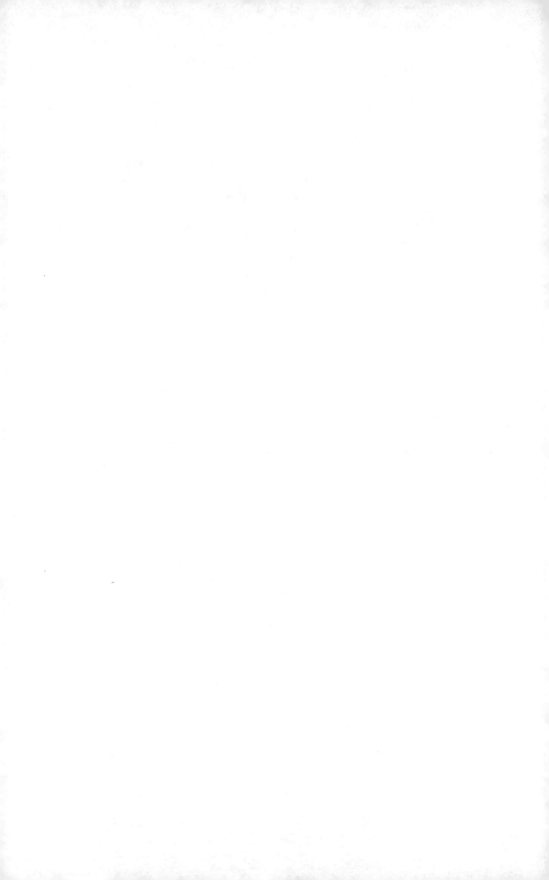

{ 1 }

Introduction

ROCK ‘N’ FILM

Forty years after the 1913 premiere of Stravinsky's *Le Sacre du Printemps*, a musical event of even greater significance occurred. On the evening of Thursday July 8, 1954, the test acetate of Elvis Presley's record "That's All Right" was first played on Memphis radio station WHBQ. Both works incorporated musical elements then considered primitive, and responses to both were passionate: riotously mixed for Stravinsky but, on this occasion at least, so uniformly fervent for Elvis that his song was broadcast some eleven times on the show. But their differences in other respects now appear as signal announcements of the distinct cultural regimes that respectively dominated the first and the second halves of the twentieth century in the transatlantic West: a live orchestral performance of European music accompanying a ballet for an haute bourgeois audience in the one case, and in the other the mass dissemination of a recording that amalgamated black and white working-class US musics; an art music constructed in difference from all the new forms of industrial culture over which cinema already presided in the one case, and in the other a vernacular music that would soon replace cinema as the medium in dominance and would invalidate previous cultural hierarchies of high and low.[1]

Rock 'n' roll's emergence coincided with the enormous expansion of industrial culture in the North Atlantic countries and the integration of its various branches. Until then, cinema had been the most prestigious component and indeed the twentieth century's paramount art form, hierarchically ranked above radio and television, though already locked in struggle with the latter. While initially appearing as a threat to both conglomerated culture and the social status quo, the new form of popular music quickly infiltrated both. Until the emergence of new forms of visuality in the digital revolution at the turn of the next century, music became the fulcrum of the media industries. Technological innovations gave it a unique mobility that allowed an initial cultural product to be activated and redeployed across all other media. Circulating on records and radio, "That's All Right," for example,

became a regional hit, even as Elvis and his musicians toured the South to promote it and then make more records. Their dissemination, especially in television appearances, made him a national phenomenon, and Hollywood called: "Hollywood is the next move, you know. That's what happens: you get a record and then you get on television and then you go to Hollywood," he remarked, " So I made *Love Me Tender*, then I did *Loving You*."[2] Initially performed on television on the Ed Sullivan Show, "Love Me Tender" had received enough advance orders by the next day it to make it a gold record and to cause the film to be retitled after it. Elvis went on to make another thirty features in Hollywood, creating a virtually autonomous genre that made him the most valuable movie star of his time.

As popular music threatened its hegemony in conglomerated industrial culture, cinema was forced to compete, sometimes to attack or attempt to contain or take revenge upon upstart rock 'n' roll, but more often to incorporate, enhance, or celebrate it in the creation of hybrid audio-visual forms. Always something of the power of the live music was lost, but much more was gained: the amplification of the sonic component, its visual elaboration in narrative or other spectacular forms, and the reciprocal promotion and dissemination of the two component mediums. As film and as cinema, rock 'n' roll danced in and with the movies.

Rock

> When modes of music change, the fundamental laws of the State always change with them. . . . Lawlessness too easily steals in. . . . Little by little this spirit of license, finding a home, imperceptibly penetrates into manners and customs.
>
> PLATO, *THE REPUBLIC*

Rock 'n' roll had many beginnings and has had many definitions. The origin of the phrase is presently dated to 1916, only three years after *Le Sacre du Printemps*, in the lines "We've been rockin' an' rollin' in your arms/in the arms of Moses" from "The Camp Meeting Jubilee," performed by an anonymous African American quartet on Little Wonder records.[3] After Trixie Smith's 1922 more fleshly "My Man Rocks Me (With One Steady Roll)," in the 1930s and 1940s the term traveled as a metaphor for both divine and carnal love through religious and secular black music: blues, gospel, boogie woogie, and eventually "rhythm and blues," that replaced the more abrupt "race music" category in *Billboard*'s chart listings in 1949. A frankly erotic jump, "Rock and Roll Blues," written and recorded in 1949 by an African American woman, Erline "Rock and Roll" Harris, was one of a cluster of similar proto–rock 'n' roll songs around the turn of the decade that also included Wynonie Harris's

"Good Rockin' Tonight" (1948) and Ike Turner's "Rocket 88" (1951), the latter recorded by Sam Phillips at Sun, his small, independent studio in Memphis. In the early 1950s white groups began recording similar material, most notably Bill Haley, leader of a Western Swing combo, who covered "Rocket 88" in 1951; and then in 1954, as Bill Haley & His Comets, his cover of "(We're Gonna) Rock Around the Clock" became a huge success. Three months later, on July 5, 1954, and again at Sun, Phillips produced Elvis's "That's All Right," his version of a song written and first recorded in 1946 by Delta blues singer Arthur Crudup as "That's All Right, Mama." The record was backed with "Blue Moon of Kentucky," a bluegrass waltz by Bill Monroe, also written in 1946.[4]

These and related musical innovations in the years between the end of World War II and the mid-1950s coincided with fundamental transformations in US society and the music industry. The steady rise of disposable income during the postwar economic boom produced unprecedented freedoms for young people, including African Americans. Panic about juvenile delinquency accompanied the emergence of teenagers as a distinct demographic with their own independent economic power. By early 1956, the average teenager's weekly income equaled the disposable income of the average US family fifteen years earlier, allowing them to spend $75 million annually on records.[5] The migration of African Americans introduced Southern musical culture to Northern urban centers, as did the wider dissemination on mainstream radio of rhythm and blues records, which were not regulated by the American Society of Composers, Authors and Publishers (ASCAP) and hence could be played royalty-free. Radio stations with all-African American on-air personnel, exclusively programming black music, emerged, notably Nat D. Williams at WDIA in Memphis; and the airwaves were integrated by white DJs playing black music, most notably Alan Freed with the "Moondog House" at WJW in Cleveland in 1951, and Dewey Phillips with the "Red Hot & Blue" show on WHBQ in 1952, where "That's All Right" was first broadcast. The increasing numbers of white teenagers listening to such shows quickly led to black and white dancers mixing in theaters and nightclubs in advance of other forms of desegregation. As the popularity of both the 33⅓ rpm 12" LP and the 45 rpm 7" single, introduced respectively in 1948 and 1949, grew, so independent record companies outside the majors proliferated.[6] The Fender Telecaster, the first mass-marketed solid-body electric guitar, appeared in 1950, and the transistor radio four years later. These combined social and musical developments produced exchanges between black and white cultures that inspired rapture in many teenagers and consternation in almost everyone else.

The consternation focused on working-class delinquency and especially racial mixing. By mid-1955, less than a year after "That's All Right" and with *Blackboard Jungle* (Richard Brooks, 1955), the first film that included a rock 'n' roll

record in release, the controversy was at its height. A three-page spread in *Life* emphasizing the music's associations with African Americans and manic dancing pegged the phenomenon:

ROCK N' ROLL

A frenzied teen-age music craze kicks up a big fuss

The nation's teenagers are dancing their way into an enlarging controversy over rock n' roll. In New Haven, Conn., the police chief has put a damper on rock n' roll parties and other towns are following suit. Radio networks are worried over questionable lyrics in rock n' roll. And some American parents, without quite knowing what it is their kids are up to, are worried that it's something they shouldn't be.

Rock n' roll is both music and dance. The music has a rhythm often heavily accented on the second and fourth beat. The dance combines the Lindy and Charleston, and almost anything else. In performing it, hollering helps and a boot banging the floor makes it even better. The over-all-result, frequently, is frenzy.

A QUESTION OF QUESTIONABLE MEANINGS

The heavy beat and honking-melody tunes of today's rock n' roll have a clearly defined ancestry in US jazz going back to Louis Armstrong and Bessie Smith of 30 years ago. Once called "race" records, and later "rhythm and blues," the music was first performed by Negroes and sold mostly in Negro communities.[7]

Accompanying the text was a small photograph of the New Haven police chief in question, followed by much larger ones of the teenagers, mostly white but some black, as they danced in a Los Angeles parking lot, in Brooklyn's Paramount Theater, and at a mock-up of an ice-cream parlor in a San Francisco television studio, along with images of the music that inspired them: the Fats Domino Band in a Los Angeles ballroom and Alan Freed spinning discs. The photo essay succinctly assembled the crucial issues: on the one hand, close on the 1954 Supreme Court decision that mandated public school integration, a musical innovation bringing blacks and whites and their respective cultures together, projecting itself as unruly dance and provocative words, or what a subsequent paragraph referred to as the "frequently suggestive and occasionally lewd" "leerics" that implied even more promiscuous forms of physical abandon; and on the other, the fears of disorder that the errant teenagers aroused in the police and in the media industry. Large numbers of musicians, sociologists, educators, politicians, and parents in the mid-1950s believed that rock 'n' roll led only to lawlessness and license. Its lyrics mocked propriety; its rhythms ignited promiscuous physical liberties; and its attitudinizing occupied the body and the mind, manners and customs.

Less circumspect than *Life*, other arbiters addressed the threat of African American culture directly. After six rock 'n' rolling teenagers were arrested in 1956, also in Connecticut, and a hundred more were ejected from a theater, a psychiatrist diagnosed the "cannibalistic and tribalistic" music as a "communicable disease."[8] White resistance to race mixing was especially strong in the South and, the same year, *Newsweek* reported a declaration made by Asa Carter, head of the White Citizens Councils of Alabama, that "[r]ock and roll music is the basic, heavy-beat music of Negroes. It appeals to the base in man [and] brings out animalism and vulgarity."[9]

Even when they avoided racial issues, assessments made by many mainstream musicians also returned to social implications. Not long after Sammy Davis had volunteered that "[i]f rock 'n' roll is here to stay, I might commit suicide," no less an authority on popular music—and veteran of rioting fans—than his pal Frank Sinatra was reported to have declared that "[r]ock 'n' roll smells phony and false. It is sung, played and written for the most part by cretinous goons and by means of its almost imbecilic reiteration, and sly, lewd, in plain fact, dirty lyrics . . it manages to be the martial music of every side-burned delinquent on the face of the earth."[10] However nostalgic it may seem today, Sinatra's execration typified the consternation. In rock 'n' roll, musical and social delinquencies were intertwined, each the other's cause and manifestation.

For the next thirty years, public discussions of rock 'n' roll were primarily sociological, almost all of them reiterating Sinatra's accusations of amalgamated transgressions.[11] As 1950s disturbances metamorphosed into 1960s cultural rebellion, the associations between music and delinquency were reconstructed. The evolved rock 'n' roll of sixties' youth was understood by its critics as the clarion call of a generation in ungodly, drug-inspired revolt; and as the countercultures disintegrated in the early seventies, heavy metal, glam, reggae, early disco, and other innovations prompted charges of new depravities that flourished until mid-decade, when punk and rap offered even more spectacular forms of deviance. But for its enthusiasts, rock's power was limitless and all-enfolding. A 1967 paean in the *San Francisco Oracle*, for example, proposed that "far from being degenerate or decadent, rock is a regenerative & revolutionary art, offering us our first real hope for the future. . . . rock seems to have synthesized most of the intellectual & artistic movements of our time & culture, cross-fertilizing them & forcing them rapidly toward fruition and function. . . . [and] any artistic activity not allied to rock is doomed to preciousness and sterility."[12] Many believed that the music's domination of other arts made it an autonomous cultural agency. Writing in the same year during the "Summer of Love," Ralph J. Gleason, a San Francisco music critic and one of the cofounders of the magazine *Rolling Stone*, introduced his article on the period's cultural transformation in a mainstream

journal, *The American Scholar*, with an aphorism of his own coining: "For the reality of what's happening today in America, we must go to rock 'n' roll, to popular music."[13] And the following spring, only days before the Democratic National Convention in Chicago, Jann Wenner, his *Rolling Stone* cofounder, argued that "[r]ock and roll is the *only* way in which the vast but formless power of youth is structured, the only way in which it can be defined or inspected. . . . It has its own unique meaning, its own unique style and its own unique morality."[14]

Wenner's argument was designed to keep rock free of political involvement, safe from a "self-appointed coterie of political 'radicals' without a legitimate constituency."[15] But the radicals also testified to the importance of rock 'n' roll and of black music generally in sowing disruption among the materialism and conformity of the Eisenhower era. Summarizing the importance of black music and black dance, civil rights leader Eldridge Cleaver declared, "The Twist was a guided missile, launched from the ghetto into the very heart of suburbia. The Twist succeeded, as politics, religion, and law could never do, in writing in the heart and soul what the Supreme Court could only write on the books."[16] And white radicals elaborated a similar historical trajectory, repeating all but verbatim the earliest critics' arguments, but positively transvaluing them. Jerry Rubin, Yippie publicist and the immediate target of Wenner's wrath, for example, claimed that "[t]he New Left sprang, a predestined pissed-off child, from Elvis' gyrating pelvis," and that "[h]ard animal rock energy beat/surged through us, the driving rhythm arousing repressed passions." He also recognized the affluence and the new ancillary technologies that allowed those passions' release: "The back seat produced the sexual revolution, and the car radio was the medium for subversion."[17] The synthesis of black and white vernacular music had been ongoing since the melodies and harmonies of British hymns had first been married to African timbres and rhythms in the earliest days of slavery; but the new conjunction of them in rock 'n' roll promoted a cultural revolution and a revolution in the ways in which mainstream US popular music was composed, recorded, performed, and experienced. It transformed the mode of musical production.[18]

MODES OF PRODUCTION

Since the 1930s the major source of US popular music had been the Great American Songbook, written almost exclusively by a small group of professional musicians and lyricists based in New York, and disseminated by stage shows, film musicals, radio, and sheet music, the last providing the basis for popular musical performance around the family piano. The market for sheet music collapsed by the late 1950s, and its role in disseminating popular music was superseded by records; rock 'n' roll became popular as recordings that variously combined the two, originally performative,

black and white folk traditions that had also long been industrialized. Blues was commercially recorded as early as 1920 with Mamie Smith's "Crazy Blues"; and, spurred in fact by race music's commercial success, hillbilly music very soon followed with Vernon Dalhart's hit, "Wreck of Old 97," recorded in 1924 and selling over a million copies. The Brill Building pop music composers continued to be important well into the sixties, but rock 'n' roll was increasingly composed by the individuals and small groups who performed it, live and on records.

After the singer-songwriters of the early 1960s folk boom, and especially as the Beatles began to follow Bob Dylan's conspicuously personal songwriting, the individualist "handicraft" element in rock 'n' roll's composition achieved a greater control over its manufacture and allowed it to claim a personal expressivity parallel to jazz and classical music but unprecedented in popular music.[19] In addition, this organic popular music was largely decentralized, developing provincially in New Orleans, Memphis, and other places in the South, but also in Philadelphia, Los Angeles, and Chicago—and, of course, later in Liverpool and Manchester. And most of it was initially recorded, not by major corporations, but in small, independent studios, with the records distributed by local independent labels. Beginning in 1953, the number of record labels finding a place in the US weekly top ten dramatically increased from 12 to highs of 46 in 1959, and 52 in 1962 and 1963, to reach a highpoint of 53 in 1964, before beginning a decline that accelerated after 1970.[20] Though many independent recording and distribution agencies were eventually assimilated by large corporations, early rock 'n' roll's radical innovations and diversity were most often inaugurated by performers themselves and by producers outside the corporate world. But though never separable from amateur and semi-amateur performance, records were rock 'n' roll's fundamental material realization. They, rather than live performances, were the staple of radio dissemination, and through the 1950s, nightclub, concert, and television live performances aimed to reproduce the record as closely as possible. Records were similarly the basis for many of rock 'n' roll's ancillary cultural products and venues, including album jackets, record players, jukeboxes, and record stores; and in early feature films, artists almost invariably lip-synced to records.

Records replaced sheet music, family listening around the phonograph replaced singing songs around the piano, and, as generationally restricted musical tastes crystallized, younger family members listened individually in different rooms or in coffee bars and similarly youth-oriented venues. But rock 'n' roll's musical simplicity and the relative cheapness of the required instruments allowed such consumption of commodity music to flower easily into amateur and semi-amateur performance and composition. From the beginning, popular practices not administered from above intersected with, nourished, and contested industrial forms of rock 'n' roll, reviving the

characteristics of pre-capitalist music. So, proposing that rock 'n' roll marked a return to the itinerant minstrelsy of the jongleurs, Jacques Attali emphasized that it entailed

> a resurgence of music for immediate enjoyment, for daily communication, rather than for a confined spectacle. No study is required to play this kind of music, which is orally transmitted and largely improvisational. It is thus accessible to everyone, breaking the barrier raised by an apprenticeship in the code and the instrument. It has developed among all social classes, but in particular among those most oppressed (the workers of the big industrial cities, Black American ghettos . . .). The number of small orchestras of amateurs who play for free has mushroomed. Music is thus becoming a daily adventure and an element of the subversive festival again.[21]

As teenagers themselves became involved in production rather than merely consuming music produced for them by adults, rock 'n' roll's expanded popular musical practices introduced new cultural possibilities. As Jim Curtis observed, "For the first time, teenagers singing for teenagers about being teenagers constituted a major force in American popular music."[22]

The musical practices that emerged in the mid-fifties were never entirely free from industrial encroachment, but nor were they controlled by it. By the mid-sixties, the primacy of amateur innovation and the countercultural ideal of the dissolution of the boundary between performers and audience encouraged the belief that, even if elements of rock 'n' roll continued to be industrialized, popular investment and participation in it and in popular rituals organized around it could transcend alienated social relations to make it a modern *folk* music. Almost anyone could compose a song, perform it, and record it. And any song could be realized by a girl or boy *a cappella* in the shower or with a guitar alone or with friends; as a record played on a phonograph in a bedroom, on a jukebox in a bar, on a radio in a car; by a band in a garage or in a recording studio, and simulated by a band at a concert or covered by a different band on record or in concert, and so on. All these forms of musical production existed before rock 'n' roll, but with rock 'n' roll, the active, performative components multiplied and proliferated, often using industrialization to their own advantage. The multidirectional circulation of innovations and appropriations between the amateur and commercial extremes and in various intermediary modes of production in this expanded musical economy never eliminated the distinctions between producer and consumer, but it did make them much more porous, contradictory, and subject to local popular intervention.

The many reciprocal interactions between folk and the industry among which rock 'n' roll was created reconfigured the concept of the popular: "popular" as an indicator of mass consumption turned like a Mobius strip around the "popular" as a reflection of a newly vitalized role for the working class as

cultural producers. In the circulation of music and its associated rituals, individual, subcultural, and commercial modes of production interacted more thoroughly than in any previous epoch, leading critics in the mid-1960s in the United Kingdom to recognize that "[t]eenage culture is a contradictory mixture of the authentic and the manufactured; it is an area of self-expression for the young and a lush grazing pasture for the commercial providers."[23] Tin Pan Alley and the American Songbook's domination of popular song waned, and the consuming public began to have a more comprehensive and generative influence over music than any other form of modern culture. Rock 'n' roll inaugurated new forms of *music*, new *modes of musical production*, and new socio-musical regimes in which multiple modes of musical production, from the completely amateur to the completely industrial, interpenetrated and reciprocally sustained each other. Buoyed and enlivened by the various forms of popular participation during both production and consumption of music and its associated culture, the belief that popular expressivity could command commercially produced music without losing its autonomy and power made it the most important art in the period of resurgent populist politics in the two decades after the mid-1950s. Equivalent forms of popular empowerment were to a degree achieved in other mediums, especially in journalism and underground cinema in the United States; but no other industrialized medium matched music's capacity for popular participation and popular control. No other medium carried such an unalienated utopian promise; but because that utopian center was surrounded and besieged by equally radical and extensive new forms of incorporation, its utopian and dystopian components were inextricably combined.

The interdependency of popular participatory culture and the commodity industrial culture constructed upon it was the comprehensive form of rock 'n' roll's many dualities, assimilating its constituent tensions between black and white, blues and hillbilly, individual and community, male and female, noir rebellion and sunshine fun, and eventually Britain and the United States. All the questions about generational self-expression and the social meaning of music became central to rock 'n' roll's own self-consciousness: debated in its lyrics, enacted in its performance, dissected by its polemicists, and dramatized in other cultural forms. But nowhere was it more crucially an issue than in films about rock 'n' roll, where these innovations were dramatized in different ways, in various modes of film production, in various cinemas.

A CULTURAL GESTALT

Rock 'n' roll's early supporters and detractors agreed that the pulsing rhythms inherited from big-band swing and juke joints reflected its most immediate function, that of facilitating popular dance. Often denigrated for its emphasis on sonic properties outside the parameters of conventional musicology,

rock 'n' roll was experienced somatically as much as heard or understood. Its communicative and affective contents were completed, not in the ear or the mind, but in the whole body, especially below the waist, so that dancing was the most fundamental of most fans' performance of rock 'n' roll. As such, it was integrated into a range of associated activities and objects, a total culture in which meaning was produced in the everyday interaction between the sounds themselves and the popular use of them. Music—making it, hearing it, dancing to it, and talking about it—was certainly rock 'n' roll's primary and most essential ritual activity. But the music was lived and its meanings elaborated and performed in multiple private and social practices of everyday life: in dance steps and styles, body language, and posture; in hairstyles, clothes, shoes, accessories, and ornaments; in argot and catch-phrases; in photographs, posters, record covers, magazines, fanzines, and graphic styles; in musical instruments, concerts, records, transistor radios, radio and television shows, and cinema; in soda fountains, high-school hops, youth clubs, and concerts; in hot rods and motorcycles; indeed, in almost anything that its community did or imagined or made, bought, or desired. Far from being merely ancillary to rock 'n' roll, these constellations of subjectivities, rituals, communities, and commodities were intrinsic to it, and all had strong visual components.[24] As popular use of rock 'n' roll interpreted the music and reframed it, it also *recomposed* it. All forms of music have to some degree realized themselves materially and socially in equivalent events and observances; but the elaboration of rock 'n' roll into a complete cultural syntax was immediate and richly inter-articulated. Rock 'n' roll culture was from its inception a social production, made and lived communally, and continually renewing itself environmentally as a total cultural gestalt.

Since its beginning, rock 'n' roll has then been almost as much a complex of visual as of auditory cultural innovations, a field of integrally interdependent sight and sound. Experienced synesthetically, heard in the eyes and seen in the ears, its audio-visuality has been elaborated in the visuality of its musical forms and in the musicality of its visual forms.[25] Rock 'n' roll's visuality developed during its first two decades in many forms of popular culture, especially in three industrialized media: print, television, and cinema.[26] Cinema indeed projected some of its essential elements, even before music realized them. "Live fast, die young, and leave a good-looking corpse," the credo of John Derek's Nick Romano in *Knock on Any Door* (Nicholas Ray, 1949) was echoed by Marlon Brando in *The Wild One* (Laslo Benedek, 1953), by Sinatra himself in *The Man with the Golden Arm* (Otto Preminger, 1955), and then by James Dean in *Rebel Without a Cause* (Nicholas Ray, 1955); all variously dramatized new forms of angst, rebellion, narcissism, generational division, and the determination to run amok at any price.[27] But as well as introducing initial rock 'n' roll iconographies, cinema collaborated in the scandal of its mass emergence; with *Blackboard Jungle*, rock 'n' roll and the

rock 'n' roll film became global phenomena, and since then musical and cinematic developments have tracked each other, sustaining a synergistic combination of aesthetic, social, and commercial vitality. Cinema has not been merely a supplement to music in rock 'n' roll culture, but one of the means by which it has existed, one of the modes of rock 'n' roll production.

'n' Film

... we are made to recognize the tremendous split, in origins and purposes, between the visual, Apollonian arts and the non-visual art of music, the Dionysian. The two creative tendencies developed alongside one another, usually in fierce opposition, each forcing the other to more energetic production.

FRIEDRICH NIETZSCHE, *THE BIRTH OF TRAGEDY*

For a quarter of a century after the early 1930s, the musical was the queen of Hollywood genres, with the films of Busby Berkeley at Warners, Fred Astair and Ginger Rogers at RKO, Jeanette MacDonald and Nelson Eddy's operettas followed by Judy Garland and Mickey Rooney at MGM being among the most prestigious and remunerative of the era. In the 1940s, the Freed unit at MGM took the genre to its Golden Age with the fully integrated singing, acting, and dancing of the Technicolor integrated book musical, culminating in *Oklahoma* (Fred Zinnemann, 1955). With sound, the movies had become the major means of disseminating popular songs, both those composed for Broadway musicals that were subsequently filmed and those written by the studio's own teams of lyricists; by 1990 some 25,000 popular songs had been introduced or reprised in Hollywood films.[28] But no sooner did rock 'n' roll appear than its integration in cinema began, and the rock 'n' roll film emerged as simultaneously a break with the Hollywood musical and a renewal of it, the decline of the one punctually coinciding with the emergence, though on a smaller scale, of the other.[29]

"When is a musical not a musical?" asked Rick Altman, the foremost historian of the film musical, before answering his question with: "When it has Elvis Presley in it."[30] Though at least partly facetious, his axiom flags the rupture between the classic musical and its rock 'n' roll successor. After Elvis appeared in 1954, stellar productions including *High Society* (Charles Walters, 1956), and *Silk Stockings* (Rouben Mamoulian, 1957) extended the musical's Golden Age. And *West Side Story* (Jerome Robbins and Robert Wise, 1961), *My Fair Lady* (George Cukor, 1964) (both symptomatically concerned with working-class delinquency) and other important musicals were produced in the next decade; but by the mid-fifties the genre had essentially run its course. A week after the release of Elvis's second film, *Loving You* (Hal Kanter, 1957),

Fred Astaire announced as much in *Silk Stockings*, crushing his signature top-hat at the conclusion of his rock 'n' roll parody, "The Ritz Roll and Rock" (added to the film from the 1955 stage show) and retiring from musicals on the film's release.[31] The new musical culture quickly created its own narratives and generic conventions, but rock 'n' roll films were constructed from the three main subgenres of earlier film musicals: the revue, the backstage musical, and the biopic.[32]

Along with operettas and comedies, the revue was one of the most important forms of early musical film. Adopting the format of vaudeville and burlesque stage shows and especially of the Ziegfeld Follies, most studios brought their contracted singing, dancing, comedy, and novelty acts together in films: MGM's *The Hollywood Review Revue of 1929* (Charles F. Reisner, 1929), Warner Brothers' *The Show of Shows* (John G. Adolfi, 1929), Paramount's *Paramount on Parade* (Dorothy Arzner, Otto Brower, and Ernst Lubitsch, 1930), and Universal's *King of Jazz* (John Murray Anderson, 1930). These revues were introduced by a presenter, whose repartee linked the various numbers, implying that they were taking place sequentially in real time and space. *The Hollywood Revue of 1929*, for example, featured large choruses of dancers along with a "Galaxy of Stars," including Joan Crawford, Stan Laurel and Oliver Hardy, and Bessie Love, who earned a nomination for the Academy Award for Best Actress. Separated from each other by curtain falls, their various musical, comedy, and dramatic numbers were linked by interactions among Jack Benny and two other masters of ceremonies, who themselves also performed. All the acts took place on a proscenium stage with the camera mostly placed front and center but capable of switching among long and medium shots and close-ups, and distinctly cinematic special effects enriched many of them. The opening dance routine, the "Palace of Minstrels," for example, featured a large chorus of dancers in elaborate, contrasting black and white costumes with the boys in blackface; it was periodically thrown into negative to reverse the tones, and at one point Bessie Love appears in miniature out of Jack Benny's pocket. Photography of several dance routines anticipated Busby Berkeley's overhead shots of patterns of female bodies, as well as his pans along lines of faces. Three of the numbers were presented in two-strip Technicolor, including a section from Shakespeare's *Romeo and Juliet* performed by Gilbert and Shearer, and the finale, "Singin' in the Rain," was performed by the entire cast underneath a huge ark and rainbow. Concomitant with their prioritizing audio-visual spectacle, the revues lacked any narrative, apart from that supplied by the presenters. The genre survived its decline after the early 1930s by becoming internalized in the narrative of the second subgenre, backstage musicals; stories about people involved in the production of a revue or some other kind of show brought narrative and spectacle to play upon each other.

Like classic musicals generally, backstage musicals contained two distinct filmic modes, a *narrative* that formed a matrix inside which the *spectacle* of songs and dance, called units or numbers, was set. Though song lyrics or other elements within the narrative may organically motivate and justify the spectacle to create an *integrated* musical, the spectacle typically interrupts the narrative and arrests its forward momentum, developing its implications in an entirely different register.[33] Even when they include a heterosexual romance, the narratives of other classic Hollywood genres are linear and are focused on one main protagonist, following the causally linked sequence of his setbacks and successes to a resolution that coincides with the closure of the other narrative elements. But, Rick Altman has argued, the musical typically contains two paired protagonists, a boy and a girl, juvenile and ingénue, representing antithetical values between whom the narrative alternates to create a "dual focus" that is successfully resolved in their marriage and the reconciliation of the values they each represent.[34] In the mid-1930s, preeminently in the sequence of musicals for which Busby Berkeley designed the numbers, the narrative recounts attempts to put on a Broadway show. The performers include a leading boy and girl who fall in love, and their romantic involvements run parallel to their efforts to stage the show, coming to a conclusion in which both are resolved simultaneously. Often, several numbers are stacked together at the end of the film, much like an interpolated revue that provides a dazzling conclusion in which the boy's expression of love to his girl in the show simultaneously completes their commitment to each other in the narrative of the show's production.

Backstage musicals as celebrated as *Footlight Parade* (Lloyd Bacon, 1933), *Stage Door Canteen* (Frank Borzage, 1943), and *The Band Wagon* (Vincente Minnelli, 1953) indicate the genre's enduring stability before the emergence of rock 'n' roll. Effectively inaugurated with *The Broadway Melody* (Harry Beaumont, 1929), the first musical to win the Academy Award for Best Picture and a huge moneymaker for MGM, the backstage musical flowered with *42nd Street* (Lloyd Bacon, 1933), *Gold Diggers of 1933* (Mervyn LeRoy, 1933), and other early 1930s Warner Brothers films, before passing though several permutations. Fred Astaire's late-1930s films with Ginger Rogers at RKO modified the genre in that the narratives do not revolve around putting on a show; the dance routines take place in real-world environments rather than in a theater; they were fully integrated into the plot; and they were filmed as much as possible as a single shot with a stationary camera for, as Astaire insisted, "Either the camera will dance, or I will."[35] But still, Astaire plays a professional dancer, and the films usually end in an especially spectacular number: "The Continental" in *The Gay Divorcee* (Mark Sandrich, 1934), for example. The genre continued in Arthur Freed's MGM "Backyard Musical" series in which younger kids put on a show for a charity of some kind. Starring Mickey Rooney and Judy Garland, and directed in their entirety by Berkeley, these included

Babes in Arms (1939), where Rooney's "Let's put on a show in the barn" was first heard, *Strike Up the Band* (1940), and *Babes on Broadway* (1941). In *Strike Up the Band*, for example, the pair are graduating high-school seniors, with Rooney's character, Jimmy, the drummer for the school's marching band. Hoping eventually to lead a "modern dance orchestra" like Paul Whiteman's, Jimmy uses his band to put on a school dance, and then wins a radio contest sponsored by Whiteman, all the while featuring Garland as his vocalist. The overall narrative, some specific motifs, and the attraction of a new especially rhythmic dance music very clearly anticipate the rock 'n' roll films of the next decade,[36] though the complete absence of intergenerational tension and of delinquency or real sexuality mark a difference, as do the superior production values, especially in Berkeley's sumptuous numbers.

Any backstage musical inevitably generates patterns of similarity and difference between the film itself and the musical show it depicts, and hence implications about the differences between and relations among film, stage show, and even song. *The Broadway Melody*, for example, is quintuply rich in these terms, with the title phrase designating the film, the stage musical whose production it narrates, the title song (which contributed enormously to the film's popularity), the cultural institution that produces the musical, and the physical space in which it occurs: "A million lights they flicker there/A million hearts beat quicker there/No skies of grey on the Great White Way/That's the Broadway Melody." The same polyvalence recurs in films featuring rock songs that are themselves about rock 'n' roll: "Jailhouse Rock" designates the song, the dance number, the event in the county jail, and the film about all of them, while "Ziggy Stardust and the Spiders from Mars" similarly references the song, band, stage show, and film. Such interlaced references produce what Jane Feuer categorized as the "self-reflective musical," and the kind of reflexivity she finds in the classic musical are fundamental to the rock 'n' roll film.[37]

Feuer argues that a recurrent subgenre of backstage musicals involves "kids (or adults) 'getting together and putting on a show,'"[38] and that the show they put on has an ideological function within the film as a whole. Invoking a distinction between "folk art" and "mass art" derived from the best of the early attempts to theorize pop music,[39] she suggests that the depiction of the represented show as "folk art" impedes the audiences' consciousness of the commodity nature of the musical film itself and of the alienated social relations between producer and consumer in capitalist cinema ("mass art"):

> The Hollywood musical as a genre perceives the gap between producer and consumer, the breakdown of community designated by the very distinction between performer and audience, as a form of cinematic original sin. The musical seeks to bridge the gap by putting up "community" as an ideal concept. In basing its value system on community, the producing

and consuming functions severed by the passage of musical entertainment from folk to popular to mass status are rejoined through the genre's rhetoric. The musical, always reflecting back on itself, tries to compensate for its double whammy of alienation by creating humanistic "folk" relations in the films; these folk relations in turn act to cancel out the economic values and relations associated with mass-produced art. Through such a rhetorical exchange, the creation of folk relations *in* the films cancels the mass entertainment substance *of* the films. The Hollywood musical becomes a mass art which aspires to the condition of folk art, produced and consumed by the same integrated community.[40]

Rather than creating Brechtian or other forms of modernist distanciation, Feuer continues, reflexive devices in the prewar backstage musical films promote a sense of community by narratively including surrogate intradiegetic audiences and emphasizing spontaneity and populist performance. After the late 1940s, the musical becomes increasingly reflexive, and the represented shows often portray the singers and dancers as themselves amateurs and emphasize motifs, settings, and incidents invoking earlier American folk communities, as in *Oklahoma* or *Seven Brides for Seven Brothers*, for example. These form a subgenre within the backstage musical, the folk musical that "reeks with nostalgia for America's mythical communal past even as the musical itself exemplifies the new, alienated mass art."[41]

The structure of the backstage musical was fundamental to the rock 'n' roll film from its beginnings through the 1960s until the emergence of the filmed rock opera in the mid-1970s. Parallel strategies of rhetorically presenting rock 'n' roll *as folk art in the film* as a means of concealing the commodity nature of *the film itself* were facilitated overall by the music's considerable folk elements. In periods when rock 'n' roll claims to be authentic folk music, films about it typically represent it as spontaneous community self-expression, in which the performers are organically linked to the intradiegetic audience and, by implication, to the film's spectators. In so presenting themselves as unmediated extensions of the counterculture, *Woodstock* (Michael Wadleigh, 1970) and other hippie-era festival documentaries similarly conceal their own commodity nature. But films about rock 'n' roll in which the promotion of the ideal of folk authenticity is subordinated to recognition of its commodity nature and industrial production, especially when they focus on recording studios and television, generate different narrative possibilities. Films that are critical of rock 'n' roll, for example, may emphasize an internal distance between themselves and the music; and by depicting rock 'n' roll as itself alienated and the music business as compromised or corrupt, they imply their own superior integrity. *Nashville* (Robert Altman, 1975), for example, presents itself as honorable and so contrary to the degenerate, alienated country music it satirizes. It was preceded by a series of British films, including

Expresso Bongo (Val Guest, 1959), *Privilege* (Peter Watkins, 1967), and *Stardust* (Michael Apted, 1974), that implied their own probity as they dramatized the co-optation of rock 'n' roll by commercial or political interests. Conversely, a series of US films released in 1956–1957, when anxiety about rock 'n' roll was at its height, attempted to justify it, not as authentic folk art, but as an innocuous and viable component of industrial culture: *Don't Knock the Rock* (Fred F. Sears, 1956), *Shake, Rattle & Rock* (Edward L. Cahn, 1956), *Loving You* (Hal Kanter, 1957), and *Mister Rock and Roll* (Charles Dubin, 1957) are important instances. But despite the differences in their analysis of the music, rock 'n' roll backstage musicals were implicitly or explicitly preoccupied with the relationship between the social meaning of the film itself and that of the rock 'n' roll it depicted, and hence the relationship between cinema and popular music generally.

Similar concerns inform the film biography, or biopic, a common subgenre of both classic and rock 'n' roll musicals that replaces the dual narrative of a paired couple with a focus on a single artist. Structurally parallel to the subgenre of films about actors' careers, themselves variants on the Horatio Alger, rags-to-riches movies that began in the early 1920s, the biopic usually dramatizes the "rise to stardom" motif: it narrates a musician's discovery of his or her vocation, struggle for success, eventual attainment of stardom, and either a happy career or a tragic decline. When placed within a narrative of his or her career as a whole, a depiction of a series of performances inevitably involves some appraisal of the musician and the music.[42] The musician may be fictional or real: one of the former, *The Jazz Singer* (Alan Crosland, 1927), inaugurated the feature-length sound film, while *The Jolson Story* (Alfred E. Green, 1946) and its sequel *Jolson Sings Again* (Henry Levin, 1949) are of the latter type, partially fictionalized biographies of its star. After the war, biopics about swing bandleaders became a Hollywood staple with, for example, *The Fabulous Dorseys* (Alfred E. Green, 1947), *The Glenn Miller Story* (Anthony Mann, 1954), and *The Benny Goodman Story* (Valentine Davies, 1956), and as rock 'n' roll displaced swing as the most popular dance music, these segued readily to fictional, semi-fictional, and biographical films about the careers of Buddy Holly, Richie Valens, Ray Charles, Tina Turner, and other rock 'n' roll musicians or groups.[43]

REPRESENTATION

Adapting its predecessors' motifs and conventions, these three subgenres—revue, backstage musical, and biopic—were the basis of the rock 'n' roll film's reinvention of the musical. Like its precursors, the rock 'n' roll musical narrates the context in which the music is produced, rather than simply using music to embellish narratives set outside it. Its fundamental attractions are the *spectacle* of musical performance and its setting in the *narrative* of

the performers' back- and offstage lives. The resulting composite film consists of two different modes, each with its specific premises and codes: the essentially documentary nature of the spectacle and the drama of the historical or fictional narrative. The former creates audio-visual compositions that variously depict, amplify, and elaborate musical performance through the mediation of cinema-specific recording technologies and the conventions of editing, special effects, and other cinematic recourses. While letting us hear and see what rock 'n' roll can (be made to) sound and look like, the narrative returns the musicians and the music to their social and historical worlds.

Though any given listener's imagination and capacity for synesthesia ensure that hearing a record is always to some degree also a visual experience, filmic representations of rock 'n' roll performance combine the attenuation of some of its pleasures with the intensification of others. Presence at a live performance enriches the audience/spectator's sensory manifold with multiple forms of audio, visual, somatic, and other pleasures: the auditory presence of music in immediate acoustic space or over a sound system superior to a domestic radio; the excitement attendant on the performance being the chief focus of all senses, rather than being accompanied by or interrupted by other activities; the pleasure of optical, acoustic, and spatial proximity with the artist, intensified by the company and energy of other fans, known and unknown co-enthusiasts who transform a private event into a social ritual; the pleasure of seeing, hearing, and perhaps touching other fans, their bodies, clothes, hair, movements; the pleasure of being seen, heard, or touched by other fans; and perhaps of being seen, of being heard, and even being touched by the performers. Surrogates, initially at least, for being present at an actual musical performance, the audio-visual spectacle that films of rock 'n' roll performance provide is, like other cinematic spectacles, constructed as a play of absence and presence. Replaced by technologies of simulation and illusion, the performers are not actually present; but at the multiple points of photography and audio-recording, editing, printing, publicizing, and finally projection, the apparatuses of cinema reproduce but also transform the original performance, bringing it closer both aurally and optically and providing a presence that may be more powerful than the source event. The musicians appear closer, larger, and in greater detail, and may be heard in high fidelity, clearer, and louder. As Frank Zappa recalled of his seeing—and hearing—*Blackboard Jungle* at the inception of rock 'n' roll film:

> When the titles flashed up there on the screen Bill Haley and his Comets started blurching "One Two Three O'Clock, Four O'Clock Rock. . . ." It was the loudest rock sound kids had ever heard at that time. I remember being inspired with awe. . . . he was playing the Teen-Age National Anthem and it was so LOUD I was jumping up and down. *Blackboard Jungle*, not even considering the story line (which had the old people winning in the end)

represented a strange sort of "endorsement" of the teen-age cause: "They
have made a movie about us, therefore we exist. . . ."[44]

Though teenagers listening to "Rock Around the Clock" hardly appeared in
Blackboard Jungle, images of fans enjoying the music in rock 'n' roll films gen-
erally offer a communal experience in which audiences may participate; the
two audiences become one, effectively making the movie theater an extension
of the audio-visual space of the high-school prom, the nightclub, and later the
stadium. But, whether superior to a live performance or not, the cinematic
musical spectacle is simultaneously aural and visual, and its pleasures are
fundamentally sexual: the pleasures of seeing and being seen, of hearing and
being heard.[45]

Cinematic spectacles in which hearing and seeing are equally fundamental
and interdependent raise the issues of the relation between image and sound
in their reception, whether they create spectators who also hear or audiences
who also see.[46] Though sound in cinema is generally considered supplemen-
tary to images, certain conjunct audio-visual filmic events may activate both
senses equally, or may even subordinate the image to the sound. But whether
or not seeing is ever preempted or directed by hearing, short visual composi-
tions, certainly those the length of a song, may be sonically structured. Sonic
events, including bar, line, and stanza divisions, other instrumental rhythmic
elements, and shifting relations among voices and instrumentation, may all be
used to organize imagery, camera position and movement, editing, and other
visual components. As sound inflects and directs the visuals, music becomes
an optic through which we see; the audio-visual composition becomes a syn-
esthetic spectacle, a visual music. Over its history, the rock 'n' roll film has
created visual languages appropriate, sometimes more and sometimes less,
to the music presented within them: forms of rock 'n' roll visuality or rock 'n'
roll filmic musicality.[47]

Except in films in the revue format exclusively, the spectacle of musical
performance is surrounded by a second form of representation, the narrative
of the music's social and historical contexts and the mode of its production.
This wider field of representation variously includes the professional and per-
sonal lives of the performers themselves, where they come from, where they
go, and whom they love; the songwriters, back-up and session musicians, and
recording engineers; other artists, those who assist and those who compete;
the agents, promoters, distributors, disc jockeys, and corporate executives; the
fans who consume the music, and the panoply of social agents who encour-
age and facilitate this consumption; those who incorporate, regulate, and dis-
seminate the music, expanding its operations in relation with other forms of
cultural practice and other branches of the entertainment industries—all the
people and apparatuses that comprise the real or imagined world in which
rock 'n' roll exists. As they document its fans' use of it, how and what they

make it mean and how they articulate it with other activities—those imme-
diately adjacent to it like dance, but also everyday life in general—rock 'n' roll
films also have the pedagogic function of disseminating and popularizing
these practices, or of teaching others how to rock 'n' roll. Though television
music shows share these functions, especially in teaching youth how to dress
for and dance to rock 'n' roll, cinema's more extensive narrative and docu-
mentary capabilities has permitted expression of a fuller panorama of peo-
ple's interaction with the music. As much as reviewers and other journalistic
media and sociological and other academic projects, cinema's stories about
rock 'n' roll elaborate and interpret the music's aesthetic and social meanings,
its effectivity and affectivity in the lives of individuals and society as a whole.
Debating and projecting, attacking and justifying these meanings, cinema
makes them sensually present and ideologically resonant. In narrating rock
'n' roll, cinema *theorizes* it.

Such theorizations of rock 'n' roll may be complicated. The spectacle and
the narrative may work in concert, each elaborating and proving the other;
but, as Zappa's anecdote above illustrates, the two may disagree; the nar-
rative may misunderstand and misrepresent the spectacle. So for Zappa,
Haley's performance of "Rock Around the Clock, "represented a strange sort
of 'endorsement' of the teen-age cause," even though the story line "had the
old people winning in the end." As in this case and as, most dramatically,
in Frank Tashlin's *The Girl Can't Help It*, released the next year, such a dis-
crepancy is most common in films whose narrative denigration of rock 'n'
roll is countermanded by the music's power, but it can also occur when a
narrative makes unjustified claims for the music it depicts. Similarly, what-
ever narrative possibilities the music offers may change over time so that the
music's meanings in the present differ from those it had in the past. In most
cases, cinematic representations of rock 'n' roll reflect the values obtaining in
the period when the film is made. But whatever meaning a phase of popular
music has in its own time is subject to retrospective historical revision, so that
within cinema's history of rock 'n' roll runs the history of the changes in the
meaning of its past. From 1950s rock 'n' roll, doo-wop, and British beat music,
through soul, disco, and punk, to yesterday's crunkcore and Christian black
metal, genres and eras of music have multiple meanings: the contested mean-
ings each has in its own time, and the changes in meaning that time brings.
A film about music contemporary with it participates in the negotiation of its
first meanings, but when it concerns earlier music, a rock 'n' roll film negoti-
ates between the music's own moment and the historical moment of the film's
production.

Finally, the representation of the meaning of music in cinema is also
shaped by the mode of the film's own production, for just as at a given
time music as a whole includes various modes of musical production,
cinema includes multiple modes of film production.[48] Most American

films, including classic musicals, are commercial projects, manufactured as commodities in the industrial cinema summarily designated as "Hollywood," which comprises the studios where they are produced, the theaters where they are consumed, the television programs where they later play as reruns, and so on, along with all the people and other establishments involved in these processes. But outside and on the edges of the commodity cinema there have been many forms of independent and semi-independent production: documentaries, especially, but also amateur, experimental, and other non-commodity practices that are created and consumed in alternative institutions. Such marginal, independent modes of film production have been especially important for rock 'n' roll.

When rock 'n' roll emerged in the mid-1950s, the US cinema industry was in a state of transition marked, on the one hand, by the crisis caused by the rise of television and by antitrust rulings against the Big Five studios that owned the large exhibition circuits and, on the other, by the emergence of popular semi-amateur filmmaking, much of it documentary-influenced, that became known as the New American Cinema or underground film. Inspired especially by Maya Deren's claims for the superiority of amateur over industrial filmmaking, these new cinemas were framed by the Beat generation's idealization of the spontaneous collective improvisation of jazz. Many of the most important early underground films were either about jazz musicians or attempts to assimilate the formal properties of jazz to its own visual language. *Shadows* (John Cassavetes, 1959) and *Pull My Daisy* (Robert Frank and Alfred Leslie, 1959), two of the inaugural underground films, were the most celebrated forerunners of avant-garde films about rock 'n' roll. In the 1960s, underground film's association with rock continued to grow, and by the mid-1970s many of the underground's screening venues had become dominated by rock 'n' roll films, most of them independently produced, where they effectively substituted for live performance.

Rock 'n' roll's development as popular innovation on the edges of and sometimes against the established music industry paralleled developments in filmmaking, in both cases, producing the interaction of multiple modes of production, an unprecedented variety of forms of musical film in which the multiple modes of rock 'n' roll culture in its first two decades found representation in different modes of film production: feature films from minor—and later—major studios, independent documentaries, and experimental shorts. Since the 1970s, most rock 'n' roll films have been studio productions concerned with mainstream commercial rock 'n' roll, but independent filmmaking has continued to sustain different narrative or documentary modes with different interpretations of the music's meaning.[49] The rock 'n' roll musical as a whole comprises a spectrum of modes of film production representing the spectrum of modes of musical production. At any given time, the different forms of determination operating on different modes of film production

frame and establish priorities and limitations on both the spectacle of musical performance and narratives about it. Each form invited music and film to join in different dances.

In contrast to the stable productive methods of the classic musical, the changes in films about rock 'n' roll from the mid-1950s to the mid-1970s reflected both the changes in the music's aesthetic and social meaning and unprecedented innovations in the mode of film production. Accounts of rock 'n' roll produced by the film industry tended to reflect the values of capitalist culture, while those made independently proposed other meanings, reflecting ideological possibilities and constraints of their own means of production, with bottom-up independent productions usually more sympathetic to bottom-up forms of music in which rock 'n' roll originated and in which it has continually renewed itself. With the exception of Frank Tashlin's satire on rock 'n' roll, *The Girl Can't Help It*, made at Twentieth Century Fox, the major studios ignored the new music, and films about it in the 1950s were independently produced by small exploitation studios, especially American Independent Pictures (AIP). Independent production of this kind continued into the 1960s, even as the major studios eventually entered the field with Elvis, primarily at Paramount and MGM, and then the Beatles in the United Kingdom at United Artists. Otherwise, the mid-1960s counterculture baffled the major studios as much as early rock 'n' roll had, and the music was primarily represented in minor cinemas, especially in independently produced documentaries, from *Dont Look Back* (D. A. Pennebaker, 1967) to *Woodstock, Gimme Shelter* (Albert and David Maysles and Charlotte Zwerin, 1970), and beyond. But in the late 1960s, when more than any other band the Rolling Stones seemed to address the political disillusionment that accompanied the disintegration of the counterculture, the band was represented in alternative or avant-garde modes of production. Hollywood was only able to reassert its hegemony as rock 'n' roll's combination of black and white music split again into separate streams, generating blaxploitation on the one hand and films about country music on the other.

These developments in music, in film, and in films about music between the mid-1950s and the mid-1970s coincided with and contributed to shifts in the relative importance of the two mediums and of other components of industrial culture they mobilized. Despite the challenges of television in the mid-1950s, film still retained its position as the most important medium, in many ways as much the model and inspiration for the other arts as it had been since the early years of the century. A decade later, rock 'n' roll and the forms of popular music from which it derived and into which it mutated had replaced cinema as the medium in dominance, especially for youth. Record sales doubled in the period to reach $1.6 billion, and for the first time exceeded the revenues of all other components of industrial culture.[50] Combining the operation of capital and of cultural resistance to it, rock 'n' roll and, as it later

became, simply "rock" replaced cinema as the most popular, the most democratic art. As its various forms penetrated all aspects of life, it became the chief means by which people in the North Atlantic and eventuallly the world discovered and performed their aesthetic and social values, the medium in which the culture breathed.

The corpus of rock 'n' roll films, especially as it appears in the alphabetized lists of popular guides, may seem a directionless miscellany, with none of the generic consistency and stability of the classic musical. In fact, cinema's encounter with the new music produced a structured evolution that marshaled innovations in sound-image relations, formal and narrative strategies, generic variations, and new and old modes of production, all responding quite directly to epochal cultural, ideological, and social developments. From the mid-1950s to the mid-1970s, rock 'n' roll films narrated a myth of the contested emergence, maturation, and eventual decline of a fundamentally biracial cultural initiative that accompanied, sustained, and in some ways preceded the utopian politics of the same period. Cinema and rock 'n' roll, musicality in the former and visuality in the latter, engaged in a complex dance: a *pas de deux* of approach, retreat, struggle for mastery, and virtuoso turns, with the one variously elaborating or challenging the other. Cinema offered immense possibilities to rock 'n' roll: the expansion of sonic qualities into visual compositions and narrative embodiments, all with the cultural prestige of what had previously been the century's most important art. Conversely, the music had its own allures for film: the freedom and creativity of youth, the desire and bewitchment that it seemed to embody and which made music the newest and most dangerous of cinema's rivals.[51] In its dreams, cinema found itself dancing with rock 'n' roll.

Absolute Beginnings

BLACKBOARD JUNGLE

The first film to feature rock 'n' roll was *Blackboard Jungle*. Released on March 25, 1955, half a year before *Rebel Without a Cause* (Nicholas Ray, 1955), it inaugurated the synergistic interaction between cinema and the new music, and introduced the ideological tasks and entertainment opportunities that subsequent rock 'n' roll films would pursue. Rock 'n'roll made the film a scandalous success, and in return the film made its theme song a hit and introduced the musical issues around which rock 'n' roll cinema would revolve: the spectacle of musical performance and the narration of its meaning.

Blackboard Jungle (Figure 2.1) was directed by Richard Brooks from a screenplay he himself adapted from the best-selling novel by Evan Hunter, published the year before, four years after John Huston's noir bank-robbery movie, *The Asphalt Jungle*, whose title it clearly echoes.[1] Both novel and film echo Huston's social binary pitting an honest cop against criminal elements, but it locates the social jungle in an inner-city New York school, where the predatory beasts are unruly teenagers. It featured Glenn Ford as Richard Dadier, a Navy veteran taking his first job as an English teacher, who struggles to maintain his idealism and integrity, and some semblance of order among his ethnically mixed, working-class seniors. To get it made, producer Pandro Berman battled both the MGM front office, who feared it would constitute communist propaganda, and the Production Code Administration, which demanded a reduction of the script's viciousness.

The most charismatic of the students is an insolent black youth, Miller, played by Sidney Poitier in his breakout performance.[2] But otherwise they are dominated by a clique of delinquents, led by Artie West (Vic Morrow), who disrupt classes, challenge the teachers' authority, and even attempt to rape one of them; outside school, they engineer the heist of a newspaper truck. Refusing to succumb to the more experienced but demoralized teachers who cynically believe that the students are all "garbage," Dadier struggles to gain

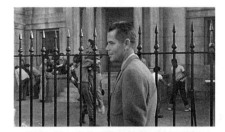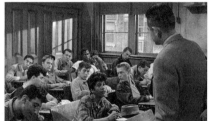
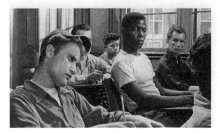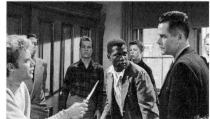

FIGURE 2.1 Blackboard Jungle.

their interest and trust, and to break the hoodlums' hold. He refuses to be intimidated or deterred, even when the delinquents mug him and send his pregnant wife letters accusing him of having an affair with a fellow teacher, which almost causes her to miscarry their child. Eventually he wins their respect and kindles their interest in learning, and when in the climax the incorrigible West attempts to knife him, Miller and the rest of the class turn against the miscreants and come to his assistance. Agreeing that there is "no place for these in the classroom," they pack them off to the head teacher and thence to reform school.

Though the narrative's pedagogy focuses on a couple of irredeemably villainous students and excludes them from the barrel of the good ones, its overall attitude to delinquency is tempered: first, by the police officer investigating Dadier's mugging, who attributes their gang membership to the absence of home and church life during their childhood, when their fathers were in the army and their mothers were working in defense plants; second, by the liberal belief that the mass of the apparently felonious students are fundamentally decent; and third, by a reversal of racial stereotypes. Despite the resonances of the title, the two main delinquents are both white, and Miller, as in the novel, is a proud, dignified, and fundamentally ethical black youth.[3]

The narrative contains no rock 'n' roll performances, but the recording of "Rock Around the Clock" by Bill Haley and His Comets accompanies the title sequence and the introductory scenes in the schoolyard as Dadier arrives for his first class. These scenes are preceded by a drum solo, playing behind a scrolled text describing the problem of juvenile delinquency in American schools and justifying the film on the grounds that "we believe that public

awareness is a first step toward a remedy." The drum dissolves into Haley's recording, and the following scenes, which show the youths confined behind the schoolyard's bars, dancing, moving their bodies and snapping their fingers, banging trashcan lids, and making cat-calls to a passing woman, are all apparently so much in time to the song as to make it seem semi-diegetic. With its heavily syncopated 4/4 beat and stunning guitar solo by session player Danny Cedrone, the record references many musical and verbal elements of earlier blues and country forms, and sustains the ambiguity of the lyrics' intention of hourly renewed "rocking" all through the night. Though the musical and sexual references of the terms "rock" and "rock and roll" had existed underground in black music for many years, their initial association with the hostile youth in the schoolyard gives the song's celebration of unleashed juvenile hedonism a new menace. As the song plays, Dadier uncertainly makes his way through the kids and, just as it ends, he enters the school building, crossing the boundary from jungle to civilization. The record is also heard over the end titles and is reprised as an instrumental underscore when the students assault him, thus framing the film and so thoroughly permeating the insubordinate teenagers' spatial and ethical environments that it becomes identified with them: it is their music, and it reflects their delinquency.

In the fall of 1954, when the movie was being shot, rock 'n' roll was still largely a regional teenage taste and was not yet a significant cultural issue. In a court case that November, Alan Freed lost his right to the Moondog sobriquet and began calling his WINS radio show the "Rock 'N' Roll Party"; and on January 15 he held his first live show in New York, "The Rock 'N' Roll Jubilee Ball." Haley had been performing the song since 1953, and had recorded it earlier the same spring, some three months before Elvis recorded "That's All Right" in July 1954.[4] It had been a minor regional hit in the Philadelphia area, but would have disappeared had not what appears to have been a chance occurrence led to its inclusion in the film. After *Blackboard Jungle* had been edited, Richard Brooks heard the record and persuaded MGM to buy the rights for $5,000 for its three uses, with an especially extended version being used for the title sequence.[5] In May 1955, two months after the film opened, "Rock Around the Clock" was reissued and immediately became a huge hit, culturally as significant as the detonation of the United States' first and biggest hydrogen bomb on Bikini Atoll the month before the record was made—and, many thought, equal in the contamination it discharged. In July it became the first rock 'n' roll song to top the *Billboard* pop singles charts, remaining there for eight weeks, and it also found an African American audience, reaching number fourteen on the rhythm and blues charts. Eventually it sold three million copies. Reciprocally publicizing, film and record together became notorious and lucrative, with frenzied jubilation from below augmenting apoplectic fear from above that linked it to threats of communism abroad and the escalation of juvenile delinquency at home—all of which was

deliberately exploited by MGM's publicity department. Local film boards, especially across the South, responded by banning the film, and the Kefauver Committee, in Hollywood for its investigation of organized crime, accused it of encouraging the very activity it indicted. It may well have been right, for—like Frank Zappa—at least one other radical musician of the next decade recalled his understanding that it was "about high school kids telling the teachers to fuck off and leave us alone."[6] News accounts of the riots that were supposed to have accompanied US and European screenings fueled the commotion. Though *Blackboard Jungle* was to have been the official US entry at the 1955 Venice Film Festival, Clare Booth Luce, wife of the powerful magazine publisher Henry Luce, then ambassador to Italy, decided it was violent and derogatory, and forced its withdrawal, only detonating further consternation on both sides of the Atlantic. Noting encomia in some countries and attempts to exorcise it in others, *Variety* reported that it became "the most highly publicized film on the worldwide market,"[7] and it was largely responsible for establishing the association of rock 'n' roll and violence. Two years later, the trailer for *Jailhouse Rock* would describe Elvis's character as "a tough *Blackboard Jungle* kid."

The narrative specifies the social implications of "Rock Around the Clock" by contrasting it with other forms of music, both diegetic and non-diegetic, and also other media. Early in the narrative, when Dadier meets his wife in a restaurant to celebrate his job, he plays an orchestral version of "Stranger in Paradise" on the jukebox. The fervent ballad from the recent musical *Kismet* supplies a nimbus for their romance, as well as advertising the film version that MGM released a few months after *Blackboard Jungle*, and it is reprised as underscore several times as a leitmotif for their marriage, most poignantly when Dadier's wife reads the scurrilous letters about his supposed infidelity. But as they leave after their meal, the song modulates into a hot jazz piece that accompanies an electrifying scene in which they only narrowly escape hooligans who crash a hotrod on the nighttime streets. A similar segue occurs when Dadier accompanies Edwards, a math teacher and collector of jazz records, to a bar to commiserate with after-work cocktails. The Stan Kenton Orchestra's record of "Invention for Guitar and Trumpet" plays on the jukebox; but when the inebriated teachers leave, it dissolves into a hot jazz instrumental underscore based on the "Rock Around the Clock" theme as the young hoods viciously beat both teachers in an alley. Recordings of hot jazz also appear diegetically in a key scene in which Edwards brings a portable record player and his collection of rare jazz 78s to his math class, hoping the students will respond to his tastes. He plays Bix Beiderbecke's "Jazz Me Blues," but they ridicule him and the music, demanding instead to hear "bop"; then, accompanied by another hot jazz underscore, they knock him to the floor and dance crazily among the desks, while West callously throws the fragile records around the room, finally upending and smashing the entire case.

Against this delinquent recorded music, the film proposes the virtue of two forms of live performance. Traditional black vocal music is introduced via Miller: a naturally gifted pianist, he is seen rehearsing "Go Down Moses" with a vocal group comprised of other black students, but he reprimands them for performing the spiritual in a "jazzed–up" style; and, signaling his shift toward an alliance with Dadier, he volunteers his group to perform the song at the school's Christmas concert. Even more schematically (and in a scene not present in the novel), after Dadier is attacked he visits a school outside the inner city to seek advice from his college mentor, whose well-behaved, motivated, wealthy students are seen compliantly singing the "Star Spangled Banner." The narrative also references other mass-cultural non-musical media: a tape recorder and a 16-mm film projector. Though Dadier hopes that recording his students' speech will kindle their interest in language, an anecdote spoken into the machine by a Puerto Rican pupil degenerates into racial name-calling. None of these media can penetrate the students' cynicism until, at the climax of the third act, Dadier brings a movie projector to class and screens a cartoon of *Jack and the Beanstalk*. At last he is able to stir the students' interest. Suspending their disruption, they become engrossed in the story until it ends with Jack killing the giant and marrying the princess, and—all but West, who defiantly dismisses it as "lousy" because it lacks "dames"—they eagerly debate its implications. Despite the cartoon's clichéd ending, the students find it rich with ethical issues, some arguing that Jack is a square and a murderer, others that it proves that crime always pays. But, prodding them into reading it as an allegory of crime and punishment and especially of racial difference, Dadier persuades them of the importance of thinking for themselves.

These incidents assemble a lexicon of various forms of music and other media, whose connotations the film evaluates and aligns with its ethical distinctions among characters and events (see Figure 2.2).[8] Underscoring the attacks on Dadier and Edwards, the rock 'n' roll of "Rock Around the Clock" is emphatically the music and the dance of juvenile delinquents. As Haley's record accompanies Dadier's first glimpses of his pupils, immediately all rock 'n' roll's visual correlatives are displayed: jitterbug dance steps, blue jeans, T-shirts, leather jackets, and slicked-back "duck's ass" hair styles. This delinquent music is contrasted with the music of Dadier and the other adults and Miller: *Kismet*, the "Star Spangled Banner," and gospel music (as long as it is not "jazzed up"). Swing jazz occupies an unstable, shifting position between these extremes, reflecting the historical itinerary by which it became respectable, middle-aged and middle-class, as its associations with delinquency migrated to rock 'n' roll. The hot swing of the records that Dadier and Edwards play in the bar is not yet categorically differentiated from rock 'n' roll, so vestiges of its waywardness are reaffirmed as the two teachers leave the school and get drunk in the bar, and motivate the dissolve into the jazz

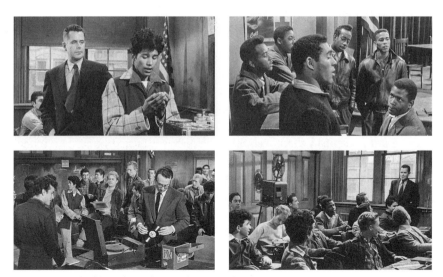

FIGURE 2.2 Blackboard Jungle: *Youth and media.*

version of "Rock Around the Clock" in the mugging scene. Elsewhere, tradi-
tional Dixieland jazz played by white musicians is positively marked: though
ineffectual but well-meaning teachers like Edwards appreciate it and recog-
nize its resemblance to mathematics, the students deride it. Similar distinc-
tions are made among the technologies that Dadier uses in his attempts to
reach the students. His tape recorder is another sound technology that they
understand as a means of making a *record*, and, like Edwards's jazz records, it
fails to interest them. Only cinema, in the form of the audio-visual narrative
of the *Jack and the Beanstalk* cartoon, can engage their imagination, and so
enable his pedagogic triumph.

As the excited students leave the classroom after the discussion of the film,
the other teachers enthusiastically crowd around Dadier as he rewinds it. One
of them congratulates him, "You finally got through to them," while another is
so encouraged that he agrees to play Santa Claus in the upcoming Christmas
show. Their recognition of Dadier's achievement and the consensus that film
can facilitate ethical education allows the drama to move to its resolution.
The incident is quite brief; nevertheless, positioned as *Blackboard Jungle's*
peripety, its assertion of cinema's redemptive power is thematically pivotal.
Succeeding where all else fails, film breaks the deadlocked institutional and
generational confrontation, and demonstrates its categorically superior value
over and against music, especially heavily rhythmical recorded dance music,
which always promotes disorder and crime. With radio and certainly tele-
vision excluded from the taxonomy, cinema is reflexively affirmed over and
against all other media. The narrative's calibration of the various charac-
ters' social worth ratifies and reciprocates the media taxonomy with which

they are associated. Just as the opening scroll proposes cinema's role in rais-ing awareness of juvenile delinquency as the film's raison d'être, this local instance is an object lesson dramatizing the same pedagogic function: cin-ema alone can rescue society from the disorder of rock 'n' roll.

The identification of rock 'n' roll and delinquency, which culminates inevi-tably in the expulsion of the inveterately depraved kids, is structurally mir-rored in the placement of their music. The sound of "Rock Around the Clock" cannot pass from the yard into the school building in the opening sequence; nor may it appear in the diegesis proper. The theme may be heard in the stu-dio orchestra's underscore, but Haley's performance may not be made visibly present, and the record may only be heard when confined to the soundtrack in the non-diegetic title and end sequences: the movie's exergual spaces, not entirely out of the film, though not fully in it either. But in this liminal space, lying in wait for the movies that will fully admit it, rock 'n' roll surrounds the film, laying claim to it as a whole, and so cementing the identification that allowed "Rock Around the Clock" and *Blackboard Jungle* to ignite each other in the spiraling dance of scandal and success that began in the serendipitous introduction of one to the other.

Though negative, the massive publicity that cinema and rock 'n' roll pro-vided for each other was commercially advantageous for both, an apparent disjuncture between ethics and economics that is one of the root contradic-tions of capitalist culture and one that has ever since been fundamental to both the cultural meaning of rock 'n' roll and its marketing. Though ostensibly condemning both delinquency and rock 'n' roll, the film exploited their inter-woven excitement and notoriety for its own profit. Even before it was released, this contradiction was announced in the trailer, the film's own advertisement for itself, where its pleasures were limned: as the record plays, a stentorian off-screen voice intones, "You are now listening to 'Rock Around the Clock.' This is the music from MGM's sensational motion picture . . . [about] teen-age savages who turn big-city schools in a clawing jungle." Allowing rock 'n' roll and the movies to promote each other, such conjoined enticement and condemnation quickly became an ongoing symbiosis. Cinema ignited mass national and international interest in the new music, and henceforward both media would renew themselves in using and being used by the other. And in giving the identification of musical and social delinquency such a dramatic audio-visual form, *Blackboard Jungle* discovered, however unconsciously or inadvertently, the main issues that would subtend subsequent pop musicals.

First, the formal and structural issue: since rock 'n' roll was too exciting and controversial to be confined to title sequences or other margins, ways had to be found to incorporate it into the diegesis proper. Second, the narra-tive and ideological issue: the music's visceral pleasures and infractions had to be mobilized, and the associations with delinquency that made it attrac-tive for teenagers had to be exploited, but without any endorsement of social

disruption. And third, the institutional problem: anxieties about competition between and convergence among different components of industrial culture raised in the film's reflexive endorsement of cinema over popular music had to be addressed; but, explicitly or implicitly, cinema's primacy over and ability to assimilate rock 'n' roll had to be demonstrated. Given the devastating competition from television, the movies had to demonstrate that rock and' roll was not a social menace, but also that it did not threaten cinema's position at the apex of the culture industries' received hierarchy. Despite its identification with African American music and dance and despite its initial production in marginal studios, the new popular music had to be assimilated into the music industry and contained within the apparatus of capitalist commodity entertainment as a whole.

Consequently, the narratives of the first rock 'n' roll films jettisoned *Blackboard Jungle*'s noir menace and proposed a sunny innocuity in rock 'n' roll records, concerts, radio and television shows, and so on—while subordinating all of them to cinema. This latter was still deeply problematic. However short-lived a fad it was expected to be, rock 'n' roll was sufficiently controversial and potentially remunerative that it could not be ignored, though for the first few years the major studios were generally obliged to hold it at arm's length and defer explicit articulation. Meanwhile, stories about rock 'n' roll were taken up by marginal modes of production, low-budget black-and-white exploitation features marketed to teenagers. And the way they told the story, the emergence of rock 'n' roll was the emergence of the rock 'n' roll industry into a prominent but still subordinate position within the television industry, which was itself contained within cinema.

In October 1955, six months after the release of *Blackboard Jungle, Rock 'n' Roll Revue*, a feature-length compilation film, was released (Figure 2.3).[9] Directed by Joseph Kohn for Studio Films, it was composed of sequences of African American musical numbers, along with several tap-dance and comedy acts introduced by the comedian Willie Bryant, who uniformly praises them, with some testament to their high-quality entertainment value. With each act framed by the opening and closing of a theatrical curtain, intercut with stock footage of a mostly African American audience, and accompanied by an applause track, the film appears to document a live concert. In fact, some of the acts had been shot in Hollywood by Snader Telescriptions around 1951, with the others, distinguishable by Bryant's interaction with artists, newly shot in New York by Studio Telescription in 1954. The earlier artists filmed included jazz greats Duke Ellington with his drummer, Louie Bellson, Lionel Hampton, and Nat "King" Cole, while the more recent ones were squarely rhythm and blues (or "blues and rhythm," according to one of Bryant's introductions): Dinah Washington, Big Joe Turner, The Delta Rhythm Boys, Ruth Brown, Larry Darnell, and The Clovers (whose "Your Cash Ain't Nothin' but Trash" was a hit in

FIGURE 2.3 Rock 'n' Roll Revue: *Nat "King" Cole.*

1954). Big Joe Turner's number "Oki-She-Moke-She-Pop" is fully rock 'n' roll, and in fact Turner would appear in an important rock 'n' roll film, *Shake, Rattle & Rock!* (Edward L. Cahn, 1956) the year after *Revue* was released. The chief comedy routine is an extended skit involving Bryant, two tap-dancers, and another dancer playing an unscrupulous booking agent, who promotes himself rather than his clients. The entire production is crude and glaringly artificial, Bryant's performance is wooden, and the photography of the rhythm and blues numbers rudimentary. All are based on a master-shot frontal to the artist that dollies in and out very slightly, interspersed with medium close-ups and a few brief cuts to the soloist during the instrumental break. Only two close-ups of the singer and one of her sax player, for example, vary the master in Ruth Brown's "Tears Keep Tumbling Down," and Turner's "Oki-she-moka-she-pop" alternates between long takes from the two frontal positions for the singer, with three short cuts to the sax. But the numbers made in Hollywood are more sophisticated. The first, Ellington's band performing "The Mooche," dispenses with a master and instead cuts freely among half-a-dozen camera positions, with medium shots of different sections of the band and close-ups of soloists. The editing is occasionally fairly rapid, allowing only a couple of bars for the bass before the trombone picks up his line, for example, and overall it is a sensitive, well-crafted visual composition, responsive to the music's structure and rhythm. Cole's performance of "You Call It Madness (But I Call It Love)" is similarly subtle; a master of all three members of his trio provides a frame into which are inserted extended close-ups of Cole's face as he sings, sometimes moving to his

fingers on the piano keys, and on the guitarist and bass player for their instrumental breaks.

The project that the earliest rock 'n' roll films undertook was to combine the modes of *Rock 'n' Roll Revue* and *Blackboard Jungle*, to marry the former's representation of rock 'n' roll performance, especially by African American artists, with the latter's narration of its social meaning, but specifically to dispute its musical, social, and industrial threat. Referencing their social milieu and the hit records they featured, they became known as "Jukebox Musicals."

Jukebox Musicals

Blackboard Jungle's release in March 1955 closely followed Alan Freed's Rock 'n' Roll Ball in January 1955 at the St. Nicholas Arena in Harlem and his other dance concerts in New York that first promoted black performers as rock 'n' roll artists and justified their records being advertised as rock 'n' roll rather than rhythm and blues. Presiding over the summer of the music's national notoriety announced by *Life*'s April 1955 report, "Rock 'n' Roll: A Frenzied Teen-Age Music Kicks Up a Big Fuss,"[1] the film preceded the release of two seminal records, Chuck Berry's "Maybellene" in July and Little Richard's "Tutti Frutti" in November. *Blackboard Jungle*'s enormously successful cross-promotion of the film and the new music was noticed by Sam Katzman, an independent producer who since the mid-thirties had specialized in quickly made and marketed low-budget films, including those designed to exploit sensational current news items. Nicknamed "Jungle Sam" after his Johnny Weissmuller "Jungle Jim" series, he had specialized in exploitation films for the teenage market since the late 1940s. In the year before *Blackboard Jungle*'s breakout, he had produced—along with nine other similarly auspicious titles—*Jungle Moon Men* (Charles S. Gould), *Creature with the Atom Brain* (Edward L. Cahn), *Devil Goddess* (Spencer Gordon Bennett), and *Teen-Age Crime Wave* (Fred F. Sears). They were all the kind of films that iconoclastic critic Lester Bangs later designated as "true rock 'n' roll movies," and the last of them invoked rock 'n' roll in its advertising, though it did not actually contain any.[2] Katzman rehired Sears, then at the height of his skills as an exploitation director, to cash in on rock 'n' roll; and to avoid any confusion and take advantage of the free publicity, he appropriated Haley's song. Shot in the last two weeks of January 1956 and released on the first day of spring, *Rock Around the Clock* turned a song into a film.

Rock Around the *Clock*

The first film to show rock 'n' roll performances was a backstage musical framed as a romance between a promoter and a young dancer, who together

discover and popularize the new music.[3] It begins when Steve Hollis (played by Johnny Johnston, himself a singer and veteran of 1940s Hollywood musicals) is fired from his job as manager of a touring ballroom band for announcing that since it no longer makes people dance, big band music is dead and, moreover, "people aren't dancing any more, they're listening." Driving back to New York, he spends the night in Strawberry Springs, a small mountain town, where he discovers that a local amateur combo making music at the "meetin' hall" has all the local kids exuberantly jitterbugging. Bill Haley and His Comets, playing a group of farmers led by a mechanic, are introduced performing their follow-up hit, "See You Later, Alligator," while Lisa Johns, a local girl who is also their manager, leads the kids in new dance steps.[4] The teenagers have their own music and dancing, and a beat jargon with which they draw a curtain against squares like Steve, who is mystified by Haley's sound. Though it resembles earlier forms, he remarks, it also differs markedly from them: "It's not boogie, it's not jive, it's not swing," he observes on first hearing it, "It's kind of all of them." Believing that what the kids tell him is "rock 'n' roll" will "get the people dancing again," he decides to make his and the group's fortunes by marketing the new music nationally, and signs them to a management contract. He attempts to seduce Lisa, but she out-maneuvers him and they fall in love, thus setting the classic musical's dual focus narrative in play.

Steve packages a revue consisting of Haley and His Comets and another (real-life) band, Freddie Bell and the Bellboys,[5] who also appear to have formed spontaneously in Strawberry Springs, along with Lisa and her brother Jimmy featured as dancers. But his plans to promote the revue are frustrated by an old flame, Corinne, manager of the biggest booking agency in the nation, who is determined to marry him. Intending to destroy the group's reputation, Corrine books them for the prom at a wealthy girls' high school, along with the Bellboys and Tony Martinez and his Mambo (the mambo then being promoted as an alternative to rock 'n' roll). The matrons are horrified by Haley, one exclaiming "Barbaric!"; but Lisa's dancing inspires the students to join her on the floor, and the package is a smash. Still determined to crush Steve into submission, Corrine blackballs the band. But Steve hears Alan Freed's rock 'n' roll radio show, and since Freed (seen in his screen debut) owes Steve a favor, he gives Haley a break at his nightclub, where the Platters (already the most successful doo-wop crossover group) are seen performing their hit, "Only You." A montage of cross-country trains and dancing youth indicates that the exposure has put the Comets on the road to success. Rock 'n' roll has got the people dancing again, and, on the condition that Lisa will preserve her status as a sex symbol by signing a contract promising not to marry for three years, Corrine ends her embargo and the band's success is assured. The film culminates in Los Angeles at the Hollywood Hall with a nationally televised "Rock an' Roll Jamboree," essentially an abbreviated version of Freed's spectaculars, which he MCs. Just before it concludes with

Haley's performance of the title song, Lisa reveals that she and Steve were in fact married before she signed the contract, so resolving the dual focus romantic narrative.

Rock Around the Clock's origin myth of rock 'n' roll and vision of its social meaning both squarely contradict *Blackboard Jungle*. Though linked with the Platters, rock 'n' roll's genealogy is stripped of any identification with black or mixed-race, working-class urban delinquents, and its only recognized roots are in hillbilly culture. Depicted as emerging spontaneously yet fully formed as a *sui generis* artisanal amateur folk music, it is played by white adults for white teenagers in an isolated, self-contained, white working-class rural community, free of any acrimonious generational or other divides. Its immediate migration to adult metropolitan nightclubs and thence to the core of industrial culture is simply a matter of strategic management that is resisted, not by any general social fear or vested musical interests, but only by a jealous lover. Corinne's attempt to manipulate *haute bourgeois* outrage to derail rock 'n' roll only briefly delays its ascent and its effortless transcendence of its actual class, ethnic, and regional origins to become irresistible for youth and for the nation as a whole. Rather than disrupting society, rock 'n' roll channels innocuous energy and joy into exuberant dance; and rather than threatening established forms of entertainment, it saves them from the vacuum of swing's obsolescence. Fully realized in a televised spectacular in Hollywood, the new music is seamlessly integrated into the other branches of the culture industries, where it combines commodity and folk functions; rock 'n' roll is industrially produced music for popular dance.

Rock Around the Clock (Figure 3.1) inaugurated the rock 'n' roll film by renovating the conventions of the classic show musical. Structurally bipartite, it is composed of the spectacle of music and dance performances set in a fictional narrative matrix. The performances, though not the song lyrics, are integrated into the diegetic world and propel the plot, which conversely winds through them and the impediments the performers encounter. Like its classic musical predecessors, its narrative components are composed of the off-stage adventures of its stars, in the course of which the institutions and practices of the entertainment industry are depicted, the experiences of its workers are revealed, and the interdependency of their professional and romantic lives are dramatized. Though the girl, Lisa, has less autonomous agency than the boy, Steve, the dual focus recurs, with each of them embodying different aspects of the entertainment industry, and their different skills and values are finally reconciled to allow her typically generic orientation to domesticity (that she shares with Corrine) to be realized in their marriage. Their shared diegetic task is to overcome the minimal adult and industrial opposition to rock 'n' roll and to ensure that the show goes on. They must develop the social and institutional contexts that will demonstrate rock 'n' roll's propriety as both music and dance, vanquish its detractors, and sustain

FIGURE 3.1 Rock Around the Clock: *Rock an' Roll Jamboree.*

its progress to a spectacular finale, where simultaneously their professional ambitions are successfully completed, their romantic union achieved, and any remaining subplots resolved. Celebrating rock 'n' roll's ability to create a harmonious community, the finale also creates a summary image of the newly restructured culture industry. As a filmic representation of a television show featuring teenagers dancing to music produced by musicians miming to records, this completed form of the migration of the Strawberry Springs' folk art to mass art is multiply mediated; but any alienation within the mutually impacted forms of commodification appears to be transcended in the audience's joyful participation. Rather than negating rock 'n' roll's utopian social promise, industrialization fulfills it on a national stage.

Unlike *Blackboard Jungle*, *Rock Around the Clock* was able to include rock 'n' roll performance, give it visual representation in the diegesis, and justify it with a positive social function. Variations on this acceptance structured most of the rock 'n' roll films that followed in the next few years. These paralleled the backstage musical in that a number of rock 'n' roll performances bringing musical producers and consumers together are set in a narrative of a romance between a main male and a subordinate female rock 'n' roller,

whose love is sparked, delayed, and finally consummated. Narrative closure achieved in a community celebration, not in a cornfield in Oklahoma, but in a Hollywood rock 'n' roll emporium; there the young protagonists and their fans listen and dance, sometimes joined by the previously hostile adults and representatives of civic agencies who have finally learned that rock 'n' roll is musically valuable and socially salutary. The narrative is transacted in a rock 'n' roll world of pizza joints, soda fountains, and jukeboxes, high-school halls and theaters, and culminates in a successful revue, often broadcast on radio or especially on television. In the true first rock 'n' roll film, Katzman renovated the conventions inherited from the classic musical and established their future viability. Despite its overall prototypically, however, *Rock Around the Clock* differed from the genre it launched in that its narrative focused on and elaborated not only the music but also two other ancillary motifs: amateur dance and professional management. Bill Haley and His Comets were the main attraction, but Steve and Lisa were the main protagonists.

As in *Blackboard Jungle*, Haley's epochal record plays over *Rock Around the Clock*'s introductory titles, but apart from a graphic of a musical staff with decorative notes winding into space and the main title jiggling over it, the only visuals indicating the film's appeal are still photographs of the upcoming musical acts. Live action begins with a couple of long shots of the moribund swing band before Steve is fired, but not until he gets to the Strawberry Springs hop, almost ten minutes into the movie, do the Comets appear. Their performance of "See You Later, Alligator" is introduced by a high, wide-angle shot of the dancers, with the musicians barely visible behind them. The band is seen in a few brief medium shots during the song, and medium close-ups show Steve's attempts to talk to the kids. Otherwise the camera's attention is captured by the jubilant dancers: whether seen from above so that their frenetic action creates vibrant patterns in the shadows on the floor, or seen from low angles that reveal the girls' legs as their skirts fly up; whether seen in wide angle as a pulsating crowd or seen up close doing virtuoso acrobatics, the energetic dancers supply the music's visual analogues. *Blackboard Jungle* reiterated the hierarchies of nineteenth-century musicology, privileging pure music and listening over lower forms involving the body; it approved the stationary students singing the national anthem and Edwards's sheer auditory pleasure in jazz, but stigmatized the students' physical response to it. As *Rock Around the Clock*, on the other hand, rejects the association between the music and delinquency, it affirms exuberant, sensual dance—the utopian "other" of fighting—and, taking advantage of cinema to display it, disseminates a communally joyful and somatic musicality. Modeling the spectators' response to the music and to the film itself, rock 'n' roll dancers begin to teach film how to dance with the new music (Figure 3.2).

Reflecting the emphatic beat and the perceived lack of specifically musical qualities, mid-fifties rock 'n' roll was understood as essentially dance music,

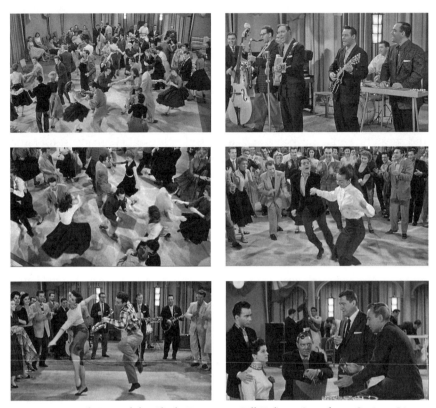

FIGURE 3.2 Rock Around the Clock: *Dancing to Bill Haley at Strawberry Springs; Lisa teaching the kids to dance; Steve making the deal.*

with the unruly abandon of its dance styles being itself scandalous and sup-posed to incite other forms of physical transgression. The Lindy Hop per-formed by the kids at Strawberry Springs and the Hollywood Jamboree began in Harlem the late 1920s; it became mainstream in the 1930s, and continued as popular practice through the swing era—and was sometimes featured in films.[6] Rather than producing new dances, mid-1950s rock 'n' roll saw white kids embracing earlier black forms, just as they embraced black music and, until more kinetic strategies for filming musical performance were inno-vated, especially by documentary filmmakers, their dancing remained the chief means of visualizing rock 'n' roll. As the best expression of the music's meaning, dance remained integral to the rock 'n' roll musical, and in some later periods became dominant, most notably in the disco era with *Saturday Night Fever* (John Badham, 1977) through the 1980s with *Fame* (Alan Parker, 1980), *Flashdance* (Adrian Lyne, 1983), and *Dirty Dancing* (Emile Ardolino, 1987). Anticipating these, *Rock Around the Clock* proposes that at a point of crisis in popular dance, the meaning of rock 'n' roll is the dancing it inspires. It invented the rock 'n' roll film as primarily a dance film, and hence a

genre that completes itself, not merely in the spectator's mental assimilation of the narrative or aural appreciation of the music, but as a response to its somatic imperative, the invitation to dance.[7] Indeed, many contemporary press accounts emphasize rock 'n' roll films as provoking people to dance along with them and of the films being linked to dance events. At the first screening in Philadelphia of another early jukebox musical, *Rock, Rock, Rock!* (Will Price, 1956), for example, nearly four hundred theater patrons were reported to have begun dancing in the aisles and lobby so enthusiastically that police had to be called to clear them. Taking advantage of this enthusiasm, another theater exhibitor staged a dance marathon in coordination with films.[8] And in England, a popular humor magazine had already depicted a rock 'n' roll movie transforming a cinema into a dance hall, an anticipation of cinemas soon becoming a major venue for rock 'n' roll concerts (Figure 3.3).

The focus on dance and management rather than music also inflects the representation of the rock 'n' roll performances. None of the musicians, not even Haley, have a significant role in the narrative and, despite the music's enormous power, the narrative continues through the numbers rather than halting to allow them visual autonomy. As the narrative continued through the introduction of the Comets in Strawberry Springs, so in the Platters' later nightclub sequence, the record runs continuously on the audio track but the visuals are intercut with Steve's arrival and his meeting with Freed. No musical number is photographed in its entirety, no single performer is seen in close-up, and even in the Jamboree finale, the showcasing of dance and the narrative's interruption of the performances continue. Four songs are featured in it: "Giddy-up a Ding Dong" by the Bellboys; "The Great Pretender," the Platters' first number one hit and the first record to top both rhythm and blues and pop charts; the Comets' instrumental "Rudy's Rock" (reputedly recorded live on set); and finally their reprise of "Rock Around the Clock," which thus encloses the film, as it had *Blackboard Jungle*. Some innovations in these sequences do visually augment the music: in "Rudy's Rock" the camera follows the bass and saxophone players' crazy antics, and in "The Great Pretender" Tony Williams's celestial tenor expressing his love is coupled in a medium close-up with vocalist Zola Taylor's similarly celestial face. Otherwise, each sequence consists of a wide-angle master, varied by medium shots of several performers and interrupted by cut-aways to the audience. The finale brings on both the Bellboys and the Platters, who clap along with Lisa and Jimmy's dance, as the entire studio joins in dancing to celebrate the national community of rock 'n' roll.

This national success resolves the formal and ideological problems that rock 'n' roll presents and the narrative motifs pivoted on Lisa and Steve, the couple who carry the paired romantic and industrial story lines. Though they infuse the Lindy with disciplined ballet and jazz movements rather than referencing popular street-level innovations, the dance routines that Lisa and

" *No thanks—I think I'll sit this one out.*"

FIGURE 3.3 *Cartoon,* Punch *September 12, 1956.*

Jimmy demonstrate are integral to the film's dual focus and to Steve's overall promotional package; its overriding function, he argues at the beginning, is simultaneously terpsichorean and pedagogic: "so the kids who like rock 'n' roll will know how to dance." The function is further articulated in Freddie Bell's number, "I'm Gonna Teach You to Rock," and demonstrated in Lisa's performances in Strawberry Springs, at the high school (where she, not the

musicians, saves the day), in the televised finale, and finally in the film's own distribution: at least one Texas theater owner advertised *Rock Around the Clock*'s pedagogic attraction with a sign reading, "All you cats who want to rock, free bop session at the Crescent Drive-In."[9] Similarly, the stages of the music's success are narratively contained in the romantic triangle of her competition with Corrine for Steve, in which Corrine's control over the established music industry is trumped by Lisa's dancing. Though the plot line of the Comets' struggle for success in the entertainment industry contains a built-in mechanism for resolving the tension between narrative and spectacle in the final performance, by this point, the romantic intrigues have already shifted narrative agency away from the band to Lisa, and she alone is essential to both spectacle and narrative.

But despite Lisa's crucial multiple roles, the main protagonist is neither she nor Haley, neither the dancer nor the musician, but Steve, the fulcrum of the romantic triangle and the manager of the musical venture. Recognizing that rock 'n' roll's ability to break the impasse caused by the obsolescence of swing depends on its professional promotion, he must transform the Comets' amateur music into a commodity form that may be exploited within the capitalist cultural economy. In Strawberry Springs, the farmer-musicians had been paid in potatoes and onions, but their "talent," Steve tells Lisa, "is something you can sell for big money," and indeed when booked into Freed's club, the Comets do make more money than any previous act. The only significant component of the industry that Steve is not seen to manage is the central one, the manufacture and promotion of records. Though Alan Freed's narrative participation is crucial, he appears as a club owner and promoter, not as a radio DJ, and the records themselves are unrepresented, hidden under the dancers' exuberance and the musicians' lip-synced simulations.

The Hollywood "Rock an' Roll Jamboree" reasserts the hierarchy of the media industries that *Blackboard Jungle* projected. With musical performances transferred to records, lip-synced simulations of them return as their form of appearance; these simulations are contained in the stage show, the stage show is contained in the Hollywood television spectacular, and the television broadcast is contained in the film. Though *Rock Around the Clock* recognizes that rock 'n' roll originated with the vernacular performance of rural, socially marginal youthful amateurs rather than the established show business industry, it fulfills itself only when an adult professional takes over its management and administers it as a component of existing industrial culture, simultaneously renewing and consolidating its integrated structures. With other mediums positioned as colonies of cinema, the dual focus narrative appropriately culminates in the girl's marriage, not to a male rock 'n' roll singer, but to the manager of the music's commercial itinerary. So at the finale, just before the reprise of "Rock Around the Clock," Lisa introduces Steve as her husband and

presents him—not Bill Haley or even Alan Freed—as the one "without whom there would be no rock 'n' roll."

The itinerary of Haley's song, both in the real world and in the movie, from small independent forms of production to the cultural center substantially mirrors the film's own adventure. Despite his record as an exploitation flick producer, Sam Katzman had been able to raise only $300,000 to finance what was considered a high-risk project. Produced independently on this shoestring, it was distributed and marketed by Columbia, one of the big eight studios, and immediately became a box-office success—and scandal. Widespread consternation in the popular press led to its being banned in several cities in the United States and other countries across the world; authorities as far away as Egypt, for example, believed it to be a plot "designed to sow trouble in the Middle East by undermining Egyptian morale."[10] It occasioned juvenile jubilation and some vandalism, especially in the United Kingdom where, the *New York Times* reported, "teen-agers have wrecked motion picture houses, assaulted policemen and danced in wild mobs through the streets" and where the Queen requested a private screening.[11] But within a year, it grossed $2.4 million worldwide, an 800% return on the investment. *Rock Around the Clock's* success revealed the rock 'n' roll film's financial viability and established a generic model. At the cost of minimizing African American culture and social, sexual, and class conflicts, it spectacularly disseminated rock 'n' roll, even as it narratively refuted the fears of its threat.

Since rock 'n' roll was expected to be a short-lived fad, further market exploitation had to be rapid. So *Rock Around the Clock* was followed by a series of films that imitated but also advanced its innovations. On an average, more than one of these were released every two months until the end of the decade, all featuring dance, legitimating it, and using it as a visual counterpart to the music; but they also developed the visual depiction of musical performance along with the singers, the fans, the components of the industry, and some of the ethnic and other social forces that rock 'n' roll culture contained, including the consternation it often caused. The most important were *Shake, Rattle, & Rock!* (Edward L. Cahn, released October 31, 1956), *Love Me Tender* (Robert D. Webb, November 15, 1956), *The Girl Can't Help It* (Frank Tashlin, December 1, 1956), *Rock, Rock, Rock!* (Will Price, December 5, 1956), *Don't Knock the Rock* (Fred F. Sears, January 1, 1957),[12] *Rock, Pretty Baby* (Richard Bartlett, January 1, 1957), *Rock Baby—Rock It* (Murray Douglas Sporup, March 21, 1957), *Loving You* (Hal Kanter, July 17, 1957), *Mister Rock and Roll* (Charles Dubin, September 1957), *Jailhouse Rock* (Richard Thorpe, November 13, 1957), *Jamboree* (Roy Lockwood, December 7, 1957), *Sing, Boy, Sing* (Henry Ephron, January 1958), *King Creole* (Michael Curtiz, July 2, 1958), *Summer Love* (Charles Haas, April 1958), *Let's Rock* (Harry Foster, June 1958), and *Go, Johnny, Go!* (Paul Landres, October 7, 1959). Aside from *The Girl Can't Help It* and the Elvis vehicles—*Love Me Tender, Loving You, Jailhouse Rock,* and *King Creole*—all

were low-budget films made by small independent production companies, the cinematic equivalents of the small companies that recorded early rock 'n' roll. The Elvis films featured him as the only significant singer, but the others presented a variety of the performers who comprised the vibrant but still unstable field of musical innovation. In these jukebox musicals, cinema began to dance with rock 'n' roll.

Jukebox Musicals

The jukebox musicals gave rhythm and blues and other forms of early rock 'n' roll a wide social audibility, visibility, and publicity, bringing to the whole nation a cultural development founded on regional black music and dance. Their fundamental attraction was the audio-visual spectacle of the stars as they lip-synced to their current or recent hit records,[13] which provided the opportunity to hear them and see them, respectively, over a theatrical sound system much louder than a domestic record player and in larger-than-life unobstructed theatrical projection, and perhaps even to dance along with them. Following the innovations of Alan Freed's radio and stage shows, rhythm and blues, doo-wop, and other black artists were fully represented, and eventually were joined by white rockabilly singers. Little Richard, Fats Domino, Chuck Berry, Frankie Lymon and the Teenagers, the Platters, the Cadillacs, the Moonglows, and the Flamingos were the most common of the former group, with Bill Haley, then Eddie Cochran, and, on occasion, Gene Vincent or Ferlin Husky of the latter, with the bills completed by miscellaneous pop and novelty acts. The logic of the narratives and other thematic elements elaborate and justify the music's and the musicians' social and aesthetic meaning. Given that the films were usually poorly scripted and acted, and hurriedly produced—Katzman, for example, could shoot an entire film in a week—the music's aural and visual pleasures, erotic promise, and somatic excitement always threatened to overspill the narrative frames. Consequently, the numbers often caused the disruption of the conventions of theatrical film spectatorship: refusing to be quiet, teenagers could sing along; refusing to be still, they could dance in the aisles; and, if the spectacle was powerful enough, refusing to be docile, they could—perhaps—tear up the seats, just as outside the theater rock 'n' roll fans were supposed in general to be refusing the proper restraints of adult life.

Such potential for mayhem gave the narrative an additional task. As well as mobilizing its own pleasures of delay and satisfaction, it was responsible for containing the excesses of the musical performances and redirecting them back to formal and social propriety and bringing the evening's entertainment to a safe closure. Reflecting this, jukebox musicals were usually integrated in that the musical numbers—though not necessarily the specific address of the

lyrics—were motivated by the narrative, took place in its diegetic world, and were resolved there, without significant interruption of its visual vocabulary. Unlike the Busby Berkeley numbers, for example, they do not entail a shift to a categorically distinct ontology or visual syntax. But as the numbers gained a degree of autonomy absent in *Rock Around the Clock*, they were progressively less interrupted by the narrative and less supplementary to dance. Cinema learned to visualize rock 'n' roll as musical performance, and so discover a filmic musicality.

Most of the films reworked motifs common in the three main generic precedents: the revue, resuscitated in 1955 with the *Rock 'n' Roll Revue, Rhythm and Blues Revue*, and others; the thirties and forties backstage musicals in which, as in *Rock Around the Clock*, the kids put on a show; and the account of the emergence of a rock 'n' roll artist. Of the last, especially important models were the then-recent biopics of Glenn Miller, Benny Goodman, and other swing bandleaders, and fictional stories of jazz musicians, such as *Young Man with a Horn* (Michael Curtiz, 1950). The subgenre focused on a DJ or rock 'n' roll musician's "rise to stardom"; though they often involved a love interest running parallel to the musical plot, the girl's significance was subordinated and the dual focus structure faded. The music's social meaning was narrated though the rock 'n' roll performer's place within the music's industrial apparatuses, especially radio and television shows, dance concerts, and theatrical revues. Indeed, since revues were often presented in movie theaters, the line between a revue seen in a movie theater and heard through its sound system and the film version of such a revue seen in a similar theater and heard through a similar sound system was porous, with the latter's ability to bring the spectacle aurally and visually closer compensating for the loss of live presence. On occasions the two forms were integrated with films shown as part of theatrical revues, completing the interpenetration of cinema and music, especially if the film shown was a jukebox musical![14]

The narratives containing these performances revolved around rock 'n' roll's social and institutional contexts. The depiction of audiences and fans not only disseminated fashions in dance, clothing, slang, and so on, but also argued the overall nature and meaning of rock 'n' roll culture. The films taught teenagers everywhere how to rock and, in stories that brushed up against delinquency, how not to rock. Narratives of musicians struggling for recognition linked the world of fans to that of rock 'n' roll musical production. *Rock, Rock, Rock!, Rock, Pretty Baby, Jailhouse Rock, Go, Johnny, Go!* and other films based on the "rise to stardom" motif depicted the progress from amateur to professional through various situations of musical performance, ranging from domestic bedrooms to malt shops, from high-school hops and youth clubs to nightclubs and theaters, and eventually to records, radio, and television. Such narratives normalized the migration of rock 'n' roll performance into its mediated industrial forms, especially to television

in concluding broadcast spectaculars that became a generic staple.[15] These narrative situations revealed what Hollywood projected as rock 'n' roll's social constituency, including its class, ethnic, gender, and age structure. Though occasionally featuring youth on the lower rungs of the working class (*Shake, Rattle, & Rock!* for example) or on the upper edges of the middle class (*Rock, Pretty Baby*), the jukebox musicals presented rock 'n' roll as essentially middle American and classless. Radically progressive in emphasizing the primacy of black musicians and integrating them with whites in concerts, they nevertheless confined African Americans to the musical numbers; and though sometimes theatrical audiences were mixed, only in the finale of *Mister Rock and Roll* did substantial numbers of blacks appear among the dancing fans. The *only* instance of a black musician migrating from the spectacle into the narrative is *Go, Johnny, Go!* in which Chuck Berry both performs and plays Freed's sidekick. The narratives always concerned white teenagers, white parents, and white industry workers, and the lead protagonist was always a white male; if a singer, he was a second-tier ingénue, notably Jimmy Clanton in *Go, Johnny, Go!* and Teddy Randazzo in *Mister Rock and Roll*, who both play roles that resemble their own lives. Carrying the storylines, and linking the more celebrated performers to the narrative, these protagonists provide a bridge to the world of rock 'n' roll for the other white teenagers in the diegesis and for the films' teenage spectators.

Occasionally a bad teenager upsets the harmony of the rock 'n' roll world: a jealous over-sexed girl, for example, in *Rock, Rock, Rock!* and *Don't Knock the Rock*. But usually the danger comes from adults, especially what Sal Mineo in *Rock, Pretty Baby!* declares as "the greatest social disease of our generation: parents." Caricatures of elderly upper-middle-class types, militant newspaper editors, or other civic leaders, often with nefarious personal agendas, these adults typically attack rock 'n' roll for putative moral deficiencies, providing the narrative with the opportunity to prove that it is a positive social force, at best capable of much good and at worst innocuous—and in fact often similar to what the elders themselves danced to when they were young, as happens in *Shake, Rattle, & Rock!* and *Don't Knock the Rock*. In *Rock, Rock, Rock!* one of Frankie Lymon and the Teenagers' songs gives the summary assurance that the parents, if not the teenagers themselves, wanted to hear: "I'm Not a Juvenile Delinquent." Of the well-intentioned adults who make rock 'n' roll available to teenagers and demonstrate its musical and social value, the most important was Alan Freed, in both real life and film.

Alan Freed on Film

Freed's radio shows, especially his "Rock 'n' Roll Party" at WINS in New York, and his concerts at the Paramount Theater in Brooklyn and later at locations

in Manhattan were pivotal in bringing black music to white audiences and in popularizing the term "rock 'n' roll."[16] Cinema allowed Freed to extend these projects to a national and international audience, and the interrelations between his five films and developments in rock 'n' roll make them the most important of the jukebox musicals. His role in the first, *Rock Around the Clock*, was minor, but his next four together re-enact the crises of the music's emergence and his part in them. In *Don't Knock the Rock* (1957), *Rock, Rock, Rock!* (1956),[17] *Mister Rock and Roll* (1957), and *Go, Johnny, Go!* (1959), which he also coproduced, Freed transformed his historic role into a myth of his crucial mediation between teenagers and the music, and also between them and their parents and society in general. Within the films, he can conjure the songs or motivate the musicians' appearance by putting the needle on a record, while his extra-cinematic power allows him to summon the singers to the concert, high-school prom, or other events the narrative requires (Figure 3.4). Sharing the teenagers' enthusiasms even while he directs them, he has privileged access to their world, but he is also responsible to the ethical world of adults and to the business of rock 'n' roll.

Also produced by Katzman and directed by Sears, *Don't Knock the Rock* featured Freed as the manager of a rock 'n' roller, Arnie Haines, played by Alan Dale, a moderately successful pop ballad singer, then thirty years old. Tiring of Freed's publicity stunts, Haines decides to return to his hometown for a summer vacation while Bill Haley takes over his dates. Arriving at Mellondale station, Haines is greeted by exuberantly dancing teenagers,

FIGURE 3.4 *Alan Freed: Explaining rock 'n' roll to parents (*Don't Knock the Rock*); leading the band at the high-school hop (*Rock, Rock, Rock!*); radio disc jockey (*Mister Rock and Roll*); the manager with his clients, Chuck Berry and Jimmy Clanton (*Go! Johnny, Go*).

but also by the mayor, who accosts him, asserts that rock 'n' roll is "outrageous and depraved" and "for morons," and tells him to go back to New York. A powerful journalist, Arlene McClaine, writes an extremely hostile story that threatens to close down rock 'n' roll nationally, but her daughter, Francine, encourages Haines to give a rock 'n' roll concert to prove that the music "is not detrimental to young people." Their plan and budding romance are temporarily derailed by a local teenager, the sex-obsessed "Everett girl," whom he spurns. In revenge, she scatters liquor around the concert, turning it into what the newspapers call "a drunken rock and roll brawl," and the mayor attempts to have the music banned statewide.

But Freed persuades a group of teenagers to stage a theatrical event that includes re-creations of American dancing from the time of George Washington and the 1920s. Confronted by their own Charleston days, the assembled elders reluctantly recognize that their children are no different from what they had been twenty-five years earlier. Arlene admits that when she and other parents tried to find a scapegoat for their own shortcomings, "rock 'n' roll was handy so it got the blame," and she apologizes to Haines, and the Everett girl's father promises to "whale the living tar out of her." Along the way there are performances by Haines, Haley, and the Treniers (a seminal rhythm and blues/rock 'n' roll combo), and a blistering two-song set just before the brawl by Little Richard accompanied by two black dancers. The movie concludes with Haines's weak rendition of Haley's "Don't Knock the Rock" as the teenagers dance among their reconciled parents.

Freed's role as Haines's manager extends to his larger mission as the spokesman for rock 'n' roll's significance and, with the odd wayward teenager safely sequestered, he heals the generational rift and restores both dancing and community harmony. Subsequent films develop and enhance both spectacle and narrative components, asserting a parallel pedagogic function and also confirming his role in rock 'n' roll's emergence. They include progressively more numbers by more important musicians, mixing the majority of African Americans whom Freed unwaveringly supported with important white rock 'n' roll, country, and ballad singers. Refuting all associations with delinquency, the narratives restore harmony between the parent and the youth cultures, between rock 'n' roll and its detractors, and among the various elements in the rock 'n' roll productive system and the culture industries generally.

Rock, Rock, Rock! resuscitates the fundamental form of the classic musical's dual focus with ingénue roles played by Tuesday Weld in her screen debut and, in his acting debut, Teddy Randazzo, a singer who had appeared with his group the Chuckles in the previous year's *The Girl Can't Help It*. Both are high-school seniors, with Weld determined to prevent Randazzo from straying into the clutches of a scheming new girl. Since she was no more able to sing than to act, Weld's numbers were voiced by a then-unknown Connie

Francis. But neither could her character do math, and her inability to comprehend the concept of percentages leads her into shady money lending to raise funds for a strapless evening dress for the prom, which in turn compromises Randazzo and his affections. Formally the film is a hybrid, intermixing songs by the two leads, whose lyrics are integrated into the plot, with freestanding numbers by artists introduced by Freed as MC of his television show, which he brings to the school. Randazzo performs in both modes, singing his entries in Freed's talent contest and also narratively integrated love songs to Weld. In the finale, as the contest's winner of a putatively live broadcast of Freed's television show, he completes the dual focus narrative by addressing his song "Won't You Give Me a Chance" ("I was wrong to make you cry, I will love you till I die") to Weld; uniting the musical's integrated and unintegrated modes, he superimposes his personal relationship over his professional career, effectively combining the industrial and folk forms of musical production.

Despite the leaden acting and plot, the film is kept alive by Freed's African American regulars, Chuck Berry, LaVern Baker, Frankie Lymon and the Teenagers, the Flamingos, and the Moonglows, along with rockabilly star Johnny Burnette in his only film appearance, and Freddie Mitchell's band, here billed as "Alan Freed and His Rock 'n' Roll Band." Freed's presentation of these acts reveals the convergence of the half-dozen components of the music industry then under his aegis and their intersection with more or less amateur practice. Having no professional ambitions, Weld's character sings to express her confused romantic feelings and, while some of Randazzo's songs have the same function, they segue into his attempt to break into the business. Rock 'n' roll dancing similarly occurs as spontaneous amateur pleasure in the malt shop, in more formalized competitive mating rituals at the prom, and as an integrated component of Freed's television broadcast, all of which are of course subsumed in the economy of cinema's own exploitation of argot, clothing, hairstyles, and other aspects of teenage rock 'n' roll culture. Respecting differences in musical importance, the film allows major acts to retain their integrity separate from the narrative, while interrupting lesser ones with cutaways to listening or dancing fans. Causing the young Rolling Stone Bill Wyman to get "shivers all over" and having a formative effect on Keith Richards,[18] Chuck Berry's sequences are shot on a soundstage as if from fifth row center with a stationary camera alternating between and long and medium shot. But in Jimmy Cavallo and his House Rockers' set at the final prom, the photography of the musicians is integrated into remarkable scenes of the teenagers' exuberant dancing. The film's pedagogy handily manages Weld's implausible delinquency, but Freed takes additional pains to affirm rock 'n' roll's respectability by linking it with other forms of popular music. While introducing Burnette as a "young man who has come out of the country field to join us rock 'n' rollers," he announces, "[r]ock 'n' roll is a river of music which has absorbed many streams: rhythm and blues, jazz, ragtime,

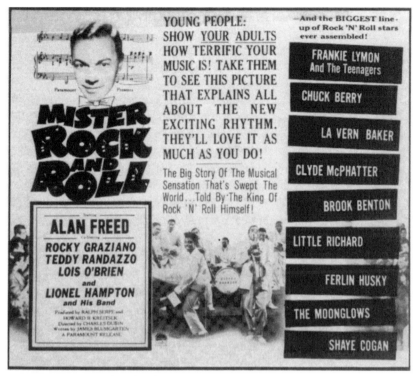

FIGURE 3.5 Mister Rock and Roll *poster.*

cowboy songs, country songs, folk songs. All have contributed greatly to the big beat."

The same inclusiveness is affirmed in his next film, *Mister Rock and Roll* (Figure 3.5), with an animated title sequence illustrating a song by Lionel Hampton (himself influential at that time in merging rhythm and blues with jazz), whose lyrics tell how Mister Blues, Mister Dixieland, and Mister Jazz all had to make way for Mister Rock 'n' Roll. Appropriating the honorific, Freed appears here as the MC, not of his television show, but of his stage show at the Paramount Ballroom in Brooklyn and especially as the DJ of his radio show at WINS. All the plotlines revolve around him, and a flimsy "rise to stardom" structure barely kept breathing by Teddy Randazzo again is quickly eclipsed by an unscrupulous newspaper editor who attacks rock 'n' roll fans as "hare-brained delinquents . . . a bunch of hoodlums jigging in theater aisles" and Freed himself as "the proverbial pied piper who's cashing in on adolescent emotions." On the air, Freed challenges the accusation that the music is "corrupting our children with a primitive beat" and that it was cooked up just to make money. Instead, he argues, it happened spontaneously, and a flashback turns the film to a justificatory autobiography by depicting the small record store in Cleveland where he discovers white teenagers' interest in rhythm and

blues; his radio program and subsequent support of "the spontaneous expression of today's youth, its restlessness, its cravings, and its sentiments"; the music's progress through the United States and to Europe; and a return to New York. There he announces to the world that rock 'n' roll is only a "new name for music that's been around for decades," that it has "no connection with juvenile delinquency" but "can be used effectively for good." The teenagers who listen to his program justify his faith in them by raising money for a medical charity, to which the now-chastened editor himself contributes five hundred dollars. If in the narrative Freed defends the music, the teenagers, and himself, in the performance spectacles he attacks, front-loading the film with a river of major black stars, including Hampton, Little Richard, Chuck Berry, the Moonglows, Clyde McPhatter, Frankie Lymon, Brook Benton, and LaVern Baker. The line-up emphasizes the black origin of rock 'n' roll, while the conclusion brings all ages and all races together in celebration of the white teenagers' interest in it and the consequent ethnic mixing.

The acts are usually introduced by Freed himself as he broadcasts his radio show. Typically, a medium shot introduces him at the microphone announcing the selection and often making a dedication to a specific listener, followed by a close-up on the spinning record until the diegesis cuts to an unmatrixed space, most often a blank background, before which the artists perform. By this point in the genre's development, except in a couple of instances where the singers perform amidst a crowd of bopping teenagers, the spectacle of performance is uninterrupted, but dislocated from the narrative. Reflecting the conditions of the film's production that caused many of the performances to be shot separately in New York, the narrative invokes them, but does not entirely contain them. Where in *Rock Around the Clock* the performance sequences are interrupted by the narrative's progress through them, here they force the suspension of the narrative and remain unarticulated chronologically or spatially with it. This degree of autonomy allows—in fact obliges—them to discover independent visual interest. Along with the dancers, the performances become the visual form of the record, not the depiction of the process of its manufacture, but the representation of its musical structure. So though still extremely rudimentary in both photography and editing, they evidence some conscious attempt to develop a visual counterpoint to the records' musical properties. Most are composed of a wide-angle master, intercut by sections of one or two, or at most three, closer shots with the cuts matching, loosely to be sure, the songs' stanzas or even its chord changes. Corresponding to the dominant, the opening wide-angle shot is maintained until a line or stanza break motivates a close-up, which then alternates with it until the end, where the return to the dominant visually reinforces the musical closure.

Though *Go, Johnny, Go!* (Paul Landres), the last film Freed produced and the last of the significant fifties' jukebox musicals, uses the same techniques for reproducing the song, its more complex plot allows a somewhat

more direct approach to the issue of delinquency and the nature of industrial musical production. After Chuck Berry's "Johnny B. Goode" plays over the titles, *Go, Johnny, Go!* opens with the crowds thronging Loew's State Theatre in Manhattan, where the marquee announces the "New Young Singing Favorite, Johnny Melody." Johnny and other acts are seen performing, then the film becomes another extended flashback, narrated by Freed, in which he recounts his discovery of Johnny, played by Jimmy Clanton, a moderately successful singer of the time.[19] An orphan who—like Jerry Lee Lewis in real life—is expelled from his church choir in his mid-teens for singing pop songs, Johnny is sustained by his determination to become a rock 'n' roll star. When Freed announces a competition for the best record by an unknown singer, Johnny invests all his money in a demo and, while recording it in the studio, he recognizes another singer, Julie, whom he had known at the orphanage. Unlike Johnny, Julie has been adopted, and with the blessings of her benevolent parents, a romance between them develops. Freed receives Johnny's record and Berry, his assistant, encourages him to play it on the air, requesting that Johnny call in to identify himself and join his show. A series of mishaps prevents Johnny from contacting Freed, and then late one night he throws a brick through a jeweler's window to steal a ring for Julie's Christmas gift. Freed arrives just before the police, and, pretending to be drunk, he takes responsibility and is arrested but soon released. The movie concludes with Johnny singing his hit single on Freed's show to an enthusiastic audience that includes the choirmaster who had expelled him, while watching off-stage, Freed, Berry, and Julie remark in sequence: "That's quite a song," "He's quite a singer," and "He's going to be quite a husband." Johnny's moment of delinquency is transcended and he is reintegrated into the combined industrial and familial harmony.

Set in this narrative frame are close to twenty songs, almost all positioned as appearances on Freed's radio or stage shows. Again they are typically photographed before a black backdrop, usually with a single camera, in a medium master shot that is occasionally punctuated by a close-up or a cut-away to the ecstatic theater audience. Most of the performers, including Berry (three numbers), Brook Benton, Jackie Wilson, the Cadillacs, and the Flamingos are black, but two white rockabilly singers also appear, Eddie Cochran and Jo-Ann Campbell, as well as the Latino Richie Valens. Lending variety are several numbers performed in a nightclub visited by Johnny, Julie, and her parents, including Berry's ostensibly live performance of "Little Queenie" in the club. Berry also performs the title track again, and appears in an ostensibly televised performance of "Memphis Tennessee," during which the montage cuts between Berry alone on the sound stage, the television camera covering him, and the television console where Johnny and Julie watch him. Clanton's own numbers are also dispersed across several mediums; in addition to the scenes where he cuts his demo, his performances are also prompted by Freed's

playing his record over the radio and by his appearance on the stage show, and he and Julie also sing a duet to each other around the family piano.

So though the film is a fairly conventional music business biopic, its depiction of the contemporary industry emphasizes the record as the primary industrial form of rock 'n' roll. Putatively live performance still provides the most intense musical experience, but the narrative revolves around records. In Berry's and Cochran's cases, the stars appear to be playing their own electric guitars, despite the lack of connecting cables, while other orchestration and back-up singers are elided. But otherwise, rather than concealing the various institutions and apparatuses that constitute the mode of musical production, the film emphasizes them: cutting the demo, getting the demo to Freed, Freed playing the record, his agency in discovering the singers and promoting them on the radio and stage shows, his management of them, getting them television and benefit appearances, and so on. Where the classic musical narratively privileged scenes of live performance and emphasized rehearsals and other behind-the-scenes activities, the jukebox musicals eliminated the popular, participatory, folk component of rock 'n' roll and presented the song as an endless repetition across the entire range of integrated industrial apparatuses and institutions.

Go, Johnny, Go! explicitly addresses Freed's role as the disc jockey and promoter who administers and arbitrates the musical system and the social and ethical systems consolidated in it. The choirmaster and some other adults associate the music and its rituals, especially dancing, with delinquency; but for intelligent adults (Freed, Berry, Julie's mother, who admits that "it's different but it's still music") and all teenagers, rock 'n' roll's pleasures are fully compatible with family values. Despite his poverty and even when he is working as an usher, Johnny is always neatly dressed, polite, and respectful, as are the more fortunate Julie and all other teenagers. The momentary lapse that could have led Johnny to prison is caused by the combination of his love for Julie and his inability to reach Freed. Freed's assumption of his guilt ensures his success, and the implied narrative closure of his marriage to Julie puts all questions of sexual delinquency to an honest bed as Julie abandons her own career to support his. Racial issues are similarly defused: though Johnny, Julie, and Freed's audiences are all white, both black and white performers are recognized equally and Chuck Berry is an integral member of Freed's organization.

As well as having the best music, Freed's last three films document the various components of the rock 'n' roll industry and make a vigorous defense of it. In his real life roles as a radio and television disc jockey, a concert and tour manager, a promoter and publicist, he played a larger part in more of rock 'n' roll's institutions than any other individual, and as a consequence he was a convenient, indeed inevitable, scapegoat for its critics and their spirited antagonist. As well as providing reciprocal advertising for his radio and

stage shows, his films brought his roles together, representing and subsuming the other components in the business and mounting an ideological defense of the music within popular culture itself. In this, his films were crucial in the production of rock 'n' roll, not merely its representation. Like the musicians, Freed plays himself, performing in film what he otherwise performed in life. The interdependency of rock 'n' roll promotion and self-promotion, of his commitment to the music and its instrumentality in his own success, preoccupied, consumed, and eventually destroyed him. If, from 1955 to 1957, Freed was not the king of rock 'n' roll, he certainly was the king of the rock 'n' roll industry and was himself a rock 'n' roll star. Along with the indisputable preeminence in popularizing black music among whites that earned him his "nigger lover" epithet, his outsized ego, his willingness to challenge authority, his financial carelessness, his three wives and multiple children, his drinking—and the adulation of a generation of teenagers—gave him first rights to the title *Mister Rock and Roll.*

Freed's five films form one pole of the spectrum of jukebox musicals; their narratives revolve around the production side of the industry and the music's overall social position and its role in the lives of teenagers and adults. His radio and stage shows gave him the power to recruit far more and better musicians than appeared in any example of the genre except *The Girl Can't Help It.* The other jukebox musicals were even more cheaply made, had lower production values, fewer and less important musicians, and so were more concerned with rock 'n' roll as popular production within everyday life, emphasizing the fans and semi-amateur musicians. As the number of musicians decreases, the importance, though not necessarily the quality, of the narrative increases to allow increased prominence for other elements of youth culture. The genre thus dissolves into teenage exploitation films set outside the world of music that, unlike the jukebox musicals themselves, typically exploit rock 'n' roll's association with delinquency.[20]

By the end of 1950s, almost all films involving teenagers, certainly miscreant teenagers, featured rock 'n' roll in some way. But the jukebox musicals themselves attempted to exploit the popularity of rock 'n' roll while also discrediting alarmist mass media accounts of its associated social disturbances. Recognizing that teenagers' response to rock 'n' roll was active and participatory and that the rituals associated with it were creating a fundamentally new and vibrant cultural sphere, they also accurately emphasized its growing importance in the music business. Radically new forms of musical composition by both black and white artists were shown as migrating effortlessly from amateur or semi-amateur, folk or quasi-folk, recreation to commodity records and attendant capitalist institutions, but even though the performers existed in the circumscribed world of industrial musical production, they were also immanent to the real-life world of the teenagers. While showcasing black musicians, the films revealed the dangers of race mixing, working-class

delinquency, and unleashed sexuality to be unfounded, and minor distur-
bances were easily returned to the generational harmony and the stability of
the middle-class nuclear family. As the jukebox musicals played a major role
in disseminating and producing the new music, their depiction of rock 'n' roll
in live performance, on records, and on television legitimized it, soothing
fears of its cultural insurgency and demonstrating its assimilation into exist-
ing mainstream cultural forms and industries.

Mutatis mutandis, these functions informed all 1950s rock 'n' roll musi-
cals with five conspicuous exceptions: the four films Elvis made before being
inducted in 1958 and *The Girl Can't Help It*. These had the same two struc-
tural elements, the spectacle of musical performance and the narration of its
social role. *Jailhouse Rock*, for example, was a "rise to stardom" biopic that also
explored the mechanics and the financial structure of the recording industry,
and its integration with television and—for the first time—the movies them-
selves, while *The Girl Can't Help It* told the story of a musician who success-
fully schemes to escape such stardom. The films' construction of rock 'n' roll's
overall meaning was, however, quite different; instead of exonerating its radi-
cally musical innovations and their social uses, they emphasized its subver-
sion and unruliness more than its innocence, its noir more than its sunshine.

{ 4 }

Dirty Stars

JAYNE MANSFIELD AND KENNETH ANGER

In *Hollywood Babylon*, Kenneth Anger's devotional account of decadence and mayhem in the film industry, first published in France in 1959, the film-maker argued that the impending demise of Hollywood could be relieved only by two figures. One, holding the "promise of a new dawn, hope entering on tiptoe" that supplied the book's final lines was "Jayne Mansfield offering herself to us, all of her. Jayne, who has made Scandal her career, who assures us that the Hollywood Way of Life is still a good one. . . . For she has listened to the fairies at her cradle who whispered: 'Lucky is she who is touched by Scandal . . .'"[1] The other was Elvis, "King of rock-and-roll, darling of the teen-agers, wiggling his magic breeches and driving them wild with his frantic belly dance and his rutting cries: a barbarous god. . . . Elvis, the first 'dirty star' in a long time."[2] The career parallels between the two are integral to their respective myths: both were Southerners who were identified with what were thought to be the least sophisticated elements of mass culture, those most working-class in their appeal; both flaunted an exuberant sexuality considered at once outré and déclassé even in Hollywood; both wished to be regarded as stars and as serious actors, but after very promising starts in critically and financially successful films, both were forced by their respec-tive studios into increasingly demeaning, under-funded schlock; both were caught between the parallel mirrors of their own self and a caricature of it, initially self-manufactured and subsequently calcified by Hollywood agents; and by the mid-1960s, their best work done, both began a quick descent into addictions that terminated in grotesque tabloid deaths. Both are monuments in the history of rock 'n' roll cinema.

The Girl Can't Help It

While most fifties' rock 'n' roll musicals were B-movies, cheaply produced by minor studios, *The Girl Can't Help It* (1956) and the four films Elvis made before

being drafted in 1958 were major studio productions, Twentieth Century Fox for *Girl*, and MGM and Paramount for Elvis. The shift to the majors resulted in quite different visions of the new music. The first A-list rock 'n' roll film, *Girl* starred Jayne Mansfield, and took her to the zenith of her fame. It was directed and cowritten by Frank Tashlin, bolstered by four-track stereophonic sound, and photographed in color and Cinemascope by four-time Oscar winner Leon Shamroy, veteran of the African American musical classic *Stormy Weather* (Andrew L. Stone, 1943). An immediate hit and one of the most successful films of the year, it grossed $2.5 million.[3] A backstage musical about a pop singer and her manager, interspersed with performances by many of the period's greatest musical stars and also culminating in a television spectacular, it followed the format of *Rock Around the Clock* (Fred F. Sears, 1956), released some eight months earlier, and so helped to establish the conventions of the genre. But in other respects, it inverted those conventions, undermining them in advance: where the other jukebox musicals celebrated rock 'n' roll and its performers, *Girl* satirized them, featuring a reluctant singer determined not to rise to stardom; and where they denied rock 'n' roll's delinquencies, showing teenagers and their culture as joyful self-expression, *Girl* presented the music and its industrial managers as criminally ridiculous and teenagers as morons. The tensions among its superior production values, its outstanding music, the disjunctions between its narrative and spectacle, and its satiric reversal of the genre's thematic conventions fractured its attempt to debunk rock 'n' roll into a deliriously contradictory dance.

In her first starring film role, Mansfield plays Jerri Jordan, the fiancée of Fats Murdock (Edmond O'Brien), a one-time bootlegger and hoodlum who decides to make her a "somebody" important enough to be his bride. Though she insists that she just wants "to be a wife and have children," he hires Tom Miller (Tom Ewell), once successful but now a washed-up, penniless, alcoholic agent, to "build the dame into a big canary." Miller's attempts to school and manage her prove ineffectual for apparently Jerri cannot sing, and is capable only of imitating a prison whistle to punctuate a song, "Rock Around the Rockpile," that Murdock himself wrote while in the penitentiary: the sex siren sounds like a jail siren. Despite Murdock's spying, Jerri and Miller fall in love, but are saved from his wrath when he himself rises to rock 'n' roll stardom, allowing them to marry and quickly have five children. Like other jukebox musicals, *Girl* combines the story of personal ambition with an overview of the music business and its relation to the film and television industries. It emphasizes the centrality of records in opening credits that feature a jukebox playing the title song, and in its return to the jukebox business for a key narrative reversal; but it also visits nightclub performances, rehearsal and recording sessions, and televised rock 'n' roll. The size of the film's budget implies the expectation of a wider, more mainstream audience than the other jukebox musicals, one more amenable to a burlesque of rock 'n' roll, and again

FIGURE 4.1 The Girl Can't Help It: *Abbey Lincoln, Julie London, Gene Vincent, Eddie Cochran, Fats Domino, Fats Murdoch.*

dramatizes a cultural hierarchy that claims its own categorical superiority as cinema over popular music and other mediums.

In their odyssey through the business, Jerri and Tom encounter stellar performers from many of the different musical streams (Figure 4.1) that, as Steve's comments in *Rock Around the Clock* and Alan Freed's in other films noted, converged in rock 'n' roll: gospel, with Abbey Lincoln's "Spread the Word"; doo-wop with the Platters' "You'll Never Know"; cocktail lounge ballads with Julie London's "Cry Me a River"; New Orleans piano with Fats Domino's "Blue Monday"; rockabilly with Eddie Cochran's "Twenty Flight Rock" (which in fact earned him his record contract[4]); the only surviving color footage of Gene Vincent as he sings "Be Bop a Lula"; and fundamentalist rock 'n' roll with Little Richard in his screen debut, letting rip with "Reddy Teddy," "She's Got It," and "The Girl Can't Help It." With all these and Eddie Fontaine, Teddy Randazzo and the Three Chuckles, the Ray Anthony Orchestra, the Treniers, and Freddy Bell and the Bellboys, apart from the rhythm and blues greats of Freed's later films, the only major omissions were Chuck Berry and Elvis himself; the latter's

manager's demanded $50,000 for a single song, which Fox thought was too much for an attempt to cash in on the rock 'n' roll fad. Nevertheless, Fox's resources allowed Tashlin to amplify the genre and put the film in a rank of its own as the most dramatic and spectacular documentation of early rock 'n' roll in all its biracial audacity; B. B. King recalled it as the first film he could remember "that was accepted as an A1 movie featuring blacks. It had Fats Domino, Little Richard and several other blacks and presented them in a beautiful way. I mean with a lot of class."[5]

Little Richard and several other stars are seen performing, not for teenagers at the high school hops of other jukebox musicals, but incongruously in upscale nightspots attended by older wealthier patrons. Cochran is seen on a television; Vincent is caught in rehearsal; and the film ends with several performers in the televised broadcast. Though still lip-synced to records, the performances and music are more richly visualized than in any other film of the period, many utilizing a moving camera with alternate long and medium shots and some close-ups, with sophisticated lighting, props, and overall visual design. Little Richard's "Ready Teddy," for example, is composed from half a dozen shots with a moving and zooming camera that begins with a close-up on his feet and ends with a full body medium shot with a facial close-up, a wide shot of the night-club, and a cutaway to Miller and Jerri in between. Lincoln's sequence begins from the reflection of her red dress on the mirrored floor and pans up to a medium close-up on her upper body for most of the song, then pans back down to her reflection as it ends. And, as a hallucination conjured by the drunken Miller playing his former lover's album, London appears in seven different costumes in as many places in his apartment, adding dramatic visual and spatial dimensions to her song.

Though some of these sequences are uninterrupted, most are interspersed by cutaways and response shots that weave them into the diegesis. But because they were shot before the dramatic action, and in fact before the screenplay was finished, these links were fabricated in editing and, with only very minor exceptions, performers and characters do not appear in the same shot. The Cochran sequence, for example, is punctuated by cutaways to Fats at home and to Miller, Jerri, and her enthusiastic maid at Jerri's apartment as they separately watch the television show. The most dramatic—and symptomatic—instance is the nightclub scene featuring Little Richard and Mansfield at her most provocative (Figure 4.2); while he sings, Jerri follows instructions to make a spectacle of her charms by sashaying across the floor in a stunning décolleté dress. Tashlin exploits the implication that she is the reference of his lyrics, allowing Little Richard deliriously to celebrate her rock 'n' roll sexuality: in "Ready Teddy," she's a "rock 'n' roll baby" with whom he's ready to "rock 'n' roll till the early, early night," and in "She's Got It," she's a "hot rod queen" who is "gone in everything." In one eloquent account of the scene, the cuts between "the mountainous movements of Mansfield's

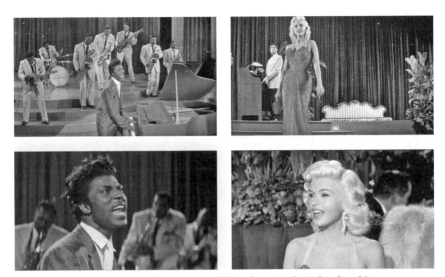

FIGURE 4.2 The Girl Can't Help It: *Noir and Sunshine, Little Richard and Jayne Mansfield*

whiter-than-white form and Little Richard's jet black lascivious response" creates a collision montage "that's pure rock and roll. Tashlin seems to be asking, Which figure is more fearful, Little Richard's aroused Abyssinian, or Mansfield's Aryan Avatar?"[6] Even though their interaction is created filmicly, in the montage, with the two never physically present in the same frame, the miscegenation of these extreme, if deeply ambiguous, icons of black male and white female sexuality caricatures the hysterical social fear that early rock 'n' roll aroused.

Though, like similar qualities in London's appearance, Mansfield's tight red dress, cascading blonde hair, and provocative walk seem oriented toward an older spectator, a parent rather than a teenager, other performers pointedly exhibit rock 'n' roll body language, dance steps, clothes, and hairstyles. Again, Little Richard's self-presentation is paradigmatic: his towering pompadour, mascara, and flashing eyes form a halo around his singing, while Vincent's long greased hair, clothing, and hip-grinding—all distinctly reminiscent of the schoolyard hoods in *Blackboard Jungle*—visually amplify his music's overwrought angst. As in other jukebox musicals, males are preponderantly the performers of rock 'n' roll visuality, and women in the black traditions are represented only in the sequence with Lincoln, who later became important in the Black Arts movement but at the time was an unknown nightclub singer. She "jazzes up" the gospel song in the manner deplored by Miller in *Blackboard Jungle*, and performs it with an erotic energy comparable to the secularized gospel of Little Richard (or Ray Charles, whose anthemic, "I've Got a Woman," was released while the film was in production).

The visuals similarly eroticize Lincoln herself: framed by her black hair and dazzling earrings, her beautiful face and her voluptuous body sheathed in a low-cut red dress (rumored once to have been worn by Marilyn Monroe) make her a black rhyme to the blonde but similarly dressed Jerri—or indeed a combination of the sexual signs of both Mansfield and Little Richard. With their unprecedented sonic and visual pyrotechnics, raucous, comic-book fusion of nascent musical energy, and sexual exuberance, *Girl*'s numbers satisfy the audio-visual desire intrinsic to rock 'n' roll cinema, augmenting the records' aural and lyric energy. But, though spectacular, the musical numbers are embedded in an ambivalent narrative that appears to denigrate the very pleasures they supply—even if on other, perhaps unconscious, levels it ratifies them.

The film's satire on rock 'n' roll begins in the title sequence, where it immediately proposes the jukebox musicals' typical hierarchical subordination of television to cinema. Like *Rock Around the Clock* and the other minor studio exploitation films, *Girl* opens with a black and white, Academy ratio sequence, revealing Ewell on a soundstage, implying him as the narrator of the coming film. As he boasts of the superiority of "the grandeur of Cinemascope" and "gorgeous lifelike color by Deluxe" over black and white television, the screen belatedly widens and the image turns to color. The sight-gag emphasizes cinema's superiority over television, but then, as he announces that the film will be about "the music that expresses the culture, the refinement, and the polite grace of the present day," his voice is drowned by a sax break and Little Richard's incantation of the theme song, and the camera comes to rest on the record playing on the gaudiest of jukeboxes. Where the other jukebox musicals typically culminated in television shows, endorsing the rival medium and the music together, *Girl* announces its difference: rock 'n' roll is unequivocally industrial and devoid of any authentic folk content, but here its successful production does not realize its musical value so much as compensate for its lack of such, and its migration to television allows both mediums to be denigrated together. Miller continues his mockery in incidental asides throughout the film, regularly expressing professional contempt for the music while other narrative elements sustain his deprecation, especially as these accumulate around Fats: his attempts to manufacture rock 'n' roll success for Jerri; his assertion that she can be made into a star in only six weeks, despite the revelation that she cannot sing; his argument that Eddie Cochran has no formal musical skills, only a "new sound"; and so on. The raillery is narratively underscored by ironic echoes of *Citizen Kane*, the most celebrated film about a gangster who tries to make his girl a star; introduced by Fats's newsreels of his bootlegging career that are an almost a point-by-point parody of the introductory newsreels of Kane's life, the parallels imply that rock 'n' roll is to opera only as Fats is to Kane. Indeed, the parallels are set in play in Fats's first appearance, when he is seen screening a clip of Betty Grable

singing "I Wish I Could Shimmy Like My Sister Kate" from *Wabash Avenue* (Henry Koster, 1950), also a Fox production about a gangster who wants to turn a pinup into a singer so that he can marry her. And the ridicule continues throughout, culminating in the final television show, again advertised as a "Rock 'n' Roll Jamboree," where, with an orchestra dressed as jailbirds, Fats sings his fatuous song to the mesmerized vacancy of his zombie children fans.

These deprecations of rock 'n' roll only amplify what is implicit in the main narrative line, specifically the two inversions of the key motifs in the other jukebox musicals' plot of the male teenager's quest for rock 'n' roll fame. *Go, Johnny, Go!* (Paul Landres, 1959) and other jukebox musicals are based on an attenuated form of the classic musical's dual focus narrative about a boy singer and a girl accomplice that culminate in the simultaneous resolution of his erotic and musical quests. But here these conventions are reversed: the protagonist is not a teenage male but a mature woman, for though she was only twenty-two, Mansfield appears older; and she strives, not to achieve rock 'n' roll stardom, but to avoid it. Though, with its similarities to Little Richard's falsetto cries, the release of her siren scream may be the essence of rock vocalizing, she gains her lover only by musical ineptitude. And where the other films are constructed from displays of the singer's abilities that further his progress to the resolution, here the visual joke of light bulbs shattering whenever Jerri sings a scale and similar incidents ridiculing her musical incompetence generate only a frustrating narrative stasis. The belittlement of rock 'n' roll is completed at the conclusion when, after the threat of the "rise to stardom" has been removed, Jerri reveals that she has only been pretending to be unable to sing, and (though Mansfield's voice was, in fact, dubbed) displays her real musical ability in a lovely romantic ballad addressed to Miller. The conclusion echoes *Rock Around the Clock*'s in that the man she finally obtains is a manager, not a singer—but only ironically so, for in the earlier film Steve's entrepreneurial skills in the economy of rock 'n' roll empowered him as the most desirable partner for Lisa, while here Jerri's attraction to Miller reflects only his kindliness and his irrelevance to the music they both despise. With Jerri-the-mouse having all the power the Tom-cat lacks, their relationship ironically echoes Jerry's inevitable vanquishing of Tom in the MGM cartoons they otherwise invoke. And finally, the threat of Jerri's exuberant sexuality is defused by her drive, not toward the outlaw zone of rock 'n' roll promiscuity or miscegenation, but toward the domestic stability of the white nuclear family and the hyperbole of her five spontaneous children. The narrative that simultaneously exploits and ridicules Mansfield also attempts to domesticate her, as if schematically advising girls that rock 'n' roll is idiotic and they should be mothers, and boys that girls like Jayne Mansfield may be won, not by rock 'n' roll stars, but by ineffectual alcoholics.

A similar ambivalence defuses rock 'n' roll's ancillary motifs and themes. The film is set mainly among middle-aged, middle-class men, not in the

world of teenagers, who hardly appear until the concluding television show. Little Richard, Abbey Lincoln, the Platters, and other black performers figure prominently in the music but—apart from a brief appearance by Juanita Moore (anticipating her role in *Imitation of Life* [Douglas Sirk, 1959]) as Jerri's maid, improbably enthralled by Eddie Cochran—not at all in the diegesis. And delinquency is shifted primarily to Fats, as washed-up a gangster as Miller is an agent, with the continuity between his slot machines in the 1930s and jukeboxes in the present emphasizing the criminality of the rock 'n' roll business. The overtones of his "Rock Around the Rockpile" that sustains Jerri's meager fame until his own eclipses it further link the music with crime, anticipating scenes of Elvis at the coal-pile in next year's *Jailhouse Rock* (Richard Thorpe, 1957). The invocation of generic motifs is always parodic, made not in the affirmative spirit of the other jukebox musicals, but reiterating the denigration of popular culture in *Artists and Models* (1955), *Will Success Spoil Rock Hunter?* (1957), and other Tashlin films. Rather than integrating the musical performances' audio and visual power into the social world in which they exist, the narrative holds them apart, contradicting the pleasures they so spectacularly produce.

Or it would have, had it not been for Jayne Mansfield herself, and the unstable combination of identity and difference in the play between her self-consciously manufactured, off-screen persona and her role in the film. Reverberating through the staging of her exuberance, bodily presence, and self-evident pleasure in her sexuality, these ironies discredit Jerri's contented domesticity and aversion to fame, so that Mansfield in fact associates herself with the music's outrageous energy and defeats the narrative's contempt for it. Though a decade later Mansfield was still rock 'n' roll enough to record a single backed by Jimi Hendrix on guitar,[7] she was not a remarkable vocalist; but she did exemplify the brash disregard and vulgar energy of early rock 'n' roll, and its interwoven erotic and thanatotic impulses.

Less than a year before the film, Mansfield had been "Playmate of the Month" in the first of her thirty *Playboy* appearances, but she had been made a star by her success as a stage actress.[8] Her several minor parts in her first six-month contract with Warner Bros. had not brought her any notice, but in 1955 her agent persuaded her to audition for a part in an upcoming Broadway show, *Will Success Spoil Rock Hunter?*, partly based on Monroe's early image, but which she herself had turned down. Though some accounts claim that, disdaining the stage and not wanting to lose her focus on the movies, Mansfield intentionally exaggerated her reading of the part, the producers were nevertheless delighted with the caricature, and the show was a hit, running for close to 450 performances. She became a critical success and a celebrity, with a raft of magazine articles, including a cover story in the November 1955 *Life*, only seven months after that magazine's first three-page spread about rock 'n' roll's associations with riotous dance and African Americans. The success

of *Girl* earned her a stage show at the Tropicana in Las Vegas and $25,000 a week, ten times her salary at Fox. Teaching her that the hyperbolic display of the physical attributes and intellectual vacuity of the stereotypical dumb blonde would bring her the adulation and the stardom she craved, all these consolidated the persona that she used (and that she was used by) through the success and eventual degeneration of her subsequent career. Though she was able to experiment with a harsher image in her later London noirs, as a gang boss in *It Takes a Thief* (John Gilling, 1960) and as nightclub singer in *Too Hot to Handle* (Terence Young, 1960), otherwise she abandoned her earlier wish to be a serious actress, and in her life and films alike devoted herself to the fabrication of a publicity image molded on titillation and repression. But even at her most outrageous and artificial, she was still also being herself.

Though Tashlin's screenplay made the film version of *Rock Hunter* a satire on television rather than cinema, still Mansfield's role in this, her next film after *Girl*, is that of a hypersexual, publicity-ravenous movie star who draws no boundaries between her private and public lives, and in fact her spat in the film with Mickey Hargitay, the body-builder who eventually became her husband, that generates the plot anticipated events in her life. But, as well as placing the film in the music business, *Girl* had inverted the same motif in advance: Jerri is Mansfield playing an ironically inverted version of her own actual personal and career aspirations, making the film a negative allegory of her life in cinema and in publicity generally. Supplemented by the reflexive dramatization of the film medium, especially its superiority to television, and the frequent alienating devices and self-conscious motifs, the interplay between actor and role becomes the film's main pivot, where its instabilities and cultural insubordinations intersect. It would be Brechtian, were it not more fundamentally Tashlinian.

Giving Mansfield her chance to become a big movie star by playing herself trying *not* to be a star, *The Girl Can't Help It* generated an ironic reflexivity and semiological instability that lent her performance a complexity and nuance impossible in *Rock Hunter* and her other roles that directly displayed her ambition. It would be premature to locate these tensions as specific to rock 'n' roll, for autobiographical expressivity did not become central to the music's own rhetoric until the next decade when, just like Mansfield's, Elvis's reputation would collapse because of the lack of authorial authenticity in his material. But she correlates happily with the combination of feigned spontaneity and genuine artifice that distinguished rock's role in capitalist culture from earlier forms of folk music. Consequently, however much the logic of Jerri's desires appears to denigrate rock 'n' roll, her performance exhibits qualities intrinsic to it.[9] The key scene is her first visit to Miller's apartment, which is accompanied by a non-diegetic reprise of "The Girl Can't Help It." Her wiggle down the street that causes the iceman's blocks to melt, the milk bottles she holds in her bosom, and the other sight gags that display her hyperbolic

sexuality make her a phallic woman, a spectacular image of femininity that is nevertheless never entirely controlled by the male gaze. But she also enacts a burlesque of female sexuality parallel to Little Richard's burlesque of the black hipster, providing for boys a performance of the object of sexual desire, just as male rock stars do for girls. Her body and her character disrupting everything they encounter, she is the first rock 'n' roll actress.

Mansfield's ambiguities are, of course, magnified by what we know of her subsequent life. Her addiction to alcohol and other drugs, her self-destructiveness, the chaos of her personal relationships, and especially the manner of her death more than exemplified all but the last element in the "live fast, die young, and leave a good-looking corpse" aesthetic of rock 'n' roll culture. But something of her complexity, the noir within her sunshine, was evident to at least two of her contemporaries, both of them acutely sensitive to the mythopoeic dimensions of US culture. Poet Michael McClure, for one, saw Jayne as "a member of a black American tradition" of elemental beings who "capture the human imagination by their *existence*"; he found her neither sunny nor contrived, but a lamb surrounded by "blackness and sexuality and mystery," and placed her in a pantheon that also included Poe, Thoreau, and Artaud.[10] And, perhaps inspired by the (false) rumors of her association with Anton LaVey's Church of Satan, Kenneth Anger found a similar charge. Both front and back covers of the first US edition of *Hollywood Babylon* featured the same photograph of Mansfield, her breasts prominently displayed, even as his text, written in 1959, proposed that she held the promise of a new dawn for Hollywood. Two years after the book's US publication in 1965, she was killed in a gruesome accident, and Anger concluded later editions of the book with photographs of the crashed car and Jayne's dead dog. By that time, Hollywood had cleaned Elvis up, emasculating both him and his music. With these dirty stars extinguished, the best sightings of the noir interweaving of sex and death in early rock 'n' roll were made by Anger himself. But where Tashlin's Cinemascope satire had brought all the resources of a major studio to counter the claims made about rock 'n' roll in small independent productions, Anger's equally radical though diametrically different intervention was made in a non-industrial, essentially amateur mode of production.

Kenneth Anger

Kenneth Anger first attained notoriety at the age of twenty with *Fireworks* (1947), a dramatization of his own homosexual masochism. The film was subject to legal harassment in the United States, but in France Jean Cocteau awarded it the Poetic Film Prize at his Festival of Damned Films, and Anger

moved to Europe, not returning until 1953. In 1970 he retrieved footage he had shot in France for a version of the Commedia dell'Arte love triangle in which Pierrot, moonstruck with love for Columbine, dies when she rejects him for Harlequin. He had it performed in traditional mime in a clearing in a visibly artificial forest on a soundstage, with Pierrot modeled on Baptiste in Marcel Carné's *Les Enfants du Paradis*. In editing this footage, Anger added a blue filter and a soundtrack of primarily late 1950s doo-wop records, mixed with fragments of abstract sound, and titled it *Rabbit's Moon*.

The five songs segment the seventeen-minute film into five parts: in the first two, Pierrot pines for his love, symbolized by the moon; in the next, he is taunted by Harlequin; in the fourth, Columbine dallies with him before leaving with Harlequin; and in the finale, he loses his soul and falls down dead. The music supplies a counterpoint of richly harmonized aural pleasure that both contrasts with and sustains Pierrot's masochistic melancholy, while the lyrics articulate his obsessive love and its failure as, for example, with "You took my heart, You took my soul" in the last song, the Eldorados' "Tears on My Pillow." The match between words is not always so exact: the mood of the first song, for example, the Capris' "There's a Moon Out Tonight," seems to accord with the scene, even though the lyrics portray the singer walking with his lover in the moonlight rather than separated from her.[11]

The irony of these disjunctions between the song lyrics and the narrative recurs in the unstable relation between visuals and audio generally, the late romantic European mime in the one case and the US teenage pop music in the other. Anger had frequently leveraged such a precarious semiosis on pop music, most dramatically seven years earlier in a film that mobilized the iconography of rock 'n' roll culture using records from the early 1960s, *Scorpio Rising* (1963). One of the half dozen most important rock 'n' roll films ever made, *Scorpio Rising* caused many scandals and prosecutions, even as its visualization of music made it seminal for non-diegetic rock soundtracks and music videos. It appeared shortly after the other important underground film that anticipated music video, Bruce Conner's *Cosmic Ray* (1961), an extremely kinetic collage of three strands of imagery: count-down leader and other miscellaneous film-specific motifs; Conner's own footage of a nude woman shimmying wildly; and found footage of guns, explosions, and other scenes of destruction, all set to Ray Charles's 1959 single "What'd I Say." Figuring the object of the singer's desire, the one who "knows how to shake that thing," the woman (Beth Pewther) plays the same *femme fatale* role in *Cosmic Ray* as Columbine in *Rabbit's Moon*, so that the film's overall conjoining of sex and death—fleetingly imaged in several shots, each only a few frames long, of a skull nestled in her crotch—suggests an ambivalence toward Charles's secularized gospel, an uncertainly as to whether it is the music of God or the Devil. Anger mythologized parallel motifs in *Scorpio Rising* but used the ideas of the occultist Aleister Crowley to reframe them in homosexual rather than

FIGURE 4.3 Scorpio Rising

heterosexual terms. The film visualizes the ambiguities of rock 'n' roll's social meaning with a sophistication and depth wholly beyond the reach of the feature narratives of the time and perhaps of any other film.

Where previous—and many subsequent—underground films privileged jazz and jazz musicians, *Scorpio Rising* (Figure 4.3) was the first major film to use rock as a soundtrack. It is a documentary of the sideburned delinquents nominated by Frank Sinatra as rock 'n' roll's constituency as they congregate in an informal Brooklyn motorcycle club, following the bikers as they assemble their machines, preen themselves in the imaginary mirror of pop-culture icons, meet with each other for a Halloween party, and take part in a cross-country race during which one of them crashes and is killed. Editing the visuals to a back-to-back sequence of contemporary pop songs, Anger transformed the narrative into a lurid comi-tragic rock 'n' roll myth, in his own words, "a death mirror held up to American Culture."[12] His composition is triply Eisensteinian: even though one of the bikers is singled out as Scorpio, overall the protagonist is the collectivity rather than the individual; the montage incorporates non-diegetic metaphors, especially shots of Marlon Brando from *The Wild One* (Laslo Benedek, 1953), introduced via a television screening of the film, and of Jesus from an educational film, *The Road To Jerusalem*, about his final journey; and throughout, the relationship between the sound and the images is contrapuntal and de-synchronized. The soundtrack to the twenty-eight-minute film consists of thirteen records, all but two of them from 1963, the year it was made. Apart from the last, the Surfaris' "Wipe Out," a manic surf instrumental introduced by a cackling laugh and the words "wipe out," all the songs are heterosexual love songs;

eight are by white singers and the rest by black, half are by girl groups and the rest by other singers who sustained doo-wop, light rhythm and blues, and other 1950s musical styles between the first wave of rock 'n' roll and the British Invasion. As in *Rabbit's Moon*, the records sequentially structure the visuals and supply an overall mood and cluster of associations, while the lyrics comment on the action with varying degrees of irony.

Recorded music had of course been used as underscore since the beginning of sound, but apart from montage title sequences (including those in *Rock Around the Clock* and *The Girl Can't Help It*), feature films had given rock 'n' roll records visual form primarily by showing performers lip-syncing to records. Contrarily, *Scorpio Rising's* separation of the audio track from its source emphasizes the free-floating autonomy of the record, liberating the music for a metaphoric rather than an illusionistic or ostensibly diegetic relationship to the images. Following each other like records played on a jukebox, the mass-market 45-rpm hits connote the rock 'n' roll culture in general that the bikers inhabit and manifest; but within this, the songs' specific narratives carry their own reference and expressivity through which the teenage erotic melodrama of the film overall is elaborated. The prominence of Brando and Dean iconography and attitudes in early rock 'n' roll visual culture integrally linked the music to bikers; but *Scorpio Rising* makes entirely original connections between the music and the subculture, using rock 'n' roll lyrics to comment ironically on both the bikers' everyday rituals of self-fashioning and their extraordinary crises. The film's overall narrative thus threads through the micro-narratives of the individual songs, each with its specific action and commentary. The big story is structurally simple, an ineluctable movement toward death or, in Anger's words, a "'high' view of the Myth of the American Motorcyclist. The Power Machine seen as tribal totem, from joy to terror. Thanatos in chrome and black leather and bursting jeans."[13] But contained within it are thirteen semi-autonomous episodes, grouped in four parts to which Anger himself gave titles:

"Part I: Boys & Bolts: (masculine fascination with the Thing that Goes)"

1. "Fools Rush In" (Ricky Nelson, 1963): introduction showing a biker polishing the parts of his stripped-down cycle, culminating in his standing erect to reveal the film's title in studs on his leather jacket.
2. "Wind-Up Doll" (Little Peggy March, 1963): biker reassembling his cycle, intercut with a child playing with toy wind-up motorcycle dolls.
3. "My Boyfriend's Back" (The Angels, 1963): close-up on a skull introduces and then is intercut with the biker completing the reassembly.
4. "Blue Velvet" (Bobby Vinton, 1963): several bikers, including one with massive muscles and a bulging groin, pull on jeans, studded jackets, caps, and chains; the bike is wheeled out of the garage.

"Part II: Image Maker (getting high on heroes: Dean's Rebel and Brando's Johnny: True View of J. C.)"

5. "Devil in Disguise" (Elvis Presley, 1963): introduction to the main Scorpio in his pad decorated with images of Dean, reading Al Capp comics, with close-ups on frames of affectionate teenage boys; eye-line matches with scenes from *The Wild One* establish a correspondence with Brando.

6. "Hit the Road Jack" (Ray Charles, 1961): intercut with scenes of Brando riding and bikers assembling at Coney Island, Scorpio dresses and adorns himself with death's head rings.

7. "(Love Is Like a) Heat Wave" (Martha Reeves and the Vandellas, 1963): intercut with images from a Dracula film, the scene continues with Scorpio taking a hit of crystal meth, kissing a scorpion talisman, and grasping a massive phallic flashlight.

8. "He's a Rebel" (The Crystals, 1962): As Scorpio walks to his bike and finds a parking ticket in its handlebars, intercut scenes show Jesus walking with his disciples and restoring the sight of the blind man; as he regains his sight, extremely brief shots of a homosexual orgy and a stiff penis are intercut.

"Part III: Walpurgis Party (J. C. wallflower at cycler's Sabbath).

9. "Party Lights" (Claudine Clark, 1962): intercut with scenes of Jesus entering a house, the bikers enter their clubhouse wearing death's head mask and carrying skeletons—which makes the party appear more like Halloween; as they boisterously mimic homosexual activity, eyeline-matched cuts position Jesus as a spectator.

10. "Torture" (Kris Jensen, 1962): a parallel montage shows both Jesus and Brando watching as one of the bikers is initiated by having mustard spread over his genitals, while Scorpio goes to a dark church festooned with a Nazi flag.

"Part IV: Rebel Rouser (The Gathering of the Dark Legions, with a message from Our Sponsor."

11. "Point of No Return" (Gene McDaniels, 1962): urged on by Scorpio standing on the altar and waving a death's head flag, the race begins and Jesus enters Jerusalem.

12. "I Will Follow Him" (Little Peggy March, 1963): the race continues, Scorpio urinates into his helmet and raises it over the altar; images of Jesus and Nazis are intercut with more bikers leaving for the race.

13. "Wipe Out" (The Surfaris, 1963): an even faster montage of Scorpio and the pixilated bikers as one of the racers crashes in front of the camera, precipitating a vertiginous collage of spinning lights and motorcycles that, as the music is replaced by a siren, comes to rest on a red ambulance light, and finally the word "end" spelled out in studs on a belt.

In the same issue of *Film Culture* as Michael McClure's "Defense of Jayne Mansfield," filmmaker Carolee Schneemann suggested that *Scorpio Rising*'s "penetrating visual relationships grow like an organism to a historical/social revelation," but concluded that throughout the film, "[r]ock and roll sound leads the senses."[14] The music, then, controls and directs the other elements in the film: Martha of the Vandellas exclaims that her love "is like a heat wave" just as the methamphetamine hits Scorpio; coupled with the drummer's propulsive rhythm, the demonic cackle at the beginning of "Wipe Out" lends an unwarranted glee to the finale's fatal crash; the irony of "She wore blue velvet" in the episode where the bikers put on their leathers undermines their threat; and in "Party Lights," singer Claudine Clark's desire to join her boyfriend in the fun is complicated by the visuals that reveal the party to be entirely male. Other episodes destabilize the biker's sexuality even more radically. The "Torture" section, for example, revolves around the song's refrain, "You're torturing me," which seems merely to express the victim's pain at his initiation. But the song is oddly tranquil, almost saccharine, making the lyric voice's address to his, presumably female, "baby's" elusiveness suggest a pleasurably painful sado-masochistic scenario; this is given an explicitly homosexual gloss in the scenes of Scorpio in his leathers, which themselves contain intercut flash-frame of a man's branded buttocks. The implication of sado-masochism is further elaborated by the implication of parallels in Christianity: the suggestion that Christ is an involved spectator to the biker's torture and the allusion to the masochism of his own passion and indeed of his entire ministry that is triggered by the quotation from the *Gospel of John*, "the Word became flesh and dwelt among us," inscribed above the altar on which Scorpio stands. Other instances of the interplay of textures and overtones in the tension between the lyrics and the visuals are even more complex.

In the episode framed by "He's a Rebel" by Phil Spector's group, the Crystals, the simple reference of Darlene Love's opening line, "See the way he walks down the street," to Scorpio as he does just that is interrupted after only a few steps by a cut to Jesus and his disciples who, whichever way Scorpio turns, always walk toward him. As the chorus—"He's a rebel and he'll never ever be any good/He's a rebel and he'll never ever be understood"—begins, Scorpio arrives at his bike, but the visuals cut immediately back to Christ and the blind man, who rises to meet him. In very brief shots, Scorpio appears to place a parking ticket on the right handlebar of his motorcycle, Jesus moves toward the beggar, Scorpio places a ticket on his left handlebar, and Jesus touches the man's eyes; but when he opens them, it is to see two or three frames of naked men from a physique pictorial, at which he falls to his knees before Jesus' crotch, which is replaced by a shot of Scorpio's erect penis. The parking ticket is shown, then a shot of Scorpio apparently looking at himself narcissistically in a mirror, naked except for a cap with an "AC" logo, and Jesus moves off into the house for the Halloween party. Meanwhile, parallel inversions have taken place in the song's attitude to the rebel. The emphasis

on the chorus lines, "He's a rebel and he'll never ever be any good/He's a rebel and he'll never ever be understood," that appeared to suggest that the singer was a good girl infatuated with a bad guy is twisted when at the end of the chorus she changes her mind—" 'Cause he's not a rebel, no no no/He's not a rebel, no no no, to me"—and positions herself within rather than outside his delinquency.

Similar clusters of multi-image and sound-image intellectual montage occur especially in Elvis's rueful address to the one he thought was an angel in "Devil in Disguise" and the uncertainty in Little Peggy March's "I Will Follow Him" as to whether she is committing herself to Scorpio, Jesus, or Hitler. As dense as any sequence in Eisenstein, interactions among these conflictual elements retard the major narrative, anchoring it in an ongoing present of contradictory implications, while at the same time thematically transvaluing received associations that link or separate the bikers, the Christ-Devil opposition, fascism, hetero- and homosexuality, and other binaries in the semiology of pop culture. By portraying the bikers as the polymorphous-perverse victims of a cultural environment in which the rigidities of Christianity and fascism are equally deathly, Anger inverts the broad cultural cliché of Hells Angels as rampant heterosexual delinquents buoyed by rock 'n' roll in their love of mayhem. But the inversion is only an initial moment in his deconstruction of the system of binaries that sustains both bourgeois respectability and its musical antithesis.[15] More than any previous work, *Scorpio* fulfills film critic Carrie Rickey's notion of films that themselves embody or manifest the properties of rock 'n' roll itself: "Movies about youthful charisma, narcissism and sex appeal dressed up in death-defying, sometimes death-embracing, attitude."[16] Articulating the mutually imbricated erotic and thanatotic myths that Janis and Jimi and Jim, Brian Jones and Kurt Cobain—and Jayne Mansfield and Elvis—would later live and die into before they were otherwise imagined, *Scorpio Rising* exploited the received cultural meanings of rock 'n' roll; but it also drastically destabilized them, opening them up to repressed possibilities and mythic resonances and discovering subversive potentials and multivalent delinquencies unimagined by even its most hysterical detractors. His radical formal and thematic richness was possible only in independent filmmaking, outside the dominant cinematic mode of production.

Anger planned to follow *Scorpio* with *Kustom Kar Kommandos* (1965), in his own words, a parallel "oneiric vision of . . . the world of the hot-rod and customized car. . . . a dream-like probe into the psyche of the teenager for whom the *unique* aspect of the power-potentialized customized car represents a poetic extension of personality, an accessible means of wish-fulfillment."[17] Unable to find funding, he completed only one section in which, to the accompaniment of the Paris Sisters' "Dream Lover," a young man with a powder puff slowly polishes his gleaming dream. Meanwhile, successful in the emerging underground cinema, *Scorpio* also proved controversial.

The theater manager who first screened it publicly in Los Angeles was found guilty of obscene exhibition, and though the verdict was reversed on appeal, its notoriety in both the developing avant-garde and gay film cultures made it the first real underground crossover hit. While Anger himself continued to create films about youth culture,[18] *Scorpio* inspired a renewed wave of biker films that began with Roger Corman's *The Wild Angels* (1966) and became the model for feature films using rock 'n' roll soundtracks.

Rock 'n' Roll Soundtrack: Sunshine and Noir

As the spectacle in the musical film inverts the usual governing priority of image over sound, it temporalizes the visuals by imposing its own musical order on both the shape of the whole sequence and its internal structure. Becoming subject to the music's temporality, the visuals conversely spatialize the music, endowing it with material presence and form that, unless they are purely abstract, may include locating it in a specific social world and hence suggesting its uses and meanings. Though elements of Busby Berkeley's numbers verge on the abstract, overall they confer social meaning on the songs and sometimes powerfully critique their function; the seduction and death of the working girl in "Lullaby of Broadway" in his *Gold Diggers of 1935*, for example, is a starkly disabused recognition of the realities underlying show music's glamor. Anger's spatialization of rock 'n' roll in a social narrative created a model that would become common in compilation soundtracks that dramatized both its fun and its threat, its sunshine and its noir.

Deeply indebted to Anger, Dennis Hopper's *Easy Rider* (1969) opened the way for feature film scores composed more or less exclusively of rock 'n' roll records.[19] But Anger's innovations were not fully appropriated until nearly a decade after *Scorpio Rising*, at the moment when rock 'n' roll's biracial cultural synthesis was collapsing, and films about it divided into separate black and white cinemas, the white looking toward the traditions of rural country music and the black to reconstructions of urban noir in blaxploitation. Disillusion with the cultural revolution's failure and confusion over its significance were displaced into nostalgia for the period before it, transforming the real social anxieties of the 1950s into a high-camp myth, though one devoid of Anger's multivalency. Introduced by Sha Na Na at Woodstock (appearing immediately before Jimi Hendrix!), a sentimentalized 1950s was forged in the Broadway musical *Grease* and turned to gold at the beginning of 1974 in the television sitcom *Happy Days*. Ron Howard's Richie Cunningham and Henry Winkler's Fonzie in the latter respectively instanced the guileless innocent in the idealized 1950s family (as seen in *Rock, Rock, Rock* and other jukebox musicals) and the now redeemed parentless delinquent greaser. These contradictory though interdependent stereotypes of 1950s culture were crystallized in

two seminal films released less than three months apart in mid-1973: George Lucas's *American Graffiti* and Martin Scorsese's *Mean Streets*.[20] Unlike Anger's amateur mode of production, both films were industrially produced features, though still on the periphery of Hollywood. Both were conceived in film school by filmmakers who came of age in the late 1950s; in both films, pronounced semi-documentary autobiographical content was matched by virtually total directorial control. Both were made Sam Katzman–style on shoestrings, and their critical and commercial success paved the way to successful commercial careers for their makers. And both used rock 'n' roll soundtracks to portray a world permeated by popular music: the one returning again to the absolute beginning with Bill Haley's "Rock Around the Clock" in the sunshine world of car radios in a small West Coast town, and the other opening with the Ronettes' "Be My Baby" in the noir bars and jukeboxes of an East Coast metropolis.[21] In this they respectively mobilized the two sides of rock 'n' roll that had been most fully exploited in two phases of the cinematic career of the greatest of all rock 'n' roll singers, Elvis Presley. Though the films Elvis made before being drafted in 1958 introduced "the first 'dirty star' in a long time," those he made on his return disguised his devil and blanched him into sunshine.

Rock 'n' Roll Noir

ELVIS BEFORE THE ARMY

When "That's All Right" was first broadcast on Dewey Phillips's "Red Hot & Blue Show" on WHBQ in Memphis on the evening of July 8, 1954, Elvis Presley had escaped his nervousness in a place with which he was deeply familiar in both reality and imagination: the movies.[1] A regular filmgoer, he had as a teenager also been an usher (until he was fired for fighting in the foyer), and cinema supplied both his early ambition and role models. Inspired by Marlon Brando, Tony Curtis, Robert Mitchum, and especially James Dean, he wanted most of all to be a movie star, and when he first went to Hollywood in August 1956, he astonished producer Hall Wallis by his ability to recite all Dean's lines in *Rebel Without a Cause*. The film he was to make there, *Love Me Tender*, was Twentieth Century Fox's first since *The Girl Can't Help It*. But Elvis had reached his goal by what he later looked back on as an established route: "That's what happens: you get a record, then you get on television, and then you go to Hollywood."[2]

Elvis's career began with the seminal records Sam Phillips coached out of him at Sun, his small, independent, but radically innovative Memphis studio. Previously Phillips had recorded primarily black blues singers, but by 1954 many of his artists had moved to the new rhythm and blues labels, and Elvis was one of the first white singers he found to replace them, soon to be followed by Carl Perkins, Jerry Lee Lewis, Johnny Cash, and other early avatars of rock 'n' roll. With radio play of "That's Alright" and the other records we now know as his "Sun Sessions," Elvis's live performances at high schools, football fields, country fairs, and eventually the Grand Ole Opry and other country music radio shows made him a sensation across the South. But his acclaim became national only with the television appearances that his manager, Tom Parker, secured immediately after Phillips sold his contract to a major label, RCA. Following these appearances, and less than two years after cutting his first commercial single and still only twenty-one, Elvis was in Hollywood.

Of Elvis's musicianship, there can be no question. Elvis's rhythm guitar was integral to the power of his early recordings and his use of it as a visual marker of his musicianship made it the fundamental rock 'n' roll signifier, though he was not accomplished as a guitarist or a pianist. But as a vocalist, he was uniquely gifted, able to glide effortlessly and with perfect control of volume through a vocal range of almost three octaves.[3] Equally as important as his management of pitch, the fundamental signifier of western music, was his consummate rhythmic flexibility and especially his ability to move his voice physically through different parts of his mouth and throat—different phonation glottal states—that gave him a richly varied palette of colorations, timbres, densities, and inflections, many of them more common in African American and other non-western musics. Together with his mastery of a wide spectrum of musical styles and genres, ranging from blues to operatic Neapolitan ballads, and his innovative manipulation and recombinations of them, these vocal resources supplied his work's endlessly evocative yet emphatically somatic sensuality.

The historical importance of Elvis's purely musical abilities is inseparable from the social resonances they enfolded and inspired. His musical and visual personae dramatized the generational breaks and historical transformations in late twentieth century US culture, its mutually implicated crises in class, race, sexuality, and regional difference. Commentators as disparate as Eldridge Cleaver and Leonard Bernstein agree that no other artist of the time had comparable musical gifts and no other so completely embodied or articulated the social issues of his time and place. The former's perception of Elvis as "like a latter-day Johnny Appleseed, sowing seeds of a new rhythm and style in the white souls of the white youth of America" is echoed in the latter's claim that Elvis was "the greatest cultural force in the twentieth century. . . . He introduced the beat to everything and he changed everything—music, language, clothes, it's a whole new social revolution—the Sixties comes from it. Because of him, a man like me barely knows his musical grammar any more."[4] This cultural revolution began in the least auspicious surroundings.

"We Presleys—we been poor as far back as I can remember,"[5] Elvis recalled, and his life and music were grounded in the harsh conditions of the Southern working class. He was born in a two-room shotgun shack to a sometime sharecropper father who had served time in jail for forging a check, and until Elvis's success his family lived on the edge of survival. After an inauspicious Memphis high-school career, as a working teenager at the Parker Machinists Shop, he spent his lunch break and $3.98 to make two amateur singles for his mother, and when his professional career began he was a truck driver, experimenting with semi-professional musicians who were otherwise also unskilled workers, Scotty Moore on guitar and Bill Black on double bass. A poor and poorly educated Southern boy, his only social capital was his whiteness, and his first musical achievement was to obscure it.

From the beginning, his singing was heard as a brazen miscegenation, with the two sides of his first single immediately recognized for interbreeding white and black music. In a local newspaper story about Elvis's early success, a Memphis journalist (named Robert Johnson, no less) noted that the two traditions were fused in complementary ways on its two sides: "'That's All Right' was in the R&B idiom of negro field jazz, 'Blue Moon' more in the country field, but there was a curious blending of the two different musics in both."[6] Johnson's analysis has been endlessly reiterated, and in what he summarized as a "white man's voice singing negro rhythms with a rural flavor," Sam Phillips found the "white man who had the Negro sound and the Negro feel" he had long sought.[7] Similar crossovers and assimilations were integral to both traditions of vernacular Southern musics and to the overall development of rock 'n' roll. Less than a year after Elvis's first single, for example, Chicago record producer Leonard Chess discovered a "hillbilly song . . . written and sung by a black guy."[8] It was Chuck Berry's "Maybellene," released as his first single backed, like Elvis's, by a blues tune. Elvis's amalgamation of black and white music was similarly audacious. The two songs he recorded for his mother were covers of the Ink Spots' "My Happiness" and "That's When Your Heartaches Begin," and for the rest of his life he repeatedly emphasized his debt to and admiration for African American music. Augmented by his imitation of many aspects of Southern blacks' clothing, body language, and other cultural signs, Elvis's saturation in black pop and blues was intrinsic to his music, his performance, and his appearance, and hence to the biracial visual and audio culture of early rock 'n' roll—and to the threat it represented. But within it he marshaled the white working-class idioms and enriched them with vernacular religious traditions where, beneath the segregation, black and white forms had always been intertwined.[9]

Elvis's parents were "Holy Rollers," regular attendees at the First Assembly of God Pentecostal tent church, where indeed they had first met. When Elvis was two years old, his mother recalled, he would run down the aisle and try to sing with the choir, and he himself remembered, "When I was four or five, all I looked forward to was Sundays, when we all could go to church. This was the only singing training I ever had."[10] In his early teens he regularly attended All-Night Gospel Singings; he attempted to join a white gospel group; he met his first real girlfriend, Dixie Locke, at the South Memphis Assembly of God; and he attended there regularly with her until he began touring. At the height of his success, he continued to record albums of religious songs, and though he received fourteen Grammy nominations, his only three wins were for gospel albums; his back-up group of choice was a gospel quartet, the Jordanaires; and throughout his career he warmed up for recording sessions by singing religious songs. The music of the Statesmen, the Blackwoods, and similar gospel quartets was as fundamental to the textures and rhythms of his singing as were the black and white forms of secular Southern country

music and commercial pop and, at the time Ray Charles and Little Richard were adapting black religious music, Elvis found his voice in his own parallel traditions. The black component in Elvis's aesthetic as a whole is immense, but it is not the center of his singing; indeed, while beginning with "That's All Right" his versions of blues songs are among his best achievements, his covers of black rock 'n' roll—of Little Richard's "Tutti Frutti," and Chuck Berry's "Maybellene," for example, and especially of Ray Charles's "I Got a Woman" in *Viva Las Vegas* (George Sidney, 1964)—are weak. On the other hand, along with Elvis's belief that "My voice is God's will, not mine,"[11] the three major components of his performance may be attributed to his religious heritage: first, the tonic range of the four parts of the quartets, which he imitated in his own effective range from bass to falsetto; second, his leg-shaking, twitching, and other body movements, which, though he quickly learned to exploit them, were initially spontaneous and unconscious reproductions of the involuntary automatism common among Holy Roller preachers and gospel musicians; and third, the emotional transport of religious ecstasy that he readily secularized and eroticized.[12] These spiritual drives were intrinsic to Elvis's sense of both himself and his art. At the lowest point in his career, trapped in a cycle of films that he felt degraded and humiliated him, he found solace in the study of religious texts that enabled him to address the unfathomable question: "there *has* to be a purpose . . . there's got to be a reason . . . why I was chosen to be Elvis Presley."[13]

Just as the porous boundaries between black and white in Elvis's musical environment subtended the racial transgressions of his music, the siren calls of both God and the Devil echoed each other in his secularization of his own gospel traditions. Where Little Richard, for example, lived out the same tensions sequentially, Elvis did so simultaneously, and the intertwined spirituality and erotic physicality underlay the ambiguities of his charismatic persona: the coexistence of rebellion and vast ambition with deference and passivity, of aggression with tenderness and vulnerability, of male and female, of black and white, of noir and sunshine. Intersecting each other, these and the unpredictable combinations among them allowed him to voice the desires and delinquencies of the time when all were being revised: the generational division, class insubordination, racial exchange, sexual discovery, and regional affirmation—and the anxiety and excitement in them all. To varying degrees, his earliest movies dramatized the same commotions, but the visual elaboration of his persona and music was first seen nationally on television, at the first of the two crucial points when television transformed his career.

Television displayed his voice's material source in his equally scandalous face, hair, loins, and legs, together an extraordinary combination of photogenic and phonogenic appeal. After six appearances on CBS's Jimmy and Tommy Dorsey's *Stage Show* between January and March 1956, he appeared

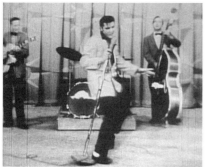
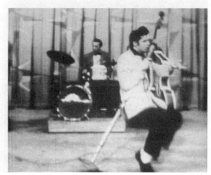

FIGURE 5.1 *Elvis performing "Hound Dog" on the* Milton Berle Show, *June 1956.*

on the *Milton Berle Show* in April and again on June 5, when his performance of "Hound Dog" was jubilantly provocative, vocally and visually (Figure 5.1). Absent the Jordanaires who supported him on the record, the three members of his back-up band, uniformed in matching jackets and bow ties, melted into the background. Apart from three brief cutaways, one to a medium close-up on Elvis and Moore and two to the audience, the number was shot in a continuous long take, with Elvis in full figure in front center. He dominated the stage, wearing an open-necked shirt with a black collar framing his face, an oversized white sport coat emphasizing the power of his shoulders, and black pants and white socks that, like Astaire's spats, highlighted his gyrating ankles. Holding the mike in one hand, he set his hair, hands, arms, head, pelvis, knees, and feet in coordinated motion, creating a physical chorus for his voice. His enactment of the song's taunts came to a climax in a half-time coda that he had developed in his stage shows (but would omit from the record), in which he rose on his toes and thrust his hips in an explicit simulation of sexual aggression. Hardly less uninhibited than his early live shows—and never fully equaled in his films—the performance earned him the "Elvis the Pelvis" nickname and triggered a storm of attacks in the national press, so ferocious that, when less than a month later Steve Allen introduced the "new Elvis" in a white tie and tails, he hardly moved as he pleaded, "I Want You,

I Need You, I Love You." Only a knowing smile as he twitched his shoulders acknowledged the bowdlerization, before he sang "Hound Dog" to an uncomprehending basset. But the recording of the song he cut next day sold over seven million copies, more than any other in the decade, and that September, Ed Sullivan reneged on his vow never to book him, paying him $50,000 for three appearances. Sixty million viewers—more that 80 percent of the nation and at the time the largest television audience ever—watched the first show on September 9, 1956, where he sang "Love Me Tender," the title song for his first movie. And on Elvis's third and final appearance, Sullivan called him "a real decent, fine boy" and wished him well as he returned to the coast, for his second movie, *Loving You*.

Noticing one of Elvis's *Stage Show* appearances, Hal Wallis flew him to Hollywood for a screen test and signed him to a one-picture non-exclusive contract at Paramount, with options for a further six for a fee that would progressively increase from $15,000 to $100,000 per picture.[14] He made four films in Hollywood before being drafted into the army in 1958, three of them containing much of his best music. When he returned from his army service in 1960, it was to a television show, "The Frank Sinatra Timex Show: Welcome Home Elvis." Though earlier Elvis had epitomized the sideburned rock 'n' roll delinquents that Sinatra excoriated, he too swallowed his pride and paid $125,000 for a single appearance, then the most ever paid to a television-show guest. On two songs of his own and two duets, Elvis sang rings around him: Sinatra's rendition of "Love Me Tender" was leaden, while Elvis's reply with Sinatra's "Witchcraft" swung consummately. Recording sessions soon after produced several singles and the *Elvis Is Back!* album, but then for seven years he made neither live nor television appearances and performed only in feature films, twenty-seven of them. All made money, some of them a great deal. But their spiraling artistic degradation suffocated Elvis in disillusionment and alienation.

Elvis's musical decline in the 1960s and the subordination of his music to his film career were framed by many personal factors: his army service and the addiction to amphetamines he acquired there; his mother's death and his father's remarriage; his dependence on Parker; and his own marriage, the birth of his daughter, and then his divorce. But cocooned in Hollywood or Graceland, he was isolated from and unsympathetic to the transformed zeitgeist of the new decade, not least from the excitement of the shifts in the music that he, as much as any other individual, had inspired. His genius had prospered during the move from Sam Phillips's studio to the corporate record industry and from a Southern, predominantly working-class audience to the national mainstream, but it did not survive in Hollywood. Though almost all his 1960s movies contain at least one good song, overall Hollywood's exploitation of Elvis gnawed at his soul. Then, at the absolute nadir, a single television appearance allowed him a rebirth, startling him as much as it did his public.

In the *Comeback Special*, broadcast on NBC on December 3, 1968, much of it recorded before a live studio audience, he found his way back to rock 'n' roll and the power of his earliest music, and to the genius that a decade of Hollywood comedies had all but extinguished. In his subsequent live performances, first in Las Vegas and then on tour, filmed and then televised, he reclaimed his crown. Before the *Special*, Elvis had become a joke; after it, his status as a national icon and then a myth was unchallenged.

Elvis in Hollywood

The first rock 'n' roll singer to star in a film, Elvis made four features in the fifties: *Love Me Tender* (Robert D. Webb, 1956), *Loving You* (Hal Kanter, 1957), *Jailhouse Rock* (Richard Thorpe, 1957), and *King Creole* (Michael Curtiz, 1958) (Figure 5.2).[15] He starred in the last three, all set in the South, with Elvis playing the persona he had developed on stage and television shows, and avoiding any "excess acting," as he had requested of Hal Wallis.[16] His attitude and accent are those of a Southern working-class male, a white hillbilly but with black inflections. Between 1957 and 1958 he was at the height of his musical power, and the last three films contain all his hits of the period and more of his best music than any other films. In these he plays a singer in fictionalized "rise to stardom" narratives, and for his numbers, he lip-syncs to records, with back-up musicians (not necessarily those on the recordings) often present but not individuated. Most performances are photographed and

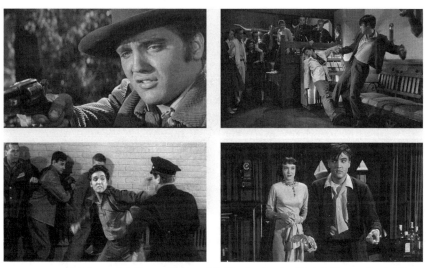

FIGURE 5.2 *Sideburned delinquents:* Love Me Tender, Loving You, Jailhouse Rock, King Creole.

edited in alternating long and medium shots showing his whole body or his chest and face, and only rare facial close-ups; the only cutaways are views of his audience, usually women. But Elvis's singing and his self-dramatization, both while performing and in the narrative, transform otherwise predictable genre pieces and make them superior to all other pop musicals of the decade. All contain the jukebox musicals' themes of rock 'n' roll's links with delinquency, romantic conflicts, and struggle for success in the music industry; but they contrarily mobilize and narratively emphasize the music's anarchic and disruptive power and even admit something of the criminality that the genre as a whole denies.

Love Me Tender set a Civil War family melodrama of confused motivation and suspicious minds in an idealized rural South. A James Dean on horseback, Elvis plays a young farmer, Clint Reno, who marries Cathy, the girlfriend of his elder brother, Vance, when he is erroneously reported killed in the war. When Vance returns, he and Cathy nobly resolve to conceal their earlier love from Clint. But complications involving money that Vance and his other brothers appropriated from the Union army a day after the war ended make Clint jealous of his brother and distrustful of his wife, and he is finally killed in a shoot-out. In an apt nod to his roots, Elvis's first screen appearance is a distant shot of him working a horse-drawn plough; after this, he does little but mount and dismount his horse, act murderously tormented and enraged—"out of his mind with jealousy"—about Vance and Cathy's supposed betrayal of him, die at the end, and sing four songs: "Love Me Tender," the first ballad he ever recorded, based on "Aura Lee" of the Civil War period; the gospel song, "There's a Leak in This Old Building" (retitled as "We're Gonna Move"); and two up-tempo hillbilly songs at a hoe-down accompanying the raising of a schoolhouse. More than a little anachronistic in the middle of these folk musical motifs, Elvis's spirited knee-jerks and hip-swivels reveal to the marveling crowds what their culture would become a century later. He ends the movie with a reprise of the title song, coming back to life in a cameo superimposed over his gravestone and grieving kin. Although Elvis himself was viciously attacked by elements in the mainstream press, the film made its production costs back in the first three days after its New York opening, something no other film has achieved since.[17]

The next two, *Loving You* and *Jailhouse Rock*, both reproduce the narrative frame of *Rock Around the Clock* (Fred Sears, 1956) and other jukebox musicals in depicting a manager's discovery of the protagonist's extraordinary gifts and the difficulties encountered in orchestrating his rise to stardom through the apparatus and institutions of the music industry. Several other motifs recur: *Loving You* reprises the scheming female agent from *Rock Around the Clock* and the public debate about the moral threat of rock 'n' roll from *Mister Rock and Roll* (Charles Dubin, released less than three months earlier in 1957), as well as the nationally broadcast television show that concludes both. But

where the jukebox musicals all featured numerous performers, here the biopic replaces the revue as the underlying structure. The only significant singer in his films, Elvis monopolizes both the narrative and musical functions in plots that are fundamentally autobiographical: the stories of how Deke Rivers in *Loving You* and Vince Everett in *Jailhouse Rock* respectively become Elvis are hardly less astonishing than his own achievement of the same feat.

Each film emphasizes a different facet of his biography and different components of the entertainment industries. *Loving You* focuses on his live performances, narrating his early touring of county fairs, tent shows, and small theaters throughout the South, and the beginnings of his rise to national fame to culminate in a coast-to-coast telecast of a forum on his music's moral effect on the young. *Jailhouse Rock*, on the other hand, concentrates on his recording career, attributing Sam Phillips's role in it to Elvis himself. As Vince Everett, Elvis is taught the rudiments of the guitar by Hunk Houghton, a fellow inmate and sometime country musician and, embarking upon a career as a recording artist on his release, he meets Peggy, who becomes his manager and later his lover. The cutting of his first record, "Don't Leave Me Now," is pivotal. After a disheartening first take, Peggy convinces him to rely on his own emotions and, moving his body along with his voice, he "gets a little fire" in the second. The sequence dramatizes the combination of spontaneous personal expressiveness and utilization of studio professionalism that, with Sam Phillips and after, enabled him to find a unique voice, and also the fusing of untutored folk creativity and commercial enterprise fundamental to rock 'n' roll's various modes of musical production. But an unscrupulous agent copies his innovations, forcing Peggy and Elvis to hire a lawyer, start their own label, laboriously distribute records to stores, and persuade disc jockeys to play them. Elvis displays Parker's obsession with money and his mastery of exploitation and publicity, and the film narrates Peggy's successful management that takes him to Hollywood, with television's biographical role and the generic requirements of the jukebox musical represented by two coast-to-coast telecasts on the way. In the first, a broadcast from the jail, he sings "I Want to Be Free," appearing as a fully mature artist even though it is the first time he has sung outside his cell; and in the second, he sings the title song, one of his most famous numbers, whose elaborate staging recalls MGM's and the Freed unit's prominence in the classic musical. In both films his genius is innate and limitless, but like Bill Haley's talent in *Rock Around the Clock*, it is fully realized only by becoming managed, commodified, and industrialized.

Elvis's spontaneous self-creation is figured in his character's lack of parents and of any status in middle-class society. Though his family in *Love Me Tender* is led by a strong matriarch, it lacks a father, and in his next two films he has neither parents nor any other family. From his gravestone at the end of *Love Me Tender*, he is reincarnated in *Loving You* where, after fleeing his burning

orphanage, Deke Rivers's gravestone supplies him with a new name, and in *Jailhouse Rock* his family is simply nonexistent. Reflecting the economic precariousness of his own background, his character is always unskilled working class: "You've never had nothing, you don't know what its like," he asserts angrily in *Loving You*, displaying a border-line lumpenness that a narratively crucial fistfight links to an aggressive virility. In *Loving You*, he is discovered while delivering beer in his hot rod, and the class migration the music business provides him is illustrated when he crashes it and takes his place in a white convertible supplied by his agent. In *Jailhouse Rock*, he appears briefly as a tractor driver, before landing a stint in jail for killing a man in a barroom brawl. His peremptory sexuality is linked musically to working-class rock 'n' roll in the only sequence that introduces him into a bourgeois environment: in *Jailhouse Rock*, Peggy takes him to a party given by her parents, faculty at a small college, but when her mother attempts to make conversation with him by remarking à propos of a modern jazz record playing in the background that "atonality is just a passing phase in jazz," Elvis claims the cultural ignorance of the delinquents in *Blackboard Jungle* and snarls, "Lady, I don't know what the hell you're talking about." He angrily leaves, and when Peggy rushes after him, he grabs her and kisses her roughly, and, to explain his action, eloquently declaims: "It ain't tactics, honey, it's just the beast in me."

Though in both *Love Me Tender* and *Jailhouse Rock*, Elvis's career takes him out of the working class, his success never irons away the rough edges of his origins. As in the jukebox musicals, professional success coincides with the resolution of the star's romantic dilemmas and of his associations with delinquency, but for Elvis exculpation remains ambiguous and he retains a minatory nimbus. Where the other jukebox musicals specifically refuted *Blackboard Jungle*'s association of rock 'n' roll and delinquency, Elvis's films embrace his outlaw sexuality and violence.

The romantic plots involve a competition between an experienced woman, typically a brunette, who herself to some degree deviates from socially sanctioned female roles, and an innocent counterpart, typically a blonde. Though inherited from nineteenth-century fiction and Hollywood conventions in general, the tension between these resonates with the conflictual noir and sunshiny components in Elvis's persona. The motif is Oedipalized in *Love Me Tender* and displaced onto Cathy and his mother (to whom he first sings "Love Me Tender") and cannot be resolved except by his death. In *Jailhouse Rock* it is only vestigially present, in a last-act rivalry between Peggy and an initially disdainful Hollywood starlet who falls for Elvis. But, though the hair colors are switched, the motif is fundamental in *Loving You*.

Deke Rivers is first discovered by Glenda, manager of a hillbilly band led by her ex-husband, Tex (that also features Scotty Moore, Bill Black, and D. J. Fontana, Elvis's actual backup trio at the time), along with Dolores Hart as Susan, a gingham-frocked singer. Reduced to using the band to promote

a small-time country politician, Glenda falls for Deke and connives to snare him, to exploit him as a gimmick that will bring success to the band but also as a lover for herself. All the women who see Deke's pelvis-thrusting performances are incited to frenzy, but he prefers Susan, who quietly mends his shirts. When his mounting fame creates disturbances in the towns they visit and a crisis in the band, he returns with her to the family farm, pledging his troth by singing the title song before her assembled kin. Their love survives Glenda's machinations and the subsequent melodramas in and around the band that culminate in the televised inquiry, broadcast nationally from Freegate, Texas, where Deke's performances have been causing riots. Those who believe that rock 'n' roll is innocuous declare that the kids use it to let off steam and cite a history of musical disturbances going back to Stravinsky's *The Rite of Spring*, but Elvis trumps the inquiry by singing "Loving You" to Susan again—before cutting loose with his wildest gyrations for "Got a Lotta Living to Do." The coda ends with him in a clinch with Susan, Tex reunited with Glenda as his managers and surrogate parents, and the offer of a record deal.

Elvis's associations with delinquency are multiple in *Love Me Tender*. Though kept at home by his youth while his elder brothers fought for the Confederacy, history places him on the edge of the law in the immediate postwar period. This position is compounded as his brothers refuse to return the Union funds and, suspecting that Cathy is unfaithfully conspiring with Vance, Clint joins the group who refuse to surrender to the Northern lawmen. These entanglements legally and ethically incriminate Clint so fully that the narrative cannot rescue him, and he is sacrificed, his ghost presiding over the implication that eventually Cathy will return to Vance and restore the family harmony. In *Loving You*, the incrimination is fundamentally sexual: Deke becomes morally suspect by virtue of his female fans' hysteria and, though artificially stoked by his manager, it erupts in a national scandal. But *Jailhouse Rock* is more explicit than either, and Vince oscillates between being morally good but legally bad and vice versa. His initial imprisonment, for example, results from a fistfight that he is forced into by his noble defense of a woman who is being maltreated by her husband, and a flogging with which he is punished in jail results from his loyalty to his fellow prisoners. On the other hand, together with his initial experiences in the music industry and his tempestuous relationship with Peggy, these occasions of abuse so embitter him that he becomes arrogant and exploitative. His cruelty to Peggy and condescension to Hunk Houghton culminate in the film's final crisis, when the latter punches him in the throat so violently that his very voice hangs in the balance, and only the success of a dangerous operation allows for a final reconciliation with them and the finale reprise of "Young and Beautiful."

But one major social issue about rock 'n' roll is repressed in all three films: Elvis's and rock 'n' roll's debt to black music. Apart from a couple of

children in the hillbilly audiences for Deke's early performances in *Loving You* and a poster of Paul Robeson glimpsed briefly in *Jailhouse Rock*, not a single African American character appears in any of them, and nowhere is the rhythm and blues component in Elvis's music—as prominent in the songs for these films as anywhere else—narratively recognized. Where the jukebox musicals after *Rock Around the Clock* all assert the prominence of black musicians in rock 'n' roll music and its wider culture, both *Loving You* and *Jailhouse Rock* narrate it as exclusively a development within hillbilly and country music; the former has Elvis singing "Lonesome Cowboy" and wearing either denims or fancy cowboy clothes reminiscent of the Grand Ole Opry, and the latter shows him schooled by Hunk in the tradition of Roy Acuff and Eddie Arnold (whom Parker had once managed). In both, he emerges from entirely white social and musical milieus and, like his gospel heritage, the African American components of his music and his persona appear as his sheerly idiosyncratic genius, the quality of pure Elvisness. Like the questions in the radio interview when "That's All Right" first aired that clarified that his high school and hence Elvis himself were white, the narratives of his first three films—though not the spectacle of his performances—reassure audiences that he and his is music are racially immaculate.

In also dramatizing rock 'n' roll's off-stage procedures, the structure of the integrated apparatuses of performance, touring, recording, and record promotion and the integration of all these with film and television, *Loving You* and *Jailhouse Rock* complete the creation of the rock 'n' roll musical out of the backstage show musical. Apart from the repression of African American music and Elvis's biracial attraction, their narratives raise and resolve the issues that made him so popular and controversial: the combination of a masculine outlaw aggressiveness and a feminine romantic vulnerability. *Loving You* holds his romantic appeal in balance with the delinquent, while *Jailhouse Rock* unprecedentedly exploits the delinquency. His next film, *King Creole*, invests these contradictory thematic issues and the music that sustains them with a unique richness. Elvis's own favorite, it also contained some of his best music and is the best of all his films.

King Creole

Stretching the acting talents of the then twenty-three-year-old veteran, *King Creole* takes Elvis back to high school, shifting the scene, however, from the outskirts of Memphis to the racier Bourbon Street in New Orleans and dramatizing his rise to fame in local nightclubs. It is very loosely based on the first half of *A Stone for Danny Fisher*, Harold Robbins's best-selling novel about the disintegration of a middle-class Jewish family in Brooklyn during the Depression. After his father loses his pharmacy, Danny falls in with

gangsters, first becoming a boxer and then joining racketeers, only to die by being machine-gunned. Set in the present, with the Jewish ethnic element removed, the film stars Elvis as Danny, equally talented with his voice and his fists. The son of a weak father who, after the death of his wife, has allowed his family to sink into poverty, Danny supplements their income by working before and after school as a nightclub cleaner and busboy. Though the prosperous small-town life and the old family home remain as dreams, like Artie West in *Blackboard Jungle*, Danny is very much a street kid, dressed in T-shirts and dungarees with a greasy pompadour. Indeed, in knife fighting and any other kind of troublemaking he consistently betters a gang of teenage delinquents led by Shark (Vic Morrow in a reprise of his role as West), who admires him for fighting "real dirty." On his last day in high school, he is caught up in an altercation in the club between drunken hoodlums and Ronnie, a call girl, leading to his being denied graduation, for he has "no concept of respect and discipline." Refusing to return to school, he sets out to make money, and hooks up with Shark's gang.

To distract the customers' attention while the gang robs a department store, Elvis sings "Lover Doll," one of his most lyrical and relaxed ballads, to a shop-girl, Nellie (Dolores Hart again), and afterward begins to date her. At the same time, he is noticed by underworld king Maxie Fields, who owns Ronnie and who accidentally discovers Danny's musical talent when he forces him to sing in his nightclub. Danny is hired instead by the owner of the King Creole, a rival nightclub and apparently the only honest one in the Quarter. But Shark tricks him into helping the gang in a heist where his father is beaten so severely that only Fields can afford the surgery that saves his life. Though indebted to the hoodlum, Danny beats both him and Shark savagely, and escapes with Ronnie to her secret retreat on the Keys. They are allowed only a few moments of love before Fields finds them and shoots her, and is himself killed by a youth Danny had befriended earlier. Danny returns to the King Creole and the possibility of a musical career, but his earlier warning to Nellie, "Don't fall in love with me: love means getting married, kids, I want to be somebody first," still hangs over the couple, and the film ends with a non-diegetic reprise of "As Long as I Have You," a song associated, not with Nellie, but with Ronnie, though here addressed to his father, who finally accepts his son's vocation.

As always, Elvis's genius is spontaneous and absolute; as God-given as America, it is already there, and all the narrative has to do is discover it. But *King Creole* is more ambivalent about its implications. In *Love Me Tender* and *Jailhouse Rock*, the rise to stardom in the music industry motif, the dual focus romantic issues, and the complications with delinquency were all cleanly resolved together, producing an atoned Elvis commanding the narrative closure. But in *King Creole*, the Bourbon Street underworld in which Danny's ethics and aesthetics are mired generates a more sinewy, ambivalent narrative

path for him through a pattern of binaries that leave his romantic relation-
ships, the consequences of his criminal acts, the possibilities of his music—and
hence the social implications of rock 'n' roll itself—all unresolved.

These complications underlie the special richness of the scene where he
first performs a rock 'n' roll number (Figure 5.3). When, in Fields's club,
Ronnie is forced to concede that she knows Danny through having heard
him sing, the suspicious gangster forces him to take to the stage and prove
her words, ridiculing him as "Caruso, the busboy." The all-black Dixieland
brass band introduces "Trouble," Leiber and Stoller's appropriation of Willie
Dixon's "Hoochie Coochie Man" made famous by Muddy Waters in the
mid-1950s. Standing on the bar before the band, Danny begins to sing, staring
Fields directly in the eye: "If you're looking for trouble/You came to the right
place./If you're looking for trouble/Just look right in my face." At first he is
restrained, but as the threats in the lyrics mount, his hip and leg movements
become more suggestive and aggressive; hair from his pompadour falls over
his eyes, and the expression on his face shifts from withering contempt for
Fields to sheer joy in his own performance. With its almost operatic control

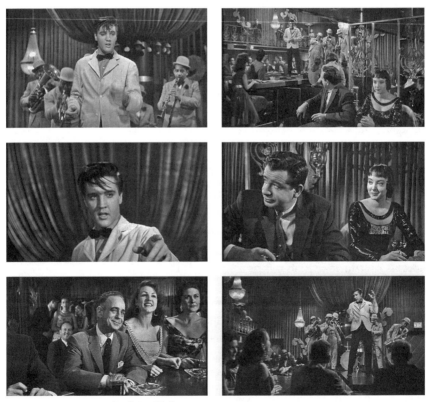

FIGURE 5.3 King Creole, "Trouble."

and restrained vibrato, his voice rides over the brass in call and response patterns. In the double-time coda, his dancing becomes as uninhibited as it had ever been; always leading from the hips, he sways his upper body, and snaps his fingers in rampant animal insolence: "My daddy was a green-eyed mountain jack. . . . I'm evil, so don't you mess around with me." Again, "It ain't tactics, honey, it's just the beast in me."

Performing the extravagant sexual boasting of a classic of African American rhythm and blues without a trace of irony, Elvis revels in its Dionysian intimations of youthful sexuality and mayhem. His performance allows Danny to humiliate Fields, safeguard Ronnie, thrill the entire audience, and discover his—and rock 'n' roll's—power. Retrieving his leather jacket, he quits his job and leaves the club to take his share of the proceeds of the store robbery. The song's complete integration into the dramatic moment is reasserted in the visual composition. Cut-aways during the first stanza show the club-goers' enchantment and Ronnie's delight in her triumph over her pimp. A series of recurrent camera angles show Danny in medium close-up, before the band on stage, in visual interaction with Fields, and among the club audience as a whole. Taking place entirely within the diegesis, being pivotal in the plot, and assembling musical and dramatic themes together, "Trouble" perfectly identifies spectacle and narrative, and perfectly expresses the mix of joy and danger in the best rock 'n' roll.

In *King Creole*, the harsh pessimism of Robbins's novel that allowed Danny no escape troubles the jukebox musicals' attempt to deny rock 'n' roll's delinquencies. Disillusioned by his father's impotence and his high-school teachers' hypocrisy, besieged by his family's poverty, and caught between two club-owners, Danny is sucked into the underworld, despite his stubborn, selfish pride, his handy fists, and his musical gifts. He eventually breaks the downward spiral of hoodlum involvement, but the final reconciliation fails to absolve his criminal mistakes and his arrogant resentment. Consequently, *King Creole* mobilizes the essential themes of 1950s rock 'n' roll more persuasively than any other film. The generational break is categorical: "I don't want to be like my old man," Danny declares, establishing an axiom for the coming youth culture. The many facets of Danny's sexual magnetism are displayed in his nightclub performances and dramatized in his relations with Ronnie and Nellie, but his characterization and Elvis's acting are more supple and nuanced than in the previous films. Danny's feeling for Ronnie rescues her from the caricature moll that Fields has made her into and, in the final idyllic interlude before she is shot, both regain a moment of innocence. And though he finally tries to treat Nellie honorably, warning her not to fall in love with him, her desire to have him respectably married remains implausible; as unambiguously a good girl as *Loving You*'s Susan, she hovers peripherally over his drama, and never succeeds in harnessing his sexual energy. Together with the parallel ethical ambiguities in Danny's relations with his father, Fields,

and indeed all other male figures, these unresolved romantic entanglements allow Elvis to dramatize a spectrum of erotic and violent contradictions.

The range of possible female social roles in whom Danny is reflected is complicated by the presence of his sister, Mimi, whom the narrative manages safely, if unconvincingly, to marry off to the King Creole's manager. Otherwise, Elvis is again positioned between a bad brunette and a good blonde: Ronnie, the gangster's moll who likes him for his combination of kindliness and strength but whose death he causes; and Nellie, the good Catholic girl, who is attracted to him despite or—though she could not know it—perhaps because of his charismatic lawlessness. Rather than preserving his and Nellie's innocence together, the narrative entangles him with gangsters and call girls. The vulnerability and gentleness that sustain one half of his romantic attractiveness is compromised by his taking Nellie to a sordid hotel room on their first date, and especially by his love for Ronnie, the fallen woman. Admired and feared by the street thugs, he is party to at least two murders, and almost to the murder of his own father. The good Danny, seen by his sister and Nellie, is not the one that he knows himself, and his self-justifying claim to his high-school principal that "I'm not a hoodlum, but I am a hustler" is as much a hope as a reality. And the tensions between his rich delinquencies and the poorer possibilities of redemption are invested in his music.

After his opening song on his apartment balcony, girls from a brothel across the street invite him in; his next two songs, both sung under compulsion from gangsters, are his ironic high-school anthem, "Steadfast, Loyal and True," which is followed by the black gangster boast "Trouble"; he sings the next one, "Lover Doll," to divert attention from the store robbery; and most of the rest are sung in the King Creole itself, which is hardly less unsavory than Maxie's joint. One of these, the title song "King Creole," embroils the nightclub, Elvis, and rock 'n' roll, together in a deeply ambivalent vortex. For "King Creole," the lyrics reveal, designates not only the miscegenated place, but also the miscegenated "guitar man" who plays there, laying "down a beat/ like a ton of coal." The lyrics accrete images of ecstatic violence: "He holds his guitar/Like a tommy gun"; "He don't stop playin'/Till his guitar breaks"; and whether "he plays something evil" or whether "he plays something sweet," he is irresistible: "No matter what he plays/You got to get up on your feet."

Danny articulates more of the emotional dualities and cultural complexities of Elvis's music than any other part he would play. Being himself a miscegenated "King Creole," he may achieve neither the stardom nor the marital closure of Elvis's previous vehicles; instead, he remains a gifted misfit, threatened by a dangerous, corrupt, and uncomprehending world, and torn internally among his sensitive intelligence, his resentment, and his ambition. Cast in the mold of the conflicted rebels played by Brando and Dean, Danny's isolation and his failure to find romantic closure leave

the film with a less settled conclusion than *The Wild One* or *Rebel Without a Cause*, the films that announced the cultural shifts that underlay rock 'n' roll itself. And though *King Creole* is rife with the weak father, the bad girl, the teenage gangs, and the other 1950s teenpic motifs, director Michael Curtiz successfully projects the ambiguities in Danny's characterization in the visual language of film noir.

The most sophisticated of the directors that Elvis worked with, Curtiz was well experienced with biopics about musicians. His long career had peaked with classics like *Casablanca* (1942) and *Mildred Pierce* (1945); though by the fifties his best work lay behind him, still he had guided Doris Day to her success in musicals in *Romance on the High Seas* (1948) and *My Dream Is Yours* (1949), and had directed an Oscar-nominated *Jazz Singer* remake in 1952. Just before this, his *Young Man with a Horn* (1950), based loosely on the life of Bix Beiderbecke (the hero of *Blackboard Jungle*'s Edwards), in many ways anticipated Elvis's career and dramatized its conflicts better than any of his own films. Featuring Kirk Douglas, it is the story of an orphan who overhears gospel singing in Los Angeles's skid row, discovers that he is a natural musician, and learns to play trumpet from a black bandleader. Totally committed to his art, he eventually becomes a successful trumpeter in big dance bands of the kind that *Rock Around the Clock* would declare obsolete. His love life has *King Creole*'s good blonde/bad brunette binary, and before the plot takes him away from Doris Day into a self-destructive infatuation with a sultry Lauren Bacall, the noir world of cheap hotels and basement jazz clubs prefigures *King Creole*'s New Orleans. Though *Young Man with a Horn* anticipates some of the later film's key scenes, most notably one when a drunken gangster forces Douglas to play, the earlier film's narrative and direction, especially the *mise-en-scène* of its interiors and night-time street scenes, are somewhat richer than *King Creole*'s. Nevertheless, Curtiz and photographer Russ Harlan (who had also shot *Blackboard Jungle*) were well prepared to find in the exteriors visual analogues for the tensions in Elvis's music and in his role as Danny. The alleys where Danny meets Shark and his gang and the colonnades where Danny's father is attacked in the rain (very similar to Orson Welles's *Touch of Evil* of the same year), the exteriors of Bourbon Street and the interiors of the clubs, and the night-time scenes in Fields's apartment, where Danny is seduced by Ronnie and where he fights Fields, are all composed with extremely low-key lighting to create strong shadows enlivened by very small areas of bright light, often on Elvis alone. The scenes in Fields's apartment are additionally shot from below so that the dark ceiling overshadows the shady transactions, and even in Danny's apartment horizontal lighting though blinds creates visual patterns as complex and ominous of those in the nightclub to underscore his interior conflicts and their tragic outcome. The only relief from this oppressive tenebrosity are brief sunlit scenes, first on the church grounds where Danny abandons Nellie, and the equally brief idyll with Ronnie before she

is murdered. And unlike all his other films, *King Creole* acknowledges Elvis's debt to African American culture.

His act in the King Creole is introduced by a nightclub dancer whose banana props resemble Josephine Baker's; though otherwise the backing musicians in his club performances are white, black musicians back him on "Trouble"; and for his introductory number immediately following the credits, Elvis sings "Crawfish." One of his most supple performances, it is a call and response blues duet performed with the marvelous (but uncredited) black jazz singer Kitty White. The film opens with a short sequence that places Elvis squarely in African American Southern folk music (Figure 5.4): introduced by several shots of each, three black street vendors announce their wares—turtles, berries, and gumbo—with call and response cries that resonate through the empty morning streets. The bass line of "King Creole" picks up their rhythm and an instrumental version of the theme song plays behind the credits that are superimposed on shots of a riverboat, recalling the opening of the Billie Holiday and Louis Armstrong vehicle, *New Orleans* (Arthur Lubin, 1947). After the credits, riding a horse-drawn trap through the wet streets, White picks up the vendors' cries to begin her song with its "crawfish" chorus. Hearing her from inside his apartment, Elvis replies with the stanzas, progressively moving through a series of almost Sternbergian framings onto his balcony until the two make eye as well as ear contact. For most of the duet the two are joined only by parallel montage, like Little Richard and Jayne Mansfield in *The Girl Can't Help It*. But the final shot puts them for a moment in the same frame, with him looking down from his balcony and her looking up from the trap, as she continues down the street until, entranced

FIGURE 5.4 King Creole, *"Crawfish."*

by Elvis's singing, the girls in a brothel across the street invite him in for a free dance. Though in the late concert documentaries, the Sweet Inspirations, a black female gospel quartet accompanying Elvis, are very prominent, the duet with White is the sole hint of a personal association with an African American—let alone a romantic relationship—with a black woman in any of his feature films, and the only dramatization of Elvis's musical indebtedness to the black working class.

Loving You, Jailhouse Rock, and *King Creole* remain immeasurably more powerful than any other rock 'n' roll films of the period. With the exception of the repression of African American culture in the first two, they create narratives that illustrate and amplify rock 'n' roll's aesthetic and social complexities, and Elvis's music in them is superior to that of any other vocalist of the period except Little Richard and Ray Charles. Many of their musical numbers occur at crucial points in narrative, commenting on it and elaborating it in the manner of the integrated musical, if not always as decisively as "Trouble." The films contain some of Elvis's greatest songs, and in fact almost all his best RCA rockers of the 1950s. His beauty, his signature physicality, and his clothes, hairstyles, sneers, and moments of grace all display a lexicon of the musical and the para-musical signs that made him both the greatest rock 'n' roll performer and the seminal and summary symbol of rock 'n' roll culture. With *King Creole*, Elvis broke through to the critics, and even the *New York Times*, which had consistently denigrated him, finally admitted, "Elvis Presley can act."[18] But it was too late. Elvis had been drafted, and in fact had needed a sixty-day deferment to finish the film. The evening before he left for his induction, he went to see a new film that, however mediocre, must have had enormous personal resonance: *Sing Boy Sing* (Henry Ephron, 1958), in which Tommy Sands played the role of Virgil Walker, a Southern rock 'n' roll star torn between religion and rock 'n' roll.[19] By this point, Elvis had sold some eighteen million records and was the most famous entertainer in the world.

Sunshine Elvis

THE DEVIL IN DISGUISE

The Persona Transformed

"Stuck on You," Elvis's first post-army single, rang with his early trucu-
lence, but the narrative of his first movie, *G.I. Blues* (Norman Taurog, 1960),
revealed a distinctively a new Elvis: shorn of his hair, resentment, and any
disruptiveness, amiable, and deferent to authority, he would play the same
part in twenty-four of his subsequent twenty-seven features.

Picking up the biographical elements of the previous three films, *G.I. Blues*
recaps his army experiences in Germany in a musical comedy in which he
plays Tulsa McLean, a soldier with vague ambitions to be a rockabilly singer.
The shuffle played on the military snare drum in the title song has interest-
ing echoes of early black New Orleans marching bands, but otherwise the
numbers are ballads or pop tunes, some with the off-screen orchestral accom-
paniment mostly absent from the earlier films. Elvis's singing is confident,
sensuous, and supple and, though not without invocations of his earlier vocal
mannerisms, it is relatively understated and lightly voiced, except where he
introduces the operatic stylings he was beginning to favor. The depletion of
Elvis's musical dynamism reflects the narrative's characterization of him,
not as alienated and troubled, but at ease in the family of his army buddies,
themselves re-enlisted from World War II comedies. Other than driving
around in tanks, their motivation is to conquer as many *fräuleins* as they can.
Nominated to "defrost" one Lili, in the form of Juliet Prowse, so his buddies
can win a bet, Elvis babysits and overcomes other trivial obstacles to win
her in his own way, which he describes as "nice, clean, and wholesome." The
only counter-movement occurs in a nightclub when Elvis's trio is performing
"Doin' the Best I Can," a lovely country-tinged Doc Pomus ballad. As always,
Elvis easily glides at a consistently low volume though his vocal range from
tenor to falsetto and back to baritone. Suddenly the lush melancholy intimacy

is interrupted by a soldier who wants to hear "the original," and so drops coins into the jukebox and plays Elvis's "Blue Suede Shoes." Momentarily returning to the violence associated with his earlier persona, Elvis leads the attack on him; a general brawl ensues, while behind it "Blue Suede Shoes" continues to recall the disturbance that, only two years before, his rock 'n 'roll had conjured. No further trouble with music interferes with Elvis's melting of Lili, even if, at its nadir, it obliges him to sing "Wooden Heart" to a Punch and Judy puppet. The movie ends with an army entertainment show, staged in front of a huge Stars and Stripes, and the principals all paired off for marriage.

Some slight ethnic complications are signaled in a mention of a Cherokee grandmother who taught Tulsa to play guitar; but otherwise his wholesome courting of Lili and the insipid army rituals make it clear that Elvis had abandoned the ambiguous complexity of his earlier art—or that it had been abandoned for him. Already he was feeling constrained by Parker's deals with the studio, and if Tulsa's role in the bar fight over the "original" Elvis signaled a musical redirection, then the larger narrative of Tulsa being pimped by his army buddies anticipated Parker's subsequent manipulation of him. But at this time, Elvis himself talked publicly of his "ambition to progress as an actor" and indicated that, having now done four "rock and roll pictures," he hoped not to do more of them.[1] Accordingly, his next two movies, for which he was lent out to Fox, showcased his acting ambitions in the troubled Brando-Dean mold and dramatized some of the complexity of his earlier music and persona.

The first, *Flaming Star* (Don Siegel, 1960), in fact, gave him a role originally conceived for Brando and was produced by David Weisbart, who had also produced *Rebel Without a Cause* (Nicholas Ray, 1955) as well as *Love Me Tender* (Robert D. Webb, 1956). Elvis appears as Pacer, a half-breed in the West Texas cow country, where an Indian war is brewing. Killings and other atrocities on both sides escalate, and his Kiowa mother is murdered by the whites and, reciprocally, his father by the Kiowa. Pacer is caught between his different kinfolk, and also between two brother-figures: Clint, his father's son by an earlier marriage who (echoing *Love Me Tender*) is engaged to the woman Pacer secretly loves; and the Kiowa Buffalo Horn, who wants him to return to his mother's people and fight with them against the whites. Increasingly alienated and confused by his shifting allegiances—"I don't know who're my people, I don't even know if I have any," he exclaims—Pacer initially commits himself to his mother's side, turning against the Indians only when they wound Clint. But then they fatally wound him, and he returns to say goodbye to Clint and rides off into the mountains to die. Often proposed as the best indication of Elvis's acting potential, the film was also the best dramatization of his own alienation and the ethnic tensions he portented.

The second, *Wild in the Country* (Philip Dunne, 1961), is a Southern Gothic written by Clifford Odets, full of devious family intrigues to which

only Douglas Sirk channeling Erskine Caldwell could have done full jus-
tice. Elvis's character, Glenn, is traumatized by his mother's death, which he
believes to have been caused by her enslavement by his father and brother,
the latter of whom Glenn, re-enacting *Jailhouse Rock*, almost kills in a fist-
fight. On probation after being wrongfully accused of stealing a car, and
tormented by his memories and by the malevolence of all authority figures,
he oscillates between stubborn resentment and a violent volatility that occa-
sions the only instance of Elvis getting drunk in a film. He can cite chapter
and verse for "Eli, Eli, lama sabachthani?" but, his father tells the court, "He's
as mean-tempered as they come. He'll drink, fish, and read books. "
and he repeatedly thrashes the local hoodlums. Only Irene, a psychiatric
social worker appointed to unpack these contradictions, can penetrate his
sullenness. Against all odds, she discovers literary talent in the therapeutic
stories he writes for her and steers him to a scholarship to the local state uni-
versity. Though both Tuesday Weld as a blonde wanton and a more demure
Millie Perkins, who finds him "wild and unsettled like a porcupine that can't
be held," lust for him, Glenn falls for Irene. But after a climactic dénoue-
ment in which she is only just saved from suicide, he leaves all three women
behind and heads off to college and a literary future.

Singing was kept to a minimum in these. Siegel managed to get the twelve
songs Parker wanted in *Flaming Star* reduced to two, and *Wild in the Country*
followed suit. Since both roles depended on the confused mixture of hostil-
ity and tenderness mobilized by Brando and Dean that Elvis had absorbed,
his confidence in dramatizing characters other than musicians gave increased
evidenced of the "power, virility, and sexual drive" that Hall Wallis had seen in
his screen test.[2] Both films also resonated autobiographically, specifically with
Elvis's own Oedipal anguish around the death of his mother and his confused
guilt about his dead twin brother; Glenn, his father declares, has "the mark of
Cain" on him. But, offering neither extensive music nor a comforting resolu-
tion, the films did poorly at the box office, and in his next outing Elvis was
returned to the musical comedy of *G.I. Blues* and its director, Norman Taurog,
who would eventually direct nine of Elvis's films, more than any other.

Flying into *Blue Hawaii* from Europe and the army, Elvis appears as Chad,
the son of a wealthy pineapple executive, who is caught between his desire
to regress to his old life with the native Hawaiian beach bums who replace
the social world of his army buddies, and his parents' expectation that he
will assume the responsibilities of the family business. The split in Chad's
ethnic identification is mirrored in his girlfriend, Maile Duval, one-half
French and the other half descended from Hawaiian royalty, who works
for a tourist agency. Into these tensions, the narrative drops an attractive
American schoolteacher with a clutch of ripening girl students, allowing
Chad ample occasion to flirt, get into fistfights, and sing as he shows them
the island's attractions. After the girls are variously satisfied, Chad resolves

the plot by marrying Maile and starting a tourist agency that allows him to enjoy his independence and the island's pleasures while still aligning him with his parents' business community. Since the songs are about love and/ or Hawaii, they are effortlessly integrated, and several of them, including the "Hawaiian Wedding Song" finale, are sung mixtures of both English and Hawaiian, an ethnic reconstruction paralleling the subordination of the black elements in Elvis's singing to his new operatic interests; indeed, two of the best songs are adapted from European originals, "Can't Help Falling in Love" from "Plaisir d'amour" and "No More" from "La Paloma."

Continuing the softening and simplification of Elvis's persona and the turn of his music toward soft-rock or pop syntheses of various musical idioms that *G.I. Blues* had launched, *Blue Hawaii* restored him to what a *Variety* review argued was Elvis's "natural screen element—the romantic, non-cerebral filmusical" from which he had recently departed but which "his vast legion of fans seems to prefer him in."[3] It became the second best-grossing film of the year in the *Variety* ratings, eventually making $4.7 million in the next two years and, as with *G.I. Blues* before it, the soundtrack album topped the charts. It eventually sold more than a million and a half copies, far more than any of Elvis's studio albums and almost five times as many as *Elvis Is Back!* in 1960. As well as helping to spawn the rock 'n' roll sunshine subgenre of beach party films, whose innocent clean-cut kids replaced the delinquents of the fifties' teenage exploitation movies,[4] *Blue Hawaii* determined the direction in which Parker would steer Elvis's career. He realized that cinema could make Elvis maximally available to the maximum number of fans for the least effort and outlay, and decided that it was the most effective vehicle by which the capital latent in him could be realized. Since more money could be made from the reciprocally promoting films and records than from any other activities, appearances outside the films were not only unnecessary, but counterproductive, and so were eliminated. Elvis had performed several live concerts in Memphis and at Pearl Harbor early in 1961, but for the next seven years until the "Comeback Special" television show, he sang only in the recording studio and for movies. He had released two albums on his return from the army and would release a gospel album in 1967; otherwise, until the "Comeback Special" he produced only movies and soundtracks whose songs, however loosely, were generated by the screenplays. Of the twenty-seven features Elvis made in the sixties, twenty were accompanied by either albums or EPs.

The twenty-three musical comedies after *Blue Hawaii* were produced on an average rate of three per year, and were obligated only to create situations in which Elvis could showcase himself and sing. As Allan Weiss, the screenwriter for *Blue Hawaii* and five others recalled, "Wallis kept the screenplays shallow. I was asked to create a believable framework for twelve songs and lots of girls."[5] Though most of them included at least one up-tempo number,

the rock 'n 'roll and especially the rhythm and blues elements that Leiber and Stoller had supplied were increasingly replaced by pop ballads, often with light operatic stylings and orchestral accompaniment, and eventually by novelty numbers. The rock 'n' roll persona of troubled defiance was similarly replaced by an uncomplicated, one-dimensional cheerfulness. Elvis appeared as a singer, or a crop-duster, racecar driver, "explosive ordinance disposal man," Native American roustabout, or photographer, with the novelty of his vocation framed in exotic locations from Hawaii to remotest Arabia. But the plot structure of the increasingly trite narratives and his role in them became so consistent that overall they came to resemble formulaic folk tales. As Elvis became the King, he became a modern folk hero, and any specific film could be no more than a pseudo-individualized variation on a standardized form: an ur-*Elvis movie* with its own, internally coherent and largely invariable morphology. Consequently their structure and appeal may best be approached using the methodology of folk tale analysis.[6]

Morphology of the Elvis Movie

The Elvis movie contains a recurrent combination of motifs:

A. Introduction: The King is cast alone into the diegetic world.

1. The King enters the diegesis, the scene of the narrative, from an unseen elsewhere.
2. The narrative occurs in the present but is located outside the mundane world in an exotic place with a picturesque touristic appeal.
3. The King is Caucasian.
4. The King assumes a white-bread name to disguise (what Scotty Moore called) his "science fiction" name.
5. The King displays the mannerisms, accent, and other cultural traits of a rural white working-class Southerner, without social capital.
6. The King is sunny, good-natured, spontaneously extroverted, and polite; he is not delinquent or defiant, resentful or internally conflicted.
7. The King has no parents, siblings, or other family.
8. The King is gregarious, seeking—or seeking to maintain—a community.
9. The King does not associate with ethnic or sexual minorities or people of color.
10. The diegesis contains no trace of contemporary political or cultural disturbances.

11. The King displays himself clothed, dressed either in work clothes or, more usually, in bright, often fashionable, outfits with tight pants that reveal his buttocks.

12. The King is paired with an ally, usually a smaller, more or less comic and incompetent sidekick, and often befriends children and/ or dogs.

13. The King reveals his unique genius as a singer.

14. The King is or would be a professional musician, and his musical career generates the narrative.

15. The King is an amateur singer, and the main narrative is driven by his other, equally remarkable, non-musical but emphatically physical gifts.

B. Presentation of females

16. The King is immediately an object of desire for all women; they display themselves to him and otherwise attempt to attract him.

17. When the King sings, all women and some men respond enthusiastically and usually dance wildly, though other men may be jealous.

18. The women are Caucasian, but include a variety of colorings.

19. The King samples several by kissing them.

20. One, usually a blonde, is selected; she either pursues the King or is pursued by him; in either case, the romance is a contest enacted within a sexual triangle.

21. The King and the selected female kiss passionately, but no further sexual activity is depicted or implied.

C. The task

22. The King is given a task that provides the main narrative.

23. A surrogate father or similar authority figure presides; he helps the King.

24. An authority figure hinders the King.

25. A villain appears, sometimes a rival or double: a pretender to his throne.

D. Completion of the task

26. The King displays his remarkable physical prowess, such as boxing, water skiing, or motorcycle or horse riding, and decisively wins fistfights.

27. The King displays himself unclothed; his fetishized body may be sadistically abused.

28. The King completes the task, defeating the rival if necessary.

29. Any other barriers between the King and the selected female are overcome and a union is achieved or implied.
30. The King celebrates his successful completion of the task and the conclusion of the narrative by singing to the chosen female and the community to which he now belongs.
31. No sexual consummation is seen to take place, and no heirs to the King are implied.

The essential form of the Elvis movie was realized in *Blue Hawaii* and, except for the presence of both the King's parents and Maile's mixed ethnicity, it manifests almost the entire combination of motifs. (Note: hereafter, a number crossed through, e.g., 7, indicates that the property is absent or denied.) It begins as the King enters the world of the film on a plane (1), arriving in the exotic present but dehistoricized world of Hawaii (2, 10), where he kisses his waiting girlfriend Maile (21). He is called "Chad Gates" (4) and displays the mannerisms of a cheerful (6) Southern, white, working-class youth (3, 5). His parents are the prosperous owners of a pineapple business (7), but he rejects them (7), and he goes instead to his beach shack to live with the community (8) of native, working-class Hawaiians (9). He strips off his army clothes (11) and puts on swim trunks (27) and, after it is revealed that Maile, a dark-haired half-Hawaiian (9), is the primary female who functions as his ally (12) but wants to marry him (20), the King sings with his beach-bum buddies (13) but displays no professional musical ambitions (14, 15). When he goes to meet his family, he agrees with his father to undertake the task of finding an alternative career (15, 22), and he begins work as a tour guide to a group of college girls (16, 18), flirting with them and their teacher and displaying his surfing skills (26). At a barbeque, the King sings and everyone dances (16, 17), but a fistfight ensues (26) and he is jailed. On his release, the King has more escapades with the girls (19), but eventually has the idea of developing his own tourist agency that will also serve his father's business (23, 24), allowing him to be both a businessman and a beach bum. No rival appears (25), and Chad's completion of the task (28) allows him to marry Maile (29), and sing to her and all their guests at their wedding (30, 31) with which the movie concludes.

When *Flaming Star* and *Wild in the Country* are excepted, the Elvis movie genre that was inaugurated in *G.I. Blues* and consolidated in *Blue Hawaii* remained fundamentally unchanged across twenty-two musical comedies and eight years until *Live a Little, Love a Little* (Norman Taurog, 1968). As Table 6.1 indicates, of the thirty-one basic motifs, twenty-four or more occur in twenty of the twenty-two. The King consistently appears in the guise of a lone, white, handsome, good-natured, virile, working-class Southerner, without ties to a family or any other place. The exotic non-urban diegetic world he enters is loosely in the present, but is untroubled by racial difference or any form of historical specificity or politicization. His

exciting music and dance and other unique talents revitalize it, attract-
ing the admiration of the community, especially its females, which may
occasion the jealousy of a villainous male. He is set a task and, aided by an
inferior (usually comic) sidekick, he displays remarkable physical prowess
in completing and defeating his rivals. He is rewarded with the chosen,
manifestly fertile, female, and the community celebrates their union and
its own renewal. The only major variations are whether the narrative is
motivated by his musical or by other skills and occupations, and whether
a father figure aids or hinders him. All the films provide the opportunity
not only to see and hear the King sing, but also to admire his face, his body
(until he gains weight), his physical accomplishments, and the elaboration
of a romantic triangle, and to celebrate his triumph over impediments as
he brings the narrative to resolution.

Elvis was the most productive and the most dependable film star of the
decade, and the genre's stability and endurance over so many retellings sug-
gest that the myth responded to some strong social desire centered on the
core narrative transactions. Fundamental to them is a myth of exogamic
community renewal, a motif whose ubiquity in folk stories and genre films
alike suggests that the Elvis movie is anchored in some deep-seated, perhaps
transhistorical and transcultural, satisfactions. The positions offered to both
men and women for fantasy identification are deeply reassuring, providing
universally learned, if not innate, gratifications. Buoyantly enacted as com-
edy rather than tragedy, the specific narrative elaborations of the core myth
are always amusing and never disturbing or disheartening, and the inevita-
ble happy ending symbolically introduces the spectators into the represented
community while smoothing their return to the real world. Sung to his new
bride as the finale to *It Happened at the World's Fair* (Norman Taurog, 1963),
the song "Happy Ending" articulates the trite but overwhelmingly reas-
suring conclusion that is axiomatic in the film musical generally: "Give
me a story with a happy ending/When boy meets girl and then they never
part again/But live forever happily, like you and me."

Such a generic stability recurs in many Hollywood star oeuvres, but the
quality that kept Elvis's appeal alive is particularly illuminated by contrast
with one of the other most successful pop cultural franchises of the six-
ties, the James Bond films. The series of almost annual movies from *Dr. No*
(Terence Young, 1962) to *You Only Live Twice* (Lewis Gilbert, 1967) starring
Sean Connery contain recurrent plot elements resembling those of Elvis's
films of the same period. Like the King, Bond is a loner, without parents,
family, friends, or other social connections, apart from those he makes while
fulfilling the tasks that each movie gives him. Their respective projects take
both to exotic locations separate from ordinary life and replete with tour-
istic appeal, where they compete with other males, invariably successfully
since both are spontaneous masters of whatever skills appear necessary, but

TABLE 6.1 Morphology of the Elvis Film

	1. Love Me Tender (1956)*	2. Loving You (1957)*	3. Jailhouse Rock (1957)*	4. King Creole (1958)	6. Flaming Star (1960)	7. Wild in the Country (1961)	5. G. I. Blues (1960)*	8. Blue Hawaii (1961)*	9. Follow that Dream (1962)	10. Kid Galahad (1962)	11. Girls! Girls! Girls! (1962)*	12. It Happened at the World's Fair (1963)	1. Fun in Acapulco (1963)	14. Kissin' Cousins (1964)*
1. King enters the diegesis		▨			■		▨	■	■	■	■	■	■	■
2. Diegesis is exotic	■	▨		■	■		■	■	■	■	■	■	■	■
3. King is Caucasian	■	■	■	■	▨	■	▨	■	■	■	■	■	■	■
4. King assumes white-bread name	■	■	■	■	■	■		■	■	■	■	■	■	■
5. King has Southern working-class traits	■	■	■	■	■	■		■	■	■	■	■	■	■
6. King is good-natured, cheerful							■	■	■	■	■	▨	■	■
7. King has no family		■	■			▨	■			■	■	■	▨	■
8. King in search of community		■	▨		■	▨	■	■	■	■	■	▨	■	■
9. King is not associated with minorities	■	■	■	▨		■	■		■	■	■			■
10. No contemporary politics	■	■	■	■	▨	■	■	■	▨	■	■	■	■	■
11. King is displayed clothed	■	■	■	■	■	■	■	■	■	■	■	■	■	■
12. King has an ally or sidekick		■	■				■	■	▨	▨	■	■	■	■
13. King reveals his singing genius	■	■	■	■			■	■	■	■	■	■	■	■
14. King's singing creates narrative		■	■				▨						■	
15. King's other talent creates narrative					■	▨	▨	■	■	■	■	■	▨	■
16. Girls desire King	■	■	■	■		■		■	■	■	■	■	■	■
17. People respond/dance	■	■	■	■			■	■	■	■	■	▨	■	■
18. Girls are Caucasian	■	■	■	■		■	■	▨	■	■	■	■	▨	■
19. King samples several		■	■	■		■	■	■	■	■	■	■	■	■
20. One pursues or is pursued by King	■	■	■	■		■	■	■	■	■	■	■	■	■
21. They kiss passionately	■	■	■	■		■	■	■	■	■	■	■	■	■
22. King is given a task	■	■	■	■	▨	■	■	■	■	■	■	■	■	■
23. Father figure helps King		▨	▨		▨						■	▨	▨	▨
24. Father figure hinders King	■	■	▨	■		■	■	■			▨	■		
25. Villain or rival appears	■	■	■	■	■	■	■		■	■		■	■	■
26. King shows physical prowess	■	■	■	■	■	■	■		■	■	■	■	■	■
27. King is displayed unclothed			▨		■		■	■	■	■	▨		■	
28. King completes task		■	■	▨		■	■	■	■	■	■	■	■	■
29. Barriers to selected girl removed		■	■			▨	■	■	■	■	■	■	■	■
30. King sings to/with girl	■	■	■	■			■	■	■	■	■	■	■	■
31. No consummation or heirs	■	■	■	■	■	■	■	■	■	■	■	■	■	■
	18	26	25	23	13	19	28	25½	26½	28½	26½	26	27	26½

MORPHOLOGY OF THE ELVIS FILM

■ = presence of the motif; □ = absence of the motif; ▨ = partial or incomplete presence of motif.

15. Viva Las Vegas (1964)*	16. Roustabout (1964)*	17. Girl Happy (1965)*	18. Tickle Me (1965)	19. Harum Scarum (1965)	20. Frankie and Johnny (1966)	21. Paradise Hawaiian Style (1966)	22. Spinout (1966)	23. Easy Come, Easy Go (1966)	24. Double Trouble (1967)	25. Clambake (1967)	26. Stay Away, Joe (1968)	27. Speedway (1968)	28. Live a Little, Love a Little (1968)	Column B			29. Charro! (1969)	30. The Trouble With Girls (1969)	31. Change of Habit (1969)	Column A
■	■	▢	■	■	▢	■	■	■	■	■	■	▢	■	19			■	■		22½
■		■	■	■	■	■	▢	■	■	■	■	▢	■	20			▢	■		25
■	■	■	■	■	■	■	■	■	■	■		■	■	20½			■	■	■	29
■	■	■	■	■	■	■	■	■	■	■		■	■	21			■	■	■	30
■	■	■	■	■	■	■	■	■	■	■		■	■	22			■	■	■	31
■	■	■	■	■	■	■	■	■	■			■	■	20				■	▢	21½
■	■	■	■	■	■	■	■	■				■	■	17			■	■		22½
▢	■		■		▢				■					14				■	■	19½
■	■	■	■			▢		■		■		■	■	14½						20
■	■	■	■	■	■	▢		■	■	▢	■	■		20			■	■		27
■	■	■	■	■	■	■	■	■	■	■	■	■	■	22			■	■	■	31
■	■	■	■	■	■	■	■	■	■				■	19				■	■	23
■	■	■	■	■	■	■	■	■	■	■	■	■	■	22				■	■	28
■	■				▢									8						11
■			▢	▢	▢	▢	■	■			■	■	■	16			▢	▢	▢	19
■	■	■	■	■	■	■	■	■	■	■	■	■	■	22			▢	■	■	29½
■	■	■	■	■	■	■	■	■	■	■		■	■	21½					▢	26
■	■	■	■	■	■		■	■	■		■		■	18			▢	■		24½
■	■	■	■	■	■	■	■	■	■	■	■		■	19					■	24
■	■	■	■	■	■	■	■	■	■	■	■	■	■	22			▢	▢	■	29½
■	■	■	■	■	■	■	■	■	■	■	■		■	21			▢	▢		27
■	■	■	■	■	■	▢	■	■	■	■		■	■	21½			■	■		29
■		■		■	▢			■		■		▢	▢	10			■	■		13
	■		■			■	■		■			■		10½						15
■	▢	■	■	■	■	■	■	■	■	■		■	■	18½			■	■		26½
■	■	■	■	■	■	■	■	■	■	■	■	■		22				■	■	30
■										■				7½						9½
■	■	■	■	■	■	■	■	■	■	■	■	■	▢	21½			■	■	▢	27½
■	■	■	■	■	■	■	■	■	■	■		■	■	21						23½
■	■	■			▢		■	▢				■	■	16						19
■	■	■	■	■	■	■	■	■	■	■	■	■	■	22			■	■	■	31
27½	24½	26½	28½	26	25	23½	26	27	26	24	19½	25½	25				16½	20½	14½	

(Continued)

TABLE 6.1 (Continued)

Note:
 1. Numbers in Column A indicate appearances of motifs in all thirty-one of Elvis's feature films.
 2. Numbers in Column B indicate appearances of motifs in Elvis's twenty-two feature films from *G. I. Blues*
 (his first after returning from the army) to *Live a Little, Love a Little,* with *Flaming Star* and *Wild in the*
 Country excepted.
 3. Numbers in Row C indicate appearance of motifs in each specific film.

especially driving and fist-fighting. In the course of this, they encounter a selection of beautiful females, all of whom find them irresistible. One is chosen, but not so conclusively that a marriage will prevent the hero from repeating the pattern in the next movie. Both Elvis and Connery's nonchalance and their easy mastery of all relevant abilities allow them to juggle the ironic distance from their role that increases through the life of the cycle, which both finally abandon. But these similarities also highlight parallel differences, for while though not wealthy, Bond lives a life of social and class privilege. His tastes, disposition, and fetishes are all distinctly elitist; his endeavors are of national significance and he gambles on an imperial stage among other internationally important figures. The King's arena, on the other hand, is always local: since Elvis's manager would not allow him to leave the United States, the King's most exotic locations are in Hawaii or on obvious sound stages, and his tasks are mundane; he operates within, not outside, the known world of a mainstream working-class audience.[7]

Even though when first released Elvis's sixties films had (and still retain) a vast popular following that should preclude any blanket dismissal, they are often denigrated on the grounds of their formulaic consistency and their renunciation of his music and persona of the fifties.[8] Only one film, *Roustabout* (John Rich, 1964), revived the delinquent: riding a motorcycle and dressed in jeans and a leather jacket with a guitar slung over his shoulder, the King asserted an explicitly working-class resentment, and appeared as a troubled loner hiding his sensitivity and need under a carapace of belligerence.[9] Otherwise, the genre eliminates the noir contradictions—the surliness and the sensitivity—of the rock 'n' roll persona: the King never shows signs of delinquency, never commits a crime, never intentionally mistreats anyone, and though of course he never backs away from a fight, he never starts one. The rock 'n' roll elements in his music are similarly largely dissolved into ballads and novelty numbers, but they are never entirely eradicated. However bad the songs become, they are always in some measure redeemed by the sensuality of Elvis's voice, and his lightheartedness always hints at some not quite extinguished potential for subversion or enchantment. Nevertheless, the King and his music no longer signal generational divide, delinquency, or association with African American culture, but mainstream values and social cohesion. Consolation replaces threat, affirmation replaces rebellion, and the King is disguised as an ordinary guy.

Social Thematics of Rock 'n' Roll:
Class, Sex, and Race

In the Elvis movie of the sixties, the King's music is never recognized as the achievement of the most acclaimed and financially successful artist in the entertainment industry, but rather appears as the spontaneous expression of personal feeling that approximates folk practice in its social reception and reciprocation. The diminution of the King's musical stature is refracted in his personality, dispositions, and preferred activities. He is unquestionably the films' star, but the delinquencies that defined the earlier persona are returned to the norm, and rather than rebelling against respectable social conventions, he embodies them. For all his musical abilities, sexual magnetism, and effort-less physical superiority, the King is unassuming and unpretentious. Cheerful and outgoing, respectful and deferential, he has neither the psychological conflicts and complexity of Elvis's pre-army persona nor his own self-doubts, religious anxieties, and chemical dependencies. Rock 'n' roll's associations with the working class, with sexual promiscuity, and with African Americans are reconstructed around this figure, but only in an etiolated form.

However paradoxically, the King is always working-class and always has a job. He maintains himself by selling his labor, either as a working enter-tainer, or by novel but almost always manual employment (see Figure 6.1).[10] His working-class habitus determines his social self-presentation, his naviga-tion of professional undertakings, and his relationships with both men and women. Though assertively working class, he is often positioned between

FIGURE 6.1 *The King at work:* Kid Galahad, It Happened at the World's Fair, Roustabout, Clambake.

his male friends and helpers, who like Elvis's real-life mafia are commonly quasi-lumpen, and his rivals, who are often bourgeois: the first group includes his crop-duster buddy in *It Happened at the World's Fair*, his assistant mechanic in *Viva Las Vegas* (George Sidney, 1964), his roommate in *Tickle Me* (Taurog, 1965), and the stooges who are his band-mates in *Spinout* (Norman Taurog, 1966); the second group includes the wealthy competitor who buys his boat in *Girls! Girls! Girls!* (Taurog, 1962), the champion diver in *Fun in Acapulco* (Richard Thorpe and Michael D. Moore, 1963), the aristocratic Italians in both *Viva Las Vegas* and *Girl Happy* (Boris Sagal and Jack Aldworth, 1965), or, hyperbolically, Prince Dragna in *Harum Scarum* (Gene Nelson, 1965), though in the case of the several foreigners among these latter, national chauvinism is superimposed on class conflict. His girls, on the other hand, are almost always several social notches higher than he, better educated, more sophisticated, and wealthier: the nurse with ambitions to be an astronaut in *It Happened at the World's Fair*; the sister of his manager in *Kid Galahad* (Phil Karlson, 1962), the daughters of wealthy fathers in *Girl Happy* and *Spinout*; and, with royal propriety, the princess in *Harum Scarum*. His romances are typically hyper-gamic, culminating in marriage to the boss's daughter or the princess, but they do not imply class mobility, for the King always is and will always stay working-class.[11] Despite this, he cannot understand himself in class terms, and in any case his unique omnipotence precludes any place in a commonality of equals. He is always a lone agent, never a team player. Replying to a request that he accept some social membership and indeed subordination by driving a car for his rival in *Viva Las Vegas*, he replies, "I don't work for anybody, I never run second to anybody, and . . . I intend to win."[12] Even when he is sensitive to his class origins and position, he has no class consciousness and can have no part in a communal project involving social contestation.[13] He may redeem a community, but his involvement in it pivots on a bond with a single female.

Though tinged with feminine elements, the King's sexuality is unquestionably masculine and, as Shelley Fabares summarizes also in *Spinout*, "He is everything a woman wants; he is strong, brave, kind, and he does things," while her rival declares him the "perfect American male." The masculine sensuality of his voice is reciprocated in his dancing and general physical presence and his amorousness, though his motivating desire is not for women, but for *girls*. Insatiably and indiscriminately, he wants *Girls! Girls! Girls!* and even though he experiences *Trouble With Girls*, he is eternally *Girl Happy*. His general disposition is best expressed in the lyrics to *Spinout*'s "Smorgasbord," where he admits to being "just wild about" and having "a cravin' for" a smorgasbord of girls, from which he can take "a little kiss here, a little kiss there" (see Figure 6.2). The girls do not share his appetite for multiple flirtations and, except in a few films in which he is obliged to pursue a reluctant partner, they immediately and spontaneously fall in love with him. The girls are

FIGURE 6.2 *Smorgasbords of Girls:* Tickle Me, Paradise Hawaiian Style, Spinout, Easy Come, Easy Go.

conventionally pretty and, hair color apart, essentially indistinguishable and interchangeable figurations, not of themselves, but of his desire. In her three films with the King, Fabares has something of an idiosyncratic, if juvenile, erotic charge; but other than she and Ann-Margret in *Viva Las Vegas,* none is individuated by any ambition, achievement, or psychological complexity that might complicate her function as the reciprocation of his generic role. And in only one instance, the very late *Live a Little, Love a Little* (Taurog, 1968), is it implied that he shares a girl's bed—though his partner does thank him the next morning for making her a woman! The Elvis movie revolves around sexual attraction, but its eroticism is prudish; the King's sexuality is boundless but adolescent, his promiscuity ends at kissing, and instead of being consummated, it is displaced into song.

After the half-native Maile in *Blue Hawaii,* the King's appetite for girls is an appetite for white girls, for indeed his whole world is as white as it is heterosexual. The jukebox musicals kept African American performers in the foreground and *King Creole* (Michael Curtiz, 1958) explicitly acknowledged them. But in the sixties, even as the civil rights movement dominated national politics, people of color are hardly present in the King's world.[14] Mexicans may be featured when he goes to Mexico for *Fun in Acapulco* and a few appear across the border in *Charro!,* but the only other exceptions are *Flaming Star* and *Stay Away, Joe* (Peter Tewksbury, 1968), where the King and his family are Native American, and several films including Asian Americans. A Chinese American is one of his many girlfriends in *Paradise Hawaiian Style* (Michael D. Moore, 1966), but otherwise, if they are not actually children,

Asian Americans are infantilized and sentimentalized: Sue-Lin, the father-
less Chinese girl that Elvis cares for in *It Happened at the World's Fair*, and
the Yung family in *Girls! Girls! Girls!* The King's friendship with the latter
gestures toward a multicultural inclusiveness, and he sings "Earth Boy" as
a duet with the two daughters, partly in Chinese and partly in pidgin. But
the Hawaiian Chinese themselves are stereotypically demeaned. Mr. Yung
is ordered around by his wife like an errant child, the girls tell the King that
he sings Chinese "velly funny," and Elvis advises his white girlfriend that
the Chinese are inscrutable. And the finale, when the King reprises the title
song to assert the catholicity of his taste ("Girls, big and brassy/Girls, small
and sassy/Just give me one of each kind"), features beauties from all over the
world in ethnic costumes, but none is black. Similarly during Elvis's search
for Ann-Margret through all the chorus girls in town in *Viva Las Vegas*, the
montage of the "thousand pretty women" that the title song declares to be
waiting for him there even includes a "gorgeous line of Korean cuties," but no
African Americans.

The Folk Musical

Though the degree of genericity varied slightly from film to film, the mor-
phology and the generic core remained essentially stable across the musical
comedies of the sixties. But over time the genre shifted in one important way,
ratifying the narratives' links with the folk tale: the musical reflexivity of the
dramatization of Elvis's "rise to stardom" in the pre-army rock 'n' roll show
musicals migrated toward the conventions of the folk musical.[15]

The King sings in all his features except *Charro!*, in which his rendition
of the title song is heard over the credits. In some his performance is a func-
tion of his work as a professional musician, while in others it is an occasional
interruption of his other activities, though these—car and boat racing, for
example, or boxing or photography—are often connected with entertain-
ment. In the films of the fifties, despite the complications of *King Creole*'s noir
elements, the accounts of his rise to stardom were fundamentally backstage
musicals in which the narratives were loosely autobiographical reflections of
Elvis's real-life climb to musical celebrity, national television, and Hollywood.
His singing and acting motivated each other, his music and film careers were
artistically and financially integrated, and his stardom was synergistically
narrated, produced, and consolidated in both mediums simultaneously.
Such an autobiographical reference lingered in *G.I. Blues*, and indeed, after
the detour of *Flaming Star* and *Wild in the Country*, *Blue Hawaii* picked the
thread up by again beginning with his return from the army. However, in it
he played an amateur rather than a professional musician, and subsequently
the films ceased to narrate or even allude to his actual life and celebrity.

The circumscribed career of the fictional King concealed all reference to the real-life Elvis.

Of the narratives from *G.I. Blues* to *Kissin' Cousins* (Gene Nelson and Eli Dunn, 1964), two-thirds were motivated primarily by the King's non-musical abilities. But the highly generic *Fun in Acapulco*, an exception in this period, initiated what would become a second series of backstage musicals, narratively organized around his work as a musician. Possessing echoes of the autobiographical mode of the fifties show musicals, *Fun in Acapulco* featured the King as an ex-acrobat whose loss of nerve causes his brother's death. He signs on as a deckhand on the yacht of a wealth family cruising to Acapulco, but is fired after complications that follow from his rejection of the daughter's sexual advances. Raoul, a street urchin, befriends him, becomes his manager, and guides him to success as a singer in the resort hotels, and other plot elements revolve around his rivalry with a champion Mexican diver and escapades with two girls, a dark Mexican lady bullfighter and the blonde Ursula Andress. In the climax, he regains his nerve by diving from the Acapulco cliffs, besting the other male and winning Andress. Several details echo Elvis's life: the dead brother recalls his stillborn twin; in playing one hotel against another to raise the King's fee and taking a 50% split of the earning, Raoul evokes Parker; and the operatic songs and romantic ballads in the casinos anticipate Elvis's future music. But even in this show musical, played out in Mexican hotel lounges, the "rise to stardom" motif is diminished, and Elvis's domination of the global entertainment industry is miniaturized virtually to the point of parody. Moreover, instead of the great songs of *Jailhouse Rock* and *King Creole*, he has to work with the dross, operatic and otherwise, of "Toro," "The Bullfighter Was a Lady," and "(There's) No Room to Rhumba in a Sports Car."

The transition away from the show to the folk musical began in Elvis's top-grossing film, *Viva Las Vegas* (1964) (Figure 6.3), in which the King plays a mechanic who races his own car. In pairing him with Ann-Margret, *Viva* abandons the single narrative line of other Elvis films and approaches the dual focus of the classic musical, as well as having songs that develop the characters and are related to the narrative. An up-and-coming singer and actress who was being developed as the "female Elvis Presley" and had even recorded a cover of "Jailhouse Rock," Ann-Margret possesses a greater sensuality and charisma than the King's other partners; she is allowed her own songs to express her perspective on their romance; in their duets, she goes toe-to-toe with him; choreographed by David Winters, her dancing is more sophisticated, but also much sexier and abandoned than his; and she is his equal in shooting, water-skiing, and motor-bike riding.[16] Even the *New York Times* found their teaming to be "happy," and regarded her as "a perfect musical foil with her galvanized dancing."[17] But despite her showbiz skills, her character really desires a stable family life, and the narrative eventually brings the King to accommodate these values. Though both Elvis and Ann-Margret

FIGURE 6.3 Viva Las Vegas.

sing throughout, the narrative presents them as amateur rather professional entertainers, and the film's culmination is a car race. The paired musical climax occurs at the end of the second act, where it takes the form of a talent contest for hotel workers, which at this point both are. Staged in a casino and charged with Vegas glitz, the contest is a triumph of spectacle, but since their performances are ostensibly amateur, the film still implies the folk musical's affirmation of community over business, which is further satisfied in their marriage in a little wooden church, albeit a Las Vegas replica.

When the film was shot, Elvis's musical preeminence was still unchallenged. But in early 1964 Beatlemania hit the United States; "I Want To Hold Your Hand" sold a quarter of a million copies in three days to top the charts. The Beatles' February 9, 1964, appearance on the *Ed Sullivan Show* was a national phenomenon, attracting an estimated 74 million viewers, nearly a quarter more than the 60 million people who had watched Elvis's first Sullivan appearance eight years earlier. Sullivan announced that Elvis and Parker had sent a congratulatory telegram, but rock 'n' roll had categorically changed. Six weeks after *Viva Las Vegas* opened in New York on May 20, Richard Lester's *A Hard Day's Night* opened in London on July 6; and four months later, on

November 14 in Los Angeles, Steve Binder's *The T.A.M.I. Show* inaugurated the concert documentary film, presenting the Rolling Stones as the apogee of a unified biracial Anglo-American cultural revolution. Rock 'n' roll cinema was transformed, but the Elvis movie declined the challenge.

As if at first to explore the musical options available to the King in the new era, after *Viva Las Vegas* the genre shifted back to presenting him as a professional singer, with his musical activity generating the plots. Resurrecting his belligerent pre-army persona, *Roustabout* began the new series of backstage musicals that continued virtually unbroken from 1964 to 1967 with *Girl Happy, Tickle Me, Harum Scarum, Frankie and Johnny* (Frederick de Cordova, 1966), *Spinout,* and *Double Trouble* (Taurog, 1967), all dramatizing him as a working musician. But rather than narrating his stardom, immensely lucrative show business career, cultural influence, or the emerging challenges to it, they all portrayed him in unimportant, marginal professional circumstances. No sign of his musical sovereignty was admitted, and no indication was given that he, more than any other single artist, had been the inspiration for the mid-sixties musical renewal and that the exploding counterculture had geminated in his music. Earning a precarious living in backwaters rather than at the center of the entertainment world, he appears as a journeyman entertainer of no artistic or social consequence, performing similarly inconsequential music. *Roustabout* finds him in a provincial roadhouse but takes him only as high as a fairground. In *Girl Happy*, he leads a bar band hired by a mobster to chaperone his daughter on spring break in Fort Lauderdale. In *Tickle Me*, even though the energy of the songs, some recorded as much as five years earlier, recalls his best work, he performs them in entertainment breaks for overweight actresses at a fat farm. A frame around the narrative of *Harum Scarum* breaks the mold by introducing him virtually *in propria persona* as a singing film star and does eventually marry him into royalty, albeit that of an Arab state that has not been seen by a Westerner for two thousand years; but in it, he sings abysmal songs to a six-year-old dancing slave girl or to market crowds to distract attention while his pal cuts purses. In *Frankie and Johnny*, when not losing at the card tables, he is a riverboat entertainer; in *Spinout*, he is the leader of a trio, so unsuccessful that between gigs they are obliged to camp by the side of the road; and finally, in *Double Trouble*, he is the leader of a third-rate combo in mod swinging London.

In all these, the King performs in the absolute lowest echelons of the music industry: bars and small nightclubs, clambakes, and birthday parties. He is never accompanied by any musicians of note and never interacts with any other significant artist; he is never depicted as making a record, a movie, or a television show, for the music business, cinema, television, and all other components of the culture industries are absent from his world. He neither achieves prominence in any branch of show business nor evinces any ambition to do so. To the contrary, in *Spinout* the King echoes Jerri Jordan's

motivation, and rather than seeking stardom, he is determined to avoid success, explaining to his uncomprehending bandmates that he doesn't want to be on the *Ed Sullivan Show*, have top-forty records, and become a star because "stars have responsibilities. . . . You know what else happens? They get married."[18] As the King wanders in ever smaller and more irrelevant musical kingdoms, as his extraordinary musicianship is disguised as run-of-the mill and its aesthetic and social effectivity is restricted to local theaters—and as the most successful Hollywood career of the decade is completely concealed—the mode of his musical production is apparently de-industrialized. With the reduction of the backstage elements, the films approximate those that are narratively motivated by his other skills, in which his singing is a non-professional diversion, an expression of personal feelings and relationships. The distinctions between him and his audience, between producer and consumers, dissolve. Hardly more than an amateur, he performs amidst an idealized, dehistoricized everyday life, and the films become essentially folk musicals.

The circumscribed dramatic possibilities that simultaneously reflected and generated the narrative construction of the King as an unexceptional family-safe entertainer eradicated all his actual historical importance and status in the global entertainment industries. As the genre evolved from rock 'n' roll films based on the show musical into pop film based on the folk musical, the latter's ideological and social contradictions became extreme. The myths that hid commodity entertainment, labor and production, and the economics of consumption also hid Hollywood's use of Elvis and Elvis's use of Hollywood. The King's lack of capital accumulation in the films concealed Elvis's own accumulation of capital in making them, and especially the capital he accumulated for Wallis and Parker. The fictional construction of a quasi-folk community similarly determined the genre's address to the real world and its target audience. His music appeared to occur outside history in a fantasy world unaffected by civil rights, the Great Society, the student mobilization, or the overall cultural movements that his early music had so profoundly affected. The odd references to the counterculture are always derisive; the only extensive instance is his encounter with an art center in *Easy Come, Easy Go*, where yoga, Yves Klein–style body painting, and poetry reading are practiced. The king thinks all the participants are "kooks," gets himself tied up in "yoga knots," and expresses his disdain in a ridiculous song, "Yoga Is as Yoga Does." In this, as in all else, the Elvis movie of the sixties appears to have been designed to appeal not to disaffected, racially mixed youth, but to a mass, white, middle-aged, blue-collar, socially disengaged audience. For several years, it found this audience. But the narration of the King's cultural insignificance at once coincided with and contributed to Elvis's own decline. Psychologically, dramatically, thematically, and musically banal, the films

eventually achieved the impossible: they made Elvis banal. They were cinema's most egregious revenge on rock 'n' roll.

The stability of the Elvis movie genre and with it the King's career between 1960 and 1968 were overdetermined by a combination of institutional and personal factors, primarily the relation between public taste and the studio practices of the time and the various objectives of Parker, Wallis, and Elvis himself. At least until 1965, the studios' priorities and public desire were easily matched. After the failure of *Flaming Star* and *Wild in the Country*, the popular, box-office, and critical success of *Blue Hawaii* and its restoration of the combined film/album format convinced Wallis that Elvis's profitability coincided with his own preference for all-around middle-class family entertainment and ensured that his sexuality and associations with delinquency and African American culture would be smoothed away. With *Blue Hawaii*, Wallis had achieved what he was looking for, "a Bing Crosby picture starring Elvis Presley,"[19] and the King's rejection of a fractious, recalcitrant persona reasserted an earlier model of popular music films. Both Crosby and Sinatra typically played ordinary guys rather than stars in their movies, even in important ones. Crosby's character in his best musicals, such as *Birth of the Blues* and *Blue Skies*, is prodigiously gifted, but he remains part of the everyday world.

The Elvis movie's remarkable consistency and continuity after the discovery of the new persona's market attraction, the shift to a folk rather than industrial milieu for the King's music, and then its precipitous decline together mark the genre as a paradigmatic instance of the "producer's game": a genre is created when a producer identifies a successful film, makes a new film with the same formula, and repeats it as long as it is remunerative.[20] Production costs were kept to a minimum, typically $1 million to $2 million dollars, and for the next few years each film made around $6 million, with Elvis receiving $600,000 and a percentage. "A Presley picture," Hal Wallis is reputed to have remarked, "is the only sure thing in Hollywood." As the franchise collapsed—Elvis was shooting *Charro!* at the time—Wallis recalled:

> The Presley films were made, of course, for strictly commercial purposes. He is one of the most popular entertainers in the world and the films were most successful, but you have to give the Presley fans, who are legion, what they want, and they want to hear him sing. . . . I never had any problems with him. He did want to do some straight acting roles, without any songs, but that would have been quite a gamble.[21]

Wallis's approach was entirely satisfactory to Parker. A one-time fairground huckster who was lauded as a master of guile by Hollywood's most ruthless, he was free of taste or any ambition other than the desire to exercise complete control over his client and to make as much money as possible for—but also from—him. He saw the films purely as product, with his own task as

maximizing income without regard for artistic quality. "All they're good for is to make money,"[22] he averred, and he relentlessly campaigned for minimal production costs, even going so far as ensuring that Sam Katzman was hired to produce two of the very worst, *Kissin' Cousins* (which nevertheless grossed almost $20 million) and *Harum Scarum*. The direction Wallis navigated initially seemed astute. The only significant rock singer to be contracted to a studio, Elvis continued the musical's tradition of Dick Powell, Ruby Keeler, and other singers who performed in a series of generically similar films. They all made money—for him, for Parker, for Wallis, and for the studios. By the end of 1962, in addition to his standing contract with Wallis for $175,000, Parker was able to sign Elvis to a three-picture deal with MGM at $500,000 per picture plus 50% of profits after his own salary, so that by the end of 1964 Elvis was "effectively the highest paid star in Hollywood."[23] Having had the three top-grossing films of 1962, he was worth it.

These managerial dispositions coincided with Hollywood's ideological boundaries, and the industry's unwillingness and inability to respond to the youth cultures of the sixties. The major studios' difficulties in appropriating rock 'n' roll in the 1950s were obviated by the evaporation of its early energy at the decade's end, but by the mid-1960s, the counterculture and its music posed even greater challenges. Elvis's own disinterest was quite compatible with the failure of the King's movies to engage with adult sexuality or in progressive political movements, but just as important was Hollywood's own parallel disinclination and inability. Apart from Roger Corman's maverick indie productions, not until 1969 did Dennis Hopper's *Easy Rider* show that the counterculture could be profitably exploited as long as a rock 'n' roll soundtrack enlivened a narrative of its destruction. In this respect, Hollywood in the sixties was even less astute or responsive than it had been in the fifties. After *King Creole*, the major studios did not make an aesthetically or financially successful film about new musical developments till the 1970s, perhaps till *Lady Sings the Blues* (Sidney J. Furie, 1972). The rock 'n' roll films of the sixties that responded to the counterculture were not made in Hollywood, and they were not narratives but independent documentaries; and not until Elvis turned to documentary was he able to rediscover who he had been or could be.

On the other hand, Elvis's own interests and ambitions were multiple. The expansion of his own, always ecumenical, musical tastes to operatic and pop stylings matched the songs the films offered, and record sales early in the decade suggested that his original audience, who were aging along with him, and his new fans shared his taste. "Stuck on You" and other post-army rock singles did not sell nearly as well as "It's Now or Never," "Surrender," and the similar pop-operatic numbers that he began to record after his first post-army album. Nor did he ever abandon the desire he expressed when he first went to Hollywood, not simply to sing in the movies, but "to be a movie

star—a serious actor like Brando, Dean, Richard Widmark, Rod Steiger."[24] He felt trapped as early as 1961 when he was shooting *Wild in the Country*, and three years later, after *Kissin' Cousins*, a newspaper story in which Wallis had averred that "artistic pictures," specifically the Richard Burton and Peter O'Toole *Becket* (Peter Glenville, 1964), were being financed by revenue from "the commercially successful Presley pictures" completed his humiliation and his realization that his acting ambitions were being exploited.[25] With increasingly mediocre scripts, mediocre songs (even "Old Macdonald" in *Double Trouble*), mediocre direction, mediocre costars, and abbreviated production schedules, Elvis became increasingly alienated from his films, from his own performances, and from his own genius. Eventually he ceased to disguise his lethargy, indifference, or condescension. Emotionally dependent on Parker and his mafia, cocooned in his chemically enhanced ego, and isolated from the culture developments that were transforming popular music, he was virtually a pawn in the hands of his managers. *Girl Happy* in 1965 was the last of his ten best-grossing films, and with his next two, *Tickle Me* and the supreme travesty of *Harum Scarum*, the decline became precipitous. By 1967 audiences had diminished and the soundtrack albums were no longer selling. *Speedway* (Taurog, 1968) barely recouped its cost, and *Stay Away, Joe* and *Live a Little, Love a Little* did even worse. Even the title single from *Live a Little* sold only two hundred thousand.[26] By this point, Elvis despised the movies and despised himself for playing in them. His escape from them came from an unexpected agency. Just as the jukebox musicals had resolved their narratives by a television spectacular, so a television show allowed Elvis to recover the genius and ambition that Hollywood had all but extirpated.

The Comeback

Shortly after Priscilla gave birth to Lisa Marie on February 1, 1968, Elvis returned to Los Angeles to film *Live a Little, Love a Little*. When it was completed, he met with Bob Finkel, the producer of what Parker had planned as a Christmas television show featuring him alone. Finkel sensed that Elvis was so exasperated that he wanted the show to counter the degradation of his recent movies, and was ready, at least to a degree, to stand up to Parker. To direct, Finkel chose Steve Binder, who had directed one of the first and best rock 'n' roll concert films, *The T.A.M.I. Show* (1964) with James Brown and the Rolling Stones, and a recent television special for Petula Clark, which had created a storm of controversy because she touched her guest Harry Belafonte on the arm in one of the first moments of interracial body contact on network television. Binder proposed to strip away the dross of Elvis's recent films and return him to his earlier music and image. Though scared, Elvis committed himself to Binder's vision and, despite Parker's interference, production

got underway. Broadcast on NBC on December 3, 1968, "Singer Presents ELVIS," commonly known as "Elvis's 68 Comeback Special," reconnected him with gospel and rhythm and blues and the rock 'n' roll he had pioneered (Figure 6.4).[27]

Immediately, in the prologue, Elvis introduces himself as the social, sexual, and musical outlaw of yore.[28] Glowering in an extreme close-up, he declaims the opening of "Trouble," the pivotal song in *King Creole*: "If you're looking for trouble/Just look right in my face. . . . I'm evil, my middle name is misery." The camera pulls back, revealing him, noticeably trimmer than in recent films, strumming a guitar, not his usual acoustic, but a phallic red electric Gibson that invokes the guitar heroes of contemporary counterculture rock. After two stanzas, the camera pulls back even further to reveal the silhouettes of perhaps fifty dancers with guitars, framed on a scaffold as in the "Jailhouse Rock" number. Continuing to play alone, Elvis segues into "Guitar Man," a song about a hobo musician who hitchhikes through the underside of the South looking for work, as gradually his image is subsumed in a huge display of electric red lights spelling out his name.

The second segment opens with Elvis in close-up, dressed in black leather pants and a black leather, high-collar jacket resembling Brando's in *The Wild One* and open to his waist; there's nothing between it and his sweating skin as he rips out Lloyd Price's "Lawdy Miss Clawdy" that he had covered in 1956. The camera pulls back to reveal the show's second set: a boxing-ring sized stage, a Suprematist red field with a white square, with Elvis sitting informally on a stool, and surrounded by four musicians, including Scotty Moore and D. J. Fontana from his earliest touring band, all dressed in matching

FIGURE 6.4 Comeback Special.

red casual suits. Closely edging the stage is a live, racially mixed audience, gathered at the last moment from Burbank coffee shops after Parker had attempted to sabotage the segment by failing to distribute invitations to fans. Most prominent are adoring young women with bouffant hair and generally prim clothes, interspersed with a few older couples—apparently a fifties rather than a sixties group—who clap along to the beat and applaud with great enthusiasm. At first Elvis seems nervous, but as the improvised wood-shedding continues with "Doing What You Want Me to Do," he relaxes and soon he is clearly enjoying himself, bantering with the band and interrupting the song with a joke about his sneer ("I did twenty-nine pictures like that") and another about the Florida show where the police prohibited him from moving anything but his little finger. After a commercial break, he returns alone to the tiny stage to perform a string of his strongest rockers with full orchestral accompaniment: "Heartbreak Hotel," "Hound Dog," and "Jailhouse Rock." He reaches back for his most histrionic moves to create a momentum varied only by "Can't Help Falling in Love with You" from *Blue Hawaii* and "Love Me Tender" from his first film. Though the opening of the set is designed to suggest an informal jam session, everything about his performance, material, and accompaniment reaffirms his pre-army persona. But as he paces the boxing-ring like stage, Elvis moves in and out of that role, occasionally hinting at an ironic distance from it, but mostly gleefully embracing it, especially as it allows him to denigrate his recent movies, interjecting, "Its been a long time, baby," in regret at having been separated from his earlier music.

After another break, he announces, "I'd like to talk a little bit about music." He mentions the big change in "the last ten to twelve years," the improvements in musicians and engineers, and admits that he "really likes a lot of the new music," jokingly mentioning the Beatles; but then he asserts "rock 'n' roll music is basically gospel or rhythm and blues." As he does so, a lap dissolve replaces his own face with that of an African American male, so that for an instant it appears that a black self is emerging from within him. The man is quickly revealed as a dancer dressed in black who is performing on a red stage accompanied by a black woman singing the spiritual, "Sometimes I Feel Like a Motherless Child," a song that must have had a strong autobiographical charge for Elvis. As the audio segues into his singing another classic, "Where Could I Go But to the Lord?" (recorded two years earlier for the *How Great Thou Art* gospel album), the camera tilts up to reveal a high platform with Elvis in a tight red suit in front of a red psychedelic design, accompanied by the Blossoms,[29] a female black trio, and about twenty mixed-race dancers, the men dressed in black and the women in white. They shift to "Up Above My Head," another gospel standard, whose many recordings including one by the Statesmen (whose version Elvis's naturally resembles), but especially associated with Sister Rosetta Tharpe, the gospel and rhythm and blues singer. As the tempo picks up, Elvis begins to sing "Saved." In this context, it too

could be mistaken for a gospel standard, but actually it was written, surely tongue-in-cheek, by Leiber and Stoller; it allows Elvis to recall how he "used to smoke, drink, and dance the hoochy-coo" and other nefarious acts, but now he only wants to tell us about the kingdom to come, because—as the bass drum and chords from the brass underline the crescendo of choruses—he is "saved." The dancing becomes more and more ecstatic, the girls' skirts swirl higher, and the entire scene turns into a joyous bacchanal.

Already the show has reassembled all Elvis's early influences, recalled his greatest achievements, and dramatized the tensions that subtend them: conformist and delinquent, spiritual and carnal, sacred and secular, black and white, noir and sunshine. But it goes even further. After another break, Elvis returns with the four-man combo, introduces Moore and Fontana by name, and after describing the conditions under which his very first recording was made, sings "That's All Right," noting that it was previously a rhythm and blues song. Then alone he performs dirty versions of "Baby, What You Want Me to Do" and "One Night," playing some of the lead guitar lines himself. By this time the festive atmosphere is complete, Elvis joking with crowd, mopping his brow with the girls' scarves, and eliciting screams of applause. Sitting on the edge of the stage and surrounded by girls, he changes the mood somewhat with a new ballad, "Memories," until a break launches the show into an extended narrative, a medley of songs framed by "Guitar Man."

On a stage created by angular lines of bright light, he first appears as a hobo loser in denims with a guitar over his shoulder, treated like a "country clown" in the "two-bit town" of "Nothingsville." A scantily clad hooker picks him up and takes him to a bordello where, embraced by a bevy of provocative women in pink haltertops and harem pants, he sings "Let Yourself Go." Back out on the street, he finds a "Big Boss Man" in the form of a pimp mistreating one of his girls. Decking the pimp and karate-chopping his flunkeys, Elvis sings "It Hurts Me" to the girl, but then he is on the streets again and soon in a gold tuxedo in a nightclub for "Little Egypt" and "Trouble" again, which then forms a bridge to his appearance in a black velvet suit in an upscale nightclub and back to the square stage and his leathers. The show concludes with his hitting the streets again as a "Guitar Man," all except for a finale in which, now dressed all in white, he performs "If I Can Dream" in front of the huge electric "Elvis" sign.

Proving that he could still electrify a live audience, the broadcast and the music were acclaimed. The show received a 32.0 Nielsen rating and was NBC's biggest success of the year. Released in advance, the single "If I Can Dream" reached number twelve, and the album, released a week before the broadcast, number eight, both Elvis's highest chart positions since 1965. Though the mainstream press reports were mixed, many of the most respected rock critics, speaking to and for the audience that had abandoned

Elvis, were rapturous: Greil Marcus wrote, "It was the finest music of his life. If ever there was music that bleeds, this was it. Nothing came easy that night, and he gave everything he had—more than anyone knew was there."[30] Elvis was elated and galvanized, his depleted self-respect and confidence were restored and, even if only for a short time, his dependence on Parker cracked. Eliding almost all the songs recorded since *King Creole*,[31] it returned him to the music that had shaped the definitive rock 'n' roll persona. But as well as being a musical and a personal triumph, the show was a televisual triumph. In the photography and editing, the staging, sets, and costuming, and the musical accompaniment, dancing, and dramatizations, Binder and his team had at last visually elaborated Elvis's music, and had made an analogue and an accomplice to it: visual rock 'n' roll.

Even on the smaller television screen, the close-ups on his face and torso allowed a more intimate visual contact with the somatic expressiveness that sustained his vocal efforts. The kinetic mobility and variety of Binder's four cameras (now including one handheld), his shifting among the close-ups, the wider shots of the audience, and overhead shots of both together, and especially his virtuoso in-camera editing with superimpositions and dissolves that visually unite Elvis and his fans were all far more sophisticated than the techniques used in any of his previous filmed performances. Beginning with the stylized motorcycle leathers of the fifties' wild ones, and segueing into the dramatically tailored suits, the costuming reinforced the range of his music but also the dualities and contradictions it included. The shifts between the informality of the small stage, live performance and the more formal staging of the gospel interlude and the "Guitar Man" sequences both illustrated the musical complexity of rock 'n' roll and manifested the spectrum of its performative practices. The consistent use of black and red or pink gave a colorful unity to the design, asserting the energy of anarchy and also recalling Elvis's favorite colors in the fifties. And though the consummately designed alternation between live performance and the narrative enacted to pre-recorded music demonstrated the range of Elvis's abilities, the event's success was sealed by his live performance.

In the "Comeback Special" Elvis rediscovered himself in the excitement of singing to a real audience, resurrected his career, and found its new direction. He immediately told Parker that he intended to return to concerts and touring, but before he could do so, and in fact before the special aired, there were three contracted films outstanding, and Elvis returned to Hollywood. In these, the genre, which had begun to disintegrate in the disastrous four movies before the "Comeback Special" was aired, collapsed.[32] *Charro!*, the first one filmed, gave him a final chance at serious acting. His character is surly, introverted, and conflicted, caught, as the lyrics to the title song—the only one he sings—have it, at "the crossroads of [his] mind," but he walked through an improbable plot concerning a gang of outlaws who have stolen a

solid gold cannon used in the Mexican revolution. With only four songs and the romantic element minimized, *The Trouble with Girls* raised issues of race, class, and gender, though projecting them on the past; he is still culturally the King, but now management rather than labor.

The last feature, *Change of Habit* (William A. Graham, 1969), finally placed the King amid the crises of the late 1960s, simultaneously reversing the Elvis movie's social conventions and taking their musical conventions to an extreme. His role as the doctor of a ghetto free clinic is a supporting one, as the plot is generated by three nuns, Sisters Michelle, Irene, and Barbara, who take a leave from their order to work with him. They instigate the main events, a potpourri of topical problems: attempting to treat a young delinquent, leading a boycott of an exploitative market, facing up to drug dealers, and holding a saints-day festival for local Puerto Ricans. Apart from falling in love with Sister Michelle (Mary Tyler Moore) and asking her to marry him, the King is narratively passive, and the question of whether she will marry him or remain with her order provides the main dramatic crisis. The narrative innovations transform the genre, leaving the film with fewer of its motifs than any other except *Flaming Star*.

The nuns initiate the plot by entering the diegesis (1), not the King, who is already there; it takes place not in an exotic environment but in an ethnic New York slum (2) that is replete with a roster of social problems, plagued by urban poverty, racism, sexism, drug trafficking, and economic exploitation controlled by a corporate-like mafia (10). Walking through his part with a stony surliness (6), the King is white Southern working-class with a white-bread name, but no family or ally (3, 4, 7, ~~12, 19~~). As a doctor with (for only the second time) a college degree (5), he dresses in contemporary clothes with a Beatle-like fringe (11). But he does associate with minorities (9), and when the black nun, Sister Irene, asks the King if he knows "what it's like to be really poor, hungry, frightened and black?" he replies, "I've been all those things except black." Though neither his singing nor any other of his activities generates the plot (~~14~~, ~~15~~), the King sings (13), if less so than in other movies, and many women, not all of them Caucasian, are captivated (16, 17, ~~18~~). The King does not flirt with them (~~19~~), and instead pursues only one (20); but she rejects him, they never kiss (21), the barriers keeping her from him are not removed (~~29, 30~~), and so there can be no consummation (31). No father figure either helps or hinders the King (23, ~~24~~), and since he is peripheral to the action, his completion of a task is marginalized (~~22~~), though he does beat a rival in a fistfight (26). And the music does emphasize African American elements: sung with black women backing him, "Rubbernecking" has the energy of the "Comeback Special," and the climax is a gospel number, "Let Us Pray," that accompanies the ultimate sexual triangle. As her dilemma is figured in a parallel montage, Mary Tyler Moore is called to choose between the King (here named John *Carpenter*) and an image of Jesus on the wall of the church.

Before she makes her choice, the film—and with it Elvis's career in Hollywood features—ends.

The Documentaries

Elated by the "Comeback Special," Elvis returned to live performance, and thence to the form of rock 'n' roll cinema that had replaced the Hollywood features in which he had been trapped: the documentary. *Change of Habit* fulfilled his commitments, and though he continued to speak of returning to dramatic roles, he abandoned film music for songs that reached back to his roots in gospel and rock 'n' roll, infusing them with the other musical influences he had absorbed. Immediately after the "Comeback Special" he recorded a double album of new material, *From Elvis in Memphis*, which was, apart from the gospel albums, his first non-soundtrack album since 1962. Combining white country and western with contemporary black soul on the model of his earliest recordings, the album was widely regarded as equal to his best. The first single from it, the protest song "In the Ghetto," reached number three and a subsequent single, "Suspicious Minds," reached number one, his first since 1962. Buoyed by this reversal of his recent chart failure, in April 1970 he completed a triumphant two-week engagement at the new International Hotel in Las Vegas, whose opening night was so successful that Parker negotiated a five-year contract for him to play two seasons a year for a million dollars. He performed with a hand-picked orchestra and biracial vocal accompaniment from two gospel quartets, one composed of white men, the Imperials, founded by Elvis's idol Jake Hess, and the other of black women, the Sweet Inspirations, who had recently worked with Aretha Franklin and whose prominence in the subsequent documentaries would emphasize the African American women that Hollywood had excluded from Elvis's films other than *King Creole*. Featuring hit songs from the fifties and the material recorded in Memphis, this engagement revealed the new Elvis. The black leathers from the "Comeback Special" continued to be used on album covers, but for the shows he wore regal jumpsuits and his vigorous physical performance, augmented by karate moves, emphasized his upper rather than lower body. In his impromptu monologues, he sometimes talked about his career: "But as the years went by it got harder and harder to perform to a movie camera, and I really missed the people, I really missed contact with a live audience. And I just wanted to tell you how good it is to be back."[33]

In his own eyes, he had won back his audiences and defeated Hollywood. For a few years he was unquestionably again the King until, especially after his divorce, he declined into even greater drug dependency and physical debilitation. Parker meanwhile still had his eyes on the movies and began to re-envision the synergistic tie-ins between the sixties films and their

soundtrack albums. When his first plans for the closed-circuit broadcasting of concerts for those who could not make the pilgrimage to Las Vegas failed to materialize, he turned to documentaries: a concert movie, *Elvis: That's the Way It Is* (Denis Sanders, 1970), and a tour movie, *Elvis on Tour* (Robert Abel and Pierre Adidge, 1972), both produced by MGM.

Though studio financed, *Elvis: That's the Way It Is* follows the conventions of the independent counterculture rock documentaries that culminated in *Woodstock*, beginning with the audience and the performers coming separately together to the musical event, where they are united. It opens with scenes of Elvis in rehearsal; dressed in the hippie finery ridiculed in *Easy Come, Easy Go*: psychedelic shirts, bell-bottom pants, and a wide belt with silver medallions. Confident and at ease, he first directs lead guitarist James Burton and his rhythm section at MGM's sound stages in Culver City, then the Sweet Inspirations and the Imperials in Las Vegas, and finally the horns and the complete orchestra in the hotel showroom. These scenes are interspersed with interviews with the fans, but also with the hotel managers, all of whom idolize Elvis, if for quite different reasons. For a couple of girls and their cat, Elvis is remarkable for his music, but also for his friendliness and patience with the fans, and for another female fan, for his sex appeal ("there's no normal woman that can't get excited" by him, she asserts); but for the hotel management, fortified by masses of publicity material supplied by Parker, he is remarkable for his profitability. His unprecedented drawing power outstrips that of Sinatra, Dean Martin, and Barbra Streisand, and always fills the 2,200-seat room twice a night.

When the film has assembled all these in the showroom, Elvis waits nervously until his entourage walks him through the underground corridors to the stage. The flamboyance of his hippie clothes has escalated into an imperial white jumpsuit, cut nearly to the navel and densely studded with rhinestones, the songs are now performed in their entirety, and the fans' love for Elvis and his for them are realized simultaneously. But the social interactions and their spatial instantiation differ from both the Hollywood features and the countercultural documentaries. Where the features had maintained the conventions of the folk musical by stripping Elvis of his stardom and figuring him as at best a semi-amateur journeyman, now his absolute singularity and professional magnificence are proclaimed, so precluding him from membership in the organic community of equals proposed in the countercultural documentaries. Where the features had proposed the erasure of any distinction among the musicians and between the musicians and the fans, now these are insistently affirmed. With his backup singers and his musicians obedient to his every whim, Elvis is categorically other than the fans, the object of their burning love and utter adoration. He may lean down and kiss them, throw them his sweat-soaked scarves, and even go among them, but he is not of

them and makes himself available to them as if from another world. Having transcended the rebel of the fifties features and the regular guy of the sixties, having transcended regular kingship to become the Sun King, virtually a god, Elvis elevates rock 'n' roll into a religious rite—but one that ironically also asserts the function envisaged for it in the jukebox musicals: its complete, triumphant integration in all the apparatuses of the corporate culture industry.

Introduced by a voice-over promising "a tour through Elvis's life told by the one man who knows it, Elvis himself," *Elvis on Tour* is in fact a loose pastiche of scenes from a fifteen-day concert tour in April 1972 through fifteen cities in the heartland from Buffalo to San Antonio, structurally similar to *Mad Dogs and Englishmen*, Aldridge and Abel's documentary of Joe Cocker's US tour, released the previous year. Again, studio production allows an aural and visual opulence, specifically four-track stereo sound, a dozen cameramen, and anamorphic Panavision that supports wide split- and multi-screens that, in the manner of *Woodstock* and other countercultural documentaries, allow multiple views of Elvis but also his juxtaposition with the audience and his vocal back-up. Occasionally supplemented by Elvis's voice-over recollections of his life drawn from an earlier interview, sequences of onstage performances from four of the concerts are interspersed with backstage jams, arrivals and departures, interviews with promoters as well as selections from of his early television performances, and a montage of kissing scenes from his sixties films (accompanying "Love Me Tender") that emphasizes their repetitiveness. Since the daily set-ups in convention centers and the like do not allow the perfect lighting and camera placement of the International Hotel, the picture quality is inferior to the previous film's, and nothing intimate is revealed about Elvis other than his persistent stage fright. But, even more than in *Elvis: That's the Way It Is*, the performance scenes reveal his total involvement in his music, so categorically different from the diffidence of his singing in the sixties features that *Rolling Stone* appropriately greeted it as the "First Elvis Presley Movie."[34] Noticeably heavier and sweating profusely, he engages the songs with the simultaneously sexual and spiritual commitment that had made his early live appearances so electrifying. In a remarkable sequence, Elvis stops singing and asks the audience to join him in listening to the Stamps, the gospel group who had replaced the Imperials, as they sing "Sweet, Sweet Spirit." As the camera alternates between the quartet and Elvis, the pain and ecstasy on his face figures their announcement of "the presence of the Lord." But no sooner is it over than he jubilantly launches into one of his raunchiest rockers, "Lawdy, Miss Clawdy." The raw expressiveness of his earlier voice is gone, but not the multiple registers of desire. With barely a break he instructs the band to "take it home" and begins his last number,

"Can't Help Falling in Love" from *Blue Hawaii*. At its conclusion he casts his microphone on the ground and holds his cape outstretched, crisscrossing the stage like a magnificent blue eagle and falling to one knee to make his final bows. His handlers rush him headlong into a waiting limousine and the camera returns to the bereft fans as the MC announces, "Elvis has left the building."[35]

Back in the UK

THE ENGLISH ELVISES

In the six years between Elvis's completion of *King Creole* and his induction into the army in 1958 and the release of *A Hard Day's Night* in 1964, the School of Liverpool replaced the School of Memphis as rock 'n' roll's vanguard academy. Strong continuities and parallels linked the Beatles to Elvis for, like all English early rock 'n' roll, theirs was emphatically working-class and based on US rock 'n' roll, just as that was based on rhythm and blues. Both Elvis and the Beatles' music began as regional phenomena, emerging as national and then international phenomena through both records and television, especially the *Ed Sullivan Show*. Both musical revolutions transformed a generation's tastes, personal appearances, and social values across the North Atlantic to spearhead the cultural developments of their respective decades. When they were the biggest attractions in the world, both abandoned live performance to concentrate solely on studio production; both were guided by visionary but deeply flawed managers, and though unlike Elvis, the Beatles outlived theirs, as a group they did not survive him long. Elvis, initially at least, refused to smile, while the Beatles perhaps smiled too much, but both were in many respects inspired by the movies and to movies they both turned. But while for almost a decade, Elvis sacrificed his music to his films, after *A Hard Day's Night*, the movies never substantially influenced the Beatles' musical career.[1]

Between their respective emergences lay the doldrums that saw Elvis in the army, Little Richard returned to the church, Chuck Berry in jail, Buddy Holly dead, and Jerry Lee Lewis anathematized for marrying his thirteen-year-old cousin. In Britain in the interregnum, grassroots experimentations were met by entrepreneurs who promoted a phylum of domestic Elvises (Figure 7.1): Tommy Steele, Terry Dene, Cliff Richard (the most successful), Marty Wilde, Adam Faith, Anthony Newley, and Billy Fury (the best), many of whom were named, groomed, and managed by a London impresario, Larry Parnes. In their and others' attempts to create a British rock 'n' roll, film and especially

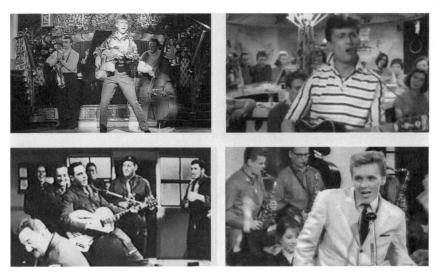

FIGURE 7.1 English Elvises: *Tommy Steele* (The Tommy Steele Story); *Terry Dene* (The Golden Disc); *Anthony Newley (*Idol on Parade*); Billy Fury* (Play It Cool).

television were as important as in the United States. All those mentioned made backstage musical films about rock 'n' roll singers, the business, the fans, and the social environment that negotiated between the British heritage and the incomparably superior power of the US import. As domestic wannabes mixed with US visitors on *The Six Five Special*[2] and other television shows, as well as in some films, they were always at a disadvantage, for outside its country of origin the excitement of rock 'n' roll was inseparable from the incendiary glamour of US culture.

In the United Kingdom a primary denotation of rock 'n' roll was *Americanness*, and if this did not so immediately inspire racial fears, it was nevertheless profoundly alarming. Given the deep-seated class stratifications of British culture, the sounds, images, and narratives exploring what British rock 'n' roll might be all threatened generational and especially class insurgency; their agency, especially the Beatles', in undermining the inherited class structure can hardly be overstated. As in the United States, films about rock 'n' roll in the United Kingdom raised questions of both musical and social delinquency, either to exploit them or to refute them, but they were shaped by two different and distinctively British film traditions: comedy, often mobilizing an idiosyncratic absurdism that was especially important for the Beatles; and a noir realism, often linked to documentary filmmaking, also important for the Beatles' films, but which elsewhere nourished unprecedentedly disabused visions of the music industry. Though in the United States, the Beatles seemed to have sprung from nowhere, in fact their music and their films were nurtured in rock 'n' roll cultures that were developed immediately after their US models. Profiting from the productive resources of major

British studios, even before *A Hard Day's Night*, several were superior to the US jukebox musicals, dramatizing the insurgent power of the new music and all its contradictions in more compelling and innovative narratives.

The Beginnings: Skiffle and Tommy Steele

The seedbed for British rock 'n' roll culture was an offshoot of a US vernacular music that emerged in the late 1930s among young musicians interested in pre-war Dixieland jazz rather than in swing or other modern innovations. By the early 1950s, it had sparked a revivalist UK "trad"[itional] jazz, with bands using instrumentation resembling New Orleans originals, so that, for example, in front of a rhythm section, a clarinet and trombone would improvise around a line articulated by a trumpet. Early bands included those of Humphrey Lyttelton, then Acker Bilk, Kenny Ball, and Chris Barber, with Lonnie Donegan playing banjo for the last. Exposed to US music while a serviceman in Europe, Donegan had a strong interest in blues and folk, which he often performed during interludes in Barber's performances. On July 13, 1954, a week after Elvis cut "That's All Right," Barber recorded an album that also included Donegan's cover with his own guitar accompaniment of "Rock Island Line," a traditional song about mid-western railroads popularized by blues performer Huddie Ledbetter, or Lead Belly. A year later, as rock 'n' roll began to cross the Atlantic, "Rock Island Line" was released as a single. Known as skiffle, this British hybrid of black and white music became enormously popular; "Rock Island Line" sold three million copies in the United Kingdom, and also inaugurated the reverse flow of British popular music to the United States, where it reached the top twenty and where Donegan subsequently toured and appeared on television. Donegan's skiffle also incorporated comic elements, most successfully in an adaptation of a twenties' novelty song, "Does Your Chewing Gum Lose Its Flavour (on the Bedpost Overnight?)," which reached number five in the US charts. Donegan remained popular in the United Kingdom for forty years, and though his own music was overshadowed by rock 'n' roll, his early recordings established the precedent of British musicians assimilating US music that became all but as influential as Elvis's own amalgamation of the black and white traditions. The British music-hall humor of his own compositions, most notably in "My Old Man's a Dustman," another number one hit in the United Kingdom, also set an important precedent for Tommy Steele, the Beatles, Led Zepplin, and the many others who later synthesized rock 'n' roll and traditional British music.

Usually played with an acoustic guitar, a washboard, and a tea-chest bass, the skiffle that Donegan popularized required neither training nor investment. It showed generations of British youth that popular music, even if it derived from the United States, need not be a culture of sheer

consumption, but could be one of popular participation, while Donegan's own entry into the US top ten as early as 1955 anticipated the transatlantic counterflows of next decade. Many of the skiffle groups graduated to rock 'n' roll; the most important was John Lennon's Quarrymen, while the first of any significance was Wally Whyton's Vipers Skiffle Group, which in 1956 became the house band at the 2i's Coffee Bar in Soho.[3] One of its members was Tommy Steele, a merchant seaman from Bermondsey in the working-class East End of London. Of the British singers who covered early American rock hits, Steele was the first to achieve celebrity. A natural entertainer since childhood, he began performing alone or in skiffle groups at the 2i's and other Soho coffee bars in interludes of unemployment. Hearing Buddy Holly when docked in the United States inspired him to turn to rock 'n' roll, and his first rockabilly single, "Rock with the Caveman," charted in 1956. His performances in the United Kingdom and later Scandinavia and South Africa were received with something of the hysteria of Elvis's early tours, promoting headlines like, "Britain's Answer to Rock Invades" and "Lock Up Your Daughters."[4] Next year saw the release of a biopic, *The Tommy Steele Story* (US title, *Rock Around the World*; Gerard Bryant, 1957). Coming only months after his rise to fame but still a few months before Elvis's *Jailhouse Rock* (Richard Thorpe, 1957) in the United States, it was the first significant British rock 'n' roll film.

It opens with him performing rock 'n' roll at the Café de Paris, an upscale London nightclub, where both the middle-aged diners and younger people watching from the balcony receive him enthusiastically. At a press conference after the show, he accedes to requests for the story of his meteoric rise, and the movie opens into an extended autobiographical flashback, beginning with his introduction to the guitar as a youth while hospitalized. Inspired by an itinerant musician's folk song about London, he teaches himself to play and develops his talent while working in the merchant marines. His inclination toward a musical career is stimulated by a shipmate who tells him his guitar playing is so good that he has "gold in his fingers," and the turning point comes, not when he hears Buddy Holly in the United States, but when he sits in with a calypso band in the Caribbean. On leave, he is immediately successful at the 2i's; he gains a manager, cuts a record, and finally is invited to the Café de Paris, the pinnacle of British entertainment. Finishing the story, he announces plans to thank the fans who made his career by hosting a free concert at the Bermondsey Hall with performances by the friends he has made, a conclusion to the film that follows the jukebox musicals' model, though without the television component. As well as his own rock 'n' roll performance of "Teenage Party," a song specifically written for the film, the finale places him at the apex of premier examples of the three competing forms of British popular music that rock 'n' roll would soon dominate: trad jazz, instanced by trumpeter Humphrey Lyttleton and his Band; calypso, instanced by

Tommy Eytle's Calypso Band; and skiffle, instanced by the Chas. McDevitt Skiffle Group.

Though all its music was derived from American models, *The Tommy Steele Story* made no narrative recognition of the United States, nor of the delinquency thematics of the US films. Steele himself plays a Cockney type; even though he wears a leather jacket and jeans, he is unfailingly spontaneous, cheerful, and uncomplicated. Occasioning no sexual or racial tensions and no social or generational divisions, his music is seamlessly assimilated into the styles and industrial structure of British pop music, renewing rather than interrupting it. His next movie, *The Duke Wore Jeans* (Gerald Thomas, 1958), a romp in which he plays both an aristocrat and a happy-go lucky drifter who captures the heart of the princess of a fictitious South American country, completed his turn from current US styles to English popular and show music and to the family entertainment that subsequently made him one of Britain's best-loved family entertainers.

The Tommy Steele Story narrativized the prominence of music in the specifically working-class subcultures emphasized in Free Cinema documentaries of the same period: the London jazz club in *Momma Don't Allow* (Karel Reisz and Tony Richardson, 1955), for example, and the transition from trad to skiffle in *We Are the Lambeth Boys* (Karel Reisz, 1958). Feature films about working-class delinquency frequently contained references to new forms of popular music, but several other low-budget films depicted the emergence of British rock 'n' roll from the coffee bar subcultures and from the skiffle and trad jazz with which it would continue to interact for the first three or four years of the decade. Examples include *The Golden Disc* (aka *The Inbetween Age*, Don Sharp, 1958) featuring Terry Dene and *Idol on Parade* (John Gilling, 1959) featuring Anthony Newley.[5]

Terry Dene was initially one of the most promising of the English rock 'n' roll singers. Also discovered at the 2i's, where he imitated both Elvis and Gene Vincent, he had an early hit with a cover of Marty Robbins's "A White Sport Coat." Other hits followed, but his arrest for petty crimes tarred him as a delinquent, and soon after he was conscripted into the army. Quickly discharged on medical grounds, he suffered a mental breakdown, then converted to Christianity and turned to gospel music. Made very early in his aborted career, his film, *The Golden Disc*, resembles the earliest US jukebox musicals in that the "rise to stardom" motif is nested in a rich anatomy of the music industry.

The twin leads, Harry and Joan, are a young couple hoping for a careers as performing artists, but their plans are postponed when Joan's aunt Sarah takes over a struggling coffee bar, the Lucky Charm. A tour of successful competitors introduces her to the drawing power of espresso machines, jukeboxes, and skiffle musicians, and after a renovation performed in the idiom of a show musical, hers becomes successful—a motif that would recur two

years later in *Expresso Bongo* (Val Guest, 1959). Learning that a hit record can sell as many as half a million copies and that seventy million discs are sold in the United Kingdom each year, Sarah is inspired to extend the coffee bar to include a record bar. Hearing Dene sing while demonstrating the use of a tape recorder, she decides to make a record. Since none of the established companies is interested, they start their own independent label, Charm; they record Dene, a skiffle group, and other musicians, and use one of the major companies, Gramadex, to press their discs. Dene's record takes off, but when the pressing sells out, Gramadex refuses to manufacture any more, requesting instead to buy Dene's contract. The owner of a US independent company breaks the stalemate by offering to press their records in return for the right to distribute Charm's artists in the United States. This brings Gramadex back to the table and a merger deal is reached, so at the end everyone's wishes come true: Dene becomes a star, Sarah has a prosperous business, and Harry and Joan declare their love. Coming so early in British rock 'n' roll, the musicians are unimpressive, and Dene himself performs mostly rockabilly-influenced ballads. But, even though they lack the argot and clothing of their US counterparts, the wide-eyed teenager fans are clearly coalescing into a distinct subculture. As well as introducing this emerging rock 'n' roll culture, the film is especially interesting for its survey of recording, record distribution, actual DJs of the period, televised rock 'n' roll and other aspects of the music business, and for its documentation of the coffee bars' role in nurturing an independent British music culture, even as it was migrating into the established industry.

The next year's *Idol on Parade* replaced the documentary realism with broad comedy. Starring Newley as Jeep Jackson, a successful pop singer drafted into the army, it echoed his own disastrous experiences with national service, from which he, like Dene, had been discharged on the grounds of mental instability.[6] But it also resonates with Elvis's then-recent induction, with Newley imitating some of his vocal mannerisms, and anticipates scenes in *G.I. Blues* in which Elvis sings for his fellow soldiers. Occasional motifs link it to other rock films; overflowing bags of mail for Jeep when the other soldiers get little, for example, recall the letters sent to Elvis in *Jailhouse Rock* and anticipate Ringo's in *A Hard Day's Night*. But unlike Parker and Elvis, who accepted the interruption in his career, Jeep's managers attempt to sustain his concert appearances and recording, so producing various escapades in which Jeep circumvents army regulations. His further exploits involve the commanding officer's daughter, who falls for him, and a caricature lifer who loves classical music. The latter inadvertently instigates a riot at one of Jeep's concerts, in which Jeep eagerly joins, anticipating Sid Vicious by bashing someone on the head with his guitar. But even these violent interludes are essentially comic, and overall the movie emphasizes his social integration and the social success of his music. Indeed the movie's four-song EP,

including two cowritten by Newley himself, established the name on which he too built a successful mainstream career as an actor and songwriter.

A year earlier, rock 'n' roll had featured in a West End stage musical, *Expresso Bongo*. Based very loosely on Steele's rise to fame, it brutally satirized the music business and the new styles. Like the similar but far less biting *Bye Bye Birdie* two years later, this in turn was adapted to cinema. It starred Cliff Richard, for both music and film, the most important of the English Elvises.

Cliff Richard

A veteran of several skiffle groups, Richard formed a rock 'n' roll band backed by the Drifters (later renamed the Shadows), and he became a star with his first single, "Move It" (1958), regarded by John Lennon and many others as the first genuine English rock 'n' roll record. He adopted Elvis's pompadour, sneer, and swiveling hips, but with his softer presence and lighter voice he never embodied Elvis's menace or his contradictory social implications, even though his first film roles were ethically ambiguous. His debut, *Serious Charge* (Terence Young, 1959), recalled *Blackboard Jungle*'s narrative task of distinguishing between redeemable and incorrigible youth. Introduced in a leather jacket and jeans, Richard plays Curley, a member of a gang of Teddy Boys, or delinquent small-town teenagers. The narrative places him between his vicious and amoral brother, Larry, and the local vicar who organizes a youth club and otherwise attempts to keep the kids out of trouble. Curley is peripheral to the main drama, which revolves around the death of a girl whom Larry had impregnated and Larry's false accusation that the vicar has molested him. Although Curley is part of a gang that undertook what the local magistrate calls "an orgy of window smashing," the vicar finally saves him from reform school. But until that point he is one of the hooligans' leaders, and his singing is unequivocally associated with their promiscuity and violence. They jitterbug wildly in a local coffee bar, breaking out into an impromptu chorus of "We're going to rock around the clock tonight," and when he performs his hit, "Living Doll," he is surrounded by adoring girls, who accompany him with the hand jive. When the gang invades the youth club, his performance of "No Turning Back," with lyrics about his being a "mean mean child since the day [he] arrived" inspires the kids to dancing so riotous and sexualized that the vicar has to interrupt it, which in turn leads to an incipient rumble with knives and bicycle chains that he is barely able to forestall. Though the coffee bar scenes are reminiscent of the early US jukebox musicals, especially the teenagers' restaurant rendezvous in *Rock, Rock, Rock!* (1956), the English teens are much more menacing and, rather than attempting to destigmatize their music, the film uses it to emphasize the most evil elements in an unrelieved ethical nightmare.

FIGURE 7.2 Expresso Bongo.

Richard's much larger role in his next film, *Expresso Bongo*, continues the stark noir disenchantment (Figure 7.2). It opens with a long tracking shot through the nighttime streets, strip clubs, and expresso bars of Soho, the center of London's music and sex industries, nostalgically imitated a quarter century later by Julien Temple in *Absolute Beginners* (1986). Laurence Harvey gives a virtuoso performance as Johnny Jackson, a fast-talking unscrupulous small-time agent whose girlfriend is an aspiring singer making a living as good-hearted stripper. He spots Richard as Bert Rudge, an upcoming bongo drummer and singer, performing a rock 'n' roll number, "Love," in a beatnik coffee bar, backed by his band, the Shadows. Though Bert is underage, living at home with his ineffectual working-class father and bitterly resentful mother, Johnny signs him to a contract that takes fifty percent of his earnings and changes his name to Bongo Herbert. Elbowing his way into a television discussion on the dangers of youth culture, he secures national publicity and a recording contact for his "gutter-lily" property, and his record climbs the charts. But in the third act, as Bongo's success brings him into show business rather than the coffee bar milieux, his music shifts, first to ballads and then to "The Shrine on the Second Floor," a religious song about his mother that is so mawkish that it betrays its origins as satire in the stage show. His rise to stardom also brings him into the company of Dixie Collins, a fading but still promiscuous American singer. A romance and possible sunny narrative resolution flicker when she helps him escape both the contract and Jackson, and makes plans to take him to Broadway to revive her own career. But Broadway wants only him, and she is left behind.

Though centered on London and assertive in their Englishness, both *The Tommy Steele Story* and *Expresso Bongo* were based on the "rise to stardom"

motif that the jukebox musicals inherited from previous Hollywood genres. But *Expresso Bongo* emphasized all the social contradictions the earlier film had overlooked. British rock 'n' roll is caught at the moment of its coalescence among jazz, skiffle, show music, and US rock 'n' roll precedents, emerging as quasi-amateur performance within a ferment of urban subcultures. But, as in *Rock Around the Clock*, the music is immediately exploited by professional agencies, here the specifically juvenile sector of the entertainment industry: "Our stake in the future of British show business," Jackson tells Bongo, "will be the idol of teenagers everywhere." Though the promoters, producers, and other performers and music industry personnel despise rock 'n' roll, especially in comparison to both classical and US show music, they are eager to exploit its financial possibilities. As the record company owner declares, "With opera I lost my shirt, but with this rock dreck I make money." Exemplified in a televised panel composed of a psychiatrist and a vicar as well as Jackson, the adult population at large understands it as merely the symptom of a social malaise that Bongo manifests. Expressing the narrative's premise, Jackson tells Bongo, "you have a chip on your shoulder, an H-bomb in your pants, a sneer, a twitch, a hell in your head, it's you against the world, baby, and the world loves you for hating it." Unlike *Mister Rock and Roll* (Charles S. Dubin, 1957), *Loving You* (Hal Kanter, 1957), and other US models, rock 'n' roll is never narratively exculpated from the mud of exploitation in which it flowers, and no resolution affirms that the kids are all right. In contrast to Alan Freed, who respects the fundamentally decent teenagers, Jackson despises them—"eight million telly-hugging imbeciles are going to fall in love with you"—and even Bongo thinks of his fans as "grimy yobs."

The discovery of the callow, naïve but ambitious working-class singer with the weak father, the sleazy nightclubs, and the exploitative manager recall *King Creole* (Michael Curtiz, 1958) (the soundtrack for which was one of Richard's favorite records), though it contains less violence, and Richard never matches Elvis's sullen resentment or his explosive musical power. But as a narrative, *Expresso Bongo* is superior to any US rock 'n' roll fiction feature of the 1950s and 1960s, except *King Creole*. The plot evolves among five major characters and as many partially realized ones, and the social and spatial environments of the culture industry—the record companies and the West End streets, theaters, night clubs, strip clubs, coffee bars—as well as the working-class London tenements are fully realized, and are documented by cinematographer John Wilcox with a noir richness. Bill Lenny's editing of the first and most upbeat of Richard's three numbers, "Love," is dynamic and sophisticated, responsive to both the song's energy and the coffee bar social milieu in which he performs it. It cuts freely but in precise coordination to the song's structure among close-ups and medium close-ups on him, on the Shadows and their

instruments, on the faces of the adoring teenagers, and on Jackson's sarcastic commentary. Especially notable are interpolated close-ups on the fingers of Hank Marvin, the Shadows' very influential lead guitarist, as he solos on the high frets of his instrument, the first important appearance of what would become a fetishized motif in subsequent rock 'n' roll films. Even in the US models, there is no superior instance of visual rock 'n' roll before it, nor after it until *It's Trad, Dad!* (aka *Ring-A-Ding Rhythm*, Richard Lester, 1962). But its very excellence highlights the film's structural contradictions. Bongo's shallowness is consonant with the overall satire on rock 'n' roll, but his excellence as a performer, both in "Love" and his other two songs, redeems it, and rather than being malcontents, the teenagers appear cheerful and innocent. Just as in *The Girl Can't Help It* (Frank Tashlin, 1956), Richard and the Shadows' vitality and musical lyricism defeat the narrative's attempt to denigrate rock 'n' roll.

As the changes in Bongo's music anticipated, after his first two films Richard, like Steele, increasingly abandoned rock 'n' roll for lighter pop material and contemporary show tunes. He modified his persona appropriately, jettisoning his associations with delinquency for a pleasant innocuity. The musical, social, and cinematic recuperations were negotiated in his next three films, *The Young Ones* (Sidney J. Furie, 1961), *Summer Holiday* (Peter Yates, 1963), and *Wonderful Life* (US title, *Swingers' Paradise*, Sidney J. Furie, 1964). Replacing the black and white rock 'n' roll noirs, they all were, like Elvis's sixties' films, big-budget color productions directed toward a family audience—though to varying degrees they all revived the classic Hollywood musical's dual-focus narrative and progressively replaced *Expresso Bongo*'s noir urbanity with exotic rural environments that sustained an idealized faux folk commonality.

Released a month after *Blue Hawaii The Young Ones* catches Richard midway in the transition. An early outing for Sidney J. Furie (who matured into *Lady Sings the Blues* in 1972), it is a backstage jukebox musical that among its fifteen or so numbers includes one rock song, a couple of rock-influenced ballads (one being the title track), a traditional music-hall novelty song, an instrumental by the Shadows, and several show tunes. The mix of show and contemporary pop music is mirrored in the invocation of the classic musicals' narrative tropes. The backstage musical's "rise to stardom" motif of the young singer's discovery and his romance with his leading girl are recast in a contemporary London youth environment, where the plot pits a group of teenagers against a pop-hating property tycoon, Hamilton Black, who has bought the land under their club for an office building. As Black's son, Richard is split between the two sides, wanting to be a pop singer and "not just a millionaire's son." He breaks with his father and leads the kids in putting on a musical show in an abandoned theater to raise money to save the club, a motif anticipated in the jukebox musicals and other rock 'n' roll exploitation forms,

for example, *Rock Baby—Rock It* and *The Ghost of Dragstrip Hollow*. The show is a great success and Richard is discovered by the BBC, his father discovers that he likes teenagers and their music, and the club is saved. The music and its filmic reproduction are undistinguished, but two aspects are significant. First, the generational divide is played out in inverted terms with the father as the villain (the kids call him "a real monster"); the class division between the older father and the teenagers that initially corresponds to it (that, for example, obliges Richard to alternate between a formal suit and jeans in his two roles) is dissolved by his mediation and then by the teenagers themselves, who include all classes, from would-be hooligan laborers, through students, to prospective show folk and even a young lawyer. Second, the teenage girls who comprise almost all the audience for the final concert scream uncontrollably during Richard's rock number, an obvious precedent for the climactic scenes in *A Hard Day's Night*, filmed the next year.

In his next film, *Summer Holiday*, Richard and his friends take a holiday driving a double-decker bus across Europe from London to Greece. On the road, they pick up four girls, a mime troupe, and a large dog and, despite parental opposition, Richard finally marries one of the girls. By this point he had replaced his earlier rocker persona with a Pat Boone–like blandness, and his shift from rock and its filmic vocabularies to show music and the conventions of the classical musical was almost complete. Choreographed by Herbert Ross, a veteran of Broadway musicals, most of the songs' musical accompaniment is orchestral and so merges easily with the similarly orchestral underscore, even though the Shadows do appear and contribute some of the music. From a rock 'n' roll perspective, the film is interesting only as an anticipation of the Beatles' *Magical Mystery Tour* (1967), but it was a huge box office success. Its choreography, duets, dual focus narrative, and other conventions of the classical musical were completely adopted for next year's less successful *Wonderful Life* (Sidney J. Furie, 1964), released two months after *A Hard Day's Night* had spectacularly reinvented the rock 'n' roll film. Richard continued to make films through the sixties but he never revived the noir thematics and persona of his first two. His film career declined even though, while British rock 'n' roll became dominated by beat music and the Mersey Sound, he prospered as a pop singer. Like Elvis, he moved from a teenage audience to a young adult and eventually a family audience. In 1964, he publicly embraced Christianity and, again like Elvis, recorded several albums of religious music. One of Britain's most successful all-around entertainers, he was knighted in 1996.[7]

Adam Faith

Adam Faith, Richard's only real rival at the end of the 1950s, initially wanted to act, but he first gained attention as a singer with a skiffle group, Terry

Denver and the Worried Men, who were for a time resident at the 2i's. After several unsuccessful singles, his "What Do You Want?" topped the British charts, and in the same period he appeared extensively on television and also began to make films. In his first, *Never Let Go* (John Guillermin, 1960), a noir re-envisioning of *Bicycle Thief* (Vittorio de Sica, 1948) in which a cosmetic salesman loses his job as a result of his car being stolen, he played the thief. Initially tough, he leads his coffee bar delinquents in riding rings around his victim on their motorcycles like Brando and his gang in *The Wild One* (László Benedek, 1953), but later displays a confused vulnerability when he takes up with his boss's moll. He does not sing in the film, but his beat version of the Civil War folk song, "When Johnny Comes Marching Home," a top-ten hit in Britain, plays behind the titles, and the excellent instrumental jazz score, terse and understated, with notably good use of bongos, was revamped by John Barry, who wrote the music for many of Faith's other hits. Barry also scored Faith's next film.

Beat Girl (aka *Wild for Kicks,* Edmond T. Gréville, 1960) was a cautionary tale of a wealthy Kensington girl getting her kicks in bohemian jazz-rock beat subculture (Figure 7.3). Jennifer, played by Gillian Hills, a Roger Vadim protégé and subsequently herself a moderately successful pop singer and actress, is a Bardotesque teenage art student, angry with her egotistical father and embroiled in an Oedipal rivalry with her new French stepmother. She escapes her privileged home for Soho where coffee bars, strip clubs, and record stores face each other across the street, all apparently integrally related components of a delinquent subterranean demimonde. The title sequence, a one and a half minute shot interrupted only by a close-up on the beat girl herself, follows her

FIGURE 7.3 Beat Girl.

down the dark stairs of a cellar where a raucous band has the teenagers dancing wildly. Finding reciprocation for her alienation in a group of self-described "rats in a hole," she understands it as generational difference: "we're nothing to do with our parents" and, since we didn't get our language from them, "we can express ourselves and they don't even know what we're talking about, it makes us different." From a chance encounter in a coffee bar, she learns that, while herself a refugee from an uncomprehending family, her stepmother worked as a stripper and worse in Paris. Attempting to destroy her with this information, Jennifer is drawn ever deeper into the underworlds of the beatniks and the criminal sex industry. Initially she is able to manipulate both; but she gets out of her depth with the former when she brings them all back to her house for a party where she herself begins to strip, and with the latter when the club owner tries to take her to Paris. His murder by an abandoned lover solves both issues, reuniting her with her father and stepmother, while the rejected cellar rats can only look on in disappointed envy as she leaves them for bourgeois security.

Jennifer's psychological alienation is projected spatially in the environment and socially in her role in the gang. The underground cellar and nighttime Soho streets are rendered in beautiful noir chiaroscuro by the great cinematographer Walter Lassally, responsible for *Momma Don't Allow, We Are the Lambeth Boys*, and many other Free Cinema and British New Wave films. With Dave (her lover in the gang), played by Faith, she is caught in a sadomasochistic relationship fraught with class tensions. The kids' unquestioned leader, Dave traces his trauma to World War II, to his birth during the Blitz and his deprived, working-class childhood among its debris; conversely, another, much wealthier but already an incipiently alcoholic, youth lost his mother in the bombing and was left to a repressive army general father. Compounded with fear of nuclear annihilation, these various grievances precipitate the kids' code of living; in Jennifer's words, "we live it up, do everything, feel everything, strictly for kicks." The kicks are provided by games of chicken played with fast cars and trains and, in the Stygian candle-lit jazz cellar beneath the coffee bar, by music. From there, John Barry's jazz-rock fusion envelops the entire film, except when it modulates into Dave's own singing and guitar playing, which includes "Made You," a song he addresses to Jennifer, complaining that he can never relax until he has done just that. Along with the frenzied dance music of the other bands that play in the claustrophobic cellar, Dave's music is the group's lifeblood, but has no existence outside it. The street does contain a record store, but otherwise the film's music is to linked to neither the culture industry nor the wider social world. Rather, it appears as the expressive vehicle of an autonomous subculture, whose attraction for Jennifer models the film's own appeal. Though, as the beats' leader, Dave does project a moral code, which includes the rejection of alcohol and physical violence, his and Barry's music stand for the underworld

of social alienation and the kicks it provides, both of which Jennifer finally rejects. Like *Expresso Bongo, Beat Girl* cannot provide a positive romantic resolution, but it is even darker and more pessimistically melodramatic than the Richard vehicle and entirely lacking its humor. It also tested the limits of the British censor: cuts were demanded before it was allowed even an "X" or "adults only" rating and, though it still reached the top ten, the song "Made You" was banned by the BBC.[8]

All these films portrayed British rock 'n' roll and the music industry as an exclusively London phenomena, even though the most significant developments were brewing in the northern provinces. One Merseyside singer, Billy Fury, however, made the move from Liverpool to London before the Beatles, and just before they became successful the Beatles had auditioned to be his back-up band. Also a member of the Parnes stable, Fury specialized in Elvis's controversial provocative hip movements as well as in melodramatic ballads of the kind introduced in *Blue Hawaii*. His first film, *Play It Cool* (Michael Winner, 1962), was unsophisticated dramatically, but was made memorable by his music. Its flimsy narrative involving an heiress and another pop singer who wants to marry her for her money and status provides the context for a series of comic crises in airport lounges and London nightclubs, where the Twist currently rules. Set among these high hijinks are appearances by a handful of British character actors, by Bobby Vee, a pop balladeer from Nebraska whose first US chart success had been a cover of Faith's "What Do You Want?" and by several superior British performers including Helen Shapiro, Alvin Stardust (then known as Shane Fenton), Danny Williams (a British Johnny Mathis), and Fury himself. Not a persuasive actor—even when playing himself, as he did later in *That'll Be the Day* (Claude Whatham, 1973)—Fury nevertheless contributes half a dozen excellent numbers, including two of his most resonant ballads ("I Think You're Swell" and "Once Upon a Dream"), two more twist numbers, and the uptempo rock 'n' roll title track, which more than justify his cult status as an Elvis rival in Britain. Thematically, it splits rock 'n' roll's social tensions by placing Fury as a potent sexy rebel between another, more malicious, pop singer who tries to exploit the heiress and his own bandmates, who appear as wide-eyed schoolboys.[9]

During the last years of the 1950s and the first of the 1960s, British rock 'n' roll was still essentially imitative of the first wave of rock 'n' roll in the United States. By 1958 the era of the jukebox musicals was over, and the release of *King Creole* marked the end of significant US cinema until Elvis returned from the army. In this interim, the British rock 'n' roll film was superior to its US sources. The groundswell of prosperity that allowed a distinctly teenage culture came later to Britain than it did to the United States; wartime food rationing, for example, did not end until 1954, and teenagers did not emerge as a distinct cultural force until the early 1960s. But in this period, native noir and comic traditions produced a spectrum of films in which rock 'n'

roll, the processes of its manufacture, and its social meaning were variously dramatized, and in which innovative and in some cases very sophisticated techniques for the filmic representation of its performance were developed. The Beatles' music developed in the environment of these combined musical and filmic cultures, but their cinema was initially shaped by Richard Lester's ingenuity, which first became fully evident in another film featuring rock 'n' roll and trad jazz: *It's Trad, Dad!*

The Beatles I

RICHARD LESTER AND *A HARD DAY'S NIGHT*

Almost all British rock 'n' roll before the Beatles imitated US developments; but their versions of black hits and especially their original compositions were quickly recognized on both sides of the Atlantic as the first innovations to match the dynamism of early rock 'n' roll and as a distinctively British form of it. Three correlative aspects of their recreation of the heritage were especially influential: their regionality, their group formation, and their charm.

All essentially working-class and of Irish ancestry, they were born during the war and grew up in Liverpool, a port city whose prosperity derived from the slave trade, and so their provincial marginality, parallel to Elvis's own, was nevertheless especially open to transatlantic cultural currents. The Northern working-class popular culture in which their music was rooted and the more broadly English musical elements only became more pronounced as their artistry matured, especially on the albums *Revolver* (1966) and *Sgt. Pepper's Lonely Hearts Club Band* (1967). So like Elvis's, their overall cultural mobilization was both aggressively regional in its assault on metropolitan cultural hegemony and fundamentally national, in their case deeply imbued with a local English environment and with the memory of World War II and nostalgia for a lost imperial past.

Second, the Beatles were a *group* who very quickly assumed an unprecedentedly comprehensive agency over their own art. Though collective composition had been the norm among jazz and folk musics, previous white pop singers had typically performed songs written by others and recorded them with studio musicians. Some rock 'n' roll artists, including Little Richard, Chuck Berry, and Buddy Holly, had written their own material, and from the beginning the Beatles' manager, Brian Epstein, and producer, George Martin, made significant contributions to their career and records, respectively; but the Beatles were the first major rock 'n' roll artists to be at once integrally dependent on each other but essentially autonomous as a group.

Their composition of their own music and their performance and record-
ing of it with their own instrumental accompaniment marked a transforma-
tion in the mode of musical production and its social implications. Though
conventionally disseminated as commodity records, soon their music was
thought to have transcended its commercial manufacture and to have
become personally and eventually generationally expressive. Their signifi-
cance for sixties' counterculture utopianism and the idea of *authenticity* can
hardly be overemphasized. This mode of musical production became more
important than both individual singers and groups in which a singer led an
accompanying band—Buddy Holly and the Crickets (otherwise the model
for the Beatles' line-up), for example, or Cliff Richard and the Shadows. With
the Rolling Stones, the Kinks, and the Animals, it quickly became the norm
in Britain and in the US counterculture, with the Byrds, the Grateful Dead,
the Jefferson Airplane, and so on. These innovations generated new narrative
possibilities for and constraints on their cinema that likewise transformed
previous conventions, especially as they had been organized around a single
main protagonist. Attenuating the classic musical's dual focus narrative, the
rock 'n' roll films of the 1950s had generally placed a number of performers in
a narrative line carried by an aspiring singer, disc jockey, or some other sin-
gle protagonist, and the Elvis films were, of course, his alone; but any Beatles
film had to accommodate four leading and ostensibly equal characters, a
complication compounded by the fact that they were always dramatized as
the Beatles and never adopted fictional identities. Eventually, all four had
cinematic involvements of many kinds, but as the Beatles, they only played
themselves, again the opposite of Elvis, who, after the army, always played
the King and never played himself. Eventually the foursome playing them-
selves became the basis for an fundamentally important reconstruction of
the dual focus narrative: the romance between the fictional leading boy and
girl was reconstructed as a social relationship between the band and their
audiences. In the US counterculture and its films, this in turn developed into
the promotion of a utopian folk community in which musicians and fans
participated equally together.

Third, the Beatles' rapid international success, together with their witty,
carefree personae, and their chirrupy songs and cheerful lyrics about adoles-
cent romance, predisposed them to comic narratives of social acceptance and
incorporation. When the issue of their making a film was first raised, John
insisted that it would be a comedy, as if to reject the noir alienation of *Expresso
Bongo* and *Beat Girl* for the sunny humor of *The Tommy Steele Story*. Initially
they been English Elvises, sporting his pompadour and delinquent leather
jackets; but Brian Epstein marketed them as the epitome of respectability,
giving them a precise visual identity in matching Pierre Cardin–inspired
suits (most of them made by Soho tailor Douglas Millings) and teaching
them to bow after every song. Where associations with delinquency had

made earlier rock 'n' rollers controversial, the Beatles' insubordination implied only joyful irreverence or surrealist absurdity, and instead of pitting teenagers against adults, the Beatles were quickly embraced by all age groups and classes, and intellectuals and media commentators alike celebrated them as agents of an inclusive social commonality. Appearing in the period of disillusion following the assassination of President Kennedy, the social promise of this inclusivity was especially pronounced in the United States where, like Elvis's, the Beatles' phenomenal success was brokered by the *Ed Sullivan Show*. Their trip to the television show and to rock 'n' roll's country of origin also generated their first film.

The Beatles in the United States

Sullivan happened to be passing through Heathrow Airport at the end of October 1963 when the Beatles were returning from a Swedish tour. Amazed by the fans' hysteria, which reminded him of Elvis's reception, he made inquiries and, discovering the extent of Beatlemania in Europe, made a deal with Epstein. By the following spring, the Beatles' popularity and record sales in the United States were sufficient to persuade them to tour, and they appeared on his show on three successive Sundays beginning February 9, 1964 (Figure 8.1). By the first of them, Beatlemania had hit the United States, and "I Want to Hold Your Hand" topped the *Billboard* Hot 100 charts, having sold a quarter of a million copies in three days. Presenting them on his show as "ambassadors of goodwill," Sullivan announced that New York had never before "witnessed the excitement caused by these youngsters from

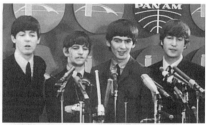

FIGURE 8.1 The Beatles in the USA *and the* Ed Sullivan Show.

Liverpool." Sandwiched between advertisements for shoe polish and Anacin, they opened the show with three numbers, and closed it with the upbeat "I Saw Her Standing There" and "I Want to Hold Your Hand." Performing all the songs live, the Beatles concentrated on their musicianship, but also gleefully responded to the audience's enthusiasm. For the occasion, a fifth camera was added to Sullivan's usual four to give one frontal, one from behind the audience, two in the wings for close-ups, and one trained on the girls in the audience and, apart from occasional slow zooms, all were stationary. Lyric sheets had been used to block the shots, so that the fairly rapid editing responded to the songs' structure, and each number contained cut-aways to the audience, mostly excited girls whose screams provided an ongoing sonic counterpoint to the music. Press accounts were largely hostile, but the show was a national phenomenon, attracting an estimated 74 million viewers, almost 60% of homes with a set and almost a quarter again of the 60 million people who had watched Elvis's first appearance.[1] The same US tour was the occasion for the Beatles' first significant film, *What's Happening! The Beatles in the USA*.

Only two hours before the Beatles' plane landed at John F. Kennedy International Airport in New York, documentary filmmakers Albert and David Maysles were offered the opportunity to film their tour for Granada, a British television company. Rushing to the airport, they captured the frenzy of the fans during their iconic descent from the plane, and followed them for the next five days. Taking advantage of light-weight cameras and new techniques of sound recording, photographer Albert and sound-recordist David had been developing a form of observational documentary filmmaking known as Direct Cinema that aspired to record events with a minimum of direction or intervention by the filmmakers. And though the Beatles' playing to the camera throughout confounded their attempts to catch their subjects unawares, the film was recognized as the "first full-length synch sound cinema-vérité film completely free of narration."[2]

Containing no performance footage, *What's Happening!* concentrates instead on behind-the-scenes events: encounters with the press and photographers; time in hotel rooms spent listening to US pop radio, especially making connections with Murray the K, disc jockey at station WINS (where Alan Freed had been so successful); news reports, including Walter Cronkite's television announcement of the British Invasion; a visit to the Peppermint Lounge nightclub where the girls teach Ringo to do the hitch-hike; a train ride to Washington for their debut American live concert; time in Miami, where they had gone for their second Sullivan appearance; and finally leaving the United States and returning to the United Kingdom to complete the narrative frame. Since the film is entirely episodic and the Beatles were so fully aware of the camera, instead of an objective narration of their visit, it is an intimate group portrait in which they self-consciously present themselves.

Despite the hectic schedule, they are always good-humored and playful; self-confident, witty, and sarcastic, rather than hostile with interviewers; innocent and self-deprecating rather than moody and ominous; and almost as much in awe of the United States, especially of the total cultural permeation of advertising, as the ubiquitous masses of screaming fans are in awe of them. Apart from very brief moments when someone's tiredness allows a momentary respite, they are a mass of ebullient energy from which Albert's handheld camera seeks out moments of spontaneous self-revelation. Whether by chance or design, there are no tantrums or difficulties, and no sex, drunkenness, drugs, or any other indication of debauchery or menace. Orchestrated by Epstein and performed by the Beatles themselves, the combination of qualities they displayed crystallized as the public face of early 1960s British rock sensibility—one radically different from that mobilized during the previous decade.

Though an early, shortened form of *What's Happening!* was televised in both the United Kingdom and United States, the film was subsequently re-edited to include footage of *The Ed Sullivan Show* performances and the Washington concert.[3] This film, currently in DVD distribution as *The Beatles: The First US Visit*, is, then, a backstage musical combining the representation of the Beatles in performance and their back- and off-stage lives. The same combination of spectacle and narrative structures their first feature film, *A Hard Day's Night*, directed by Richard Lester.

Richard Lester

The Beatles' film career was launched by Richard Lester, an American whose experience in the early days of television had given him an entrée to the English industry just when commercial broadcasting was beginning. Lester had been generally successful as a director of low-budget series and commercials (sometimes using Nicolas Roeg as a cameraman), developing innovative cinematographic techniques, especially the use of multiple cameras. But one of his shows was such a spectacular disaster that its hilarity prompted British comedian Peter Sellers to see him as a likely collaborator for a television version of the seminal early 1950s BBC comedy radio program, *The Goon Show*. Lester's television series with the Goons led to offers to direct films, two of which decisively influenced his work with the Beatles and hence the rock 'n' roll film generally: *The Running Jumping & Standing Still Film* (1960) and *It's Trad, Dad!* (1962).

The first attempt to reproduce in film the Goons' absurdist gags, *Running Jumping & Standing Still* was an amateur project, initiated and co-directed by Sellers, and featuring himself and Lester as well as Goons Leo McKern and Spike Milligan. Shot in two days, and completed for less than a hundred

dollars, the eleven-minute short begins with a caricature bourgeois looking though the wrong end of a telescope to see a washerwoman scrubbing an area in the middle of a field, where a bizarrely dressed man pitches a tent. Another figure, dressed like a villain in a Victorian melodrama, uses an ancient studio camera to take a photograph of him, and attempts to develop the plate in a stream, but a hunter wearing frogman flippers interrupts him. A violinist on a bicycle briefly interrupts the ongoing refrain of simple trad jazz tunes, then the whole group reassembles and attempts to launch a large kite decorated with a Union Jack, but succeeds only in destroying it. Following the numbers on her face, a man paints a woman in the field, while another places a gramophone record on a tree stump and runs round it holding a needle to its grooves. Two men fight a duel, which is won by the one who shoots a bullet from a Gurkha *khukuri*. Sellers beckons a man from across a field, only to knock him out when he arrives, and then ends the film by going to sleep in evening clothes.

The Running Jumping & Standing Still Film had affinities to such contemporary British underground pop and absurdist filmmakers as Jeff Keen and Bruce Lacey (the latter of whom appeared in it and later as the unexplained flutist in Lester's *Help!*), and it was something of an Anglicized version of the seminal avant-garde surrealist shorts made in Paris in the 1920s; the buffoonery of the bourgeois types echoes Rene Clair's *Entr'acte* (1924), and though its humor is less macabre, its disjunctiveness recalls Luis Buñuel and Salvador Dalí's *Un chien Andalou*, (An Andalusian Dog, 1929). It was nevertheless a thoroughly Goonish production; if today it appears jejune, in its own time it was considered radical and successful enough to be nominated for an Academy Award—and it was a favorite of the Beatles. Some of this Goonishness informed Lester's two music films, *It's Trad, Dad!* (aka, *Ring-a-Ding Rhythm!*, 1962) and *A Hard Day's Night* (1964). Together, these transformed the musical's narrative and spectacle. The role of the audience and fans in the former was radically increased, and their active participation as protagonists allowed the reconstruction of the dual focus narrative as a relation between them and the musicians; and Lester's innovations in the representation of the spectacle produced dazzling new forms of filmic musicality.

Written and developed by another US ex-pat, Milton Subotsky, an exploitation producer with two jukebox musicals, *Rock, Rock, Rock!* and *Jamboree* among his credits, *It's Trad, Dad!* (Figure 8.2) was a jukebox musical about the three major forms of British popular music immediately before the Beatles appeared: trad jazz, US rock 'n' roll, and UK imitations of it.[4] Much superior to the US jukebox musicals, it is in some respects superior even to *A Hard Day's Night*. The narrative begins in a drab, apparently deserted provincial English New Town, enlivened only by a coffee bar where teenagers congregate to dance to trad jazz on the jukebox and watch it on television. Disturbed by "the wild, the furious, and the frantic music," the

FIGURE 8.2 It's Trad Dad!: *Gene Vincent, Gene McDaniels, Acker Bilk, and disc jockeys David Jacobs, Pete Murray, and Alan Freeman.*

mayor decides to ban "creeping jazzism," prompting two of the teenagers to attempt to justify their music by arranging a televised free concert in the town square. Playing themselves, the two are Helen Shapiro, a promising young singer who the previous year at the age of fourteen had had two number one singles (and for whom the Beatles would open on their first national tour), and Craig Douglas, a Pat Boone clone who had successfully covered several US records. Setting off to gain the assistance of three of the best-known English disc jockeys, David Jacobs, Pete Murray, and Alan Freeman, the pair make their way through radio and television recording studios and a televised show from an expensive cabaret, the Clique Club, all featuring musicians who mostly lip-sync to and otherwise perform along with their records. The three kinds of music are extensively represented: trad bands by Chris Barber's, Acker Bilk's, Terry Lightfoot's, Kenny Ball's, and the Temperance Seven; US rock 'n' rollers by Chubby Checker, Del Shannon, Gene McDaniels, Gary U.S. Bonds (all of whom appear at the Clique Club) and Gene Vincent; and British pop acts by John Leyton, the Brook Brothers, and Shapiro and Douglas themselves. When the disc jockeys eventually agree to help to arrange the concert and recruit the jazz musicians to play without charge, the mayor calls in the police, who mount a quasi-military siege of the town to waylay the bands, setting the scene for comic routines recalling *Running Jumping & Standing Still* and anticipating the magicians' surveillance of the bus in *Magical Mystery Tour*. But the musicians make it through, and join the townsfolk in a festive street party whose huge success allows Shapiro easily to convince the mayor to take credit for it.

Like the many musical rivers that flowed into the eclectic jukebox musicals, the US rock 'n' roll and the Anglicized Dixieland are happily compatible in the film, even though they were favored by different youth groups: the rock 'n' roll by the British biker and teddy-boy delinquent subcultures and the trad jazz by students and would-be bohemians. Trad, however, was soon displaced by the Beatles and Merseybeat music (which quickly made Shapiro's pop so passé that she became a jazz singer), which also polarized the musical and social differences that erupted two years later in the mods and rockers riots. But in the film the rock 'n' rollers are safely ensconced in the nightclub, and only the trad musicians escape the radio and television industries to join the party. The juvenile delinquency afflicting the new towns at that time is omitted and the only observable cause of conflict is the mayor's personal bumptiousness, for neither parents nor teenagers, nor even the other members of the town council, are offended by jazz or rock 'n' roll. The social inclusiveness of the final scenes contrasts vividly with the social divisions around trad that were foregrounded in Karel Reisz's *Momma Don't Allow* (1955), where the cohesiveness and camaraderie of a working-class London jazz club was interrupted by a group of pompous and conspicuously slumming bourgeoisie, dressed in tuxedos and driving a Rolls Royce. But in *It's Trad, Dad!*, the mayor's formal dress aside, sartorial differences among the teenagers, the jazz bands, and the DJs do not mark social distinctions, and the final party resolves the plot, not when the adults have a change of heart and realize that popular music is harmless teenage fun, but when all the townsfolk respond to the teenagers' initiative, reject the mayor's interference, and dance.

The absence of any real social tension allows *It's Trad, Dad!* a blithe lightheartedness, quite different from the satire of *The Girl Can't Help It* and the earnest self-justification of the other jukebox musicals that would remain impossible in the United States until a decade later when, with *American Graffiti*, for example, the social implications of 1950s rock 'n' roll had been nostalgically reconstructed. Its utopian social vision is kept afloat by comedy, with the mayor, police, and supporting bourgeois establishment characters all played very broadly. Their humor is matched by a spectrum of inventive sight gags, meaningless plot detours, and other absurdist devices and reflexive Goon-like surrealist interpolations: spurious words graphically placed over the screen, a zoom down a megaphone that rotates into abstraction, a diner entrapped by an endless piece of spaghetti, and a model of the police blockade made with toys. The most important of these deflationary devices is an ironically condescending voice-over narrator, who not only introduces, describes, and comments on the story, but also interacts with the protagonists and directs the plot. For example, when the two teenagers are stumped, the narrator directs their attention to a poster for the Clique Club and tells them to try it; with an invisible cut, he dresses them in evening clothes and

takes them there, then complains of their failure to thank him. The primacy accorded to sound in his disembodied voice also informs the visual presentation of the musical numbers.

Though a major attraction of the jukebox musicals was the dramatic enhancement contributed by the visual appearance of the performers, auditory pleasure was still paramount: the opportunity to hear music at a fidelity and volume not otherwise possible. But while the US jukebox musicals had made little attempt to recreate musical qualities visually—to create visual rock 'n' roll—*It's Trad, Dad!*'s brilliantly inventive filmic presentation of the US performers and the English trad bands marked a major advance in rock 'n' roll visuality. The performances of the mostly solo US rockers are—like Little Richard in *The Girl Can't Help It*—edited so as to make them appear to be present to their Clique Club audiences, but in fact they were spatially separated, for Lester had at his own expense flown to the United States to film them independently. This allowed him to photograph and edit the numbers more imaginatively than had occurred in any previous rock film, inventing a different technique for each. Whereas the Gene Vincent section in *The Girl Can't Help It*, for example, is shot full frontal and with the master-shot interspersed only with similarly frontal close-ups, here his sequence alternates between a close-up on his face from the side with a long shot that frames him between a saxophone and a guitar seen in extreme close-up. And for Gene McDaniels' number the camera slowly circles his backlit face and upper body, with its movement punctuated by all but abstract superimposed counter shots.

The jazz band sequences are even more innovative. Working with veteran photographer Gilbert Taylor, Lester took full advantage of his experience in commercials and live television, using three cameras and filming each number three times.[5] With nine available shots at every point, editor Bill Lenny (who had cut *Expresso Bongo* the previous year) was able to make dazzling montages that interweave moving-camera and stationary shots; multi-planar compositions in depth and flat close-ups; wide-angles and long shots; shots with multiple and single performers; freeze frames and juxtapositons of negative stock and positive printing. In the finale (Figure 8.3), where three jazz bands perform live among the dancing townsfolk, the compositional possibilities of these montages are further multiplied: the musicians and their instruments, the DJs and the dancers, the interaction of the organic shapes of the trees with the architectural elements of the surrounding buildings, and the television cameras and press photographers moving among them are all brilliantly interwoven. Angles, shapes, volumes, instruments, and in- and out-of-focus elements in the frames together create a visual polyphony, counterpointing the multiple interacting lines of the Dixieland orchestration and enriching both its formal structure and the redemptive social pleasures it manifests: a visual trad jazz.[6] Its augmentation of the music's sonic and social

FIGURE 8.3　It's Trad Dad!

properties—the disciplined spontaneity with which the visuals dance with the music and the happy community—make *It's Trad, Dad!*'s finale a classic of filmic musicality.

Though the narrative has exposed the multiple forms of commodification involved in the various forms of British popular music, the concluding free concert appears to escape the alienation of capitalist culture and dissolve the spatial and social boundaries separating performers from fans. Taking the generic concluding television broadcast from the studio to the streets, its final presentation of trad jazz as folk music spontaneously uniting musicians and audiences in an integrated commonality anticipated the US festival documentaries of the late sixties. The film's utopianism is—like *Woodstock*'s—of course deeply ideological and, like other forms of folk musical, its depiction of a moment where music appears to transcend commodification simultaneously works to conceal the commodified social relations actually generated by the musical and filmic mode of production. Lester's skill in visualizing rock 'n' roll spectacle as emancipatory popular culture and his subordination of narrative momentum to performance and the kinetic vitality of his visual music recur in the Beatles' first and best feature film. A story about four

cheerful, cheeky musicians who leave Liverpool for London, *A Hard Day's Night* definitively pictured their creation of a new form of rock 'n' roll.

A Hard Day's Night

In late 1963, just as Beatlemania was sweeping the United Kingdom and Europe, a British representative for United Artists Records discovered that the Beatles' contract with their record company, EMI, did not include rights to film soundtrack music. United Artists quickly made a three-picture deal with Epstein, giving the company the bulk of the profits from both the film and the accompanying soundtrack album. Though *Beat Girl* had already been the first British rock 'n' roll film to generate a soundtrack album, it had been supplementary to the film; but in the case of *A Hard Day's Night* it was expected that the film would be supplementary to the album, all of which was written and recorded specifically for the film, making it the first Beatles' album composed entirely by John Lennon and Paul McCartney. The primary motive behind it was not to create a significant film so much as to generate and promote recordings to capitalize on what was again expected to be a short-lived musical fad. With a very small budget of £200,000, production began two weeks after the Beatles returned from the February 1964 *Ed Sullivan* appearances, and an upcoming tour to Europe and the Far East crammed shooting into a six-week schedule.[7]

Although the music was primary in the entire project, *A Hard Day's Night* turned out to be an extraordinarily original amalgamation of virtually all previous forms of rock 'n' roll film. Its overall mood and its main motifs mediated between the noir and comic modes of the British precedents, leavening the exploits of rock 'n' roll delinquent teenagers with the flippant comedy and mass appeal of Tommy Steele and Cliff Richard's later films. And it combined in condensed form the backstage jukebox musicals, the fictionalized pre-army Elvis biopics, and the documentary concert film that would become the dominant form of sixties' rock 'n' roll cinema, the first significant example of which, *The T.A.M.I. Show*, would be released at the end of the same year. As in *It's Trad, Dad!* and the earlier jukebox musicals, the narrative frames a series of performances lip-synced to previously recorded songs, and culminates in a broadcast television spectacular. But where *It's Trad, Dad!* had envisioned the broadcast as the occasion of a popular music festival, *A Hard Day's Night* elided the rich folk elements in Liverpool's rock 'n' roll culture and reverted to the show musical's emphasis on the integration of music into other forms of commercial culture. The Beatles appear only as a fully professionalized and massively popular group, enclosed in a bell jar of fame that enforces a division between them as producers and their fans as consumers.

Despite the synecdochical condensation of the Beatles' "rise to stardom" into the train journey from the northern provinces to the metropolitan center

of the culture industry, the film resembles biopics, including Elvis's *Loving You* and *Jailhouse Rock*, in concentrating almost entirely on a single act, though it is a group of four. The "day in the life" (actually, two days in the life) narrative of escapes from fans in the streets, relaxing in hotels or night-clubs, press conferences, rehearsals, and other showbiz events that lead up to the concluding concert were the stuff of the Beatles' everyday existence. Alun Owen, a television writer and fellow Liverpuddlian who spent a couple of days on tour with them, developed their roles in the screenplay from his notes about their behavior and sayings, following producer Walter Shenston's intention of creating "characters for them that reflect their own. We want to put over their non-conformist, slightly anarchist characters. We want to present their almost Goon-like quality."[8] Some incidents were fabricated and a shooting script was written, though delinquent behavior was scrupulously omitted.[9] But the line between fiction and documentary was constantly breached, by the fans, most obviously, but also by the four stars who manifest, if not their real selves, then the personalities they had accumulated in prior self-performance: Paul, the cute one; George, the quiet or cynical one; John, the aggressive, sarcastic one; and Ringo, the other one—morose, laconic, and apparently unloved behind his drums, but really the nation's favorite. The film's immense appeal was grounded in the intimacy of the contact it seemed to afford with the Beatles themselves.

By this time the lack of sufficiently large venues in England made live performance impossible for the band, effectively prohibiting the motif of kids getting together to put on a show. Again appropriating the jukebox musicals' generic television broadcast, *A Hard Day's Night* elaborated preliminary incidents around it to extend the film to feature length. So rather than being generated within the plot, the broadcast is prior to it; the four come to London for it, other developments occur under the arch of its imminence, and as soon as it is over the film ends and the boys fly off to their next engagement. Once they have arrived in London, their excursions from the hotel and the television studio are anecdotal rather than incremental, and even then the action is mostly instigated, not by them, but by Paul's grandfather: his personality generates the visit to the casino, Ringo's disappearance, his own arrest, and the other complications that delay the final concert. Though narratively unproductive in themselves, these antics visually and aurally display the Beatles as individuals and in their group interaction. *What's Happening!* had been criticized for insufficiently differentiating them and, since the uniformity of their haircuts and clothes tended to obscure their separate identities even off-stage, product identification for each of them was a significant part of the film's marketing project. The script called for their individual personalities to be revealed in separate episodes, but Paul's was cut, leaving only Ringo's urban *dérive*, George's encounter with the fashion designer, and John's brief flirtation with the showgirl, along with his more aggressive acting out. Like the

overall plot, these are slight; nevertheless, differences between these incidents and the Beatles' appearance in performance generates a discrepancy between narrative and spectacle reminiscent of that in *The Girl Can't Help It*: despite the screaming girls, the narrative infantilizes and de-eroticizes the Beatles, while their performance projects a hyperbolically intense sexuality.

By 1963 the Beatles were all in their mid-twenties, but *A Hard Day's Night* presents them and certainly their fans as teenagers, and comically reconstructs the rock 'n' roll thematics of delinquency and sexuality within the terms of the sexually segregated English secondary educational system. Unlike Elvis's resentful high-schooler in *King Creole* (that had obliged him also to appear almost a decade younger than he actually was) and the vindictive miscreants of *Blackboard Jungle*, the Beatles are at worst naughty schoolboys. Their world is a homosocial ersatz family composed of two male parents, Norm and Shake, one more aggressively masculine than the other, and a grandfather. Like frustrated monitors on a boarding-school outing, their managers try to preserve order, preventing their charges from wandering off and insisting that they stay in their rooms and do the homework of answering their fan letters. But since they are the Beatles' employees, they are impotent even in this, and Norm's "Are you listening to me, Lennon? Don't be cheeky," is as severe as their rebukes may be. Themselves excessively clean and bright, and with their tight mod suits matching their fans' school uniforms, the four typically behave like juveniles, but not juvenile delinquents: "Can we have our ball back," they shout at the gent in the first class compartment, and when they have been caught playing outside, John begs, if ironically, "Don't cane me, Sir." At the press conference and in their exchanges with the staff and the other artists at the theater, they are similarly impudent, but the extent of their rebellion is to slip off from their homework to dance at the nightclub or from rehearsals to run around in the playing field. Only Ringo flirts with truancy when the old man goads him into "parading," and in that he proves inept, knocking over a glass of beer, nearly spearing a parakeet with a dart, and dropping a woman into a mud hole; rejected by the only girl he approaches, he pals around with another truant schoolboy. Though the police eventually take him into custody, they are courteous, even when grandfather tries to provoke them. Rather than generating real social tension, Ringo's waywardness produces humor and then farce, as the police turn from benign to ridiculous in the Keystone Cops chase sequences. With all rebellion contained, and Elvis at most a name on the cover of a magazine that only grandfather reads, generational divides appear in parodic inversion, with recidivism characterizing not the juveniles, but the old man. Setting mom against dad, the boys against the television director, and, most critically, Ringo against the other three to jeopardize the family's cohesion and the group's triumph, the assertively ethnic granddad is the only consistent delinquent, the only one running on testosterone, the only real teenager.

Although the train journey offers Paul and John the chance to "pull" schoolgirls and provides Ringo an explicit sexual invitation, the formers' shy dalliance is quickly interrupted and the latter is fearfully declined. Once in London, almost all heterosexual contact ends. John's banter with a woman backstage leads nowhere and, at the mention of girls, his "Please, Sir, can I have one?" is only a joke. Ringo's parading bears no fruit, and Paul's individual episode, in which he had an afternoon *affaire* with an actress, was shot but cut from the film. They do dance with girls at the nightclub, but these meetings lead nowhere and, as if any romance would be an extramarital threat to their union, they form liaisons only with each other. When sexual innuendo occurs, it is homosexual: John claims a kiss only from the businessman; as George reads *Queen* magazine, the priapic grandfather calls them "a bunch of sissies"; and they flirt with the fairy stereotypes in the television studio. By denying the Beatles any erotic attachment, the narrative subverts the musical's crucial generic culmination, the sexual union of boy and girl. This generic rupture cannot be ascribed to their number, for cinema had found as many as seven brides when needed for seven brothers, nor to the possibility that romantic entanglements for the boys would have *ipso facto* interrupted the pleasure of female spectators and fans—which it conspicuously did not do in Elvis's films. Rather, it subtends the film's central structural innovation: the reconstruction of the classic musical's romance of juvenile and ingénue as an erotically invested audio-visual encounter between the Beatles as a group and the collectivity of their fans.

Without emphasizing the classic musical's dual focus, *Rock, Rock, Rock* (1956), *Go, Johnny, Go!* (1959), and other earlier rock 'n' roll films sustained the generic narrative figure of a romance that culminates with the leading boy singing a love song to the leading girl, while two groups of fans look on: the intradiegetic observers and by implication the extradiegetic, theatrical audiences. In the former's finale, for example, the entire school and the Freed show watch as Teddy Randazzo sings, "Won't you give me one more chance/ To give my heart to you?" to Tuesday Weld; close-up eye-line matches indicate that they are looking into each other's eyes, and while no direct eye contact with the camera is made, others at the prom and in theatrical audiences may also have imagined themselves as the objects of his affection. At the crisis of *Jailhouse Rock*, Elvis as Vince Everett similarly sings, "You're so young and beautiful/And I love you so" to Judy Tyler as Peggy; Hunk, the doctor, and the band look on, as eye-line matches again link the pair until she goes to him. He puts his arm round her shoulder, and he gazes directly forward over the camera (even making eye contact with it momentarily) and, now to the film's audience, he completes the stanza "Then you'll be forever young/And beautiful to me." In both instances and in the classic musical generally, the rhetorical figure positions the leading girl as the surrogate for both groups of spectators, those in the narrative and those in the theater.

But by prohibiting romantic relations between the Beatles and women in the narrative, *A Hard Day's Night* also eliminates the leading girl's mediating role, and the band's erotic relations are redirected onto the intradiegetic fans for the reconstructed form of the dual focus. Positioned, not as third persons vicariously observing the singer's love for another girl, but as its direct object, they become a collective ingénue parallel to the Beatles' collective boy. As in the classic musical, the narrative introduces the possibility of a relationship between them, then impedes and delays it until finally completing it in the concluding concert, when it dissolves into the spectacle, consummating their union across the proscenium stage in audio-visual rock 'n' roll. The eroticism of the proffered musical pleasure is articulated in the direct address of the lyrics to the fans and via them to the extra-diegetic audiences. "If I fell in love with you, would you promise to be true," "All my loving I will send to you," "I wanna be your lover, baby, I wanna be your man," are all expressions of a relationship between the Beatles and their fans, the narrative delay of which produces a massive intensification of their visually and aurally eroticized spectacularity. And the love between the Beatles and the fans in the concert at the Scala Theatre in Soho is reconstructed for the movie's audience in every theater where *A Hard Day's Night* is screened.

The replacement of individual erotic relations by the collective eroticism of performance is constructed in narrative incidents that interrupt physical contact between the Beatles and their fans so as to defer the consummation of visual and aural relations until the final performance. The film's first act establishes the prohibition of visual contact in encounters with possible lovers in the train. As Paul is signing a group photo in the dining car, Pattie Boyd and another actress, both playing posh schoolgirls, come into the compartment; John says, "Look at the talent" and he, Paul, and George look toward them. But rather than approaching the girls as themselves, they adopt personae that invert class relations. Paul appropriates a bowler hat and an haute bourgeois, Southern accent to ask to join them, but then confessing in his own voice that he is too shy to continue, he averts his eyes until grandfather interrupts the encounter, claiming the boys are his prisoners. Later, when the girls are re-engaged in their compartment, John assumes a raw working-class Irish voice, pretending to be a convict, before Paul pulls him away. Between these two scenes, Ringo refuses a woman's invitation to come into her compartment on the grounds that she will inevitably reject him. Finally, in the "I Should Have Known Better" sequence in the luggage van, as John sings, "when I tell you that I love you," the boys and the girls look directly at each other, but only though the wire frame that imprisons the musicians. Pattie Boyd magically appears inside the cage, but as she becomes subject to their concerted visual attention, she is overwhelmed, and when John repeats the line, looking directly at her, she closes her eyes and covers her face with her hair. In the second act, the proscription of visual and aural interaction recurs in wider terms: on the one hand, the screaming Maenadic

fans pursue the boys while their managers and the police protect them from their frenzied infatuation, and on the other, the boys reveal themselves and sing in the safety of the studio rehearsals, where they can be seen and heard only by the workers and other entertainers.

Even though in the finale the Beatles and their fans remain physically separated by the proscenium and alienated in their respective roles as producers and consumers assigned by capitalist culture, the concluding performance ends the earlier prohibitions, allowing them at last to see and hear each other. As the new mode of dual focus narrative is resolved, the boundaries between fiction and documentary and between narrative and spectacle are erased; in the documentation of their performance, the Beatles emerge into the full eroticism the narrative had denied them and the never-fully-fictional relationship of the fans to the musicians dissolves into sheer documentary *vérité*. Though most of the fans were drama students from local schools, in the Scala—like the audiences in the theaters where the film will play—they are no more *acting* as fans than George, John, Paul, and Ringo are acting as Beatles, and they participate actively and fully in the narrative resolution. Eye-line matches in the montage bring them into the same filmic space and, as the orgasmic intensity of the girls' screams threatens to obliterate the Beatles' voices and music, the technology of cinema rescues their sound; it restores their songs, creates visual counterparts for them, and also narrates the dissemination of both via the represented apparatus and spectacular processes of television. Television becomes a surrogate and metaphor for the film's function of making their performance available to the general public, and the structure initiated in *Rock Around the Clock* reaches its apogee.

Though the Beatles' records had made their attraction initially aural, the band had increasingly become a visual phenomenon, to be seen as well as heard. Just as Lester made them visually present in *A Hard Day's Night*'s narrative, so their presence in the spectacle becomes the basis for enhanced visual correlatives to their music. Together with television's own visual capabilities, the composition of filmic reproductions of the musical performances translates rock 'n' roll aurality into cinema.

The Visualization of Music

Along with fragments of Paul doodling at the piano and television opera, the music appearing in *A Hard Day's Night*, almost all of it Beatles' songs, includes the following:

1. Records as underscore: "A Hard Day's Night" in the title sequence and conclusion.
2. Records heard in the diegesis: "I Wanna Be Your Man," "Don't Bother Me," and "All My Loving" at the nightclub.[10]

3. Songs ostensibly performed live in the rehearsal and the television show but actually lip-synced to records: "If I Fell," "And I Love Her," "This Boy," "I Should Have Known Better," and "She Loves You."

4. Instrumental versions of songs as both underscore and source music: respectively, the instrumental version of "This Boy" that accompanies Ringo's excursion, and the piano version of "I'm Happy Just to Dance with You" accompanying the Lionel Blair dancers.

5. Semi-autonomous audio-visual units (proto music videos): "Can't Buy Me Love."

6. An anomaly: "I Should Have Known Better" performed in the train, which begins as underscore but dissolves into a performance, a porous transition between diegetic and non-diegetic sound, from type 1 to type 3.

The "Can't Buy Me Love" (Figure 8.4) sequence is usually considered the most radical innovation. Prompted by the Beatles' escape from the school/ prison of their professional responsibilities to play spontaneously on a school athletic field, it is framed by Ringo's "We're out" that kicks it off and the adult's interruption, "I suppose you realize this is private property," that ends the fun. Though spatially and ontologically continuous with the main diegesis, it is filmicly distinguished by its pixilation, suspension of surrounding narrative grammar, and other anomalies, as well as its subordination of visual structure to the sound in the manner of the diegetically autonomous numbers in the classic musical. The audio-dissolve transition is provided by their descent down the fire escape, much of it almost abstracted by the close-ups on the metal grids, from which the four enter the under-cranked world of

FIGURE 8.4 A Hard Day's Night, *"Can't Buy Me Love."*

alternately choreographed and spontaneous games: dancing on the square, running around the field, pretend boxing, and so on. The montage maximizes the visual conflicts both within the shots and between them: obliquely canted angles, shot from high above, some of them rotating, are cut against ground-level close-ups. Though the editing of the visuals does not correspond to the song's structure, nevertheless the music's energetic rhythm seems to inform and inflect the action, rather than merely underlie it. The boys' interlude of freedom is reciprocated in the film's own escape from the regulations of realism and orthodox sound/image hierarchies into a different form of audio-visual composition, one of a pleasurable excess outside the narrative economy. Looking back to the anarchic silliness of *The Running Jumping & Standing Still Film*, it also anticipates "Strawberry Fields Forever" and other shorts made in lieu of television appearances.

Even if it is not quite as sophisticated as the final scenes in *It's Trad Dad!*, the visualization of the Beatles' concluding musical performance follows the models created there and is attributable to Gilbert Taylor, the director of photography (who shot and edited *It's Trad, Dad!*) and the editor for this project, John Jympson (Figure 8.5).[11] Using six cameras, three on the stage

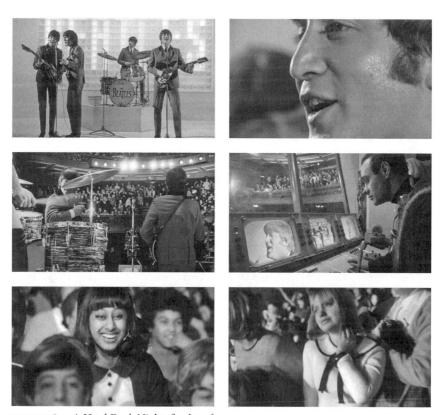

FIGURE 8.5 A Hard Day's Night, *final performance.*

and three in the audience, Taylor innovated brilliantly, including shooting from a variety of positions on all three spatial axes, vertical, horizontal and front-back, so as to create complex compositions not bound by any stable two-dimensional screen and to foreground diagonals in all three dimensions; mixing all lens lengths from extreme close-up on the singers' lips to wide shots of both the stage and audience; using backlighting and high key lighting; zooms and moving-camera shots, especially those in close-up that traverse the musicians' bodies and instruments; and positioning the musicians amidst the apparatus of musical production, television recording, and television directing. This material is densely and dynamically edited in a visual montage that is cut to the song structure, but not mechanically so; that is, all cuts occur at bar breaks and coincide with line or half-line breaks, but not all such breaks generate cuts, so that the audio and visuals simultaneously reinforce each other and run in a shifting counterpoint. The visual fragmentation of the Beatles' numbers and their reconstruction in editing amplifies the sonic structure of the records they were simulating. And the creation of dense patterns of visual interaction among the four musicians, their instruments, their audience, and the stage environment and apparatus that allowed their interaction all took the place of the concluding dance of the classic musical's leading boy and girl—and created an unprecedented and subsequently unequaled audio-visual dance, an exemplary Beatles' filmic musicality.

A Hard Day's Night in Film History

The combination of the Beatles' music, Lester's direction, and Taylor and Jympson's audio-visual compositions made *A Hard Day's Night* enormously successful and influential. Lester's use of techniques associated with *cinéma vérité* and the French New Wave in a hybrid documentary/fictional but still eminently accessible form prepared the ground for the New Hollywood art film of the last half of the decade.[12] Normally acerbic in his treatment of rock 'n' roll films, the *New York Times'* Bosley Crowther commended it as "a whale of a comedy" and "done with such a dazzling use of camera that it tickles the intellect and electrifies the nerves." In his *Village Voice* review, Andrew Sarris declared that after such a "cataclysmic cultural event . . nothing would ever be the same again: Popular commercial art could never again be dismissed out of hand as *kitsch*" and he crowned it "the *Citizen Kane* of juke box musicals, a brilliant crystallization of such diverse cultural particles as the pop movie, rock 'n' roll, *cinéma vérité*, the *nouvelle vague*, free cinema, the affectedly hand-held camera, frenzied cutting, the cult of the sexless sub-adolescent, the semi-documentary and studied spontaneity."[13] But the combined film and soundtrack made considerably more money than *Citizen Kane*. Released before the film in July by Parlophone in the United Kingdom and by United

Artists in the United States, the album had become one of the fastest selling in history by October, with the 1.5 million sold in its first two weeks recouping the film's negative costs several times over. The album stayed at the top of the charts for twenty weeks in the UK and for fourteen in the US, while the first single topped the charts and sold more than one million copies in the United Kingdom and the United States; eventually two more singles were released, all of them hits containing two songs from or composed for the film.[14] After the film's London premier in July 1964 as a Royal Command Performance, more than 1,500 prints were struck for global distribution, the US opening week box office was $1.3 million, and it eventually earned more than $13.5 million—all on a £200,000 initial investment. The success of the planned synergy between film and soundtrack album marked a major advance for the integration of the cinematic and musical components of the culture industries. Tom Parker had restructured Elvis's production to join his film and musical work; though the convergence worked to Elvis's monetary if not his artistic advantage, the companies involved were separate and none of the studios involved in his films had any financial interests in the tie-in albums. But United Artists and the studios took most of the profits from both film and records. The Beatles' transformed rock 'n' roll transformed the marketing of rock 'n' roll, and they fulfilled the jukebox musicals' hopeful conclusions: the synthesis of mediums and of components of the media industries, the creation of visual rock 'n' roll, and the amalgamation of the rock and film industries.

The Beatles II

NEXT MORNING

Richard Lester's expansion of the fan's role in the rock 'n' roll musical's narrative and his creation of dynamic filmic musicality in the spectacle transformed the genre. No subsequent rock 'n' roll film, not even *Woodstock*, which extended his innovations in both modes, had as powerful or enduring effect as *A Hard Day's Night*—or such a return on a miniscule financial investment. Many other films imitated its combination of the spirited insouciance of the group's pranks and Lester's audio-visual compositions. As the Beatles became themselves aware of the possibilities and responsibilities of their leadership of the counterculture, they turned to contemporary innovations in other cinematic forms, avant-garde, documentary, television, and animation. But their next project was another commercial feature with Lester: *Help!* (1965). Its budget of £400,000—double its predecessor's, but still small—nevertheless allowed for color photography, extensive location shooting, more expansive treatments of the group's unity and its Britishness, and more innovations in rock 'n' roll visuality. But as it replaced *A Hard Day's Night*'s documentariness and parsimonious narrative with extravagant fantasy, its anecdotal discontinuity and its exploitation of popular English silly surrealism caused its diegetic coherence to collapse.

Help!

In a plot loosely parallel to that of a Victorian novel, Wilkie Collins's *The Moonstone*, Ringo is again dramatized as the group's outsider and most vulnerable member. His possession of a large red ring, a gift "from an Eastern bird in a fan letter" which he cannot remove, marks him as the sacrificial victim of a sect that worships Kaili to whom they chant (though in an Anglican musical idiom), led by Clang (Leo McKern, a veteran of *The Running*

Jumping & Standing Still Film) and his daughter, Ahme (Eleanor Bron). Designated as "Easterns," the cult members are played very broadly for comic effect by British character actors with much eye-rolling and clumsy Indian accents. Despite their difficulty in distinguishing Ringo from the others, they leave the East for England to find and sacrifice him, following the Beatles to their house in Liverpool, then to an Indian restaurant in London, a ski resort in the Swiss Alps, back to Scotland Yard, Buckingham Palace, and a London pub with a tiger in the basement, and finally to the Bahamas—all exotic locations like those of the Elvis and Bond films. The plot is complicated by a mad scientist who believes a Wagnerian power in the ring will allow him to rule the world and a cowardly, ineffectual Scotland Yard police superintendent assigned to protect them. The escapades are tricked out with various Bond-like motifs and gadgetry, including an umbrella containing a sword, exploding elevators, castrating mechanical saws, and massive underground weapons centers, all of which alternate with other absurdist or whimsical figures, including a flutist clipping the rug with a pair of false teeth and Paul shrinking to Lilliputian dimensions. But eventually the lack of narrative necessity makes the chase so directionless and dangerous to the other Beatles—"We're risking our lives to save a useless member," John observes—that they suggest cutting off Ringo's finger so as to end it. But in the finale, on a beach like that where Bond found Honey Rider, just as Ringo is about to meet his end on the blade of a *khukuri* (also recurring from *Running Jumping & Standing Still*), the ring falls from his finger and onto Clang's. Ringo escapes and Ahme moves to sacrifice Clang, but he manages to pass the ring on, and the final scene inverts generic expectations, turning not into the generic festive concert but into a violent mêlée involving all the cast except the Beatles themselves.

The parodic reference to the Bond films is musically underlined by quotations of *Dr. No*'s theme music and the extensive underscore that includes Beatles tunes played with the Bond-like orchestration into which John Barry's musical idiom had developed since *Beat Girl*. And as in *Running Jumping & Standing Still* and many of the Bond films, the narrative is framed in colonial nostalgia, especially its two climactic battle scenes. In the first, armed with a mix of late Victorian and World War II artillery, the cult attacks the Beatles' tank on Salisbury Plain; and in the second, the final hyperbolic wrap-party, a battalion of Gurkhas from the Khukuri Rifles takes on the cult members and the Bahamas' military police. Though the film is as discontinuous and irrational as its surrealist antecedents, nevertheless something of its unconscious structure bursts through at the end, especially in resolving the skein of implications accumulated around the main motif, the premise that each day the person with the ring must be painted red and sacrificed to Kaili, a fate that is supposed to be one of ecstatic fulfillment. Kaili is an ill-disguised appropriation of Kali, the dark mother, the Hindu goddess of both destruction and eternal energy, and in his final peroration Clang does address her as "the black

mother." The red ring—a crystalline *glans penis*—that signals Ringo's induction into this circuit of mayhem is doubly associated with castration: it is the "member" always in danger of being cut off and the sign that will lead him to be painted red and stabbed to death. In the end title sequence, the ring turns into a multifaceted prism though which, to the accompaniment of the *Barber of Seville* overture, the abstracted and multiplied images of the protagonists are reprised in a visual vocabulary soon to be associated with psychedelics. Though never clarified, these subtextual resonances suggest that the Beatles are attempting to escape from associations with dark people's rituals whose destructive yet ecstatic energy resembles rock 'n' roll. Otherwise, subtended by the visits to Scotland Yard and the palace, the film's and hence the Beatles' Britishness is not that of an oppositional or delinquent working class, but of a metropole besieged by its insurgent colony; a barbaric but ridiculous empire strikes back, forcing them into the incompetent protection of the crown and the domestic and colonial police.

Again sexuality is all but absent from the narrative, limited to the Beatles' tight pants and a few winks exchanged between Ahme and whichever one catches her eye. Otherwise their social environment, friend and foe alike, is entirely homosocial. Girls are nowhere to be seen, and the Maenadic fans who pursued them in *A Hard Day's Night* are parodically replaced by the two local women who wave at them as they arrive home and who remark, not on their celebrity, but on the fact that they are still "just the same as they was before they was." This moment generates one of the more imaginative visuals that represents the group as a barely differentiated community of boys: they each enter one of four adjacent identical working-class row houses through four, color-distinguished but otherwise identical, front doors; the reverse angle reveals that the internal walls have been removed and the resulting single dwelling refurbished as a glorified bachelor dormitory in which each Beatle has his own area, color coded to match his own little bed and pajamas.

By this point the Beatles were so unfathomably famous that *A Hard Day's Night*'s condensed biopic structure could no longer offer a narrative adequate to their celebrity. Since they were so inescapably themselves, no other dramatic roles were feasible and, though the plot is not propelled by their musical career, they again play themselves. Lacking dramatic motivation or integration, the songs occur as arbitrary audio-visual interludes; but since the entire film is episodic, they occasion hardly any greater rupture than the other lurching changes of course. The lyrics, including those of the title song, are still those of a male voice addressing his girl, responsive or unresponsive as the case may be, but the narrative supplies no intradiegetic addressee and no audience other than the film's own. Whereas in *A Hard Day's Night* the dramatization of the four as musicians automatically justified the numbers, here the lack of such a narrative underscores the numbers' autonomy, anticipating the promo films for "Paperback Writer" and "Rain," made the next year.

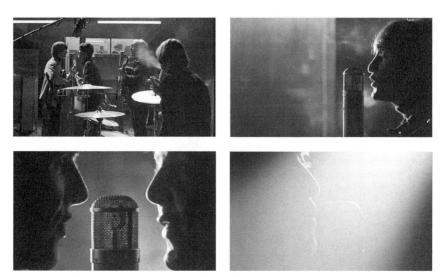

FIGURE 9.1 Help! *"You're Going to Lose That Girl."*

The first number, "You're Going to Lose That Girl" (Figure 9.1), is drama-tized as a recording session and makes excellent rhythmic visual parallels to the song's call-and-response structure in alternating between John's lead voice and the others' replies to him, between formally balanced close-ups of faces and more internally disorganized shots of the group as a whole, and between shots of the singers and the instruments they are playing, adroitly also inter-mixing shots in which backlighting turns the faces almost into abstraction. Its restraint and clarity are quite unlike the better known "Ticket to Ride" sequence, in which various unrelated antics in the snow are more loosely cut to the lines of the song; but even though it adds a couple of focus pulls and a superimposed stave with the notes of the tune, it is nowhere near as coher-ent as the otherwise similar "Can't Buy Me Love" sequence in *A Hard Day's Night*. Later, while being bombarded by the cult in the middle of Salisbury Plain and seemingly on the edge of hypothermia, the Beatles are presented as apparently recording—but very obviously lip-syncing to—"I Need You" and "The Night Before," both love songs without narrative motivation. The visuals contain a variety of material shot with a variety of lenses and include tricks not present in the earlier film's montages (such as a rack pull from a close-up of George's fingers on his guitar frets to a distant shot of Stonehenge), but neither the structure of the visuals nor their relation to the lyrics are remotely coherent. Hailed in terms such as "90 crowded minutes of good, clean insan-ity," *Help!* stumbled into cinema.[1]

A Hard Day's Night and *Help!* consolidated the image of the Beatles that, with Epstein, they had crafted: madcap moptops, sexualized in memorable songs about teenage romance, but with only caricature identities outside

them. Though both films emphasized innovative visual vocabularies for the representation of musical performance, the fictional frame narrated them as witty, reassuring, Northern working-class singing comics, updated versions of George Formby and Arthur Askey. The Beatles themselves subsequently felt that, like the suits Epstein had them wear, the roles misrepresented their significance. Lennon, for example, said that *Help!* "was just bullshit because it really had nothing to do with the Beatles" and that they had "'felt like extras' in their own film."[2] In their next project, they took control over their images, aligning themselves with independent cinema's trend toward subcultural self-representation, though of course from a position of great privilege. McCartney had begun making experimental home movies in 1965 and, outside studio oversight and in an era when amateur filmmaking had great authority in the avant-garde, he led the others in producing, writing, and directing what was called the most expensive home movie ever made.[3] With their personal authorship and control over production, they dramatized their own development and its role in the renewal of rock 'n' roll.[4]

The Beatles' Own Films

MAGICAL MYSTERY TOUR

John Lennon and George Harrison had been introduced to LSD in April 1965 and the lyrics to Lennon's "Help!" recorded the same month ("Now I find I've changed my mind and opened up the doors") were taken as referencing the experience, even though they all were stoned on marijuana during much of the shooting of the film. The two years following *Help!* were transformative. The albums *Rubber Soul* (released December 1965), *Revolver* (August 1966) with the lyrics of the final song, Lennon's "Tomorrow Never Knows" ("Turn off your mind, relax/and float down stream/It is not dying") supposed to derive from the *Tibetan Book of the Dead*, and *Sgt. Pepper's Lonely Hearts Club Band* (June 1967) completed the transition from pop to genuine, if drug-fueled, self-expressivity, from "rock 'n' roll" to "rock" and indeed way beyond it. The last commercial concert in San Francisco at the end of August 1966 freed them to work in the studio, completing the transformation of their mode of musical production into the in-studio composition of material assisted by George Martin's technical wizardry and too complex for live performance. *Magical Mystery Tour* (Bernard Knowles and the Beatles, 1967) was to be the televisual equivalent of this transformation in which they would intervene radically in the only medium they had not already conquered (Figure 9.2). Produced, directed, and "made in England" by the Beatles, it was essentially Paul's project.[5]

Coming to him during a vacation in the United States in April 1967, Paul's initial idea had them each conceiving separate scenes, all to be set in the

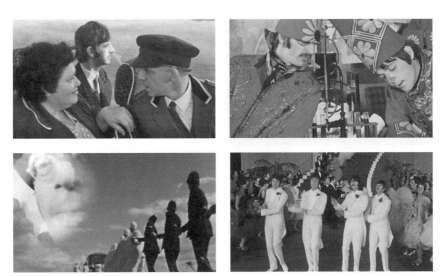

FIGURE 9.2 Magical Mystery Tour.

narrative of a bus ride through the English countryside. Shooting began on September 11, 1967, only two weeks after Epstein's death on August 27, and the loss of his managerial direction, together with Paul's lack of experience in film production, made the project considerably less efficient than Lester's had been. Before the trip was over, some ten hours of material had been shot, which was cut down to fifty-five minutes for television. Broadcast on Boxing Day, the day after Christmas, 1967, in a black and white format that erased its psychedelic color, it was a disaster. But despite failures in execution that are equally disruptive in the musical spectacles and the narrative frame, in other respects the film marked a real innovation for the possibilities of a genuinely populist, English, music-based psychedelic film.

A "mystery-tour" was popular form of working-class recreation deriving from factory outings in the earlier part of the century in which people without other forms of transportation signed up for bus excursions to undisclosed destinations. As a "magical" version of this, the title repeats the punning superimposition of an LSD trip over a working-class British ritual introduced in the song "Day Tripper" recorded two years earlier for *Rubber Soul*. But between them lay *Sgt. Pepper*, considered the Beatles' greatest aesthetic achievement and the culmination of their attempt to create a popular music based as much in vernacular English forms as US rock 'n' roll. Paul had originally proposed that for *Sgt. Pepper* each of them would perform in the personae of other musicians. Surviving only in a couple of songs, such as Ringo's singing "With a Little Help from My Friends" as bandleader Billy Shears, that idea was generally replaced by their re-creation of the popular culture of their Liverpool childhood and vignettes of everyday working-class

life already initiated in "Strawberry Fields Forever" and "Penny Lane." In these, demotic traditions were musically invoked by the fairground calliope and brass, both especially prominent in "Being for the Benefit of Mr. Kite!," whose lyrics John had developed from an old circus poster. On the other hand, producer George Martin's double-tracking, flanging, vari-speeding, and other studio innovations, together with the audiotape editing and reversing that Paul adapted from Stockhausen, and George's sitar, spacey and lush but also redolent with imperial memories, created a complexity unprecedented in popular music. These developments were so distant from previous rock 'n' roll that, rather than simply representing an Anglicization of US sources, the album created a fully articulate musical idiom of its own. Just as US rock 'n' roll had combined previous forms of American popular music, the Beatles amalgamated rock 'n' roll with a spectrum of English popular musics, especially from the pre-war period, and with art and world music; the result held the promise that musical, visual, and dramatic vocabularies capable of carrying the utopian aesthetic and social promises of LSD could be conceptualized from within British culture. Paul attempted to recreate this vision cinematically.

Many of the film's strategies and vocabularies did derive from independent filmmaking in the United States in the 1950s and 1960s, especially from the expanded cinema component in underground film and from Kenneth Anger's setting of visual narratives to pop songs in *Scorpio Rising*, one of the precursor forms of the music video that the promotional film clips had recently pioneered. Paul had been intrigued by accounts of Ken Kesey and the Merry Pranksters' attempt to make what they designated as "the world's first acid film" during their 1964 excursion in a modified school bus that eventually became Kesey's *Intrepid Traveler and His Band of Merry Pranksters Look for a Cool Place*. But the Beatles were just as clearly recapitulating a domestic analogue, *Summer Holiday* (Peter Yates, 1963), the film with which Cliff Richard left the noir world of teenage delinquents for wholesome family entertainment. In it he leads a group of three mechanics on a European tour in a refurbished red double-decker bus, and some of its numbers are hardly less surreal than *Magical Mystery Tour*'s: an elaborately extended mime routine in a French barbershop, for example, and a delirious Yugoslavian wedding banquet occasioned by Richard's inadvertent proposal to a local shepherdess. *Magical Mystery Tour* marked a stylistic and demographic development of both precedents. Despite their quite different social milieux, the narratives of both *Intrepid Traveler* and *Summer Holiday* are posited on a kids/adult binary, but in both narrative and musical spectacles the Beatles' film rejects the generational divide for a catholic social inclusivity, reconstructing their appeal in an expanded social spectrum parallel to their expanded musical sources.

Paul had prepared a provisional schema and the three musical interludes had been given some thought, but once the tour was underway the filming

became spontaneous and chaotic.[6] From the accumulated footage approximately a dozen scenes were selected: the introduction in which Ringo brings his aunt and the tour gets underway; Paul's flirtation with the blonde guide that dissolves into his imagined "The Fool on the Hill" sequence; the army barracks with the inane sergeant; a sports day in which "She Loves You" heard on a fairground calliope accompanies children playing tug-of-war while the adults race buses and cars; the scene of the magicians waiting for the arrival of the bus; Bloodvessel's courtship of Aunt Jessie; John's "I Am the Walrus" interlude; Jessie's pasta nightmare; the descent into the tent/rabbit hole for George's "Blue Jay Way"; the sing-along on the bus; the gentlemen's visit to the strip club for "Death Cab for Cutie"; and the ballroom finale for "Your Mother Should Know."

The narrative does then have a beginning and an end, the latter in fact resembling both a movie wrap-party and *A Hard Day's Night*'s concluding concert. It contains at least the implications of possible narrative armatures—the magicians' role in guiding the trip and the romance between Bloodvessel and Ringo's Aunt Jessie (whose role resembles the grandfather's in *A Hard Day's Night*)—but otherwise the plot lacks causality or logic. The various oppositions between the Beatles and their elders, fans, Indian pursuers, and mad scientists that provided the previous films' tensions are here subsumed in a social commonality. The assortment of English types that, if not actually on the bus, can be reached by it mobilizes a microcosm of the nation, all joined in exuberant ludic fellowship: Northerners (Ringo) and Southerners (his Aunt Jessie), pensioners and babies, housewives and soldiers, vicars and dwarves, magicians and bus drivers, rock 'n' roll musicians and strippers, all periodically greeted in unmotivated cutaways by large, flag-waving crowds that (like the crowd noises in *Sgt. Pepper*) stand in for the film's projected audience and the population generally. But apart from Paul's very brief flirtation, lovers are still inadmissible into God's plenty. Recalling *Beat Girl*'s noir world, George and John do visit a strip club; but, as in *A Hard Day's Night*, only old folks like Jessie and Bloodvessel are romantically active. Otherwise the motley crew subsumes unruly sexuality and other delinquencies in a mild Chaucerian comic bawdiness ("Within the limits of British decency" as Bloodvessel affirms, not to mention the requirements of a national holiday broadcast) and a sequence of Goonish disjunct incidents comprised, if not the pilgrims' tales, then the escapades, songs, and visions they share.

The film's vision of the Beatles' social meaning dissolves into a magical commonality the boundary between them and their fans that had been so absolute and structurally pivotal in *A Hard Day's Night*. As a folk musical, it was, as Ringo argued, "aimed at the widest possible audience.... [It] is for children, their grandparents, Beatle people, the lot."[7] Where in the early music, the keyword, "love," had referenced adolescent heterosexual eroticism, by this point it was expanding into a principle of general social renovation.

By proposing such a commonality, *Magical Mystery Tour* became the first real musical-filmic expression of the key component of ideology of the counter-culture. Yippie spokesman Abbie Hoffman explained:

> Well, the Beatles are a new family group. They are organized around the way they create. They are communal art. They are brothers and, along with their wives and girlfriends, form a family unit that is horizontal rather than vertical, in that it extends across a peer group rather than descending vertically like grandparents-parents-children. More than horizontal, it's circular with the four Beatles the inner circle, then their wives and kids and friends. The Beatles are a small circle of friends, a tribe. They are far more than simply a musical band. Let's say, if you want to begin to understand our culture, you can start by comparing Frank Sinatra and the Beatles. It wouldn't be perfect but it would be a good beginning.[8]

This social vision of the role of the rock 'n' roll family would be filmicly mobilized in the utopian documentaries, especially *Monterey Pop* (D. A. Pennebaker, 1968) and *Woodstock* (Michael Wadleigh, 1970), respectively one and three years later. And like these, *Magical Mystery Tour* hides the actual social and economic relations between the musicians and their audiences under the appearance of an unalienated unity.

Equivalent conditions subtend the music. The Beatles' own songs dominated *A Hard Day's Night* and were clearly counterpoised against the orchestral underscore in *Help!*. But here, as in *Sgt. Pepper*, the music is elaborated with the Beatles' combination of psychedelia and vernacular British forms: the fair-ground pipe organ that plays "She Loves You"; the instrumental and choir music of the "look to the right" across the multi-hued solarized landscape that leads to the magicians; the orchestral version of "All My Loving" that accompanies Bloodvessel's dream of courting Jessie on the beach; and the Bonzo Dog Doo-Dah Band's song "Death Cab for Cutie." The Bus the passengers' drunken sing-along includes popular standards that had become virtually folk songs: Al Jolson's "Toot, Toot, Tootsie (Goo' Bye)" and "When the Red Red Robin Comes Bobbin Along, " the post–World War II "The Happy Wanderer," and the pre–World War I "When Irish Eyes Are Smiling." Overall the Beatles and their own songs are framed within a nostalgic mosaic of British popular music that, in the cast-party finale rendition of "Your Mother Should Know," culminates in their production of a song that had been "A hit before your mother was born."

Some of the non-musical interludes reflect a degree of individual autonomy—Jessie's nightmare, for example, derived from one of John's dreams—while the musical interludes clearly individuate three of the Beatles. Paul's "The Fool on the Hill" is lyrical, John's "I Am the Walrus" is absurdist, and George's "Blue Jay Way" is mystical, and each designed the accompanying visuals. Despite his previous filmmaking, Paul's is the least accomplished: the

footage of him prancing in the mountains above Nice is sophomoric, and the simple close-up correlating with "the eyes in his head" and the point-of-view long-shot of "the sun going down" do little to augment the song's lovely wistfulness or its implication of a hermit guru. For John's deliberately nonsensical "I Am the Walrus," derived equally from LSD and Lewis Carroll, visual interest is immediately established by the eclectic colorful designs of the band's psychedelic tunics as they perform outdoors in an airfield that again, like so much else, recalls *The Running Jumping & Standing Still Film*. The performance footage is fragmented and not edited to the song's structure, but the verbal imagery is visualized in the walrus and the eggmen's bizarre costumes, for example, and the "pretty little policemen in a row." Superimpositions, mattes, and solarizations correlate visually with the surrealist lyrics, though attempting nothing as challenging as the "semolina pilchard, climbing up the Eiffel Tower"—reputedly a reference to the corrupt police officer, Norman Pilchard, who framed Lennon and the Rolling Stones for possession of drugs. George's "Blue Jay Way" is filmicly more accomplished, blending motifs from *Help!* with techniques developed in underground film. Like the "Help!" sequence itself, it is presented as an interpolated film screening, in this case its projection allowing for montages of the actual number and the excited response of the audience of mystery tourists watching it in a small cinema; and, like *Help!*'s end-titles, it uses a prismatic lens to produce multiple hazy images of George as he sits singing amidst the "fog upon LA" of the song's opening lines. Justified perhaps by George's falling asleep, among these are interpolated shots of the other Beatles playing white cellos in a garden, of dancing children with multiple superimpositions of animals and abstract color, and of brilliant kaleidoscopic lights playing over someone's hands that echo shots in Kenneth Anger's *Inauguration of the Pleasure Dome* (1954). Accompanied by the droning sitar, overall the number is the most abstract and dreamily psychedelic visual any of the Beatles had so far produced.

These numbers, like the program as a whole, are ambitious attempts to draw on experimental filmmaking for visual vocabularies commensurate with the Beatles' expanded musicality, and it would be unreasonable to expect that overnight they could have become as sophisticated in the new medium as they had in music. But by attempting to introduce these experiments on Boxing Day television, the most obdurately conservative mass-market and mass-cult context that could be imagined, they courted—and found—catastrophe, one whose degree may be gauged by Paul's later habit of justifying the film as more exciting than the Queen's speech. The reviews were vitriolic.[9]

YELLOW SUBMARINE

Yellow Submarine (George Dunning, 1968) was the diametric opposite of the Beatles' attempt to take full control of their cinema in *Magical Mystery Tour*.

Just after *A Hard Day's Night*, Epstein had licensed rights to animated versions of the group to a US company, King Features Syndicate, which produced a series of more than fifty half-hour cartoons. Beginning in 1965, the series was successful on US television, but had only limited distribution elsewhere. The original agreement also included rights to a cartoon feature, which Epstein honored but, other than writing four songs, the Beatles had no involvement in the project until the rough-cut had been completed, at which point they agreed to a final cameo. Though based on the personae developed in previous films, it is infused with both their earlier music and their more recent interests, now including classical and older forms of British popular music. As always, the Beatles have neither individual interests nor romantic relationships outside the group; but here, as in Abbie Hoffman's projection, the quasi-erotic relations with their fans in general that had been extended to the communality of *Magical Mystery Tour* brings love and renewal to the world at large, envisioned as a product of the Beatles' imagination: Pepperland. The lyrics and themes of a dozen songs are adapted to create the main lines of the narrative.

It opens in the "unearthly paradise" of Pepperland, a brightly colored undersea garden of string quartets, dancing children, and brass bands, whose timeless joy is broken by an invasion of the music-hating Blue Meanies, reminiscent of both the British police and World War II Nazis. With anti-music missiles, Snapping Turtle Turks, the "dreadful flying glove," and Shakespearian phrasing, they imprison Sgt. Pepper's Lonely Hearts Club Band in a blue sphere and freeze Pepperland into a silent gray stasis. Only one person escapes, "Young Fred," a vaguely nautical type who pilots a yellow submarine to Liverpool. In the gloomy industrial streets, he finds Ringo, lonely and complaining that nothing ever happens to him, and they round up the other Beatles to liberate Pepperland from the Meanies. The submarine takes them though the Seas of Time, of Science, of Monsters (where, as in *A Hard Days' Night*, Ringo takes a solo excursion, but is rescued by the US Cavalry), of Nothing, of Holes, and finally of Green. Most of these seas occasion a song: in the Sea of Time, "When I'm Sixty-Four" is illustrated by the Beatles getting alternately older and younger as time flows back and forth; and in the Sea of Nothing, a "nowhere man" they meet prompts his eponymous song.

Arriving in Pepperland, they find the Sgt. Pepper Band's uniforms and instruments, and as they sing the Sgt. Pepper song, color and life return, the hills come alive with music, and the Meanies counterattack. The turning point comes with "All You Need Is Love" which turns the vicious "glove" into "love," before it disappears in a blue cloud as all the people celebrate and the last strains dissolve into "She Loves You." When they spy the blue sphere containing the original band, John invokes Einstein to explain that they are only "extensions of our own personality suspended in time" and a hole that Ringo kept from the sea enables them to open the ball, and greet their resuscitated alter egos. Together they defeat the Meanies' final attack, and persuade them

to abandon their negativity and enjoy love and music. The film ends with a coda in which the real Beatles directly address the audience, projecting the redeemed Pepperland onto contemporary space and time and inviting all to repulse the Meanies, whom John sees in the vicinity of this theater by singing "All Together Now," as its lyrics appear on the screen in all the world's languages.

The narrative of paradise lost and regained is phrased not as simply of the amelioration of grey postwar deprivation, though shades of this are visible in the representation of Liverpool, nor of post–Kennedy assassination gloom in the United States, but as the perennial myth of British culture, a retrieval of organic premodern rural folk society. Also a paradigmatic expression of love-generation utopianism substantially inspired by the Beatles, the fantasy is epitomized by John's song, "All You Need Is Love," which had become the era's anthem since they had performed it for more than four hundred million people worldwide on a global television link in June 1967. This panacea is specifically localized in the same historical context that had informed McCartney's musical projects. A sentimentally idyllicized psychedelic landscape, Pepperland is identifiably Edwardian England, J. B. Priestly's "lost golden age," basking in the Belle Epoch and the dog days of the Empire. Appearing as a paradise of sunny social and cultural harmony from Ireland to India—the musical antipodes around which the Beatles had folded US rock 'n' roll—it is undisturbed by the actual class, ethnic, and gender conflicts of the time. The threat to it comes from outside, not from within, where the different classes and sexes, all white, mingle harmoniously and pursue their respective musical interests. Appropriately, they do so as performers, for the period invoked, when recording was in its infancy and film still a marginal adjunct to the musical hall, was the last before the industrialized media became dominant. The film's great popular success reflected the potency of its nostalgia for the time when the Beatles performed for live audiences, an issue soon to be debated in their next and last film, *Let It Be* (Michael Lindsay-Hogg, 1970); but it also invoked folk music, and the time before the industrial consolidation of the distinction between performer and audience and its objectification in the record industry. A bucolic version of the popular musical commonality dramatized in *Magical Mystery Tour*, the regaining of Pepperland became the most expansive myth of the Beatles' social meaning and historical significance, all the more symptomatic for having been created without their involvement.

The latent contradictions in Pepperland, however, cannot be entirely repressed. One dramatization of them lies in the divergent echoes of the iconic 1914 army recruitment poster of Lord Kichener: his face and hat are worn by "the one and only Billy Shears," but his pointing finger has become the love-canceling glove. And when Fred brings the Beatles back, the lord mayor recognizes them as the Sgt. Pepper Band, reversing the previous genealogy.

Before the film, Sgt. Pepper had been the Beatles' fantasy self-projection, but in *The Yellow Submarine* myth the Beatles are Sgt. Pepper's descendents, the contemporary instantiation of a nostalgically invoked earlier British popular music and harmoniously musical society. So when the Beatles recognize Sgt. Pepper as their own alter ego and retrieve their costumes, they perform, not as a guitar combo, but as a brass quartet. Rock 'n' roll may still inform the Beatles' compositions, but it is not narratively or iconographically present; rather, it has migrated to the psychedelic graphics, with all their countercultural associations. Similarly, the song "All You Need Is Love," which defeats the glove and ends the Meanies' tyranny, is dominated by orchestral brass and strings, and is visualized in the form of its lyrics, which have in any case subtended all the film's activity.

Accessible in different ways to a wide range of audiences and age groups, *Yellow Submarine* succeeds as the family but still "Magical" entertainment Paul had hoped his *Mystery* Tour would be. Though it has been tasked for commercializing animation styles,[10] when it opened in July 1968, a year after *Sgt. Pepper*, it was a critical success and initially a popular one, especially in the United States. But its vision of the community of the Beatles and their regenerative social power was dashed less than six months later. The events were recorded in their first significant documentary since *What's Happening! The Beatles in the USA*.

LET IT BE

Let It Be (Figure 9.3) is a documentary of the Beatles rehearsing and recording songs for the album *Let It Be* in January 1969. Released shortly after the album in May 1970, the film was initially conceived as an adjunct to a television concert in which they would "Get Back" (the film's first title) to the basics of rock 'n' roll, without overdubbing and other studio effects, to be broadcast before the album was released. It was, then, as director Lindsay-Hogg himself noted, "a film about the making of a television special about the making of an album."[11] But instead of retrieving their early vitality, the dissension among the band revealed in the film culminated in their split, with Paul publicly announcing his departure in April before either the album or film were released.

After a brief prologue of studio hands preparing the drum set and pushing the piano into place, the group are seen in a hangar-like movie studio in Twickenham (where Ringo was shortly to act in *The Magic Christian* [Joseph McGrath, 1969]), casually jamming on early rock 'n' roll tunes and rehearsing the songs that would appear on the album. After about twenty-five minutes, the scene shifts to their studio at Apple, where they are joined by Billy Preston on organ as they continue to rehearse and begin recording. Half an hour later, the third act begins, what is now known as a guerrilla concert of the kind

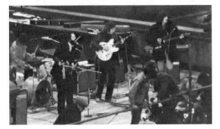

FIGURE 9.3 Let It Be.

invented by Jean-Luc Godard in 1968 when he had the Jefferson Airplane per-
form on the roof of a mid-Manhattan hotel for his projected documentary,
1 AM (One American Movie). On January 30, 1969, amplifiers and micro-
phones were set up on the roof of the Apple Corps building at 3 Savile Row
and, braving the blustery weather, the Beatles performed five songs. Attracted
by the unannounced spectacle, people fill the streets below and the adjacent
windows and rooftops, and soon the crowds are so large that police come to
control them. Filmed on-the-spot interviews confirm that most of the spec-
tators are delighted to see and hear the Beatles, but eventually complaints
lead the officers to enter Apple and reach the rooftop. Paul greets them with
a naughty grin, but no altercation takes place and the band launches into a
final number, a reprise of "Get Back." As the guitars are unplugged to end the
Beatles' last public performance, John quips to the crowd in a faked London
accent, "I'd like to say 'thank you' on behalf of the group and ourselves, and
I hope we passed the audition!"

Other than very brief production and location credits, no dates or person-
nel are given, nor are the events explained by titles or voice-over. Internal
evidence is similarly meager, though, for example, variations in clothes indi-
cate that shooting in the first two locations took place over several days. Like
the rehearsals themselves, the photography is casual, a loose mix of mostly
medium-wide and wide shots of one or two of the band members, interspersed
with extremely tight close-ups on faces or instruments of the kind introduced
in *A Hard Day's Night*. With Yoko Ono hovering over John's shoulder and
Paul's girlfriend, Linda Eastman, occasionally appearing, the film's recogni-
tion that the Beatles have the love interests of the traditional musical coincides

with the dissolution of the group and of the previously exclusive romance between them and their fans. Otherwise the unidentified studio hands, filmmakers, and a few friends mingle unobtrusively, with George Martin making an uncredited appearance playing a shaker on "Dig It." Shot on 16 mm and blown up to 35 mm for distribution, the film is grainy throughout, especially in the first section, where insufficient light often flattens the image to murky monochromes, illuminated by rough patches of oversaturated bright color. In their everyday clothes and at their hairiest, the Beatles are disheveled, ill-kempt, pimpled, and, in John's case, strung out. The editing is as informal as the photography and, though the 30 hours shot were cut down to 90 minutes, there is no apparent structure and no patterned interaction between images and sounds; even when quite fast, the montage is not cut to the beat or the vocal phrases, so that the visuals do not rhythmically enrich the music.

Instead, the absence of structure, information, or any discursive element appear to allow an unmediated personal intimacy with the four; even as they are rehearsing the music, their personal interaction is unrehearsed and unselfconscious, lacking in the facetious playing to the camera and the crowds that made their earlier film and especially television appearances so novel. Despite the camera's occasional visibility and the extreme close-ups, only very rarely does it make eye contact, and even then there is little more than a brief acknowledgment, more often than not, an unfriendly one, except with Paul, who as always looks to keep the camera's attention. The same *vérité* seems to inform the rehearsals' difficult moments and its tenderest ones, especially when members of the group's more extended family appear: George sketching "I Me Mine" as John and Yoko kiss and then waltz, silhouetted before the violet studio lights, or Eastman's daughter swirling with joy as the band jams on "Kansas City." At last the Beatles appear to make themselves available as they really are, unguarded, without makeup, without an agenda or plot, as they are to each other and to themselves.

This ostensible *vérité* is, of course, constructed. Much of the bitter infighting that marked the sessions was cut, including George's week-long departure from the group. On the other hand, several incidents appear to weave a reflexive meta-narrativity, all of them involving Paul, whom the film promotes as the dominant figure. These include a testy exchange with George, in which each seems exasperated by the others' guitar playing, that ends with George sullenly saying, "I'll play, you know, whatever you want me to play. Or I won't play at all if you don't want me to play." Later Paul reminisces about the early days in Liverpool and the unsophisticated rock 'n' roll songs they wrote but never recorded, notably "One after 909." To John, he relates that his home movie footage of their visit to Maharishi Mahesh Yogi in India shows that he controlled them, and that conversely they were "not very truthful" but "put [their] own personalities under." In an especially revelatory argument about the relation between film and live performance, the stationary shot frames

the back of Paul's head and John's skeptical face as he listens to him: first he asserts that George's opposition to films (by which he means *A Hard Day's Night* and *Help!*), to television, and to live performance are wrong, and points out that he is himself happy with the film that is presently being made; second, he recounts an engagement soon after their return from Hamburg when, after a few nights, they got over "the hurdle of [their] nervousness," they very successfully engaged the audience, and produced superior music that should have been recorded; and finally, he raises the possibility of a live performance at the Albert Hall as the only alternative to never performing for an audience again.

John remains uninterested, the conversation ends, and the jam session resumes. But these comments highlight the way that, despite the exigencies of its production and its generally negative reception—*Rolling Stone* found it "so formless and badly made that the final effect is simple, crashing boredom"[12]—the film is symptomatic of and resonant with many of the major tensions of the Beatles' career: the relation between fundamentalist rock 'n' roll and musical innovations; the different possibilities of live performance and studio composition (the two modes of musical production across which their work had been divided); the possibility of a cinematic component to their art; even the associations with African Americans and delinquency that had so far not surfaced in their cinema. All these anxieties bubble under the film's surface, and even come to a resolution, however negative, in its conclusion.

In the film's tripartite structure, the band ascends spatially from the underground of Twickenham studios, where the overall visual tenebrosity and the camera's inability to frame all four of them together correspond to the fractious dissension about the group's direction, expressed in the dispute between Paul and George. The lighting, the photography, and the mood are all improved at the Apple studio, where Billy Preston appears to both catalyze more amicable and productive personal interactions and re-ground their music in its African American foundations. Here, the songs gel, aligning their earliest compositions, John's 1957 skiffle-rock, "One after 909," with their most recent, Paul's concluding anthemic "Let It Be," with its offer of a redemptive promise to "all the lonely people" who live in and outside his lyrics: "And when the broken hearted people living in the world agree/There will be an answer, let it be."

The third section puts the group's renewed productivity and Paul's utopian vision to the test. Atop their corporate West End headquarters (just across Regent Street from the Soho of *Expresso Bongo*), they return to public performance in an unannounced live appearance, looking back to their last live concert in August 1966 at Candlestick Park, over the ocean and over three and a half years—and over the North Atlantic musical counterculture that they, more than any other musicians, had ignited. And, whereas in their first US press conference John had announced that they "need money" before they

will sing, here they perform unpaid, if for the financial elite. The streets and nearby rooftops quickly fill with businessmen and secretaries and though one of the former objects that while this kind of music is "good in its own place. . . . it's a bit of an imposition to absolutely disrupt all the business of this area," all others approve: "it's great, brightens up the office hours," "fabulous, fantastic," "great, I'm all in favor of it." Shooting with four cameras in broad daylight, Lindsay-Hogg is able to capture the group as a whole and close-ups on individual members, and to show their interaction with their live audience, a *cinéma vérité* reproduction of Lester's technique in *A Hard Day's Night*.

That this performance marks, not a new beginning for the Beatles, but their end, is of course outside the film's control, though the editing ensures that the police intervention is seen to result from the few Blue Meanies who censor the spontaneous joy of the people of Pepperland. But *Let It Be* does anticipate some of the motifs of some of the most important subsequent rock 'n' roll films: as well as being a concert movie, it is also, like *One Plus One* (Jean-Luc Godard, 1968), a making-of-a-record documentary; like *Ziggy Stardust and the Spiders from Mars* (D. A. Pennebaker, 1973) or *The Last Waltz* (Martin Scorsese, 1978), it is a "last concert" movie; and, like *Woodstock* (1970) and *Gimme Shelter* (Albert and David Maysles and Charlotte Zwerin, 1970), it is a free-concert movie.

Beatles Impersonators

These six feature-length films comprise the Beatles' significant involvements in the medium, even though individually they continued to have various cinematic interests and, as with Elvis, their lives and careers became the focus of numerous fictional and semi-fictional films.[13] The success of *A Hard Day's Night* inspired several other features about British beat groups, most notably the Dave Clark Five in *Catch Us if You Can* (US title, *Having a Wild Weekend*, John Boorman, 1965) and Gerry and the Pacemakers in *Ferry Cross the Mersey* (Jeremy Summers, 1965).[14]

Initially conceived of as *A Hard Day's Night* imitation, *Catch Us if You Can* revolves around a group of boys prone to Beatlesque high jinks. But though songs from several Dave Clark Five albums are used both as source music in various party scenes and as underscore, the group plays, not themselves, but movie stuntmen. Their leader, Steve (Clark himself), encounters Dinah, a model who is currently the face for a Meat Marketing advertising campaign, "Meat for Go." Both frustrated in their respective roles in commercial culture, they decide to escape to an uninhabited island off the coast of Devon that Dinah is contemplating buying, and the rest of the group tag along. Publicizing her flight as a case of kidnapping, the advertising agency sets the police after them, thus motivating the use of the title song on the soundtrack

("Here they come again/Catch us if you can/Time to get a move on"). The movie turns into a chase-*cum*-picaresque with Steve and Dinah encountering a group of sullen proto-hippies living in what appears to be an abandoned village but is in fact a staging ground for army maneuvers; a kinky bourgeois couple who take them to a costume party in Bath that turns into a bacchanalian brawl in the city's Roman spa; other oddball police and press agents; and finally the island. With Dinah realizing that "it smells of dead holidays," the narrative is stalemated here, and instead of living there with Steve, she returns to the ad agency's elderly Svengali.

Hinged on the manipulation of Dinah, the film proposes itself as a satire in which she, the group, and by implication mod pop culture as a whole represent the free-spirited, spontaneous new energies struggling to escape from the moribundity of both traditional Britain and its new commercial developments: West End girls finding satisfaction with East End boys. But what one cynical character summarizes as Dinah's "image: rootless, classless, kookie, product of affluence, typical of modern youth" short-circuits the satire, for the ad agency and the filmmakers themselves exploit precisely this image. The ubiquitous posters of her that sell meat could equally well be selling the film. On the other hand, like some elements of mod culture itself, the film's refusal to allow Steve and Dinah a life together on an unspoiled island outside modern capitalism contrasts with the film industry's more typical exploitation of counterculture idealism. Unlike McCartney's dream of an escape to a whimsical premodernity in the structurally similar *Magical Mystery Tour* a couple of years later, the film has more in common with the disabused vision of the corporate exploitation of pop music in Peter Watkins's *Privilege* (1967).

An English backstage musical, *Ferry Cross the Mersey* (Jeremy Summers, 1965) stars Gerry and the Pacemakers, Epstein's second signing after the Beatles and for a short time almost as popular as they, earning a number one single before them (Figure 9.4). Also produced by Epstein and clearly indebted to *A Hard Day's Night*, it contains remarkable documentary elements, as well as brilliant photography, again by Gilbert Taylor. Gerry Marsden and his bandmates play themselves as art-school students on the verge of becoming Merseybeat stars. A proleptic introduction of documentary footage shows screaming fans greeting them on their return to Manchester airport after their successful US visit, where they too had appeared to great acclaim on the *Ed Sullivan Show*. The shots of their exit from the plane doors recalls the iconic Beatles' arrival in New York in *What's Happening! The Beatles in the USA*, but the close-up field/reverse-field shots of the band and their fans establish an eye-contact intimacy beyond the capacity of the Maysles with their limited equipment. Subsequently the film adopts *A Hard Day's Night*'s day-in-the-life structure, but locates it earlier, condensing into it the period before the group's success and employing the jukebox musical's motif of a competition among bands to narrate their emergence. But before that narrative line takes over, the

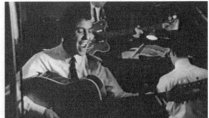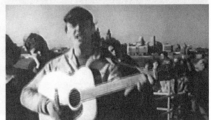

FIGURE 9.4 Ferry Cross the Mersey.

film explores in detail working-class conditions in Liverpool, the city's urban and dockland architecture, an art college of the kind crucial to the emergence of 1960s British rock, the Cavern Club, and other aspects of the Liverpool Beat music scene, including guest appearances by several other local bands and by Cilla Black—the entire rich, vibrant, regional popular culture that *A Hard Day's Night* abandoned for the metropolitan culture industry.

As the band enters a limousine at the airport, the opening chords of their hit, "It's Gonna Be Alright," are heard under the schoolgirls' ecstatic screams; they follow as it drives them to the city through the Queensway tunnel, whose traffic tracking monitors resemble those of a television studio. A close-up on the car's spinning hubcap dissolves into a spinning reel of tape in a studio where the band is recording the song, which now fully occupies the soundtrack. Using close-ups on the musicians and their instruments that are more extreme than anything in *A Hard Day's Night*, and taking advantage of the angularity of the studio's internal architecture to produce complex deep-focus compositions that play the white of the musicians' shirts off against the dark of the studio's recesses, Taylor creates a beautiful and visually dramatic sequence. But just as the final refrain dies away, the film cuts to the streets of Liverpool, where it is far from clear that "It's Gonna Be Alright." The footage of poor children playing among the postwar deserted buildings and vacant lots, especially a repeated scene of a little girl trying to climb over a high wall, are more clearly indebted to the Free Cinema Movement, particularly Lorenza Mazzetti's *Together* (1956), than anything in the Beatles' films. Over these scenes, Marsden's voice-over describes his childhood in the tough city: how they would play anywhere in the streets, how he escaped the

alienation by joining a youth club and forming a band that "played anywhere," in clubs, pubs, and cellars, and, of course, the Cavern. Though the close-ups, canted camera angles, and swish pans in this ostensibly documentary footage clearly reveal Taylor's hand, the limited lighting and the rough handheld camera provide a powerful aura of documentary authenticity. Though stylistically quite different, the sequence is as notable as his work on *It's Trad, Dad!* for its representation of the social interaction between performers and audience, the bonds between them, rather than the separation that generates the narrative of *A Hard Day's Night*. In little more than eight minutes, the film has vividly sketched the performance of the music, its recording, and the social and spatial environments of its creation.

Again a sound dissolve, from applause in the Cavern to Gerry's aunt banging on a pan to wake him, introduces the next sequence that gets the plot underway. He is revealed to be an orphan living in her lodging-house, where his older, fellow boarders have formed an amateur combo to play classical music. After his aunt rouses him, a helicopter shot shows Gerry driving his motor scooter through the city streets to the docks and the ferry that takes him and his bandmates to art college, all the while displaying the Liverpool waterfront. At college, he meets his girlfriend, Dodie, a British Shelley Fabares. Her schemes soon net the band an Epstein-like manager who provides them with new instruments; she introduces Gerry to her wealthy father, and persuades the boys to rehearse for the competition. The ferry ride, a class in the art college, lunch in a Chinese restaurant, and other narrative incidents all provide occasions where the band can spontaneously break into song, and the competition that forms the film's finale, where the group win the right to represent Merseyside in the European Beat Competition, allows for the appearance of Black, the other local musicians, and disc jockey Jimmy Savile. The narrative places Gerry in a series of social tensions: the elderly lodgers disapprove of his "heathen" rock 'n' roll guitar, he paints modernist abstractions in class rather than drawing the model, and Dodie's father is initially unenthusiastic about her working-class boyfriend. But all these dissolve in the band's zany japes and sustained good humor, the vernacular vitality of their music, and the affectionate recreation of the Liverpool working-class culture that nourished the Beatles.

Conversely, the most audacious of the fictional representation of the Beatles was *All You Need Is Cash* (Eric Idle and Gary Weis, 1978), a play-by-play satire of the Beatles' career, starring the Rutles. Ron Nasty (John, Neil Innes), Dirk McQuickly (Paul, Eric Idle, who lip-syncs to the voice of musician Ollie Halsall), Stig O'Hara (George, Rikki Fataar), and Barry Wom (Ringo, John Halsey) play exaggerated versions of the *Hard Day's Night* personae; Stig, for example, modeled on George, "the silent one," never speaks. It contains cameos by George Harrison, Mick Jagger, Paul Simon, and others. Innes also wrote the film's score of songs, some so brilliantly reminiscent of actual

Beatle music that they prompted legal action. The film is structured as television documentary, with reports by Idle as he visits significant locations in the Rutles' story, interrupting performances that meticulously reproduce their musical development and their sartorial and tonsorial transmogrifications. Beginning in the streets of Liverpool, Idle visits the Cavern and the Rat Keller in Hamburg, and traces early British Rutlemania and the first US tour and *Ed Sullivan* appearances. After their last concert at Che Stadium, the scandal over their public admission of their use of tea disrupts the group, and Stig's involvement with Arthur Sultan, the Surrey Mystic, and Nasty's with Chastity, a "destructo-artist" dressed like a Nazi, completes the disintegration, leaving only *Feet*, a parody of Yoko Ono's film, *Bottoms*, the financial machinations with a plethora of lawyers, and the final concert on the roof of Rutle Corps.

Developing as a rough palimpsest laid over the original, the Rutles' story gains its force from the exuberance and evocativeness of its music, together with its combination of fidelity to the Beatles' own history and the wit of its satiric tweaking. It segues between stock documentary footage and Rutles' re-enactments shot in grainy, 16-mm black and white in scenes of early fan hysteria, for example, and the Royal Command Performance. It returns to locations used by the Beatles themselves, including New York's Plaza Hotel and the airfield used in *Magical Mystery Tour*. And it wittily transposes pivotal incidents: John's "more popular than God" is explained as a mistake for "more popular than Rod" (Stewart); the controversy surrounding the Beatles' use of marijuana is commuted into their consumption of the tea introduced to them by Bob Dylan; Mick Jagger concludes his account of the occasion when McCartney and Lennon went to the pub to write the Rolling Stones' first hit, "I Wanna Be Your Man," by saying, "It was 'orrible, so we never bothered to record it." He, apparently spontaneously, also articulates the crucial fact in the history of the Beatles, but which their films entirely repress when, to the question, "Why did the Rutles break up?" he bluntly replies, "Women, just women, getting in the way." The chief thread of metaphors for the disparagement of the Beatles' achievements and the overall frame for the satire are generated out of "Rutland," the smallest county in Britain, that produces "Twist and Rut," *A Hard Day's Rut*, *Sgt. Rutter's Dart's Club Band*, and so on. All this is interlarded with sight gags, emphasis on the Beatles' personal tics (particularly Idle's wicked take on Paul's exaggerated facial expressiveness), and ongoing malapropisms that, for example, make *Sgt. Rutter* "a millstone in pop music history."

The parodies of the Beatles' films—*A Hard Day's Rut, Ouch!, The Tragical History Tour*, and *Yellow Submarine Sandwich*—are based on one or two specific scenes in each. *A Hard Day's Rut* elaborates on the routine of passing in and out of various cars when the Beatles arrive in London, and also the scene when they steal down the fire escape away from the studio for "Can't Buy Me Love."

Animated by the same team that produced the original, the imitation of the various graphic styles in the numbers for *Yellow Submarine Sandwich* is precisely convincing. The strongest satire occurs in *The Tragical History Tour*, the story of four Oxford history professors on a hitchhiking tour of teashops in the Rutland area. A return to the aerodrome used in the original for the tent/ rabbit hole sequence again emphasizes Goonish *Monty Python* humor, but it shifts to a more "nasty" register in a parody of John's "I Am the Walrus" sequence that becomes "Piggy in the Middle." The structure of the original is faithfully reproduced with Nasty playing a white piano before the same wall in the aerodrome, and the lyrics alternate stanzas of unredeemed nonsense ("evangelistic boxing kangaroo") with digs at Lennon's political inanities ("They say revolution's in the air/I'm dancing in my underwear")—which are skewered later in Nasty and Chastity's "Wet-In" for peace. The number is unified by references to pigs, picked up from the words to the nursery rhyme "This Little Piggy," into which the lyrics finally dissolve, but most of all by the grotesque pig-face masks that the band members all wear.[15]

All You Need Is Cash's satire and the financial priorities of its title apply equally well to a group of US Beatle impersonators to whom the term "pre-fab four" had been applied a decade earlier: the Monkees and their film *Head* (Bob Rafelson, 1968).

HEAD

A Hard Day's Night inspired Bob Rafelson and Bert Schneider, two Hollywood television producers, to develop a sitcom about an aspiring Los Angeles rock 'n' roll band. Putting an advertisement in the trade papers in 1965 for "4 Insane Boys" who were "Folk & Rock Musicians-Singers," they fabricated a group, two—Davy (Jones) and Micky (Dolenz)—being primarily actors and two—Peter (Tork) and Mike (Nesmith)—musicians, and created a television sitcom around them.[16] After an expensive promotional campaign around their first record, "Last Train to Clarksville," released two weeks before the Beatles' final public performance, *The Monkees* debuted on NBC in September 1966. With its theme song announcing, "We're the young generation/And we've got something to say," and the four Monkees playing themselves in irreverent Marx Brothers slapstick, much of it improvised, it became a phenomenal critical and popular success, especially among preteens, and in its first season was awarded the Emmy for Outstanding Comedy Achievement. Each segment featured two new songs, providing the publicity that helped make their records equally successful; three singles and their first four albums topped the charts, and at their peak the group's sales matched even the Beatles'. Initially their records were produced by studio musicians, with the four only adding the vocals; but, stung by charges that the group was merely an ersatz fabrication, they demanded more musical input and began to perform live,

again with phenomenal success, and then to tour, on one occasion with Jimi Hendrix (whom Dolenz had encountered at Monterey) opening for them. During the second, 1967–1968 season, the combination of declining popularity and dissension between the group and their management persuaded them to end the sitcom, but also to make a movie that would dramatize the contradictions involved in the band's fabrication for television, the fact that, as a song in the film declared, they were "A manufactured image/With no philosophies." Calling on the assistance of Jack Nicholson, who had written the first Hollywood psychedelic movie, *The Trip* (1967), for Roger Corman, Rafelson and the four concocted the script for another "head" movie.

Head (Bob Rafelson, 1968) reversed the itinerary of *A Hard Day's Night*: where the Beatles' film had narrated their appearance in a television show as the culmination of their career to date, the Monkees are seen again and again attempting an impossible escape from an entirely televisual world (Figure 9.5). The television spectacular that concluded the jukebox musicals now occupies the entire film, whose structure is based on channel surfing through a series of genres, including westerns, war films, and music shows, all of them starring the Monkees as victims. Interspersed with sequences of actual channel surfing, the jammed fragments of these reveal rock 'n' roll musicians—at least these rock 'n' roll musicians—to be trapped in an uncontrollable and incomprehensible meta-televisual nightmare, figured in a sequence in which twenty television screens contain frames from all the segments: a scene where a football player terrorizes the Monkees in battle-front trenches; a commercial in which they are dandruff in Victor Mature's hair until a vacuum cleaner sucks them out and into prison inside it; a version of

FIGURE 9.5 Head.

Clifford Odets's *Golden Boy* in which Davy is brutally beaten by Sonny Liston; or a prison wall in a horror film that rotates to reveal them lined up against the wall of a bathroom, behind whose medicine cabinet Davy has seen an eye as big as a room. At any point these may be punctured to reveal the studio lot (where Frank Zappa advises Davy to concentrate on his music because "the youth of America depends on you to show them the way"), or the commissary (where Bob Rafelson, Jack Nicholson, and Dennis Hopper make guest appearances. But escape into the world outside television is impossible. Schneider described the go-for-broke innovation of the sitcom as "jumping off the bridge,"[17] and *Head* begins with Mickey chased by the others, making a suicidal leap from a bridge into the ocean; and it ends when the four all run out of the studio and repeat his act. They swim underwater, but another shot reveals their moment of freedom to be a program screened on the side of a huge black metal box in which they have been repeatedly incarcerated.

Like *The Monkees, Head* punctuates these escapades with the group's songs and, being three times the length of the sitcom, it had six, three by Brill Building writers and three by themselves. Three of them appear to be live performances, all visualized differently and enhanced with innovative filmic effects. For Nilsson's "Daddy's Song," Davy dances as a music hall hoofer, alone or with Toni Basil, both in evening clothes that, either on the bar lines or in single-frame montages, alternate between black on white and vice versa. Shot on tour, Mike Nesmith's "Circle Sky" splits the screen with internal mirroring, superimposes the band on the fans, or intercuts images from the invasion of Viet Nam. And Peter Tork's "Long Title: Do I Have to Do This All Over Again?" is filmed at a frenetic party where a complex light show energizing the dancers' movements is matched by advanced special effects that fragment them into pure abstraction. "As We Go Along" is the least interesting, tracking Peter as he walks from the snow-covered mountains, through a flower-filled jungle, to a rocky beach. The other two sequences are highly erotic, even though, like *A Hard Day's Night, Head* allows its protagonists no sexual partners. "Can You Dig It" appears as Mickey's hashish dream of a harem of exotic dancers in transparent costumes multiply superimposed so that the screen becomes a shimmering cascade of gauzy colors behind which the band members can sometimes be glimpsed kissing the girls.

The visualization of Gerry Goffin and Carole King's "Porpoise Song" that both begins and ends the film beautifully elaborates the lyrical psychedelic folk rock song. As Mickey's body falls from the bridge deep into the ocean, it is abstracted by solarization; he begins to swim, transforming his suicide into sensual rebirth in which he is joined by several mermaids who frolic in slow motion underwater with him in imitation of the porpoise in the lyrics who laugh at humans "Wanting to feel, to know what is real." The constantly changing pairs of highly contrasting colors (scarlet and deep blue, pink and green, yellow and blue), the shifts between close-ups on Mickey's face or the

mermaids' bodies and longer shots of them all swimming over distant reefs, and the undulations of the intertwined swimming figures oscillate hypnotically between abstraction and legibility. With its prominent organ and echoing ethereality, the song somewhat recalls George Harrison's "Blue Jay Way" in *Magical Mystery Tour*, even if the brittle brilliance of its effects replaces Harrison's homespun visual whimsy.

Head typified the commercial surrealism produced at the intersection of hip Hollywood producers and the Sunset Strip psychedelia, and many of its filmic innovations were appropriated from the local and New York avant-garde cinemas: the solarizations and similar techniques reflected the traditions of Los Angeles visual music, while Davy's melting ice-cream cone either quotes or steals from Thom Andersen's short, *Melting* (1965); and one of the puns on "Head" used in the film's only television commercial invoked Andy Warhol's *Blow Job* (1963). But, losing the eight-year-old audience, the film lacked even the sitcom's nebulous social grounding; its visual innovations and the candor of its self-denigration presented no real critique of corporate culture, and so were stranded in the vacuous reflexivity of purely financial aspirations. Dismissed by critics and fans alike on its original release, it later acquired a cult following for, like *The Monkees*, its signal anticipation of music videos depended on advertising, pastiche, and mashups, all of which became the vernacular of broadcast television. What once seemed a self-defeating self-satirization came to appear prescient.

Apart from *Magical Mystery Tour* and *Let It Be*, cinematic participation in mid-1960s British rock 'n' roll, from the English Elvises, though the Beatles, to their various, and eventually US, impersonators, took the form of feature narratives. Parallel feature production in the United States was monopolized by Elvis, the only rock 'n' roll musician Hollywood was able to assimilate. But new forms of popular music, especially folk and the folk rock that developed into the music of the late 1960s counterculture, produced new forms of US rock 'n' roll cinema now outside Hollywood: documentary.

Toward Documentary

BRINGING IT ALL BACK HOME

Back in the USA

Between Elvis and the Beatles, the vitality and insubordination of early rock 'n' roll was sustained in the United States mostly by rhythm and blues. The most important of the girl groups—the Chantels, the Shirelles, the Crystals, and the Ronettes, and later the Marvelettes, Martha and the Vandellas, and the Supremes from Motown—were black, and the crossover success of Ray Charles ("What'd I Say," 1959) and Ike and Tina Turner ("A Fool in Love," 1960) kept currents of social complexity and sexuality pulsing through vernacular music. Many of these musicians appeared on television, but apart from miscellaneous Scopitones, notably the Exciters' seminal "Tell Him" in 1962, cinema gave them little attention at the time. Somewhat later, Charles appeared as himself in *Ballad in Blue* (Paul Henreid, 1964), in which classic performances by him, along with his orchestra and the Raelettes, were improbably set in a domestic melodrama in London.[1] Otherwise, the most important development of the early 1960s was the revival of participatory traditional song. Folk music soon became integral to the youth cultures organized around the anti-nuclear and the civil rights movements; and its development into folk rock that became the musical core of the cultural insurgencies of the second half of the decade supported rock 'n' roll's claim to be the folk music of the moment.

Folk initially recapitulated rock 'n' roll's early social and industrial marginality, being, as Bob Dylan later recalled, "considered junky, second rate and only released on small labels."[2] But in the culture that grew around it, rock 'n' roll's associations with teenage rebellion, delinquency, and eroticism were largely replaced by ethical seriousness and criticism of social conformity, inequality, and corporate power at home and US imperialism abroad, with the expression of these concerns entailing a more articulate discursivity

and hence attention to lyrics rather than dancing. Where the jukebox musicals had justified rock 'n' roll on the grounds of its compatibility with the music industry, folk was suspicious of capitalist culture and aspired instead to an unalienated and rooted social commonality. Folk encouraged amateur participation that brought performers and fans together in hootenannies, coffee shops, protest marches, and other popular rituals. As a consequence, folk music and eventually folk rock fundamentally changed the filmic representation of the audience and of audience–musician relations. Reasserting the values of the folk musical, new filmic structures were developed to present fans and performers united in what was often claimed to be a non-commercial community. Despite the proscenium arch and the fame that separated the Beatles from their fans in a *A Hard Day's Night*, its reconstruction of the dual focus narrative as a romance between musicians and audiences provided a model of such a commonality, but it was developed within the conventions, not of the fictional feature, but of new forms of documentary film.[3]

Folk Music

On the last day of 1945, the postwar folk music revival began when activist and musician Pete Seeger and several others founded a mimeographed magazine, *People's Songs*, in order to "create, promote, and distribute songs of labor and the American people."[4] Despite the repression of the cold war period, the movement included the rediscovery of the Wobblies' *Little Red Songbook* and other music of 1930s and 1940s Popular Front activism, especially Woody Guthrie's, and also gospel and rural blues: Mahalia Jackson, one of the greatest of all gospel singers (who tutored Aretha Franklin), on the one hand, and Lead Belly, Odetta (a strong influence on Dylan), Josh White, and Sonny Terry and Brownie McGhee, on the other. In the 1950s, recordings of this music began to be commercially successful. Lead Belly's "Goodnight, Irene" was a number one hit for the Weavers, a group that included Seeger, who were later dropped by their label because of his left-wing politics. But his transmission of radical populist music was taken up by young singer-songwriters, initially in Greenwich Village and Cambridge, and before long across the country, most notably Ramblin' Jack Elliott, Dave Van Ronk, Phil Ochs, and especially Joan Baez and Bob Dylan.[5]

Sustained by magazines like *Sing Out* (founded in 1950), folk clubs and festivals, especially the Newport Folk Festival (founded in 1959), the movement was—ideally and in fact—largely amateur and, at first, only minimally commodified. But in 1958 the Kingston Trio's version of a nineteenth-century Appalachian song, "Tom Dooley," sold over six million copies, sparking a commercial boom. The growth of the market for recordings prompted various degrees of professionalism along with a wider consumer culture

including a television show, *Hootenanny*, that, despite problems with censorship, ran on Saturday evenings on ABC for over a year from 1963 to 1964. Other hits, notably Peter, Paul, and Mary's version of Seeger's composition "Where Have All the Flowers Gone" in 1962, smoothed the grain of folk with commercial schmaltz, but more authentic musical aspirations also received commercial acceptance: Joan Baez's first two albums, *Joan Baez* (1960) and *Joan Baez Volume 2* (1961), both gold records, were composed almost entirely of traditional songs, as was Bob Dylan's much less commercially successful first album, *Bob Dylan* (1962). In November 1962 a painting of a barefoot Baez was featured on the cover of *Time*, and by the next year folk music was at the height of its popular success; Sam Katzman abandoned the jukebox musicals to make a film about it, *Hootenanny Hoot* (Gene Nelson 1963), with Johnny Cash and the Brothers Four, soon followed by another quickie, *Once Upon a Coffee House* (aka *Hootenanny a Go-Go*, Shepard Traube, 1965) with Oscar Brand.[6] A generation of singer-songwriters, including Tom Rush, Judy Collins, Buffy St. Marie, and Joni Mitchell, found a place in mainstream US culture, while in the United Kingdom skiffle coincided with a parallel revival of traditional British song by Ewan MacColl, A. L. Lloyd, and others that was taken up by younger singers. On both sides of the Atlantic the folk movement flourished in its own terms and as the basis of folk rock, which became the musical foundation of the counterculture.

Dylan's transition from folk to folk rock became public during his second set at the Newport Folk Festival in July 1965, in which he was accompanied by members of the Butterfield Blues Band.[7] Subtending the difference between this and his acoustic first set and also the reprise in which he returned to perform an acoustic valedictory, "It's All Over Now, Baby Blue," was his album, *Bringing It All Back Home*, released the previous March; on its first side he played electric guitar accompanied by a band, while on the second he performed alone on acoustic guitar. His return to amplification and rock 'n' roll was largely inspired by the Beatles.

The Beatles discovered Dylan when Paul bought *The Freewheelin' Bob Dylan* early in 1964, just before their January visit to Paris. George recalled that "for the rest of our three weeks in Paris we didn't stop playing it,"[8] and in *What's Happening! The Beatles in the U.S.A.* Lennon mentions "Robert Dylan, fantastic, very good indeed." In February 1964, only a few weeks after the Beatles bought *Freewheelin'* and when their hits occupied most of the US top ten, Dylan heard them repeatedly on the car radio during a cross-country drive, and his enthusiasm dispelled his initial skepticism: "They were doing things nobody was doing," he later observed, "Their chords were outrageous, just outrageous, and their harmonies made it all valid. . . . I knew they were pointing the direction of where music had to go."[9] When the Beatles came to New York for the *Ed Sullivan Show*, he sought them out and introduced them to marijuana, and his songwriting inspired their shift away from bubble-gum

pop toward folk instrumentation and the greater thematic and musical complexity of *Rubber Soul*, their first album after *Help!* Reciprocally, Dylan returned to his teenage interest in rock 'n' roll, when he had formed several bands and in his yearbook noted his ambition "To follow Little Richard." He returned to the electric guitar and began to use a backing band with amplified instrumentation and a drummer in live performance and on records.

Other aesthetic and social implications involved in the forms of folk rock that Dylan innovated corresponded to changes in the mode of his music's production. First, advances in recording and radio technology, especially the increased popularity of the vinyl LP and the emergence of FM radio allowed for music more extended and complex than the fifties rock 'n' roll song, a development that coincided with the increased importance of concerts, festivals, and tours, where extended musical improvisation was prized more than the accurate simulation of hit singles. Second, in writing and singing topical protest songs, rather than simple permutations of the emotions of teenage romance, folk generally—but Dylan especially—demonstrated that the lyrics in popular music could be thoughtful and serious, important beyond their subordination to other elements. But while Dylan's early songs addressed topical social issues in relatively direct language, his use of amplified instrumentation coincided with his turn to an often opaque surreal lyricism derived from French symbolist poetry but unprecedented in popular music. Third, while Dylan retained individual authorship of his songs, he placed himself within a group, integrating his own performance with the other musicians. In and of itself, this was not inconsistent with folk's sing-along rituals and communal composition; but amplification was seen by many folkies as a capitulation to rock 'n' roll, and hence to teenage triviality and irresponsibility. It suggested the sacrifice of folk's political project: commercialization and the consolidation of commodity production within the music business, dislocation from the commonality of folk singers and fans, and the spectacularization of the performer. Symptomatically, Dylan abandoned his scruffy folk image for Carnaby Street mod, and at Newport he took the stage in a red shirt and black leather jacket.

These musical developments—the folk boom, its fraught relation with rock 'n' roll, and the emergence of a synthesis of both forms in folk rock—were all paralleled in developments in cinema in the same period.

Documentary

Despite the promise of *A Hard Day's Night*, subsequent Beatles feature projects failed to narrate their musical and social significance persuasively, and in *Let It Be*, the cinematic punctuation of the group's disintegration, they abandoned fictional narrative to return to the documentary mode of their

first film, *What's Happening! The Beatles in the USA*. During the same period, between 1964 and 1970, the rock 'n' roll musical was fundamentally transformed, and 35-mm studio fictional features were supplanted by independent, usually 16-mm, documentaries, often designed for television broadcast, resulting in the restructuring of the relation between rock 'n' roll film and television. After *A Hard Day's Night*'s concluding dramatization of a live television broadcast in the manner of the US jukebox musicals, innovations in the field of documentary filmmaking led to new permutations of the two mediums that, as the counterculture developed, temporarily severed their interdependence.[10]

By the late 1950s, innovations had transformed documentary filmmaking in France, Canada, and especially the United States, where technological possibilities and social aspirations converged to produce a practice committed to the recording of selected events as they developed without preconception or interference and their presentation without interpretative or editorializing comment. Designating this Direct Cinema, Robert Drew, its chief originator, hoped to make documentaries as purely observational as *Life* magazine's photojournalism. The project was facilitated by a new generation of Auricon and Éclair 16-mm cameras, light enough to be shoulder-mounted or even handheld. Loaded with fast film stocks that permitted available-light photography and with sound exactly synchronized to portable Nagra tape recorders by the pulse of a quartz crystal, these cameras allowed mobile long takes within which the photographer and sound recordist were free to follow spontaneously and in real time the evolution of the scene's most important and revealing events. With these resources, Drew believed, if the cinematographer avoided directing or interviewing the participants and/or otherwise interfering with pro-filmic developments, he would become as inconspicuous as a fly on the wall, and so produce a synchronized audio-visual record of events that had transpired unaffected by his presence. The same principle of observational non-intervention recurred during editing: explanatory voice-over commentary was rejected, as were the internal cutting and resequencing of episodes, but the editor was to emphasize the subject's essential drama by structuring the narrative to culminate in a crisis and its resolution.

Despite its contradictions, Direct Cinema's advance over previous expository forms allowed an unprecedented immediacy and fidelity. Drew's *Primary* (1960), a theatrical documentary that followed John Kennedy and Hubert Humphrey as they stumped across Wisconsin for the Democratic presidential nomination, is usually credited as the mode's first great achievement, its long takes and intimate close-ups capturing hitherto unobtainable candid details and nuances in personality revealed in the tension of campaigning. Its success spurred him to found Drew Associates early in 1961, hiring D. A. Pennebaker (*Primary*'s editor), Richard Leacock and Albert Maysles (its photographers), and Albert's brother, David (a sound specialist), and he began

making documentaries intended for television broadcast rather than theatrical distribution. These included *The Children Were Watching* (1960), about desegregation in the Deep South, *Jane* (1962), about actress Jane Fonda as she worked on a new play, and *The Chair* (1962), about last-minute attempts to save a prisoner from execution.

Drew's cinema emerged during the cultural renewal that accompanied the inauguration of President Kennedy, when hopes for progressive social change gave a new importance to independent journalistic inquiry that now could include documentary filmmaking. But Direct Cinema was also part of a larger cinematic renaissance that included avant-garde aspirations. In his 1961 *Film Culture* manifesto, "The First Statement of the New American Cinema Group," for example, Jonas Mekas invoked the British New Cinema and the then-emerging French New Wave as he proclaimed that the "official cinema all over the world" was "morally corrupt, aesthetically obsolete, thematically superficial" and argued for small-budget, personally expressive films, uncensored, cheaply produced, and independently distributed: "We don't want false, polished, slick films—we prefer them rough, unpolished, but alive."[11] The Group included both documentary and avant-garde filmmakers; indeed, alongside essays by Maya Deren and other pioneers of what would soon be known as "underground film," the same issue of *Film Culture* included Leacock's essay, "For an Uncontrolled Cinema," one that "has nothing to do with theater," with "the film-maker as an observer and, perhaps, as a participant capturing the essence of what takes place around him, selecting, arranging but never controlling the event."[12]

Leacock's envisioning of the filmmaker as a "participant" departed from Drew's removed, objective observer; but both minimized scripting and editing, collapsing the stages of filmmaking that usually precede and follow photography into the present moment of shooting, as did underground film. In 1961 *Primary* won both the Robert Flaherty award for documentary and *Film Culture*'s "Independent Film" award, with the latter's citation praising Leacock, Pennebaker, Drew, and Al Maysles for having "caught scenes of real life with unprecedented authenticity, immediacy, and truth."[13] Like the avant-garde, then, Direct Cinema was committed to notions of existential presentness, authenticity, and spontaneity, as well as to an overall sense of cultural urgency—the same skein of values that sustained folk music and would soon transform rock 'n' roll. Unwilling and unable to access these cultural currents, Hollywood was stuck in the morally corrupt and aesthetically obsolete Elvis movies. So as Beatlemania galvanized the US cultural scene, the general congruence of the socio-aesthetic values of Direct Cinema and the New American Cinema with those of the counterculture and its music made the new form of documentary uniquely capable of creating a new form of rock 'n' roll film.[14]

After *Primary*, some of Drew's staff struck out to work on their own projects: the Maysles made their own documentary about the film producer

Joseph Levine, and Pennebaker and Leacock cofounded their own production company in 1963. But their most influential and important films were about popular music: *What's Happening! The Beatles in the USA* (Albert and David Maysles, 1964); *Dont Look Back* (D. A. Pennebaker, 1967); *Monterey Pop* (D. A. Pennebaker, 1968); *Sweet Toronto* (D. A. Pennebaker, 1970); and *Gimme Shelter* (Albert and David Maysles and Charlotte Zwerin, 1970).[15] By mid-decade Drew's protégés had so closely affiliated with the counterculture that Direct Cinema's axiomatic dispassion was making free love with the underground's expanded visual subjectivity and with Jean-Luc Godard's reflexive modernism. Attempts to make purely observational, uncontrolled cinema were greeted by musicians and fans performing for the filmmaker, and by invitations for them to participate in musical events geared to and financially contingent upon cinematic reproduction. The early ideal of a transparent, purely cognitive use of the medium expanded into highly subjective expressionist and emotive effects and the reflexive recognition of its presence. The reciprocal engagement of the two media culminated in *Gimme Shelter* (Albert and David Maysles and Charlotte Zwerin, 1970), where one of cinema's most brazen assaults on rock 'n' roll also documented the collapse of the counterculture's innocence and utopianism—as well as the principles of Direct Cinema.

Direct Cinema's route to Altamont through folk, folk rock, and eventually rock films ran alongside other forms of concert documentaries for cinema and television, most notably *Jazz on a Summer's Day* (Aram Avakian and Bert Stern, 1960), shot on 35-mm film for theatrical release; *The T.A.M.I. Show* (Steve Binder, 1964) and *The Big T.N.T. Show* (Larry Peerce, 1966), both shot on high-resolution video but transferred to 35-mm film for theatrical release.[16] Together, the three films traced the displacement of jazz by folk and rock 'n' roll as the music of youth culture, the British renewal of rock 'n' roll's rhythm and blues roots, and the amalgamation of rhythm and blues with folk that became the music of the late sixties counterculture. In doing so, they followed Richard Lester's innovative emphasis on the fans, giving them new prominence in the narrative and making them, if not equally as important as the musicians, still an integral element in the spectacle of performance in the way they had rarely been figured in feature films. The emphasis on audiences in the films reflected the increasing importance of fans in what was beginning to be understood as a rock 'n' roll cultural community. It also modeled the imaginary participation and investment of the films' audiences, continuing the extension of the space of the concert into the space of the theater, with variously the use of color film, increasingly sophisticated visual effects, and multi-track sound recording, to which *Monterey Pop* and subsequent counterculture films aspired. The expanded cinematic reproduction of the rock concert dreamed of a similar—if not greater—spectacularity for itself, a dream encouraged by an enormously important innovation: instead of being based on pre-recorded music, the documented concerts were performed live.

Early Rock Documentaries

JAZZ ON A SUMMER'S DAY

Though also a member of the New American Film Group, Bert Stern was an extremely successful fashion and celebrity photographer. Earnings from his commercial work enabled him to finance his documentary of the 1958 Newport Jazz Festival, *Jazz on a Summer's Day*, which set the mold for later rock concert and festival films (Figure 10.1). Like the jukebox musicals based on Alan Freed's shows, it mixed black and white, and male and female performers, including Thelonious Monk, Louis Armstrong, Dinah Washington, Mahalia Jackson, Jimmy Giuffre, George Shearing, Anita O'Day, Gerry Mulligan—and Chuck Berry, the only rock 'n' roller. Despite his proclaimed aversion to modern jazz, Berry was accommodated into the concert's music by an accompanying bop clarinetist. But he asserted his own style sufficiently that at least one of the film's enthusiasts, Keith Richards, found it "a parable on film of the changeover of power between jazz and rock and roll."[17]

Initially, Stern had planned to make a fiction film set amid the festival, and fragments of scripted and staged interludes of beatnik parties and other off-stage events remain. Otherwise, two of the festival's four days are edited into a continuous narrative of one afternoon and a night. After an introductory performance by the Jimmy Giuffre Trio, people begin to arrive and the concert continues through the afternoon and evening and, after Mahalia Jackson has sung the Lord's Prayer as a finale, it ends with a Dixieland band driving away in the deserted early morning roads. But scenes of tourists in the city and other local events also interrupt the *vérité* documentation of musical

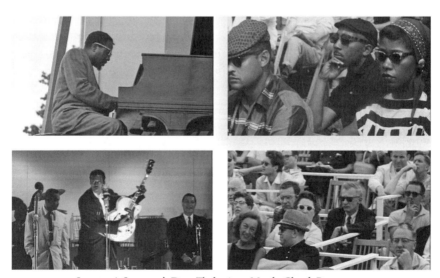

FIGURE 10.1 Jazz on A Summer's Day: *Thelonious Monk, Chuck Berry.*

performance. Monk's set, for example, is intercut with footage of the America Cup trials taking place in Newport at the same time; the shots of billowing yacht sails echo the free-flowing jazz, and the extended takes of abstract patterns in the water appear as visual correlatives, but the intrusive voice of a radio announcer desecrates the music.

Anticipating Direct Cinema, the film has no voice-over, and its main structural armature is the interplay between performers and audience members. With his five 35-mm cameramen shooting Kodachrome color negative, control of the stage lighting, and access to the sound board's tapes, Stern's documentation of the concert is rich, intimate, and glamorous, seamlessly mixing long and medium shots and close-ups. His fashion photographer's eye is adept at capturing nuances in the faces and clothes, and the postures and the attitudes of the mostly well-heeled and fashionably dressed crowd. The musicians are similarly stylish in suits and ties or flamboyant frocks, and they are linked to the audience by editor Aram Avakian's dense connective montages, often with implied eye-line matches. But however enthusiastically the audience responds and however often the film pinpoints African Americans among it, still producers and consumers seem stiffly separated by racial, class, and other differences. Though be-jeaned kids do sometimes dance, especially in the nighttime numbers, neither they nor the musicians appear to transcend their respective positions in musical production to form a cohesive participatory community of equals. Four years later, Chuck Berry and his peers and acolytes, including Keith Richards, showed rock 'n' roll beginning to do so.

THE T.A.M.I. SHOW

The first significant rock 'n' roll concert documentary was *The T.A.M.I. Show*, "T.A.M.I." being an acronym for "Teenage Awards Music International" and/or "Teen Age Music International" (Figure 10.2). Executive producer William Sargent planned it as the first of a series of rock 'n' roll films whose profits would fund musical scholarships for teenagers, but since he lost the rights to the film soon after it went into distribution, it remained a one-off project for him. It reconstructed the form of the jukebox musical even more radically than had *A Hard Day's Night* some six months earlier, returning the genre toward the revue form in which it had originated, condensing the pre-concert events, minimizing the narrative, eliminating fictional interludes, and enlarging the spectacle of live performance so that it all but totally occupied the film.

Like the Freed jukebox musicals, it intermixed a cross section of the major black acts with prominent white ones, specifically those of the British Invasion. Ten to fifteen minutes each were assigned to the best of Motown, black rock 'n' roll, and rhythm and blues: the Supremes, the Miracles, Marvin

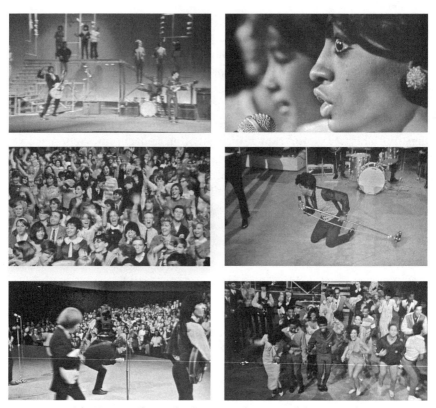

FIGURE 10.2 The T.A.M.I. Show: *Chuck Berry and Gerry and the Pacemakers, Dianna Ross, audience, James Brown, the Rolling Stones, finale.*

Gaye, Chuck Berry, and James Brown (the last then not generally known to white teenagers), and also to the Rolling Stones, Gerry and the Pacemakers, and Billy J. Kramer and the Dakotas, all of whom had been variously inspired by black music and US rock 'n' roll. The mix was augmented by a scattering of surf music (the Beach Boys, and Jan and Dean), "girl" singers (Lesley Gore), and early garage rock (the Barbarians), all accompanied by a house band that included Leon Russell, Glen Campbell, and other outstanding Los Angeles studio musicians, with Jack Nitzsche as musical director. Assembled specifically for the sake of the film, these stellar musicians were rehearsed by television director Steve Binder on October 28–29, 1964, in the Santa Monica Civic Auditorium before an invited audience of local high-school students, with the entire film shot on the second day. Binder photographed the concert in Electronovision, a newly developed process by which high-resolution electronic signals from the television cameras were processed directly to 35-mm film. It had a short but very influential theatrical release by American International Pictures, distributor of teen exploitation movies and jukebox

musicals.[18] Despite its return toward the revue format, the film marked a formal advance both in its documentation of live performance and (apart from the few lines with which Jan and Dean introduce the performers) in its rejection of voice-over narration. For the first time, a live rock 'n' roll concert became a feature-length film.

Los Angeles locals Jan and Dean, whose "Surf City" had been a huge hit on both Billboard's Hot 100 and its rhythm and blues charts the previous summer, introduce the acts, perform two of their hits, and open the film with the specially written song "Here They Come (From All Over the World)" that lists the performers and their places of origin—including "Those bad lookin' guys with the moppy long hair/The Rolling Stones from Liverpool." In emphasizing, as does the film's title, the specifically teenage nature of the event, their lyrics reflexively reference the concert itself and the culture the music sustains so that, as in the later Direct Cinema documentaries, song lyrics explicate the meaning of the visuals and the overall event. Their opening song is accompanied by a rapid collage of vignettes of people hurrying to the concert: Jan and Dean hurtle through the streets of Santa Monica on motor bikes, skateboards, and go-carts; the British groups approach in their tour bus while the black bands take cabs from their Hollywood hotel; in their dressing rooms, the Supremes fix their hair and makeup and James Brown tends to his pompadour; the dancers rehearse; police cars cruise by; and finally, clutching their tickets, the fans crowd in. A condensation of the Beatles' train ride to London and the only vestige of the jukebox musical's narrative frame, the prologue shows the gathering of the youth tribes and their musical gods, a motif that would become a fundamental convention of the festival documentary.

Once inside, the audience finds on stage a minimalist scaffold with steps connecting its several levels for the score or so of racially mixed go-go dancers, all directed by the most celebrated rock 'n' roll choreographer, David Winters, and Toni Basil.[19] Most of the girls are dressed in brief bikinis or go-go shimmy dresses, and they frug and hitchhike furiously, displaying their dancing skills and also their highly eroticized bodies. As they echo and elaborate the choreography, especially of the black groups, the dancers create a kinetic interactive environment for the performers and a visual amplification of the music's momentum and sexuality. The uninterrupted chorus of screams from the audience and the cutaways to them for both extended facial close-ups and wider shots in which they hand-jive, the numerous shots that include both performers and audience, and the minimal breaks between acts all together sustain a delirious interactive communality among fans and performers and dancers, black and white; and even though the audience is predominantly white—and patrolled by the police—their euphoric celebration of black performers is unprecedented in cinema.

Chuck Berry, named by Jan and Dean as "the guy who started it all," opens with "Go, Johnny, Go," and then half way through "Maybelline," he is joined

on stage by Gerry and the Pacemakers, who take over the song. Thereafter, as the two acts trade numbers, their presence together on the same stage and the mixed-race dancers behind them announces the film's overall marriage of black and white music. After the Miracles and Marvin Gaye (backed here by the Blossoms, who would later contribute so much to Binder's production of Elvis's "Comeback Special"), Lesley Gore completes the first half with "It's My Party," and all the previous performers join her on stage as if to literalize her lyrics. The second part opens with a string of the other white bands, then in succession, the Supremes, James Brown and the Famous Flames, and the Rolling Stones. Brown's peerless set displays his uniquely influential combination of impassioned vocals and virtuosic dancing. Along with the musicians, his group includes three males who accompany him in both singing and dancing and, as in his stage shows, at his set's climax one of his team attempts to wrap him in a robe and lead him off-stage, while he maniacally breaks free for yet another and another chorus. The Rolling Stones top the bill, performing covers of Berry's "Around and Around" and four other rhythm and blues hits, but only one of their own songs, "Off the Hook." Binder shifts seamlessly among wide shots of the band, close-ups on Jagger, shots from stage rear showing Jagger's interaction with the audience, and extended lap dissolves that superimpose the band on the audience, all visually reproducing the act's sonic synergy. They end with "Get Together," a simple repeated riff, and the go-go dancers join them on stage, then the Supremes, Berry and Brown, and the other performers: young and old, stars and supporting acts, black and white, Mick Jagger and Diana Ross, all singing and dancing together. Brief medium shots focused on particular groups are cut with shots from behind, with the band, the stage camera, and the ecstatic audience framed together. Finally, a wide shot with a slowly rising camera showing them all dancing and singing in biracial joyous terpsichorean abandon ends the film, positioning the Stones at the center of a black-white, male-female, UK-US musical commonality.

Since all the music is performed live for an overwhelmingly enthusiastic audience, the concert has a categorically greater energy and momentum than the lip-synced spectaculars that concluded previous rock 'n' roll films, especially since Binder's camera at the rear of the stage is able to capture so much of the audience's delirious participation. But the visual projection of the musical vitality is enhanced by the dancing and by the photography and editing. Though the other British bands are restrained, Jagger had already learned some elements of black dance to accompany the Stones' versions of black music. For the black groups, the visual performance of dance is as integral to their acts as music. Brown's own set is physically the most accomplished, and indeed it is recognized as one of the very best rhythm and blues performances ever filmed, as well as the immediate source for Michael Jackson and other black singer/dancers from Prince to Janelle Monae.[20] But one of the Miracles' numbers is paradigmatic. As they did on the Motown Revue

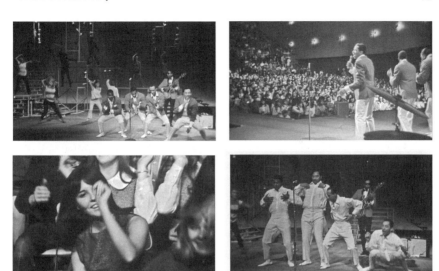

FIGURE 10.3 The T.A.M.I. Show: *The Miracles, "Mickey's Monkey."*

stage shows of the time, the Miracles close with their recent hit, "Mickey's Monkey" (Figure 10.3). Placed somewhat apart, Smokey Robinson sings lead, noticeably more hoarsely than on the single, while grouped together the three Miracles supply back-up vocals and complementary dance routines, their synchronization with the song's structure somatically and visually enacting the music. But in this case, the dance-song interplay is particularly specific, for as Robinson sings, "C'mon and do the Mickey's Monkey," they perform the named dance, facing each other, bending at the waist, jerking their arms up and down, and making other monkey movements. As the song builds to a climax, they throw off their jackets, their movements become increasingly exuberant, and the song rises to an abstract chant of swapped exclamations, "Yeah, Yeah, Yeah!" All the while, the Miracles' singing is musically supported and extended by their own guitarists behind them; and their physical, visual display is further echoed and amplified by both the ensemble of stage dancers who surround them and whose choreography also matches the song's structure, and the audience members who do a seated version of the same dance. Rather than simply a song, the number is a multimedia, polycentered audio-visual composition, in which lyrics, voice, music, costume, dance, lighting, stage architecture, and audience all interact in synchronized synergy. The same vernacular *gesamtkunstwerk* is achieved in sets by Diana Ross and the Supremes, and Marvin Gaye, and in the latter the dance specificity recurs in his performance of "Hitchhike." But in all cases, the film's dance was choreographed by Steve Binder.

Having produced daily episodes of both the *Steve Allen Show* and the *Jazz Scene* for several years, Binder was by this time a uniquely experienced

and skilled television director of music. For *T.A.M.I.* he used Allen's crew with four large and still cumbersome RCA studio cameras, three of them on mobile pedestals: two of them on the sides used mostly for close-ups and one from the rear of the stage facing into the audience, with the fourth mounted on a crane in the audience. All controlled by their operators under Binder's direction, they were able to zoom, pan, and move fluidly around the set to provide him at every moment with a choice of four shots, from extreme close-ups to wide angles of the ensemble dancing. In a makeshift control room, he edited the video feeds with a sophistication unprecedented in live-performance filming. Generally his cutting between cameras is understated, but his responsiveness to song structure, the dancing, and multiple performers is so dexterously coordinated that, working live, he is able to cut on action and beat count as precisely as John Jympson had done with Gilbert Taylor's footage for *A Hard Day's Night*.

As the concert progressed, his confidence appears to have increased and his treatment of the last three acts is superb, perhaps best of all in Brown's set. Brown had been the only artist who refused to rehearse, but Binder still was able to predict the star's pantomimic movements across the stage and among his back-up dancers, and at rhythmically crucial points to cut exactly between wide shots of Brown dancing and close-ups of his face. Directing the four cameramen to his choice of lens and position, he used the switching board to compose the video feeds into the single mix processed directly on film. Spontaneously and in real time, Binder *played* the performers and the entire televisual apparatus as if it were a musical instrument.

Like *A Hard Day's Night*, the film is mediated by television; but whereas the earlier work used film technology to depict a television show and at its visual apogee exploited the compositional techniques of television advertisements, *The T.A.M.I. Show* used television technology and the techniques of live television variety shows to create a film on the spot. Binder's own live performance of television and film composition both controlled the concert's audio-visual elements and itself enacted its affirmation of the combination of disciplined artistry and communal physical spontaneity. Together with his direction of the concert's combination of cutting-edge black and white musicians, his use of photographic and editing techniques to represent the audience and performers as a united commonality, and his manipulation of multiple forms of rock 'n' roll visuality, he made *The T.A.M.I. Show* a superlative dance of cinema and rock 'n' roll.

For the Santa Monica teenagers, *The T.A.M.I. Show* was a free concert. In fact, as in *A Hard Day's Night*, the filmmakers appropriated their performance to energize and legitimize the concert, making it a use value that subtended the film's exchange value. As documentary filmmaking moved into the ideological field of the late sixties counterculture, issues around the

representation of the audience became more contentious, but in this moment of relative innocence Steve Binder created a rock 'n' roll film that bridged the divides between black and white, between music and dance, between the United States and the United Kingdom, and between rock 'n' roll and rhythm and blues of the fifties and the renewal of them that the British Invasion bands brought back home to the United States. Shot only four months after the end of the fifty-four-day filibuster that allowed the enactment of the Civil Rights Act on July 2, 1964, Binder's orchestration of music, dance, and cinema remains a beautiful image of liberation that transcended the social reality of its time, transcended even its own contradictions. And as it became the model for mixed-race mid-sixties rock 'n' roll television shows, especially ABC's *Shindig!* (which was also choreographed by Winters, featured Toni Basil and Terri Garr as dancers, and employed members of *T.A.M.I.*'s house band and the Blossoms) and NBC's *Hullabaloo* (also directed by Binder and choreographed by Winters), its utopian social and aesthetic innovations quickly entered mass culture and the general political field.

THE BIG T.N.T. SHOW

A follow-up to *The T.A.M.I. Show, The Big T.N.T. Show* (Figure 10.4) was produced a year later by Phil Spector, who also acted as musical director, with Samuel Z. Arkoff and Henry G. Saperstein as executive producers and Larry Peerce, who had previously worked mainly in television, as a director.[21] Recorded on November 29, 1965, at the height of folk rock's success, it too was shot on Electronovision and transferred to 35-mm film for theatrical release by AIP. Again Los Angeles teenagers formed the mixed-race audience, though on this occasion in a Hollywood nightclub, the Moulin Rouge, rather than an auditorium. Again it began by setting a montage of the arrival of the audience and stars to a song, "This Could Be the Night," by MFQ (Modern Folk Quartet). But this time they arrive at night among the lights and excitement of the Sunset Strip, where the marquee for The Trip nightclub, advertising upcoming performances by Marvin Gaye, is briefly visible. David McCallum, the "blond Beatle," then at the height of his fame as the star of *The Man from U.N.C.L.E.*, opens the concert by conducting the house band in an instrumental version of "Satisfaction," but subsequently he introduces the performers only in off-screen voice-over. The mix of white and black acts on this occasion is more disjunctively polarized: where *T.A.M.I.* brought together the African American musicians with the British beat groups they inspired, here there is no such continuity between the black performers and white folk and folk rock singers. The more intimate nightclub setting allows some of the singers to perform among the audience, but the dancers are less numerous and frenetic than in *T.A.M.I.* The cameras are mobile, but the editing rarely approaches Steve Binder's precisely composed visual music.

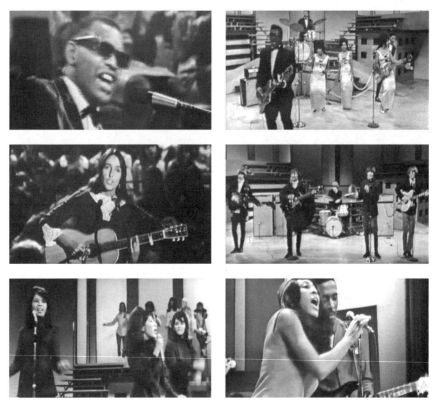

FIGURE 10.4 The Big T.N.T. Show: *Ray Charles, Bo Diddley, Joan Baez, the Byrds, the Ronettes, Ike and Tina Turner.*

The white standouts are the Byrds, then riding the crest of the folk rock boom, who perform "Mr. Tambourine Man," which had topped both the US and UK charts the previous summer, and their equally important "Turn! Turn! Turn! (To Everything There Is a Season)." Of the others—Petula Clark, the Lovin' Spoonful, Joan Baez, Roger Miller, and Donovan—only Baez's self-accompanied renditions of the traditional song, "Five Hundred Miles" and Phil Ochs's "There But For Fortune" are memorable. But then, turning to the pop-rock with which she was beginning to experiment, Baez flounders with a bizarre version of the white soul hit, "You've Lost That Loving Feeling," accompanied by a full orchestra and Spector on the piano. The black acts, on the other hand, are sterling. Ray Charles sets the bar high with "What'd I Say" and "Georgia on My Mind," only to blast it through the roof on "Let the Good Times Roll." Bo Diddley and the Duchess mount a stream-roller minimalism; dressed in black Viet Cong pajamas, Ronnie and the Ronettes are a nectarous wet-dream; and the finale by Ike and Tina Turner is beyond compare, with the magnificently physical Tina, unspoiled by the degrading self-parody she

would soon adopt, approaching James Brown's intensity, especially on her version of his "Please, Please, Please."

As revues with only minimal narrative introduction, both *T.A.M.I* and *T.N.T.* stand or fall on the quality of the performances and their filmic representation. Both concerts were staged specifically to create films, and though the heavy studio cameras are often visible, they do not appear to affect the musicians, but allow a *vérité* documentation of their live music. The interweaving of the black and white acts, the US and the British, on equal terms in the line-up marked a revolution in musical and social history that would subtend the hopes of the remainder of the decade. But neither film provides access to the performers' or the fans' off-stage lives, or to the general cultural milieu, and no exploration of the music's aesthetic and social meaning beyond the MC's remarks. Meanwhile, and in fact a month before *T.A.M.I.* was released in the United States, in *What's Happening! The Beatles in the USA*, Albert and David Maysles had done exactly this for the Beatles. Though the fly-on-the-wall observational axioms of Drew's idea of Direct Cinema had been compromised by the musicians' interaction with the filmmakers, otherwise in the scenes with the fans, the disc jockeys, and the journalists, in the press conference, the visit to the Peppermint Lounge, and the train journey, the film displayed the possibilities of uncontrolled documentary, providing an unprecedentedly informal and intimate access to rock 'n' roll musicians. And if *Primary* had introduced a new president and a new developments in documentary, *What's Happening* announced the panacea to the gloom surrounding his death, cultural stars to stand in his place, and the most significant innovation in the new documentary form's evolution: the complete break with the voice-over narration.

The next step in the evolution of the documentary rock 'n' roll film was its employment for autonomous concerts, those not arranged specifically for the films. With the folk culture understanding itself as a less mediated and hence more authentic form of music than commercial pop or rock and Direct Cinema promising a generally equivalent freedom from fiction and artifice, it was all but inevitable that the first of the new documentaries should have been concerned with the most important folk singer, Bob Dylan, in *Dont Look Back* (D. A. Pennebaker, 1967). Where in shooting *A Hard Day's Night* in 1964, Richard Lester married the Maysles' documentation of the Beatles' off-stage performance to the jukebox musicals' lip-synced hits, Pennebaker documented to Dylan's live concerts in United Kingdom. As, to varying degrees, both folk music and Direct Cinema privileged popular participation in culture, both envisaged art's direct responsiveness to current social and political events, and both aspired to freedom from corporate control and commercial priorities. And as documentary filmmaking represented popular music, not as a subordinate branch of the entertainment industry, but as a radically disaffiliated counterculture, it began to aspire to be itself part of it.

D. A. Pennebaker

DOCUMENTARY FROM FOLK TO FOLK ROCK AND ROCK

Born in 1925, D. A. Pennebaker had been at the forefront of the renewal of US independent cinema since the mid-fifties, variously combining innovations in both documentary and experimental film. Along with Ricky Leacock, Robert Drew, and Al Maysles, he received *Film Culture*'s "Third Independent Film Award" in 1961 for *Primary*, which he had edited. The citation summarized the principles of Direct Cinema in noting that the filmmakers "have caught scenes of real life with unprecedented authority, immediacy, and truth. They have done so by daringly and spontaneously renouncing old controlled techniques; by letting themselves be guided by the happening scene itself."[1] Continuing to be "guided by the happening scene itself," Pennebaker made numerous films about music over the next decade, two of which illustrated the transitions from folk to folk rock and then to rock, along with the wider cultural developments they involved: *Dont Look Back* (1967) and *Monterey Pop* (1968).[2] Shooting sync-sound from within events as they evolved, he ignored the jukebox musicals' compositional procedures and stylistic conventions, and created a documentary form of the backstage musical in a new mode of film production with new cinematic languages for the representation of musical performance and its social context. Though anticipated in some respects by the Maysles' television documentary of the Beatles' first US tour, *What's Happening! The Beatles in the USA* (1964), his work established the essential form of the late sixties rock 'n' roll musical that was imitated in increasingly ambitious films, most notably *Woodstock* (Michael Wadleigh, 1970) and *Gimme Shelter* (Albert and David Maysles and Charlotte Zwerin, 1970). But the engagement with the counterculture and its music challenged the distanced, observational, aesthetic that Direct Cinema initially espoused, causing its modification and eventual transformation into new expressive modes.[3] Like Pennebaker's *Jane* (1962) and the Maysles' *Meet Marlon Brando* (1966), *Dont Look Back* was an intimate portrait of a celebrity, showing Bob

Dylan in performance on-stage and in his social life behind the scenes during the period when he was attempting to manage the complications entailed in his turning of folk music into rock 'n' roll.

Dont Look Back

Though not released until May 1967, *Dont Look Back* documented Bob Dylan's English tour two years earlier in April and May 1965, a little over a year after the Beatles first visited the United States. Like John Lennon and Elvis, as a teenager Dylan had idolized James Dean and Marlon Brando; in London in January 1963 he had played an anarchic young folksinger and performed several of his own songs in a BBC television play by Evan Jones, *The Madhouse on Castle Street*; and by early 1965 he was becoming interested in other possibilities that cinema might hold for him. He had admired Pennebaker's first film, *Daybreak Express* (1953), an experimental short shot set to Duke Ellington's eponymous recording, and he had his manager, Albert Grossman, approach Pennebaker. Interested in making a film about music, Pennebaker enthusiastically took on the project without funding. He flew to England with Dylan and shot twenty hours of footage of the two-week, eight-performance tour, including the final two concerts at the Royal Albert Hall in London. Apart from two anomalous scenes, the film was shot in Direct Cinema fashion. Pennebaker used only one camera, and much of the time he himself operated both it and the microphone. Even when other crewmembers assisted, they remained inconspicuous; in a long scene where Dylan berates a *Time* journalist, for example, sound-recordist Jones Alk sits in the background, but her microphone is barely visible. He used only environmental sound and available light, and since the high-speed 16-mm Tri-X was pushed in the lab, much of the film appears grainy and high-contrast.

The film opens with a stationary-camera long take of Dylan standing in the street, holding and successively throwing away large cards inscribed with words from the lyrics of "Subterranean Homesick Blues," the recording of which accompanies the scene. The credit sequence follows, beginning with a close-up on his face, then the camera follows him in long takes as he warms up, chats with his entourage backstage, walks down a dark corridor to the stage, and opens the concert with "All I Really Want to Do." The visual track is cut at this point while the song continues over the credits, after which the film returns to sync-sound and his earlier arrival at London airport. Accompanied by Grossman and Bob Neuwirth, the tour manager, he is thronged by fans and conducted to a press conference where, still in single-camera long takes, he good-naturedly toys with such questions as "What is your real message?" and "Do the young people who buy your records understand a single word of what you are saying?" The prologue and the editorial resequencing aside,

the sequence establishes the film's structural pattern: fragments of Dylan's performances are set in a matrix of off-stage activities: traveling by car and train to engagements, jamming or bantering backstage; visits by friends, musicians, and fans; parties in hotel rooms; and interviews in which he is questioned about the meaning of his music. Similar motifs comprised *What's Happening! The Beatles in the USA* that, in the abbreviated form of *The Beatles in America*, had been televised the previous November, with the Beatles breakthrough in the United States mirrored, though much lesser apocalyptically, in Dylan's UK reception. Unlike *The Beatles in America*, however, *Dont Look Back* included live concert performances, not complete numbers to be sure, but still visually and aurally powerful selections. Both the spectacle of musical performances and its narrative setting were entirely documentary, rather than lip-synced simulation and fiction, respectively; and in reconstructing both components and reversing their relationship to subordinate the spectacle to the narrative, *Dont Look Back* created a new kind of musical. But as it did so, tensions between the two emerged, somewhat reminiscent of the disjunctions in *The Girl Can't Help It*, though here based on unrecognized transitions in Dylan's personae, that at crucial points forced Pennebaker to abandon Direct Cinema's axioms.

THE SPECTACLE OF AUTHENTICITY

From *Rock Around the Clock* in 1956 to *Double Trouble*, Elvis's own visit to what its trailer designated as "mod London and swinging Europe," released only weeks before *Dont Look Back*, the attraction of the rock 'n' roll film had been the audio-visual representation of musical performance. But, reflecting Pennebaker's desire to make a film about the Dylan behind the music, rather than a music film per se, the amount of concert footage is meager, barely twelve of its ninety-five minutes, though several times this amount of Dylan's impromptu jamming with friends, as well as some concert sound used with non-synchronous visuals, are also included. Nevertheless, the most persuasive demonstration that Dylan is a radically new pop phenomenon—according to one journalist, "a poet, not a pop singer"—occurs during the concert performances, in both the songs themselves and their filmic representation.

The performance sequences (Figure 11.1) mobilize a starkly minimal visual vocabulary. On stage, Dylan appears aurally and visually alone in an abstract darkness into which his own clothes disappear. Since only his face, hands, guitar, and microphone are visible, his presence is identified with his music: framed by a halo of dark curls, his handsome face announces his stardom, his mouth is the source of his voice and his harmonica accompaniment, his hands play the guitar, and the microphone broadcasts his music to the invisible audience. Depicted in this way, he performs onstage in several cities, but more than half the concert footage is from the concluding appearance in

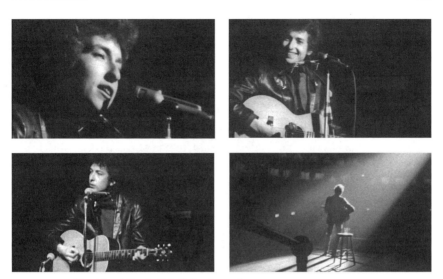

FIGURE 11.1 Dont Look Back: *Bob Dylan in performance.*

the Albert Hall, where a couple of stanzas from each of five songs are, as in the classical and jukebox musical traditions, stacked sequentially to form a finale. Each is shot in an uninterrupted long take with a handheld camera, most from below front, though between songs Pennebaker moves to create several different points of view. For the first song, Dylan is seen in a medium shot from below left, then the camera zooms in on his face; for the next song, he is seen from behind, then again in close-up from front and side; and the encore, "Love Minus Zero/No Limit" is shot from the highest seats in the theater, so that Dylan becomes a tiny figure caught at the confluence of two distant spotlights. Otherwise, since his body or face is always centered, he remains the sole focus of attention, with visual variety limited to his movements to and from the microphone and the combination of zooms and the handheld camera's haptic trembles.

The longest single number, a more than three-minute take of the first three stanzas of "The Lonesome Death of Hattie Carroll" (truncated because Pennebaker ran out of film), exemplifies his creation of a folk version of musical visuality. Shooting from the floor, he frames Dylan's face as tightly as the Beatles' in the *Hard Day's Night* finale. Even in the relatively low-budget Beatles' film, the studio lighting and 35-mm format produce a complete grey-scale chiaroscuro that rounds the contours of their faces and is detailed enough to register the individual hairs on their head and eyelashes, all of which are set in a clearly three-dimensional space; but Dylan's monochrome face, flattened by the zoom lens and rendered grainy by the fast 16-mm film, floats in a black void that almost assimilates his hair and microphone, leaving him alone with the gravitas and gothic injustice of the narrative of Hattie

Carroll and William Zanzinger. Having only a single camera, dependent on the theater spotlight, and limited to one take of each number, Pennebaker lacked the resources that had allowed John Jympson to compose the most sophisticated reproduction of rock 'n' roll performance to date. But turning the meagerness of his resources to advantage, his filming reciprocated Dylan's minimalist stage spectacle. Dependably linked by crystal sync to the tape recorder, the lightweight camera allowed him unobtrusive proximity to the singer, which in turn facilitated Direct Cinema's formal techniques: continuous long takes, internally inflected by zooms, pans, and other rhetorical figures that traced the filmmaker's responsiveness to illuminating moments or gestures: the intra-shot montage of his dance with Dylan through his camera's lens. These filmic techniques were signally appropriate, their technological minimalism loosely corresponding to folk music's plain speaking and to the minimal instrumental accompaniment that proclaims its uncommercial integrity. Combining these tokens of artless authenticity, Pennebaker created a visual musicality whose dramatic austerity complemented Dylan's music; the close audio-visual contact with the single singer-guitarist reciprocated the music's humanist ethic and, unlike rock 'n' roll's kineticism, demanded earnest attentiveness. The invisible audience to whom he sings silently performed a new mode of pop music appreciation, entirely unlike the fans' in *A Hard Day's Night*. Each song received applause but, as the *Daily Mirror* review read to Dylan as he leaves Sheffield in a limousine reported, the kids who "used to scream for the Beatles" now listen to him "without one single scream and with rapt attention to every word."

Dont Look Back's single-camera long takes concomitantly replaced the montages of orthodox Hollywood continuity editing, especially the shot/reverse-shot figure. This figure and its corresponding suturing effect are missing from the representation of the music and from the narrative around it; just as the single camera excludes the possibility of shot/reverse-shot montages, Dylan has no female love object, the audience is not visible during his concerts, and the few instances when he encounters fans do not generate closure. A summary instance occurs in Liverpool, where several girls stand outside the hotel hoping for a glimpse of Dylan in the windows up above. One of them apparently sees him ("Pinch me! Oh, my dream's come true"), but the camera fails to see him, and their subsequent encounter with Dylan is also photographed in long takes that lack reverse shots. The only significant instances in which a character looks back at the camera are performed by Dylan himself, in the "Subterranean Homesick Blues" prologue and other rare occasions where he glances at Pennebaker. Whatever else *Dont Look Back*'s appropriation of baseball pitcher Satchel Paige's catch-phrase for its title might mean—not looking back to the folk era, for example—it also announces an injunction against Hollywood film language: the long takes on which its narrative grammar is constructed do not allow the

shot/reverse-shot figure to be completed by another protagonist returning the gaze or *looking back*.

The depiction of Dylan's musical authority and personal charisma in the live performances sustains an unprecedented intimacy. But the brevity of his on-stage scenes reciprocally shifts greater attention to the everyday events of life on tour: his entourage, the journalists, the institutions and apparatus of the music business, his fans among other musicians, and beyond them the general public who attend the concerts. Isolated on-stage, Dylan is simultaneously powerful and vulnerable, apparently absorbed in the ethical earnestness of his songs that made him such a crucial cultural figure. But his off-stage interaction with the press and his entourage reveals this persona to be something of a charade. In the performance scenes, Pennebaker's visual acumen and the sensitivity of his camera's attention and responsiveness create Dylan's dramatic sincerity; but the off-stage scenes explore Dylan himself, his personal interactions, and the social circles that expand around the phenomenon of his accomplishment and the operation of his fame. In this context, the presentation in the musical spectacles of the public persona Dylan had crafted stands as a measure against which his real-life comportment off-stage may be gauged—or as the sign of Dylan's resistance to any authentic self-presentation, the filmmaker's failure to secure it, or its existential impossibility. Since *Primary*, many Direct Cinema films had explored the tension between public and private selves, and none more so than Pennebaker's earlier film, *Jane*, which plumbed the multiple levels of celebrity self-fabrication by focusing on Jane Fonda's rehearsal of a Broadway play. In it she declares, "I didn't know when I was acting and when I wasn't," and concluded that *Jane* "was a false thing about a false thing, and it is that which was true."[4] The various Dylans in *Dont Look Back* establish a parallel dialectic among the modalities of artifice entailed in a life in show business: Pennebaker's skills as a photographer and an editor allow him to portray a celebrity musician who is systematically evasive and erratically duplicitous.

THE NARRATIVE OF INAUTHENTICITY

When *Dont Look Back* was shot, Dylan was a rock star struggling to be born while the socially conscientious folk singer in him was dying. Looking back to the time of the tour, he told Nat Hentoff in an interview the next year, " Everything is changed now from before. Last spring. I guess I was going to quit singing. I was very drained. . . I was playing a lot of songs I didn't want to play. I was singing words I didn't really want to sing. . . But 'Like a Rolling Stone' changed it all: I didn't care anymore after that about writing books or poems or whatever. I mean it was some thing that I myself could dig."[5] Recorded three months before the tour in January, the album *Bringing It All Back Home* implied rock's return to the country of its origin, while its

separate acoustic and amplified sides also figured the return of folk to rock 'n' roll—or perhaps vice versa—that "Like a Rolling Stone," written after the tour, exemplified. With drums, electric guitar, and bass accompaniment, *Bringing It All Back Home*'s leading track, "Subterranean Homesick Blues," was a surrealist pastiche based on Chuck Berry's 1956 rock 'n' roll hit "Too Much Monkey Business" that became his first top-forty hit in the United States. Released in both the United States and Britain in March, just before the tour began, the album became Dylan's most successful to date, reaching sixth place in the United States and, buoyed by the publicity surrounding the tour, number one in England, even though his embrace of rock 'n' roll and the hallucinatory interiority of his lyrics dismayed those of his English fans who had regarded his political music as an alternative to vacuity of the Beatles and other commercial pop. Both phases of his music, the earlier acoustic folk songs and the new folk rock songs, were charting in Britain at the time of the tour: "The Times They Are a-Changin'" single, as is mentioned in the film, reached number sixteen, and the eponymous folk album, which had been released well over a year before, eventually reached number one. "Subterranean Homesick Blues" and "Maggie's Farm," both from *Bringing It All Back Home*, are heard, one non-diegetically opening the film and the other diegetically playing on a radio. But during the tour, Dylan performed almost exclusively his earlier personal and topical songs, accompanying himself on acoustic guitar. Not until the concluding evening did he include songs from *Bringing It All Back Home*, though all were accompanied by his own acoustic guitar, and even then only after two titles from his older acoustic folk albums.[6] Pennebaker occasionally reveals that he has undergone a fundamental transformation in, for example, portraying the dismay of the young fans who object that the newer songs are commercialized and "don't sound like you at all," and his gleeful examination of electric guitars in a shop window. But overall, with Dylan depicted as playing songs he "didn't really want to play" and performing only as folk and protest singer and while constantly denying being either, Pennebaker collaborated with with his subject in depicting his return to rock 'n' roll in the "Subterranean Homesick Blues" prelude, but obfuscating it thereafter. The epochal musical transition that Dylan had already made remained hidden.

In his account of the film, Pennebaker invoked a Direct Cinema's axioms: "It is not my intention to extol or denounce or even explain Dylan, or any of the characters herein," he observed, "This is only a kind of record of what happened."[7] Pennebaker's observational non-intervention and his rejection of the voice-of-God narration combined with Dylan's elusive self-presentation to produce a complex interplay of revelation and dissimulation. Paralleling Dylan's rejection of the spectacular paraphernalia of rock 'n' roll production, Pennebaker's Spartan resources and his minimization of artifice and spectacle in the performance scenes appear to corroborate his musical and social sincerity. But in the behind-the-scenes sequences, the nature of Dylan's music

is confused, rather than clarified. Dylan's apparent autonomous authentic-
ity is revealed to be sustained by a battalion of road and stage managers,
journalists and reviewers, friends and hangers-on, all watched over by his
aggressively avuncular manager. Hovering protectively, Grossman reassures,
runs interference, and makes the deals that keep his cash cow's career mov-
ing forward. A long scene in which he and British impresario Tito Burns
(himself a musician and sometime manager of Cliff Richard) pit television
networks against each other to milk the maximum fees comically manifests
the integration of Dylan's enterprise, not in some folk commonality, but in
the commercial system that his earlier protest songs had indicted. His alle-
giance to Woody Guthrie's hobo heritage now a thing of the past, Dylan has
a career that must be managed in order to expand its social and economic
position within the prevailing culture industries. Previous rock 'n' roll films
had revealed the music's production within these industries, often with a dis-
abused insight into their corruption. *Rock Around the Clock, The Girl Can't
Help It, Jailhouse Rock, Expresso Bongo*, and *A Hard Day's Night* all displayed
the tension between the rock 'n' roll ideal of spontaneous underclass expressiv-
ity and the strategic realities of its commercial management, even if they also
indicted the machinations of exploitative elements in the industry: Corinne
Talbot in *Rock Around the Clock*, for example, or Johnny Jackson in *Expresso
Bongo*. Folk music's relation to the music industry had been more sensitive
and contentious, but Pennebaker allows Dylan's commercial involvements
unrestricted visibility, especially his supportive menagerie and his involve-
ment with publicity and the press.

 Given Pennebaker's refusal to "explain Dylan," audiences are free to find
in his general behavior, especially his treatment of journalists and visitors, the
Dylan they choose, whether engagingly eccentric or boorishly obnoxious. But
unlike previous rock 'n' roll films, *Dont Look Back*'s ethical frame of reference
is constructed in personal and psychological terms around Dylan himself and
his music, rather than in social terms about musical trends more generally.
The film is not fundamentally concerned with the relation between Dylan
and teenage delinquency, with sexual promiscuity or drug taking, though
it does conceal his actual behavior at the time as rigorously as *A Hard Day's
Night* did the Beatles'. In the only extended incident of mayhem, when a bottle
is thrown from a bathroom in his suite onto a car below, he sides against the
culprit. Among his admirers are teenage girls, but his relationship with them
is not eroticized and, unlike the protagonist of virtually all previous musical
films except the Beatles', he has no lover. Joan Baez initially appears to play
this role, but he ignores her, Neuwirth ridicules her, and she quits the film.
Marianne Faithfull and other possible replacements are briefly glimpsed, but
none breaches the defenses of his homosocial entourage.[8]

 As in other Direct Cinema films, interviews and press conferences do sur-
reptitiously permit the direct questioning that the observational principles

prohibit to the filmmaker himself, and these are supplemented by other, less formal, scenes in which people attempt to understand Dylan and the significance of his music: Maureen Cleave's disbelief that young people understand his lyrics; the *Manchester Guardian* journalist filing his belief that Dylan is not so much singing as sermonizing to the "bearded boys and lank-haired girls" who have no real connection to political struggles; the young rock 'n' roll band that plays amplified versions of Dylan's songs but whose members complain because people don't listen to the words; the various press reviews that are read and ridiculed; the jam of Hank Williams songs, and Dylan's interest in Alan Price's rendition of a George Formby song; the meandering discussion with the science student about how friends can be known; and finally his attack on the *Time* journalist's incapacity to understand him. All these incidents raise the question of his music's meaning, but always with inconclusive or opaque results. Dylan's own comments are especially baffling; all he will admit to is being "just a guitar player" or "just an entertainer," and he insistently denies any insight into the meaning of his lyrics, the key element that distinguished folk from rock 'n' roll. "I just go out there and sing them," for example, "I don't believe in anything," or "I've got nothing to say about these things I write. I just write them down. I don't write them for any reason. There's no great message."

Dylan's mercurial elusiveness, not to say the incoherence, arrogance, and overt mendacity of his self-presentation, is overdetermined by a combination of filmic, personal, and especially musical issues. The absence of a fictional narrative where that meaning could be dramatized, along with Robert Drew's desire for "reporting without summary and opinion" that engendered Direct Cinema's refusal of voice-over commentary, forestalls its clarification. On the personal level, Dylan's evasiveness reflects his inveterate self-mythologizing and reinvention, or his determination to retain his privacy. Contrasting dramatically with the Beatles' good-humored repartee in *What's Happening!*, he is suspicious of or hostile to the press, perhaps in response to their earlier incomprehension and misrepresentation of him; such is surely the case with the *Time* journalist, given *Newsweek*'s earlier exposé of his lies about being an orphan. All these may have been intensified by the film's reproduction of the more general spectacularization that his fame had imposed on him; for whatever authentic sense of self he possessed had for years been eroded by assumed identities, even by an assumed name. But Dylan's personal dissimulation and *Dont Look Back*'s uncertainty about the nature and social meaning of his art are subtended by a fundamental shift in popular music of which the film is unaware. Presenting itself as a behind-the-scenes exposé, yet obscuring his crucial personal transition and the historical transformation of folk to folk rock of which he was the symptom and vehicle, it appears to reveal everything, but explains nothing. Since the contentious elements in Dylan's current convictions and even their existence are never revealed, the disjunction

between his on-stage performance of the folk singer image with the single acoustic guitar and his move to fronting a rock 'n' roll band made the film an anachronism when it was shot, let alone when it was released.

An exercise in ambiguation, *Dont Look Back* redeploys Drew's crisis structure, but instead of occurring around a summary climax and dénouement, the crisis is ubiquitous, implicit in all situations without ever coming to a narrative resolution. And in the film's final sequence, it appears, not in a summary form, but only vestigially. As Dylan leaves the concert in the car with Grossman and Neuwirth, the latter asserts, "They were all there," referring to the Beatles and the Rolling Stones. Obviously pleased, Dylan begins to say, "I feel like I've been through some kind of a—thing," only to have his attempt to understand his new importance to the rock royalty interrupted by Grossman's announcement that, since he refuses to give answers, the media have labeled him an anarchist. The possibilities of the moment of introspection are lost ("Give the anarchist a cigarette") and the movie ends with Neuwirth quietly singing, "It's all over now, baby blue"—Dylan's farewell to folk that he sang when he returned to the stage after his controversial amplified set at Newport later that year.

THE LIMITS OF DIRECT CINEMA

Though the film cannot otherwise represent it, Dylan's transition from folk to folk rock is revealed in the film's two conspicuous departures from the axioms of Direct Cinema, in the visuals accompanying two songs, neither of them recorded live by Pennebaker: "Subterranean Homesick Blues" and "Only a Pawn in Their Game" (Figure 11.2). The former, the lead track on the first, rock 'n' roll, side of *Bringing It All Back Home* and his first top-forty hit opens the film as a prologue before the titles, and apart from fragments overheard on the radio, it is the only use of a record in the film and the only song heard in its entirety. Lacking any structural connection to other parts of the film, it opens with reverse zoom from building materials and milk churns in an alley behind the Savoy hotel, Dylan's headquarters for the tour, that comes to rest as

FIGURE 11.2 Dont Look Back: *"Subterranean Homesick Blues" (left) and "Only A Pawn in Their Game (right)."*

a carefully composed frame with Dylan on the right and Allen Ginsberg and Neuwirth talking in the corner opposite. Occasionally glancing at the camera, Dylan doesn't lip-sync, but rather displays a series of large cue cards with most of the song's rhymes—"fire hose," "clean nose" "plain clothes" "wind blows," and so on in various styles—drawn on them, the film will later reveal, by himself, Baez, Neuwirth, and others. Their size and the calligraphic variety (along with Ginsberg's presence) emphasize the importance of his lyrics as poetry, and also their materiality as visualized words. As the song ends, Dylan walks out the front of the frame toward the camera and the poet and tour manager depart in opposite directions. One of three similar versions filmed, Dylan himself proposed it, conceiving it as an imitation of a Scopitone short, and like similar promo films for television being made by the Beatles and others at the time, it anticipated music videos and has often been imitated.

The other one, quite different, is introduced by an Afro-Caribbean journalist interviewing Dylan who, after suggesting that he has a "deeply humanistic attitude to . . . Negroes," asks him, "How did it all begin for you, Bob? What started it off?" But instead of showing his reply, Pennebaker inserts a clip shot years earlier by another filmmaker. In July 1963, Theodore Bikel, the Freedom Singers, and Pete Seeger had performed at a voter registration rally in Greenwood, Mississippi, organized by the Student Non-Violent Coordinating Committee. Dylan had never been to the South and had no real experience of anti-segregation activism, but on Bikel's invitation, he accompanied them at no inconsiderable danger to himself. On Silas McGhee's farm, he performed "Only a Pawn in Their Game," his song about the murder a month earlier of Medgar Evers, field secretary for the National Association for the Advancement of Colored People. Ed Emshwiller filmed Dylan's performance and gave the footage to Pennebaker. It begins with swish-pan that settles on a close-up on the singer before opening out to reveal him dressed in a work shirt and dungarees and surrounded by black farmhands and organizers then zooms back into a tight close-up on his face as he finishes the last verses, with the listeners' applause used as a sound bridge to one of his English concerts.

Though both are unedited long takes, they otherwise infringe Direct Cinema's axioms, the first being staged specifically for the film and the other an editorializing insert misleadingly implying that Dylan's musical career began in his political involvement in the civil rights movement. Like eruptions from the film's unconscious, they reveal the two repressed personae over which it is stretched: the former depicts the rock 'n' roller that Dylan had already become but which the film otherwise conceals, while the latter, instancing one of the rare occasions when he put his reputation as a protest singer on the line over a political issue, reveals the Dylan that obsesses the film's various interlocutors but which he himself refuses to acknowledge. The possibility that "Maggie's Farm," the song in which Dylan signally abjured

his earlier career, may well have derived from McGhee's farm completes the irony.

The commitment to reportorial objectivity envisaged by Drew is discarded in many other respects. Chronology is reorganized in, for example, Dylan's first performance, which appears to precede his airport arrival, and the notion of the camera's fly-on-the-wall inconspicuousness collapses, for (as in *Jane* and *What's Happening!*) the celebrity protagonists are not only accustomed to the camera's presence, but adept at playing to it. But in this case, the main obstacle to discovering the truth behind the image was ontological rather than formal. Since he had recrafted so many layers of contradictory personae, the possibility of any access to a real Dylan would appear to be obsolete, if not meaningless. "I'm glad I'm not me," his remark on hearing a news account of his smoking, could stand for the guiding principle of his self-presentation.

A new kind of backstage musical, *Dont Look Back* overturned the conventions of the rock 'n' roll film as they had been consolidated in the Elvis genre and in *A Hard Day's Night*. It established documentary as the primary form of the countercultural US musical, and did so in ways analogous to Dylan's own musical innovations. It abandoned the two and a half minute 45-rpm single as the fundamental compositional unit that had endured through the Beatles' films and the Los Angeles documentaries, the artifice of lip-sync for live performance, and color and studio sound for grainy black and white and mono; and it created a film form that in many ways corresponded to the critical social aspirations of the folk revival itself and for the folk rock boom that followed it. But the originality of the new genre initially marginalized it in the cinema of its time. Despite Dylan's fame, Pennebaker was unable to secure the film's distribution until the owner of a chain of small theaters, the Art Theatre Guild, then in the process of shifting from foreign to adult films and who believed that its grainy 16-mm black and white resembled pornography, agreed to open it at the Presidio, a pornography theater in San Francisco, in May 1967. During this time Dylan was not making live appearances, so the film was the only way his fans could see him, and it ran for almost a year. Not until it subsequently opened in New York was a 35-mm print struck.

Direct Cinema's rejection of exposition and the persisting animus against authorial discursivity, combined with the contradictions of Dylan's transition from his protest and other forms of folk music to rock 'n' roll's commercial mainstream, prevented *Dont Look Back* from fully recognizing the emergence of folk rock. But in his next musical film, Pennebaker abandoned more of Direct Cinema's axioms and indeed all documentary distance, and committed his cinema to the counterculture and its music. Inspired by Bruce Brown's blissful surfing odyssey, *The Endless Summer* (1966), which he mistakenly believed to be about California culture, he made a euphoric documentary that announced the musical and cinematic springtime that would mature in the high summer of *Woodstock*.

Monterey Pop

Barely a month after *Dont Look Back* and two weeks after *Sgt. Pepper's Lonely Hearts Club Band* were released, the first of the major rock festivals was held at the Monterey County Fairgrounds just south of San Francisco over the three-day weekend of June 16–18, 1967.[9] The Monterey International Pop established the festival as the summary social ritual for late sixties' music, occasions where musicians and fans consolidated their sense of themselves as communality, an autonomous generation, and even an independent nation.[10]

Like the Newport Jazz and Folk festivals, founded respectively in 1954 and 1959, and the Monterey Jazz Festival, founded in 1958 on Newport's model, the Monterey Pop festival initially mixed financial and cultural motivations. Inspired by the 1966 Monterey Jazz Festival, Alan Pariser, a Los Angeles concert promoter, initially conceived it as a commercial venture in the fall of 1966. Securing Ben Shapiro, a booking agent, as his partner, he also recruited Derek Taylor, previously the Beatles' press agent, and Tom Wilkes, a graphics artist, who designed a logo. Obtaining sponsorship from ABC television, he secured commitments from Ravi Shankar and several bands from Los Angeles and San Francisco. Through Taylor, Paul McCartney suggested the Who and Jimi Hendrix, the latter then virtually unknown in the United States. Needing a headline act, they approached John Phillips, leader of the Mamas & the Papas, who had recently had half a dozen top-ten singles and a chart-topping album. Intrigued, Phillips introduced his friend, producer Lou Adler (then married to Shelley Fabares, whose second film with Elvis, *Spinout*, was on release). Under their influence the festival was reconceived as a nonprofit charity event, designed to validate rock 'n' roll as a fully mature musical form, equivalent in status to the jazz and folk of previous festivals. Only Ravi Shankar, Shapiro's client, who had been signed previously at $3,500, was paid, while all other acts agreed to donate their performances in return for expenses. Shapiro soon withdrew and, with input from a festival board of directors including McCartney, Paul Simon, Mick Jagger, Andrew Loog Oldham, Brian Wilson, and Smokey Robinson, it became the first rock 'n' roll festival to be organized, not by entrepreneurs, but by musicians, who were motivated not by money, but by music and the public cultural good: the first instance in which rock 'n' roll created a ritual of its own self-production on such a scale. The innovation was reproduced cinematically in *Monterey Pop*, which correspondingly became the first film in which rock 'n' roll culture represented itself in its own terms.

Almost everyone approached agreed to perform, producing a final line-up of more than thirty groups or individual performers: folk rock recording artists from Los Angeles, including the Byrds, Buffalo Springfield, the Mamas & the Papas, and Simon and Garfunkel; the new psychedelic San

Francisco bands including Quicksilver Messenger Service, the Steve Miller Band, Country Joe and the Fish, Moby Grape, Big Brother and the Holding Company, the Grateful Dead, and the Jefferson Airplane, almost all of whom had begun in acoustic folk but followed Dylan in converting to amplified instrumentation, and who were primarily still oriented to live performance rather than recording; contemporary African American soul artists, including Otis Redding, Booker T. & the M.G.s, and Lou Rawls—a group smaller than it would have been had not Chuck Berry declined, Dionne Warwick dropped out at the last minute, and the Impressions failed to appear; white US electric blues bands, including the Blues Project, Al Kooper, the Butterfield Blues Band, the Electric Flag, and Canned Heat; non-Western music including Ravi Shankar and Hugh Masekela; British groups including the Animals and the Who; and the Jimi Hendrix Experience.[11] Summarizing the tastes and the utopian yearnings of the Flower Children, the musicians performed on a stage decorated with a yellow banner on which was emblazoned, "Music Love and Flowers." A hundred thousand orchids were flown in from Hawaii, and for the occasion John Phillips wrote and Scott McKenzie recorded "San Francisco (Be Sure to Wear Flowers in Your Hair)." And come they did, with estimates ranging between forty and two hundred thousand. Owsley Stanley, pharmacist to the counterculture, freely distributed a special batch of LSD called Monterey Purple. Several performances resulted in recording contracts, and bands including Janis Joplin and Big Brother and the Holding Company, Electric Flag, and Otis Redding became stars of the counterculture overnight, and Jimi Hendrix's performance made him instantly mythical. As Eric Burdon later sang, "Even the cops grooved with us" and "Young gods smiled upon the crowd/Their music being born of love/Children danced night and day/Religion was being born/Down in Monterey."[12] Or as the Mamas & the Papas sang at the festival itself in "Creeque Alley," "California dreamin'" was "becomin' a reality." The summer—if not the Endless Summer—of Love began.

Where Alan Freed's mid-fifties shows had assembled the "many rivers" of black and white music that contributed to rock 'n' roll, Monterey presented a spectrum of the youth musics that had emerged after the decline of fifties' rock 'n' roll. Becoming known as "rock" rather than "rock 'n' roll," it too melded many elements. If not fully explicit, Big Brother and the Holding Company's song, "Combination of the Two" that opens the film celebrated the reconciliation of the very different cultures of Los Angeles's commercial folk and San Francisco's amplified folk blues. To this pairing could be added the Britain and the United States, and East and West (as articulated in the Butterfield Blues Band's "East-West," which had already incorporated Indian ragas and John Coltrane into Chicago blues). But the fundamental elements in the synthesis were black and white. For the first time in mainstream public rock 'n' roll, the programming together of diverse black and white musicians

was matched by the racial integration of several of the bands. The Jimi Hendrix Experience embodied all these developments. Though in *Monterey Pop* the group performs only the troglodytic garage band paean, "Wild Thing," in the actual concert and (in *Jimi Plays Monterey*, Pennebaker's later assemblage of the Monterey footage) in addition to his own compositions, his set list laid claim to virtually the entire counterculture catalogue: the main blues tradition with Howlin' Wolf's "Killing Floor" and B. B. King's "Rock Me Baby"; Bob Dylan's signature "Like a Rolling Stone" and the Beatles', "Sgt. Pepper's Lonely Hearts Club Band"; "Hey Joe," previously a folk standard, recorded by the Byrds and many others; and even a quotation from Sinatra's "Strangers in the Night" tossed into "Wild Thing." Hendrix's years in workaday rhythm and blues bands and his familiarity with Greenwich Village's folk and blues clubs and Chas Chandler's spiriting him away to London at its most swinging had allowed him to assimilate all the most important music of the period, informing an improvisational virtuosity matched only by Ravi Shankar. His genius welded his two white sidemen into the essential power trio, and his assertion in his introduction to "Wild Thing" at Monterey that "we're gonna do the English and American combined anthem together" summarized the most complex winding of the moebius strip of Anglo-African vernacular music that made him the most important musician of the period.[13]

But more than simply defining a new era in popular music, Monterey announced a tectonic cultural shift that first emerged in Northern California but would quickly spread over the United States and Europe. As Brian Jones told *Newsweek*'s correspondent, "I saw a community form and live together for three days."[14] The festival closely followed the "Gathering of the Tribes for a Human Be-In" in Golden Gate Park on January 14, 1967, an event similar to the civil rights sit-ins, but organized in response to the October 1966 outlawing of LSD in California; the drug was distributed, Timothy Leary and other counterculture gurus spoke, Allen Ginsberg and other poets read, and all the San Francisco bands who would appear at Monterey performed. The hippies and psychedelics became national news and a visible counterculture, with some factions committed to radically challenging the existing social order, and others to disengagement from it. As the major cultural form sustaining these developments, rock became the lifeblood of the movement and youth politics generally, and its values were dramatized and celebrated in the music and also in films about it. At Monterey the summary term for them was "groovy": in the film, David Crosby gushes, "Groovy! A nice sound system at last"; themselves "Feeling Groovy," Simon and Garfunkel sing, "Life I love you, all is groovy"; Hendrix avows that "Wild Thing" makes "everything groovy"; and *Newsweek*'s correspondent, Michael Lydon, confirmed, "The only word for it then was groove."[15] Film too became groovy; Direct Cinema was entranced, its sobriety stoned in bliss.

GROOVY: THE CONCERT FILM

From the beginning there had been plans to film the festival, with ABC purchasing the rights for a television special for $250,000. Bob Rafelson, creator of the Monkees television series was approached, but he withdrew and Pennebaker was hired. Working with Leacock, Albert Maysles, and three other cameramen, he photographed the festival in very fast 16-mm color reversal film, using cameras he had modified himself. Each cameraman had his own sound recorder, but all were synced to eight-track recording equipment borrowed from Brian Wilson and operated by soundman Wally Heider, who recorded directly from the stage system. As with *Dont Look Back*, only the stage lighting was used, but the visual austerity of Dylan's shows was replaced by the exuberance of lighting designer Chip Monck, a veteran of the Newport folk and jazz festivals and the Apollo Theater. But ABC found the rushes of Hendrix and other scenes inappropriate for a family audience and relinquished their interest, allowing Pennebaker, in collaboration with Phillips and Adler, to turn his footage into a feature-length film, free from outside influence on either its form or content.

Overall, *Monterey Pop* synthesized the structure of *Jazz on a Summer's Day*, with elements of previous live-performance documentary films. Whereas *The T.A.M.I. Show* and *The Big T.N.T. Show* featured concerts staged specifically for the respective films, *Monterey Pop* instead resembled *Jazz* and *Dont Look Back* in that the concert existed autonomously and prior to it. Like *Jazz*, it recreated the jukebox musicals' division between spectacle and narrative as a montage of scenes of the performances, cutting between the musicians and the audience members, and the crowds and other events at the fairgrounds. *Dont Look Back* was preoccupied with Dylan himself, in performance and in private offstage situations, leaving the audience unseen during the concerts and visible only briefly in the finale when (as in *The T.A.M.I. Show* and *The Big T.N.T. Show*) they enter the concert hall. But here Pennebaker reverses that structure; apart from three shots of John Phillips making arrangements by phone, there are no backstage scenes, and the film takes place entirely in the festival's public spaces. And whereas *Dont Look Back* had contextualized Dylan's music primarily among his entourage and the press, leaving the concert audience invisible and minimizing encounters with fans, here the audience becomes part of the narrative and the spectacle, eroding the division between musical producers and consumers.

Roughly equal screen time is given to musical performance and the attendees, and shots of Brian Jones, Jimi Hendrix, Mama Cass, and other musicians as audience members themselves, strolling with the crowds, display their commonality. The audience has an unprecedented prominence and autonomous thematic and visual interest: their presence is integral to the collective event the film celebrates, and their clothes, appearance, and

behavior, especially as they resemble the San Francisco bands, are part of the counterculture's visual aesthetics. So unlike *Jazz* and *T.A.M.I.*—and *A Hard Day's Night*—where performers and spectators were spatially segregated by the stage, *Monterey Pop*'s open space allows them to mingle; social boundaries become porous, and the montage emphasizes not the distance between musicians and the audience but the reciprocity between them and even the inhabitants of Monterey. The film documents the festival as a whole, rather than just the musical performances, portraying a commonality bridging musical and social differences and inviting the audience to join it.

As this utopian affirmation of the counterculture's aesthetic and social values takes over, the film further discards the aesthetics of Direct Cinema, and especially Pennebaker's own declared intention, "I wanted to capture the process of showing somebody what happened, almost scientifically."[16] In fact, his sympathetic identification with the counterculture leads him to modify or abandon the techniques by which the new documentary movement had claimed objectivity: observational discretion, fidelity to chronological and spatial integrity, sync-sound, and internally unedited long takes. Instead, together with his cameramen and editor, Nina Schulman, he drew on the avant-garde for techniques and forms of visuality commensurate with and reflective of the festival's aesthetic and social principles. As the filmic recreation of the festival and its values, *Monterey Pop* inaugurated another new rock 'n' roll visuality.

Each of its three opening sequences departs in a different way from Direct Cinema's principles (Figure 11.3). The simply animated, multicolored, handwritten titles, apparently homespun but in fact drawn by illustrator Tomi Ungerer (who also designed the event's poster), introduce the film as

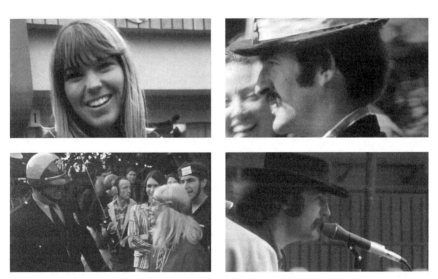

FIGURE 11.3 Monterey Pop: *Opening sequence.*

produced by The Foundation, "a non-profit organization." The performers are listed over a background of a rapidly pulsing mix of multiply superimposed abstract lights, fragments of live photography, and liquid-projection by the Headlights, the Fillmore Auditorium light show that accompanied several of the acts. These titles are accompanied by "Combination of the Two," a progressive rock instrumental by Big Brother, the Avalon Ballroom's house band. Over its repeating and modulating patterns, brief lyrics sung by (male) Sam Andrew invite the listener to "come to San Francisco and dig our sound," to "see all the people coming to the Fillmore," and to "feel more," while (female) Janis Joplin's accompanying choral whoops and shrieks promise to "knock you" and "rock you." Discursively minimal, the vocals are little more than an invitation to participate in the music's acoustic and somatic pleasure and in the sexual and communal "combinations" it promises, that is, an invitation to experience the polyvalencies of "rock" itself.[17] The highly edited combination of audio and visual tracks—the naming of the community of musicians, the San Francisco sound, and the lightshow coordinated with it—is essentially reflexive; the song is about itself as an audiovisual performance event and its social manifestation as festival. Its invitation is immediately replayed in another, diametrically contrary, cinematic form.

The next sequence introduces a dazzling blonde flower child addressing the camera as it zooms in on her face; tossing her long blonde hair and caressing the air with her hands, she asks, "Haven't you ever been to a love-in?" Though the implication of a question from the filmmaker suggests a subject-object relation that the film will subsequently try to erase, she continues, "God, I think it's gonna be like Easter and Christmas and New Year's and your birthday all together, you know. Hearing all the different bands. . . . The vibrations are just going to be floating everywhere." At this point, the third sequence interrupts. The opening chords of the record "San Francisco (Wear Some Flowers in Your Hair)" are heard as extradiegetic underscore, then the lyrics repeat the first song's and the girl's invitation to join the "whole generation with a new explanation" who are coming to join the "gentle people" of San Francisco for the summertime love-in. The visuals cut to a series of brief vignettes of these gentle people, and close-ups of another radiant girl and of a man kissing a baby. Over the lyrics "if you're going," a group of three people dressed in classic freak finery walk by; and over "flowers in your hair" another girl, garlanded with a crown of some of the orchids, smiles blissfully and blows bubbles in the air that are caught by other flower girls. The collage continues with more costumed freaks, more smiling beauties, a couple dancing on the grass before a psychedelic schoolbus, and the helmeted police laughing with a hippie girl. At "all across the nation," a group of boys unload a trailer of tent poles, followed by several shots of the stage being constructed. More brief shots of the people—painting, making flags, building a teepee—then a return to the stage, where Phillips gives instruction to the sound crew and David

Crosby hears it and contributes his "Groovy, a nice sound system at last." As the song fades, a plane flies overhead, and then on the tarmac, musicians are seen to arrive at an airport, so introducing the other element in the dual focus narrative that will culminate in their union and mutual love.

In their manifest constructedness, these three sequences negate Direct Cinema's fundamental principles of both shooting and editing. Of the three forms of audio-visual composition, only the second with the flower child reflects the priority of the sync-sound long take, but as an obvious interview it is interventional rather than observational. Marrying song lyrics to the abstract visual collages, respectively of the lights and community, the montages of the first and third sequences instance the film's more general use of underground film's expanded visuality, the filmic reconstruction of space and time, and especially the use of the commentary of festival participants and their reciprocation of the song lyrics to supply the equivalent of voice-over narration. In cutting non-performance events to the music and allowing the gentle people and music to speak for themselves, the film integrates itself with the festival, and in its audio-visual musical spectacles, field/reverse-field figures will show performers and audience *looking back* at each other—and position the film's audience amongst them.

The first color rock 'n' roll documentary, *Monterey Pop* gives the musicians a rich sensual presence in both daytime natural light and the festival's stage lighting at night, the latter generating starker, more contrastive, and often more textured, compositions, especially in picturing a brightly lit face against a black background. In the Hugh Masekela, Jefferson Airplane, and Otis Redding sequences, the stage lights are augmented by the Headlights, who introduce swirling psychedelic abstractions and as well as scenes of San Francisco hippies. The camerawork is flexible and fluid, shifting among close-ups of individual musicians and wider shots of bands, interspersed with cut-aways to audience members, and freely mixing long takes and clusters of shorter ones. Some of the five handheld cameras, with zoom lenses that allow close-ups as tight as Lester's in *A Hard Day's Night*, mingle intimately among the musicians on-stage and the crowds off it, free to search out and spontaneously track visual highlights with an agility reflecting Direct Cinema's emphasis on the cameraman's virtuoso improvisation. Perhaps the most stellar instance is the eighteen minute performance of "Raga Bhimpalasi" from Ravi Shankar's three-hour set; beginning with a collage of short takes of the attendees, it segues into a similar series of short takes of the group warming up, which give way to a very tightly edited montage of mostly longer takes as his music moves into its extended improvisations, though here Pennebaker still periodically cuts away to shots of the astonished crowd. The combination of the festival system's soundtrack and his own five cameras, whose own sound recording could be reliably synced to it, allowed him an editorial flexibility similar to that enjoyed by Lester. But rather than imitating the

television-advertising rapidity of Lester's montage and patterning his own editing on the regular simple structures of the Beatles' pop, Pennebaker counterpoints the visuals against the more organic, improvised, and irregularly repetitive qualities of Shankar's music, which also characterized the developing currents in counterculture music.

After the opening scene with the flower child, only in a couple of instances are there sync-sound interviews with attendees, but brief shots of them are collaged together and introduced as temporal markers to indicate the passing of a night, for example, or to display the distinctiveness of the counterculture's appearance. Few of them are substantially individualized but rather, as tesserae placed in thematic mosaics, they appear as instances of the emerging counterculture and hence often as manifestations of the music's reflexive cultural themes. An extreme example is the Animals' "Paint It Black," where the line, "I see people walk by dressed in their summer clothes," motivates an extended, minute-long cut-away collage of freaks in their finery (including Brian Jones resplendent in velvet, chiffon, and jewelry) that then modulates into more general festival scenes. The sequence is a visual jam that sympathetically documents the counterculture as the social manifestation of the ethos personified in the musicians.

The montage in these interludes reflects the artifice and constructedness of the film as a whole, the rejection of sync-sound long takes being a local re-enactment of its overall rejection of temporal and spatial fidelity to the real. The editing down of the long takes for the montage clusters recurs most crucially in the deployment of the editing figure rejected in *Dont Look Back*: the shot/reverse shot. Most extreme are several reverse-shot close-ups of audience members inserted into shots of the musicians that artificially construct spatial relations that have no ontological warrant: Mama Cass responding to Janis Joplin, for example, or mesmerized girls watching Hendrix destroy his guitar. Again this local version of the editorial restructuring of the festival's overall chronology is anticipated in the opening sequence: Big Brother and the Holding Company, who are heard during it, in fact performed on the second and third days, not at the beginning of the festival, and McKenzie, only on the last evening; and the grassy park where the "whole generation with a new explanation" is seen was in fact some two miles from the performance area. At the other end of the film, Ravi Shankar did not close the festival; he played on Sunday afternoon and ten other acts, including Hendrix, followed him that evening, the last of which, the Mamas & the Papas, appears to precede him. But though the performances were entirely re-sequenced, the temporal narrativization is unemphatic, neither noticing nor constructing much of a plot beyond observing the crowds arriving, introducing the police and management, and using morning scenes to suggest a cycle of three days. The acts are arranged as a disc jockey might arrange an evening's music, alternating among rhythms, mixing black and white and foreign and domestic performers,

but building to a climax with the back-to-back Redding and Hendrix perfor-
mances, before bringing the heat down with the Mamas & the Papas in prep-
aration for Shankar's blissful conclusion. Thematic rather than chronological,
the composition is designed to visualize the rhythms of a utopian community
of love founded on music.

Pennebaker's presentation of the festival in terms of its own self-definition
allowed him to revise the social codes of earlier rock 'n' roll films, especially
in relation to delinquency, which is reconstructed as the principled contes-
tation of the defunct ethical systems sustaining the violence and repression
of the corporate imperialist state. The identification of the rock generation
as a cultural gestalt constructed on music entailed a more categorical break
between its youthful adherents and those outside than in previous subcul-
tures in which music did not yet imply the radical transformation of an entire
way of life. And so, even though mainstream society attributed infractions of
social norms and laws to the counterculture, when represented from within
its own agency and self-understanding, norm and deviation were reversed.
Marijuana, LSD, and other drugs became essential rituals, and several times
attendees are seen smoking marijuana. Confrontations with the police over
the issue had been avoided by their tacit agreement not to bust pot smokers,
so in this respect the police are seen to be behaving themselves. In more gen-
eral terms, the Monterey Police Chief talks about his fear of the Hells Angels
and the Black Panthers that had caused him to call in six hundred National
Guardsmen extras, but the film shows a jocular familiarity between police,
concert organizers, and attendees, while the few Hells Angels, made groovy
by the good vibrations, sit peaceably in their seats.

Parallel transformations accommodate rock's sexuality and its association
with African Americans. Rather than being minimized, the black masculin-
ity that had been demonized by critics of fifties' rock 'n' roll is hyperbolically
celebrated in two of the film's most powerful sequences at its climax, back-to-
back sets by Otis Redding (Figure 11.4) and Jimi Hendrix (Figure 11.5), in
which musical and filmic virtuosity are combined. The former begins with
a one-minute shot from center front by Jim Desmond, showing the soul
singer and his band performing "Shake" before a liquid-projection by the
Headlights; it moves into medium close-up as he begs the audience to join in
and then out again to a wide shot for the conclusion.[18] The sequence ends with
a three and a half minute close-up shot by Pennebaker himself from the rear
of the stage looking into the lights for the dramatically agonized "I've Been
Loving You Too Long (To Stop Now)"; as Redding moves into various posi-
tions before the lights, the shot is by turns realistic or forced into abstraction,
with highlighted silhouettes of his head between. Though the shots produce
quite different visual effects, their beauty depends on the cameramen's agil-
ity in responding to the lights' intermittent interaction with Redding's danc-
ing. But in editing, Pennebaker inserted a brief, fifteen-second, wide shot by

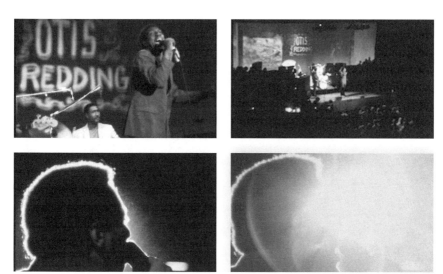

FIGURE 11.4 Monterey Pop: *Otis Redding.*

Al Maysles between the numbers, one that holds both Redding and the audience together in the same frame as he declares their commonality; "This is the love crowd, right? We all love each other, don't we? Let me hear you." The crowd's enthusiastic vocal response completes an audio correlative to their union with the musician in the visuals, constructing his epic of desperate sexual infatuation as a social commitment. As his performance ends with his repeated cries of, "Good God Almighty, I love you baby!," his movement in and out of the lights turns the screen first into flashing pulsations, then into a darkness from which, without transition, Hendrix's face emerges, as indeed his own hybrid music had emerged from Redding's more traditional black music.

Photographed by Desmond and Pennebaker, the Hendrix sequence (Figure 11.5) begins with a close-up on his face, dominated by a gleeful grimace as he acknowledges the applause for his previous number, his upper lip outlined by the pencil-thin moustache he imitated from Little Richard (who so inspired his appearance and his music that he supposedly once remarked, "I want to do with my guitar what Little Richard does with his voice").[19] As he walks forward, his fingers pointing to his ears to communicate with the sound controller, he moves into a medium shot, and his full sartorial extravagance becomes visible: in place of Otis Redding's more formal two-piece suit with an open-necked shirt (albeit both in different shades of electric green) and close-cropped hair, Hendrix appears as a dazzling theatrical gypsy pirate in skin-tight red pants, a frilled gold shirt, and an embroidered black vest, with miscellaneous scarves and silver chains and a head-band restraining his wild hair. Holding his red Stratocaster upside down in front of his face to display the curling florals he had painted on its white front, he moves it around

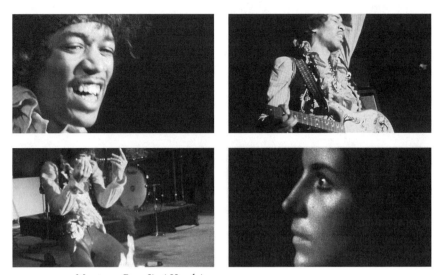

FIGURE 11.5 Monterey Pop: *Jimi Hendrix.*

in the air generating waves of feedback. The same shot continues as he hits the opening chords of "Wild Thing" and, interrupted only by a couple of very brief cutaways each to bassist Noel Redding and drummer Mitch Mitchell and a shot from the audience of the entire band, it continues through the whole song, through his rolling over on the stage, grinding the guitar with his pelvis into the stack of amps, spraying it with lighter fluid, lighting it, and eventually breaking it on the stage. With two final cut-aways to startled girls in the audience, the shot lasts almost seven minutes, zooming in and out and continually reframing, following him around the stage and keeping his face, his playing, and violent motion as the visual center: a *tour de force* of rock theatrics captured in a *tour de force* of Direct Cinema photography.[20]

Hendrix's extravagant visual and musical self-spectacularization may have been ignited by nervousness occasioned by his first US appearance since his London metamorphosis, by his rivalry with Pete Townshend, or by the enormous amounts of Monterey Purple he is supposed to have consumed. And it must be understood in respect to his genius, ambition, command of virtually the entire catalogue of black music and much of white popular music, and other personal issues. Though he had included guitar-smashing rituals in his Greenwich Village performances before going to England as well as in his performances there, and had on several occasions set his guitar alight during the performance of his song "Fire," his incendiary reinvention of what had become meaningless in the Who's rote shows parallels his transformative covers of the monuments of white rock: the Troggs' minimalist dirge here, "Sgt. Pepper" (which had led Paul McCartney to insist on his inclusion in the festival), and later Dylan's "All Along the Watchtower." As such, it also epitomized

the wider cultural aspirations of the moment, the amalgamation of blues and country music, the heritage of African American and white working-class British culture: "the English and American combined anthem."

THE LOVE CROWD

Even as Monterey inaugurated the pop festival as late 1960s rock's most important social ritual, so Pennebaker's documentary about it made the concert film the most authoritative form of rock cinema.[21] Its basis in live musical performance entailed a new *vérité* representation of both the spectacle of music and the narrative of its social matrix that further restructured the motifs of the jukebox and the classic musicals. The biopic narrative of a star's rise to fame echoed residually in the instances of Hendrix and Joplin becoming stars at the festival; but the classic musicals' dual-focus narrative was further transformed beyond *A Hard Day's Night*'s re-creation of the culminating union of the star and his lover in the Beatles' ecstatic audio-visual consummation with their female fans. *Monterey Pop* extended that commonality so that romantic relations become a generalized love among the musicians and the audiences of the kind that Otis Redding invoked in exclaiming, "We all love each other, right?" Moreover, the prominence of males among the fans inhibits the feminization that *A Hard Day's Night* imposed on them, while simultaneously sustaining heteronormativity and allowing the performing musician to be female almost as readily as male: Grace Slick, Janis Joplin, or Mama Cass. This shared, however unequal, commonality of musicians and audience transformed the classic musicals' motif of the kids putting on a show. Though it had survived occasionally in *Rock Baby—Rock It* (Murray Douglas Sporup, 1957), *Shake, Rattle & Rock!* (Edward L. Cahn, 1956), and other jukebox musicals, more usually it was replaced by the industrial alternative, the concluding broadcast television spectacular. But by the mid-1960s, a rock concert organized by Alan Freed, an adult from outside the subculture, or the unseen television producers of *A Hard Day's Night* had lost cultural credibility. Though the Monterey festival was not in fact free, it was the first charity festival, and the intention of making it nonprofit gave it a degree of credibility as genuine folk event.[22] Social groups that were part of or committed to the counterculture created the festival, the music, and their cinematic representation, expressing the transformation of the aesthetic, ideological, and social meanings of music that occurred in the transitions from folk to folk rock to rock. By making the festival unsuitable for ABC, Hendrix's performance of musical and sexual excess finally liberated the rock musical from the dependency on television that *Rock Around the Clock* had inaugurated more than a decade earlier. Cinema was now—for a short time—able to celebrate the music and itself as folk culture, liberated from corporate involvement. The liberation extended to the film's audience, who were implicitly invited

to join the same commonality, recognizing their actual or desired selves in the Monterey freaks and audio-visually experiencing their musical and social pleasures. They found themselves directly addressed by Otis as he testified, "I've been loving you too long to stop now," or by Janis as she asked, "Hon', tell me why love is like/Just like a ball and chain," and even by Jimi when he affirmed, "Wild Thing, I think I love you."

The utopian promises of Monterey and of *Monterey Pop*—and the social contradictions underlying them—were all hyperbolically extended at Woodstock and in *Woodstock*.

Utopia and Its Discontents

FROM *WOODSTOCK* TO *MESSAGE TO LOVE*

Other two- and three-day pop festivals soon followed Monterey: in 1968 in Miami, and in 1969, beginning with the last live Beatles' performance recorded in *Let It Be* (Michael Lindsay-Hogg, released 1970) on January 30, in Toronto in June, in Atlanta over the July 4 weekend, in Newport a few days later, and in Woodstock in August. But in the two years between Monterey and Woodstock, the US political situation and especially its youth cultures had been transformed. Despite the half million US troops in Viet Nam and the monthly draft of nearly 25,000, the Tet offensive in the intervening year of 1968 revealed the absurdity of predictions of the invasion's imminent success, consolidating opposition to it and so increasing social polarization. The assassinations of Dr. Martin Luther King and Robert Kennedy increased the militancy of the civil rights and student movements, and violence escalated with popular riots in over a hundred and fifty urban ghettos. In June 1969 the Weathermen faction seized control of Students for a Democratic Society (SDS), and some youth groups followed it and other elements of the New Left into open confrontation with state power. Others responded to the apparent impossibility of influencing the government's imperialist policies by returning to the Beats' social disaffiliation. Freaks, hippies, and Yippies rejected what was perceived as a one-dimensional, administered, and immoral social system, and variously amalgamated sensory renewal, psychedelic drugs, psychic liberation, Eastern spirituality, communal living, and free love into a totalized alternative to it: a counterculture.

Having replaced film as the most important element in youth culture as a whole and especially in the counterculture's core aesthetic and ritual practices, music too had changed since Monterey. Jimi Hendrix's prominence spurred new popular amateur and semi-professional performance, but also a new generation of super-groups, with Led Zeppelin first performing in October 1968. Industrial developments facilitated both amateur and

commercial production: with its capacity for extended tracks, the LP album increasingly displaced the 45-rpm two-minute single as the main form of record distribution, which in turn furthered FM radio's shift from classical music to "alternative" or "album-oriented" rock. As had jazz for the Beats, late sixties' rock simultaneously figured both aesthetic and social priorities: the more extended, free-form, improvisatory performances associated especially with Hendrix, the San Francisco bands, and Cream exemplified rebellion and freedom, while the bands themselves remained metonymic of a new social order.

In early 1968, Abbie Hoffman's observation that the Beatles were "a new family group . . organized around the way they create . . [that] extends across a peer group" contained the key element: the notion of youth as a distinct ideological and social formation, modeled on the Native American tribe.[1] But at Woodstock, after the riots in Chicago, the tribe became a nation, and one committed to interracial cooperation. For Woodstock, Hoffman wrote a tract, "The Hard Rain's Already Fallin,'" that was distributed with the festival's free program. Referring to the arrest and jailing of both white radicals and three hundred Black Panthers, he described the state's offensive against the conjoined cultural and political revolution. He admitted that he and the seven others arrested in Chicago were all guilty of being members of a "vast conspiracy" "pitted against the war in Vietnam and the government that still perpetuates that war, against the oppression of black communities . . against the growing police state, and finally against the dehumanizing work roles that a capitalist economic system demands." "Digging rock or turning on" were still essential, but now implied a systemic social contestation. Hoffman's dramatic conclusion echoed the phraseology of Black Power, "With our free stores, liberated buildings, communes, people's parks, dope, free bodies and our music, we'll build our society in the vacant lots of the old and we'll do it by any means necessary. Right On!"[2] Woodstock did not fail him. Afterward he argued, "the sheer number of beautiful people struggling against the inclement weather, and basic needs of survival, turned the festival into a Nation dedicated to victory."[3] During the trial of the Chicago Seven (after Bobby Seale had been separated from the other defendants), when the presiding judge asked for Hoffman's place of residence, he replied, "I live in Woodstock Nation. . . It is a nation of alienated young people. We carry it around with us as a state of mind in the same way as the Sioux Indians carried the Sioux nation around with them. It is a nation dedicated to cooperation versus competition, to the idea that people should have better means of exchange than property or money, that there should be some other basis for human interaction." And he stated that one of the things he had done himself to participate in the revolution was to have been a rock 'n' roll singer.[4]

A similar but more apocalyptic analysis was made by John Sinclair, a poet, journalist, and for a time, manager of the Detroit band, the MC5. In a series of

essays published in the underground press between March 1968 and July 1969 (when he was jailed for ten years for the possession of two joints), Sinclair called for a "Total Assault on the Culture" and, echoing Black Panther Fred Hampton's "Rainbow Coalition," proposed a Rainbow Culture of youth, blacks, prisoners, and indeed all people opposed to the dominant society, founded on the liberating energy of what he termed "Self-Determination Music": rock 'n' roll, the blues, and Free Jazz. Released from prison in 1971 when Michigan's marijuana laws were ruled unconstitutional, he republished these essays together with a long summary panegyric on rock 'n' roll that, he argued, had both "destroyed history," and "created a whole new-life form on this planet," a "Guitar Army."[5] *Blackboard Jungle* (Richard Brooks, 1955), he argued, had been "the first movie about our culture," and the black music it introduced to white youth had been regenerative:

> . . . we learned our music from black people, we learned that we could resist the established order, but we also learned how to *live* from black people, we learned about the sense of *community*. . . . And we learned how music can be a first term in people's lives from them too, how a whole culture can be built up on a strong musical foundation.[6]

Only one caveat troubled Sinclair's visionary Maoism: control over the means of production of rock 'n' roll; the possibility that, rather than being integrated in the rainbow community, rock 'n' roll and especially its stars could be co-opted by capital. The music might still sound good, but its revolutionary potential would be nullified if it became a commodity and "turned into an entertainment form instead of a life form."[7]

Even at the time, when real social possibilities appeared to justify his utopian hopes, not even all those affiliated with the counterculture agreed. A couple of months before Woodstock, in "Rock For Sale," Michael Lydon, who had written so enthusiastically about the Monterey festival for *Newsweek* two years earlier, more starkly warned the readers of the popular leftist journal *Ramparts* of corporate involvement in rock.[8] He discounted Sinclair's notion of a popular mode of musical production, contending that it had always been "a product created, distributed and controlled for the profit of American (and international) business."[9] Ridiculing the White Panthers' proposal of rock's centrality in a "total assault upon the culture," he cited *Billboard*'s announcement that in 1968 the record industry had become a billion-dollar business and an infamous ad line by Columbia Records, "The Man can't bust *our* music," to argue that rock's integration into corporate capital circumscribed whatever liberating effects might be proposed for it, imprisoning almost all its performers no less than its audiences.

> So effective has the rock industry been in encouraging the spirit of opti- mistic youth take-over that rock's truly hard political edge, its constant

exploration of the varieties of youthful frustration, has been ignored and softened. Rock musicians, like their followers, have always been torn between the obvious pleasures that America held out and the price paid for them. Rock and roll is not revolutionary music because it has never gotten beyond the articulation of this paradox. At best it has offered the defiance of withdrawal; its violence never amounted to more than a cry of, "Don't bother me."[10]

However much they professed political radicalism, he argued, even the Jefferson Airplane, stars at Monterey, Woodstock, and Altamont, failed to resolve these contradictions.

Both Woodstock and *Woodstock* (Michael Wadleigh, 1970) came into being amidst the tensions limned in Sinclair's vision of rock as potentially a "life form" and Lydon's contempt for its debasement into commodity entertainment, tensions made all the more complex by the increased interchange between the corporate world and the counterculture, their mutual interpenetration, and the variety of intermediary positions. Rather than questioning rock 'n' roll's commercialization, the jukebox musicals had endorsed it, even when, as in *The Girl Can't Help It* (Frank Tashlin, 1956), *Jailhouse Rock* (Richard Thorpe, 1957), or *Expresso Bongo* (Val Guest, 1959), they dramatized the venality of some specific component of the industry. But when the corporate role in music was linked to the politics of corporate capital, and when corporate capital was linked to the invasion of Viet Nam,[11] then it became harder to believe that rock could reconcile folk music's demotic communal energy with its own commodity function—as both Woodstock and *Woodstock* discovered.

Woodstock

The Woodstock Music and Art Fair was held August 15–18, 1969.[12] It came about through the enterprise of four young men, variously positioned between the counterculture and its commercialization: John Roberts, a wealthy business student; Joel Rosenman, a recent law graduate; Michael Lang, a concert producer, most recently of the Miami Pop Festival in 1968, who had since taken over management of a rock band; and Artie Kornfeld, an executive at Capitol Records and a record producer and songwriter. In 1966 on his twenty-first birthday, Roberts received $400,000, the first installment of an inheritance of several million dollars. He and Rosenman placed an advertisement in the *Wall Street Journal* reading, "Young Men with Unlimited Capital looking for interesting and legitimate business ideas." It led to their meeting Lang and Kornfeld, who had independently conceived the idea of a music festival in Woodstock, where Dylan and other folk rock musicians had settled, and the four went into business as Woodstock Ventures because, as Roberts later recalled, it "seemed like an easy way to make money, have fun and 'do something meaningful'

with my life."[13] Their explorations of several sites in upstate New York precipitated local fears of a hippie invasion, and only after tickets had been sold and other arrangements were well underway were they able to settle on 600 acres of pasture that included a natural amphitheater on Max and Miriam Yasgur's dairy farm in Bethel, seventy miles from Woodstock itself.

Bill Hanley of the Fillmore East was hired to create the sound system and record the master tapes; Chip Monck, lighting director at Monterey, hired to design and light the stage, also became the master of ceremonies; and Arnold Skolnick designed the logo with the guitar and dove for what had become "Three Days of Peace and Music . . . An Aquarian Exposition." Hugh Romney (not yet christened "Wavy Gravy") and eighty other members of the Hog Farm, a California commune, were brought in to help with security planning, bad trips, and cooking. The promoters met with Abbie Hoffman to ensure that the Yippies would not disrupt it or defame it as a corporate rip-off, and in return provided them space for the distribution of political literature. Even before the bands were announced, word-of-mouth and feeds to the underground press emphasizing a broadly countercultural celebration had generated enormous publicity across the country. Days before the scheduled opening, crowds descending on Bethel caused traffic congestion. Construction of the stage and lighting towers ran late, and the fences, ticket booths, and concession stands were never properly completed. And while the festival had been planned for a maximum of 150,000, more than 186,000 tickets were sold, and over the weekend perhaps three times that number attended. The fences were broken and a free festival was declared. No one had ever before performed live for so many people.

The thirty-three acts were a less ecumenical mix than at Monterey. Los Angeles folk was replaced with the less commercial Richie Havens, Arlo Guthrie, and Joan Baez; the British bands were fewer, Ravi Shankar was the only other performer from outside the United States, and no attempt was made to include Motown musicians. Apart from Sha Na Na's camp performance of fifties rock 'n' roll, after the folk and folk rock of the first day, most performers were US hard- and blues-rock bands from both coasts, which of course included racially mixed groups, most notably, Sly and the Family Stone, Santana, and Hendrix's Gypsy Sun and Rainbows. Having passed beyond its dependence on the Beatles, the counterculture now had a confident vision of its own synthesis of black and white music, what Sinclair called "Rainbow Music," or what, introducing his own set, Country Joe called "Rock and Soul Music."

Woodstock

A week before the festival was to begin, preparations for filming it had still not been completed, and with only three days to go, a deal was finalized with

Michael Wadleigh and Bob Maurice, who respectively became the direc-
tor and producer.[14] On leaving New York University (NYU) film school in
the mid-1960s, Wadleigh (camera) and John Binder (sound) had founded
an independent company, Paradigm Films. Working independently outside
the unions, first for National Educational Television producer Dale Bell, and
also on location shooting for the Merv Griffin show, they produced several
innovative documentaries, often employing Martin Scorsese and Thelma
Schoonmaker, whom they had known at NYU. Wadleigh himself worked as
a photographer on important experimental films, including Jim McBride's
faux-documentary, *David Holzman's Diary* (1967), Scorsese's *Who's That
Knocking at My Door* (1967), which Schoonmaker edited, and Paradigm Films'
own production, *No Vietnamese Ever Called Me Nigger* (David L. Weiss, 1968).
He became especially skilled with the lightweight Éclair NPR handheld
16-mm camera, whose many advantages included minimal noise and a rotat-
ing turret that allowed rapid switching among different lenses. In the spring of
1969, Wadleigh formed a new company, Wadleigh-Maurice Productions, with
Maurice, Schoonmaker, and Sonya Polonsky, who became production man-
ager. Though D. A. Pennebaker and the Maysles brothers had expressed inter-
est, and though neither Wadleigh nor Maurice had experience on a project
of this size, in return for a percentage of the film's profits Wadleigh-Maurice
Productions secured the rights to film the festival, with them being respon-
sible for production costs and finding a distributor.

Despite the abbreviated preparation time, Maurice and Wadleigh with Bell
and Polonsky quickly assembled a crew as big as one for a studio produc-
tion; eventually it would include thirteen cameramen and thirteen cameras,
twenty-one camera motors, 350,000 feet of raw stock, and seventeen cars,
vans, and motorcycles.[15] The difference between spectacle and narrative was
formalized, with different teams assigned to each: Larry Johnson oversaw
sound, Binder and associate producer Bell were responsible for three camera/
sound teams that would film the attendees and the event as a whole, while
Wadleigh himself oversaw the picture for the concert scenes, and Bill Hanley
took charge of the concert sound recording. Six cameramen, each with a
magazine changer, note-taker, and runner under his supervision, covered the
stage. Wadleigh himself always shot from front and center, covering the lead
performer either on the stage itself or on a somewhat lower lip constructed
in front of it. All cameramen were allowed to follow their own impulses,
Wadleigh's only instructions being "Film what turns you on."[16] They shot 875
cans of 16-mm film: 350,000 feet, almost 70 miles, and 175 hours.

Post-production was equally complicated. After the festival, when the
promoters were around $1,600,000 in debt, Kornfield made a deal with Fred
Weintraub, formerly the owner of The Bitter End folk music club, who had
recently been appointed executive vice president of Warner Bros. Though
vehemently opposed by other executives, the deal gave the studio exclusive

distribution rights and 90 percent of the film's net box office receipts and the filmmakers $1 million for post-production costs and total control of the editing. Supervised by Schoonmaker, the editing took seven months. The original plan to maintain synchronization by means of an on-stage digital clock had been foiled by the lack of clock, so all the footage had to be laboriously matched by sight, a process that at one point occupied some fifty editors working continuously in three eight-hour shifts. Though Schoonmaker was the final arbiter, the editing of the performance and the audience material was, like the shooting, allotted to separate teams, with different editors assigned specific musical performances, producing discrete compositional units. Synchronization of the several picture tracks was facilitated by the use of five Keller Editing Machines (KEMs) that allowed three shots to be seen simultaneously and in sync with a soundtrack, and three Steenbeck editing tables were also used. The 16-mm original was blown up to 35-mm Cinemascope, often using the wide-screen format to create multi-screen compositions. Even though it involved non-union personnel, the music mix was completed at Warners' own facilities in Hollywood under the supervision of George Groves, a veteran of sound mixing since *The Jazz Singer* (Alan Crosland, 1927) and *Gold Diggers of Broadway* (Roy Del Ruth, 1929). Mixing was made to four-track magnetic sound (three front channels and one rear) using—for the first time ever in a feature film—Dolby Type-A noise reduction. The result had a range and fidelity much superior to the mono optical tracks typical of feature films of the period, one that later earned an Academy Award nomination for best sound. Final prints were not ready until the day before the press screenings but, despite Warners' desire for a much shorter film that could be turned around faster in the theaters, all three hours and four minutes of *Woodstock: Three Days of Peace and Music* opened in New York on March 26, 1970.[17] Next year it won the Oscar for Best Documentary Feature.

Woodstock is the utopian culmination of the dual focus rock 'n' roll folk musical. It represents the eponymous Music and Art Fair as a communal cultural and social ritual in which performers and people are brought together in a proleptic transcendence of the division between cultural producers and consumers and indeed of commodity relations in general in a new, unalienated nation, with music as the central sacrament and ritual.[18] It portrays these epochal events as enacted within a double frame that represents and discursively articulates their implications. In the outermost frame, the visuals in which the MPAA "Restricted" rating certificate spontaneously explodes into flames is accompanied by the opening notes of Jimi Hendrix's performance of "The Star-Spangled Banner," which is resumed in his concluding performance. Inside these are placed, at the beginning, a direct address by Sidney Westerfield, a homespun local dressed in western duds who declares, "The kids were wonderful . . . nobody can complain about the kids. This thing was

too big, too big for the world. Nobody has ever seen a thing like this. And when they see this picture ... they'll really see something"; and at the end, Max Yasgur's benediction, "the important thing that you've proven to the world is that a half a million kids, have nothing but fun and music, and I ... God bless you for it." All the film is thus appropriately contained within a bar or two of Hendrix's musical reconstruction of the nation and its contradictions. In this it structurally resembles experimental films that similarly compress time into an apocalyptic instant, Jean Cocteau's *Le Sang d'un Poète* (*Blood of a Poet*, 1930), for example, whose action takes place within a fraction of a second marked by a slow motion shot of a falling chimney that it interrupts. Similarly, as an audio-visual excavation of the interior of Hendrix's apocalyptic notes, as soon as *Woodstock* is seen, it has already happened and, as Westerfield's understatement affirms, it is beyond ordinary expression. In William Blake's visionary proposal, "all the Great/Events of Time start forth & are conceiv'd in such a Period,/Within a Moment, a Pulsation of the Artery."[19]

The drama involves two main and two subsidiary groups of protagonists: on the one hand, the musicians (Figure 12.1) and the attendees, who

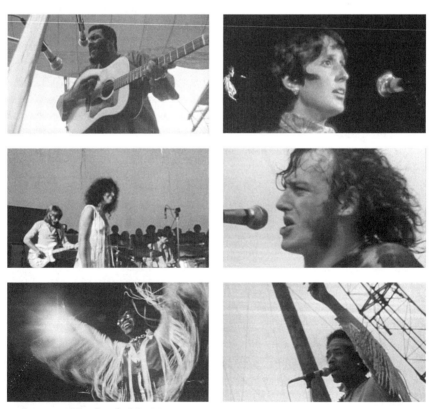

FIGURE 12.1 Woodstock: *Musicians.*

typically refer to themselves as "freaks" (Figure 12.2); and on the other, the local people and the promoters, the latter including the workers who build the stage and lighting and sound systems, provide food and security and so on, and the facilitators or stagers. A period of time before the "Three Days of Peace and Music" and the morning after it were structured into the film and, much more radically than in *Monterey Pop*, time and space—the actual chronology of the festival, and single point perspective—were disregarded and the events resequenced so as to form a classical five-act structure.[20] Framed by the four intervening nights, the constituent events were mobilized in a dramatic arc of exposition, rising action, climax, falling action, and dénouement:[21]

Act I, the period before and culminating in "Thursday": To the accompaniment of "Long Time Gone" by Crosby, Stills & Nash, with its invocation of a new day, the exposition introduces the rural location and the secondary protagonists, the local farmers and the stagers, all working in the beautiful land, with the stage itself an echo of the schoolhouses and churches raised in countless westerns and musicals, including Elvis's *Loving You*. After Mike

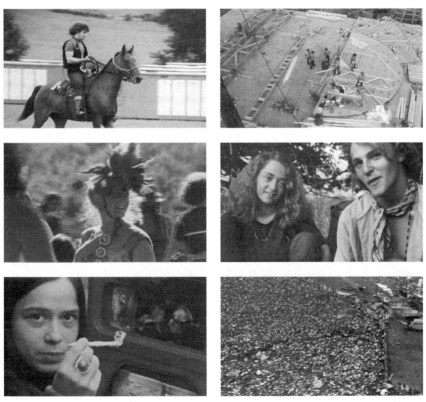

FIGURE 12.2 Woodstock: *Fans.*

Lang admits the hassle of the politics involved to the ABC newsman, Canned Heat sings "Going Up the Country" for the first major protagonists, the happy, beautiful, young people who arrive in buses, cars, but most on foot: "I'm gonna leave this city, got to get away." Night falls but, juxtaposed on the film's first split screen, still the people come, ghostly outlines in the car lights, and still the workers continue, building the "Wooden Ships" that will carry the elect away from the dead war-torn world: "Horror grips us as we watch you die/All we can do is echo your anguished cries."

Act II, "Friday": As dawn rises over the stage and the crowds, the rising action introduces conflicts and complications: the locals' and stage workers' response to what Jerry Garcia calls the "biblical, epical, unbelievable" numbers of freaks. Lang states the film's premise: "Music is more involved in society than it was. . . . If you listen to the lyric, if you listen to the rhythm and what's in the music, then you'll know what's going on with the culture." And, completing the *dramatis personae*, the musicians arrive and the momentum accelerates. Helicopters descend from the skies like those in Viet Nam seen daily on prime-time news; but here they bring the gods and goddesses, and their performances begin. In response to Richie Havens's impassioned song, "Freedom," the fence is breached and as the freaks pour in, Artie Kornfeld announces, "It's a family, man," and the promoters ratify the people's rejection of the cash nexus by declaring that from now on the concert is free. Woodstock has been *liberated* from commodity relations, and the Who conclude the day.

Act III, "Saturday": after a beautiful young couple has expressed the freaks' thoughts on love and how the festival should be understood, Swami Satchidananda confirms that "the time has come for America to help the whole world with spirituality," and the action moves to its climax: the rainstorm. But rather than being a catastrophe, this peripety proves the festival's success. The people themselves become musicians, playing in the mud and drumming with cans and sticks. As a dramatic chorus, Lang and Kornfeld articulate the implications. "This culture and this generation . . . away from the old culture and the old generation. You can see how they function on their own, without cops, without guns, without clubs, without hassle. Everybody pulls together, everybody helps each other, and it works. It's been working since we got here and it's going to continue working." Though it is a "financial disaster," such terms are irrelevant for "[t]hese people are communicating with each other, that rarely happens anywhere anymore. It has nothing to do with money, it has nothing to do with tangible things. . . . These last three days, these last three million years . . . all of us have undergone a turnabout . . . and realized, if you can't live together and be happy, if you have to be afraid to smile at somebody, what kind of a way is that to go through this life?" As they speak, on the opposite screen a couple synecdochically undress to make love. Night falls, the music resumes, David Crosby tells the freaks,

"you people have got to be the strongest bunch of people we ever saw ... we just love you, we just love you," and Ten Years After concludes the day.

Act IV, "Sunday": after the "Interfuckingmission," during the falling action, an expanded chorus of opinions further assesses the turnabout. While the outside world has declared the festival "a disaster area" and at least one local finds it "a disgraceful mess," the people continue to work together. Bringing supplies and medics, the US Army "are with us, not against us," and a montage of local voices notes the absence of fighting or stealing and concludes, "they're very lovely children," as indeed they are seen to be, playing naked in the pool. As night falls, ecstatic performances by Santana and Sly and the Family Stone move the drama toward its resolution.

Act V, "Monday": morning rises over the dénouement with the Hog Farm preparing a post-nuptial "breakfast in bed for four hundred thousand," and Yasgur delivers the benediction: "You people have proven something to the world ... you have had quite a few inconveniences in terms of food water and so forth [but] your producers have done a mammoth job to see that you were taken care of. . . . But above that, the important thing that you've proven to the world is that a half a million kids . . . can get together and have three days of fun and music and have nothing but fun and music." Jimi Hendrix plays the freaks' version of the national anthem, and as the weary veterans slog though the mud, the lyrics to "Purple Haze" venture the apocalyptic question: "Is this tomorrow or just the end of time?" before a long aerial flashback revisits the festival at its fullest.

Despite its appearance as a loose narrative, both the internal structure of the separate sequences and the film's progression from one of them to another are premised on neither classical Hollywood's chronological continuity and continuity editing nor Direct Cinema's fidelity to real time; rather, the dual focus narrative as a whole and the musicians and freaks who comprise its constituent pair are structured in patterns of dialectical montage in which ostensibly conflicting or opposite elements are spatially or chronologically juxtaposed and brought to resolution. This montage structure is continually enacted in local incidents and elaborated in subsidiary patterns, but three macro-structural forms are primary: the film's main action, the myth of the creation of the Woodstock nation as the community of performers and fans; the synthesis of composite images from the separate sections of split screens; and audio-visual syntheses of the music and picture tracks.

MONTAGE

Combining virtuoso Direct Cinema photography with innovative editing and complex optical effects, each unit of musical performance was designed by a single editor. More elaborate than any numbers since Busby Berkeley's, many of them are autonomous audiovisual poems that figure the counterculture's

aesthetic and often its social values. Their basis is the handheld long takes, some as long as eleven minutes of continuous photography allowed by the cameramen's 400' magazines, which are able to accommodate the longer, improvised musical forms. At Monterey the cameras had been mostly stationary, but here the cameramen were able to move freely around the stage, following Wadleigh's injunction to film whatever turned them on. In conjunction with the Éclair's wide-angle lenses and powerful zooms, and its multi-lens turrets that are able to shift quickly between close-ups and more distant framings, their mobility allowed them to follow the most telling or resonant visual incidents. The framing of most shots is in constant motion, responding to the movements of the music, the dance of the musicians' bodies, and the cameraman's own reflexes. Wadleigh's own takes from stage-front dominate; shot from below and most often using wide-angle lenses in close-up, these are simultaneously intimate and monumental, filling the whole frame with Havens's mouth, Joe Cocker's boot, or Hendrix's hands chording the neck of his guitar.

In some instances, these long takes were only minimally modified in editing, and the montage elements lie within the shot, especially the distinct close-ups created in-camera as the photographer moves between different visual foci. The first performance, for example, the Havens sequence, is one of the simplest, consisting of unmodified takes up to one and a half minutes long, with only occasional brief cutaways to his accompanying musicians, the audience clapping their hands at his request, or glances at a helicopter overhead when he mentions the Korean War. Ending the festival, Hendrix's two songs are presented almost entirely in Wadleigh's single take that bridges "The Star-Spangled Banner" and "Purple Haze." In contrast to his frenzied performance at Monterey, here Hendrix's demeanor is restrained and pensive and, rather than attempting a correlative to the audio pyrotechnics of the whammy-bar and feedback, the visuals are presented as lovely close-ups on a stable single screen, moving between his meditative face and flying fingers to emphasize his concentration and musicianship. Only after almost five minutes do the extended interpolated wide shots of the bedraggled survivors leaving the muddy field appear.[22]

More typically, however, such long takes are used as the basis for two- and three-screen compositions that create quasi-cubist multiple perspectives. Working with the several available takes of any given moment in a song, the editors exploited the wide-screen format to juxtapose side-by-side images of different angles on a single performer, of different members of a group, or of performers and audience together. Outstanding among these multi-screen performance numbers are those featuring Joan Baez, the Who, Joe Cocker, Ten Years After, Santana, and Sly and the Family Stone.

Santana's "Soul Sacrifice" (Figure 12.3), blocked out by Martin Scorsese and completed by Stan Warnow, is close to perfection in its simultaneous

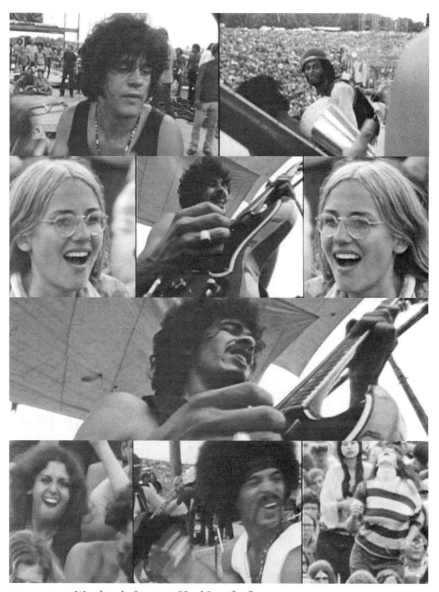

FIGURE 12.3 Woodstock: *Santana, "Soul Sacrifice."*

visualization of the song's structure and its context in the festival, and the clarity of its own, again five-act, internal organization that reflects the inter-play between group and solo performance.[23] The previous sequence with the nude bathers concludes as a shaggy dog that has been watching them turns to look into the camera, apparently in response to a voice announcing the song's title. Bass player David Brown leads off with a hand-clapped rhythm; shots of the other individual members of the multi-racial band are added one by one,

cropped and placed as smaller inserts within the full screen until the audience and percussionists join in, and the band and audience are juxtaposed as a collectivity, two sides of the same organism on the two sides of a split screen. Carlos Santana's first guitar solo begins the second act with a single screen of Wadleigh's long take of him alone, grimacing as he reaches for the notes of the melody and meticulously adjusts his tone controls, filling the frame vertically but leaving black spaces on either sides. The composition switches to three screens, placing other musicians beside him to fill the horizontal axis, but leaving blank space above and below. With the frame alternating between single and triple screens, attention switches to the percussionists as they take the lead, especially to the angelic young drummer, Michael Shrieve. Comprising the third act, his extended solo begins as a single-screen close-up long take of him and his drums, seen from below, which is doubled with one side mirroring the other, and then these two are pushed to the sides by a longer shot of him so as to form a triple screen.

Responding to the drum interlude and picking up on his first solo, Santana's second solo announces the climactic fourth act with Wadleigh's long take of him in the center of a triple screen. But this time he is surrounded by the audience in shots that alternate between larger or smaller sections of it but eventually settle on a close-up on a blonde girl. This initiates *within the spectacle's montage* a metonymic form of the classic musical's dual focus narrative of an erotic relation, here between a brown eyed handsome man and a white woman. At first she seems uninterested, but interpolated single screens of Santana *in extremis* move her to an ecstatic response. As the solo and her excitement rise to their climax, the editor creates a triple screen with Santana and his guitar in the center and mirrored close-ups of her *jouissance* on either side that is sustained for several seconds. Wider shots generalize their sonic coitus into an encounter between the band as a whole and the audience at large: a naked man, one caressing a snake, one with arms stretched wide as if crucified, and one dancing with a sheep in his arms. The ecstasy is shared aurally and visually among the musicians and audience until a momentary break in the sound generates a brief black screen. A fifth act coda reprises the blonde girl and the crucified man, and as the conclusion is flourished, the stage camera pans round among the exhausted musicians and the stage hands, and out over the crowds that stretch to the horizon—until they are all abruptly displaced by a close-up on the face of Sly Stone as he and the Family launch into "I Want To Take You Higher."

In terms of ecstatic visual composition, the desire Sly announces initially appears quixotic, but editor Yeu Bun Yee manages to build further on Warnow's dynamism. Shot at night under monochrome lights, the footage is midnight blue and silver set in a black space. Alternating among one, two, and three screens, the composition initially emphasizes close-ups on Sly himself, and then begins to add the other musicians, especially the horn players,

all dancing in time with the repetitive riff. As the music settles in to a steady pulse, he begins a spoken interlude, exhorting the audience to forget the need for approval and join with him in making the music by chanting "higher" and throwing the peace-sign. The visuals hold him in a single frame, with each response punctuated by a momentary double screen, one side from the stage showing both the band and (despite the darkness) the audience and the other toward the stage showing Sly. As the music resumes, both sides are occupied by the entire band dancing ecstatically, the single frame returns in a long take that moves from musician to musician, then out over the audience, then finally to Sly and a series of freeze frames in which he raises his arms over his head, with the long fringes on his jacket filling the frame like a silver peacock's tail.

As the climactic affirmation of the triumph over the storm at the film's crisis, these two numbers and especially the call and response in the church of Sly's music that takes the community higher, mark the complete integration of freaks and musicians that has been building through the earlier numbers. Like Sly's number, Country Joe's "I-Feel-Like-I'm-Fixin'-to-Die-Rag," for example, features the audience directly, both aurally and visually. It begins with a collage of inattentive audience members as he is heard shouting, "Gimme an F . . . " before introducing him visually as he asks, "What's that spell?" and starts the song. Thereafter an alternating montage links him with the audience gleefully clapping and singing along, with their unity cemented by the visual effects of the ball bouncing across the lyrics. After the first run-though, he rebukes them, all 300,000, who must sing louder to stop the war, and the visuals cut to a reverse zoom that includes him and ever wider sections of the crowd, ending with a pan back from them to him. Apart from Ten Years After's unit, it is the one most entirely focused on a single musician in a group and which does not cut away to the audience, even though their enthusiastic aural response is featured. Other units explicitly link audience and performers visually by montage, or by panning from the stage, or by shooting out from behind the musicians. But some units elaborate a more extended narrative and thematic connection between musicians and audience, in montages that take advantage of a song's lyrics to articulate the narrative into the spectacle. Two, quite different, instances are especially intricate, those featuring Joan Baez and Arlo Guthrie.

The Baez section begins backstage in late afternoon as she jokes about the puniness of the crowd and appears to walk toward the stage. After a transition formed by a couple of still photos of her and her husband, anti-war activist David Harris, she appears on stage in a medium shot facing screen left, but lit in a black night-time space. She announces that she will sing one of her husband's favorite songs, adding, "He is fine" and, patting her plainly pregnant stomach as the audience applauds, "we're fine too." Her account of Harris's relocation to a new prison is interrupted by a brief flashback to the backstage

afternoon scene, where she talks in more detail about guards who had threatened him. The montage returns to the stage, but now she is photographed from the opposite angle, where she continues to describe the hunger strike he had already organized. The camera zooms to a medium close-up as she begins one of Harris's favorites, "Joe Hill," a song about the legendary labor organizer and Wobbly songwriter, singing "I dreamed I saw Joe Hill last night." But when she sings Hill's own words, " 'I never died,' said he," the montage returns to first angle, and throughout the song it continues to shift between the two camera angles, according to the speaker of dialogue in the lyrics, until for the final lines the two positions are superimposed. The lighting and the photography and editing of the song dramatize it in their different ways; embedding it in material about her personal and political relationship with Harris brings it into the present, from the world of folk music into the counterculture.

Though it shows signs of resulting from insufficient footage of his performance, the Guthrie unit similarly embeds his song in the collectivity. As the previous unit, Country Joe and the Fish's "Rock and Soul Music," ends with a chant of "Marijuana," a cut introduces Guthrie in a split screen: he on one side, and on the other, the crowd, whom he addresses as a "lot of freaks," and strums the opening chords of "Coming into Los Angeles." As he sings about smuggling marijuana and the pleasures associated with the drug, the visuals cut first to a shot of mounted police patrolling a portion of the fence, then to an arriving helicopter, which turns out to be the one "coming into" Woodstock with him on board. The flashback continues with him happily walking toward the stage, meeting with Kornfeld, gazing out over the crowds, then segues into a collage, an extended sequence of a man fashioning a hash-pipe, then more than twenty brief vignettes of people smoking. In this case, the unit relates to the previous by linkage rather than by collision, so that music, lyrics, and visual images all one bond musicians and audience across their collective primary ritual.

Absent the structuring songs, the *vérité* documentary portraits of the festival attendees are rarely as unified as the performance numbers, but several of them are also autonomous compositions, including two of the most idealistic. Its interview mode aside, the Port-O-San man unit is a classic of Direct Cinema (Figure 12.4). Though it actually contains two cuts, it appears to be a single take, more than three minutes long and all single screen, but with two distinct sections. In the first, cameraman David Myers effortlessly maintains virtuosic framing and zooming in response to the changing center of visual interest, all the while swapping double entendres with the sanitation engineer as he cheerfully and efficiently goes about his work. With his task complete, the man moves away and—without a cut—a stoned freak emerges from one of the toilets, allowing that his experience in there was "out of sight." Offering his hash pipe to the crew, he asks them if they are doing a movie and what it will be called; Myers replies "Port-O-San," while shifting to a close-up of the corporate logo. The juxtaposition of the two perfect and perfectly antithetical

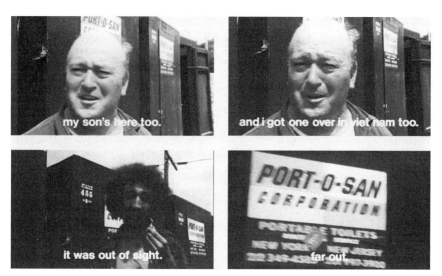

FIGURE 12.4 Woodstock: *Port-O-San Man.*

types—the workingman and his non-working customer—and the perfectly timed moment of reflexivity form a succinct image of the generational and class differences subtending the festival. But between the two parts lies the engineer's devastating comment, "Glad to do it for these kids. My son's here too and I got one over in Viet Nam too, he's up the DMZ right now flying helicopters." As lapidary as a haiku, it summarizes the entire film, its utopianism as well as the political contradictions in which it flowers.

Where this unit is a collision montage, another constituent film poem, the nude bathing sequence, depends on lyrical continuity and reconciliation. It begins on one of a pair of screens: on the left, a distance shot shows a couple making their way down a wooded hillside toward a distant pool, while on the right, the locals raucously debate the freaks' morality. As one man angrily complains about pot use and sexual immorality, a zoom shows three young women in underwear, gingerly entering the water, then on both screens groups of people, girls and boys, variously enjoy the water and the non-coercive nudity. One of them remarks on their pleasure and its larger implication—it's "normal and natural, but we've been made to feel that it's wrong"—justifying the joy and innocence of the glimpses of breasts and penises; the scene is markedly less exploitative than, say, Pennebaker's recurrent focus on attractive women in *Monterey Pop.* The double screens continue for three minutes, then the right one is replaced by a head shot of a talking police office; but instead of repeating the criticisms of the prequel, he concludes with the film's own position: "We think the people of this country should be proud of these kids. . . . They can't be questioned as good American citizens." The framing of the sequence by the contrasting voices gives it the

force of a syllogism by which the beauty of the bathing scenes are made to disprove the former and prove the latter, all the more authoritative in being delivered by the officer, to reconcile the freaks and the older generation, and implant their social innovations in the mainstream of US life.

WEEDS IN THE GARDEN

The entelechial realization of *Monterey Pop*'s innovations, *Woodstock* was the apogee of the rock musical film. Reflecting the filmmakers' own place within the Woodstock nation, it also reflected the nation's idealized, self-congratulatory conception of the festival as a manifestation of its best nature. As well as being discursively elaborated in the song lyrics, the musicians' remarks from the stage, and in the interviews, the narrative of the triumph over both local adversity and the alienation of mainstream society is reciprocated by the freaks' celebration of their return to the garden and the affirmation of their cultural rebirth. In this utopian moment, the idealized reconstruction of the themes developed in fifties rock 'n' roll films becomes complete. As the disturbed young hooligans sighted in *Blackboard Jungle* have grown into a self-conscious nation, their delinquencies have transmogrified into the principled rejection of capitalist imperialism in Viet Nam and its concomitant domestic repression. As editor Schoonmaker proposed, Viet Nam "resonated throughout Woodstock Festival and the film."[24] In the variable gear of social disaffiliation and contestation, the invasion stands as both the festival's dialectical opposite and its precondition.

Figured in the Port-O-San man's own two kids, "one here and one in Vietnam," recognition of the invasion's role in the counterculture is recurrent in the songs: Richie Havens's positioning of the Korean war immediately before the "Birmingham War," in "Handsome Johnny"; Joan Baez's linking of "Joe Hill" to David Harris's anti-war activism; the black humor of Country Joe's "I-Feel-Like-I'm-Fixin'-to-Die"; and two of the film's three culminating performances: Sly Stone's request to the audience that they "throw the peace sign" and Hendrix's final tortured elegy. United in opposition to the invasion, youth has become a revolutionary class that has reconstructed the rock 'n' roll film's dominant themes: drugs have become an access to higher forms of consciousness; sexual promiscuity has become innocent nakedness and free love; African Americans are honored as the advance guard of a new cultural wholeness; and unfettered dancing has become the somatic celebration of community and liberation. And cinema has created in its own materials and languages an equivalent to the music's own achievements: not just a documentation of the festival, but its visual correlative, a liberated filmic musicality. Following important theatrical films that bridged experimental and commercial, including *Chelsea Girls* (Andy Warhol, 1966), *The Trip* (Roger Corman, 1967), and most recently *Easy Rider* (Dennis Hopper, 1969), released

a month before the festival, *Woodstock* exceeded them all.[25] Virtuoso Direct Cinema photography danced with avant-garde montage structures within the scope of the 35-mm theatrical film, one indeed twice normal feature length; together with the opulence of industrial optical effects and the cream of studio sound editing, they produced a classic that set the standard by which future rock 'n' roll films would be measured.

But *Woodstock*'s ideological and formal achievement entailed radical contradictions in the mode of its production, which it perforce both conceals and allegorizes. The dual focus narrative and the montage of its elements were created by parallel collisions—and in many cases, conflicts—among the various agents, differentially positioned in the music business and film industry, who produced it. The elements of folk commonality outside commodity relations would have pleased any remaining ghosts of those who had founded the American Communist Party at a 1921 convention in Woodstock. But, though it reflected an ideological moment when the contradictions of capital appeared solvent, as in John Roberts's recollection of his motives ("seemed like an easy way to make money, have fun and 'do something meaningful' with my life"), the creation of *Woodstock* was not as entirely outside alienation and capital as its ideologues asserted. While *Monterey Pop* had been produced by musicians with almost all the performers unpaid and the profits at least intended for charity, something like Roberts's easy mix of pleasure, social purpose, and financial profit allowed the venture capitalists and the music industry insiders to work together to initiate *Woodstock*. But however different from the commercial cinema the film's inception might have been, later stages of production brought it back into Hollywood's orbit.

Woodstock was conceived, financed, and shot outside both the feature film studios and the less formal companies founded by the graduates of Drew Associates that produced *Monterey Pop*. The work of recent film school graduates who understood themselves to be part of the counterculture, its primary commitment was to the music and to the music's cinematic realization, making its relation to the film industry roughly analogous to the musicians' relation to their record labels. Like the unprecedented control over their own music that some rock musicians had gained, the filmmakers determined their personal and social expressivity, but they had not gained control over distribution. Independent production allowed some documentary filmmakers to express the counterculture's own perception of itself, rather than the culture industry's sense of it or its most profitable exploitation. But, as Pennebaker's initial difficulties with *Dont Look Back* (1967) revealed, this did not guarantee any wide distribution, and even *Monterey Pop* played only in a Lower East Side porn house for the first year. *Woodstock*'s production crew was indeed of industry size, far greater than the half-dozen who had made *Monterey Pop* and, as its credits note, it had been organized by an industrial division of labor, with a director, producer, and crews with specific functions. But the

combination of Direct Cinema's cooperative interaction between subject and object—here between the cameramen and sound men and the musicians and freaks—and Wadleigh's instructions to his cameramen to shoot only what turned them on effectively distributed authorship at the first point of production, as did the autonomy of the unit editors at the next.[26] Within this the filmmakers, especially Schoonmaker as editor and assistant director, did make the final decisions; but *Woodstock* was, like Woodstock and like the music there, fundamentally a collective social production, in which the filmmakers' sympathy for the festival and its ideals allowed the film to become the counterculture's own *prise de parole*. Its production was posited on community self-representation and propagation, not on the valorization of invested capital or commodity cultural values.

But even if *Woodstock* was conceived and filmed in New York, the home of the US documentary film tradition, it could only be completed in Hollywood. Production resources had been minimal, and Wadleigh assembled his entire crew and purchased film stock with only $24,000 in the bank. The footage and sound he obtained were sufficient for him to finish the film in the way he wanted, but only with the addition of $1 million from Warner Bros., who had also inadvertently acquired distribution rights to the film for just $25,000, could post-production be completed. The film industry appropriated a work conceived outside and against it.

On release, *Woodstock* was an instant sensation, both a critical and a commercial success. Among the many adulatory reviews, *Time* spoke for the consensus, praising in a way that became common, not merely the film's value as a documentation of the festival, but as its replication: "It is happening all over again. Woodstock . . . has just been re-created in a joyous, volcanic new film that will make those who missed the festival feel as if they were there. . . . But *Woodstock* is far more than a sound-and-light souvenir of a long weekend concert. Purely as a piece of cinema, it is one of the finest documentaries ever made in the US."[27] And the *Rolling Stone* reviewer echoed Frank Zappa's acclaim for *Blackboard Jungle*: "*Woodstock* works because it makes you a part of the trip. . . . Finally . . . there is a movie about *us*."[28] Acclamation of this order allowed the distributors to raise admission prices to a then-unheard of four and even five dollars, which approached the price of the festival's seven dollars a day. It was so expensive that some people who had attended the festival were unable to afford to see the film—which in any case, they thought, should be free since it starred them. The studio organized saturation radio, newspaper, and magazine advertising that reproduced its axioms of peace and love in images of nude bathing. Accordingly, its first release returned $16.4 million to Warners, and in a decade it earned $50 million, saving the studio from imminent bankruptcy while the three-record set soundtrack, released earlier with a list price of $14.98, sold two million copies in the first year. Because of the deal made with Warners, and the money the studio had provided for post-production costs,

95% of this money accrued to them, rather than being returned to Roberts and the festival's financiers, who did not recoup their $1.6 million loss and break even until many years later.[29] The costs of the free festival's expenses were eventually retroactively repaid, but Warners made the profits. *Woodstock* allowed the studio to valorize its capital investment many times over at the expense of the festival's promoters and film attendees, the Woodstock Nation.

These contradictions among the politics of the festival, the politics of the film, and the politics of its distribution were recognized, if not fully understood, by many elements in the Nation, especially the Yippies, who organized protests and boycotts in Los Angeles, Berkeley, and other cities. And Abbie Hoffman summarized: "Woodstock Nation is not the *Woodstock* movie. Woodstock Nation is at war with the Pig Empire; the *Woodstock* movie is a weapon in the arsenal of the pigs, designed to defeat the Nation by rendering it impotent. People at Warner Brothers brag how they purged the Nation from the movie."[30] If *Woodstock* appears to film history as a signal occasion of generous representation of a rock festival's attendees, to Hoffman it appeared as a repression of the event's social accomplishment. In short, as in the classic folk musical, the transcendence of commodity relations within the film was reversed in the film's own economic existence, the mode of its social consumption: as Jane Feuer argued, "the creation of folk relations *in* the films cancels the mass entertainment substance *of* the films. The Hollywood musical becomes a mass art which aspires to the condition of folk art."[31] In *Woodstock*, cinema danced its most ecstatic dance with a musical counterculture; but Hollywood exacted its revenge on both the festival's hip capitalist producers and the Woodstock nation.

Underground Documentaries: *Aquarian Rushes*

Woodstock was not the only film about Woodstock. Another documentary, even more closely affiliated with counterculture utopianism, more radically revised film language in the light of those ideals and in some ways implicitly critiqued the feature sensation: Jud Yalkut's *Aquarian Rushes* (1969).

Yalkut had been involved in the beat poetry scenes in Greenwich Village and then in San Francisco before returning to New York in 1959, where he began to make 8-mm and 16-mm films. In 1965 he joined USCO, or the Company of Us, a collaborative intermedia group in upstate New York. Influenced by Marshal McLuhan, Buckminster Fuller, and Meher Baba, USCO used combinations of advanced communication technologies to mount installations and events designed to expand human consciousness to states of mystical awareness. Yalkut also collaborated with Nam Jun Paik on making alternative forms of television both with the Sony Portapaks that became publicly available in 1965 and by electromagnetically distorting broadcast television signals, and he began to combine film and video in USCO events. USCO appeared at

the "Expanded Cinema" symposium held at the New York Film Festival in 1966, and was featured in a special issue of *Film Culture*, entitled "Expanded Arts." By the late 1960s, working with USCO and Paik, Yalkut had created a dozen short psychedelic films, screening them at New York Film-Makers' Cinematheque and other underground venues. Many of the films he made with USCO and Paik used music, especially but not exclusively rock 'n' roll. *US Down by the Riverside* (1966) juxtaposed abstract, pulsing lights with the Beatles' "Tomorrow Never Knows," itself containing many kinds of electronic sound manipulation. *Turn, Turn, Turn* (1966) set images of a rotating USCO light sculpture, abstracted with superimpositions and kaleidoscope effects, to a loop of the Byrds' peace song, "Turn! Turn! Turn!" *The Godz* (1966) was a documentary short about a rock 'n' roll noise band. And *Beatles Electroniques* (1969) set Paik's electromagnetically distorted television images of the Beatles in performance to a track composed from electronically modified loops of their singing. In 1969 Yalkut completed *Aquarian Rushes*, a fifty-minute documentary of the Woodstock festival.

For about six years in the 1960s, Yalkut had divided his time between Woodstock and New York City, and when the possibility of filming the festival arose, he made a proposal as part of an USCO offshoot, Maverick Systems. When the project was assigned instead to Wadleigh and Maurice, he went ahead independently with his partner, Jeni Engel. Obtaining press passes, they photographed in both 8- and 16-mm from Saturday afternoon until Sunday night, recording sound on a portable cassette audio recorder.[32] Later in the fall, his footage was screened in New York, along with a ½-inch video shot by friends including artist Ira Schneider, who also made his own video, *The Woodstock Festival* (1969). Yalkut transferred some of Schneider's video to 16-mm film and edited it with his own footage, adding color filtering and other laboratory effects. His friend, Ted Wolff, mixed Yalkut's own sound with the sync-sound from the video and very slight samples of commercial recordings, augmenting it with flanging and other electronic effects.

Like *Woodstock*, *Aquarian Rushes* alternates between musical performance and scenes of the festival attendees, but largely preserves the event's chronology. Several personnel appear in both films, including Richie Havens, Santana, Sly and the Family Stone, Swami Satchidananda, and Hugh Romney, though *Aquarian Rushes* also features Canned Heat, Janis Joplin, the Grateful Dead, the Band, Johnny Winter, and other musicians omitted from *Woodstock*. And similar scenes occur in both: crowds arriving by road and musicians arriving by helicopter, nude bathing, drug sharing, and the rain. But where *Woodstock*'s extensive financial and technological resources enabled the film to reproduce studio production values, *Aquarian Rushes* is abrasive and challenging; superimpositions replace the split screens as its fundamental trope, and its combination of lights, sounds, technology, and human actors envisions the festival as an USCO-like collective happening.

As *rushes*, the film conjoins the senses of unedited footage (though it was edited both in-camera and in post-production), the sudden onslaught of drug-induced exhilaration, and the first reports of an important event. The only stable, conventional shot in this message from the psychedelic frontier is a pan in 16-mm and color across a group of people passing a joint from one to another and ending with a close up on the face of the last as she inhales and smiles into the camera while edge-flares burn the frame into red and gold. Recalling the tradition of avant-garde trance films dating back to *The Cabinet of Dr. Caligari* (Robert Wiene, 1920) in which a standard film language is used to introduce an extraordinary protagonist and his heightened vision, the shot suggests that the film is a hallucination, collectively authored by these young Aquarians. Recalling Jonas Mekas's invocation of a Rimbaudian "*complete* derangement of the official cinematic senses," as the only "way to break the frozen cinematic ground,"[33] its visual and aural textures diametrically differ from standard film form and are, as much as was the festival, the vehicle of a utopian vision.

A hybrid of 8- and 16-mm film and of a ½-inch Portapak video, all trans-ferred to 16-mm film, *Aquarian Rushes* also mixes black and white, and positive and negative. Though combined onto film, the two source mediums generate quite different visual textures, the film being much cleaner than the video, with its conspicuous glitches, camera roll, and overall lower resolu-tion. Intercutting between black and white video and color film of the same scene emphasizes the heteroglossalia. Some of the video is solarized and arti-ficially colored, especially the Janis Joplin section, where a close-up on her head is forced into a high-contrast abstract composition in rust and green. Apart from the mentioned pan, the shots are never steady or transparent, but are transformed by in-camera superimpositions, pixilation, rapid zooms, over- and under-exposure, and jittery motion producing a sensory overload, as well as reflexively foregrounding their manufacturedness. Often looped and flanged, the sound is similarly fragmented and abstracted. The audio and visual tracks are autonomous and simultaneous rather than synchronized and unified, evolving in counterpoint rather than equivalence. The overall effect is one of energy and vibrancy, on the one hand, and destabilization and disorientation, on the other, while the lack of internal cues to an overall structure keeps the film in an unmatrixed continuous present.

In *Aquarian Rushes* the breached fence is not seen, and though it does include a brief shot of a poster headlined "Revolution," its political engagement appears as the expanded consciousness of USCO's techno-euphoria. It opens with a white light resembling an exploding sun, its first scenes juxtapose a shot of Swami Satchidananda with the closing chorus of Richie Havens's "Freedom," and it ends with a hug-in of a dozen naked people followed by a distant shot of the earth, like that used on the cover of USCO associate Stewart Brand's *The Whole Earth Catalog*. These frame the intersecting currents of the festival, the music, and the more famous film about it—all "different parts of the same

revolution," as Hugh Romney declares in *Woodstock*. Together they herald a genuinely popular, collective, and emancipatory culture, outside corporate control and the alienation of capitalist entertainment. *Aquarian Rushes* adds the interdependence of chemical and electronic technologies of expanded consciousness, and new conjunctions of art and science. But its multiple forms of estrangement do hold its euphoria at a distance, especially in comparison with *Woodstock*, whose rich aural and visual imagery is so replete with immediate pleasure. *Aquarian Rushes*'s more rigorous and demanding utopianism precludes the compromise with corporate capital that allowed *Woodstock* to snatch alienation from the jaws of commonality. It did have some limited circulation, both domestic and European, and in fact Martin Scorsese, then a film student at New York University, picked it for a film festival in Italy. Otherwise, emerging from the techno-visionary idealism of the independent cinema, it remained largely unseen, its historical potential eclipsed by its spectacular other.[34]

The Concert Film

Woodstock completed rock 'n' roll's restructuring of the classic musical's dual focus narrative by unifying musicians and freaks together in a generalized euphoria of love, manifest as much in the musicians' regard for the people as the reverse, all subtended by the free festival's ostensible transcendence of commodity relations between them. It also completed a parallel development across the history of Direct Cinema rock 'n' roll films. In *Dont Look Back*, Dylan was confined within the reflective circle of his entourage, and in the darkened theaters, the fans were invisible and otherwise only occasionally glimpsed; and in *Monterey Pop*, the musicians mingled with the people and the montage sequences only tentatively combined the two groups to give visible form to the emerging commonality. *Woodstock*'s mythic validation of the counterculture's ideals and *Woodstock*'s retroactive financing of the festival and its own concealment of the festival's many contradictions and its own economic effectivity created the expectation that future festivals would realize the transcendence of commodity relations in similar folk utopias. As a result the concert, the tour, and the festival—all variously joining the community of musicians and fans and invoking the films' audiences—became the music's primary social rituals, and films made about them became the dominant form of rock 'n' roll cinema.[35] They commanded the independent screening venues, largely displacing the lingering elements of underground film as it lost the cultural authority it had in the last half of the sixties. By the late 1970s, more than half the scheduled offerings of Midnight Movies at San Francisco's Presidio Theater, for example, where *Dont Look Back* had had its year-long run, and the dozen other theaters in the same national chain were rock 'n' roll films (Figure 12.5).

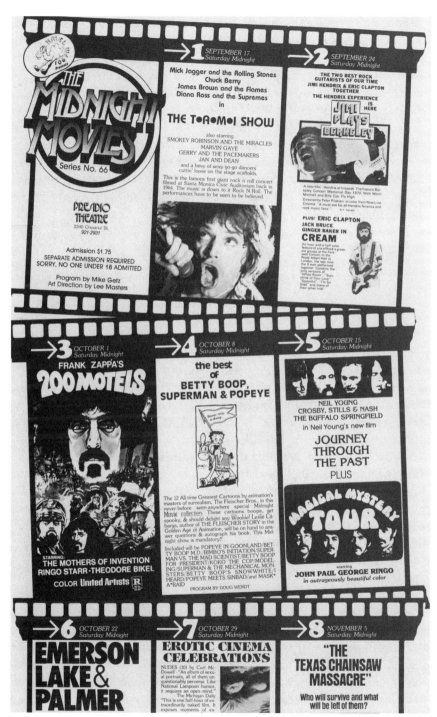

FIGURE 12.5 *Midnight Movies calendar, Presidio Theater, San Francisco, Fall 1977 (detail).*

These concert documentaries variously reflected and sustained the counterculture as it faced challenges of the next decade. But two films in particular documented the collapse of *Woodstock*'s dream into nightmare. *Gimme Shelter* (Albert and David Maysles and Charlotte Zwerin, 1970) documented the Rolling Stones' free concert at Altamont on December 6, 1969, less than four months after Woodstock, where the paramount band of the era was assaulted by a black man and by the Hells Angels, the very constituencies it had claimed as the symbolic foundation of its significance. A similar disastrous refutation of the commonality that Woodstock had celebrated, including the resurgence of commodity relations that despoiled the music occurred a year later, this time in England at the Isle of Wight Festival that took place in August 1970. The devastating irony of the resulting film's title announced its refutation of the core of the counterculture's aspirations.

Message to Love

The first Isle of Wight Festival in 1968 was quite small, but some 150,000 attended the second in 1969, which took place immediately after Woodstock and featured several of the same performers, as well as Bob Dylan in his first paid appearance since his motorcycle accident. Organized by Fiery Creations, the brothers Ron, Ray, and Bill Foulk, with Rikki Farr as the MC, the following year's five-day festival on August 26–30, 1970, presented fifty acts, including folk singers, rock bands, and Miles Davis, that attracted an estimated five, perhaps six, hundred thousand attendees. Difficulties with ticket prices, with the site that allowed unticketed fans on the hills surrounding the stage to see and hear just as well as those who had bought tickets, and with equipment malfunctions that spoiled some sets were exacerbated by various radical political factions who dramatically escalated demands of the kind that Hoffman had made at Woodstock. On the last day, the fences were torn down and the festival promoters lost so much money that the festival was not repeated until 2002.

The promoters had invited Murray Lerner, hoping to screen *Festival!* (1967), his documentary about the Newport Folk Festivals, but instead the director made arrangements to film the festival. His eight 35-mm camera crews shot 175 hours of color footage on high-speed Ektachrome reversal, but financial difficulties and disputes with the Foulk brothers caused the film's completion and release to be delayed until 1997, by which time Lerner had won an Oscar for Best Documentary Feature for another music film, *From Mao to Mozart: Isaac Stern in China* (1980). Produced, written, and directed by Lerner, his film appropriated the title of a song Jimi Hendrix had performed there: *Message to Love: The Isle of Wight Festival*.[36]

Accounts of the festival concur that it was marred by dissension, violence, and some below-par performances, including from Hendrix, who died three weeks later, and it certainly was a financial debacle. But it did contain its own Arcadian moments, including some excellent music and great enthusiasm for it,[37] nude romping on nearby beaches, and fine weather until the very last hours; and in a report submitted to a parliamentary inquiry in 1971, the chief of the local constabulary emphasized its overall peacefulness and testified in favor of future events.[38] But Lerner suppressed these aspects, deliberately presenting the festival as an unmitigated catastrophe and constructing his film as a point-by-point refutation of *Woodstock*.[39] Like the earlier film, it is a parallel montage of musical performances and off-stage scenes and interviews, framed by the arriving and finally departing crowds, and it also narrates the interaction among the four main groups, freaks, musicians, promoters, and locals. But where *Woodstock* progressively synthesized these into a harmonious, mutually adoring commonality, *Message to Love* emphasized hostility among them all, especially between the promoters and the attendees. These social conflicts usurp the music: many songs are abbreviated, and only one number by each act is included, except for Hendrix and the Who, but the coherence and momentum of their sets are destroyed by interruptions. Apart from the beginning and the end, there is little sense of chronology, real or constructed, to provide dramatic shape.

The idea of a nation that Woodstock had expressed is transposed in the negative and to England. The opening shot gives the film's first voice to an obviously conservative young man who declares, "I don't believe you can wear long hair, long sideburns, and goodness knows what, and still say you are somebody who believes in Great Britain." A cut reveals a couple of freaks walking past a tattered flag on a broken stick, and the shot dissolves into aerial views of the island and a sea of tents set to the audio of Tiny Tim's grating warble of the World War II classic, "There'll Always Be an England." After a local woman, her face grotesquely made up, exclaims how much she likes the kids' youth and beauty, a rapid proleptic montage of fragments of subsequent events accompanies Hendrix's performance of "Message to Love" and introduces the elements that will test the nation: a close-up on Hendrix's face; the arriving crowds; massed police; several men sorting through a huge stash of banknotes; police dogs; a man being hustled from the stage; security manhandling a naked woman; freaks smearing paint on corrugated iron fence walls; and finally a close-up on a long-haired man identified by titles as "'Rikki': Master of Ceremonies." A diabolical parody of Woodstock's Chip Monck, Rikki Farr screams, "We put this festival on, you bastards, with a lot of love! We worked for one year for you pigs! And you wanna break our walls down and you wanna destroy it? Well you go to hell!" He stalks off the stage and a cut returns to wide shots of the crowds joyfully singing, "Give Peace a

Chance," before another cut introduces an elderly local who, on the authority of his experience with the British police, avers that behind this hippie fun is "black power and behind that communism."

He was, of course, absolutely correct: as Sinclair argued and Woodstock demonstrated, African American culture had provided the ideal image of the transcendence of commodity relations between musical producers and consumers and the cash nexus generally. But here those relations are reimposed: bundles of notes are sorted for Chicago, who "get cash before they go on"; when asked what the promoters and musicians are interested in, an agent replies, "Couldn't be love, because they love money"; and even Tiny Tim, while agreeing that the festival should be free, "doesn't tune up without the money." The freaks, on the other hand, want a free concert, and are prepared to take it. One, naively proclaiming that "most of the musicians will back us up," invokes the Woodstock model: "This started as a commercial concern, but it's fast becoming a people's festival, and the people here are going to use this festival as they want." Another, a Charles Manson look-alike and self-proclaimed veteran of Woodstock and ten other festivals, is bitter: "this festival business is becoming a psychedelic concentration camp where people are being exploited." And at the beginning of the film, a third, who gave up a career in a New York advertising agency for a life of "poetry and songs . . . just roaming around, talking to the trees," sardonically declares: "Our plastic Gods, the musicians are coming and taking away, like, eight thousand pounds. Those are the new saints," and returns toward the film's end with: "It's like a feudal court scene where you've got your royalty on the stage, and back stage you've got the courtiers, the groupies, and the managers—the people that keep the pop kings in power. And then you have your serfs out in the audience . . . behind corrugated iron fences or inside corrugated iron fences."

As he points out, the feudal class structure is indeed figured spatially. As if in illustration of the lyrics to the Doors' "When the Music's Over," in which Jim Morrison mentions that the earth, "our fair sister," has been tied with fences and dragged down, the festival area is surrounded by two fences, one of corrugated iron and one of wire, with the space between them patrolled by security and attack dogs. This provides for the film's most deliciously absurd, even Goonish, shot: a security agent with bullhorn warning the iron fence that, "you will not be allowed in without a ticket." Inside are the fifty-sixty thousand who do have tickets, barely a tenth of the total, while outside on the overlooking hills, are the rest, many of them destitute and living in an area known as "Desolation Row." Fearing that these would force the walls open, the promoters tried to co-opt them by giving the Manson look-alike a hundred free tickets to be distributed to the kids in return for their painting the fence; but daubed swastikas and anti-capitalist slogans were their reward.

Interspersed among these conflicts, the performances are all colored by them, and two in particular are interrupted, Kris Kristofferson's and Joni Mitchell's. Performing on the opening day, Kristofferson is intercut with shots of the outside of the fence at night, where freaks are pounding on it with tin cans and the promoters are telling a French freeloader to go back where he came from. Clearly disturbed by the racket and the tensions underneath it, the singer remarks, "I think they're going to shoot us," but launches into "Me and Bobby McGee," and at the line, "Freedom's just another word for nothing left to lose," the film cuts to the Desolation Row kids hammering on the fence and walking its perimeter through the night. Not knowing that malfunctions in the sound system were making his performance barely audible, Kristofferson interprets the audience's jeers as a personal rejection and, as if he were anticipating his rejection by fans in *A Star Is Born* (Frank Pierson, 1976), he angrily stalks off the stage, leaving Farr to berate the crowd, especially the foreigners who refuse to pay the three pounds that he claims the promoters are obliged to charge. The contrast between the impasse and the abjection of Kristofferson's lyrics and the parallel scene in *Woodstock*, where Richie Havens's impassioned cries for "Freedom" are matched to the fall of the fence, could hardly be sharper. And, instead of moving on to, for example, Kristofferson's well-received performance on the last day, the filmmaker juxtaposes it immediately with a similar confrontation in Joni Mitchell's set that in fact occurred three days later.

With golden hair and wearing a long golden dress, Mitchell accompanies herself on the piano as with a golden voice she sings "Woodstock," the song she wrote while watching televised reports of the festival: "We are stardust/ We are golden/And we've got to get ourselves/Back to the garden." Having missed the earlier event, she was surely attempting to recreate it in a foreign land, and the freaks respond, applauding enthusiastically. But before she can rise from the piano, she is accosted by the Manson look-alike, and the film cuts to him being wrestled off stage as he proclaims, "I believe this is my festival." The cheers turn to jeers and whistles that continue even when the film returns to Mitchell, who also appears to take them as a personal attack. On the verge of tears, she admits her pleasure in performing, but accuses the audience of acting like tourists and asks for their respect. Most of the crowd apparently agree and break into applause, but the film again cuts to the Manson look-alike, who before being hurried away declares that the freaks "are uptight about commercial music co-opting our festival" and tells how Farr tried to co-opt him with the hundred free tickets. Now playing guitar, Mitchell resumes with her signature, "Big Yellow Taxi," but now its lyrics, "You don't know what you've got/Till it's gone" have a new resonance. And, even though the surrounding iron fence is visible in the shots of her and of the audience, she receives a standing ovation.

But the conflicts continue and eventually escalate into violence. Security personnel menace the freaks with dogs, and they reply by pelting trash. The fence is breached and, just as Sly Stone's lyrics gave voice to *Woodstock*'s boundless ardor, as fights break out among the trash, the Doors intone the threnody, "The End." Ironically, though musically lackluster, it is one of the more interesting numbers visually. Attempting to prevent the filming of his set, Morrison refused to allow the stage to be properly lit, so instead of the rich color of most of the sets, his is under-lit, leaving him visible only in monochrome shades of brown. But turning the limitation to advantage, the cameraman shot directly into the single stage light, producing bursts of explosive abstractions that complement the apocalyptic lyrics. By the time of the film's release, the song was, of course, additionally freighted with Morrison's own death and especially with its exploitation in Francis Coppola's egregious Viet Nam fantasy, *Apocalypse Now* (1979); even so, the Oedipal drama of the lyrics exactly correspond to the film's desire to kill its parent, and bring "The end of laughter and soft lies" which Lerner accuses *Woodstock* of perpetrating.

Where *Woodstock*'s revenge on rock 'n' roll was economic, concealing its commodity relations beneath the festival, *Message to Love* made a frontal attack, proposing that the midsummer night's dream had really been a diabolical nightmare. This other vision of the counterculture, not of peace and love but of exploitation and violence, became the great theme of films about the Rolling Stones.

The Rolling Stones

THE GREATEST ROCK 'N' FILM BAND IN THE WORLD

After the Beatles' final performance on Apple's roof on January 30, 1969, the Rolling Stones were the most consequential rock 'n' roll band in the world. From their beginning, they stood aslant from both the Beatles' sunshine rock 'n' roll based on teenage romance and the political ethic of peace and love into which the counterculture had transformed it. Reviled and persecuted for their blatant trafficking in musical and social infraction, they reignited rock 'n' roll's associations with delinquency that had been reconfigured in the mid-decade's optimism. They also gained a reputation for inciting their fans to mayhem and indeed they were not invited to Woodstock for fear of the violence that they might introduce. But with the splits in the Students for a Democratic Society, the Nixon presidency and the emergence of right-wing offensives, and the increased lawlessness and social polarization at the turn of the decade, the Stones' inflammatory songs of noir malevolence and decadence seemed the best reflections of the spirit of the times. After *Their Satanic Majesties Request* (1967), their diabolic reply to *Sgt. Pepper's Lonely Hearts Club Band*, they abandoned their mid-sixties flirtation with mod psychedelia for what Keith Richards termed "the backbone stuff."[1] In the quartet of albums produced by Jimmy Miller, *Beggars Banquet* (1968), *Let It Bleed* (1969), *Sticky Fingers* (1971), and *Exile on Main St.* (1972), Mick Jagger and Richards's songwriting returned to the US fundamentals: the blues, rhythm and blues, and country music. Fusing these, not with British folk music, but with English blues-based rock 'n' roll, they produced a baroque vision of a mythic delta, peopled by a ragged company of shattered outlaws and sinners, rebels and demons, that became in equal measure a metaphoric projection of their own renegade status in British society and a vocabulary for the time's apocalyptic public imaginary. The same period also saw their most intense involvement in cinema, when some of the most innovative filmmakers engaged them in ambitious works employing the most radical film languages of the time.

Films about them faced the task of plumbing their omnifarious derelictions, and no band was better served by cinema.

Deliberately cultivated by their first manager, Andrew Loog Oldham, as an antidote to the Beatles' impish innocuity, the Stones' combined musical and social infractions delighted rebellious youth as much as they threatened the establishment of parents, press, police, and the music business. Their early atavistic covers of obscure US black music distinguished them even among British blues enthusiasts, and displayed a skein of cultural aspirations more fractious and unaccommodating than other British group's. The sideburns Sinatra pinpointed a decade and a half earlier as the sign of rock 'n' roll delinquency had given way to long hair and other cultural markers whose deliberate offensiveness quickly infected, not just a working-class minority, but large phyla of youth in general. Like those to which *Life* had objected in its first 1955 address to rock 'n' roll, their "leerics" were "frequently suggestive and occasionally lewd"[2] and, even when bowdlerized, "Let's Spend the Night Together," for example, upset Ed Sullivan in a way that Elvis or the Beatles never had. But just as obnoxious as the double entendres compounded from the blues and their own sexual aggression was their constitutional resentment. Bespeaking a refusal of reconciliation as categorical as it seemed unwarranted, the primal guitar riffs, the petulance, and the bad grammar of "(I Can't Get No) Satisfaction"—and not least its echo of Muddy Waters' "I Can't Be Satisfied"—made it a generation's anthem.

The Stones were visually as well as musically offensive. As various in their ugliness as the Beatles were indistinguishable in prettiness, their very faces were an affront. When British beat groups dressed in identical tailored suits, Brian Jones's mod and proto-hippie flamboyance was quickly imitated by Richards and Jagger sartorially to complement their music's aggressive nonconformity. As Jagger asserted himself as the frontman, his body became the site of semiotic provocation, all the more threatening for its contradictions. With a large, raw-featured head, tiny buttocks, and conspicuous genitalia, he was emaciated yet kinetic, epicene yet dynamic, offensive yet seductive. Imitating James Brown and later Tina Turner, his dancing invoked not only black and white, but also male and female, straight and camp, so that like Elvis, he was often compared to a burlesque queen. As he explained after a 1965 Berlin concert in which his on-stage Nazi salutes catalyzed his audience into citywide acts of violence:

> I get a strange feeling on stage. I feel all this energy coming from an audience. They need something from life and are trying to get it from us. I often want to smash the microphone up because I don't feel the same person as I am normally. . . . What I'm doing is a sexual thing. I dance, and all dancing is a replacement for sex. What really upsets people is that I'm a man not a woman. I don't do anything more than a lot of girl dancers, but they're

accepted because it's a man's world. What I do is very much the same as a girl's striptease dance.[3]

Where the Beatles in performance were locked in place, at most able to bob up and down, Jagger was unencumbered by an instrument and, whether performing in cramped clubs or movie theaters in the early years or vast arenas in the later ones, he commanded the entire stage. Visually refracted by the dependably debauched Richards, his jumps, struts, swirls, and pelvic thrusts performed a sexual drama that goaded audiences into hysterical rampages. Both spontaneous and calculated, the sexual instability of his body was matched by the dualities in his voice, the combination of the vowels and phrasing learned from blues records with the Cockney affectations becoming one of rock 'n' roll's seminal amalgamations of conflicting racial, national, and sexual characteristics, all paraded on a similarly ersatz working-class attitudinizing.

The visual proto-cinematic elements in the Stones' performance were enhanced as the lyrics to their early compositions began to narrate social vignettes that often read like brief screenplays: "Mother's Little Helper," for example, or "You Can't Always Get What You Want" and especially "Sympathy for the Devil." Along with a dramatic structure, such tales often had a strongly characterized narrative voice: initially it was a misogynistic cockney male (in "Under My Thumb," for example, and "Mother's Little Helper"), but as the scenarios shifted back to the United States and appropriated the blues motif of souls sold to the devil, the personae were mythically aggrandized: Willie Dixon's Little Red Rooster grew into Jumping Jack Flash, the Midnight Rambler, the "scarred old slaver" of "Brown Sugar," the Street Fighting Man, and Lucifer himself. With Jagger assuming these roles, as much as an actor as a singer, his histrionic dramatizations became the concert high points; he often stretched "Midnight Rambler" to twelve or more minutes, falling prostrate and whipping the floor with a studded belt in time with the guitar chords. Performing themselves as promiscuous, misogynistic, hedonistic, androgynous, narcissistic, avaricious, faux-black Londoners, the Stones generated riots on stage, while off-stage their actual social infractions escalated from public urination to what was still a scandalous felony—drugs.

In 1967, after Jagger threatened suit against a scandal sheet that, mistaking him for Brian Jones, had exposed his putative use of hashish and Benzedrine, the press and police closed ranks on the band and set up a sting at Redlands, Richards's country home. Though during his cross-examination at the trial, Richards had explained, "We are not old men. We're not worried about petty morals," he and Jagger were nevertheless sentenced to jail, respectively, for one year and three months.[4] Also jailed was their close friend, Robert Fraser, whose London art gallery had become one of the epicenters of the London beau monde.[5] The London *Times* editor William Rees-Mogg noted that,

taking a "primitive" or "pre-legal" view of the sentence, many felt that he had "got what was coming to him," and summarized what he saw as the establishment's attitude to them: "They resent the anarchic quality of the Rolling Stones' performances, dislike their songs, dislike their influence on teenagers and broadly suspect them of decadence."[6] In the event, both Stones' (though not Fraser's) sentences were quashed on appeal, but the persecution backfired, and the escalation of judicial confrontation gave a aura of judicial significance to the band's outlaw prestige.

The events of May 1968 in Paris and the following August at the Democratic National Convention in Chicago and the subsequent violence of both the state and the student movements in France and the United States were more ambitious and concerted than equivalent disturbances in England. But one important London precursor to both Paris and Chicago, also broken up by a police riot, was specifically focused on the main issue of the time, the US invasion of Viet Nam. In March 1968, after a rally in Trafalgar Square, around eight thousand protestors delivered a letter to the US Embassy in Grosvenor Square. When they refused to disperse, mounted police attacked and a protracted battle ensued, with more than two hundred people eventually arrested. Jagger was present, though it appears he kept to the outskirts of the confrontation, but that same afternoon, he wrote the lyrics to "Street Fighting Man" and sent them for publication to the radical socialist journal, *Black Dwarf.* In "Revolution," John Lennon's song also inspired by the event, he counted himself out, affirming instead the Maharishi Mahesh Yogi's transcendental politics of love. But the song Jagger and Richards completed was their most defiantly agit-prop work, and they used it as the explosive finale for their concerts on the 1969 US tour and after. Though as recently as a year earlier (in, for example, the documentary *Tonite Let's All Make Love in London*, discussed later in this chapter) Jagger had denigrated political violence, in "Street Fighting Man" he seemed to aspire to it. The narrative voice complains that while he thinks "the time is right for a violent revolution," in London "the game to play is compromise solution," and rather than fighting in the street all he can do is follow his trade: "But what can a poor boy do/ Except to sing for a rock 'n' roll band/Cause in sleepy London town/There's just no place for a street fighting man." But though the lyrics declare there's *no place* for a street fighting man, the music's momentum and rhythm contradict the assertion of the impossibility of engagement, making it feel like a call to revolt in the streets. And violence accompanied the Stones everywhere. Richards later recalled that as early as 1964, "There was a period of six months in England where we couldn't play in ballrooms any more because we never got through more than three songs every night . . . it was like the battle of Crimea."[7] An extreme case occurred in Birkenhead in April 1964 when fans attacked the stage after only three bars of the opening song, forcing the police to intervene to protect the band and end the show. Such riots,

rituals not of love but of rebellion, were endemic at Stones' concerts until the early 1970s.

Recapitulating the Beatles' creation of a populist avant-garde but within a comprehensive negativity, the Stones' musical re-enactment of their personal transgressions allowed them to dramatize the period's turbulence and disillusion more powerfully than any other band. As the world's best rock 'n' roll band when rock 'n' roll's influence had extended beyond youth to become the dominant cultural form, they were the period's most important artists. Celebrated by the rich and famous, they were ubiquitously photographed and otherwise represented, with "Swingeing London," Richard Hamilton's painting of Jagger and Fraser in a police car after the drugs trial, instancing a most influential British artist's engagement with them. Similarly, they were sought out by some of the most important filmmakers of many branches of the avant-garde and documentary: Steve Binder, Peter Whitehead, Jean-Luc Godard, Albert and David Maysles, Donald Cammell and Nicolas Roeg, Kenneth Anger, and Robert Frank, with these followed in later decades by outstanding commercial directors from Hal Ashby to Martin Scorsese. No other rock 'n' roll band attracted remotely as significant a spectrum of cinematic collaborators, but the combination of the filmmakers' iconoclasm and the Stones' recalcitrance bled over into both the form and content of films to produce a perversely delinquent cinema.

Rolling Stones films were so often found deficient or offensive that until recently their filmography appeared as a series of projects whose infractions prevented their full acceptance into cinema. Filmed in 1964, *The T.A.M.I. Show* (Steve Binder) had a brief theatrical release before disappearing. Peter Whitehead's documentary of a short Irish tour, *Charlie Is My Darling* (1966), was denied a general release, as was his "Swinging London" documentary featuring the Stones, *Tonite Let's All Make Love in London* (1967), while his promotional film for the "We Love You" single was rejected by the BBC as being in poor taste. The producer changed the director's cut of Jean-Luc Godard's *One Plus One* (1968) before releasing it as *Sympathy for the Devil*, causing Godard to disown it. *The Rolling Stones Rock and Roll Circus* (Michael Lindsay-Hogg) was made in 1968, but Jagger delayed its release until 1996, and *Performance* (Donald Cammell and Nicolas Roeg, 1970) shocked Warners' executives— reportedly the wife of one of them so much that she vomited—and only serendipity and much recutting saved it from being permanently shelved. And CBS found *Gimme Shelter* (Albert and David Maysles and Charlotte Zwerin, 1970) so disturbing that they refused it for broadcast television, and it secured an independent release only with private funding. The most notorious of them all, *Cocksucker Blues* (Robert Frank, 1972), is still under a court order that prevents its distribution.

All but one of these were documentaries, but documentaries of a new kind whose radical experimentation further challenged the Direct Cinema

tradition that *Monterey Pop* and *Woodstock* had transformed. That tradition and the Stones' myth collapsed together in *Gimme Shelter*, a film about the final US concert performed in the last month of the sixties. But the violences in *Gimme Shelter*—the musical violence, the social violence, and the filmic violence—had been brewed in their previous films.

Peter Whitehead

The Rolling Stones' first singles gained them spots on British television in 1963 and thereafter they became regulars on *Ready, Steady, Go! Top of the Pops* and then television in the United States followed the next year with appearances on *The Ed Sullivan Show* and *Shindig!* Cinema first entertained them in *The T.A.M.I. Show*, filmed only days after the *Sullivan Show* appearance and immediately before their second US tour, in which they headlined a contingent of British Invasion acts matched with African American hit-makers. With four of their five songs being covers of rhythm and blues songs, the Stones positioned themselves across racial divisions, introducing black roots music to white US youth. For their segment, director Steve Binder seamlessly weaves wide shots of Jagger dancing in front the band with close-ups on him, on the others in the group, and on the audience, more frenzied here than for any of the other acts, with one of them holding a handmade sign, "We luv Rolling Stones." Jagger moves more expansively than the other English frontmen, and during the last number he dances out along the edge of the stage, shaking his maracas directly at the audience. Augmented by the house band, the Stones' set continues into the finale, which they lead with "Get Together." The Supremes, Chuck Berry, Brown, and all the other US soul and British beat groups return, frolicking with each other and with the multiracial dancers. Where the Stones' first US tour six months earlier had been met largely by incomprehension or hostility, *The T.A.M.I Show* presented them at the pinnacle of the music world and at the center of a transatlantic interracial musical community.

On their return to England, the group undertook the first of several projects directed by Peter Whitehead, then working in London as a freelance cameraman for Italian television. His own first film, *Wholly Communion* (1965), documented one of the inaugural British countercultural events, the International Poetry Incarnation, a festival that attracted seven thousand people to the Royal Albert Hall on June 11, 1965, a month after Bob Dylan's appearance there that concluded *Dont Look Back*. In its use of grainy black and white 16-mm film, a handheld camera responsive to the filmmaker's shifting points of interest, long takes with internal zooms, and changes in framing, *Wholly Communion* resembles *Dont Look Back*, though it was released almost two years earlier. Since the original sound recording was unusable, the

segments of ostensibly sync sound were constructed from other audiotapes, but nevertheless it earned Whitehead a reputation as a Direct Cinema film-maker. It was as such that Oldham invited him to film the Stones' Irish tour on September 3–4, 1965, their next outing after the US tour that followed *The T.A.M.I. Show*.

With its title a tribute to drummer Charlie Watts's photogenic appeal, the fifty-minute *Charlie Is My Darling* (1966) is a backstage musical that follows the band as they fly to Dublin for the first date, take the train to Belfast for the second, and then fly back to England (Figure 13.1).[8] Set within this frame-work are performance scenes, loosely structured off-stage interviews with the band members and with fans in the street, and intimate scenes with the band in dressing rooms as they wait to go on stage or relax afterward with impromptu play-alongs in hotel rooms, with Richards leading the others in Elvis impersonations and English vaudeville songs. Extended sequences are cut to non-diegetic Stones' recordings, including "Play with Fire," and "The Last Time," and instrumental versions of their songs by Oldham's studio band. But apart from the first interview with Jones, conversations with fans in Dublin, and some of the performance footage, the sound is again not syn-chronized, not even in the interviews.

The off-stage scenes with the musicians are low-key, fueled by cola rather than cocaine, with nary a groupie to be seen, and from them Whitehead cre-ates mosaics of casually spontaneous observations of unguarded moments. Still much less popular than the Beatles, the Stones are able to travel freely in public, exciting interest and curiosity but not hysteria, and the alterna-tion between them and the Irish fans has the rudiments of the dual-focus

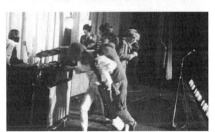

FIGURE 13.1 Charlie Is My Darling.

structure that would later emerge in the US concert documentaries. Like *Dont Look Back*, *Wholly Communion* had largely ignored the audience, but *Charlie* is almost as interested in them as in the musicians. Whitehead plays truant from the tour to explore the city, picking out Irish faces from the crowd, noticing horse-drawn carts among the buses and other anachronistic details of the cityscape, and interviewing the fans. One of them is a forty-year-old woman who claims to have a "bit of a go" in her still, but the others are mostly teenagers, enthusiastic but unsure why. "I like Mick Jagger," a young girl says, "I don't know [why], I just like him." If the fans do not understand their fascination, the musicians are hardly more insightful or articulate. In his first interview, Jones prophetically remarks, "Let's face it, the future as a Rolling Stone is very uncertain," and admits that his "ultimate aim in life was never to be a pop star" and that he is "not really satisfied either artistically or personally"; but then he adds that he is "very satisfied with what's happened." And at the end, nervously playing with a paintbrush, a self-deprecating Watts attempts to explain why he believes that what he does is not really an art form and that "pop music is restrictive," before conceding that perhaps he has an inferiority complex.

But the film's desultory progress among fans and musicians is galvanized at the Dublin concert. In the second set, responding to the rising pulse of "The Last Time" and Jagger's leaps, the adolescents scream and crowd the footlights. In the finale performance of "It's Alright," Jagger taunts them with his maracas and lyrics ("Do you feel it?") and the boys and a couple of girls invade the stage. Some dance and sing in the spotlight, but most try to make physical contact with the Stones, joyfully hugging them, jumping on them, and then flailing at them. The security manages to rescue the musicians, hurrying them off stage as the song collapses into chaos and the concert is terminated. The riot continues outside as the crowd chants, "We want Stones," while the police spirit the band away and the injured are carried out on stretchers. Energized by Whitehead's gestural camerawork and rapid editing (with clothing differences indicating the sequence has been augmented by footage from the earlier performance), the shy polite children previously introduced are transformed into an ecstatic throng. The Belfast performances are more heavily policed, with ambulances at the ready, but still the kids are frenzied. Though a young priest in attendance interviewed by Whitehead blames any "immoral effect" on them rather than on the Stones, the band obviously deliberately incites hysteria so intense that it expresses its pleasure in violence. As Whitehead himself later observed, "There are some shots in *Charlie Is My Darling*, there's no doubt about it, those boys who get up on that stage, they want to kiss Mick Jagger and Brian Jones, but when they get there they feel so damned silly, they don't know what to do, so they hit them."[9]

Together with the impulsiveness of the photography and the chronological looseness of the editing, the prominent sound-image disjunction distances

the film's overall verisimilitude. All shot by Whitehead with one camera, it was as much his vacation home movie as a Stones documentary; he inscribed his own curiosity and made no attempt to create a favorable image of the group or even to report on them objectively. Though Oldham had instructed him to make the film honest rather than commercial like the recently released *Help!*, he disliked its representation of the Stones so much that he refused to allow it a general release. But Whitehead remained enthusiastic about future collaborations.

He photographed the Stones in drag for the cover for their next single "Have You Seen Your Mother Baby, Standing in the Shadow?" and directed two black and white promotional films for it, both consisting in large part of footage of fans invading the stage as in *Charlie Is My Darling*. The first intercuts documentary street scenes of the Stones, including some from *Charlie*, with shots of them in drag for the single's cover shoot. The other opens with pixilated back-stage scenes and then for the remainder of the very fast song cuts to a frantic, disorienting montage of live performance scenes at the Albert Hall, with audience members again frenziedly invading the stage, jumping on Jagger and the others, while Jones grins in devilish delight at the melee as the security personnel struggle, if not to maintain order, at least to keep the fans at bay. The next year, Whitehead made a four-minute promo film for "We Love You," the song in which the Stones caustically replied to the police hounding that culminated in the Redlands drug bust. An opening sequence showing Jagger walking into a jail cell is followed by scenes of the band performing the song, some of them pixilated; then the scenes of stage violence from the "Have You Seen Your Mother" promo are intercut with fragments of a narrative dramatizing the Stones as the bohemian victims of a disproportionate establishment persecution. Based on the trial of Oscar Wilde, it features Jagger as Wilde, Marianne Faithfull as Bosie, his lover, and Richards as the judge, all considering the evidence of the fur rug that Faithfull had been wearing. But the BBC thought the promo to be in poor taste and rejected it.[10]

Together these works developed a visual vocabulary of filmic effects that match the ferocity of the Stones' music and the hysteria it incited in their fans: pixilation, swish pans and zooms, jump cuts, extremely rapid, non-synchronous editing, and grainy, low-resolution black and white 16-mm film. Quite different from both *A Hard Day's Night*'s precisely calibrated montages and the flowing long takes of the Direct Cinema documentaries, this aggressive, cacophonous, unpolished film style, self-assertive rather than transparent, was specific to Whitehead's visualization of the Stones; his promo film for the Small Faces "Here Come the Nice," also made in the summer of 1967, for example, lacks all these elements.

His envisioning of the Stones musicality recurred in his most ambitious documentary of mid-sixties English culture, *Tonite Let's All Make Love in London* (1967) (Figure 13.2). Taking its title from a line in Allen Ginsberg's poem

FIGURE 13.2 Tonite Let's All Make Love in London.

"Who Be Kind To," written for the International Poetry Incarnation docu-
mented in *Wholly Communion*, the film explores the "Swinging London" phe-
nomenon that became a cliché of mass-market journalism, producing—if it
was not produced by—*Time*'s April 1966 "London: The Swinging City" cover
and *Playboy*'s December 1966 "A Swinger's Guide to Good Times in the Land
of Mod."[11] The self-designated "Pop Concerto for Film" opens with a kinetic
montage of Pink Floyd in performance, interspersed with pixilated city lights
and other London sights, hysterical concert-goers, magazine covers and
newspaper headlines, miscellaneous dolly birds including one removing her
union jack bra, all set to Pink Floyd's "Interstellar Overdrive." A conclud-
ing montage returns to single-framed scenes of frenetic dancing culminat-
ing at the "14 Hour Technicolor Dream," a concert held in the Great Hall of
the Alexandra Palace in April 1967 to raise funds for London's underground
newspaper, the *International Times*. The montage creates an audiovisual por-
trait of psychedelic London, less innovative perhaps but otherwise not dis-
similar to US contemporary countercultural documentaries of hippie music
rituals, such as Ben Van Meter's *S.F. Trips Festival, an Opening* (1966). Between
the two montages, the film's main body is divided by inter-titles into seven
movements, each illustrated by documentary clips accompanied by pop songs
and/or by Whitehead's interviews with representative scenesters, here in
lip-sync. "The Loss of the Empire" is a collage of imperial guards on parade,
while "Dolly Birds" features one who explains that a "dolly girl is someone
who dresses how she feels and does what she likes," which is seen to include
dancing to a cover version of the Stones' "Out of Time." In "Protest" Vanessa
Redgrave recites a poem about Cuba, the last part of which is accompanied

by footage of London protests against the invasion of Viet Nam. After footage of Pink Floyd recording "Interstellar Overdrive," "It's All Pop Music" mostly features Oldham at work in the recording studio. For "Movie Stars," Julie Christie proposes that "a good time is much easier had by all now than ever before," but Michael Caine laments that mini skirts indicate that "we are selling our morals for a mess of cultural pottage." Alan Aldridge, best known for painting naked girls in psychedelic designs, admits, "The sort of stuff I am doing is absolute ephemera," to make one half of "Pop Painting," with David Hockney disputing that London is a swinging place the other. And "As Seen from USA" examines the arrival of Playboy bunnies and the decision to build the first European club in England because "this is where it's all happening."

Though *Tonite Let's All Make Love in London* alternates between images from an advertising agent's dream of "swinging London" and the vacuous commentary of its spokespeople, Whitehead retrospectively claimed that it contained a critical component: "With *Tonite* I was trying to examine the mythology that everybody in London was having fun. Ginsberg's poem, which is very much about the theft of British culture by American cultural and capitalistic imperialism, is actually very dark. For me the 1960s was the Aldermaston march, the war in Vietnam and the Dialectics of Liberation. The only miracle about those years is that it was a moment of extreme change that managed to get through without savage violence."[12] Hardly any of this misgiving is apparent, and the failure to present evidence of US influence on Britain leaves it conjectural, especially since the historical moment was rather one of an unprecedented reverse flow in which British music and fashion colonized the United States. And apart from Redgrave's reference to "Fidel's Revolution" and a couple of protest scenes, the film ignores progressive politics and the British avoidance of "savage violence" that Whitehead cites as being his real interest. Ironically, only Jagger attempts to address them, and so he becomes the spokesperson for the London counterculture, of which the Stones' music appears the essential catalyst.

Immediately after an indulgent interlude of Oldham's airheaded musings on his future in politics, the film cuts to an extended clip from the same footage used in Whitehead's first "Have You Seen Your Mother Baby" promo, showing the girls rushing the stage and attacking an exultant, preening Jagger as he incites them, "Live through the shadow, tear at the shadow." In the interview immediately after, he adopts an entirely different persona and without a trace of irony makes several thoughtful if inchoate arguments: that not liking "the war" is itself a form of "violence"; that anti-police violence reflects the protestors' lack of organization; that he is not a leader even though he writes "from anger"; and that his generation's moral and political self-consciousness is made possible by their affluence. The section then returns to the audience mayhem footage used in "Have You Seen Your Mother, Baby," but this time, it is accompanied by the Stones' acoustic ode to the female genitals, "Lady Jane,"

and shown in slow motion that turns the chaos into a graceful ballet. Though the sequence is no more conclusive than the other sections of the film, it nevertheless assembles powerful aural and somatic images, not only of the disjunction between Jagger's off-screen identity and his knowingly exploitative incitation of Dionysian mayhem, but also of Whitehead's own exploitation of parallel libidinal contradictions.

Political Theater: Jean-Luc Godard

For his first English-language film, Godard had initially planned to explore the politics of rock 'n' roll by starring John Lennon in a film about the assassination of Trotsky.[13] Rebuffed by Lennon, who also refused to allow him to film the Beatles in the recording studio, he turned instead to the Rolling Stones. Even though he had "no idea really" what the film was about, Jagger said "I have seen all his pictures and I think they're groovy."[14] Initially envisioning a project that would have intercut footage of the band in the studio with the story of "a tragic triangle: a French girl in London is picked up by a Right-wing Texan but then falls for a Left-wing Negro militant,"[15] Godard began photographing the band on June 5, 1968, at Olympic Studios in London as they began to rehearse "Sympathy for the Devil," and eventually paid them $50,000. Bill Wyman recalled, "His method suited us perfectly, for he had no real master plan or film script. He worked from one point to another, filming a piece and then deciding what to do next after looking at the result."[16] Completed that year, *One Plus One* (Figure 13.3) is conventionally divided between spectacle and narrative and, like *Jailhouse Rock* and *It's Trad, Dad!*,

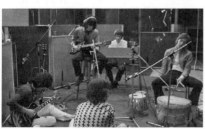

FIGURE 13.3 One Plus One.

its scenes of musicians recording in the studio are intercut with scenes in the public world. But the Stones appear only in the studio and have no narrative connection with the protagonists outside. A diegetic rupture categorically separates the two tracks of the montage, rendering any links between them analogical or metaphorical rather than social and ontological. Derived from a graffito popular during the May 1968 Paris insurrection, the title, *One Plus One*, thus invites the audience to see the elements of the montage separately, and leaves them to decide whether to put one and one together to see if they do "add up" in any significant way.

The film contains ten, approximately ten-minute sections, all introduced by colorful hand-drawn intertitles.[17] Beginning with "The Stones Rolling," they alternate between five sync-sound scenes of the band in the recording studio exploring various arrangements of "Sympathy for the Devil" and five scenes outside the studio that Godard shot separately on a return visit to England in August. The second sequence—the first outside the studio—"Outside Black Novel," features black militants in a Thames-side automobile junkyard; one reads aloud from LeRoi Jones's *Blues People*, describing how the blues has been debased by white imitators, another from Eldridge Cleaver's paean to white women in *Soul on Ice*, and another from Black Panther Party texts. Halfway through, three white women in white shrouds are driven into the yard, roughly manhandled, and some of them perhaps executed. In the fourth, "All About Eve," a woman in a pretty yellow dress who identifies herself as Eve Democracy (played by Anne Wiazemsky, then married to Godard), strolls aimlessly through lush English woodlands; after failing in her attempt to make telephone contact with Jones, Cleaver, Malcolm X, and other black power leaders, she is interrogated on a variety of political questions to which she answers only yes or no. In the sixth, "The Heart of Occident," a man (Iain Quarrier, one of the film's producers) stands in a used bookstore reading loudly from the "Weltanschauung and Party" and "War Propaganda" chapters of *Mein Kampf*, while the camera tracks across rows of girlie magazines and pulp fiction. "Inside Black Syntax," the eighth, returns to the junkyard, where two beautiful black women interrogate activist Frankie Dymon, Jr., about the politics of black power. And in the tenth and last, "Under the Stones the Beach," a pun on the May 1968 slogan, "*Sous les pavés, la plage*" ("Under the paving-stones, the beach"), several young activists with guns run around on a beach. They appear to kill Eve Democracy, and place her body on a movie camera crane that, flying a black and a red flag, rises into the sky. Zooming into the tableau, the film ends with a freeze-frame on her.

All these scenes are shot in continuous long takes, with the camera tracking and panning, usually horizontally but sometimes vertically, and only very rarely zooming, and all are periodically interrupted both visually and audibly: by fragmentary scenes of Wiazemsky spray painting enigmatic slogans like "CINEMARXISM" on walls, windows, and cars in London; and by the voice-over of a self-identified spy trapped in London who kills time by

reading from an absurdist pornographic novel featuring a range of political and media figures: for example, "John Birch's daughter spread herself out and spread her legs for her master. In deeply and firmly went Brezhnev's prick." In the last scene, the novel finally converges on the political allegory as the narrator describes himself being on a beach, "waiting for Chairman Mao's yellow submarine to come and get me." Noticing all the people on the beach, he concludes with a succinct Godardian reflexive flourish, "It was my opinion they must have been making a film."[18]

Recurring among these heterogeneous contrived vignettes, the Stones' five scenes become a stable ostinato, producing an object lesson in the fundamentals of film language: the Bazinian deep-focus realism of the long-takes of the manufacture of pop music are set within an Eisensteinian montage in which implied parallels to or implications of it are metaphorically elaborated. Continuing over several days, the rehearsals show the Stones constructing "Sympathy for the Devil" from an initial chord pattern, exploring different rhythms and instruments, and eventually transforming the Dylanesque ballad into a densely layered propulsive samba anthem. Even more than the scenes of Bob Dylan writing in *Dont Look Back*, they form a fascinating documentation of the composition of a classic rock song. Though Jagger and Richards are clearly the leaders, it is a communal process involving the entire band (still including Jones), sometimes gathered together in a group but more commonly separated behind baffles or isolated in their individual headphones, as well as assorted collaborators and technicians and the girlfriends who perform the haunting "Whoo-whoo" choruses.

Markedly different from the gestural handheld 16-mm cameras used in the Direct Cinema documentaries, the measured precision of the movements of the dolly-mounted 35-mm camera and the high-resolution image portray the musicians in all their spotty idiosyncrasy and sartorial extravagance. But, as in Godard's other documentations of work, they appear, not as inspired creative artistes, so much as intermittently laboring artisans. On the one hand, their unrestricted access to studio time, their expensive instruments and extensive equipment, and a small army of engineers, assistants, studio musicians, and hangers-on indicate their privilege as labor aristocracy and by implication their product's financial value for the culture industry. On the other, their labor appears desultory and unproductive; they do discover the samba rhythm, but otherwise the song hardly improves or develops, and in the final section it is as rudimentary as it has ever been—unlike "Don't Leave Me Now" in *Jailhouse Rock* in which, after one unsatisfactory take, Elvis puts his own emotions into the second and produces a masterpiece. Indeed, the scenes serve to undermine any such myths of rock 'n' roll spontaneity, demystifying the primal inevitably of the finished record which in subsequent live performances the band worked so hard to reassert. Godard represents their music, not in the energized ritual of such performances, but

in the labor that produces the more fundamental commodity records, manufactured to be sold across the store counter. And the revelation of the constructedness of the rock song parallels the film's foregrounding of its own artifice, its own rejection of organic unity and humanist expressivity.

Made when Godard was a member of the Dziga Vertov Group, a Marxist film collective formed at the time of the May 1968 Paris events, *One Plus One* shares many of the group's strategies, though directorial credit is assigned to him individually.[19] After the failure of the May 1968 alliance between students, workers, and artists and the general strike that attempted to overthrow the de Gaulle government, the group turned to film essays investigating the mechanisms of film language as a means of critiquing cinema's role in capitalist society. Believing that the emotional identification prized in the commercial entertainment cinema—and of course in rock 'n' roll performance—was the vehicle by which bourgeois ideology was subjectively reproduced, they disjoined sounds and images so as to break the cinematic illusion of reality and force the spectator to analyze the film's ideological effects. Given that rock had replaced cinema as the central cultural forum for radical youth and that the Rolling Stones were thought to be the most "revolutionary" band in rock, a film undertaking a critical investigation of their music could quite logically be thought especially important in similar terms.

The Stones project was especially timely: recorded June 4–5 and 8–10, 1968, "Sympathy for the Devil" coincided first with the assassination of Robert Kennedy on June 6 (causing one of its key lines to be rewritten as "Who killed the Kennedys?"), and second with the defeat of the Paris insurrection as the students were evicted from the Sorbonne, and the leftist parties lost the first round of elections before those of the right won an overwhelming majority a week later. Though it was purely by chance that when Godard arrived to work with them the Stones were rehearsing "Sympathy for the Devil" rather than any of the other songs being readied for *Beggars Banquet*, both the song and the whole album were replete with issues that intersected with the political questions that concerned him: the role of culture in revolution; and the conflict between a working-class communist offensive against capitalism and civil rights struggles organized around blacks, women, and other minority identity groups. It was his great good fortune to have caught the Stones at the point where their, or at least Jagger's, engagement with these issues was most explicit, if not coherent.

The most ambitiously novelistic of Jagger's compositions and the most complex dramatization of his personae, "Sympathy for the Devil" was inspired by Mikhaíl Bulgakov's novel *The Master and Margarita,* written during the Stalinist period but not published in its entirety until 1967, also the year of its first English translation.[20] A satire on the government and literary bureaucracies and a meditation on the nature of good and evil, it has—like *One Plus One*—two separate diegetic strands. The first narrates a

visit by Satan, disguised as a gentleman, to the Soviet Union in the 1930s. His machinations are interwoven with the second, extracts from a novel by "The Master" about Pontius Pilate's responsibility for Christ's execution, and it ends with Pilate, the Master, and his lover, Margarita, whom Satan had turned into a witch, reunited with Christ. The novel's tension between the inevitability and omnipresence of evil and the possibility of redemption recur in Jagger's lyrics. Speaking in the first person, he introduces himself as a "man of wealth and taste" and then as Lucifer, while recounting a series of historical catastrophes over which he claims to have presided: the agony of Christ, the execution of Czar Nicholas II and his ministers and wife, the Nazi Blitzkrieg, the murder of the Kennedys, but not the US invasion of Viet Nam or other contemporary atrocities. Along with its historical survey, the song hints that the puzzle of Lucifer's "game" has metaphysical implications, especially the interchangeability of good and evil ("Just as every cop is a criminal/And all the sinners, saints"), the complicity of all people in the activity of evil ("It was you and me" who killed the Kennedys), and the fact that at present Lucifer is "in need of some restraint."

But as well as *The Master and Margarita*, the song invokes black vernacular culture's intense preoccupation with the devil that produced, among so many other instances, Robert Johnson's "Me and the Devil Blues" (which Jagger plays in *Performance*). Several forms of Romantic Satanism are also echoed, including William Blake's *Marriage of Heaven and Hell* and Aleister Crowley's *The Book of the Law*, as well as Jagger's own earlier remarks in *Tonite Let's All Make Love in London* about the need for nonviolent political action. But, even if contradictions such as the Stones' trafficking in fan violence, the ambiguous politics of "Street Fighting Man," and the elitist scorn for the working class on *Beggars Banquet*'s "Factory Girl" and "Salt of the Earth" are disregarded, the analysis precludes any distinction among conflicting agents: the National Liberation Front of Viet Nam cannot be distinguished from US imperialism and, as in the Hegelian master-trope, the "scarred old slaver" is just one moment in the dialectic of "brown sugar."

Godard's montage interrogates the Stones' cultural contribution to the politics of the revolutionary year by returning one of their most emblematic songs from metaphysics to contemporary history, to the politics of the North Atlantic countercultures, especially to the black and women's identity politics that were replacing working-class socialist initiatives. The issues of race and sexuality, of black men and white women, were also primary to the polemics of rock 'n' roll, and both were flash points for the Stones, who had founded a subgenre of rock 'n' roll on misogyny and black culture. But rather than proposing a linear argument, *One Plus One* surrounds the Stones' appropriation of evil with symptomatic vignettes of politico-cultural acts, a spectrum of comparisons and contrasts, against which it may be assessed. As ironic, pantomimic, or allegorical analogues, they provide occasions where "the nature of [their] game" might be fathomed. Godard's reflexive dismantling of the

elements of a Stones' song enables his interrogation of the politics to which their music inchoately lays claim.

The "All About Eve" section, for example, a single deep-focus long-take, is an allegorical film-specific dramatized political essay. Its title invokes Joseph L. Mankiewicz's eponymous cold war melodrama about sexualized competition among actresses, and its protagonist, Anne Wiazemsky, starred in of one of cinema's greatest humanist achievements, Robert Bresson's *Au Hasard Balthazar* (1966), an art film about an abused animal and an abused woman. Born in Budapest, she is linked to the 1956 student-led Hungarian Revolution, the first major resistance to Soviet communism, and here her character is being visually and acoustically recorded in an Edenic landscape, explaining, or rather failing to explain, democracy in a film that will never be seen, just as on the other track of the montage the Stones are visually and acoustically recording versions of "Sympathy for the Devil" that will never be heard outside Godard's film. In fact, Wiazemsky did not understand English, and her replies were flagged by Godard himself; thus the agents of cinema speak the positions to which she assents or dissents (themselves derived from a *Playboy* interview with Norman Mailer[21]), standing in for Godard himself, who directs her to articulate his own political position. Including references to drugs and US imperialism, his concerns are wider than Jagger's, but otherwise they often coincide: Eve agrees that "maybe the devil is god in exile"; that the "tragic irony is that in fighting communism we are creating the absolute equivalent of communism in our own society"; and she does not "have a theory about who killed Kennedy." But symptomatically they disagree categorically over the revolutionary role of culture. Against Jagger's belief expressed in "Street Fighting Man" that though he can "scream, I'll kill the king," he sees no role for himself in violent political protest and all he can do is "sing for a rock 'n' roll band," Eve agrees with Godard that "there is only one way to be an intellectual revolutionary and that is to give up being an intellectual." Hence the plangency of her unanswered phone calls to the black militants with which she begins, a failed attempt to make common cause across racial, sexual, and other political boundaries.

The other dramatized chapters similarly use a variety of discursive forms to mobilize issues around the politics of culture. Wiazemsky herself recurs in one different role as the activist spray painting visual poems that, like the slogans of May 1968, wittily put one and one together to make something new and condense the links between two realms: cinema plus Marxism becomes CINEMARXISM. In another, as one of the three white women brutalized by the black militants, she represents the actualization of Cleaver's racist misogyny. And finally, as the dead woman who rises with the movie camera between the flags of anarchy, she is the victim sacrificed to cinema. The pornographic novel similarly interweaves politics and sexuality, as does the scene in the bookstore where the rows of women's bodies on the magazine

covers illustrate the degradation of women in capitalist patriarchy that forms the context for *Mein Kampf*'s distinctions between the political nature of mass and elite cultures expressed in, for example, "Propaganda must always address itself to the broad masses of the people. . . Propaganda has as little to do with science as an advertisement poster has to do with art, as far as concerns the form in which it presents its message." And the final section with the militants employs the black women, themselves parallel to the male filmmakers in the "All About Eve" section, who skeptically investigate the politics of Black Power, even to ask what the militant recognizes as "the same old question": "What is the relation between Communism and Black Power?" Generalized as a question of the relation between a socialist revolution against capital and identity politics, the question would dominate radical thought for the next quarter-century.

In an interview soon after the film's completion, Godard expressed his disillusion with the possibility that the Stones had any progressive political significance. He initially planned that their recording would instance "something in construction" in the film and so mark a contrast to the lack of any constructive potential in democracy. But he quickly decided that their "new music could be the beginning of a revolution, but it isn't" and that it was "a palliative to life" rather than a contribution to "class struggle or the struggle for production," and he felt their failure to stand with him against Quarrier marked a betrayal.[22] Nevertheless, *One Plus One* positions them, not as Whitehead's mildly political conscience of Swinging London, but as the most radical cultural force of the period, the one where the most pressing political questions were raised, though not solved. Godard thought the Jefferson Airplane to be "more like tribal people," though less accomplished and less political than the Stones, but it was to them he next turned to explore the political implications of rock 'n' roll.[23] The Stones, meanwhile, returned to the entertainment industry and competition with the Beatles.

The Rolling Stones Rock and Roll Circus

Less than two weeks after the November 30, 1968, presentation of *One Plus One* at the London Film Festival, Jagger organized the Stones to shoot their own, considerably less ambitious, performance film: *The Rolling Stones Rock and Roll Circus* (Figure 13.4). Clearly emulating the Beatles' interest in British vernacular culture that produced *Sgt. Pepper's Lonely Hearts Club Band* and *The Magical Mystery Tour*, it was like the latter, which had been broadcast the previous Christmas, designed to be a BBC television special. Michael Lindsay-Hogg, who had previously made videos for both the Stones and the Beatles, directed it, shooting over eighteen hours beginning on December 11. In the event, its release was withheld until the 1996 DVD, reputedly because

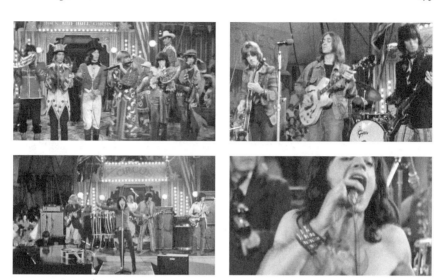

FIGURE 13.4 Rolling Stones Rock and Roll Circus.

set-up delays postponed the Stones' own performance until the next morning, by which time they were exhausted and had in any case been outperformed by the Who, fresh from a highly successful tour. As well as the Who, the circus also featured a pair of elderly trapeze artists and a fire eater assisted by African American model Donyale Luna (who had been featured in the last section of *Tonite Let's All Make Love in London*), along with Jethro Tull, Taj Mahal, Marianne Faithfull, the Dirty Mac (a supergroup led by John Lennon that also included Eric Clapton, Mitch Mitchell, and Keith Richards), and Yoko Ono accompanied by the classical violinist, Ivry Gitlis. All the acts performed live in a big-top erected on a sound stage before an invited audience of teenagers and twenty-somethings dressed in brightly colored hats and ponchos. The musicians' costumes flaunted London psychedelia, with Jones, in his last public appearance with the band, being especially dandified. Dressed as a circus-master, Jagger introduced the entire event as "Sights and sounds and marvels to delight your eyes and ears," and the musicians made the other introductions. Each act was allowed one song, except the Stones themselves, whose six occupied the last half of the hour-long show.

They open with "Jumping Jack Flash," here noticeably less propulsive than usual, and the two slow blues they follow with, "Parachute Woman" and "No Expectations," fail to establish any momentum. Jagger's movements are unusually constrained and he stays close to the floor microphone, slipping out of his persona between songs. His hair is much longer than seen before on film, breaking over his shoulders and dyed black so that it contrasts with the pallor of his complexion and exaggerated features, which seem at once more masculine and more feminine. But as the band moves into an again sluggish,

"You Can't Always Get What You Want," he attempts to arouse the audience, leaning into the camera to fill the screen with his leering face, and rolling his eyes and lips to underscore the lyrics. Then he removes the microphone from the stand and begins to work the whole stage, taking advantage of the intimate setting to move among the schoolgirls in the audience and address them individually. His dancing becomes more frenzied, with exaggerated hip thrusts and leaps, and the editing becomes more energetic as the multiple television cameras allow rapid cuts between close-ups and medium shots on his gestures.

Resting only for a brief reaction shot of the audience, the band moves into "Sympathy for the Devil," with Lindsay-Hogg alternating extreme close-ups on the individual band members, then giving Richards' first solo close attention before moving to Jagger as the central attraction. Suddenly he seems possessed by his role, enacting it and the music with his face and whole body. As the choruses mount, he falls prostrate on the stage, pulling off his pink T-shirt to reveal images of the devil painted on his scrawny arms and chest, and completes the song screaming hoarsely and dancing frenetically, naked apart from tight maroon pants with his genitals clearly outlined against his tiny hips. But though Lennon, the Who, and the schoolgirls dance and applaud with the rest of the audience, they lack his delirium, as if they recognize it without themselves sharing it. And, rather than ending the circus there on what he had created as a climactic finale, an already out-of-character Jagger leads a coda of a lethargic falling about to a previously recorded "Salt of the Earth," one of their most supercilious songs.

In the *Circus*, Jagger positions the Stones and himself especially at the acme of rock 'n' roll aristocracy, to whom the London beau monde and a black American representative in the form of Taj Mahal are in thrall. With the mobile television cameras and the stage lighting accentuating his histrionics, the performance of "Sympathy for the Devil" is one of his most riveting dramatizations of his persona. Where its political ramifications had been explored in *One Plus One*, Jagger's next film projects, made by two of the most radically experimental filmmakers of the time, explored the metaphysical and libidinal dimensions of his satanic majesty, if not his satanic imposture.

Mick Jagger, Demon Brother

Several years before *Time* designated the Rolling Stones as "Satan's Jesters,"[1] their album *Their Satanic Majesties Request*, with Mick Jagger dressed as a medieval wizard on the cover, was released in December 1967. The next year's "Sympathy for the Devil" reflected an interest in the occult and Satanism shared by Jagger, Keith Richards, Anita Pallenberg, and others in their circle. Their demonic equivalent of the Beatles' Eastern mysticism was catalyzed by Kenneth Anger's arrival in London. After completing *Kustom Kar Kommandos* (1965), Anger had moved to San Francisco, intensifying his involvement with Satanism and Aleister Crowley and further developing his vision of a Magickal cinema devoted to Lucifer, the Angel of Light.[2] He began working on a new film *Lucifer Rising*, planning it as a celebration of the hippie counterculture that, he believed, manifested an epochal transition. Where *Scorpio Rising* had portrayed a deathly Piscean culture founded on Christian guilt and renunciation, the Aquarian age would be characterized by "the unexpected, revolution," including "a revolution of inner space—Man dis-covering himself."[3] And Lucifer, the God of Light and hence of cinema, would be its guiding power: "Lucifer is the Rebel Angel behind what's happening in the world today. His message is that the Key of Joy is Disobedience."[4] Anger became friends with Bobby Beausoleil, a veteran of Arthur Lee's seminal Los Angeles band *Love*, who had started his own band in San Francisco, and the two attended the San Francisco Human Be-In in January 1967 together. Deciding that Beausoleil would both star in the film as the resurgent Lucifer and compose its music, Anger began shooting footage of him and also of Anton LaVey, the "Black Pope" who had founded of the Church of Satan, and he had Ben Van Meter film himself (Anger) as he performed an equinoctial Magickal ritual. But the event ended in chaos and, claiming that Beausoleil had stolen most of his footage, he temporarily abandoned the *Lucifer Rising* project.

Beausoleil left San Francisco soon after, only to become involved with Charles Manson, and, after a dispute concerning bad mescaline, he partic-ipated in the Family's murder of Gary Hinman. Anger moved to England in 1968, where his reputation as a filmmaker, Satanist, and connoisseur of

LSD quickly gained him entrée into the London beau monde known as the Chelsea Set, and the art world, initially through late-night screenings of US avant-garde films, including Bruce Conner's as well as Anger's own, at Robert Fraser's gallery. Fraser introduced him to Jagger, and eventually he also became acquainted with Marianne Faithfull, Richards, Brian Jones, and Pallenberg. Anger also befriended Led Zeppelin's Jimmy Page, a collector of Satanist materials, who was so obsessed with Crowley that he bought Boleskin House, once his mansion in Scotland. Meanwhile, even as Jagger and Richards had put police harassment over drugs behind them (the latter for a few years at least), Jones's drug usage and persecution had both escalated. Increasingly incapacitated, he had become marginal to the band he had created and, a month after being asked to leave it, he was found dead at the bottom of his swimming pool. Two days later, on July 5, 1969, the other members of the group, along with replacement guitarist Mick Taylor, performed a free concert in Hyde Park for a quarter of a million people, dedicating it to his memory.[5] Wearing a white frock, Jagger read from Shelley's "Adonaïs," an elegy on the death of Keats, and three and a half thousand white butterflies were released, though many of them were already dead.

Jagger's dalliances with satanic imagery were engaged in two films, Anger's own *Invocation of My Demon Brother* (1969) and *Performance*, directed by Donald Cammell and Nicolas Roeg in 1968, but not released until 1970. Though many thought that Richards and Charlie Watts formed the band's musical core, Jagger was its face, voice, and summary icon, and the two films featured him, rather than the Stones as a group. He appears as a rock 'n' roll star in both films, and both drew on and augmented his reputation as a threat to public morality. Though one was an artisinally made avant-garde short and the other a Hollywood-funded feature art film, they have many similarities; one in its entirety and half of the other are chamber films, in which social encounters in an isolated room dramatize rituals of self-realization through the interaction between and union of psychic contraries. Adopting a gnostic term, C. G. Jung designated such a pairing of sexual opposites or of the conscious and unconscious minds as *syzygy*, while Anger understood it as an encounter with the "eidolon," "the secret double who is possibly a demon and possibly an angel. It's either your better self or your worse self, or the part of you that's needed to become complete."[6] One film is completely and the other substantially constructed with highly unconventional rapid montage sequences that may operate subliminally, and both revolve around forms of sexuality considered decadent that challenged conventional cinema as categorically, if quite differently, as had *One Plus One*. Where Godard's interest in the political implication of the Stones' music had entailed a critical distance from the band, these films attempted the opposite, to facilitate as directly as possible the operation of Jagger's psychosexual and perhaps metaphysical influence. Both films aspired, not simply to represent an event, but to transform the

spectator's consciousness, an aspiration which they, of course, shared with the Stones' own performances. Both are fully inhabited by "youthful charisma, narcissism and sex appeal all dressed up (or down, if you prefer) in death-defying, sometimes death-embracing, attitude,"[7] and both perform a distinctive filmic rock 'n' roll musicality.

Invocation of My Demon Brother

Anger believed that Jagger's ability to incite euphoric frenzy in his audiences made him the era's Lucifer who would lead the children of the Aquarian age. Hoping eventually to star him in *Lucifer Rising*, he filmed the Stones at the Hyde Park concert, along with their girlfriends and the English Hells Angels (not officially chartered as such by the US headquarters until two months later), who had been invited as security. News of Beausoleil's arrest for the Hinman murder increased Anger's mystique and inspired him to assemble the surviving fragments of the previous version of *Lucifer Rising*, and to edit the Hyde Park and other footage with it for a new film, *Invocation of My Demon Brother* (Figure 14.1). For the soundtrack, Jagger improvised a repetitive atonal drone on the recently released Moog synthesizer.

According to Anger's own program notes prepared for the August 1969 screenings in New York, *Invocation of My Demon Brother* is the "shadowing forth of Our Lord Lucifer, as the Powers of Darkness gather at a midnight mass. The dance of the Magus widdershins around the Swirling Spiral Force, the solar swastika, until the Bringer of Light—Lucifer—breaks through. 'The

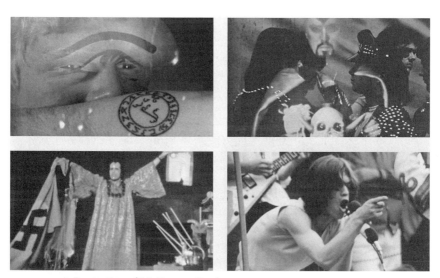

FIGURE 14.1 Invocation of My Demon Brother.

true Magick of Horus requires the passionate union of opposites.'"[8] The film's core is the whirling ritual dance of the Magus—Anger himself, costumed as an Egyptian god—performed at the Straight Theatre on Haight Street in San Francisco. Superimposed on and intercut with it is a variety of other ritual material: soldiers descending from a helicopter in Viet Nam, Beausoleil and two others smoking a marijuana cigarette held in a miniature skull, a band of musicians, various alchemical and Egyptian symbols, naked boys wrestling, several animals, other symbolic figures including LaVey, who plays "His Satanic Majesty," Beausoleil himself as Lucifer, and brief images of the Hyde Park concert with the Hells Angels, the audience, and the Stones. After the smokers have ingested the drug, the film erupts as a hyper-kinetic volcano of images, with the very brief shots and often several layers of superimpositions generating a headlong montage of images outside any coherent spatial or temporal continuum. It is held together by the stable sonic ostinato of Jagger's Moog and a skeletal chronology in which the Magus succeeds in raising Lucifer, a shot of whom, made with a prismatic lens and illuminated by a circular moiré of red light, brings the film to a conclusion—apart from a very brief shot of a black mammy doll holding a card on which is printed, "Zap, You're Pregnant. That's Witchcraft." Otherwise, the relation among the visual concepts is metaphoric and/or metonymic: they are all aspects or manifestations of Lucifer, the forms of the vital disobedience and self-realization that he encompasses.

Apart from one brief but very clear shot of Jagger taunting the crowd, most of the Hyde Park concert imagery occurs in the montage superimpositions: the Hells Angels with their brightly studded leathers appear to emerge from a fiery lake, the concert audience is combined with a multiply refracted image of Lucifer and juxtaposed with the Viet Nam soldiers, and the shots of Richards, Faithfull, and Pallenberg, so brief to be almost invisible, are intercut into the multiple images of Beausoleil as Lucifer at the end of the film. The context of the intellectual montage of the "magick" symbols frames the Stones, not as Whitehead's London neo-aristocracy or Godard's politically ambiguous revolutionaries, but as a historical manifestations of a transhistorical, indeed transcendental, spiritual force; they are one of the collective forms of the Demon Brother that the film has successfully invoked, or perhaps the force that has summoned the Demon Brother, as proven by the presence of the Hells Angels.[9] Like Beausoleil, Jagger is both subject and object of the invocation.

A Magickal film, a ritual undertaken to conjure Satan, *Invocation of My Demon Brother* was, like the Stones performances, designed to raise hell rather than merely depict it, and it aspires to the same function in its effect on the spectator. Anger himself described it as "an attack on the sensorium," an attempt to cast a spell on those who see it, to raise the demon brother of a generation.[10] The final "Zap, You're Pregnant," then notifies the spectators that by watching

the film, they have been inseminated with its demonic power. The motif had a particular currency at the time: recently introduced in *Rosemary's Baby* (Roman Polanski, 1968), it recurred later in Cammell's *Demon Seed* (1977) and in both, the devil's impregnation is visualized in a deviant, experimental film style (with contributions by Bay Area avant-garde filmmaker Jordan Belson in the latter), stylistically akin to that of *Invocation* as a whole. Like these, Anger's film pivots on an impregnation by the devil, but rather than (like *Demon Seed*) representing the act performed biologically on a female protagonist, *Invocation* is designed to fertilize the mental state of its viewers, to spur them to a qualitative advance in disobedience that will effect their own ritual of self-realization and demonically arouse them to violent insurrection, like the Dublin teenagers of *Charlie Is My Darling*. Similar ideals were narratively elaborated in Cammell's breakout film, *Performance*.

Performance

Performance also dramatizes the mutual imbrication of rock 'n' roll and violence, combining Anger's metaphysical projections with Godard's social and political concerns on the diegetic ground of the London criminal underworld.[11] In it, violence is proposed as isomorphic with British capitalism, subject to slumps but otherwise an endlessly predatory process that renews itself by forcibly assimilating smaller units. Similarly brutal mergers also occur within the psyche of individuals, especially in psyche of people who have been touched by rock 'n' roll.

Cammell's father wrote a biography of Aleister Crowley, and as a child he had himself met the magus. After first gaining acclaim as a portrait painter, he turned to abstraction, moving to New York, then to Paris, where he became involved in the *nouvelle vague* film scene. There he met Pallenberg and later, in 1965, the Stones, who sparked his interest in rock 'n' roll and pop culture generally. With his brother David, he worked on the script of what became *The Touchables* (Robert Freeman, 1968), a "Swinging London" caper involving four girls who abduct a young man for their pleasure, and a similarly contemporary heist movie, *Duffy* (Robert Parrish, 1968). Now determined to direct, he wrote an early version of *Performance*. It interested Sandy Lieberson, a Hollywood agent working in London, who secured Jagger, James Fox, and finally Nicolas Roeg, who became co-director as well as cinematographer. With these committed, Lieberson was able to obtain funding from Warner Bros., and shooting began on location in London in September 1968, a couple of months after the "Sympathy for the Devil" recording sessions and the release of *Tonite Let's All Make Love in London*.

A fictional feature, *Performance* (Figure 14.2) is cleanly divided into two parts, the somewhat shorter first being generically a gangster film and the

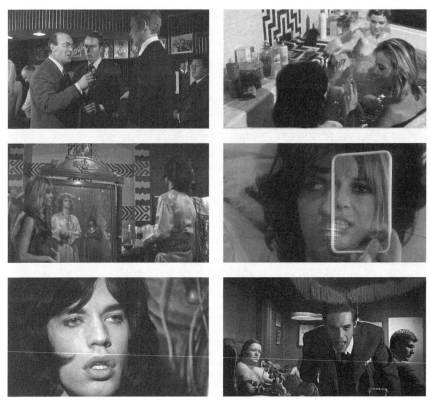

FIGURE 14.2 Performance.

second a domestic melodrama. Chas (James Fox), the only protagonist who spans the whole, is a heavy for a London criminal organization resembling the Kray Twins, whose fashionable notoriety at the time had endeared them to the Chelsea Set. Contrary to the instructions of the boss, Harry Flowers (Johnny Shannon), he interferes in a protection scheme involving Joey, a friend from his days as a boxer, whom he now claims to despise as a "ponce" with a vehemence that suggests a repressed homosexual attraction. Angered by Chas's breach of protocol, Flowers observes that by allowing his relationship to Joey to become "double personal," Chas has revealed himself to be an "out of date boy" and so a danger to the organization. After being forcibly inducted into Flowers's "firm," Joey ambushes Chas in his apartment and beats him viciously until Chas manages to reach his gun and kill him. Disguised and on the run from Flowers, he serendipitously overhears a conversation involving a black guitarist that leads him to the basement room of a house in Notting Hill, then a racially mixed, largely slum area of London. Pretending to be a professional juggler, he asks to rent the room so that he may lie low before escaping to the United States. The house is owned by Turner (Jagger), a formerly successful rock 'n' roll musician who has lost his

creativity and now lives in a bisexual *ménage à trois* with Ferber (Pallenberg) and Lucy (Michèle Breton).

Initially reluctant to allow Chas to stay, Turner becomes fascinated by his aura of violence but, wanting to "see how he functions" and intuiting that he may help him break his blocked creativity, he relents. Similarly intrigued by the psychosexuality of Chas's violence and rigid homophobia, Ferber feeds him an overdose of magic mushrooms. As Turner strums Robert Johnson's "Me and the Devil Blues," she dresses Chas in a variety of costumes, ostensibly to help him obtain a photograph of himself in disguise for use in a fake passport that will allow him to escape. Holding a mirror to his face, she produces a split image of the two of them but, even under the influence of the hallucinogens, Chas insists on his unambiguous masculinity—"I feel like a man, all the time. . . . I'm normal"—and accuses Ferber of being perverted when she counters that Turner is "a man: a male and female man." She further explains that Turner "is stuck" because he has "lost his demon." One day, she explains, he was looking at his image in a mirror and saw himself as "a beautiful little freaky stripy beast," but the image faded and his demon abandoned him. Now he thinks of Chas as a "little dark mirror," and she sends Chas to him, saying, "He's waiting for you, he's been waiting a long, long time." Still under the influence, he finds Turner singing and dancing, and a zoom into Chas's ear introduces "Memo from Turner," a diegetically autonomous musical interlude that presumably takes place in his mind.

Dressed like Flowers but with his hair slicked back like Chas's when disguised, Turner performs the mid-tempo blues number in his office accompanied by other members of the firm. The surreal Dylanesque lyrics draw a sequence of hallucinatory vignettes of violent criminals, all working for the Flowers/Turner narrator. After the interlude, the drugs and the overall experience appear to have transformed Chas, mollifying his rigid masculinity to allow him a tender, loving encounter with Lucy. But he has missed his passport connection, and Flowers's men have tracked him down. Before they drive him away to be killed, he demands a last meeting with Turner, who declares that he knows where he is going and asks to be allowed to accompany him. Chas shoots him though the head, and the camera follows the bullet alighting briefly on an image of the Argentine writer Jorge Luis Borges, before exiting to the streets outside, where Flowers awaits him, now in a *white* Rolls Royce. As it draws away, the condemned man inside is seen to be Turner. This last shot in fact reprises the film's second, the first of an extended sequence of shots of a *black* Rolls Royce driving through the English countryside, which is intercut with scenes of violent sexual activity, so rapid as to be barely legible. Retrospectively it suggests that the whole film is a flashback contained within this edit, structurally parallel, not only to Cocteau's *Blood of a Poet* (1930)—and *Woodstock* (Michael Wadleigh, 1970)—but also, and more appositely, *An Occurrence at Owl Creek Bridge* (Robert Enrico, 1962). As in the last film, at

the moment of his execution, Chas's life flashes before him, but as it has been transfigured by his encounters with various forms of his previously repressed unconscious selves, with perhaps the changes in the car colors lending a suggestion of transcendence.

All the film's main transactions deconstruct equivalent psychic binaries, following the logic of Jung's *syzygy*, Crowley's "passionate union of opposites," but also Jagger's "Sympathy for the Devil." The logic that "every cop is a criminal, and all the sinners, saints" subtends the reciprocal identification of gangsters and rock 'n' roll singers and the instability and interchangeability of sexual identities. Recapitulating the first part of the film's portrayal of gang violence as the mirror of capitalism that collapses the distinction between high and low crime in the social world, the second part proposes the dialectical coupling of criminality and creativity in the libidinal world. If Flowers's homosocial gang and his own collection of muscle-men magazines reveal the homosexual underpinnings of his firm, against which Chas's violence is a homophobic defensive reaction, so the polymorphously perverse sexuality and passivity of Turner's female "firm" need Chas's violent masculinity. Most crucially, Turner and Chas each become complete in recognizing and assimilating his demon (br)other. During his ordeal, the "normal" all-male Chas finds himself reflected in the flagrantly female Ferber; in the male and female man Turner; and in the female and male woman Lucy. Conversely, Turner re-engages himself and regains his musicality by being envisioned by Chas in the image of Flowers, the magus of violence. Their respective psychic reintegrations become complete in the transcendent escape into death that the two "out of date" boys bring to each other, perhaps suggesting that it is a moment in their regeneration on some higher plane of being.

This thematic and visual richness is reciprocated in the innovations of the film's montage, specifically its patterns of Eisensteinian collisions of opposites: generically, the male outside-world gangster film is folded into the female domestic melodrama, so that the two halves of the film mirror each other; Flowers's firm is reflected back in Turner's firm, and all the characters are exchangeable with their opposite numbers. Almost every significant scene is intercut with some parallel or contrasting scene to which it is dialectically equivalent; and the texture of the film is studded with local incidents of intense conflictual montage.

The opening of the car driving Chas/Turner to his death and the fragments of sexual intercourse establish the controlling Eros/Thanatos inversions that are interwoven throughout. Though narratively Turner is structurally only one among the other foils for Chas, he undergoes a psychic transformation inversely parallel to Chas's restructuring of his machismo. Initially characterized as a failed rock 'n' roll star, fruitlessly tinkering with elaborate recording equipment (including the Moog synthesizer he used for *Invocation of My Demon Brother*), when imagined by Chas, he creates "Memo from Turner,"

often cited as both one of the Stones' greatest songs and one of the best music videos.[12] Just as the Rolling Stones resuscitate themselves as a band by returning to "the backbone stuff,"[13] as imagined by Chas, Turner miraculously recovers his creativity in the roots of rock 'n' roll, the acoustic country blues, specifically in Robert Johnson's "Me and the Devil Blues." Invoking the legendary figure's supposed pact with the devil, the line, "Hello Satan: I believe it's time to go," reads as Turner's direct address to Chas, who enables him to recover the demon he had lost and who takes him on their joint final journey. His trajectory from the country blues to Rolling Stones rock 'n' roll is rich with all the dualities and associations with delinquency the band had accreted, the polymorphous sexuality, the hard drugs, and especially the violence. As a dystopian/utopian take on the "Swinging London" phenomenon and its associated film genre, it both emerged from and contributed to Jagger's persona and his real life.

Jagger is said to have based the character of Turner on Brian Jones, or perhaps a combination of Jones and Richards, respectively Pallenberg's previous and present lovers, and though she asserts that she and Jagger were not intimate during the shoot, some of the footage was so graphic that the lab found it necessary to destroy it, while a collage of other censored material later won a prize at an erotic film festival. Designed by Christopher Gibbs, an original member of the Chelsea Set who all but single-handedly created the craze for Moroccan paraphernalia, Turner's home epitomizes the taste of Jagger's own circle, one that also intersected with the polymorphously perverse lovers, the fashionable criminals, and the gangsters who were hired as advisors, who act in the film, and among whom Fox honed his role. The film reflects the aesthetic and social mores of the entire intertwined artistic/criminal subculture. Though written by Cammell (with early input from Pallenberg) and directed by him, it is inconceivable without the multiple contributions from Nicolas Roeg as cinematographer and director; the acting of Fox, Pallenberg, Jagger, Breton, and Shannon; Jack Nitzsche's original music featuring Ry Cooder, Merry Clayton, Randy Newman, and other musicians; David Litvinoff's dialogue coaching; Deborah Dixon's costumes; and Frank Mazzola's editing. Like producer Lieberson, none of these were experienced in film production but, especially the Londoners, were connected by networks of friendship. A home movie of the Chelsea Set, *Performance* is a subculture's collective self-representation on an industrial scale, all courtesy of Warners, at the same time the studio was doing the equivalent for the Woodstock nation.

Marianne Faithfull summarized the film's emergence from the Stones'—or at least Jagger's—social milieu: "*Performance* was truly our *Picture of Dorian Gray*. An allegory of libertine Chelsea life in the late sixties, with its baronial rock stars, wayward jeunesse dorée, drugs, sex and decadence—it preserves a whole era under glass."[14] The personal associations that Jagger brought to the film were fundamental to his role in it, even though he made no claims

to authorship, simply doing whatever Cammell asked him. His role as Turner embellished his image as a pansexual decadent, but equally important was his association with Chas and hence his ability to mobilize both identities in his subsequent performances. Faithfull has pointed to the film's reciprocal instrumentality in Jagger's restructuring of his persona that fed back into his public identity: "In the same way that some actors get to keep their wardrobe, Mick came away from *Performance* with his *character*. This persona was so perfectly tailored to his needs that he'd never have to take it off again." She emphasized the centrality of "Memo from Turner," claiming it "first appears when Mick sweeps his hair back and becomes the ruthless thug who will do *anything* (including killing people) for money. The money-mad Mick, devotee of Mammon."[15] As Turner assists Chas to break the armor of his sadistic sexuality and become like Turner/Jagger, so Jagger, who years before had assumed Flowers's and Chas's Cockney as his public speaking voice, here used the film to appropriate the street credibility of their violence. Though it was aided and abetted by Ry Cooder's slide guitar, his solo composition and performance of "Memo from Turner" dramatizes his revitalization in the film, and displays his autonomy from Richards in his life outside it. Again, he found his demon brother.

Jagger's next film, *Ned Kelly* (Tony Richardson, 1970) attempted, if not too successfully, to embellish his new persona's combination of musicality and criminality. The film was neither a critical nor a commercial success and Jagger did not even attend the opening, referring to it as a "load of shit."[16] But his leading role remobilized *Performance*'s motifs: the son of an Irishman transported to Australia for stealing a pig, Kelly is a member of a criminalized minority community; in affirmation of that community, he sings "The Wild Colonial Boy," an outlawed song celebrating an outlaw; he is regarded by the authorities as "a very flash young man" from whom society must be protected; and he kills the first policemen sent to take him. And as in *Performance*, the whole narrative is encapsulated within the moment of his execution.

Expecting a Rolling Stones version of rock 'n' roll caper film like *A Hard Days Night*, Warner Bros. executives were horrified by Cammell's first cut of *Performance*. A second cut was made with Frank Mazzola, a Warners' editor who was sympathetic to the project. He substantially shortened the first part, made Jagger appear earlier by simply inserting a few seconds of him spray painting a wall red in the scene where Joey Maddox similarly defaces Chas's apartment, and most important, in shortening it, he created its defining montages. Finding this also unacceptable, the studio decided to abandon it, and only a change in the studio's ownership saved the film from being permanently shelved. Further cuts were completed by February 1970, and on August 3, *Performance* was released. Polarizing the press, it received several ecstatic reviews in London, but devastating ones in New York, where, for

example, writing for the *New York Times*, John Simon wondered whether it was not "The Most Loathsome Film of All?"[17] But by that time, all the Rolling Stones, if not the counterculture they had come to epitomize, had in the cold California winter's night encountered their demon brothers in the flesh. That encounter was depicted in what had become the logical extension of the concert film: the tour film.

Rock 'n' Film Crisis

THE ROLLING STONES IN THE UNITED STATES

After *Ned Kelly*, Mick Jagger suspended his acting career to prepare for the Rolling Stones fall 1969 US tour in support of *Beggars Banquet*, released the previous winter and their first album produced by Jimmy Miller. Though a movie of the tour had not been planned, the one that in the event was produced, *Gimme Shelter* (Albert and David Maysles and Charlotte Zwerin, 1970), marked a crisis in the history of the rock 'n' roll film and hence in the rock counterculture's social meaning. Where Woodstock and *Woodstock* epitomized a utopian cultural regeneration, the violence at the post-tour's free concert at Altamont and *Gimme Shelter*'s emphatic focus on it came to represent the failure of the sixties' best aspirations, so much so that accounts of Altamont are often simply accounts of the film. If not the cause of the cultural disillusion, the Stones were positioned as its manifest image. *The Berkeley Tribe*, the most popular underground paper in the Bay Area, announced "Stones Concert Ends It—America Now Up for Grabs.[1] And in the short-lived radical journal *Scanlan's Monthly*, Sol Stern designated Altamont as the "Pearl Harbor to the Woodstock Nation." He also gave the most succinct analysis of its implications in noting how the initially communitarian subculture, in which "the audience was as important as the bands, and observers spent at least as much time discussing the people who danced, wore beautiful costumes, and made a kind of music of their own as they did discussing the performers," had been destroyed by the commercialization and industrialization of rock: "The distance between the stage and the spectators kept expanding, and soon all the music came from the stage and very little energy came to the stage from the crowds."[2]

In 1972 the Stones toured again, just after the release of their third Miller-produced album, *Exile on Main St.*[3] By this time, counterculture idealism had unraveled, the political situation had further deteriorated, and any residual emancipatory promise the Stones represented had evaporated. On

this tour, two documentaries were made, *Cocksucker Blues* (Robert Frank, 1972) and *Ladies and Gentlemen: The Rolling Stones* (Rollin Binzer, 1974), both very different from *Gimme Shelter* and from each other. As films of tours, all three extended the parameters of the earlier concert documentaries; they projected the Stones' musical and cultural primacy but also capitalized on their contradictions, especially the hubris that both reflected and contributed to the crisis rock 'n' roll faced as the new decade unfolded. All made remarkable innovations in rock 'n' roll spectacle and narrative, in documentary film style and structure, and in the representation of music, musicians, and their social contexts. Each differently managed the band's associations with violence: *Gimme Shelter* exploitatively inflated it into the essence of their social meaning; *Cocksucker Blues* sublimated it to sex and drugs; and *Ladies and Gentlemen: The Rolling Stones* concealed it, stripping the band of any social meaning and honing their image for its afterlife as a sheerly commercial brand. In the first two, encounters with demonic others were seen to create, not a vital liberation and renewal, but catastrophe; and the utopian dual focus narrative of musicians and audience brought into a folk commonality disintegrated in division and conflict. But the first, *Gimme Shelter*, was the most damaging; it proposed Altamont as the meaning of the Stones and a murder as the meaning of Altamont and hence of the counterculture's music. Its revenge on rock 'n' roll was the most brazen.

Gimme Shelter

When the Rolling Stones arrived in November 1969, the cultural situation in the United States was very different from what it had been when they last toured in July 1966. Though it was less than three months since Woodstock, they found themselves on the counterculture's downslope, where the Summer of Love's optimism was dissolving into violence. In the previous year, Martin Luther King Jr. and Robert F. Kennedy had been assassinated, and state aggression against the black civil rights and anti-war movements had escalated, the latter culminating in the police riots at the Chicago Democratic National Convention. By the summer of 1969, Richard Nixon was president, the Weatherman faction had taken control of SDS, and recent news items included the Tate/LaBianca murders, the Chicago "Days of Rage," the My Lai Massacre, and on December 4, two days before Altamont, the murder of Fred Hampton, deputy chairman of the Black Panther Party, by the Chicago Police Department and the FBI. The Stones' music had also been transformed. Their immediately previous tour had been in support of the psychedelic folk rock of *Aftermath;* but their latest album, *Beggars Banquet*, especially the apocalyptic lead cuts of its two sides, "Sympathy for the Devil" and "Street Fighting Man," seemed directly to express the times' unrest.

ALTAMONT

Moving from west to east, the tour concluded with two shows in New York at Madison Square Garden, one in Boston, and one in West Palm Beach on November 30 (Figure 15.1). Stung by complaints about high ticket prices, Jagger had announced a post-tour free concert in the Bay Area and, after spending December 2–4 at Muscle Shoals studio in Alabama recording "Brown Sugar," "Wild Horses," and "You Gotta Move," the Stones arrived in San Francisco late on December 5. Permission for a concert in Golden Gate Park had been granted contingent on its not being announced in advance, and when word leaked out it was rescinded. Negotiations with a replacement, the Sears Point Raceway in Sonoma County, also collapsed when its parent company, Filmways Corp., a Los Angeles-based entertainment conglomerate, demanded distribution rights to any film made at the event. To assist in securing a site, the Stones management called in Melvin Belli, a celebrated San Francisco torts lawyer, formerly attorney to Jack Ruby, and a recent bit-part player in the teen exploitation rock 'n' roll classic *Wild in the Streets* (Barry Shear, 1968). At the last minute, on December 4, when the tour stage manager Chip Monck indicated the feasibility of moving the stage and the sound and lighting equipment in time, Belli finalized an arrangement with the owner of the Altamont Raceway, some seventy miles east of the city. Off-duty police and other security were hired, and for $500 worth of beer the Hells Angels were recruited to escort the Stones and to keep the crowd from the stage. On Friday December 5, the new album, *Let It Bleed*, with its opening cut, "Gimme Shelter," was released, and as the stage crews worked all through

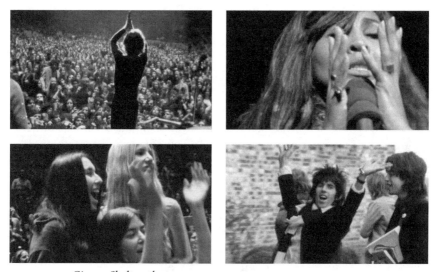

FIGURE 15.1 Gimme Shelter; *the tour.*

the freezing night, people began to arrive, eventually about three hundred thousand in all.[4]

In the afternoon, Santana began the concert, and undistinguished sets by the Jefferson Airplane, the Flying Burrito Brothers, and Crosby, Stills, Nash & Young followed. For most of the huge crowd, it was no more or less eventful than similar gatherings, though the poor sound system, the bleak terrain, and the cold forestalled the communal euphoria of Yasgur's summer farm. And for those close to the stage, recurrent aggression and violence marred the festivities. The combination of a very low stage and the absence of any reserved area in front of it created a porous proscenium that under other conditions would have spatially figured, if not actually facilitated, the breakdown of the boundary between the musicians and the fans that the free folk festival implied—had not elements in the crowd been unruly and had it not been policed by the Angels. Invited on stage by the Airplane and honored in their song "We Can Be Together" as fellow "outlaws in the eyes of America," they responded by beating several people who brushed against them or their cycles. Even musicians were not safe, and the Airplane's Marty Balin was knocked unconscious when he tried to intervene. The Grateful Dead, for whose free concerts the Angels had previously provided security, were aghast at the spectacle and, hearing that they were beating up musicians, left the site rather than perform. Delayed by Bill Wyman's difficulty in finding transportation, the Stones finally took the stage after dark, with the Angels guiding them through the freaks.

Though three other people died during the night, two run over and one drowned in an irrigation ditch, accounts of Altamont overwhelmingly concentrated on the killing of eighteen-year-old Meredith Hunter by the Hells Angels. After an altercation, Hunter pulled a gun and rushed toward the stage twenty-five feet from where Jagger was singing. One of the Angels stabbed him repeatedly, others stomped him into unconsciousness, and he was pronounced dead by medics at the site.[5] Few in the crowd, and certainly not the Stones, knew the details of Hunter's death, and the concert resumed, though interrupted several more times by the savagery. But, beginning with a postmortem discussion that began the next evening with a San Francisco four-hour radio special on KSAM-FM, the killing took center stage. Though few would have doubted it, Sonny Barger of the Oakland chapter phoned to clarify that he was "not no peace creep by any sense of the word" and that Jagger had used Angels "for dupes."[6] The show was followed some six weeks later by a collectively authored fifteen-page essay in *Rolling Stone* entitled "Let It Bleed," the name of the magazine and the title of the article indicating how completely the Stones had been internalized in the counterculture's imaginary.[7] Though rife with contradictions and errors, most notably the incorrect assertion that the staging of the concert specifically for the sake of a film had knowingly jeopardized public safety, the article became the source of much

subsequent commentary. In accusations by the many parties involved in the decision to hire the Angels, to stage the concert, and to film it, the Stones and the Angels were assigned the lion's share of the blame. Though numbering less than a hundred, the Angels commanded the stage and crowds, and effectively controlled the festival. While also criticizing the hiring of the Angels, David Crosby was one of the many who indicted the band: "I think they have an exaggerated sense of their own importance. I think they're on a grotesque ego trip. I think they're out of touch with the people to whom they're trying to speak. I think they are on negative trips intensely, especially the two leaders."[8]

In press conferences announcing the free concert, Jagger had uncharacteristically saluted the Woodstock Nation's own sense of its achievement by proclaiming the purpose of the concert to be the creation of "a sort of microcosmic society which sets an example to the rest of America as to how one can behave in large gatherings." With "Street Fighting Man" released a week after the police riots at the Chicago Convention, they were unlikely setters of such an example, and they had not even been invited to Woodstock. But Jagger still envisioned the concert as fundamentally a free folk festival, even if donated by *noblesse oblige* rather than liberated by the people. Though the boundaries between performers and audience would not be eliminated, as they often were in recent Bay Area free concerts, they would be breached, at least symbolically. Commodity-based social relations would be transcended, and in some way all the outlaws would indeed feel themselves together. But Altamont did not re-enact Woodstock; it provided neither utopia nor even breakfast in bed for a quarter of a million people, but an object lesson in *Performance*'s most extreme axioms. In a place where nothing was true and everything was permitted, Altamont really made it: it achieved madness for the Stones and for cinema. *Gimme Shelter* shattered the myth that the Stones had constructed in their music and that previous films had constructed for them, and the combined utopian projects of Direct Cinema and the dual-focus folk musical that it had created disintegrated together.

GIMME SHELTER

Wanting a filmed record of the two Madison Square Garden concerts, the Stones first considered Haskell Wexler, writer and director of *Medium Cool* (1969), a film partially set among the police riots at the Chicago Convention. When he declined, they hired David and Albert Maysles, who six years earlier had made the first Beatles' film, *What's Happening! The Beatles in the USA* (1964).[9] For a payment of $14,000, they shot the performances and some exteriors using three 16-mm camera-sound teams, all synchronized to sound recorded by Glyn Johns on a Wally Heider 16-track machine parked in a truck outside the stadium.[10] Though not previously familiar with the Stones' music, the Maysles were sufficiently intrigued to continue photographing the

group at their own expense during the following week, and gradually the possibility of a feature documentary emerged. The Stones provided them with an additional $120,000, and they eventually invested half a million dollars of their own money to complete the project (Figure 15.2). Filming continued on the road in the South and at Muscle Shoals Sound Studio in Alabama. The advance group moved to San Francisco, shooting the legal and logistical maneuvers of the relocation to Altamont in lawyer Melvin Belli's office and the concert itself. In post-production, the Maysles invited Charlotte Zwerin, who had edited *Salesman*, their feature-length Direct Cinema documentary about Bible salesmen released the previous spring, to edit down to feature length the 100,000 feet of film they had shot, resulting in a shooting to edit ratio of about 38:1. While her work was in progress in London, the story of what actually had happened at Altamont emerged. She persuaded the Maysles to add a new layer to the film by adding sequences of them showing Jagger and Watts the killing scenes in slow motion on the monitor of her Steenbeck flatbed, and constructed the film's structure and rhetoric around the killing.

Gimme Shelter is then bipartite, not simply in its generic division between spectacle and narrative, but also in juxtaposing two distinct modes of

FIGURE 15.2 Gimme Shelter, *Altamont.*

documentary. One, the *vérité* depiction of both performances and the linking events, mainly appears to be uncompromised Direct Cinema in respecting spatial and temporal realism, sync sound, and the non-interventionist principles that committed the filmmaker, in Ricky Leacock's seminal formulation, to "capturing the essence of what takes place around him, selecting, but never controlling the event."[11] The other, the staged interviews where Watts and Jagger are confronted with the evidence that the Steenbeck discovers in that Direct Cinema footage, are by contrast modernist reflexive events deliberately staged by the filmmakers who do "control the event," foregrounding the material and social forms of the act of filmmaking and its signifying processes. Each part has its own crisis, and both precipitate failure: at Altamont, Jagger fails to control the Hells Angels' violence and prevent them from killing Meredith Hunter; in London, he fails to assess the killing that the film reveals and especially to articulate his own involvement in or responsibility for it.

Like Elvis's *Loving You* (Hal Kanter, 1957), for example, or the Maysles' own, *What's Happening! The Beatles in the USA, Gimme Shelter* is generically a backstage musical that focuses on not a single concert but a sequence of them: a tour, however truncated. Other acts opened for the Stones, including B. B. King, Chuck Berry, and Ike and Tina Turner, but only a single performance by the last of these appears in the film. Of the other bands who played at Altamont, the Jefferson Airplane and the Flying Burrito Brothers are seen briefly, but all others are excluded by the focus on the Stones, especially Jagger. The film opens at Madison Square Garden with "Jumping Jack Flash," shot in three long takes, interrupted only by one brief cutaway to Watts and several to the audience in the front rows excitedly reaching out to Jagger. Other members of the band are seen only when his hyper-kinetic dancing across the stage brings him close to them. As well as following his movements, the camera also finds tight close-ups of his face that reveal his fleeting expressions as they rapidly alternate between his impersonation of his songs' protagonists and his own evident pleasure in performing them. The filming of subsequent numbers continues to be virtuosic, but it becomes more fragmented and the *vérité* structures are jettisoned.

In the next number, "(I Can't Get No) Satisfaction," also at the Garden, some shots are filmed from the back of the stage, framing the band and audience together, while close-ups on Jagger and the others are mostly brief. The rapid editing is augmented by quick zooms and pans, but the visual breaks are sutured over by continuity cuts, the song's rhythm and driving riffs, and of course Jagger's singing. But after this, the film abandons audio-visual synchronization of all the numbers until the Altamont performances. The three songs recorded at Muscle Shoals, for example, are very sophisticated extended sound bridges, sometimes diegetic and sometimes not, joining a variety of visuals. "You Gotta Move" begins as underscore as the Stones leave their hotel

but becomes apparently diegetic in intimate off-stage scenes as they listen to the playback in the studio. The scene continues with "Wild Horses" being played back straight through as Richards's mouthing of the lyrics implies sync, at least until the camera leaves his face to explore his snakeskin boots. "Brown Sugar" begins played diegetically on a tape recorder in Richards's hotel room, but then modulates into underscore as the band takes a helicopter to Miami. And in the next number, sync and spatiotemporal veracity are entirely abandoned: announcing a "slow blues," Jagger sings "Love in Vain," but the accompanying visuals are in fact composed of him singing a different song at Madison Square Garden, with optically superimposed, slow-motion long takes lending the multiple images of his floating scarf, hair, and entire balletic body an ethereal beauty. But then the visuals cut to the band in the Muscle Shoals studio listening to the conclusion of "Love in Vain," implying that it, too, was being played back after being recorded there with "You Gotta Move," "Wild Horses," and "Brown Sugar," whereas it had in fact been recorded six months before the tour began. This fabrication of sound-image relationships within the numbers and their interruption by non-performance material erodes the distinction between spectacle and narrative more thoroughly than in any previous rock 'n' roll documentary. Rather than arresting the narrative, the numbers increasingly occupy and dominate it. The on-stage performance scenes are aurally and visually compelling, and indeed the artificially constructed "Love in Vain" sequence is stunning; but overall the film accumulates them as steppingstones on the way to the Altamont denouement. They are incorporated into the spectrum of techniques of visual and filmic analysis and discursiveness that combine to position the Altamont killing as the pivot around which the meaning of the Rolling Stones and the counterculture revolves.

Of these specifically filmic tools of analysis, the most comprehensive is the London playback of the unedited footage, the cinematic parallel to the playback at Muscle Shoals, when the musicians hear the records they have just made. In these montages, the film amalgamates live performance scenes and Watts and Jagger's response to them months later. "Jumping Jack Flash" at the Garden ends with Jagger luxuriating in the audience's response, and the film cuts to Richards, apparently exchanging his guitar for the next song. But after only a few frames, a continuity edit conceals the transition to a new shot, made in London, of the monitor on Zwerin's editing table, where Richards appears to continue to lift the guitar to his shoulder. While the live stage sound continues, the next shot pulls back from the monitor to show Jagger looking at it; as onstage he says, "Charlie's good tonight," a brief shot of Watts on-stage behind the drums is followed by a shot, eventually a series of shots, of the drummer now watching the sequence on the Steenbeck. Bridging the film's first two sequences, the transition juxtaposes *Gimme Shelter*'s two, fundamentally contrary, techniques: the uncontrolled *vérité* recording of real life

and the constructivist manipulation and interrogation of the audio-visual data so acquired. From this point on, the narrative of the tour alternates contrapuntally with the narrative of the Stones watching it in Zwerin's studio and gradually converges with it. And until the tour arrives at Altamont, its crisis and thematic denouement, the on-stage performances are regularly interspersed with those off-stage; the negotiations in Belli's office, the scenes in Alabama, and so on are all interrupted by Jagger and Watts's scrutiny of the Altamont footage.

As the deliberations in Belli's office are concluded and the Stones end their tour with a final performance of "Street Fighting Man" in Florida, the KSAM disc jockey announces that the free concert will be held at the speedway. Paralleling *Woodstock*'s dual-focus opening, the film shifts to the stage crews working through the night as the people arrive, building fires in the cold night, smoking dope and drinking wine, while the song continues as underscore, "I'll shout and scream, I'll kill the king, I'll rail at all his servants," and into the final choruses. A brief flashback shows Jagger throwing rose petals into the crowd and dawn breaks to reveal the miles of cars stretched over the bare hills. This a-chronological edit precipitates Jagger's most macho and confrontational persona into the *Walpurgisnacht* of the film's concluding act and to its most extended period of chronological narrative uninterrupted by the London interviews. Arriving by helicopter, the Stones make their way through the crowds to their trailer, work continues on the stage and lighting scaffolds, and short vignettes introduce the fans: a girl distributes roses, groups congregate in small families, people kiss in the afternoon sunshine, the birth of a baby is announced. Stage manager Sam Cutler announces that "this could be the greatest party of 1969," the music begins, and boys and girls dance joyfully as if they had indeed found their way back to Woodstock's garden.

But less idyllic events quickly interfere: some people appear to be on bad trips, appeals for medical assistance are made, arguments break out among the organizers, and the arriving Angels' motorcycles cut a swath through the revelers. At first the Angels appear restrained in keeping the fans back from the stage, but amid frenzied dancing during the Jefferson Airplane set, a couple of black people are roughly thrown off, a mêlée of pool cues brings "The Other Side of This Life" to a halt, and guitarist Paul Kantner announces that the Angels have knocked singer Marty Balin unconscious. But Sonny Barger seizes a microphone to reply, the Angels command the stage, and the beatings continue. Not until after dark do the Stones perform, with Jagger appearing in a satin cape of red and black, the colors of anarchy. "Sympathy for the Devil," the first song shown (in fact, the third performed), ironically but tragically aligns him with the Hells Angels: "Just call me Lucifer/Cause I'm in need of some restraint." But the tragedy unreels inexorably as the Angels wade into the audience with their pool cues, causing Jagger to interrupt the

song to ask his "brothers and sisters" to cool out. As his appeal continues, the visuals break the realism by returning briefly to the reflexive mode and reveal him, months later, viewing the scene on the flatbed monitor. A cut takes him back to Altamont, where he eventually quiets the crowd, remarking disingenuously, "There's always something very funny happens when we start that number."

As the song is resumed, photography from the rear of the stage sequentially fills the screen with huge "Hells Angels" jacket insignias, close-ups on the audience (a girl crying, others shaking their heads as if in disbelief), the Stones mixed among the Angels, and more beatings. The music stops again, the camera picks out an African American youth dressed in an incongruous bright green suit; again Jagger appeals—against all precedent—for audience restraint: "Why are we fighting?" "Let's just keep ourselves together," and, asserting the countercultural communality of musicians and freaks, "If we are all one, let's show we're all one." Despite Richards's threat to quit playing, they resume with "Under My Thumb," which continues uneventfully until, after the final chorus of "It's all right," suddenly the camera focuses on a fracas before the stage: the same black youth rushes forward, and one of the Angels appears to stab him. Again Jagger threatens to end the concert, but an Angel tells him that the youth had a gun. Cutler announces that the concert will continue, as in fact it did, with the remainder of the tour set, all performed, reports agree, with unusual intensity. But, for the film, the concert and the tour are over.

Zwerin returns Jagger to the studio (Figure 15.3), where he asks for the killing to be replayed, and a freeze frame reveals the gun outlined against the

FIGURE 15.3 Gimme Shelter, *reflexive cinema.*

white blouse of Hunter's white girlfriend, at last disclosing the truth that had been invisible and unknown. A brief return to Altamont shows the body with its blood-stained jacket strapped to a gurney and removed, the final chorus of "Street Fighting Man," and the Stones are helicoptered out as if they had been rescued from an ambush in Viet Nam. Interrupted only by a freeze-frame of Jagger's face as he leaves the editing room with a cursory "All right, see y'all," the crowds depart in the early morning sunshine, all accompanied by an extra-diegetic "Gimme Shelter." Though it does not explicitly blame Jagger for the killing of Hunter and the failure of Altamont, the freeze-frame on his face positions him as the object of the film's interrogation, and overall Zwerin's focus on Jagger's encounter with the Hells Angels creates the implication that it was a disaster for both parties. The freeze-frame on his face, a constructivist pedagogic device, became an icon of the collapse of the counterculture, but it also marks the rejection of the principles of Direct Cinema.

The principles of a non-interventionist, observational cinema were always jeopardized by editing. Initially the dividend of sync-sound long takes allowed composition to be limited to their arrangement, mitigating issues of editorial intervention. But the desire for more kinetic or complex visual augmentation of the music and also for greater articulation of the significance of the cultural developments it sustained had led to the more sophisticated editing and especially to the a-chronological montages in *Monterey Pop, Woodstock*, and other rock 'n' roll documentaries. Indeed, Al Maysles had himself criticized *Woodstock* for being a "point of view" documentary; a real documentary, by contrast, he argued, "has one obligation above all, it has to be factual."[12] The inevitable tension between "being factual" and presenting a point of view had already been illustrated in Zwerin's contributions to his own best work. In the previous year's *Salesman* (1968), she had selected a single flawed male protagonist, Paul, and emphasized him as the one among all his associates failing to meet his quota of Bible sales. She repeated the strategy in *Gimme Shelter*. Like *Salesman*, it is the story of a homosocial group on the road selling their respective brands of religion, and is also divided between their living-room pitches—the equivalent of the on-stage numbers—and narratives where they travel from performance to performance, retreating between times to motel rooms. Like *Salesman*, it focuses on one of the group, Jagger, and shows him as ultimately failing to make good on his pretensions, much like Paul. It also ends with a freeze-frame on the inscrutable face of the one person selected as the embodiment of the fundamental crisis, photojournalism's defining moment.[13]

Making the footage of Jagger and Watts reviewing the killing the film's thematic pivot as well as its structural frame, Zwerin's editorial interventions made the film expressive of her personal point of view, her vision of Altamont as a battlefield where the demon brothers vanquished the Stones, especially Jagger. Just as *Primary* (Robert Drew, 1960) had established its structural tension on the conflict between Humphrey and Kennedy, *Gimme Shelter* makes

Altamont's thematic core the confrontation between the Stones and the Angels; within that, the authorial implication of Jagger's complicity in the latters' killing of Hunter is made the tour's climax and dénouement. With that implication established, the documentary is complete, and so no depiction of subsequent events is allowed—not, for example, the performance that continued after the murder and which could have been construed as the Stones' triumph in a desperately difficult situation. In fact, some events actually occurring after Hunter's killing—a naked heavyset girl being manhandled, for example—are positioned earlier, before it. The retroactive editorial positioning of the killing as the film's crisis and the reflexive foregrounding of it together mark, not disinterested, neutral observation, but cinematic intervention and interpretation. The Angels' killing of Hunter was not discovered in the real life that the cameraman observed, but only in the editing process, and even there it can be seen only when the film is artificially slowed down. Neither Baird Bryant, the cameraman who shot the stabbing, nor anyone else associated with the film had any knowledge of the information latently contained in the footage until it was played back in slow motion, and only in this form can its pivotal role in Jagger's story be observed—much as the question of Jagger's culpability necessitates the freeze-frame, a similarly cinematic production of meaning that transcends the insufficiency of being there in real time.

In her editing of *Gimme Shelter* and foregrounding of the film-specific generation of meaning, Zwerin abandoned US Direct Cinema's defining principles: uninterrupted sync-sound long takes, principled adherence to chronological continuity, the absence of a preconceived controlling thesis, the self-effacement of the filmmakers, and the effacement of cinematic intervention and processes. The trajectory of the concert documentary had progressively sacrificed these since *Dont Look Back* (D. A. Pennebaker, 1967), and *Gimme Shelter* marked the complete return to a reflexive constructivist Vertovian cinema that resembled the analytical modes of *cinéma vérité* developed by Jean Rouch, Edgar Morin, and others in France. The belief in film's ability to allow reality to reveal itself, which subtended Direct Cinema's affiliation with the counterculture, collapsed in the crisis of the more desperate forms to which it had come to be embodied, the Rolling Stones' outlaw romance with sexual and racial transgression. *Gimme Shelter*'s denunciation of rock 'n' roll was pyrrhic: in mythologizing the expulsion from Woodstock's garden and indicting Jagger as the devil responsible, it sacrificed observational cinema.

THE STONES MYTH IN CRISIS

Like *Invocation of My Demon Brother* and *Performance*, *Gimme Shelter* revolves around Jagger's confrontation with his demonic others. Affirming him as the triumphant manifestation of a new Luciferian, hedonic self-affirmation,

Anger's conjoining of Jagger's music and his visual image was itself supposed to cause a parallel transformation in those who experienced it. Cammell's project allowed Jagger to experience and identify with a violently sadistic working-class masculinity through which he regenerated himself as an ascendant cultural force, as well as making new claims for himself as an actor; and as the author-performer of "Memo from Turner," he renewed his independent musical creativity, visual identity, and ability to produce filmic musicality. *Gimme Shelter* demolished all these exalted pretensions. Though the early performance scenes portray Jagger's mesmerizing stage presence as the epitome of the counterculture's hubris, the film's two crises reveal its precariousness. Confronted with the violence at Altamont, he is impotent; and confronted with the evidence of it in London, all he can muster is a helpless, dismayed, "It's so horrible." Simultaneously the film discredits the counterculture's celebration of the Angels as confreres in outlaw individualism. Instead of portraying a renewal of the kind that Turner and Chas found in each other, *Gimme Shelter* narrates the demon brothers' reciprocal destruction of each other's cultural authority.

The peripety is foreshadowed when Jagger arrives from the helicopter and is hit in the face by a fan screaming, "I hate you, you fucker. I want to kill you," but it begins in earnest during one of the Stones' most arrogant and misogynistic songs, "Under My Thumb," Jagger's celebration of his reduction of a lover to a "squirmin' dog who's just had her day." His eidolon then appears in the multiple forms of Meredith Hunter and the Hells Angels. As a working-class black male, Hunter is a member of the group Jagger had appropriated for his own persona, while the Hells Angels are the contemporary instantiation of the Crowleyan Satanic ethic of lawlessness. But rather than reaffirming his identity among these, Jagger discovers their mutual antipathy and their antipathy to him. Hunter does not greet him as a brother, but attempts to murder him, and he does so clothed almost identically to the black male musician in rock 'n' roll cinema who had signally brought African Americans and the white counterculture together; though here worn over an appropriately funereal black shirt, Hunter's electric green suit is virtually identical to the one worn by Otis Redding when in *Monterey Pop* he completed the dual-focus narrative joining the musicians with the people and declared, "This is the love crowd, right? . . . We all love each other." Jagger is saved from the black man's revenge by violent working-class white males, but only at the cost of their mutual esteem. As the Stones restart "Symphony for Devil" after the eruptions of violence, the Angels respond with manifest contempt to the sexual ambivalence of Jagger's singing and especially his dancing. All redemptive confrontation with demon brothers is short-circuited; and the killing—the core event that *Gimme Shelter* excavates and an event that became known by cinema's intervention—bifurcates Jagger's persona and forces him to watch impotently as its constituent parts destroy each

other. Symbolically destroying the rock counterculture's ideal of interracial outlaw commonality, the Satanic working-class whites stab the black man, and he dies while the Stones perform, for the first time in public, "Brown Sugar," a song in which a white master rapes a black slave. The same moment ended the myth of the Angels as a radical fraternity proclaimed only minutes before in "We Can Be Together" but dating back to one of the primary sources of rock 'n' roll iconography: Marlon Brando and *The Wild One*'s Black Rebels Motorcycle Club, especially as transmitted through the cinematic association of bikers and rock 'n' roll in *Scorpio Rising* (Kenneth Anger, 1964), *The Wild Angels* (Roger Corman, 1966), and *Easy Rider* (Dennis Hopper, 1969).

Released on December 6, 1970, *Gimme Shelter*'s Dance of Death negated the cinematic utopia created in *Woodstock* less than a year earlier. Though the Altamont concert did for a few hours eliminate commodity relations in music, the film about it decisively annulled the myth of the unalienated community of musicians and audience. Along with exposing the myths of the Angels and the reconciliation between black and white, it precipitated a crisis in the sexual and racial dimensions of the Stones' mythology, demonstrating their inadequacy to Lucifer and to the social forms in which Lucifer appeared. It also confounded the film's theatrical audience. Where *Woodstock* with its all but unanimous celebratory reviews transmitted the festival's unified community to the culture at large, *Gimme Shelter* perplexed and divided its audience. Well used to taking the audiences within the film as a point for their identification with the film, theatrical audiences found themselves positioned as victims; its reviews were mixed, with many critics unequivocally condemning it, some using the *Rolling Stone* article as evidence.[14] Musicians and fans, black and white, England and US, and Angels and Devils were no longer one.

Cocksucker Blues

In the spring of 1972, the Stones were in Los Angeles, completing *Exile on Main St.* For the album cover, they were also in negotiations with photographer Norman Seef, who had become celebrated for his work with musicians, and John Van Hamersveld, designer of the famous poster for Bruce Brown's surfing epic, *The Endless Summer* (1966), and more recently the album cover for the Beatles' *Magical Mystery Tour*. In preparation, Jagger and Watts browsed photography books and Watts suggested using Robert Frank after finding his 1959 collection *The Americans*, in whose introduction Jack Kerouac had noted that "he sucked a sad poem right out of America onto film, taking rank among the tragic poets of the world."[15] Frank's stark, disabused images of working-class people, including many African Americans, documented a mythologized alienation not unlike the album's. In the event

a detail of Frank's photograph of a photo-collage "Tattoo Parlor, 8th Avenue, New York City, 1951" occupied the entirety of the front of the gatefold album cover, and for the obverse and inside spreads and for the two record sleeves, Van Hamersveld made collages, of single frames and filmstrips blown up from an eight-minute film Frank made, *S-8 Stones Footage from Exile on Main St.* (1972), together with details from several photographs from *The Americans*.[16]

At the end of the fifties, Frank had generally turned away from still photography and had collaborated with Alfred Leslie on the seminal underground film, *Pull My Daisy* (1959), an ostensibly spontaneous and improvised short featuring Allen Ginsberg, Larry Rivers, Alice Neel, and other Beat Generation icons. In awarding it *Film Culture*'s Second Independent Film Award, Jonas Mekas had cited "[i]ts modernity and its honesty, its sincerity and its humility, its imagination and its humor, its youth, its freshness, and its truth."[17] For the Stones' assignment, Frank made an even more modest film by photographing them on an excursion to Main Street, Los Angeles, a working-class business street close to skid row, and also as they posed for him in the lush garden of their Bel Air mansion. The jerky, handheld, and low-resolution footage begins with a brief zoom into "Tattoo Parlor," and over some still photos of Jagger and Richards singing, and written phrases from the album's lyrics, including "You've got to scrape the shit right off your shoes," before finding the Stones and their entourage strolling unhindered on the downtown sidewalks, passing miscellaneous signage, cafes, shoe shines, pawn shops (one advertising, "Loans and Music"), and an exploitation movie theater with a prominent poster for *Sweet Taste of Joy* (C. Walsh, 1970) that resembles the "Tongue and Lip" logo (Figure 15.4).

FIGURE 15.4 S-8 Stones Footage from Exile on Main St.

The film cuts to a shot of a black man on the sidewalk in the Bowery in New York, strumming what appears to be a toy guitar and another of a man walking amid traffic holding a liquor bottle, all interrupted by fleeting images of Jagger's baby daughter.[18] More shots of the downtown Los Angeles freeways shift the scene to the mansion, where he and Watts are seen on its balconies and among the garden's luxurious foliage. A fast collage revisits some of the photos from *The Americans* and the album cover to introduce another Bowery scene in which a shabbily dressed white man waves cleaning rags at the passing cars. The film returns to Los Angeles, to a glimpse of the cover of Gertrude Stein's *The Making of Americans*, then to the Main Street excursion, where the Stones and friends rest in a dilapidated café, and then back to the mansion for portraits of the other band members, but especially close-ups on Jagger. A new reel returns to the third Bowery interlude, a much more extended portrait of another black man who dances with great animation and bravura among the cars in the street as he tries to earn tips for wiping windscreens. During this last section a series of roughly drawn titles is superimposed: "words/point/I am/looking/for/words."

The enigmatic but crafted informality of *S-8 Stones Footage* suggests that Frank associated the musicians with the alienated, sometimes minority, outsiders of *The Americans*, and the locations and his montages link them with the destitute poor and with African American street artists. But the comparisons are also ironic: the Stones may be exiles on Main Street, but only because they had been pushed into tax-exile from England by the mismanagement of their considerable income, and whenever they wish, they may return to Bel Air luxury. With their exotic clothing and long hair, on skid row they are slumming tourists from another world and another social stratum. Similar tensions between entitlement and sleaze inhabit Frank's other film about the Stones, the notorious *Cocksucker Blues* (1972), a documentary of the tour in support of *Exile on Main St.*

By 1972, both the liberal consensus and the counterculture it had engendered were collapsing, and the emerging radical political movements were of the New Right rather than the New Left. US withdrawal from Viet Nam would end the draft in 1973 and further sap the momentum of the student movements. Not only was there was still no place for a street fighting man, but rock 'n' roll was changing. Building on rock 'n' roll's blues roots, flamboyant clothing, and big hair that the Stones had pioneered, Led Zeppelin was about to become the most important band of the seventies and to make enormous amounts of money. But, even if the Stones' tenuous association with progressive social movements had seeped away in Keith Richards's heroin addiction and Jagger's ascent to high society, they were still the greatest rock 'n' roll band in the world. And despite Altamont, they had no intention of abandoning their place at the eye of a scofflaw crossfire cultural hurricane.

Beginning with the first night in Vancouver, the two-month, thirty-city tour was marked by riots, injuries, and arrests in half a dozen cities. A bomb exploded in their equipment truck at the Montreal concert, and on the way to the next stop an altercation with a photographer led the police to arrest Jagger, Richards, Frank, and others, and only a last-minute rescue by the mayor of Boston forestalled a riot there. Frank himself was charged with assaulting a police officer, and was fined a hundred dollars. Events backstage were often similarly violent and debauched. In response to the Hells Angels' threats on Jagger's life, Richards packed a revolver, while the sex and drugs in the extended parties that included a four-day stay in the Chicago *Playboy* mansion reached epic levels. Some of it—though not, to Frank's fury, the *Playboy* parties—was documented in *Cocksucker Blues*.[19]

The film conventionally alternates between on- and off-stage scenes. Though barely twenty of its ninety minutes are sync-sound performance footage, they are based on the concerts' set list, beginning with "Brown Sugar" and ending with a blistering "Street Fighting Man." Its mid-point is a rapturous four-minute jam, during which the Stones and Stevie Wonder's band all dance together as they play "Satisfaction," with Jagger guiding Wonder as they whirl around with the brass section and the back-up vocalists, a utopian moment of black-white and English-UK unity that recalls *The T.A.M.I. Show*'s finale. Three other numbers—not including "Sympathy for the Devil," which was not on the set list—are performed, and after the final number, the audio for "Brown Sugar," accompanied by non-sync images of Jagger leaving the stage, brings the film back to where it began. Shot in color with energetically gestural handheld camera work, the concert scenes contrast markedly with the more extended, mostly black and white, off-stage scenes (Figure 15.5).

Frank with his 16-mm Éclair and Danny Seymour, his soundman and sometime cameraman, had unrestricted access (except to the *Playboy* orgies); several other cameras were available to the tour party, and members of it, especially Jagger himself, are seen shooting film. Some of their footage may have been included in *Cocksucker Blues*, but there are no instances where specific authorship is indicated. Nevertheless, the implied plurality of photographers suggests a kind of collective authorship; though Frank controlled the editing, at least at the point of shooting, the film is to a degree the touring party's own collective self-representation, and in this it recalls not only *Woodstock*, but also interactive underground films in which the participants photograph each other. These offstage scenes are often a blur of apparently inconsequential fragments: the band warming up backstage, for example, or hanging out in hotel rooms, listlessly killing time. Apart from the title sequence introducing the individual band members, no people, places, or dates are identified. All these remain anonymous, and the film's repetitive recurrence to indistinguishable events makes it appear to develop randomly

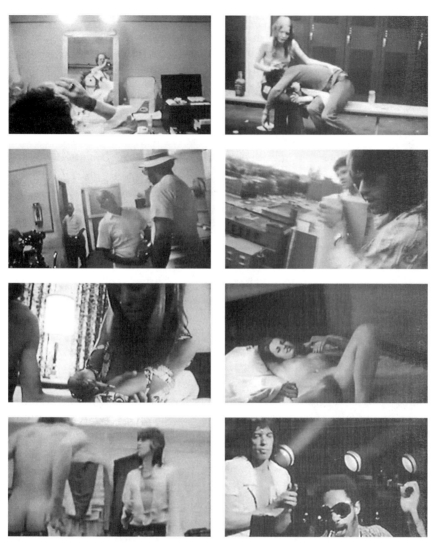

FIGURE 15.5 Cocksucker Blues.

and formlessly, with the punctuation of the concert performances being the only internal cues to structure.

It does, however, contain clearly demarked narrative sequences, some of them quite sensational. The most substantial are an in-flight orgy in which one groupie copulates with an unidentified man and two others are stripped and appear to be coerced into performing sex acts, urged on by the tour party, led by Jagger and Richards, beating on makeshift percussion instruments; a backstage visit by luminaries, including Andy Warhol, Lee Radziwill, Ahmet Ertegun, and Truman Capote, the last having been commissioned to write

an account of the tour; an extended scene in Jagger and his wife's hotel room, in which they each dress and pack and she plays with a tinny music-box; a drive through the rural South in which Jagger, Richards, and others escape from the entourage and encounter a white country singer (as a non-diegetic country version of Elvis's "Love Me Tender" plays on the soundtrack) and visit an African American juke joint, dramatizing their engagement with the two forms of vernacular US roots music that informed *Exile on Main St.*; a long take of a recumbent naked woman in post-coital reverie, stroking what appears to be semen on her breasts while her legs remain wide-open to the camera; a comical interlude in which an obviously stoned Richards attempts to order fruit from room service; a long scene in which Seymour assists a beautiful young woman shoot heroin in her arm; an escapade in which Richards and saxophonist Bobby Keys throw a television set from a hotel window; and scenes from Dick Cavett's television show in which he interviews Bill Wyman and Jagger and reports on the New York concert.

Like similarly lubricious incidents in the lyrics and music that punctuate *Exile on Main St.*'s sprawling, layered murkiness, these sensational scenes puncture the film's overall tedium, making it something of a dirty blues, like "Sweet Virginia." Such an intention is suggested by an interview early in the film. The opening title sequence—a miscellany of brief monochrome shots of the band members warming up for a concert, Keith Richards playing the piano, Mick Jagger filming himself as he masturbates though his pants, and somebody rolling a joint—abruptly cuts to the first of the few off-stage color interludes, an interview with Marshall Chess, the tour manager and the film's producer. Sitting in his underpants, he gleefully recounts how the Stones had been planning to play their record "Schoolboy Blues" (aka "Cocksucker Blues") at a meeting with the head of Decca records, a "very stuffy Englishman." Indeed, Jagger had written the song to fulfill a contractual engagement to the company, which they had left to start their own label, but its deliberately obscene lyrics ("O where can I get my cock sucked?/Where can I get my ass fucked?") made it effectively unreleasable. The song gave Chess the idea for a pornographic album, "a modern version of a party record," and thence the idea for a "dirty" film.

As the realization of that project, *Cocksucker Blues* is "dirty" both ethically and formally, its salacious content matched by extreme offenses against filmic propriety. Apart from the music, its high points are graphic scenes of sex and drug taking (though, despite the song's refrain and Jagger's bending over to show his ass, there are no implications of homosexual activity). These dirty scenes are all reproduced in an insistently dirty style: all shot with handheld cameras, the footage is grainy, often poorly exposed, some obviously blown up from 8-mm and some with a disconcerting coloring that makes it both literally and metaphorically a "blue movie," resembling nothing so much as a sub-par underground film.[20] Either the debauched content or the insistently impoverished production values alone would have sufficed

to sabotage the film's mass commercial viability, but it was the content that ensured the film would never be seen in theaters. Jagger is reputed to have said, "It's a fucking good film, Robert, but if it shows in America we'll never be allowed in the country" and the Stones sued to prevent its release, succeeding in restricting it to a single screening per year and then with the stipulation that Frank himself be present.[21]

Despite an opening title claiming that, except for the musical numbers, the events depicted in the film are fictitious, most of the sequences are observed from life as it passes in Direct Cinema fashion, and at one point, an angry Jagger looks directly into the camera and says "Fuck you .. bloody bunch of voyeurs." Some of even the most scandalous appear to be spontaneous; high from her fix, the heroin user, for example, asks Seymour "Why did you want to film it?" to which he replies, "It didn't occur to me to film it, it just happened." But internal evidence corroborates accounts that others were staged. A post-coital conversation reveals that the "semen" on the woman's breasts was actually pHisoHex, a skin cleanser deposited for the camera's benefit; before dumping the television, Richards is heard asking Frank, "Tell us when?"; and the in-flight orgy overall, if not its actual development, was premeditated and staged. Such constructedness does not disqualify the film's its documentary status, for only very recently had the idea of *cinema vérité* discredited re-enactment. But, together with the insistent reflexivity asserted by the many shots of people with movie cameras and the disjuncture of sound from image in the editing, such moments where the profilmic is clearly not uncontrolled parallel the Maysles and Zwerin's abandonment of Direct Cinema's noninterventionist ideals in *Gimme Shelter*.

But where the genre had come to center on relations between the musicians and the fans, utopian in *Woodstock* and catastrophic in *Gimme Shelter*, here the fans are excluded. No longer are even the boldest of them allowed to rush the stage to perform the earlier documentaries' rituals of ecstatic violence. The fans are of course present during the performance scenes, but only abstractly, the implied but invisible signifier of the Stones' power. Otherwise, *Cocksucker Blues* returns to *Dont Look Back*'s backstage focus; apart from brief scenes of excited kids in the street, an acid-head girl, and a group of young ticket scalpers, the rock 'n' roll community no longer includes the fans. Garrisoned in hermetic exclusivity by a phalanx of security, the Stones Touring Party is inaccessible to all but other members of the media aristocracy or those who minister to it, especially groupies and drug dealers.[22] The royal preeminence of Jagger, then Richards and the other band members, is absolute in the court hierarchy, and their contempt is passed down the pecking order, through snobs and mob alike. The amateur commonality that the folk rock 'n' roll musical had worked so hard to create is jettisoned for the visibly professionalized production of commodity entertainment and its attendant social

relations. Onstage, the Stones' life is electrifying rock 'n' roll: save for sex and drugs, off-stage it is tedious, and repetitive.

Presenting drugs and sex as the twin pillars that sustain rock 'n' roll as once wine and women did song, the film shows them shorn of the emancipatory promise they had as recently as three years before: disposable groupies administer free love and the visions of LSD are dulled by Sister Morphine.[23] The resurrections of the delinquencies of early rock 'n' roll have not lost their Dionysian appeal, and they are not denied or exonerated, but they are covered with a dim, grainy, and sordid film. Though the shield of privilege around the touring party has replaced the generational divide of the mid-fifties, the music's other early social associations recur, but again are transvalued. As well as being introduced in the juke joint, African Americans are prominent in the touring party in the figures of Stevie Wonder, Tina Turner, and the tour's chief security officer; but now they no longer automatically signal either social infraction or the source of musical and social authority; both Wonder and Turner are opening acts, warm-ups to the Stones' usurpation of their musical heritage.

Though apparently in large part a directionless collage of fleeting glances, at least sections of the film reveal subtle editorial control, especially in the counterpointing of image and sound. For instance, after the film's first performance, "Brown Sugar," the visuals cut briefly to kids outside the concert hall, and then to the band members walking to their plane. The sound continues to be that of the applause at the end of the concert, culminating in the announcer's valedictory, "Ladies and gentlemen, the Rolling Stones," but then returns to Jagger's voice and, as he introduces the band members, inserted close-ups identify them. A voice fragment of an interviewer identifies Jagger himself, then the sound cuts to another radio broadcaster describing him as "the Lucifer of Rock, the Dionysus of the rebellious young millions"; then, as it cuts back to the first interviewer, Jagger is seen on the plane being interviewed by a third journalist, while a fourth voice recounts how one of their records was banned from many radio stations "because they felt it advocated revolution." At precisely the point when a naked woman frolics with a tour member as Bill Wyman films them, the voice continues, "What can we expect next from the Stones?" and the opening chords of "Street Fighting Man" are heard.

After Frank's own *Pull My Daisy* (1959), such weaving of fragments of documentary images and sound had become a standard compositional procedure for Bruce Baillie and other underground filmmakers, and for Frank it is also sometimes similarly personally expressive. Just over half an hour into the film, for example, visuals of Richards and Seymour in a hotel room, both with ministering women, are accompanied by the wild sound of a girl's stoned voice-over ruminating about how she became entranced with Richards after seeing a photo of him with a tooth earring and how, determined to have a good time, she has been preparing by going to wild parties for the past week.

The disjunct visual track cuts to the band in a locker-room, perhaps waiting to go onstage. Obviously wasted, Richards lies with his head on a girl's lap, and as the camera surveys other people, the sound cuts to a different clip in which two voices are superimposed, Seymour's and Richards's. A brief moment of sync-sound identifies them, then the visuals cut back to the waiting band as Richards's now disjunct rambling voice recounts a conversation with a would-be Swiss rock musician, in which he observes that since Switzerland (where he had been living) is "like a little wrist watch" and "so fucking comfortable," in order to make rock 'n' roll, he has to "get out of Switzerland and starve." While the separate image and soundtracks weave a small audio-visual poem on the conditions of rock 'n' roll production, the scene also has an auto-biographical resonance for Frank himself, who had anticipated Richards's advice by leaving the comfort of Switzerland in order eventually to become a rock 'n' roll filmmaker.

Following Direct Cinema principles, *Cocksucker Blues* has no voice-of-God narration, and its viewers are left to make their own evaluation of its ethics and of the ethics of the transactions it depicts.[24] But whether it is a moralistic exposé of Rolling Stone degeneracy or a Baudelairian garland of their beautiful flowers of evil and so another case where Frank "sucked a sad poem right out of America onto film," it was an affront to cinema. Ever since the prohibition of its commercial release, *Cocksucker Blues* has existed more as myth than reality, appearing only in occasional, semiclandestine screenings or on pirated video dubs that further exacerbate the original's poor visual quality. Like the early Dada films, or like Jack Smith's *Flaming Creatures* (1963) and later punk films, it negated the possibility of its own existence in mainstream cinema's institutions. In making "Cocksucker Blues," a record that could not be distributed, Jagger had both fulfilled and repudiated the Stones' contractual obligation to Decca; in making *Cocksucker Blues*, Frank—however unintentionally—re-enacted his strategy, bequeathing a deliberately contradictory testament to the contradictions of the Stones' music, but one so incriminating that they had to suppress it. The excesses and delinquencies that it recorded also shaped the other film of the tour, but only in their rigorous exclusion.

Ladies and Gentlemen: The Rolling Stones

Recorded during four shows in Fort Worth and Houston, *Ladies and Gentlemen: The Rolling Stones* (Figure 15.6) combines footage from all of them, as *Charlie Is My Darling* (Peter Whitehead, 1966) had done for the Dublin concerts some eight years earlier and, as in that case, only the costume changes reveal that it is not a single continuous set.[25] Fifteen songs are performed in their entirety, all originals from *Beggars Banquet* onward, except for one

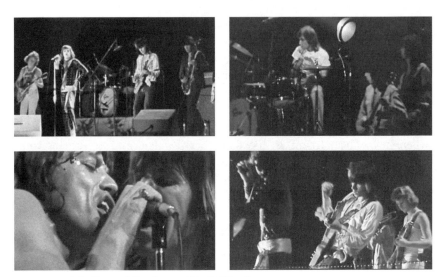

FIGURE 15.6 Ladies and Gentlemen, The Rolling Stones.

Chuck Berry number. As on *Exile on Main St.*, the electric up-beat rock 'n' roll numbers are leavened with the acoustic country-influenced numbers. Though appropriately rough in spots, the fabricated concert captures the Stones at the zenith of their career with their best ever line-up, prominently featuring Mick Taylor winding his sinewy blues lines through Richards's invincible riffs. But not a single off-stage event is shown, and though the audience is heard, it is not so much as glimpsed until the finale. Unlike any previous rock 'n' roll film, there is no narrative context or interruption of the spectacle of the concert itself. It begins in silence and darkness, which, after the tour logo and the title, are gradually interrupted by the voices of the stage technicians, fleeting scales of the piano, and odd flickers of light. A voice announces, "Ladies and gentlemen, the Rolling Stones," the crowd roars. Spotlights find Watts and Richards on stage, followed by Jagger, who urges a barely audible, "Let's go, Keith," jumps in the air, and churns his hips into "Brown Sugar."

Photographed from the rear of the hall with two 16-mm cameras equipped with 600-mm lens[26] on relatively small stages that crowd the musicians together, almost all the images are close-up or medium shots, rarely depicting more than two people, with few master shots of the group as a whole. Made even more grainy and textured by Chip Monck's unaugmented stage lights that place the musicians in pools of monochrome red or blue surrounded by darkness, the images are flattened by the telephoto lenses. Binzer constructs the numbers from myriads of very short takes with highly contrastive shifts in camera angles and focal length, cut to punctuate line or phrase breaks in the songs. These contrasts play within or across the simplified but also highly contrastive stage lighting: in one shot, for example, Jagger's whole body is

illuminated as a red mass against the darkness, while in the next he is backlit with only a red outline of his head and hair; in another shot, Richards is seen in blue, while in the next, a red Jagger dances in front of him. The dominant brief close-ups are only occasionally varied with wide-angle, longer takes; in the slow interlude of an especially good "Midnight Rambler," for example, the cameraman moves in and out to follow Jagger's extended histrionics. Otherwise, the montage's reciprocation of the musical rambunctiousness is almost as sophisticated as that of *A Hard Day's Night*'s finale. Positioned in the middle of the band, the viewer must look this way and that, as if physically enmeshed in the excitement, rather than distanced from it as in *Cocksucker Blues*. The first two and a half minutes of "Brown Sugar" in the earlier film, for example, is a single take, shot from in front of the stage with the cameraman limited to panning from Jagger to the other musicians and occasional very slight zooms, with only a cluster of half a dozen barely noticeable very short shots interpolated, some nearly subliminal; but the first two and a half minutes of the same song in *Ladies and Gentlemen* has sixty shots, giving an average shot length of two and half seconds, and including close-ups on Jagger and other musicians from several angles, medium shots of two or three performers, and even occasional wider shots in which half a dozen are seen, at least partially. Though both are sync-sound documentaries, one is a distanced realism and the other an ecstatic montage.

But *Ladies and Gentlemen: The Rolling Stones* presents only the spectacle of performances, with no suggestion of their social context or significance. Its only narrative is the implication of the spectator's attendance at the concert and experience of its temporality. The opening in darkness is matched by the conclusion, in which a triumphant Jagger throws the rose petals into the light, turning them into an abstract visual shower, and thanks the spectators at the concert and by implication those at the film. The applause continues but, apart from a brief shot of the tour logo, the screen goes dark. As the credits roll, the announcer's "We beg your forgiveness but we are through" urges both audiences to leave, and as the credits end a motorcycle is heard to drive away. More completely spectacle than any previous rock 'n' roll film, it offers no commentary, no suggestion of rock 'n' roll's meaning, other than what might be implicit in the photography and editing.

In its review, *Variety* made the critical generic distinction: "The premise behind the rockumentary 'Ladies and Gentlemen The Rolling Stones' is, as its credits make clear, to present a 'film concert' rather than a 'concert film'—a film with narrative or even documentary shape."[27] *Rolling Stone* elaborated, "Not a movie in the traditional sense, the film is being touted as a new concept in cinema, a concert in and of itself."[28] Sold to an investment group, it was blown up to 35 mm, with the 32-track sound mixed down to four-track "Quadrasound" and with $5 tickets sold in advance; it received a limited four-wall release in 1974 only in major US cities in theaters equipped for the

occasion with special 100-decibel quadrophonic speakers with a sound-mixer in attendance.[29] Just as at the beginning of the rock 'n' roll film Frank Zappa had celebrated *Blackboard Jungle* (Richard Brooks, 1955) because the theatrical sound system made the music "so LOUD I was jumping up and down,"[30] so the sheer aural and visual spectacularity of *Ladies and Gentlemen*, its manufacture of an audio-visual experience that replicates but also in some ways exceeds the concert, made it a surrogate form of concert—and a repetition and extension of the concert's commodity function.

It thus became the dialectical complement to *Cocksucker Blues*. Frank's film was *bad*, as dirty as feasible in both form and content and foregrounding its minimal production values as if in earnest of an unflinching authenticity. But both sound and image in *Ladies and Gentlemen: The Rolling Stones* are as *good* as could be made. Where *Cocksucker Blues*'s paucity of concert material made it mainly backstage narrative, the depiction of the social relations of the tour party, *Ladies and Gentlemen* is entirely on-stage spectacle. *Cocksucker Blues*'s exposé, if not evisceration, of the Stones sabotaged its own economic potential and added nothing to the band's capital value; but *Ladies and Gentlemen*'s filmic fabrication of a concert re-enacts and extends its economic function. The culmination of the process that began with the short films the band made to promote their singles and which stood in for the Stones themselves on television shows, it also betokened their future direction.

Developments across the three concert films tell the larger story. Though *Gimme Shelter* has relatively few behind-the-scenes intimate moments with the Stones, both it and *Cocksucker Blues* juxtapose musical with non-musical events to present the band in a social context. The relation between spectacle and narrative maps the band's social significance, specifically the refraction in the public sphere of its musical and social delinquency. *Gimme Shelter* envisions their invocation of unruly, perhaps demonic, musical energy as precipitating a real rather than symbolic social chaos, one that they are impotent to control. Three years later, *Cocksucker Blues* emphasizes their privileged degeneracy. Their stardom has garnered them a power and prestige that encompass both the cultural elite and the marginally criminal. From these they have drafted a coterie of underlings and sycophants, united by the currency of destructive drugs and exploitative sexuality, an aristocratic demimonde that largely excludes any wider social world.

These two films bring cinema's narration of the social meaning of the Stones to its end, especially in respect to rock 'n' roll's fundamental tension between commerce and community. Reflecting the regularity with which even the earliest Stones' performances ended in riots, *Charlie Is My Darling* observed that the Dionysian excitement the Stones aroused not only tipped over into violence, but tipped over into violence against the Stones themselves. The dual narrative of the long-term relation between the Stones and their fans was one that was as likely to be aborted by aggression as unified in love. This propensity was brought to an

apocalyptic pitch in *Gimme Shelter*, whose narrative began as an attempt to transcend commodity relations and make the Stones and the audience one, but ended in Jagger's demon brothers' attempts on his life. Here the boundary between spectacle and narrative was tragically broken, ending the possibility of a utopian resolution of a dual-focus narrative in a non-alienated community of musicians and fans. Returning to *Dont Look Back*, the beginning of the concert film cycle, *Cocksucker Blues* marginalizes the fans to concentrate on the immediate social circle of the touring party. But in *Ladies and Gentlemen*, the only narrative is that of the spectacle itself, with the fans and the immediate coteries alike excluded. The Rolling Stones' film could no longer tell rock 'n' roll's social story, only its financial one.

Through the rock 'n' roll film's history, the intradiegetic audience had been a surrogate for the cinematic audience, modeling its relation to the musicians and covering over the audience's relation to the film. *Ladies and Gentlemen*'s exclusion of the concert audience makes it impossible to imagine a social relation between the film and its spectators. Their participation preempted, the spectators can no longer be part of commonality, only part of the economically exploited; their only role is as paying customers for the film, and the Stones relation to them is that suppliers of commodity music. Cinema's attempt to fathom the nature of the Stones' game is abandoned. All that is left is the audio-visual spectacle of their musical performance, reproduced as cinema. Rather than being the image of a folk community, they and rock 'n' roll appear only as a money-making machine. For cinema, this was the end of the Stones as story rather than spectacle. There would be no more concert films, only filmed concerts. The concerts would be increasingly cinematic, and the films would be extensions of the concerts, integrated into all the music's other commodity components.

Beginning with the giant inflatable phallus and the lotus flower–shaped stage of the "Tour of the Americas '75," created by a Broadway set designer, the Stones' later concerts were designed to be intrinsically cinematic events, influenced by and in competition with the extravagant stadium productions that became a new element in the rock 'n' roll mode of production in the 1970s. *Cocksucker Blues* was the last significant Stones film made about them by independent parties. With *Ladies and Gentlemen: The Rolling Stones*, they took control of their representation and made cinema an extension of their touring, and albums, tours, films, and eventually DVDs became integrated packages.[31]

The Rolling Stones continued their romance with African American music through the 1970s, incorporating elements of reggae and disco as they emerged, but the power of their music to represent an integrated biracial musical counterculture was gone. With both *Cocksucker Blues* and *Ladies and Gentlemen: The Rolling Stones* out of circulation, *Gimme Shelter* carried the last word, and after it no one, least of all Mick Jagger, could claim that "we are all one." James Brown, who

had joined them in the first great biracial rock 'n' roll party film, *The T.A.M.I. Show* (Steve Binder, 1964), noticed the split: "A funny thing was happening to music on the radio [in the early 1970s]. It was starting to get segregated again, not just by black and white but by kinds: country, pop, hard rock, soft rock, every kind you could name."[32] Along with reggae and disco, new subgenres included jazz-rock fusion, progressive rock, heavy metal, glam rock, country rock, soul, and funk, but by the late 1970s these were overshadowed by the new, virtually autonomous and radically distinct black and white popular musics: hip-hop and punk. Reggae and disco were especially indebted to cinema, with *The Harder They Come* (Perry Henzell, 1972) and *Saturday Night Fever* (John Badham, 1977) turning underground cults into mass-marketed phenomena, and most of the other mutations eventually involved cinematic components. But, anticipating the division between hip-hop and punk of the second half of the decade, in the early 1970s the biracial countercultural cinemas were succeeded in the United States by two distinct autonomous cinemas associated, respectively, with black urban and white rural music: soul and country.

Back to Black

SOUL

In the late 1960s and early 1970s, the black struggle for civil rights, judicial equality, and economic advancement generally shifted from nonviolent strategies directed toward racial integration to militant separatism, nationalism, and even armed self-defense. The former had dominated from the 1955 Montgomery Bus Boycott through the 1965 marches at Selma, Alabama, and had produced the 1964 Civil Rights Act and the 1965 Voting Rights Act. But while this federal legislation did lead to improved economic conditions for some African Americans, nevertheless the ongoing poverty, anger, and hopelessness in many black communities erupted in riots in Los Angeles in 1965, in twenty cities in each of the next two years, and then, following the 1968 assassination of Reverend Martin Luther King, Jr., in over a hundred more. After King's assassination, the Congress of Racial Equality (CORE) and other formerly integrated organizations became exclusive and separatist, and Malcolm X and the Black Panther Party's (BPP) espousal of violence in self-defense eclipsed King's commitment to nonviolence. Judicial offensives against civil rights movements, especially the FBI's COINTELPRO war on the BPP, exacerbated racial tensions, even as the promise of political power for black people failed to materialize and, in the absence of significant structural social change, black unemployment and the income gap between blacks and whites increased. The reorientation toward black economic autonomy and self-governance was justified by analyses of the racial situation made by both the government and the black political vanguard. Concluding its investigation of the urban riots, the 1968 Kerner Report starkly announced, "Our nation is moving toward two societies, one black, one white—separate and unequal." Four years later, an amplified anger was expressed in the National

Black Political Agenda, adopted at the black-only National Black Political Convention, held in Gary, Indiana in March 1972:

> From the sprawling Black cities of Watts and Nairobi in the West to the decay of Harlem and Roxbury in the East, the testimony we bear is the same. We are the witnesses to social disaster.
>
> Our cities are crime-haunted dying grounds. Huge sectors of our youth—and countless others—face permanent unemployment. Those of us who work find our paychecks able to purchase less and less. Neither the courts nor the prisons contribute to anything resembling justice or reformation. The schools are unable—or unwilling—to educate our children for the real world of our struggles. Meanwhile, the officially approved epidemic of drugs threatens to wipe out the minds and strength of our best young warriors.[1]

Culture was integral to the civil rights movement, with both secular and religious music celebrated for sustaining black identity and community, and much popular music—Martha and the Vandellas' anthemic "Heatwave" and "Dancing in the Streets," for example—was invested with radical political significance. And, despite limited popular audiences, aficionados understood the rejection of harmonic and rhythmic standards by Ornette Coleman, Cecil Taylor, and others in the Free Jazz movement as presaging equivalent forms of political liberation. But African American popular musicians, promoters, and (when they emerged) label owners were generally loath to associate themselves with freedom marches or other overt forms of contestation that might threaten their growing crossovers to white markets. With the notable exceptions of Odetta, who sang "O Freedom" at the 1963 March on Washington, and Nina Simone, whose direct engagement after "Mississippi Goddam," her 1964 song about the murder of Medgar Evers, never faltered, in the early 1960s the musicians most visibly supportive of black civil rights were white folk singers: Pete Seeger, Phil Ochs, and especially Joan Baez.

But in the latter half of the decade, more popular black musicians lent vocal and financial support to the protests, and created more aggressively nationalistic music with lyrics that explicitly articulated the demands of Black Power.[2] Both musicians and audiences understood the "Memphis Soul" created at Stax, for example, as blacker than doo-wop and Motown. Though often indebted to countercultural rock, especially as mediated through *Woodstock* laureates Jimi Hendrix and Sly and the Family Stone, funk and soul were rooted in rhythm and blues and Little Richard and Ray Charles's secularized gospel; but they replaced the earlier emphasis on harmony, melody, and chord progressions with emphatic yet often complex rhythms, forming percussive grooves based on repetitions of a single chord and, in the case of the most seminal innovator, James Brown, emphasizing the first down beat of the bar, rather than the backbeats. Brown himself noted that

his own innovations first matured in "Out of Sight," his 1964 composition with which he opened his set in *The T.A.M.I. Show*, together with "Papa's Got a Brand New Bag" the next year.[3] The latter celebrated a cultural nationalism, while in later songs, notably in his 1968 hit "Say It Loud: I'm Black and I'm Proud," his lyrics became unabashedly militant: "I say we won't quit moving until we get what we deserve" and "We'd rather die on our feet/Than be livin' on our knees."[4]

Black music's newly synergistic relation to black politics also brought changes to black cinema, and especially to music's role in it. The combination of civil rights agitation and the discovery of the economic power of black audiences after the turn of the decade provided unprecedented opportunities for black actors, writers, and even directors in films and television aimed at niche markets, while the casting of stars such as Bill Cosby, Flip Wilson, and later, Richard Pryor in westerns, comedies, horror, and other generic staples produced new representations of black people in the mainstream.[5] But black music's role in the reconstruction of previous white genres was especially pronounced in the gangster film, the biopic, and the concert documentary. Unlike more innovative independent black cinemas later in the decade, these frankly commercial undertakings reproduced established genres, deferring the quest for "authentic" black representation and aesthetic forms characteristic of other black arts of the period.[6] The new directions were initially exemplified in three films released within a six-month period in the early 1970s that differently used music in dramatizing the black community: *Super Fly* (Gordon Parks, Jr., August 4, 1972), *Lady Sings the Blues* (Sidney J. Furie, October 18, 1972), and *Wattstax* (Mel Stuart, released February 4, 1973). Their financial and critical success, especially the combined returns of ticket sales for the movies and record sales for the soundtrack albums, reflected a symbiosis between the two media that was unprecedented in black culture, though of course common in the case of white rock 'n' roll films since the synergy of *Blackboard Jungle* and *Rock Around the Clock*. And just as black music generated new filmic possibilities, so cinema prompted, shaped, and nurtured innovations in black music.

Like rock 'n' roll films, *Super Fly*, *Lady Sings the Blues*, and *Wattstax* all in some way involved delinquency, but in terms that reflected the politics of the period: in place of white youth assimilating black music as the basis for trans-ethnic generational offensives against the parent culture, a generationally unified black community, exploited and criminalized by the white hegemony, grounded a nationalist resistance in new forms of music that, though incorporating elements from white traditions and sometimes very successfully crossing over, were nevertheless marked as specifically black. And though all were produced by various combinations of black and white people and institutions, they largely de-emphasized or concealed the biraciality of production agencies to promote the appearance of black autonomy.

Blaxploitation

At the turn of the decade, *Cotton Comes to Harlem* (Ossie Davis, 1970), a black-directed comedy from a novel by a black writer and featuring a mostly black cast, was unexpectedly successful. Grossing over $15 million on a $2 million investment, it alerted the industry to the possibilities of black genre films. The roots of blaxploitation, the first successful development, lay in the moral ambiguity of film noir, which had recognized cases of police corruption and conversely allowed sympathetic presentation of lawbreakers enmeshed in treacherous social systems. The genre had been renovated the mid-1960s in *Point Blank* (John Boorman, 1967) and other films that made innovations in narrative structures and visual vocabularies, sometimes embellishing them with *nouvelle vague* motifs. The new roster of conventions included speeding cars, nighttime city streets, and petty criminals obscurely linked to an overlord, who from establishment respectability controlled a pervasive chain of corruption. Between 1969 and 1974 a series of between forty and sixty films (many more, in some accounts) relocated these conventions in impoverished black communities terrorized by violent crime and drugs, the "crime-haunted dying grounds" invoked in the National Black Agenda. There, empowered by black pride, a physically and sexually powerful black male, and sometimes a strong black female, confronted the contagion, invariably controlled by whites, summarily, the Man.[7] Such protagonists broke with the liberal black star image developed especially by Sidney Poitier who, in a series of problem films culminating with *To Sir, With Love* (James Clavell, 1967) and *Guess Who's Coming to Dinner* (Stanley Kramer, 1967), had resolved the ambiguities of his character in the first rock 'n' roll film, *Blackboard Jungle* into an earnest integrationist compliance. By contrast, blaxploitation heroes displayed an aggressive individualism, reverting to the male and female "Bad Nigger" images from folklore and early rhythm and blues, whose similarities with racist stereotypes were often criticized by black groups.[8] Though linked to local communities like the ones in which the films were marketed, these heroes were typically contemptuous of organized nationalist political movements, especially of the BPP's attempts to organize with progressive whites along class lines. The earliest blaxploitation films had substantial black involvement in production, but as Hollywood realized the genre's economic potential, whites remained ubiquitously as villains before the camera while monopolizing the roles behind it.

Blaxploitation was integral to concurrent developments in black music. Movies, singles, and soundtrack albums reciprocally promoted one another, while cinema occasioned and financed significant musical production and inspired important musical subgenres. The need for soundtracks stimulated more varied musical palettes, and innovative combinations of soul,

gospel, rhythm and blues, and even jazz; and, reflecting recent black concept albums with integrated thematics such as the Temptations' *Psychedelic Shack* (1970) and Marvin Gaye's *What's Going On* (1971), it fostered quasi-operatic extended compositions in which narrative lines extended across entire albums, restating and playing variations on a cluster of thematic concerns and musical motifs. Curtis Mayfield's soundtrack album for *Super Fly* (Gordon Parks, Jr., July 1972) combined all these possibilities. One of the decade's seminal musical achievements, it was a searing indictment of urban neglect, with lyrics that insistently critiqued the narrative's contradictions, and it justly became one of the few instances in which a soundtrack album out-grossed the film.

Though no blaxploitation films had a musician as the main protagonist, in less than three years, seventeen appeared with distinctive soundtracks composed and/or performed by prominent soul, funk, and also jazz artists. The most important of such collaborations were Earth, Wind & Fire's soundtrack for *Sweet Sweetback's Baadasssss Song* (Melvin Van Peebles, April 1971); Isaac Hayes's soundtracks for *Shaft* (Gordon Parks, Sr., June 1971), *Three Tough Guys* (Duccio Tessari, March 1974), and *Truck Turner* (Jonathan Kaplan, April 1974);[9] Curtis Mayfield's for *Super Fly* (Gordon Parks, Jr., July 1972); Solomon Burke's for *Hammer* (Bruce Clark, September 1972); Marvin Gaye's for *Trouble Man* (Ivan Dixon, November 1972); Bobby Womack and bop trombonist J. J. Johnson's for *Across 110th Street* (Barry Shear, December 1972); James Brown and his arranger Fred Wesley's for *Black Caesar* (Larry Cohen, February 1973) and *Slaughter's Big Rip-off* (Gordon Douglas, July 1973); Willie Hutch's for *The Mack* (Michael Campus, April 1973) and *Foxy Brown* (Jack Hill, April 1974); Roy Ayers's for *Coffy* (Jack Hill, June 1973); J. J. Johnson's for *Cleopatra Jones* (Jack Starrett, July 1973); Edwin Starr's vocals in Freddie Perren and Fonze Mizell's for *Hell Up in Harlem* (Larry Cohen, December 1973); and *Willie Dynamite* (Gilbert Moses, January 1974); and the Impressions' for *Three the Hard Way* (Gordon Parks, Jr., June 1974). Like Elvis's movies in the 1950s, Beatles' films in the 1960s, and *Saturday Night Fever* (John Badham, 1977) later in the 1970s, these soundtracks—one every two months—featured and in many cases inaugurated some of the most important developments in popular music of the period.

The soul and funk soundtracks inflected the films' mood, sustaining the action genre's excitement while also providing a change of pace during amorous interludes. Given the films' Black Power rhetoric, the music's association with the heroes allowed it to assert a militant cultural commonality, but also to mobilize a strong authorial expressiveness. Lyrics described conditions in the ghettos and celebrated the potency of the protagonists who would right them and, as with all rock 'n' roll films since *Blackboard Jungle*, the music was endowed with implications of social contestation. The reciprocal identification of the film and its music was especially strong when the film, the protagonist, and the theme song were all eponymous; though only *Sweetback* was specifically designated a *song*

in its title, *Shaft, Super Fly, The Mack, Trouble Man, Foxy Brown, Coffy, Slaughter, Hammer,* and others all grafted the film as a whole onto its hero and subsumed both in the title song. Roy Ayers's minimalist lyrics to "Coffy" made the identifications even more comprehensive: ostensibly addressing the star, Pam Grier, the song assimilates the whole film to her, but also the community and its signal emotive capacity: "Coffy is the color of your skin/Coffy is the world you live in/. . . Coffy is feeling something deep." In this and similar multileveled, multimedia aggregations, the heroes or heroines were *musicalized*; though not actually musicians, they were empowered by the music, and their virtuosity and bravura in the narrative became quasi-musical performances that subtended their identification with the community.

Blaxploitation's integral thematic and economic association with music coalesced in three of the earliest and most important films, *Sweet Sweetback's Baadasssss Song, Shaft,* and *Super Fly,* all released within just over a year. Whether on the side of the law, as in the case of Shaft, or outside it, like Sweetback and Super Fly, the protagonists were all cast from the same mold. Though all were adult males rather than juveniles, the films raised issues of delinquency, promiscuity, and interracial sexuality similar to those that had haunted 1950s rock 'n' roll films, with the marijuana and LSD introduced in the 1960s replaced by cocaine and heroin—the same drugs used by the Rolling Stones and other rock 'n' roll bands of the time successful enough to afford them. Overall blaxploitation may have replaced the generational conflicts of rock 'n' roll films by the black struggle against white exploitation; but the black community was itself divided by tensions between the singularity of the independent, omnipotent hero, paramount in the narrative and celebrated in the songs' lyrics, and the commonality prioritized in the period's politics and implied by the music. As the identification of the protagonist with the community and its essence in "Coffy" indicates, such tensions were symptomatically more easily resolved in films with female heroes, so that, for example, Foxy Brown's affiliation with the militants of the "neighborhood committee" in their struggle to "abolish the slavery of hard dope" is uncomplicated. But the male protagonists' need to assert their autonomy made parallel affiliations more problematical, especially with political organizations whose commitment to Black Power was projected in community rather than individual terms.[10] *Sweetback, Shaft,* and *Super Fly* muster tensions between the narratives and the music in particularly complex ways, some of them cogent and others less so, leaving each film divided against itself, with the music's communal implications tangential to the narrative and the visual iconography. The three protagonists are all variations on the Black Buck stereotype: both fighters and lovers, badass but sweet, noir and sunshine.

SWEET SWEETBACK'S BAADASSSSS SONG

An independent production whose expanded visual vocabulary had much in common with the avant-garde and art films of the sixties, *Sweetback* (Figure 16.1) was written, produced, and directed by Melvin Van Peebles. He also starred in it and composed the theme song and the score, recording them with the then unknown jazz-funk group Earth, Wind & Fire. After making amateur films in the late 1950s, Van Peebles had had a peripatetic career as a filmmaker, novelist, and musician. An independent feature he directed in Paris prompted Columbia Pictures to invite him to direct *Watermelon Man* (1970), a comedy about a black man who overnight turns white. Dissatisfied with this experience in Hollywood, Van Peebles raised the money for his own project, *Sweetback*, and created a character who embodied and seemed to endorse stereotypes of the hypersexualized violent black male, but whom the narrative restores to dependency on the community. Raised in a brothel, while still a child Sweetback is sexually initiated—raped, in fact—by a prostitute who, in gratitude, gives him his name, and thereafter he makes his living as a performer in bordello sex shows. When white policemen attack Moo Moo, a young black radical with whom he has been arrested, he is suddenly politicized. He beats the police almost to death and spends the remainder of the film running through Los Angeles, where he is aided by the black community, until he escapes though the desert to Mexico whence, a final title warns, he will return "to collect some dues."

The film and especially its protagonist were immediately controversial. BPP cofounder Huey Newton's declaration that it was "the first truly revolutionary Black film made" and that Sweetback himself was "a beautiful exemplification

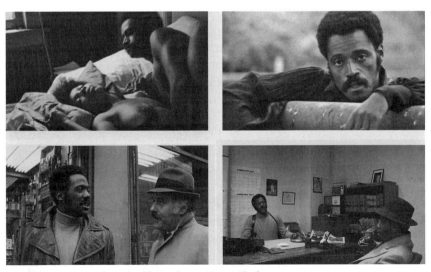

FIGURE 16.1 Sweet Sweetback's Baadasssss Song, Shaft.

of Black Power" was countered by critiques of its reproduction of racist cli-
chés about black men, its objectification of black women, and its failure to
envision more progressive black political movements.[11] The implication that
Sweetback's contact with Moo Moo liberates him from passive sexual objec-
tification into political maturity and active rebellion is anticipated by two
introductory titles and the disjunction between them and the visuals over
which they are superimposed: the words "This film is dedicated to all the
Brothers and Sisters who have had enough of the Man" appear as Sweetback
runs alone at night though a highway tunnel, a typical Los Angeles film noir
environment; then, only minutes later, over the ecstatic face of the prosti-
tute he brings to orgasm and to the accompaniment of Sweetback's musical
theme, appear the full-screen titles, "Starring THE BLACK COMMUNITY/
and BRER SOUL." Whatever relations between individual sexual satisfaction
and Black Power might subtend this skein of divergent motifs, they are not
realized dramatically. Apart from several instances of sexual and other forms
of violence, including an episode in which he defeats an outlaw biker in a
fucking contest, the bulk of the film is occupied by Sweetback's flight through
the city and the desert, an odyssey made more miasmic by color solariza-
tions, multiple superimpositions, loop printing, jump cuts, step printing, and
other forms of psychedelic image manipulation characteristic of avant-garde
film in Los Angeles at the time that also provide a visual counterpoint to
the music's improvisational energy. Pursued by policecars and helicopters, he
flees on foot, and his constant running brings the nineteenth-century motif
of the escaped slave to resonate within the noir city.

Though dependent on his personal physical strength and goodwill assis-
tance from the people he encounters, Sweetback is also sustained by two forms
of music: a recurrent leitmotif, "Sweetback's Theme," played on guitar and bass,
elaborated by horns, that, like James Brown's pioneering funk, lacks chromatic
variation;[12] and a series of vocal collages mixing community voices address-
ing Sweetback ("they bled your momma, they bled your papa") and a capella
fragments from gospel and other black song. The last, for example, is listed
on the soundtrack album as "The Man Tries Running His Usual Game but
Sweetback's Jones Is So Strong He Wastes the Hounds (Yeah! Yeah! and Besides
That He Will Be Comin' Back Takin' Names and Collecting Dues)." These con-
versely define the music as the sound and emblem of his resistance and the
black community's assistance to him. The continuities between the orchestral
and the choral music and their mutual invocation reiterate the main theme of
Sweetback's discovery of his identity with the community that allows him to
represent their struggle; but the music also allowed the film itself to find a voice
and visibility in spite of the dominant cinema's repression of that same struggle.

When *Sweetback* was completed, no major news outlet would review it,
and, unable to secure distribution, Van Peebles opened it in only two theaters,
one in Detroit and one in Atlanta. Deciding to use the music to promote it,

he negotiated with Al Bell at Stax Records to release the soundtrack album in April 1971, with an edited version of the title song released as a single in July.[13] As had happened with *Blackboard Jungle* and *Rock Around the Clock*, music and film symbiotically advertised each other, in this case so successfully that *Sweetback* secured wide distribution with an independent exploitation distributer, Cinemation Industries, and became one of the most successful independent films ever made, with some sources claiming returns of more than $15.2 million on the estimated $500,000 invested.[14] As a result, according to Van Peebles himself, it "became the whole stencil for using the soundtrack as a marketing tool."[15] Establishing the importance of music as both a textual element and promotional element, it was similarly influential in dramatizing political tensions between the super-masculine hero and the wider community.

SHAFT

Unlike *Sweetback, Shaft* was a studio production, made at MGM, a studio synonymous with musicals. Its hero, John Shaft (Richard Roundtree), is a private detective rather than an outlaw and, as his name implies and as Isaac Hayes's lyrics in the title song assert, his masculinity is rampant and, together with a degree of ethnic indeterminacy,[16] it allows him to move confidently though the insular worlds of the black community, a group of ineffectual political progressives known as the Lumumbas, the Greenwich Village bar and restaurant scene, the Harlem drug and prostitution syndicates, and the police. A black drug kingpin, Bumpy Jonas, hires Shaft to rescue his daughter, who has been kidnapped by the downtown mafia to force him to relinquish his turf. The narrative organizes the various social factions so that Shaft joins with the police and the Lumumbas to save Bumpy's daughter, defeat the mafia, and so prevent a war between the white mafia and the Harlem underworld from erupting into what Androzzi, a sympathetic police detective, warns him will misleadingly appear as a race war of "black against white." But, if not entirely financial, Shaft's own motives are at best egotistical. Indications that he may have been friends with the Lumumbas' leader in the past are negated by his present scorn for them, and he has neither real commitment to them nor organic roots in the community. Cooperative with the police only when it suits him, he nevertheless appears most deeply bonded with Androzzi, the Man, whose concern for the black community is more heartfelt than his own.

Rather than reflecting Black Power's social analysis, the scenario is drafted from forties noir: Shaft's office resembles Sam Spade's in *The Maltese Falcon* (John Huston, 1941) and Bumpy tells Shaft he wants to hire him because he is a "black spade detective," albeit one who has "his foot in whitey's craw." But he is also characterized as a local black James Bond, the clipped monosyllables of whose name those of his own recall. Once a model, the handsome

Roundtree is conspicuously dandified, sporting neither pimp suits nor the Lumumbas' ill-fitting work clothes, but tight-fitting leather coats over elegant tweeds, double-breasted blazers, and cashmere sweaters. He lives in a Greenwich Village playboy bachelor pad, replete with works of art, modern furniture, and expensive hi-fi equipment, where between excursions into the uptown ghetto, he casually beds white women. And in much the same way that John Barry's arrangement of the "James Bond Theme" for *Dr. No* (Terence Young, 1962) echoed through the subsequent Bond movies, Isaac Hayes's seminal score and especially the Shaft theme itself became models for subsequent blaxploitation funk and the vehicle of its breakthrough into the popular musical mainstream, mobilizing the blackness that the narrative fails to assert.

By the late 1960s, despite management mistakes, Otis Redding's death, and other crises, Stax Records in Memphis was matching Motown's success. Beginning as a session musician, Hayes became the studio's top songwriter and record producer, cowriting some of the company's most important hits, many of which dramatically affirmed ethnic pride.[17] Among his own records, his seminal 1969 album, *Hot Buttered Soul*, elegantly amalgamated the label's characteristic stripped-down production with wah-wah guitars, lush orchestrations, and extended mixes. Initially hired to write three songs for *Shaft*, Hayes so impressed Parks that he assigned him the entire film. Generally it is sensitively understated orchestral underscore, but it also contains the three vocal compositions, the "Theme from *Shaft*," "Soulsville," and "Do Your Thing," all presented non-diegetically with lyrics that directly address the relationship between black individuality and its community roots.

Opening the film, the "Theme from *Shaft*" identifies the hero musically and discursively before he is narratively engaged. Combining musical badass and sweet, the instantly recognizable sixteenth note high-hats and the wah-wah rhythm guitar matched with lyrical strings introduce him as an aggressive urban loner, striding purposefully through the harsh winter streets around Times Square. In the lyrics, Hayes's smoldering baritone affirms the combination of sexual and physical virtuosity that the film will celebrate. First and most important, like Sweetback, he identifies his profession with his phallic prowess: a "black private dick," he is "sex machine to all the chicks." But he is also a "cat that won't cop out/When there's danger all about" and, summarily, "a complicated man" whom no one "but his woman" understands. Where the Shaft theme is a third-person boast, exaggeratedly aggrandizing the hero, "Soulsville" diagnoses the plagues suffered by the community. Played as underscore while Shaft walks the Harlem streets and visits its dilapidated apartments, it bemoans the "Black man, born free" and promises to reveal the chains that bind him: poverty, rising crime rates, slum housing, pimps and prostitution, and drugs. Despite this grim assessment, the song's voice still asserts that the ghetto and the projects are in fact "Soulsville" (also a

name for Stax studio), and in the last stanza's description of "church sisters" and their belief that one day the Lord will "put an end to all this misery" to realize Soulsville, the lyrics reflect the gospel timbres of Hayes's music. But even though the song finds musical richness amidst the barbarity of pandemic racism, the visuals are preoccupied with Shaft himself, focusing on him in long shots and in repeated extreme close-ups, rather than picturing the community that the song proclaims. Finally, the attraction of egotistic individuation is hyperbolically affirmed in the lyrics of the third song, "Do Your Thing": "If you wanna make love all night/And you feel it's right/Right on, right on/Cause whatever you do/You've got to do your thing." Playing as if on the jukebox in a bar scene where—prototypically—Shaft traps two heavies sent to kill him and then picks up a white woman, it is a hypnotic ode to physical, especially sexual, self-affirmation; when re-recorded in a twenty-minute version for the soundtrack album, it became an epic, albeit one that celebrated individual rather than community fulfillment.

Both Hayes's score overall and the "Theme from *Shaft*" received many awards, including two Grammy Awards. In 1972, the soundtrack was nominated for Academy Award as the best Original Dramatic Score and the "Shaft" theme won for Best Original Song. Crossing over, the album reached number one on both the pop and rhythm and blues charts, and the single reached number one on the pop and number two on the black charts. Sustained by the music, the film earned $13 million on half a million invested, and saved MGM from bankruptcy, at around the same time that *Woodstock* did the same for Warner Bros.

SUPER FLY

Curtis Mayfield's music for *Super Fly*, both orchestral underscore and the half-dozen songs, is one of popular music's greatest achievements. As with *Shaft*, the song lyrics maintain an ongoing commentary on the hero that, along with social contradictions in the narrative, again complicates Black Power's racial binary. But since *Super Fly* contains the only significant depiction of musical performance in blaxploitation, the relation between music and cinema is unusually intricate. In his performance with his band, Mayfield interrogates the relation between music, drugs, and delinquency that, while implicit in other blaxploitation, was also conspicuously exploited by the Rolling Stones, who, in July 1972 when *Super Fly* was released, were on the US tour documented in *Cocksucker Blues*.

Like *Shaft*, *Super Fly* (Figure 16.2) places Priest, its again allegorically named protagonist, in a conflict with the New York criminal underworld. But since he is himself both a dealer of cocaine and a conspicuous user of it, the film is caught between the contradictory implications of drugs as simultaneously a hedonistic recreational luxury for the bourgeoisie and a catastrophe

FIGURE 16.2 Super Fly.

for the working class. On the one hand, cocaine is romanticized by its links to Priest's power and prestige in the city and his attraction for both black and white women, but also by its presentation as the vehicle of a benign community ritual. On the other, its destructive effects are vividly recognized in vignettes of strung-out addicts, the impoverished ghetto, and acts of violence: the conditions described in "Soulsville" but only glimpsed in *Shaft*.

These contradictions and Mayfield's refraction of them are established before the title sequence. Like *Shaft*, the film opens with aerial shots of Manhattan's mean winter streets, but where the genre conventionally introduces the film's name, title song, and the eponymous hero together, here attention initially focuses, not on the hero and the dealer, Superfly, but on two of the black addicts who are his victims. The images are set to Mayfield's "Little Child Runnin' Wild," which is sung in the first-person voice of a man who was born "just a nothin' child" into poverty in a broken home and has since become hopelessly addicted. The first scene follows the junkies as they hassle people for money, and the camera holds them together in medium close-up at exactly the point where the lyrics announce, "I've gotta jones/Running through my bones." Only then is Priest introduced by a cut to a close-up of a cross-shaped spoon hanging on his naked chest. As the camera pans up to his joyless face and bleak eyes, the lyrics admit, "Don't care what nobody say/I got to take the pain away/It's getting worser day by day." The shot widens to reveal him in a luxurious post-coital bed with his white mistress, but the song continues, "Can't reason with the pusherman/Finance is all that he understands"; using the spoon to snort cocaine, he abruptly announces that he has to leave her to make a pick-up. While seeming to continue to describe the two

addicts, the lyrics have shifted reference to introduce the pusher on whom
they are dependent. Indeed, after the immediately following title sequence
has revealed Priest in all his pimp finery, the scene brings them all together
and illustrates the junkies' subordination when they attempt to mug him
and he savagely beats them. But the lyrics' synchronization with Priest's own
drug use and his obligation to meet his connection also allow the addiction
to be attached to him, anticipating subsequent developments in the plot that
will more explicitly reveal that, as a low-level dealer, he is as trapped in the
hierarchy of the system as they are. A petty capitalist swimming with bigger
capitalists, to those below him he appears as the privileged pusher; but he also
resembles them in his inability to escape from the pushers above him. Unlike
the marijuana and LSD of *Woodstock* and the counterculture that subtend the
rhetoric of peace and love, here cocaine is a socially administered plague that
divides the community against itself.

Complicated by the eventual implication that he has himself become
chemically as well as economically dependent on cocaine, Priest's intermedi-
ate position in the criminal hierarchy generates the narrative, which again
defaults on Black Power's racial binary. It does indeed reveal that the Man
who ultimately controls the system is white and in fact is the deputy commis-
sioner of the police. But the substantial rewards enjoyed by Priest as the Man's
agent are expropriated from the black community, which provides his cash,
women, sartorial flamboyance, and automotive distinction. His vines and
hog with its Rolls-Royce grille display pimp style at its most extravagant, and
the latter was actually owned by a K. C., a real-life pimp who makes a guest
appearance. And the community provides his apartment, which, though
not as upscale as Shaft's, comes, as his buddy Eddie observes, with "8-track
stereo, color TV in every room, and . . . half-a-piece of dope everyday. That's
the American Dream." To maintain these, he must re-enact the Man's power
over him by absolutely controlling his stable of subordinates, who are all also
black. In this position of divided ethnicity, to those above him he is black and
hardly distinguishable from the ghetto residents; but to those below him, he
is functionally "white," himself the Man. So, despite his pimp attire, Priest's
light complexion and long straight hair prompt one foolhardy craps player to
call him "white looking." And when a trio of unprepossessing militants con-
front him with the argument that, since "black folks have been mighty good"
to him and since they "are out here building a new nation for black people,"
it's time for him to pay some dues, he dispatches them with the unconvincing
reply that when they and other black people get guns, he will be "right with
you, down front killing whitey." Eddie proposes that such contradictions are
structural and are imposed on black people by an intrinsically racist social
system, "a rotten game, the only one the man left us to play," but the narrative
offers Priest the oldest ruse in the book, one last big score: a plan to move huge
amounts of cocaine that will make him and Eddie half a million dollars each

to escape the system. Though the plan causes the deaths of Eddie and Priest's mentor and surrogate father, Scatter, he does himself finally escape by pitting elements of the racist system against each other, further complicating the black-white binary. Whereas Shaft used the white police to defeat the mafia, Priest uses his drug profits to buy insurance from the same mafia in the form of a contract to kill the police commissioner who controls the system if he is injured after his defection.

These social and ethical contradictions are refined and elaborated in the tension in Mayfield's music between the mellifluousness whisper of his high tenor voice and the engaged militancy of his lyrics. The pronounced social conscience of his previous work as writer and lead vocalist for the Impressions and in his solo productions had made him, more than any other African American pop musician, the voice of the civil rights movement, while correspondingly limiting his crossover success. As the Black Power movement developed, his commitment to it and his indictment of racism, drugs, the invasion of Viet Nam, and the general exploitation of the black community in songs such as "We're a Winner," "Beautiful Brother of Mine," and "We Got to Have Peace" had given him a political prominence that matched James Brown's. His songs in *Super Fly* explicitly indict dealers and drugs, counterpointing and critiquing the narrative's exploitation of Priest's outlaw glamor and disregard of its sources and consequences.

Most crucial is "Pusherman," the song Mayfield is seen performing. It begins as underscore as Priest drives to Scatter's nightclub restaurant, where he persuades him against his deep misgivings to help him obtain the bulk cocaine he needs for his plan, but which will eventually lead the police to murder Scatter in retaliation. Priest is greeted by the clubgoers, including K. C. and his girls, and the song's diegetic source is revealed to be Mayfield with his band performing in the club. As in the classic musical, the narrative is arrested and the camera singles out Mayfield in close-up for several stanzas, then intercuts shots of the audience responding enthusiastically and Priest and Eddie watching. In adopting the persona of the pusherman, Mayfield identifies himself with Priest, creating a nimbus of power and pleasure around him, but also articulating the ambiguity of his noir heroism. The lyrics describe his general occupation ("I'm your doctor when in need/Want some coke, have some weed"), its rewards (he is "super cool, super mean" with the "baddest bitches in the bed," and "Ghetto Prince is my thing"), a rationalization for it (his "silent life of crime" makes him a "victim of ghetto demands"), and its insecurity ("how long can a good thing last?"); and he articulates Priest's immediate predicament: "Got a woman I love desperately/ Wanna give her something better than me/Been told I can't be nothin' else/ Just a hustler in spite of myself/I know I can break it/This life just don't make it." The music's erotic pulse and the seductive timbres of Mayfield's voice reflect the allure of drugs, while the lyrics' bleak diagnosis spells out their

curse. Singing to and as Priest, he recognizes his macho glamor, but also the costs of his addiction to it.

The same critique appears summarily in the theme song, "Superfly." It is first heard, not as is typical during the opening titles, but in the scene in which, unknown to the audience, Priest makes the deal with the mafia and so sets up the last scene in which he escapes the life. The lyrics elaborate the various difficulties and contradictions Priest has faced in "trying to get over," while the central stanza recognizes that he was "a hell of a man," who "had a mind, wasn't dumb," while also unambiguously indicting him and point-ing out that the flaw that almost led him to tragedy was his separation from the community: "But a weakness was shown/'Cause his hustle was wrong/ His mind was his own/But the man lived alone." In its dramatic context, the analysis is particularly pointed. The immediately previous two sequences have seen, first, Priest declare to his rich white lover that the "vines, hog and a woman like [her]" no longer compensated for the anxieties of hustling; and second, the police murder of Scatter by giving him a hot shot immediately after he has come to Priest for help. The placement of the song underlines the irony of Priest's realization that his crimes against the community and his own escape caused his mentor's death.

Depending on the degree to which *Super Fly*'s narrative is perceived as a glorification of Priest as a "Ghetto Prince" who finally does defeat the Man, Mayfield's lyrics in "Superfly," "Pusherman," and "Little Child Runnin' Wild" will appear as a more or less critical counterpoint to what he initially took as a "cocaine infomercial."[18] His discomfort was certainly justified by one inter-lude, a three and half minute multi-screen montage sequence of Parks's still photographs depicting a group of hip young people who purchase a kilo of cocaine from Priest, cut and package it while sampling it liberally, and deal it across Manhattan to a spectrum of businessmen, construction workers, and other prosperous clients, black and white, all of whom consume it with evident delight. Though set to a reprise of "Pusherman," much like televi-sion beer commercials of the time, it so persuasively disguises all the drug's dangers as a festive middle-class multi-racial social ritual that the song's negativity evaporates in a euphoric haze. But in another instance, Mayfield's intervention was so forceful that it was excluded from the film.

A crucial dramatization of Priest's exploitation of the black community occurs when one of his underlings, Fat Freddie, is short on his payment. Threatening to put his wife on "whores' row," Priest forces Freddie to rob a mafia courier. Picked up by the police, he is beaten so savagely that, while Priest and his lover stroll through the snow in Central Park, he reveals his boss's plans. As Freddie tries to escape from the police, a car runs him down, sacrificing yet another life for Priest. Mayfield wrote an extended elegy, "Freddie's Dead," that began and ended with the same denunciation of Priest: "Everybody's misused him/Ripped him up and abused him/Another

junkie plan/Pushin' dope for the man." Released as a single before the film appeared, it reached the top five of both the pop and the rhythm and blues charts and, like Van Peebles's release of the *Sweetback* album, it served as a marketing publicity device. But, perhaps because its indictment disrupted the overall idealization of Priest, the film excluded the single's vocals, and contains only an instrumental version of the number. Its unforgettable bass line initially accompanies Priest's first excursion to make a pickup, and for spectators who had previously digested its lyrics, its periodic recurrence as a leitmotif is an ongoing reminder of Priest's responsibility for the death of Freddie and so many others; one reprise, for example, accompanies the police murder of Scatter. Its subtitle, "Theme from *Super Fly*," only multiplied these ironies by attaching to the film's overall lavishly glorification of Priest, Mayfield's indictment of the social costs of his drug dealing and its utility for the Man.

Similar ironies surround the genre as a whole. *Sweetback* was independently produced and distributed, while *Shaft* and *Super Fly* were independently produced but studio distributed, respectively, by MGM and Warners, and all three were black directed. But almost all other blaxploitation films were studio produced and distributed, and most were written and directed by whites. Like cocaine, they were extremely enticing, and these early three at least made huge returns on invested capital.[19] Subsequent blaxploitation films did not take quite as much money from the community, but even so almost all of it went to the Man.

The Biopic: *Lady Sings the Blues*

Three months after *Super Fly* opened, another film explored a relationship between black music and drugs. In her film debut, Diana Ross, the most successful singer of the time, played neither a dealer nor a bad blaxploitation chick like Coffy or Cleopatra Jones who, beginning the next year, would take their revenge on the ghetto pushers; rather, she portrayed a victim, a revered singer whose career and life were destroyed by drugs, dealers, and pandemic racism: Billie Holiday, Lady Day.

Lady Sings the Blues was loosely based on Holiday's ghostwritten autobiography, itself similarly loosely based on her life.[20] Credited to Sidney J. Furie, it revived and combined two Hollywood genres, biographies of swing-era musicians, such as *The Glenn Miller Story* (Anthony Mann, 1954) and *The Benny Goodman Story* (Valentine Davies, 1956), and melodramas about women who bring destruction on themselves, such as *In This Our Life* (John Huston, 1942) or *Leave Her to Heaven* (John M. Stahl, 1945). Nominated for five Academy Awards, it also returned over $9 million in the next year, while the soundtrack album containing both music and dialogue from the film became Ross's only solo album to top the charts and eventually sold over two million

copies. It was the first and most successful film from Motown, the record company founded in 1959 by Berry Gordy, Jr.

Descended from a white plantation owner and his slave, Gordy was the seventh child of parents who had left Georgia in the 1920s to work in the Detroit automotive factories. After being drafted and serving in the Korean War, he began writing songs, most successfully for Jackie Wilson, before founding the Motown Record Corporation. Signing the Miracles and other local artists, he soon had sufficient regional and then national hits to justify converting a house into a recording studio that he named "Hitsville U.S.A." There he assembled an extensive stable of remarkable artists, eventually also including the Supremes, the Temptations, Martha and the Vandellas, Gladys Knight & the Pips, the Four Tops, Marvin Gaye, Stevie Wonder, and the Jackson 5. With local musicians, many of them with extensive jazz backgrounds, he also assembled an ongoing studio orchestra known as the "Funk Brothers,"[21] and songwriting and record production teams, most notably the trio Holland–Dozier–Holland, who wrote most of the Supremes' hits. All his acts were impeccably dressed and groomed, and were provided with coordinated dance routines so as to maximize their crossover audience appeal. Gordy's control over their careers and daily lives quickly made their production of hit records as efficient as Detroit's assembly lines, over a hundred of them in the 1960s, more than justifying the mainstream aspiration of the label's slogan, "The Sound of Young America."

The Supremes' releases failed until Gordy established Ross as the trio's lead singer in 1964 and, after "Where Did Our Love Go?" topped the US charts and reached number three in the United Kingdom, they became his most successful group. For the next two years, they traded places at the top of the US singles charts with the Beatles, the only group in the world who could compete with them, and by mid-decade their dozen number one hits had made them global superstars. While retaining their identity as Motown artists, Gordy constantly extended the Supremes' repertoire; their second and third albums, both released in 1964, were *A Bit of Liverpool* and *The Supremes Sing Country, Western and Pop*, and in 1967 they released *The Supremes Sing Rodgers & Hart*. That year, Gordy changed the group's name to "Diana Ross and the Supremes," and their second album in the new configuration in 1968 was *Diana Ross & the Supremes Sing and Perform "Funny Girl."* Two years later he split his star from the group, and in May 1970, Ross released her first solo album, *Diana Ross*, the second single from which, "Ain't No Mountain High Enough," topped both the pop and rhythm and blues charts and confirmed her crossover appeal.[22]

In a decade Gordy had made Motown one of most successful record labels in the world and the largest black-owned business in the United States, while his success in appealing to both black and white audiences made it one of the most progressive popular cultural force on both sides of the Atlantic. As

early as 1964, for example, records by Martha and the Vandellas, the Miracles, and other Motown artists were featured diegetically, playing in bars or on the radio, in the pioneering anti-racist classic, *Nothing But a Man* (Michael Roemer). The Beatles' inclusion of three of Motown's most important songs on their second album, *With the Beatles* (1963), and Bob Dylan's observation that Smokey Robinson was "America's best living poet" evidenced Motown's place in the heart of rock 'n' roll, even as their music crossed virtually all social boundaries.[23] Diana Ross's distinctive voice was at the center of Gordy's conquest of the music industry, and when he moved part of his operations to Los Angeles in 1969 and directed his attention to another medium, she accompanied him.

In 1969, Jay Weston, co-producer of *For Love of Ivy* (Daniel Mann, 1968), a romantic comedy starring two black actors, Sidney Poitier and Abbey Lincoln, proposed to Gordy that Ross, rather than Lincoln, who had been his first choice, star in a film about the life of Billie Holiday (whom Gordy had in fact known).[24] Ross had demonstrated acting abilities in an ABC television special in which she played Charlie Chaplin, Harpo Marx, and W. C. Fields; and "My Man," a song associated with Holiday, had been part of her repertoire since her final concert with the Supremes, though her interest in it then was focused on outdoing Barbra Streisand's version of it in *Funny Girl*.

Nevertheless, the decision was a huge gamble. Gordy was initially reluctant, concerned about Ross's suitability for the part and about the lack of crossover success for films with predominantly black casts, but he eventually agreed and financed a screenplay. It failed to attract studio interest until Frank Yablans, a new president at Paramount, noted the money being made by blaxploitation and agreed to finance the film with $2 million. Weston signed Furie, veteran of two Cliff Richard musicals, *The Young Ones* (1961) and *Wonderful Life* (1964), and more recently *The Ipcress File* (1965), to direct. Enthusiastic about Ross, Furie also found Gordy entirely in accord with his intentions: "I didn't want to make a serious, deep important movie. I wanted to make a piece of entertainment that would make big money for all of us."[25]

Unfamiliar with Holiday's music, Ross immersed herself in it while pregnant with Gordy's child, studying especially the eighteen songs that Gil Askey, musical director of the Supremes and many other top Motown acts, had selected as most appropriate for her voice. Several musicians who had worked with Holiday were recruited for the recording sessions, which took place at Motown's Los Angeles studio. Dissatisfied with the script, Gordy had it rewritten by Motown staffers, and dissatisfied with the wardrobe, Ross had new gowns made by Bob Mackie and Ray Aghayan. Shooting began on December 6, 1971, and, with Gordy and Furie vying for control, it was almost completed by early February. But Gordy's insistence on repeated takes so infuriated Yablans that he threatened to close down production. In

FIGURE 16.3 Lady Sings the Blues.

response, Gordy repaid Paramount's $2 million and invested another $2 million of his own, ending Paramount's involvement except as distributor. With the tagline derived from Ralph Gleason's *Rolling Stone* review, "Diana Ross *is* Billie Holiday," *Lady Sings the Blues* (Figure 16.3) opened in New York to rave reviews, especially for Ross's performance.[26]

Leonard Feather, a renowned jazz critic and personal friend of Holiday, spoke for the cognoscenti: "Miss Ross brought to her portrayal a sense of total immersion in the character. Dramatically, this is a tour de force. . . . Musically, there was no attempt at direct imitation of Billie's timbre, but the nuances and phrasing were emulated with surprising success"[27] The project Gordy described as "not a Black film but a film with Black stars" crossed over to the white market as easily as "Baby Love."[28] With it, Gordy himself crossed over from music to cinema and, disarming even those who had most criticized the project, Ross herself became a film star. Where Gordy's previous insistence on broadening her range had involved assimilating the Beatles and *Funny Girl*, in this she laid claim to classical black music, to jazz, and to a singer considered by many to be one of the century's greatest. Conversely, the narrative also endowed Ross with the biographical misery that the white mainstream demanded of a black artist, as well as with the addiction to narcotics that Hollywood insistently ascribes to black musicians of genius.[29] In her first role, she became the first black woman to win a Golden Globe award and the first since Dorothy Dandridge to be nominated for an Oscar as Best Actress.[30] Having struck gold in music, television, and now in cinema, she was only steps away from her 1976 Billboard Award as "Female Entertainer of the Century."

The degree to which Diana Ross could play, let alone *be*, Billie Holiday had been questioned when the project was announced. Slightly built and often appearing almost anorexic, Ross was physically the opposite of Holiday, a self-described "big fat healthy broad" "with big breasts, big bones."[31] The adequacy of her experience to Holiday's calamitous life was also doubted; but even though she had not suffered as horribly, as a working-class black woman she had experienced prejudice enough. A Motown Revue tour of the South in late 1962 had exposed her to segregated public facilities, and just before work on *Lady* began, two of her brothers were brutalized by the police. Other achievements linked the two, notably Ross's recapitulation of Holiday's success in crossing over to a white audience while maintaining the affection of her initial black public; one had wanted to play the Café Society, and the other, the Copacabana, and both fulfilled their ambitions. But differences in their voices precipitated the most scorn, with Ross's teenage breathiness deemed inadequate to Holiday's biting authority. In fact, Holiday had a limited vocal range, hardly more than an octave, and even if her style derived from the blues and Ross's from doo-wop, both had thin, nasal voices, quite unlike the powerhouses of their respective eras, Bessie Smith, for example, and Aretha Franklin. And though Ross did not attempt to imitate Holliday's timbre, Feather was correct in noting that she had learned the nuances of her phrasing, her practice of bending pitch, for example, or hesitating over a note rather than immediately hitting it on pitch. But while emphasizing the interconnected itineraries of her musical career and addiction, Gordy's final script had many inaccuracies and omissions; the sketchy biography excludes her life among jazz musicians and other artists; if her close friend, Lester Young, who coined the sobriquet "Lady Day," appears at all, it is only in the displaced form of the entirely fictitious Piano Man; and the film even gives an incorrect date for her imprisonment, placing it, not in 1947, but in 1936. And the triumph of her life was shifted to the film's narrative conclusion at Carnegie Hall; instead of allowing Holiday to descend into poverty and die under arrest in a hospital bed, Gordy reimagined her demise as Ross's triumph.

The musical differences between Holiday and Ross are most marked in two areas, the former's interaction with her fellow musicians and her double-consciousness. A distinctive facet of Holiday's genius as a jazz singer was her phrasing of her vocal lines in response to her instrumental accompaniment, her weaving of her voice among other elements in a collective improvisatory ensemble. This may be heard in her recordings, but films show her listening closely to the other musicians and constructing her improvisation in dialogue with theirs. In the only visual record of her singing live, a performance of "Fine and Mellow" in the television program *The Sound of Jazz* (1957), her attention to Lester Young is palpably intimate.[32] But in *Lady Sings the Blues*, Ross sings without any reciprocal collaboration with her

accompanists. Musically as much as narratively, they are merely a backdrop, props for her star performance.

Though in her 1930s performances and recordings, Holiday had been an exuberant jazz singer, in the postwar years, she narrowed her focus almost exclusively to torch songs, establishing a consistent persona as an abandoned or abused woman. "Strange Fruit," the only major exception, generalized her personal victimization into the situation of African Americans as a whole. The rhythmic and tonal consistency of her songs and their largely unvaried dramatic situations allowed her to inhabit her postwar persona with an extraordinarily expressive conviction. But at the same time, the strength of her voice sustained a distance from her victimhood, as if she were quoting it in a fashion that has often been likened to a Du Boisian "double-consciousness." Ross's characterization lacked this complexity. So James Baldwin, for example, justifiably faulted the film for failing to portray Holiday's readiness to confront white police, managers, and other authority figures, arguing first that "[s]he was much stronger than this film can have any interest in indicating, and, as a victim, infinitely more complex," and then, that a "victim who is able to articulate the situation of the victim has ceased to be a victim: he, or she, has become a threat."[33] But Ross is never a threat, and never displays any autonomous power and, apart from one moment in the extremity of her addiction when she attacks him, she is psychically and emotionally dependent on Louis McKay.

If *Lady Sings the Blues* contains any interpretative question, it is not the relation between Ross and Holiday but the relation between Gordy and McKay. Consciously or not, Gordy made the film a self-congratulatory allegory of Ross's career under his direction and control. The real-life McKay was a mob enforcer and sometime pimp who, like many of Holiday's other lovers, abused her. Married to her in 1957, he outlived her, and when the film was in production, his threats were taken sufficiently seriously that he was hired as a consultant.[34] He need not have been concerned, for the film's McKay, though a composite of Holiday's three husbands, is impossibly idealized. Physically gorgeous, impeccably tailored, unfailingly generous, and possessed of endless unexplained wealth that allows him to move effortlessly among all echelons of white society, he is simultaneously Prince Charming and Svengali. Saving her from ridicule at her debut, he takes her downtown to dance all night, then to his luxurious apartment and his bed. Under his tutelage, her musical career soars, and when he is absent she succumbs to drugs and other calamities that take her lower and lower until he comes to her rescue. The ballad of her dependency on him is counterpointed by the white music industry's exploitation. The blond devil, Harry, who ensures her drug addiction for the advantage of his own career and then abandons her at the radio broadcast and withdraws her supplies, personifies the musical and chemical exploitation from which only McKay can save her. To ensure that the lesson is learned,

Gordy has the film tell it twice; first by financing her stay in the sanatorium and second by securing her Carnegie Hall performance. Just before that, in California at her second nadir, terrified, drugged, and confined with Piano Man's bloody body, she phones him, crying, "We can't do everything by ourselves." McKay/ Gordy again comes to save her; "I knew you'd come, I've been waiting for you," she greets him, and he transports her magically to Carnegie Hall, where she reiterates her dependency by singing, with a full orchestra rather than history's trio, "My Man." "My Man" is the only song addressed to McKay, but their relationship is isolated from the drama of her music with, as Drew Casper notes, "their seven romantic scenes accorded a lush underscoring absent from the rest of the film."[35] By transmogrifying Billie Holiday into Diana Ross, Gordy was able to represent himself as McKay and her savior.

Lady Sings the Blues, then, abandons the sixties ideal of music as subcultural production and reverts allegorically to the fifties model, presented in *Rock Around the Clock* and other jukebox musicals, of the priority of the manager and of popular music as an industrially manufactured commodity that Gordy's own career had so summarily manifested. So the world would well know that he, not the Ross whom he managed so brilliantly, was the real star of Motown, he told the story again three years later in *Mahogany* (1975), and to ensure it was told correctly, Gordy took over direction, firing Tony Richardson, whom he had initially hired. Ross's recording of the film's title song, "Do You Know Where You're Going To?," topped the *Billboard* Hot 100 and Easy Listening charts as well as being nominated for an Academy Award, but in the film she played a dress designer rather than a musician. The theme song articulated and accompanied Ross's recurrent choices of direction between an independent career and subordination to her man, between individual fulfillment and social responsibility. Though her independent career leads to professional success as the toast of the Rome fashion world, she descends into emotional and sexual misery among the wealthy but effete and impotent whites. On the other hand, again as Gordy's surrogate, Billy Dee Williams appears as a community leader and an aspiring politician determined to serve the black community. Returning home from European decadence, she finds him addressing a political rally and from the crowd she proclaims, "I want you to get me my old man back!" In return he offers her the chance to "stand by him when the going's gettin' rough," and to "love and cherish him for the rest of [her] life." Only when she agrees, does he guarantee, "I'll get you your old man back." Even Billie Holiday never had to promise so much.

The Concert Film

After the failure of the countercultural community depicted in *Gimme Shelter* and the Stones' subsequent films, other documentaries that attempted

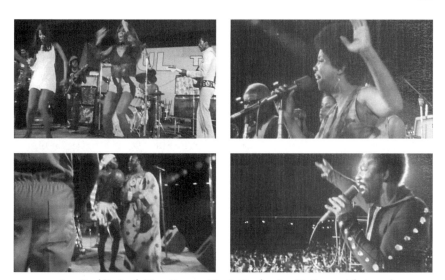

FIGURE 16.4 Soul To Soul: *Tina Turner, Mavis Staples, Les McCann with Amoah Azangio, Wilson Pickett.*

to depict communities created around popular music often took an inter-national frame of reference. Though the proscenium wall limited the inter-action between musicians and audience documented in the *Concert for Bangladesh* (Saul Swimmer, 1972), the film included Ravi Shankar and other black musicians, as had *Monterey Pop*. The most prominent invocation of a global commonality would be the July 13, 1985, Live Aid concert for fam-ine relief in Ethiopia, held simultaneously in London and Philadelphia with satellite link-ups and television broadcasts to 150 countries and an audience estimated at nearly two billion. But an earlier, more localized, event occur-ring in Ghana and linking the United States and West Africa produced one of the most jubilant of concert documentaries, *Soul to Soul* (Denis Sanders, 1971) (Figure 16.4).[36]

SOUL TO SOUL

In October 1970, prominent US entertainment lawyer Ed Mosk and his son Tom were in Nigeria on a film project when James Brown first visited Africa for a concert in Lagos. Rebuffed by Brown's staff when he suggested filming the concert but awed by Brown's reception, Tom decided to stage another concert for a film.[37] With support from Cinerama Releasing Corp. and funds from Atlantic Records, he received a go-ahead from the Ghanaian govern-ment and began planning in collaboration with the Ghana Arts Council. The concert was scheduled for March 6, 1971, in Black Star Square, Accra, where, exactly fourteen years earlier, Kwame Nkrumah had declared the state's

independence. As well as being the first sub-Saharan country to be decolo-
nized, Ghana had been an important center of the transatlantic slave trade,
which gave the event an immense historical resonance. And though by that
time Nkrumah had been deposed, the organizers' plans to bring together dia-
sporic Africans from the United States and Ghanaian musicians manifested
his pan-Africanist vision.

A cross-section of black musicians, including Wilson Pickett, Ike and
Tina Turner, Les McCann and Eddie Harris, the Staple Singers, Santana,
Roberta Flack,[38] and the Voices of East Harlem, flew to Ghana, while the Arts
Council recruited an equally diverse group of Ghanaian musicians, includ-
ing the Kumasi Drummers from the Ashanti region, a Ghanaian rock band
called the Psychedelic Aliens, the Damas Choir, and Amoah Azangio, a
calabash player, witch doctor, and tribal chief who amazed—and sometimes
terrified—the Americans. Situations were organized where the visiting art-
ists could meet their counterparts and mingle informally with local people
for several days before the concert, including an excursion to the Elmina
Slave Castle. With proceeds going to the Arts Council, ticket prices for the
all-night, thirteen-hour concert were low enough to draw an estimated
100,000 people. And the pleasure was mutual, the Americans reveling in the
Africans as much as the locals in the visitors, all with recognition and amaze-
ment in equal measure.

The romance between the performers and the audience that structured
Woodstock and other late-sixties US concert documentaries was renewed
in this film, not simply in the creation of a folk community that appeared
to transcend commodity relations, but also in the discovery and renewal of
cultural forms, elements of which were still fundamentally unalienated and
uncommodified. The US performers, descendants of Africans sold hundreds
of years ago into slavery in a foreign land, returned to their historical and
musical roots and discovered the sources of the music, rhythms, and dances
that survived through the enforced exile; and the traditional African musi-
cians encountered their art, transmogrified in the New World and amalgam-
ated with white and Latin idioms.

Before the generic sequences showing the US musicians flying to Africa,
the film interpolates a short extract from Ike and Tina Turner's performance
that articulates the concert's significance. It opens with a blistering dance
routine by Tina Turner in a see-through blouse and the Ikettes in barely-there
white mini-dresses, which quickly switches into a performance of a song
written specifically for the concert, "Soul to Soul." Her face incandescent in
close-up, Tina sings, "This is where it all came from/Where the rhythm will
turn you on/Back in our native homeland" with the chorus, "Soul to Soul"
sung by the entire band, alternating with a translation of it into an African
language. Ike, who in 1951 had composed and produced arguably the first
rock 'n' roll record, "Rocket 88," had been one of the seminal black musicians

of the 1950s. But in the mid-1960s his shift in directions toward white audiences, which resulted in his topping the bill on *The Big T.N.T. Show* (Larry Peerce, 1966) and appearing with the Rolling Stones on the 1969 Tour and in *Gimme Shelter* (Albert and David Maysles and Charlotte Zwerin, 1970), made Ike and Tina Turner one of the most popular crossover acts in the both the United States and the United Kingdom. On this occasion, when the band again crossed the Atlantic, to Africa rather than Europe, Tina, especially, seems overwhelmed by what she finds. At a nighttime street performance by the Accra Nandom Bawa Group, her joy is palpable as she watches the lines of dancing women, their movements resembling the boogaloo routines she teaches the Ikettes, tapping her pointed black boots in time to with their bare feet and joining with the call and response vocals. And when the whole crowd begins to dance, she allows a young boy to lead her among them and, though her movements seem stiff compared to theirs, she appears delighted to perform among them rather than for them. On a later trip to a village in the countryside, her attempts to learn a local song are wonderful enough to make even Ike crack a smile.

Such street-level encounters with the people of Ghana alternate throughout the film with the stage performances, with the joyfulness of their reconnection with the homeland seeming to inspire and energize everyone, audience and performers alike. Well-known in West Africa as "Soul Brother Number Two," Wilson Pickett has the entire audience, even the police, dancing, and as his set reaches its climax with "Land of a Thousand Dances," teenage boys leap onto the stage, taking off their shoes to demonstrate their own. Accompanied by Willie Bobo on timbales, Santana's set, a medley including "Black Magic Woman" and "Gypsy Queen," outdoes even the Woodstock performance. In the middle of his own set, Les McCann announces a new song, explaining that it will be accompanied by "a great musician from Ghana," Amoah Azangio, and explains to the audience that, as we say in the United States, we must all "learn to honor our black heroes." The Staple Singers' performance is also especially soulful. The concert's location at the slave trade's departure point gives the lyrics of their song about reparations, "When Will We Be Paid," an acute poignancy: "We have stumbled through this life for more than three hundred years/We've been separated from the language we knew/Stripped of our culture"—especially when the film follows it by showing Mavis and her sisters buying brightly colored fabrics in the market.

Soul to Soul was not widely seen, but next year in the United States its vision of an Afrocentric, entirely black, commonality was re-staged in a concert in Los Angeles and a film made about it. In both, the romantic couple subtending the musical's dual focus were re-envisioned as a black district in South Central Los Angeles and a Memphis record label that had created a popular idiom of African American music: Watts and Stax came together to make *Wattstax* (Mel Stuart, 1973).

WATTSTAX

In the immediate postwar years, Watts had been a relatively prosperous working-class African American community with a considerable musical culture based on jazz. But the combination of deindustrialization, racist city administrations and police departments, restrictive property covenants, and high unemployment had created such poverty and anger that on August 11, 1965, it exploded into one of the most extensive and important insurrections of the decade. Lasting for five days, the Watts Rebellion resulted in thirty-four deaths, ten times that many arrests, and the looting or burning of some three hundred establishments. At the same time, a Southern record company was developing an assertively black music that, in contrast to Motown, was not crossover oriented.

Originally founded as Satellite Records by a white brother and sister, Jim Stewart and Estelle Axton, in 1957 to record white country singers, the company changed its name to Stax in 1961 and began to focus on a new secularization of Southern black religious music that developed as Memphis Soul. The roster eventually included Wilson Pickett, Carla and Rufus Thomas, Sam & Dave, Johnnie Taylor, and the Staple Singers, with Otis Redding on Volt, a Stax subsidiary, and was often backed by the racially mixed house band, Booker T. and the M.G.'s. Created in a converted movie theater in South Memphis, a mile and a half from Sun Studios, the Stax sound was considerably grittier and funkier than Motown, with stronger gospel and fewer pop elements, which made it immensely popular with blacks and, by the end of the decade, with some white youth. In mid-decade, Isaac Hayes became a main writer and producer and joined the house band, taking the label to the pinnacle of its success around 1967, after which Stax unfortunately lost rights to its master recordings in legal complications caused by corporate mergers with movie studios. Al Bell, a black entrepreneur strongly committed to both black civil rights and economic advancement, then became executive vice president, guiding the company's revival to the great success of Hayes's albums *Hot Buttered Soul* (1969), *Black Moses* (1971), and of course, *Shaft*, and Stax also released the soundtrack for *Sweet Sweetback's Baadasssss Song*. In early August 1965, one of Stax's rare revue shows arrived in Los Angeles for club appearances in Watts, promoted by the charismatic Los Angeles disk jockey, Magnificent Montague, whose habit of exclaiming "burn, baby burn" to accompany favored records made it a catch-phrase in the city. The weekend shows were very successful, but some of the artists were temporarily prevented from leaving the city by the eruption on the following Wednesday of the Watts rebellion.

Along with the label's success later in the decade, Bell's commitment to black enterprise led him to support Reverend Jesse Jackson and his Operation PUSH (People United to Save Humanity), and in 1970 he recorded Jackson's litany,

"I Am Somebody," for an eponymous album on the Stax subsidiary label, Respect. Bell also became interested in emulating Berry Gordy by making inroads into television and cinema, and in 1972 he established a Los Angeles office and a film division headed by Larry Shaw, chief of marketing at Stax. Bell and Shaw planned Wattstax to commemorate the seventh anniversary of the insurrection and to raise money for the Watts Summer Festival that had been created in 1966 to provide a cultural expression for the frustrations that had erupted the previous year. Funded by Stax and Schlitz beer, the seven-hour concert was held at the Los Angeles Memorial Coliseum on August 20, 1972. Some free tickets were distributed, but the pricing of the others at only a tax-deductible $1 attracted more than 100,000 people. As well as Jackson himself, MCs for the event included Melvin van Peebles, Billy Eckstein, and movie stars Fred Williamson and Richard Roundtree. The other performers, all Stax artists, included Kim Weston, Jimmy Jones, the Rance Allen Group, the Stax Golden 13, the Staple Singers, the Bar-Kays, Albert King, Carla Thomas, Rufus Thomas, Luther Ingram, and Isaac Hayes. Wally Heider, renowned for his work for *Monterey Pop* and the late 1960s San Francisco bands—and *Soul to Soul*—recorded sound with a newly developed 16-track two-inch recorder. The concert was broadcast live on both AM and FM by local radio stations, and the nearly $75,000 produced by ticket sales were donated to the Watts Summer Festival and other local charities. Stax later released music from the concert on two double albums and several singles, and the new film division produced the documentary with $250,000.[39]

To make the film, Shaw had turned to David Wolper Productions, known for their very successful film and television documentaries, and hired Mel Stuart, who had recently completed the feature *Willy Wonka and the Chocolate Factory* (1971), to direct.[40] In order to present the concert's context, camera crews made up of people who lived in the community shot footage of the buildings and streets of Watts, as well as extensive scenes in which local people candidly discuss social issues; and Richard Pryor, fresh from his performance in *Lady Sings the Blues* but still not widely known, added further commentary. More music was recorded and included for the film, notably performances by Johnnie Taylor at a Los Angeles nightclub and a gospel song by the Emotions at a neighborhood church; and blues singer Little Milton was photographed by the Watts railroad tracks lip-syncing to his record, "Walking The Backstreets and Crying."

Even though it recorded almost exclusively black artists, Stax was an integrated company with an integrated house band. The documentary was a similarly interracial project, and one of its producer's important achievements was, at a time when minorities were struggling to get into the Hollywood unions, to comb the community and local universities for black workers; in the event, they assembled twelve crews, 90 percent of their members being black.[41] The rhetoric of both concert and film similarly focused on autonomous black

empowerment and cultural solidarity. Bell's account of his motives attests to his interdependent economic and cultural priorities; the event was undertaken, he recalled, "to aid in [increasing] the visibility of black culture, but it was also designed as a PR tool for Stax and its artists. [Thirdly, filming] it was my investment in a training program for Stax Films to start preparing us for motion pictures."[42] Though Bell's economic motives are implicit in the commodity function of the film, its rhetoric and structure present it as a pure folk event grounded in the continuities through the three main strands of the montage structure: the musical performances, the community conversations, and Pryor's comedic monologues.

The introductory sequences, more than twenty minutes in all, frame the film as the self-expression of the historically and culturally distinct African American community (Figure 16.5). Shedding his comic persona, Pryor addresses the camera and affirms the festival as the cultural manifestation of the same need for self-expression that he attributes to the 1965 Rebellion: "All of us have something to say, but some are never heard. Over seven years ago, the people of Watts stood together and demanded to be heard. On a Sunday,

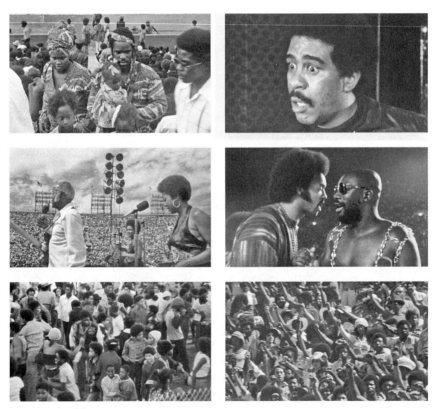

FIGURE 16.5 Wattstax.

this past August, in the Los Angeles Coliseum, over 100,000 black people came together to commemorate that moment in American history. For over six hours the audience heard, felt, sang, danced, and shouted the living word in a soulful expression of the black experience. This is a film of that experience and what some of the people have to say."

Immediately, to the accompaniment of the Dramatics' "Whatcha See Is Whatcha Get," the camera introduces that community. An aerial survey picking out the landmark Watts Towers cuts to a collage of street scenes: young and old people chatting, a couple pushing a shopping cart, laborers in an auto shop, a postman, a boy playing with a tire, and men shooting craps, smoking a joint, or drinking whiskey, all interspersed with store-front churches, record stores, and other local architecture, many adorned with hand-painted images, as well as retrospective snatches of footage of the burning city seven years before. These flashbacks to the rebellion introduce a group of people arguing about its significance: "Up until the point when we had a riot, every body said, 'Those niggers are all right, they're doing fine.' Then when we had a riot, the white man said, 'Something's wrong.'" The film moves into the present as a Rams football game in the Coliseum ends, and workers build the stage overnight. Accompanied by the Staple Singers' "We the People" on the soundtrack, the crowds begin to arrive in the morning sunshine, the stars in limousines and the people on foot, their colorful clothes—dashikis, fine vines, or California casual—painting a vivid sartorial canvas whose distinctiveness recalls the freaks' costumes noticed by D. A. Pennebaker in *Monterey Pop*.

The program proper begins with former Motown star Kim Weston, who is seen in a distant shot singing the national anthem; no one in the audience rises, and a cut introduces a community debate about various experiences of exclusion and discrimination, for example, "I got no county, no flag and not a damn thing to fight for." Back on the stage, with Bell beside him, Jackson announces a different commonality: "This is a beautiful day, a new day; it is a day of black awareness, it is a day of black people taking care of black people's business. Today we are together. We are unified and of one accord.... We have shifted from 'Burn, Baby, Burn' to 'Learn, Baby, Learn.'" He then challenges the crowd to chant with him, fists raised in the Black Power salute, what he calls "the national black litany," "I Am Somebody" with its insistent response, "When we stand together, what time is it? Nation Time." He announces "Sister Kim Weston" who, now in close-up, this time sings the "black national anthem, "Lift Every Voice and Sing." The crowd rises and joins in, many of them with their fists in the air, justifying a cut to Tommie Smith and John Carlos's salutes at the 1968 Mexico Olympics. This modulates into a collage of images of black people, of slavery, imprisonment and lynching, then of black heroes from Marcus Garvey, through Louis Armstrong, Babe Ruth, Muhammad Ali, Malcolm X, and Angela Davis; finally Martin

Luther King Jr. is seen and heard delivering his "I've been to the mountain top" speech on the eve of his assassination.

The affirmation that, rather than being a commodity, the event is the expression of this once enslaved but now liberated historical community informs the film's subsequent structure. The various acts performed for varying amounts of time, but the film generally allows each only one song; headliner Isaac Hayes, who in fact performed for over an hour, is the major exception, but even he is allowed only two. And even the one song allowed the others is rarely presented in its entirety; rather, part way through, the film cuts away to groups of people who forthrightly discuss the issues raised in the song's lyrics, and this in turn is followed by Pryor riffing on the same topics.

For example, introduced by Melvin Van Peebles, who reaffirms the event's purpose "to commemorate a revolution [that was] one of the milestones in black pride," the Staple Singers' performance of the down-tempo grind "Respect Yourself" begins with a medium shot of the leader, Pops Staples, flanked by two of his daughters who clap in time as he sings the first stanza. At the line, "How in the world do you think/Anybody's gonna respect you?" he exclaims, "Help me y'all," and the camera cuts to a medium close-up pan of the audience who are seen clapping and moving their bodies to his rhythm. For the second stanza, the camera returns to a close-up on him, then several medium shots of the ensemble for the chorus, "Respect Yourself," at which the montage introduces close-ups of the audience members glowing with evident pride. For Mavis's three solo stanzas, the camera is first in close-up on her, though the wide angle allows her immediate family and the larger family of the audience to be seen in the same frame, until for the climax of her part it moves into extreme close-up.

For the final two stanzas, the film introduces views of the community: a church adorned with a sign "Africa is the beginning," marchers in the Festival pageant, the beauty queen, Miss Watts, and the streets of the community and Martin Luther King Hospital, Malcolm X College, a religious service featuring a black Jesus, and finally back to people in a barbershop. When the song ends, these last address the issues raised in the song; as his is being trimmed, one young man exclaims, "I dig the natural." He is followed by a kaleidoscope of voices, ending with a woman saying, "Black is beautiful because it feels so good," and a young man contrarily claiming, "If black is beautiful, white is divine." An eye-line match links to Pryor, remarking, "That nigger's crazy." As he launches into his own account of pride in the community in which he grew up, the film cuts to the Bar-Kays, whose leader sports a huge afro, and they launch into "Son of Shaft," which is itself in turn interrupted when the leader says, "Right now, we'd like to give everybody a chance to get down," and the film returns to a community discussion, this one revolving around one person's remark, "If I can't work and make it, I steal and take it." The photography of the song integrates the Staple Singers into the audience; the latter are then allowed their own voices, with

Pryor's humorous meta-commentary tying the section up and platforming the next.

This tripartite structure of song, community discussion, and Pryor's comedy is repeated for each performer. A sequence initiated by Taylor's "Jody's Got Your Girl and Gone," for example, focuses on marital infidelity, while Carla Thomas's "Pick Up the Pieces," whose lyrics affirm a desire to re-establish a broken love affair, leads to a discussion of relations between black men and women. But the regularity of the tripartite structure is interrupted two-thirds of the way through during the next performance, by her father, the veteran Rufus Thomas (whose first record, "Bearcat," had in fact given Sun its first national hit in 1953). Appearing in a bright pink cloak and white boots, he instigates a call and response with the crowd that culminates in his asking them, "Ain't I'm clean," as he proudly pulls the cloak aside to reveal an identically colored pink shirt and suit with short pants. As he throws the cloak aside and begins to sing and dance his hit, "Breakdown," the crowd enthusiastically joins in, leaving their seats to perform the dance and respond to its chorus. At its high point, an extremely rapid montage of him and the audience provides an abstract visual punctuation, as well as again collapsing the distinction between performer and audience. Meanwhile the crowd becomes so enthusiastic that they begin to break down the wire fence and surround the stage. Joking that he doesn't want anybody on the field until he tells them, he persuades dancers to retreat to its edges; but when he begins his "Funky Chicken," he invites them down and they fill the football field, flapping their arms and dancing wildly. After the song is over, the joy and goodwill he has ignited is so strong that his injunction "Power to the people but let's go to the stand" persuades them to return peacefully.

Though the music's momentum is only briefly suspended by a Pryor sketch but not the community debate, the next segment, beginning with Luther Ingram in the gathering twilight performing his recent chart-topper, the soul-searching "If Loving You Is Wrong, I Don't Want to be Right," reasserts it, until the film moves to its climax. Huge spotlights cross the night sky, Jackson introduces "a bad, bad brother," and Hayes takes the stage as his band plays the introduction to the "Theme from Shaft."[43] Like Thomas, he appears in a brightly colored cloak, which he removes to reveal an even more outrageous sartorial invention: pink tights and, over his powerful chest, a vest of gold chains. Both arms raised high in the Black Power salute, he displays himself to the rapturous crowd, then breaks into song: "Who's the black private dick/That's a sex machine to all the chicks?" Priapic black machismo triumphs over centuries of enslaved impotence as Hayes makes explicit his identification with Shaft that was only implicit in the earlier film. After a Pryor riff on the vagaries of black handshakes, and a visit to the community where some of them are demonstrated, the film returns to Hayes for the finale celebration of the community, *Shaft*'s "Soulsville," whose lyrics, "The hood,

the projects, the Ghetto; they are one and the same./And I call it Soulsville," recall Jackson's initial peroration: "I may be in the ghetto, but the ghetto isn't in me."

Known as "Blackstock" during planning and later as the "Black Woodstock," the concert was utopian in its use of live music and dance to create and celebrate community and, despite the shift from a rural to an urban setting, many of *Woodstock*'s motifs recur in *Wattstax*: the construction of the stage in a green field, the separate arrival of performers and audience preparatory to the sanctification of their community in the music, the aerial view of the site and the massed population, the exhortations from the stage celebrating the audience, and the focus on idiosyncrasies of costuming and dance as markers of cultural commonality that also demarcate the group from outsiders. Summarily, the invasion of the field during Thomas's "Breakdown" recalls the break through the fence in *Woodstock* that liberated the festival from commodity relations. But in *Wattstax* the professional musicians are symbolically more fully integrated into the community by virtue of the film's emphatic presentation of the latter as themselves performers, if not of song, nevertheless of rhythmic, somatically sustained discursive participation: the singers realize the most formal patterns of black talk; as Jackson preaches the music's redemptive potential, he himself performs verbally, his call inspiring the audiences' equivalent response; and, like Pryor's rehearsed soliloquies, the more spontaneous verbal performances in the barbershop all display practiced kinetic self-conscious routines and formulae. The continuities across the whole spectrum are integral; in their various ways, all perform the continuity of black popular culture from the religious to secular, grounded in the people's activity. The music and the community manifest each other, or, as Pryor insisted, "the audience heard, felt, sang, danced, and shouted the living word in a soulful expression of the black experience."

Like *Woodstock*, then, *Wattstax* is a particularly complete instance of "a mass art which aspires to the condition of folk art, produced and consumed by the same integrated community," as well as of the romance between musicians and community.[44] But whereas *Woodstock*'s community was composed of largely white countercultural youth, the community in Wattstax and *Wattstax* is entirely African American. Though a handful of the accompanying musicians are white, barely a white face may be glimpsed in the audience and none in the community discussion. Both films are designed to erase any differences within the respective communities, so that in the latter case, blackness is supposed to override any gender or class difference (even though the candid community conversations and Pryor's humor revolve around them) and of course the commodity relations generated in capitalist cultural production. At a moment where attention to such alienation was overridden

by the ideology of black enterprise and the hope for an autonomous black cin-ema, Al Bell was able to elide any tension between the concert's two functions of community building and public relations for Stax. But though the money from the ticket sales was returned to Watts, the profits from the film, if only $1.5 million in 1973—when *Lady Sings the Blues* made $9 million—and the profits from the two double soundtrack albums all went to Stax.[45]

. . . And White

COUNTRY MUSIC

Like jazz and acoustic blues, white popular music originated in the South, but much earlier and among the Appalachian working class, especially from the ballads, hymns, instrumentation, and dance of Anglo-Celtic folk traditions. Since the late eighteenth century, these had been supplemented and modified by African American culture and by commercial forms of music, eventually vaudeville and Tin Pan Alley.¹ In the early 1920s, what would by mid-decade be known as hillbilly music was industrialized with records: the first of duets by old-time fiddlers A. C. (Eck) Robertson and Henry Gilliland in 1922, and then by Fiddlin' John Carson singing and playing the fiddle on "Little Log Cabin in the Lane" in 1923. The next year, classically trained Vernon Dalhart affected a Virginia accent to record a double-sided single, "Wreck of the Old '97," backed with "The Prisoner's Song"; selling over one million copies, it became first huge nationwide hillbilly hit. Such sales motivated scouts to comb the rural South for talent, and musicians presented themselves for recording company auditions. Among the major artists discovered in this way was Jimmie Rodgers, a railroad brakeman who learned to play from fellow workers and who was considerably influenced by black country blues. "Blue Yodel (T For Texas)," recorded during his second session in 1927, made him a national star and, until he died in 1933, he was the single most influential hillbilly writer and singer. In his only film appearance, he performed three songs in *The Singing Brakeman* (Basil Smith, 1930), a short made for Columbia Pictures that thereby inaugurated country music cinema. Hank Williams, Rodgers's only rival among the early hillbilly singers, also influenced by black music, was a generation younger and did not record until after the war. But, beginning in the late 1940s with "Lovesick Blues," his records continued to top both country and pop charts until, aged only twenty-nine, he died in 1953.

The decline of both hillbilly and race record sales during the Depression increased the importance of live radio broadcasts. Founded in Nashville in

1924, the Grand Ole Opry became the model for the National Barn Dance and other radio "barn dance" shows that spread across the country. In the late 1930s, such radio shows also began to include cowboy songs, producing "country and western" music and the first major wave of genre films exploiting it: westerns starring Gene Autry, Roy Rogers, Tex Ritter, and other "singing cowboys."[2] Having become famous as a hillbilly singer on records in the early 1930s, Autry made his film debut in a western, *In Old Santa Fe* (David Howard, 1934), which earned him a starring role in the twelve-part matinée serial, *The Phantom Empire* (Otto Brower and B. Reeves Eason, 1935); in it he played himself as the owner of Radio Ranch, a dude ranch from which he made daily live music broadcasts of western songs, accompanied an acoustic combo. Interspersed with the broadcasts were a series of cliffhanging adventures involving the evil queen of the futuristic "Scientific City of Murania" located miles beneath the ranch, and present-day evil scientists bent on stealing Murania's radium. Autry made more than forty singing cowboy B-westerns before the war and, resuming his career after distinguished military service, he had made a total of ninety-three "oaters" when he retired in 1953, many of them named after the songs he performed, including *South of the Border* (George Sherman, 1939), *Back in the Saddle* (Lew Landers, 1941), and *The Last Round-Up* (John English, 1947). In the 1940s and early 1950s, emulating the conceit of *The Phantom Empire*, he did indeed have a very successful radio show, *Melody Ranch*, for which he created the Cowboy Code, ten ethical rules for his audience. Another singing cowboy, Tex Ritter, made a similar move from radio to cinema and, though not as successful as Autry, he had starred in some forty films before the end of the war. Roy Rogers, the third to make the transition from radio to cinema in the mid-1930s, starred in more than eighty films, some with his wife, Dale Evans, before moving to television in the mid-1950s.

Both musically and economically productive, the grafting of cowboy songs and motifs onto country music made it viable for radio, cinema, and eventually television. It also had an important visual component; country musicians adopted cowboy costumes, replacing their earlier nondescript everyday attire or Jimmy Rodgers's brakeman's cap. Often flamboyant, especially when made by Nudie's Rodeo Tailors in North Hollywood, these endured after the singing cowboy movies in and out of cinema as visual markers of country music generally, and crossed over into rock 'n' roll clothing after the mid-1960s.[3]

In the early 1950s, country and western or hillbilly music began the amalgamation with rhythm and blues that produced rockabilly and rock 'n' roll. The most notable innovators were, of course, Bill Haley and Elvis, the "Hillbilly Cat"; but rock 'n' roll also grew from black versions of country music, most notably Chuck Berry's. In his autobiography, Berry described how as a child in St. Louis he first heard hillbilly music on the radio: "The beautiful harmony of the country music that KMOK radio station played

was almost irresistible. Kitty Wells, Gene Autry, and Kate Smith singing love songs."[4] A decade later, in 1955, he launched his career with "Maybellene," his version of a nineteenth-century fiddle tune, "Ida Red," recorded in 1938 by a western swing bandleader, Bob Wills. Like Elvis, Berry made his breakthrough with a record that backed a hillbilly song with a blues number. A similar familiarity influenced the most unexpected African American to record country music, Ray Charles. Later recalling, "I just wanted to try my hand at hillbilly music. After all, the Grand Ole Opry had been playing in my head since I was a kid in the country,"[5] Charles tuned his gravelly gospel baritone to country in 1962 for two albums, *Modern Sounds in Country and Western Music* and *Modern Sounds in Country and Western Music, Volume 2*. His interpretations of country standards, accompanied variously by strings, big band arrangements, and the Raelettes' vocals, mirrored Elvis's synthesis of black and white music, and sold records almost as quickly. The first album topped *Billboard*'s Pop Albums charts, and the first single from it, "I Can't Stop Loving You," topped the Billboard Hot 100 singles charts, as well as the Rhythm and Blues and Adult Contemporary charts, and is reputed to have sold a million and a half copies. Introducing Charles himself to a dramatically expanded white audience, it did more than any other record to make country music mainstream. For the rest of the sixties, the country element in rock was periodically reasserted, and by the last third of the decade, country rock formed a distinct subgenre. Bob Dylan sparked the development when he turned away from electronic rock and went to Nashville to record the country albums *John Wesley Harding* (1967) and *Nashville Skyline* (1969), with Johnny Cash collaborating on the latter. Gram Parsons was an equally important influence, with the Byrds and then with his own group, the Flying Burrito Brothers; later his friendship with Keith Richards influenced the great Rolling Stones albums of the turn of the decade.[6] By the early 1970s, country rock was well established as a subgenre of rock 'n' roll, but equally radical developments had reshaped country, especially as they produced the "Nashville Sound."

In the late 1950s in Nashville, a new phase in the industrialization of country music emerged as the crossover success of Elvis and rockabilly and of other pop-country fusions coincided with the proliferation in the city of recording studios, music publishers, and the arrival of many young musicians and songwriters.[7] The era of the "Nashville sound" began with the founding of the Country Music Association (CMA) in 1958 to promote the creation of all-country radio stations and to increase its use in advertising. The drive for commercial viability prompted musical developments, most notably a compromise between the honky-tonk styles that had dominated in the 1940s and early 1950s and smoother pop sounds, developed by Chet Atkins, who was appointed as head of operations at RCA Victor's country division in 1957. The former classic instrumentation of steel guitars and fiddles was

replaced by larger combos of guitars, supplemented by pianos, drums, and even strings, while the regular use of a stable of versatile session musicians for recordings furthered the trend toward the music's homogenization.[8] The cinematic response to these musical developments produced two main sub-genres. Both were fundamentally backstage musicals, combining documentation of live country music performance with stories about its social context; but one emphasized the spectacle of real country artists and the utopian folk commonality they appeared to sustain, while the other used actors to portray musicians in dystopian fictional narratives about the music's various delinquencies.

Hillbilly Jukebox Musicals

In the jukebox musical *Rock, Rock, Rock!* (1956), Alan Freed mentioned both cowboy songs and country songs in his list of the streams that fed into the river of rock 'n' roll, and country and rockabilly singers appeared in several jukebox musicals: Johnny Burnette in *Rock, Rock, Rock!*, for example, Ferlin Husky in *Mister Rock and Roll* (1957), and Eddie Cochran and Jo Ann Campbell in *Go, Johnny, Go!* (1959). Country's constitutive contribution to early rock 'n' roll was also emphasized in Elvis's first three films, *Love Me Tender* (1956), *Loving You* (1957), and *Jailhouse Rock* (1957). And in the 1960s, even as country became subordinated to black music in the counterculture, well over a dozen jukebox musicals were made about it in its own social and institutional spheres, outside any rock 'n' roll context: *Country Music Holiday* (Alvin Ganzer, 1958), *Country Music Caravan* (no director listed, 1964), *Tennessee Jamboree* (Albert C. Gannaway, 1964), *Country Music on Broadway* (Victor Duncan, 1964), *Forty Acre Feud* (Ron Ormond, 1965), *The Las Vegas Hillbillys* (Arthur C. Pierce, 1966), *Second Fiddle to a Steel Guitar* (Victor Duncan, 1966), *Music City U.S.A.* (Preston Collins, James Dinet, 1966), *That Tennessee Beat* (Richard Brill, 1966), *Nashville Rebel* (Jay J. Sheridan, 1966), *The Gold Guitar* (J. Hunter Todd, 1966), *Hillbillys in a Haunted House* (Jean Yarbrough, 1967), *What Am I Bid?* (Gene Nash, 1967), *The Road to Nashville* (Will Zens, 1967), *Johnny Cash! The Man, His World, His Music* (Robert Elfstrom, 1969), and *The Nashville Sound* (Robert Elfstrom, David Hoffman, 1970). Most of these were fundamentally documentary revues, cinematic versions of the radio and television barn dance shows, and resembled rock 'n' roll jukebox musicals by more or less elaborately framing performances by important artists. But since the performances were usually live, rather than lip-synced to records, they were more spirited and spontaneous and allowed for an interactive relation between spectacle and narrative that more firmly yet flexibly linked the music to its social environment. The four main forms were pure revues, revues with additional documentary material, revues set

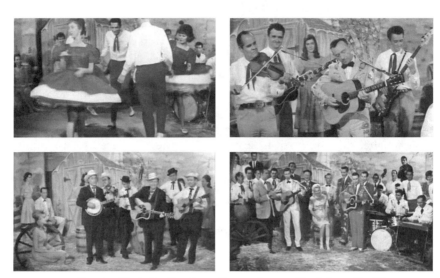

FIGURE 17.1 Country Music On Broadway: *Square dancers, Hank Snow, Earl Scruggs and Lester Flatt, finale.*

within fictional narratives, and narratives with occasionally interpolated performances.

The purest revues were *Country Music Caravan, Tennessee Jamboree*, and *Country Music on Broadway*, all from 1964, in which a master of ceremonies interrupted the acts by only the briefest of introductions. Though actually shot in Nashville, *Country Music on Broadway* (Figure 17.1), for example, is ostensibly a documentary of a New York theatrical show: it opens with night-time shots of Broadway theaters, including one of crowds outside a theater with a banner announcing a "Country Music Jamboree," and the MC remarks that the audience has come with the musicians by bus from Nashville. After an introductory square dance sequence, he serially introduces Hank Snow, Ferlin Husky, George Jones, Buck Owens, Lester Flatt and Earl Scruggs, Skeeter Davis, Porter Wagoner, and a dozen other acts who, on a stage deco-rated with flats depicting a country barn, straw bales, and cartwheels, per-form one or two songs with live instrumental and vocal accompaniment. They all face the audience frontally, and the camera is stationary apart from an occasional zoom, with the long takes varied by similarly occasional cuts to medium close-up. Other than a few brief comic diversions with country rubes, the only interruption to the music is an interlude in which Hank Snow reminisces backstage with Hank Williams, Jr., about the latter's father, recall-ing the first Hank Williams Memorial Day. He screens clips from a 1950s tele-vision show, claiming them to be his own home movies of Williams's singing. This most rudimentary format is elaborated with brief scenes of the perform-ers off-stage, the disc jockeys, and the fans, the nightclubs, recording sessions,

FIGURE 17.2 Music City U.S.A: *T. Tommy Cutrer and Webb Pierce, Roy Acuff's fiddle, Loretta Lynn, Pierce's guitar-shaped pool.*

and other institutions that comprise the world of country music. Two other important revue-based films contain documentary interludes that densely elaborate country music's history and social world, its entire culture: *Music City U.S.A.* and *The Nashville Sound,* the city of Nashville itself.

The performances in *Music City U.S.A.* (Figure 17.2) are placed in a narrative of a tour of Nashville and its institutions. The guide is T. Tommy Cutrer, a country and gospel singer who became a prominent disc jockey (and helped to popularize Elvis) and later was an announcer at the Grand Ole Opry. Descending from the plane, he is met at the airport by Webb Pierce, one of the most renowned honky-tonk performers of the 1950s (and, with additional appearances in *Second Fiddle to a Steel Guitar* and *Road to Nashville,* a fixture of county music films) and a couple of other country boys. As they drive to the city in Pierce's famed Bonneville, custom-designed by Nudie Cohn with six-shooter door handles and steer horns over the bumper, Pierce lip-syncs to his current release, "Who Do I Think I Am," with the others apparently accompanying him. Once downtown, T. Tommy meets a party of visiting disc jockeys, surrogates for the film's audience, who are taken on a bus tour of the city's hallowed sites of country music: Roy Acuff's Museum of Music, where fiddles belonging to Jefferson Davis and to Acuff himself are on display, then across the street to Ernest Tubbs's record store where, among the walls covered with albums by Hank Williams and other stars, Elvis's debut 1956 album, *Elvis Presley,* is glimpsed. There they meet singer Lorene Mann, who invites them to a television show that she is recording. After a visit to a guitar store

owned by Shot Jackson, one-time steel guitar player for Roy Acuff and now a designer of new instruments, the group joins the studio audience at "Music City Star Time." Here, with Bob Jennings as the master of ceremonies, the revue format asserts itself as the group enjoys televised performances by half a dozen stars, including the Wilburn Brothers, Loretta Lynn, and Dave Dudley with "What We're Fighting For," his then-current apologia for the invasion of Viet Nam. Hillous Butrum, formerly a guitarist for Hank Williams and at the time a record producer (as well as the producer of this film), diverts the narrative to the Columbia Recording Studios for a session with a new singer. The party of DJs meanwhile visit Pierce's home where, as they stand around his guitar-shaped pool, he lip-syncs to his recent hit, "Memory No. 1." Their bus takes them through the countryside past other stars' homes, then back to the city to the "Record World Awards," where Loretta Lynn receives the award for "Top Vocalist" and the Wilburn Brothers for "Top Vocal Group." By this time, evening has fallen and the group goes to a nightclub where, as the audience dances, T. Tommy introduces another half-dozen performers for the finale.[9]

Of the third type, revues with a narrative rather than documentary framing, the best were *Second Fiddle to a Steel Guitar* and *The Road to Nashville*. The former opens with a brief comic prelude concerning a Nashville society matron whose attempt to bring an opera company from Italy for a charity concert misfires when its members get stuck in a New York pizza parlor. Suddenly asserting himself, her milquetoast husband declares that country and western music is "the American Way," "our heritage," and "born right here in the hills." His quickly organized "Country and Western Opera" saves his wife from social disgrace, and, delighted by the switch, the cream of Nashville society is treated to an hour and a half of the cream of "the music we love, sung in the way we love," with only very brief interruptions by a comic duo. Introduced by Merle Kilgore, himself a successful singer and songwriter, and accompanied by a house band, a cornucopia of nearly thirty of the finest country entertainers each perform one or two numbers. The many sub-genres include bluegrass ("Blue Moon of Kentucky" by Bill Monroe), comedy ("Sleeping at the Foot of the Bed" by Little Jimmy Dickens in his only feature film appearance), crossover pop ("Young Love" by Sonny James), and virtuoso fiddle ("Black Mountain Rag" by Buddy Spicher), along with Lefty Frizzell, Dottie West, George Hamilton IV, Billy Walker, Connie Smith, Minnie Pearl, Faron Young, Del Reeves (with a parody of Elvis's "Heartbreak Hotel"), and more mainstream stalwarts, topped by Kitty Wells performing "It Wasn't God Who Made Honky Tonk Angels," her early fifties hit that made her the first female country star and opened the way for many more.

Of the fourth type, narratives with some interpolated performance scenes, four feature Ferlin Husky, three of them starring him opposite buxom blondes, some of whom who also appeared in the rock 'n' roll jukebox musicals or related teen exploitation films: *Country Music Holiday* with

Zsa Zsa Gabor; *Forty Acre Feud*; *The Las Vegas Hillbillys*, with both Jayne Mansfield and Mamie Van Doren; and *Hillbillys in a Haunted House* with Joi Lansing. The best of them, *Country Music Holiday*, a direct adaptation of the jukebox musical format, is a comedy about Verne Brand, a country singer from Puffin Bluff in rural Tennessee, who returns home from army service in Tokyo determined to be a singer, and finds a manager, Sonny Moon, to steer him to fame and fortune in New York. Husky sings half a dozen songs and the narrative creates occasion for as many again from other country and rockabilly acts, including the Jordanaires, Elvis's chief vocal back-up group.

Other jukebox musical generic motifs occur, including the discovery that his talent is marketable, intrigues among agents, and a concluding television show as the marker of success. Narrative motifs from the previous year's *Rock Around the Clock* and *The Girl Can't Help It* reappear, including the manager's determination to manufacture the singer's stardom ("make him the biggest thing that this town has seen in ten years"), parading him through classy nightclubs to secure the gossip columnists' notice; and a gallery of supporting buffoons. Despite the broad comedy, the narrative is tightened overall by the doubling of key roles. Brand himself is in competition with another singer from his hometown, played by Faron Young, the "Hillbilly Heartthrob" and himself a very successful singer; and his hometown country girl, Marietta, played by June Carter (Cash) is—as is common in Elvis movies—matched against a glamorous blonde, in this case, Gabor, who sees Brand as "peasant singer," though one with business and perhaps romantic possibilities. In a confrontation between the two women after the concluding television show, Brand decides to give up singing and return home with Marietta; but Moon's promise to open a recording studio in Tennessee (ironically invoking the Sun studio) allows him to keep both girl and career. Though the narrative dynamic is posited on country music's fundamental country/city binary, here the city slickers are as comical as the country rubes.

In *The Las Vegas Hillbillys*, Husky plays Woody Wetherby, a guitar-picking wood-hauler from Johnson Corner, Tennessee, who no sooner escapes from an exploding moonshine still than he learns that his uncle, a Las Vegas gambler, has died, leaving him as sole heir of the Golden Circle Casino. Driving across country with Jeepers, his sidekick and would-be manager, he arrives to find that the inheritance is only a ramshackle desert saloon, a large debt with pugnacious creditors, and a contract for the services of a bar-girl singer, Boots Malone, played by Van Doren. She keeps the plot stumbling along through visits by a gang of motorcyclists and a dream sequence in which Woody sees himself as a successful singer, and Tawny, the owner of a big casino played by Mansfield, sings "Chantilly Lace," until his aunt Clem arrives from Johnson Corner to take charge. Enlisting Tawny to manage the gambling, she brings in a slew of singers from Nashville for a Country Music Jamboree, and suddenly the Golden Circle is thronged with well-heeled customers and Husky is

the star of the cabaret. As well as Husky, Van Doren, and Mansfield, the per-
formers include Del Reeves again and half a dozen second-tier country acts.

In a less persuasive sequel, *Hillbillys in a Haunted House*, Husky as Woody
drives back to Nashville with Jeepers and Joi Lansing replacing Van Doren.
Known for "The Web of Love" and other early sixties Scopitone shorts, Lansing
has a presence and intelligence the others lack, but she is unable to prevent the
film from descending into bathos when the group discovers that the house is
being used by a gorilla and an international spy organization led by a Chinese
dragon lady. Again the plot finds occasions for music performance, an inter-
lude in which Lansing imagines herself singing, for example, and a televi-
sion show, and the film ends with a tacked-on "Nashville Jamboree." Apart
from Lansing, the film has nothing to recommend it, other than two songs by
Merle Haggard on the television show. Despite his limitations as both actor
and singer, Ferlin's twin roles in his four features as protagonist and main
performer keep narrative and spectacle coherently integrated.

Documenting a powerful and continuous tradition that extended from the
earliest British settlers through its industrialization in the thirties, these low-
budget B movies remain rich repositories of the stylistic variety of country
music's folk origins and of their residual presence in the sixties. Their fiddles,
steel guitars, and other traditional honky-tonk instruments and arrange-
ments had not yet been fully homogenized into the more commercial pop
music of the Nashville sound that emerged in the period. The more extended
narratives and documentaries into which the revues were elaborated revolve
around a roster of recurrent motifs: at one extreme, semi-professional work-
ing musicians living among everyday hillbilly folk and a few comic back-
woods rubes, local dialects, square dances, farmyard settings with bales and
barns, moonshine stills, and pie fights; at the other, women performing in
prim and proper frocks while the men strut in their peacock western outfits,
Nashville sights and historic places, visiting DJs and fans, all capped by pro-
fessionals at the Grand Ole Opry. In the context of the specifically Southern
settings, these motifs knit into a homogenous conservative refusal of the cos-
mopolitan sophistication of the city and the coasts, and affirm a past uninter-
rupted by the civil rights struggles and other political issues of the time, as
well as of developments in popular music outside the South. Notwithstanding
Nashville's centrality and the odd excursions to New York and Las Vegas,
their nostalgia for the rural past posits a social and cultural ideal that plays
an imaginary role similar to that of Africa in blaxploitation. Their affirmation
of the country against the city, however the importance of Nashville may con-
tradict it, and their implicit address to the Southern white working class sug-
gest a commonality undivided by the sexual or generational conflicts of rock
'n' roll films or, since African Americans are almost totally excluded, by the
racial conflicts that will structure the later black films. Any slight class fric-
tions evaporate in this universality of the music's appeal, as does any social

differences that emerge during moments of melodrama and farce. Virtually all forms of otherness and estrangement are absent, unknown, and unimagined. The people, the places, and the music join to sustain a simple yet regularly reaffirmed and celebrated virtue. As if speaking for them all, the concert organizer in *Second Fiddle to a Steel Guitar*, for example, asks rhetorically, "What's finer than country and western music and the people who sing it and the people who write it and play it?" while the MC later answers him, declaring, "There's something universal about county music entertainers. It's just like one big family the world over. We're proud of each and every one of our entertainers." The way sixties cinema portrayed them, the states of country music had seceded, remaining as autonomous and entirely white as the positive figures in the blaxploitation films were black.

In this, their ideological operation paralleled that of the classic musical, offering "a vision of musical performance originating in the folk . . . produced and consumed by the same integrated community";[10] but they were never a mass art. With no substantial connection to the Hollywood industry, all were independently produced by small, often one-off, companies, and though two had some distribution by major studios, all the others were independently distributed, mainly to drive-ins in the South.[11] Overall, their mode of production was hybrid: industrial but still motivated and controlled by enthusiasts on the edges of regional music institutions. Excluded from the dominant cultural ethos by the prejudices of the musical politics of the sixties, they nourished a communal culture, deeply rooted in pre-capitalist traditions and to a degree resistant to the homogenizing effects of corporate media. Marginalized by their mode of production and mainstream disdain for their content, they are almost lost, and today they are rarely seen.

But while these marginal films celebrated country music and its residual folk elements in rural drive-ins, mainstream cinema maligned it. Exploiting literary and journalistic satiric traditions of Dixie backwardness, Hollywood disparaged the white Southern working class and its culture. As Lenny Bruce observed, "I mean, it's the fault of the motion pictures, that have made the Southerner a shitkickuh, a dumb fuckhead."[12] Where the jukebox musicals had defended rock 'n' roll against early criticisms, Hollywood recycled them for country, portraying it as both musically and socially delinquent.[13]

Nashville

Despite the hillbilly musicals' buoyant optimism, country music had always counterpoised the sunshine security of the rural homestead against the nefarious attractions of city lights and roguery on the road that led there, especially to Nashville. Beginning when rock 'n' roll was thought to be the most malignant form of music, in mainstream Hollywood features actors played

FIGURE 17.3 A Face in the Crowd (top), Your Cheatin' Heart (bottom).

country musicians in noir narratives exploiting and denigrating the city and its music: *A Face in the Crowd* (Elia Kazan, 1957), *Your Cheatin' Heart* (Gene Nelson, 1964), *Payday* (Daryl Duke, 1973), and *Nashville* (Robert Altman, 1975).[14] All were variants of backstage musicals, but instead of dramatizing quasi-folk relations among performers and fans, they subordinate the spectacle of musical performance to cynical narratives that revel in projections of country's decadent commercialism and the debauched amorality of its musicians, using country music as a scapegoat, a surrogate for the culture industry, including Hollywood itself.

With elements recalling *All the King's Men*, Robert Penn Warren's satire on populist demagoguery published a decade earlier, *A Face in the Crowd* (Figure 17.3) told the story of a freewheeling but devious hobo who works his way up through the echelons of commercial country music to become the advisor to a presidential candidate. "Lonesome" Rhodes, played by Andy Griffith, is discovered among "outcasts, hobos, and nobodies," in the drunk tank of a small Arkansas town by Marcia, an ambitious radio programmer. For her and her audience, he spontaneously composes and performs a hillbilly song, "A Free Man in the Morning," whose lyrics resemble those of "I Want to Be Free" that Elvis, also performing in public for the first time and also broadcasting from prison, sings in *Jailhouse Rock*, released the same year. Like Elvis, Rhodes immediately receives a deluge of fan letters, but in his case they persuade the station owner to hire him for a daily morning radio show. He appears naïve but so completely sincere that his initial performances remind Marcia that "the real American music comes from the

bottom up." His singing, his homespun advice, his disregard for the station advertisers, and especially his repeated insistence that he is "just a country boy" produce a phenomenal popularity that is not even diminished by his conspicuous sympathy for African Americans. Attracting the attention of a Memphis television show, he goes to Nashville and performs on the Grand Ole Opry. His outrageous persona and intuitive ability to manipulate public opinion bring him to the attention of New York advertising agencies, precisely illustrating the CMA's attempt to link music to the advertising industry. Again he secures his own show and moves into politics, a "demagogue in denim" with the possibility of becoming "Secretary for National Morale." But he also increasingly reveals his scorn for the populace, insulting them as soon as the microphones are off and claiming that in "every strong and healthy society . . . the mass had to be guided by the strong hand of a responsible elite. In television we have the greatest instrument for mass persuasion in the history of the world." Eventually Marcia exposes his apparent guilelessness as hubristic hypocritical fabrications by leaving the broadcast microphone on during one of his rants: "Shucks, I can take chicken fertilizer and sell it to 'em for caviar." Further undermined by evidence of his personal amorality, his mistreatment of those who have helped his career, and especially his unscrupulousness exploitation of women, his career collapses.

Writer Budd Schulberg claimed that Rhodes had been in part inspired by Will Rogers, an actor and comedian, rather than a singer. But the inclusion of several professional country musicians in the cast and the choice of country music rather than Rodgers's skill with words and a lariat as the vehicle of the protagonist's rise to fame reflect Hollywood's endemic association of country music, cornpone idiocy, and the South. Few Elvis films are free from the same prejudice, though it is especially blatant in *Follow That Dream* and *Kissin' Cousins*, in both of which he plays a hillbilly. Correspondingly, *A Face in the Crowd*'s satire is directed, not simply at Rhodes himself, but also at the music and television businesses that exploit him and his fans, whom the film represents as being as gullible as he describes them. Until Marcia finally exposes him, she is as complicit as the station owners and advertisers who use him for their own ambitions. Her discovery and promotion of him echoes the role of Steve, the agent in the previous year's *Rock Around the Clock* but where that film saved rock 'n' roll, its fans, and television shows featuring it from the machinations of the rapacious culture industry, here they are all denigrated together, leaving only cinema by implication as the uncorrupted medium. The welding of Rhodes's absolute venality onto the persona of the redneck musician and the music business negated the innocence, virtue, and musicianship celebrated in the hillbilly musicals.

Though presenting a sanitized version of Hank Williams's tempestuous and painful life, the biopic *Your Cheatin' Heart* hinges on the tensions between his desire to remain a man of the people and the effects of the artifice of the Nashville music industry. After being taught basic guitar in Alabama by an elderly black man, he appears, played by George Hamilton, as a singing snake oil salesman. Audrey, a young woman in an itinerant hillbilly band, the Drifting Cowboys, spots him and, believing she can tame his uncivilized ways, she recruits him to the band. She persuades him to marry her and, realizing the potential of his remarkable ability to compose marvelous songs at will, she sends one of them to the famous Nashville publisher Fred Rose. While recognizing that Williams's rough edges must be smoothed out to make him marketable by the sophisticated Nashville machinery, Rose signs him to publishing and recording contracts and arranges an appearance on the *Louisiana Hayride*. Wealth and fame quickly follow, but rather than exploring his music, the film turns to domestic melodrama. Angered by his wife's purchases of fancy western clothes for him and fearing that her ambition and aggressive management of his career will isolate him from the people, Williams quickly becomes an alcoholic, disappears, and dies just before his comeback concert. Though here portrayed as stormy, his marriage to Audrey was in fact marked by much worse infidelities on both sides, and his second marriage is entirely omitted. Sam Katzman's production is not as parsimonious as usual, but the direction by Gene Nelson (who earlier that year had made *Kissin' Cousins*) is insipid, and Hamilton is a travesty as Williams. Even the re-recordings of Williams's songs by his son Hank Jr., to which Hamilton lip-syncs, are poor.

A Face in the Crowd's prejudices reappeared a decade and a half later in *Payday* (Figure 17.4),[15] also essentially a character study of a promiscuous, alcoholic psychopath whose career as a country musician crashes to a tragic end; Rip Torn, its star, had had an uncredited role in *A Face in the Crowd* as another self-identified "country boy" being groomed as Rhodes's successor. In *Payday*, he gives a virtuoso performance as Maury Dann, a middlingly successful country singer-songwriter, every bit as amoral as Rhodes. Putatively based on events in Waylon Jennings's life, the film is narratively more circumscribed, covering just a few days in his life. After an opening performance in a roadhouse, he drives with his band and assorted miscreants across the red dirt flatlands of northern Alabama en route to Nashville to appear on the Grand Ole Opry. Along the way, he seduces a couple of fans, dumps his girlfriend, takes up with Rosamond, an ingénue groupie, shoots quail, visits his mother, his ex-wife, and a disc jockey, gets into a fight over a dog with his guitarist and then fires him, kills a man who had attacked him, and finally has a heart attack at the wheel of his Cadillac that leaves him dead under the car door. Until then, he sustains himself with whiskey and pills, insulated from the consequences of his cruelties and crimes by his fame, a

FIGURE 17.4 Payday.

resourceful manager, and loyal employees, one of whom is willing to go to jail for the murder. With no flicker of a redeeming quality, he is entirely egotistical and unscrupulous, and incapable of any restraint on his sexual appetites or violent impulses.

Dann is seen performing only one complete song, "She's Only a Country Girl," which plays during the opening credits, but fragments of several others are heard diegetically, over the radio and the like, and he is seen briefly composing a new song. Even though the venality of the nether social reaches of the world of country music is relentlessly displayed the only facet of Dann's musicianship the narrative develops is the power his fame supplies. Echoes of his music's origins in community folk practice occurs in the traditional violin and mandolin instrumental colorings of the main song and briefly in an afterhours hoedown in the motel in which he conspicuously plays no part. And nostalgia for community exists, if very abstractly, in "She's Only a Country Girl"'s lyrics, which describe one who prefers "her homespun ways" to the bright lights of the city and rejects an urban suitor who offers "a bright social whirl." But she is a country music cliché, and no girl like her exists in Dann's world, where all women are immediately seduced, if not by his music, then by his celebrity.

With the depressed inhospitable environment of urban slums transposed to rural Alabama, and its promiscuous violent males, corrupt cops, exploited subservient females, and copious drug users, *Payday* is a white country equivalent to the blaxploitation of the same period. Though shot in 1970, it was not released until February 1973, the same month as *Black Caesar* whose hero also dies alone at the end. But where, however ambiguously, blaxploitation did

invoke a real social commonality, the equivalent "whitesploitation" occurs in an essentially monadic world. As with *Stardust* (Michael Apted, 1974), the dystopian fictional rock biopic of the same period, the musician disintegrates in his alienation, bereft of any sign that popular music could promise redemption. Nashville does hold out the possibility of fame, if not community, for Dann, but he kills himself before he gets there.

NASHVILLE

In retrospect, *Payday* appears as a sketch for *Nashville* (Figure 17.5). The brutally priapic singer-songwriter Dann returns as Tom Frank, L. A. Joan is a more experienced Rosamond in hot pants, the leading singers are both guided by ruthless managers, and both die at the film's end. *Payday*'s thirty-six hours are expanded to five days, its one protagonist into a dramatis personae of some two dozen, and its crabbed rancor inflated into Altman's gaudy but similarly totalized contempt. But the later film's structure derives not from the biopic, but from the tradition of show and jukebox musicals, both fictional and documentary. Like the Beatles in *A Hard Day's Night*, for example, the star Barbara Jean makes a high-profile arrival at the musical capital, and her performances are interrupted by various events that delay the finale, where it follows other performances, culminating in a syndicated television special. But the narrative line of her progress is loosely interspersed with stories of other musicians and would-be musicians, all of which are orchestrated around a presidential political campaign. Together, these present a comprehensive representation

FIGURE 17.5 Nashville.

of country music in its home, Music City USA, and grandiose if shallow intimations of its political significance.

The opening titles play over two scenes in a recording studio: Haven Hamilton (Henry Gibson), a doyen of the local music industry, pompously intones an ode to the upcoming bicentennial, while down the hall a local homemaker, Linnea Reese (Lily Tomlin), leads the Fisk Jubilee Singers in a spiritual. Both singers' roles in the television comedy show *Rowan & Martin's Laugh-In* code them as ridiculous, and their paltry vocal abilities discredit in advance any thematic resonance their singing might otherwise sustain. Subsequently, the film reveals both to be absurdly incompetent, but nevertheless not untypical of a spectrum of Nashville musicians. The top of the hierarchy of both fame and achievement is occupied by Barbara Jean (Ronee Blakley), a gifted and popular singer/songwriter from the rural South (often referencing Loretta Lynn), whose career is presently jeopardized by her ill health. Collapsing on her arrival at the Nashville airport in the opening scenes, she is hospitalized for most of the movie, missing her scheduled appearance at the Grand Ole Opry but performing two days later at the Opryland USA theme park, and next day again at a political rally at the Parthenon for the presidential campaign of one Hal Phillip Walker. In direct competition with her is another star, Connie White (Karen Black), who stands in for her at the Opry. The roster of other established musicians includes a black country singer, Tommy Brown; a folk rock trio, Bill, Mary, and Tom, the last of whom (Keith Carradine) announces that he is going solo; and miscellaneous others, including bandsmen and studio musicians. Below these paid professionals are two young women, both doggedly determined to become the next Barbara Jean: Albuquerque (Barbara Harris) and the disastrously untalented Sueleen Gay (Gwen Welles), whose voice is tolerable only if accompanied by a striptease. Further down, the hierarchy descends through agents, managers, drivers, gofers, groupies, and fans who sustain the professionals, as well as a journalist, Opal, purportedly sent by the BBC to make a documentary about Nashville, who becomes something of an ironic stand-in for Altman. Everyone in the narrative is caught up in the music business, which inhabits all individual identities and social relations.

This cross section of the industry's personnel provides access to its various components and institutions: the studio where songs are recorded to supply its primary commodity form; the live performances at the radio barn; dance shows at the Grand Ole Opry, where the hit records are performed and new songs are tried out for the attendees, the radio audience, and the sponsoring advertisers; the final big concert at the Parthenon, where all the film's musicians are assembled for the television special to aid Walker's campaign; the spectrum of nightclubs, bars, and smokers where people congregate to listen to music and socialize; and even the churches where people sing for both their own pleasure and the glory of God. No other film so extensively catalogued

the range of professional, semi-professional, and amateur modes of country musical production, of popular pleasure and commercial projects, whose interpenetration and cross-fertilization constituted late-twentieth-century popular music. Nor has any other film so relentlessly denigrated them all, or so thoroughly insisted on their corruption.

The strands of the musical narrative are variously knitted into Walker's Replacement Party and his attempt to win the Tennessee primary. Declaimed rather than reasoned, his message is populist and anti-government; but he is never seen, and only a television commentator testifies to his willingness "to battle vast oil companies, eliminate subsidies to farmers, tax churches, abolish the electoral college, change the national anthem, and remove lawyers from government." The ubiquitous vans blaring his litany over loudspeakers are laced into the musical narratives, while Triplette, his publicity agent, schemes to persuade the musicians to appear at the Parthenon rally for him. His importuning runs parallel to Barbara Jean's attempt to maintain herself in the public eye: she is his most important prize, he and she together are the main narrative ligatures, and her appearance as headliner at the rally brings together most of the *dramatis personae*. Also attending the rally is Kenny, an obviously troubled young man who has stalked the movie carrying a violin case. At the rally he takes a pistol from it and shoots Barbara Jean, terminating both her and Triplette's endeavors. The ensuing confusion is stabilized by Albuquerque, who takes Barbara Jean's place to lead the other musicians and then the crowd in a performance of one of Tom's songs, "It Don't Worry Me": "The price of bread may worry some, it don't worry me./Tax relief may never come, it don't worry me./Economy's depressed not me, my spirits' high as they can be,/and you may say that I ain't free, but it don't worry me." When a spontaneous collective public performance—the essential folk moment—is finally achieved, it is of a song written by an amoral egoist celebrating political amnesia.

Nashville's contempt for the industrial, social, and political contexts of the city's culture is reflected in its representation of musical performance. Deriving from the visual presentation of hit records, the rock 'n' roll musical had learned to respect the integrity of the song, interrupting the spectacular images of the performer only with shots of the fans who manifest the pleasure that the audio-visual spectacle produces. The music was always primary, and even though in the counterculture concert documentaries the narrative continues through the performances, it never directs attention away from them. Reversing this, *Nashville* prioritizes the narrative and subordinates the music to it. Though all the performances were filmed live, editing does not augment or elaborate the documentary realism, but regularly interrupts it with extraneous incidents among the immediate audience and also in scenes outside the performance. Even Barbara Jean cannot entirely command the camera's attention. Her first song at Opryland USA, "Tapedeck in

His Tractor," is heard in its entirety, shown mostly in long takes that zoom slowly from wide shots of her and the band to extreme close-ups on her face, though there are cutaways to Opal and the audience. "Dues," her second, is similar and includes the same extended close-ups on her; but it also contains cutaways to specific musicians, her steel-guitar player and fiddlers when they solo, and much longer cutaways to the audience: an extended medium-close-up on Kenny intensely staring at her that coincides with the song's line, "You've got your own private world," and also an extended two-shot in which Opal interrogates Pfc. Kelley about his experiences in Viet Nam. Both detract attention from Barbara Jean's song and allow the narrative to usurp the spectacle. Similarly, when Connie White replaces Barbara Jean at the Opry, her first song, "Memphis," is also shown in its entirely, unobtrusively alternating among mid-shots on the singer herself and wide-angle shots of her, the band, and audience. But after a few bars of her second song, the film cuts from White at the Opry to Barbara Jean's hotel room, where Barnett, her husband and manager, is listening to her on the radio in preparation for thanking White for stepping in. They begin to quarrel and Barnett turns the radio off, abruptly ending White's aural presence and leaving her song incomplete as the narrative moves in a new direction. Less important singers are treated even more rudely. In an early scene at the Demmen's Den amateur night, the Smokey Mountain Laurels introduce themselves and begin to sing "Going Down to the River." After the first line, the film cuts to brief shots of Sueleen (who will perform next) and Opal, then returns to the two singers. But the next stanza is monopolized, first by Opal as she presses herself on Tom, who is in the audience, and then by Lady Pearl, as the scene cuts back to her Old Time Picking Parlor, where the Misty Mountain Boys have been performing the only real high lonesome bluegrass in the film. Lady Pearl's announcement of Tommy Brown's presence in the club prompts an extended racist harangue and a fight, which Lady Pearl has no sooner ended by pulling two pistols than the scene returns to the Demmen's Den, where the Laurels are just finishing their song, which has thus been reduced to soundtrack.

Though the visual representation of musical performance is similarly subordinated to narrative development throughout the film, the music, both good and bad, is much better filmed and recorded than that of *A Face in the Crowd* and *Payday*, and two of its stars had professional musical experience, Keith Carradine and Ronee Blakley. Carradine had appeared in the stage musical *Hair* in 1969, and Altman claimed that his two songs (which he wrote himself) inspired the film.[16] One of them, "I'm Easy," won the film's only Academy Award, that for Best Original Song. In context, both songs reinforce his character's amorality and the film's overall cynicism. He plays a tape of "I'm Easy" as he phones another woman after seducing Linea, and "It Don't Worry Me," which had been conceived as a hobo's song of wistful personal freedom, is devastatingly ambiguous when performed by Albuquerque,

the entire cast, and audience at the end. On the one hand, it appears that the film has at last achieved a utopian folk moment where the boundary between artists and public is spontaneously transcended; on the other hand, in the immediate context of the shooting of Barbara Jean, Walker's pseudo-populist political campaign, and the huge waving Stars and Stripes, the massive political apathy of the refrain, "You may say that I ain't free/but it don't worry me," epitomizes the film's dogged nihilism.

Brought in as a last minute replacement for Susan Anspach, who quit because of Altman's "condescending attitude" to Nashville musicians, Blakley too was an accomplished singer-songwriter who released two folk rock albums of her own.[17] Her lapidary Barbara Jean performs the opposite of Carradine's self-centeredness, salvaging moments of grace amid depravity. She has none of the tough vitality that Loretta Lynn displays in the hillbilly musicals, let alone the often-scandalous combativeness of her songs' address to philandering men, the pill, and even the invasion of Viet Nam; but the willowy fragility of the combination of sentimentality and tenacity in her characterization is subtended by exquisite singing and writing. "Tapedeck in His Tractor," "Dues," and "My Idaho Home," her three self-composed numbers and respectively a love song, a lament for love lost, and a nostalgic evocation of rural family life, are all deft imitations of well-established conventions that her singing re-creates with such conviction and nuance that they become her. "My Idaho Home," especially, effortlessly dissolves the boundary between autobiographical self-expression and the simulation of a distinct type of female country singer; its deceptively simple melodic invocation of her childhood is a brilliant recreation of its Celtic sources in a contemporary idiom, as well as being a utopian counterpoint to the hardscrabble poverty of Loretta Lynn's Kentucky childhood that she conjured in her 1970 hit, "Coal Miner's Daughter." But her brilliance is to no avail, for the beauty of her performances and the banality of most of the others are alike subordinated to the narrative's metaphoric ambitions, all of which are set to prove the venality of country music and county musicians.

The most apposite surrogate for Altman is not Opal but Triplette, whose task of manipulating the performers' egotism to entice them to appear in his television show parallels the director's own, and he articulates what appears to be Altman's own attitude to the music they both exploit: "this redneck music is very popular right now. I got an awful lot of these local yokels on the bill singing . . . [Bill completes his thought] . . . your basic country crapola." Though no matter how asinine or depraved, almost every character is allowed a redemptive moment, with even Hamilton displaying courage after he and Barbara Jean are shot; otherwise the film represents them all as "local yokels," all amoral, and all eager to sacrifice personal scruples for publicity or profit. And all but Frank and Barbara Jean are portrayed by actors of beggarly musical abilities.

The raison d'être of the previous twenty-year tradition of popular musi-
cal films had been the audio-visual presentation of musical performance, in
which the performers' musical achievement had been more important than
their acting ability; only on those occasions when the narrative preceded the
musical content, especially the narrative of a specific musical star, had actors
capable of carrying the role been sought. *Love Me Tender* and all the subse-
quent Elvis films were made to showcase Elvis, *A Hard Day's Night* was made
to showcase the Beatles, and *Country Music Holiday* was created as a vehicle
for Ferlin Husky. *A Face in the Crowd* and *Payday*, on the other hand, recruited
actors of sufficiently plausible musical capabilities to appear as singers. While
Altman's cast also consists of actors rather than musicians, *Nashville* differs
from *A Face in the Crowd* and *Payday* in that, except in two instances, his
contempt for county music and his desire to satirize it and its social world
licensed him to use musically incompetent actors.

The mockery is especially flagrant when specific country musicians are
implied: Roy Acuff or Hank Snow by Haven Hamilton, Loretta Lynn by
Barbara Jean, Lynn Anderson by Connie White (though five years earlier
Karen Black had been satirically identified with Tammy Wynette in Bob
Rafelson's *Five Easy Pieces*) and Charlie Pride by Tommy Brown. Particularly
brazen is the use of Gibson to suggest Acuff. Some aspects of Hamilton's
characterization do recall "the King of Country Music," who did in fact run
for state governor in 1948. But Acuff was an accomplished musician, a vio-
linist with roots in the 1920s fiddle bands and singer whose powerful tenor
had forged the lead vocal style from the group harmonies of 1930s hillbilly
music.[18] Trading on the stiff stupidity of his *Laugh-In* personae, Gibson's vir-
tual monotone and vapid complacency allow Altman to insult a great and
seminal artist. Not all are equally blatant: Karen Black as Connie White and
Timothy Brown as Tommy Brown are passable, while Sueleen is much worse.
But, Barbara Jean and to some extent Frank apart, the quality of Nashville
musicians is in every respect grossly inferior to those featured in *Music City
U.S.A.*, *The Road to Nashville*, and other hillbilly musicals, and the film's
vision of country music as a whole is scurrilous—and was recognized as such
by the people of Nashville.[19]

Except around the edges, with the amateurs at Demmen's Den or the
bluegrass bands at the Old Time Picking Parlor, *Nashville* is blind to all
the forms of country music connected to the folk traditions that were still
alive in the city and to the outlaw resistance to the commercial standard-
ization that Willie Nelson, Waylon Jennings, and others had nurtured.
And its summary instance of a fan is a psychopath who stalks and mur-
ders an outstanding artist. Though the film would exploit the soundtrack
album to augment its returns, its attitude to country music combines met-
ropolitan anti-Southern prejudice with the musical ignorance displayed
in Frank Sinatra's and the dominant music industry's attitude to early

rock 'n' roll: musical and ethical delinquency sustain each other, and the performers' artistic fraudulence reflects their ethical unscrupulousness.

In his interviews, Altman himself typically insisted that the music's poverty, the musicians' amorality, the politicians' vacuity, Kenny's murderousness, and the ferocious publicity-hungry swamp of Nashville as a whole were not to be taken as references to the city and its music, but were rather metaphors for the moral confusion of the whole nation in the aftermath of Viet Nam and Watergate, and in fact Nixon resigned the presidency while the film was shooting. He commonly claimed, "I wanted to do *Nashville* to study our myths and our heroes and our hypocrisy," but he also asserted that the satire was more precisely focused: "*Nashville*," said Robert Altman, "is a metaphor for my personal view of our society. It is not the story of Nashville." But then he added, "Nashville is the new Hollywood, where people are tuned in by instant stars, instant music and instant politicians."[20]

Altman's commitment to formal experimentation, the history of his difficult relations with the studios, and the unevenness of his critical and popular reception may have persuaded him of his personal exemption from his generalizations about Hollywood's vacuity—even if the popular and critical success (and a reputed domestic gross five times its estimated $2 million budget) of the film in which he claimed to allegorize it would suggest that his principled superiority over his industry rivals was perhaps less than he assumed. Nevertheless, like *A Face in the Crowd, Your Cheatin' Heart, Payday*, and the entire history of Hollywood rock 'n' roll films, *Nashville* is posited on implicit claims for cinema's superiority over popular music, and of actors over country singers: thus, the sophistication of Elliott Gould, Altman's star in *M.A.S.H.* (1970) and *The Long Goodbye* (1973), and Julie Christie, star of his *McCabe & Mrs. Miller* (1971), when they visit Hamilton is signally contrasted with the singer's doltishness. In *Nashville*, Hollywood's prejudice against popular music that had been mobilized in 1950s criticism of regional rock 'n' roll exploited long-standing prejudices against the white Southern working class. As a filmmaker and industry insider with those prejudices intact, Altman's visit to Nashville allowed him to gesture toward a reflexive criticism of cinema, but only by cynically and ignorantly projecting its faults onto music, folk and commercial alike. Tom Parker and Hal Wallis's degradation of another working-class Southern musician, Elvis, is the only comparably egregious case of cinema's revenge on popular music.[21]

Rock 'n' Roll Suicide Film

Retrospection and Reflexivity

Along with the resurgence of separate black and white musics in the United States after the turn of the decade, other events seemed to portend the death of the biracial guitar-based rock 'n' roll that had sustained a continuous evolution since the mid-fifties. The Beatles' final performance in January 1969, and then the premature deaths of Jimi Hendrix at twenty-eight in September 1970, Janis Joplin at twenty-seven in October 1970, and Jim Morrison at twenty-seven in July 1971 were accompanied by more fundamental developments. Especially after Kraftwerk's first album in 1970, the central Anglo-US musical axis was challenged from outside by European and global innovations, but also from within by proliferating subgenres and offshoots, including heavy metal, reggae, glam, disco, and progressive rock, many of which featured compositions more extended than the single song, and which were often coupled with stage shows, concept albums, and rock operas.[1] Even though the market for popular music overall expanded greatly in the early 1970s, the divarications of what soon would be retroactively termed "classic rock" became so pronounced that it seemed that the rock 'n' roll era itself might have ended.

Even as tours by Alice Cooper, Led Zeppelin, and supergroups were unprecedentedly remunerative, utopian teleologies gave way to dystopian stasis or archaeological retrospection that framed earlier phases of rock 'n' roll as nostalgic markers of the past. Both released in 1973, *American Graffiti* (George Lucas), the first major feature whose soundtrack was a compilation of oldies, and *Mean Streets* (Martin Scorsese) were the seminal renegotiations of rock 'n' roll's social meaning, respectively signifying teenage innocence and noir complexity. And then the paradigmatic forms of new black and white musics that appeared in mid-decade—hip-hop and punk—were unprecedentedly, even catastrophically, innovative, not least in mobilizing collage procedures that wrested earlier music from its own historical moment and reframed it in mirrors of directionless repetition. Rock 'n' roll songs had always been

reflexive, but increasingly rock 'n' roll culture as a whole looked back on its history with a newly ironic self-consciousness and performed itself with a new and often artificial theatricality, epitomized in glam rock.

Reflecting the apparent failure of the counterculture's utopian promises, British films of the early seventies revisited *Expresso Bongo, Beat Girl*, and other noir tocsins that the Beatles had so joyfully dispelled. But by this time, the United Kingdom had a rock 'n' roll history of its own and, rather than responding to the arrival of a new culture from the United States, cinema saw rock 'n' roll as a national story based on a strong sense of generational identity within a specific postwar history. John Lennon (born in 1940), Mick Jagger and Keith Richards (1943), and Eric Clapton (1945) were all war babies who had lived through part of World War II, the austerity of the immediate post-war years, the creation of the welfare state, and then the unprecedented social mobility of the 1960s that rock 'n' roll facilitated. The rock 'n' roll that had the world on fire by 1963 was specifically English, and a decade after *A Hard Day's Night*, Led Zeppelin was the most profitable band in the world. But with the Labour government's defeat, unprecedented unemployment, the troubles in Northern Ireland, and especially the rise of nihilistic, violent, and sometimes racist youth cultures in the vacuum left by failure of hippie idealism, England was no longer swinging with its previous élan.

The significant British rock 'n' roll films of the early seventies were of two types, studio features and independently produced documentaries: *That'll Be the Day* (Claude Whatham 1973), *Stardust* (Michael Apted, 1974), and *Flame* (aka *Slade in Flame*, Richard Loncraine, 1975) in the one case; and in the other, *Born to Boogie* (Ringo Starr, 1972), *Ziggy Stardust and the Spiders from Mars* (D. A. Pennebaker, 1973), and *Remember Me This Way* (Bob Foster and Ron Inkpen, 1974) about glam rock stars Marc Bolan, David Bowie, and Gary Glitter, respectively.[2] The casting of actual rock 'n' roll stars to play the protagonists in the former and the pronounced fictional elements in the latter qualified the generic distinction so that both contained elements of the other.

As in the sixties, independent documentaries allied themselves with the music they disseminated to become extensions of it. But the studio features, though admitting facets of nostalgia and celebration, were fundamentally critical, adding new charges of rock 'n' roll culture's increasing integration into corporate finance to the old bromides of its hedonism and amorality. They projected satirical narratives of the death of British rock 'n' roll: the collapse of the sixties' emancipatory promise, the venality of musicians and especially managers, and the music's corruption by capital. None portrayed any participatory folk commonality among musicians and the public; one ended with the dissolution of the band, and another followed *Lady Sings the Blues* (1972) and anticipated *Nashville* (1975) in ending with the star's death. The failure of rock 'n' roll narrated in these dystopian features released in successive years in the early seventies had, however, previously been proposed at

the height of the swinging sixties in Peter Watkins's *Privilege* (1967). All four British films were subtended by competition among different branches of the culture industries. Invigorated and renewed by the counterculture and at last able to contain rock 'n' roll within the conventions of the narrative feature, a resurgent corporate cinema began a return to order, castigating what since the jukebox musicals had been an unmanageable upstart competitor.

Privilege

Privilege dramatized an imminent Orwellian Britain in which a coalition among business, government, and church maintains totalitarian control by manipulating the populace's adoration of a massively successful pop star, Steven Shorter, whose initials allowed ubiquitous "SS" insignia to invoke the overall fascist state he facilitates.[3] It starred Paul Jones (chosen over Eric Burdon), formerly lead singer of the successful jazz and blues-based pop group, Manfred Mann, who left in 1966 for the solo career that the film appeared to offer.[4] The film recapitulated the advertising industry's exploitation of popular music depicted in *A Face in the Crowd* and anticipated its co-optation by politicians in *Nashville*.

Like Altman, Watkins served an apprenticeship in television, and in his first major work, *Culloden* (1965), a recreation of the last battle of the Jacobite Rebellion, he developed docu-drama newsreel techniques, including a hand-held camera and interviews in his own voice with the participants in the unfolding action. These innovations broke both the temporal and ontological boundaries of the diegesis, allowing the representation of historical events to interface with his analysis of them. He used similar techniques in *The War Game* (1965), placed not in the historical past, but in the immediate future when a thermonuclear attack was supposed to have caused a total breakdown of British society, but government pressure forced the BBC to cancel the program as too horrific for broadcast television. His next project, *Privilege* (Figure 18.1), was similarly a fictional feature in faux documentary mode in which a voice-over narrator, again Watkins himself, commented on the historical events depicted and interviews the protagonists in them.

It begins with a ticker-tape welcome to Shorter on his return from a successful US tour. Low-angle shots show him with his right arm raised in a Nazi salute, riding in an open car through streets full of enraptured fans, who are only with difficulty restrained by the police. The pandemonium cuts to his homecoming performance, in which the police now frog-march him in handcuffs across the stage and lock him in a metal cage, beating it and him with their truncheons. The narrator explains that "the reason given for extreme violence of the stage act . . is that it provides the public with a necessary release from all the nervous tension caused by the state of

FIGURE 18.1 Privilege.

the world outside" and that it has made him "the most desperately loved entertainer in the world." As he throws his body against the cage, cascading drums and guitars underline his first song, "Free Me." His maudlin complaint, "my spirit's broken, no will to live" escalates into an anguished appeal for freedom, and the women in the audience, young and old, who had been either mesmerized or weeping hysterically like the fans in *A Hard Day's Night*, begin to echo his cry, "Free, free, free!" The police release him from the cage, but when they manhandle a fan who has jumped onto the stage, he attacks them. As they beat him to the ground, the fans invade the stage and fight with the police, while the narrator observes that the coalition government has persuaded the "entertainment agencies" to divert the violence of youth from the streets and from politics. Rather than as popular self-expression, pop music is depicted as a sadistic spectacle, designed to provoke the audience into an administered catharsis that serves to maintain their subjection.

Shorter, the pivotal agent in this process, is miserable and enervated but helplessly docile. Flickerings of self-consciousness arise when his management introduces him to Vanessa Ritchie, a young artist engaged by the Ministry of Culture to paint his portrait, played with persuasive vacuity by Jean Shrimpton. But her compassion stirs him, and he begins to bring her to his various engagements: to a party for his managers in one of the three hundred Steven Shorter discotheques, where they dance to his next release, "I've Been a Bad, Bad Boy," to one of the three hundred Steve Shorter Dream Palaces, department stores that "keep people happy and buying British," and to his appearance in a ridiculous television advertisement to persuade

people to buy domestic apples. Meanwhile, the merchant bankers who control Steven Shorter Enterprises have decided to transform his role. Realizing that the "forces of communism and anarchy" that threaten "national cohesion and survival" make it necessary for a unified front to "subdue the critical elements in the country's youth," they decide to change Shorter's persona. He will repent for his rebellion and his future performances will dramatize his return to society and obedience to law and order. A cabal of bishops is enlisted, an uptempo version of "Onward Christian Soldiers" prepared, and a stone-faced vicar introduced as the coordinator of the film's climactic set piece, a huge rally at the National Stadium subsidized by the coalition government that will inaugurate Christian Crusade Week, where Shorter will declare his penitence.

The opening night of what the narrator announces as "the largest staging of nationalism in the history of Great Britain" is plainly modeled on the Nuremberg Rallies, replete with marching bands, standard bearers, Roman salutes, Union Jack arm bands, fireworks, and a huge illuminated cross. After the "Hallelujah Chorus" and a rock 'n' roll version of William Blake's hymn "Jerusalem," the vicar makes an impassioned peroration on the need for a national renewal, and in response the crowd chants the new creed, "We Will Conform!" Introduced as a "shining example" of the new attitude, Shorter appears, now dressed entirely in red and free from his handcuffs. Backed by violins and soft female voices, he confesses his evil past but describes how he has seen a shining light and a shepherd and, as the song rises to its crescendo and the crowd reaches out to him, he falls to his knees asking for forgiveness, not just for himself, but for "us all." The narrator dryly announces that on that evening "forty nine thousand people gave themselves to God and Flag through Steven Shorter." The spectacle achieves its political purpose, but Shorter's new persona intensifies his self-alienation to the point where, fortified by Vanessa's love, he makes a stand. At a televised banquet given in his honor by his record label, he breaks down, blurting his accumulated resentment. "I'm someone, I'm a person. . . . I'm nothing. This is me . . . I hate you." Over the ensuing chaos, the narrator comments again, "All that Steven Shorter has just done has been to express the wish to become an individual. But that in an age of conformity can become a social problem." Next day, it is announced that he will publicly repent, but when he appears outside the Steven Shorter Television Station Number Three, police hustle him through the angry crowds, and it is announced that he will be "barred from this and any further appearance on television just to ensure that he does not again misuse his position of privilege to disturb the public peace of mind."

When *Privilege* was made, the comprehensive critiques of the culture industries' role in the state's repressive apparatuses made by Theodor Adorno and Guy Debord were not widely known in the Anglophone world.

But their essential positions had been anticipated in Herbert Marcuse's *One-Dimensional Man*, which had been widely influential in the New Left on both sides of the Atlantic since its first publication in 1964.[5] The film all but diagrammatically illustrated Marcuse's main arguments: that the state's encouragement of rock stars to incite a cathartic violence produced what he termed "repressive desublimation" in which consumerism ("Shorter Dream Palaces") and the mass media ("Shorter Television Stations") were ideologically complicit in repressing critical thought and shrinking the individual's ego to the point where no authentic sense of self was possible. Such a depletion of identity appears in Shorter's lethargy and his anguished attempt to affirm himself, even while acknowledging that he is "nothing," which so diametrically contrasts with the popular image of the rock star's libidinous egotism. The constellation of agencies manipulating Shorter and *via* him the entire population is distinctively British in its inclusion of the church—as well as being deficient in its omission of the role of the crown and the British landed aristocracy, the younger elements of which were already very much at home in swinging London. But in the context of *One-Dimensional Man*, the film's overall critique is original only in making pop music, rather than the entertainment industry as a whole, the pivot of fascist control, and in suggesting that the will to resistance could be found in the insight and arms of the first supermodel. Attacks on rock 'n' roll stars as latter-day Pied Pipers leading the young to perdition had been ongoing since Elvis, and had been renewed in England in the month of the film's release with the persecution of the Rolling Stones by the police and gutter press; but the idea, even if projected into the future, that rock 'n' roll could inculcate passive conformity to church and flag was as novel as it was implausible.

Jones's previous career informs his rendition of "Set Me Free" and "I've Been a Bad, Bad Boy"; though the dramatic context precluded the spirited nonchalance of his singing with Manfred Mann, the latter number did imitate its role in the film by becoming a hit. Otherwise, Shorter's uncomprehending, masochistic torpidity makes his ascent to mass adulation as a rock star and the social coercion sustained by his music incredible, as well as misrepresenting the social effectivity of rock 'n' roll at the time. The film was released in the United Kingdom in February 1967, six months before *Sgt. Pepper's Lonely Hearts Club Band* became the soundtrack for the Summer of Love. And Jones's histrionic anguish had been anticipated by Johnny Ray's "Cry" and other fifties hits, since then rock 'n' roll had been associated with revolt against authority (as indeed is momentarily invoked in the origin of his "Set Me Free" in an unspecified juvenile crime), and even that revolt had recently turned to peacefulness and to a pseudo-folk authenticity. Its depiction of a top-down structural social binary in which the establishment markets music to the masses admits no popular musical practices, no cultural resistance, and none of the relatively independent institutions of contemporary popular

music. Shorter is presented as a solo performer, and the film gives no indication of how his unique popularity was manufactured, and no explanation of his individual agency.

Rather than engaging recent or even future developments in British rock 'n' roll, *Privilege* was cobbled together from previous films, Leni Riefenstahl's *Triumph of the Will* (1934), most obviously, and especially from pre-counterculture music films. The overall model of rock 'n' roll as an inflated version of the West End music business derives from *Expresso Bongo*, while Shorter's song "Set Me Free" recalls Elvis's "I Want to Be Free" in *Jailhouse Rock*, and "I've Been a Bad Bad Boy" reworks Marty Wilde's hit, "Bad Boy," of the same year. And many incidents are copied from *Lonely Boy* (Roman Kroitor and Wolf Koenig, 1962), the documentary about the late fifties Canadian ballad singer, Paul Anka; *Lonely Boy* in fact contained extensive staged scenes, including a sequence closely imitated in *Privilege* in which Shorter's management personnel are introduced and he gives a portrait of himself to his manager. And pop music's role in consumerism recurs from the Dave Clark Five vehicle, *Catch Us if You Can*, as does Vanessa's suggestion that she and Shorter escape to the country.

These film-mediated music references aside, *Privilege* would be allegorically coherent only if Shorter represented, not rock 'n' roll, but the film and television industries, for despite its industrialization and appropriation by corporate agencies, popular music was still the least completely administered component of capitalist culture and the one most accessible to popular intervention. The television industry had already betrayed Watkins with *The War Game*, and the movie industry would do so over *Privilege*. After *The War Game* was banned, Watkins resigned from the BBC to campaign for his film, and secured a screening at the National Film Theater and a commercial release in Europe and the United States, where it won an Oscar for Best Documentary. But with some notable exceptions, *Privilege* was poorly received by critics and was not given extensive distribution. It was accused of being anti-Christian in the United Kingdom; complete censorship followed, with J. Arthur Rank cutting short its UK distribution and Universal withdrawing it after very few screenings in the United States.[6] Anticipating *Nashville*'s dystopian critique of popular music, *Privilege*'s betrayal of popular culture failed to match the US film's critical and commercial success. It nevertheless anticipated a trio of corporately produced British films that allegorically projected their own commodity status as cinema onto the putative alienation of rock 'n' roll.

Glam and Glitter

That'll Be the Day and *Stardust* were both written by the London journalist Ray Connolly, and produced by David Puttnam, formerly an account executive in

FIGURE 18.2 That'll Be the Day.

the advertising agency most conspicuously associated with swinging London,
Collett Dickenson Pearce & Partners.[7] Both films narrate stages in the career
of Jim MacLaine, played by David Essex, who had been a pop singer and
recording artist since the early sixties as well as an actor, appearing in the
London production of the musical *Godspell* in 1971. *That'll Be the Day* (Figure
18.2) traces Jim's youth, and *Stardust* his ascent to global celebrity as a rock
star. A war baby, he comes to maturity in the early 1960s as US rock 'n' roll
was unfolding vistas of unimagined excitement across the tedium of work-
ing-class British life. After being demobilized, his father returned home to his
family and their small grocery store, but quickly finding both suffocating, he
abandons them to the care of Jim's mother. A decade and a half later, Jim in
turn quits school on the morning of the examinations that would have led to
a state-supported university education, and abandons his struggling mother
to drift through casual employment on the beach, a holiday camp, and a fair.

Returning home, he tries to settle down into petty bourgeois respectabil-
ity, expanding the shop, marrying, and fathering a child. But the excitement
of a rock 'n' roll show at a local hall proves irresistible; he buys a red gui-
tar, abandons his family, and hits the road again. Jim is counterpointed by
two other youths: Terry, a school friend who follows the prescribed path to
respectability through university, where all the students like trad jazz; more
important is Mike, a lumpen but sensitive casual laborer. Played by Ringo
Starr dressed in late 1950s Teddy Boy clothes, Mike teaches Jim the sexual and
monetary hustles of the camp and fair. Jim quickly learns to take advantage
of his handsome large eyes and soft, sensuous smile, his propensity to scribble
poetic lyrics, and what appears to be his fundamentally good, if wayward,

nature. But his nonchalant amiability is punctuated by streaks of cowardice and selfishness, especially in sex. When he finds hoodlums beating Mike after he has cheated one of them at the fair, he hides; his promiscuity and especially his rape of a schoolgirl startles even Mike, and on the eve of his marriage he seduces his future wife's best friend. Profligate and irresponsible, self-centered and self-indulgent, he is good boy gone bad; originally disturbed, like the delinquents in *Blackboard Jungle*, by the absence of his father during the war, he also exemplifies the postwar decline of British fortitude caused by US rock 'n' roll.

As the soundtrack of his life and eventually the focus of his aspirations, rock 'n' roll appears in two diegetic forms: records imported from the United States and covers of them by youthful British bands. Though they include Little Richard and other early rock 'n' rollers, the records that dominate the jukebox in the small-town café, Jim's record player in his room, the holiday camp, and especially the fair are mostly from the late fifties, including those by the Everly Brothers, Bobby Vee, Frankie Lymon, and Buddy Holly. The live covers are performed in the ballroom at the holiday camp by a professional band led by the best of the English Elvises, Billy Fury, here as Stormy Tempest, with the Who's Keith Moon on drums. Otherwise, in local town halls and youth clubs, unknown amateur groups struggle toward competence and recognition, all attired in one of two uniforms: the brightly colored drape jackets, drainpipe trousers, and outrageously greased hair of the Teddy Boys, or matching suits like those Brian Epstein chose for the Beatles. The overall picture of working-class youth culture is historically precise, with rock 'n' roll contentiously defined against the music of the previous generation and the trad jazz favored by university students, including Terry, who believes that rock 'n' roll is "just a craze." The subordination of English to US rock 'n' roll at the end of the fifties is expressed by Moon when Jim asks him if Tempest's band ever performs their own compositions: "you've got to be American to write rock 'n' roll songs these days, it's the words, in it?" thus implying the future use for Jim's poems. The presence of Starr in his pre-Beatles persona and of Fury and Moon add dramatic color as well as intimations of the developments that lie just over the horizon.

Stardust (Figure 18.3) begins a few months after *That'll Be the Day* ends. As the news of the Kennedy assassination is broadcast over television in November 1963, Jim returns to the fair to find Mike, now played by Adam Faith and limping as a result of the beating, and recruits him to be the road manager of a band he has joined, the Stray Cats, an undisciplined group of oafs led by a singer-guitarist, Johnny, along with Moon and veteran guitarist Dave Edmunds. At a lunchtime gig at a warehouse club resembling Liverpool's Cavern, audience acclaim for the Cats' performance of one of Jim's compositions persuades Mike of the group's possibilities. He proves to be an adept manager, finding a launderette owner to invest in them and, a few days after

FIGURE 18.3 Stardust.

the first Liston-Clay fight in February 1964, an agent played by Marty Wilde, one of the more successful of the late 1950s Elvises, signs them to a record contract. Playing bass and as pretty as Paul McCartney, Jim edges Johnny out and becomes the leader. Renamed Jim MacLaine and the Stray Cats, the band prospers, moving socially upward and gathering interest from disc jockeys and influential journalists. Jim's songs take them to the top of the UK charts and, introduced by popular DJ David Jacobs (not seen on film since 1962's *It's Trad, Dad!*), they make a triumphant television appearance as the top group of 1965.

US success follows, with news footage of the group's arrival resembling the Beatles', and Jim pontificates in television interviews about youth and the world's problems. A French girl further separates him from his friends, but the group's real crisis follows when a brash American, Porter Lee Austin (played by Larry Hagman, anticipating the ruthless persona he would perfect in the soap opera *Dallas* in the next decade), introduces himself as their new manager, announcing that he has bought 75 percent of Stray Cats Incorporated. Aided by Mike, Austin isolates Jim and, though he has no regard for what he terms "nigger music," confidently guides his career to the

industry's summit, where his fans regard him as "some kind of a messiah," even as his financial manipulations keep Jim trapped on an assembly line of record production. Realizing that he has become a commodity, Jim nevertheless makes a final megalomaniacal attempt to prove that he is "an artist not a jukebox." Replaying on a much larger scale Cliff Richard's performance of a mawkish religious song about his mother at a parallel point in his career in *Expresso Bongo*, Jim composes a "tribute to woman," an inflated "rock symphony" with orchestral accompaniment and massive choir of white-robed women. Broadcast live by satellite to 300 million fans, it is a global triumph, but immediately afterward, Jim abandons the industry. Addled by drugs and his unimaginable fame, he retreats with Mike to a castle in Spain, where their co-dependent, love-hate rivalry ferments until it erupts in a boxing match. Finally, a television interview that he agrees to is abruptly terminated when he collapses and dies from a self-administered overdose of heroin.

Stardust traces a schematic but still richly realized history of English rock 'n' roll from the fall of 1963, when "She Loves You" marked the Beatles' breakthrough, to the present of the film's production, during the popularity of glam rock signaled by Marc Bolan's success and the release of David Bowie's 1972 album, *The Rise and Fall of Ziggy Stardust and the Spiders from Mars*. The band makes a paradigmatic evolution from a loose assortment of locally active, semi-amateur working-class musicians; more professional management that turns them into chart-topping recording artists; television success, and victories in national polls; US and international triumph; and finally, Jim's solo global spectacular. The various stages of their climb through the business are marked by escalation in the available drugs from alcohol, through cough syrup and marijuana, to champagne and cocaine; and by a parallel sartorial progression from leather jackets through matching suits to post-hippie splendor. The accompanying personnel of British rock 'n' roll history includes both Moon and Edmunds in the Stray Cats and Faith and Wilde as their roadie and agent. All come together in a sequence at the Cats' first recording session, in which the managers look down at the band through the studio's glass wall. Embroidering these figures, the film makes other historical allusions, especially to the Beatles, who became similarly embroiled in managers and financial debacles: baby-faced Jim first resembles Paul McCartney and then Marc Bolan; his pre-fame marriage and child resemble John Lennon's; Mike, the closeted gay manager, recalls Brian Epstein; and Jim's overdose has many parallels. Where the real-life stars simply embellished *That'll Be the Day*, in the sequel they and the intertextual references they knit together combine with invocations of earlier rock 'n' roll musicals and the historical reference points to propose a declension narrative in which Jim's personal story becomes metonymic of the history of British popular music through the turn of the decade.

Where *That'll Be the Day* was a bildungsroman unfolding in an early 1960s world of absolute beginners in which rock 'n' roll promised personal and social liberation, the later film's disillusion reversed those dramatic possibilities, presenting rock 'n' roll's decay into social manipulation and corporate corruption. As his stardom alienates him even from Mike, Jim's social world shrinks, and the possibility of his personal development is preempted by his imprisonment in a music industry that is entirely integrated into corporate capital and its concomitant ethical and psychic degradation. As in the generic tradition, rock 'n' roll is associated with uncouth delinquency, sexual promiscuity, and drugs, all of which are glamorized rather than condemned. The narrative keeps a keen voyeuristic eye on Jim's selfish profligacy, but its main concern is the expanded corporate interests, especially the financial investment that eradicates the residual, quasi-folk component prized in rock's own ideology and exemplified in the early Stray Cats. However public spirited, Puttnam's indictment of the iniquities of corporate rock 'n' roll also proved profitable for his production company, Goodtimes Enterprises: *That'll be the Day* cost £288,000 and by the mid-1980s had made net profit of £406,000, while *Stardust* made a net profit of £525,000 on a £555,000 investment.[8] But then, Goodtimes well knew how to turn a dollar on rock 'n' roll, having previously produced *Performance* (1970) and *Glastonbury Fayre* (1972). So the next year the company released another exposé of managerial malfeasance in the world of popular music: *Flame*, also known as *Slade in Flame*.

Flame (Figure 18.4) returned to an amateur rock 'n' roll band's successful professional career and the concomitant loss of community, both within the group and in its connection to its working-class origins and fans. Set during

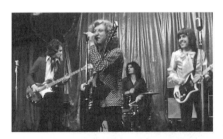

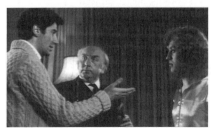
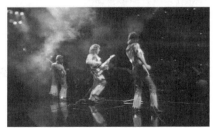

FIGURE 18.4 Flame.

the second half of the sixties through to the triumph of glam rock in the early seventies, it featured Slade, one of the most popular and financially successful UK band of the early 1970s, virtually playing themselves as the band Flame.[9] A very loosely dramatized version of their early career, it begins with the rivalry between two bands in the West Midlands, the ejection of an Elvis impersonator who leads one of them, and combination of some of the other members to form the new group, led by the charismatic lead guitarist and singer Stoker (Slade's leader, Noddy Holder) along with Paul (Jim Lea), the cowriter of most of the songs. With a narrative largely cut from the same mold as *Stardust*, the working-class kids' musical career progresses from being a marginally professional avocation as they perform at local weddings and social events, though their acquisition of a roadie, a van, and—again—two equally unscrupulous managers from different ends of the financial spectrum.

Many of the film's local incidents were reworked from real events that happened to Slade or other bands, and their own songs were fitted into the narrative. But the dramatic development is fictional, framed by the conflict between the two managers, both of whom again have no interest in the music apart from its commercial possibilities. While still unknown, Flame is signed by Ron Harding, a local hoodlum played by Johnny Shannon, who brings to his role all the menace of Harry Flowers, whom he played in *Performance*. Thinking the band has no future, he fails to promote it, and Flame is taken over by Robert Seymour, a merchant banker resembling Stephen Shorter's handlers, with an entirely different class cachet and financial frame of reference. Believing that image and publicity are more important than music, he approaches the group as a promotional project, intending to market them the same way he markets fish fingers, and dresses them in red and gold silk "Flame" costumes. The resolutely lumpen band members are equally uncomfortable with Seymour's social world and his extravagant publicity gambits, but his packaging and promotion bring the promised results and, like the Stray Cats, they soon they appear on television and earn a silver record. Noticing their success, Harding renews his interest, and the film turns into a bloody contest between the two racketeering managers.

Reminiscent of early 1960s Kitchen Sink cinematic realism, *Flame*'s richly realized working-class characters and milieux distinguish it from *Stardust*'s more cosmopolitan and exotic settings. Whether in the interiors of nightclubs and concerts or exteriors of nighttime city streets, the cinematography's overall emphasis on flashes of lurid color against the low-key lighting visually echoes the band's power chords. Illuminated by the contrast with Seymour's haute bourgeois luxury, its depiction of volatile unemployed provincial youth, of the declining industrial environment with bleak boarded-up terraces and bingo parlors, and of the seedy underworld of small-time hustlers sustains an anarchic vitality that reciprocates the boisterous populism of Slade's anthemic music. But as in *Stardust*, the strains of fame and managerial manipulation

cause dissensions in the band, and jealousy of Stoker's prominence and sexual infidelities causes a couple of the band's members to drop out and return home. Harding finally regains control of the band, but his victory is pyrrhic, for Stoker, alone and disgusted after a night's sybaritic excess, himself quits, and nothing remains to be exploited.

Flame's jaundiced exposé of managerial maleficence had little connection to the reality of Slade's fortunes. The group was in fact skillfully managed by Chas Chandler, the engineer of Jimi Hendrix's career. Initially less successful with them when they sported a skinhead look, he persuaded them to abandon it for glam and to write their own material, steering them to success. They had peaked by the time *Flame* was released, but rather then breaking up, they worked through a period of decline and then emerged with renewed acclaim in the United States and Europe in the early 1980s.

Together, *That'll Be the Day, Stardust*, and *Flame* trace the sequence of musical styles and personal plumage in British rock up to mid-seventies glam, roughly 1959–1962 in *That'll Be the Day*, 1963–1970 in *Stardust*, and 1966–1974 in *Flame*, with *Privilege*, made in 1967 but set in "Britain in the near future," hyperbolically anticipating the totalized corporate control of popular music they project. They were all backstage musicals showing English kids getting together, not to put on a show, but to create a sixties band, specifically a *group*. The construction of the narrative on the emergence and development of a group rather than a single singer, introduced in the jukebox musical *Rock, Pretty Baby* (Richard Bartlett, 1957) but only very occasionally deployed since (as, partially at least, in *Ferry Cross the Mersey*), reflected the dominance of that mode of rock 'n' roll production characteristic of the communitarian musical vision of the sixties: the idea of the group as the core and emblem of a tribe, "a family unit that is horizontal rather than vertical, in that it extends across a peer group" summarized by Abbie Hoffman as the Beatles' revolutionary promise.[10] But in all of them, the egalitarian musical combo with its celebration of expressive working-class vitality is destroyed, not by its own delinquencies, but by being converted into commodity-producing enterprises and media spectacles. In reviving the cynicism of *Expresso Bongo* and other early sixties satires, the later UK subgenre negated the utopian optimism of all its major predecessors in the rock 'n' roll musicals: the US jukebox musicals of the fifties, the Elvis movies, the sunny UK Cliff Richard and Beatles features, and the US Direct Cinema documentaries.

In the jukebox musicals and the UK features, the narrative allows disc jockeys and other low-level management to overcome both parental and industrial hostility and discover an inclusive community that transcends the alienation introduced by the commodity record; in the Elvis movies, management and other industrial functions are all concealed, hidden behind the King's uniqueness and the folk community it nevertheless sustains; and in

the documentaries, management and commercial interests are again sub-
sumed in the folk commonality of musicians and freaks. But in the British
satires, the group's dramatic context is no longer the community of fans, who
partner with the musicians and who socially elaborate the music's cultural
renewal; rather, they and audiences generally are narratively marginalized
to appear only as disposable groupies or the unindividuated masses of con-
sumers in the television specials that replace public festivals. The only social
context the films allow the musicians is that of managers and other agents of
corporate development, whose sole interest is in maximizing their short-term
financial value, irrespective of any aesthetic or socially ameliorative function.
Management capitalizes on the group's commercial potential and consolidates
its own control over it by reducing its original organic sociability: isolating
the star, disposing of secondary members, and outsourcing musical support
to anonymous professional personnel. Alienated at the height of its fame and
with the fans erased, the possibility of a romantic dual focus was gone; the
group collapses, and with it all of rock 'n' roll's promise. Tiring of promiscu-
ity and exploitation, Flame's members return to their hometowns; like Steven
Shorter, Stoker quits the business; and Jim MacLaine commits suicide.

In the renewed US capitalist feature cinema of the same period, black and
white alike, equivalent dystopian narratives found such suicide unnecessary,
for the women stars of *Lady Sings the Blues* (1972) and *Nashville* (1975) are both
killed, one by the state and the other by a fan. In Britain, cinema's retribu-
tion may have been less severe but, as in the satires of the early sixties and in
the mid-sixties with *Privilege*, the corporate British cinema in the early 1970s
continued to find it ideologically useful and lucrative to project its own alien-
ated financial imperatives onto popular music. Meanwhile, as in the United
States in the mid-sixties, independent documentary filmmaking rather affili-
ated itself with the music and made films that celebrated it. The industrial
features' denigration was countered in three documentary films about glam
rockers: *Born to Boogie, Remember Me This Way*, and—though much more
ambiguously—*Ziggy Stardust and the Spiders from Mars*.

Glam Documentary

An Apple Film directed by Ringo Starr, *Born to Boogie* introduces Bolan with a
photograph of him labeled "Age 9: an Eddie Cochran fan," which dissolves into
a more recent still image and thence into a concert performance at Wembley
Empire Pool after a six-month foreign tour. Resplendent in a silver jacket at the
zenith of "T. Rex-stacy," he performs "Jeepster," "Hot Love," "Children of the
Revolution," and more of his riff-driven hits, either with his band or, for acous-
tic numbers, sitting alone cross-legged on the stage. Interspersed among the
concert scenes are a studio jam session with Elton John and Ringo himself and

two silly surreal interludes reminiscent of the *Magical Mystery Tour* and hence of the Goon Show, though based on *Alice in Wonderland*. After an encounter with a red car driven by the Cheshire Cat, Bolan appears at the "Mad Hatter's Tea Party" (to which he is linked by his trademark top hat), playing acoustic guitar accompanied by a string quartet while a butler grills hamburgers for a group of nuns. To conclude, the film returns to the concert for an extended "Bang a Gong (Get It On)" and a multi-screen end-title sequence, both of which recall mid-sixties acid euphoria.

Documenting Gary Glitter at his peak, *Remember Me This Way* a-chronologically samples the different activities that constitute his life and work, culminating in a twenty-minute selection from a concert at the Rainbow Theater in London. Before this finale, the film shows him recording a song, discussing plans for a new album, being interviewed by DJs and journalists, attending a party, visiting Paris, and even taking part in a screen test for a feature film. The organization around him is further detailed in scenes of an art designer working on a pop-out album cover; discussions among various marketing and promotion personnel and other agents who handle his career; Mike Leander, the musical arranger with whom he had a close and successful working relationship for over thirty years, at the mixing console; and records being pressed in a plant and boxed for mailing. Though less than an hour long, it comprehensively overviews the glam rocker as the central cog in an integrated industrial project that, in 1973 when the film was shot, was in the middle of a dozen top ten hits. But rather than exploiting Glitter, the business appears enormously rewarding for him and for all the others who have a part in it.

In contrast to the feature films, these two documentaries portrayed glam rock, its stars, its fans, and its industrial apparatus as altogether comprising a dynamic cultural enterprise, unspoiled by the disenchantment and alienation in which the features luxuriate. But the third documented a more complex vision of rock 'n' roll, one whose stark ambition triumphantly renewed it, even as it gloried in its ending. Shot between *Born to Boogie* and *Remember Me This Way*, *Ziggy Stardust and the Spiders from Mars* was even more completely a film of a single concert, but a concert within which a narrative was dramatized. Again based on the "rise to stardom" motif—in fact the birth of a "Starman"—it was an opera of a glam rocker's meteoric emergence and apocalyptic demise.

Rock 'n' Roll Suicide

While in school David Jones played in several bands, and just before leaving he declared his ambition: "I want to be a pop idol."[11] He quickly left his first job in an advertising agency, and in the next few years he formed more bands

(including one called the Hype), changed his name to Bowie, ran an arts lab, and acquired a manager, Kenneth Pitt. By the end of 1971, he had released several singles and four albums, none of which made a mark apart from the 1969 single, "Space Oddity," inspired by Stanley Kubrick's 1968 film, *2001: A Space Odyssey*, which entered the British top ten. As possible career alternatives to music, he also made forays into mime, studying with Lindsay Kemp, and acting. He failed an audition for the musical *Hair*, but he gained a role in an ice cream commercial, one as an extra in *The Virgin Soldiers* (John Dexter, 1969), an army comedy for which he had to cut his shoulder-length hair, and one in a short homoerotic experimental melodrama, *The Image* (Michael Armstrong, 1969). The same year, Pitt produced a promotional film, *Love You till Tuesday* (Malcolm J. Thomson) featuring "Space Oddity" and seven more Bowie compositions.

Though none of these film projects attracted interest, many anticipated the fatal doppelgängers who would feature in his most celebrated album, *The Rise and Fall of Ziggy Stardust and the Spiders from Mars* (1972). In *The Image*, for example, Bowie haunts an artist who is painting a portrait of him, driving him to such a point of distraction that he stabs his inspiration to death and slashes the portrait. Most of the numbers on *Love You till Tuesday* were fey folk ditties, but it also included "The Mask," a mimed story in which Bowie finds a mask in a junk store; wearing it, he becomes increasingly popular, leading to requests for "autographs, film and television, the lot" culminating in an appearance at the London Palladium during which the mask strangles him. Despite his lack of professional success in cinema or music, by the turn of the decade, Bowie was already projecting alter egos in strongly visual dramatic performances, acted as well as sung, in which metamorphoses in his assumed identities culminate in his death. Where Jagger's demon brothers offered renewal, Bowie's portended only destruction.[12]

Bowie's ideas were well developed in his imagination when, sponsored by a new manager, Tony Defries, he went to the United States for the first time on a coast-to-coast promotional tour for his album *The Man Who Sold the World*. In an interview tellingly published on April 1, 1971, he summarized his complete dismissal of all the shibboleths of countercultural authenticity and his espousal of masquerade, reminiscent specifically of Kenneth Anger's *Rabbit's Moon*. Dressed in floral-patterned velvet dress and "cosmetically enhanced eyes" that the interviewing journalist found "almost disconcertingly reminiscent of Lauren Bacall," he spoke of the importance of "the idea of performance-as-spectacle," and his plans to "focus the attention of the audience with a very stylized, a very Japanese style of movement." He continued, "I don't want to climb out of my fantasies in order to go up on stage—I want to take them on stage with me" and "I think [the music] should be tarted up, made into a prostitute, a parody of itself. It should be the clown, the Pierrot

medium. The music is the mask the message wears—music is the Pierrot and I, the performer, am the message."[13] The priority of the performer's "tarted-up" persona for which the music was a vehicle—like a movie star and a role—had already been accomplished in Bowie's songwriting.

After his bluesy mod beginnings, his early music was mostly in the passé singer-songwriter mode of Bob Dylan, although he still wore long hair and sometimes a dress. On his fourth album, *Hunky Dory*, in 1971—along with one for Andy Warhol—he included a "Song for Bob Dylan," whose play on the relationship between Robert Zimmerman and his "good friend Dylan" reflected his own oscillation among his given name of David Jones, his assumed name of Bowie, and his eventual Ziggy persona. Though his lyrics were not as surrealistically bizarre as Dylan's had been in the mid-sixties, they were vividly dramatic and cinematic, often with sharply observed characters and narrative vignettes, all vividly metonymic but with rapid shifts in perspective and focus. They were conspicuously literate, if often opaque, and enriched by a dense intertextuality in which pop music references rubbed shoulders with avant-garde art: Iggy Pop, the Velvet Underground, Warhol, Aleister Crowley, Greta Garbo, William Burroughs (especially *The Wild Boys*, his apocalyptic novel about homosexual youth gangs), and Kubrick's 1971 film of Anthony Burgess's novel *A Clockwork Orange*.

Taking all the elements of glam rock to extremes, his clothing, pronouncements, and songs prized spectacle, artifice, surface, stylization, bisexuality, and sexual indeterminacy. His rejection of all the signs of unalienated folk sincerity privileged in the counterculture and its music half a decade earlier included its political aspirations, and the protagonist of "All the Young Dudes" characteristically admitted never getting "it off on that revolution stuff." Identities were costumes to be assumed and discarded, but without ever implying a stable presence behind them. Elements of identity-as-performance had always been integral to rock 'n' roll since Elvis's African American feel and sound: not just whites playing blacks, but also British playing Americans, the rich pretending to be working class, and boys acting like girls—and vice versa. But still the degree of Bowie's erasure of self in favor of fabricated personae embodying shifting cultural gestalts was unprecedented, especially when his aesthetic coalesced around Ziggy. With the Spiders from Mars under the musical direction of Hype guitarist Mick Ronson, Bowie followed the path of Bob Dylan and Marc Bolan in transforming his acoustic folk music into electric rock 'n' roll, but conceiving it as a drama premised on the destruction of self—and the destruction of rock 'n' roll.

By the middle of 1971, Bowie had made little impact on the British pop market and, despite the promotional visit, virtually none on the United States. But *The Rise and Fall of Ziggy Stardust and the Spiders from Mars*, his fifth album, changed everything: his music, his persona, and his fame. Recorded in September and November 1971 and January 1972 in London, with ten of its

eleven songs being his own compositions, it deliberately featured a harder rock sound than he had previously favored. Though twenty years later in conversation with William Burroughs he proposed a detailed narrative supposed to inform the lyrics, during a US radio interview just before the album's release in June 1972, he more accurately noted that in fact the songs were only loosely linked: "It wasn't really started as a concept album. . . What you have on that album when it finally comes out is a story which doesn't really take place. It's just a few little scenes from the life of a band called Ziggy Stardust and The Spiders From Mars, which could feasibly be the last band on Earth, because we're living the last five years of Earth."[14]

Ziggy appears several times, initially in the album's first song, "Five Years," where he is noticed among a soldier with a broken arm and a cop kneeling to kiss a priest's feet and other surreal urban incidents in an ice cream parlor just after the "news guy" has announced that "the earth was really dying." His music and his relationship with his fans is detailed in "Ziggy Stardust," and in the last song, he is the "rock 'n' roll suicide" who has lived too long and whose brain is lacerated by knives. But otherwise any suggestion of a point-to-point narrative, such as that of Brecht and Weill's 1930 opera, *The Rise and Fall of the City of Mahagonny*, echoed in the title, is replaced by a series of vignettes involving an androgynous extraterrestrial rock 'n' roll singer that Ziggy variously manifests, invokes, identifies with, or perhaps kills, along with an earthly community of his adoring fans. Re-engaging Bowie's meditations on isolation and estrangement essayed over the previous decade, his self-dramatization in the song sequence as the charismatic figure of Ziggy allowed him to perform a role that previously he had disdained: a rock 'n' roll star.

Earlier that year Bowie had signed a contract with Defries's promotional company, MainMan, and Defries had obtained a recording contract for him with RCA and had arranged a US tour for the fall of 1972. Using advances from RCA, the new manager promoted him lavishly, parading him to the press as if he were already a superstar and billing him as the headliner in shows that, except in a few coastal cities, were nevertheless very poorly attended. Back in England and undeterred, Defries flew in a party of US journalists, and when the Ziggy US tour resumed in the fall, his publicity stunts had achieved their aim: warm-up shows in Cleveland and Memphis were sold out, and Bowie's New York debut at Carnegie Hall on September 28, 1972, was the social event of the year. Despite some demurrals, the press was largely positive, and massive publicity ensured that the tour continued triumphantly. Later Bowie realized that Defries's contract was extremely exploitative, making him the promoter's employee for the next ten years and garnishing most of his income. Though Defries had made himself a puppet-master Svengali, he had done what Bowie himself and his previous managers had failed to do: he had made Bowie the "pop idol" he desired to be and, like Stephen Shorter, "the most desperately loved entertainer in the world." David Jones's

self-fabrication in the rock 'n' roll personae and music of David Bowie and Ziggy was made real in Defries's manufacture of rock 'n' roll stardom in the culture industry's publicity apparatus.

The careers of many previous rock stars had been engineered by rapacious and unscrupulous managers, from Elvis's Tom Parker to the Beatles' Allen Klein and Dylan's Albert Grossman. Conversely, many of the supergroups who claimed an origin in an organic local community were invented by publicity agents; the Who's credentials as emissaries of London Mod were, for example, largely fabricated by their managers. But Bowie's emergence was an unprecedented manufacture of stardom in an orchestrated publicity campaign without grounding in any previous achievement, but which was transposed to the persona he performed, one founded, not in any extant social community or even a human being, but in an imaginary company of bisexual extraterrestrials. Ziggy was fabricated equally in the publicity apparatus of the culture industry and in his own imagination: the image reflected its fabrication. Not the least of Bowie's contribution to postmodernism was his glittering demonstration of the primacy of the manufactured image over any other reality; not until a decade later would this syndrome be recognized as "the precession of the simulacrum": "a real without origin or reality," a sign "never again exchanging for what is real, but exchanging in itself, in an uninterrupted circuit without reference or circumference."[15] In rock 'n' roll, the precedent for the fabrication and manipulation of an unreal stardom was in the movies, in *Privilege*, with *Stardust* and *Flame* subsequently dramatizing the process. But where those films took revenge on the stars they exploited, excommunicating or killing them, the performance of Ziggy's suicide created stardom for David Bowie. And where their emphasis on industrial production marginalized the fans, Bowie made them the heroes.

Ziggy and the Spiders performed the drama over 150 times, touring the United Kingdom, the United States, and Japan in April 1973, and returning to the United Kingdom for shows in May and June and a final performance on Sunday, July 3, 1973, at the Hammersmith Odeon in London. A few days before the concert, RCA hired D. A. Pennebaker to fly to London to record half an hour of the show for use as demonstration material on a new form of video disc. With perfect appositeness, Bowie became cinema, not as himself, but as the content of a new media platform. Accompanied by Jim Desmond, the primary cameraman for Jimi Hendrix's epochal performance for *Monterey Pop*, Pennebaker arrived only the day before. Ignorant of all Bowie's music except for "Space Oddity," he attended Saturday's penultimate concert, meeting the singer for the first time in his dressing room and shooting what became the film's opening sequence, and returned the next afternoon to complete his assignment for RCA. But, like the Maysles encountering the Rolling Stones at Madison Square Garden in 1969, he quickly realized that Bowie's Ziggy show warranted a complete feature-length documentary, and he recorded the

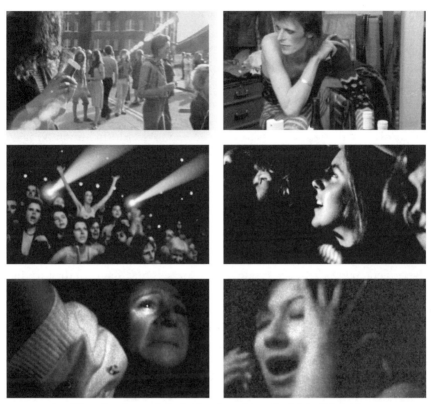

FIGURE 18.5 Ziggy Stardust and the Spiders from Mars: *Rock 'n' roll Suicides.*

entire concert on 16-mm film and sixteen-track audio. Complications pre-vented all but a few college and festival screenings of a rough cut in 1973, and the film was unavailable until 1983 when, with the soundtrack remixed and augmented with overdubs supervised by Bowie and one of his musical pro-ducers, Tony Visconti, it was released on video. In 2002, the sound was again remixed, but not until 2003—thirty years after the concert—was the film was released theatrically on 35 mm as *Ziggy Stardust and the Spiders from Mars: The Motion Picture.*[16] (Figure 18.5).

WHEN THE KIDS HAD KILLED THE MAN, I HAD TO BREAK UP THE BAND

During the prolonged touring, the show's song list had been modified so that the final performance documented on the film omitted four from the original album and added nine from other Bowie albums and three from other compos-ers that together limn a more continuous narrative than the "few little scenes from the life of a band called Ziggy Stardust" that Bowie initially ascribed to the album. The lyrics intertwine reflexively to address the present experience

of a momentous rock 'n' roll performance involving a singer, his band, and a community of fans, together with the implication of their imminent annihilation. The performance culminates in an ecstatically decadent apocalypse, in which, as a "leper messiah," Ziggy simultaneously redeems and destroys himself and his fans, gloriously epitomizing the "Deathwatch rockfilm."[17]

After the opening credits (actually made later by Pennebaker using a New York cinema's electronic signage), Bowie is seen in his dressing room, smoking as his hair is styled and his face is made up to transform him into Ziggy. He receives a telex but says he cannot read it because "it's all in code"—a nod toward the heavy coding of his own act and also of the costumes of his fans waiting outside the theater, to whom the film cuts. The camera picks out their high glam clothes and makeup, *Aladdin Sane* Nazi lightning bolts across some faces and glitter around the eyes of others, and the police mingling among them, while as in *Privilege* and *Born to Boogie*, a voice-over announces that the star is returning from a US tour. Bowie's wife, Angela, arrives and the camera follows her back inside, where she tells him about all the arriving limousines. Ziggy whistles softly as two assistants dress him in the first of his costumes, a kabuki-inspired quilted satin cloak in turquoise, black, and scarlet, and the camera follows as he leaves for the stage, dark apart from two red discs of light crossed by the lightning bolt. The strains of Beethoven's *Ninth Symphony* from *A Clockwork Orange* are slashed by guitar chords from musical arranger and lead guitarist Mick Ronson to open "Hang on to Yourself." The Spiders' rhythm sections joins in, and the band appears briefly in three pools of turquoise light before the camera cuts to a medium close-up of Ziggy alone, the orange light dressing the red hair and eye makeup in a virtually monochrome portrait of icy command. Pennebaker's camera briefly finds Ronson, but returns to a close-up on Ziggy for the key lyric, "You're the blessed/We're the spiders from Mars," that prompts shots of the audience. But where the full lighting of equivalent cutaways in other concert films, especially *Born to Boogie*, allows the fans to be seen clearly, here the saturation often blurs the images to create almost abstract color figurations. All the erratic flashes of the strobes can reveal in the ecstatic nightmare are momentary hallucinations, open-mouthed faces etched on the grain of the film.

Apart from two further brief returns to the assistants backstage for costume changes, the film consists entirely of Ziggy, the Spiders, and the teenage fans massed in delirium at the front of the stage. The backstage interludes and the fans make it less exclusively a "filmed concert" than the only previous major documentary about one concert by a single band, *Ladies and Gentlemen: The Rolling Stones*, shot the previous week in Texas. But Pennebaker's fidelity to the concert itself and to Direct Cinema's observational, non-interventionist principles, much more closely observed here than in *Monterey Pop*, supplies the film's immediate power and its historical significance. A veteran of several other music documentaries since *Monterey Pop*, including a short film about

the US glitter rocker *Alice Cooper*, Pennebaker was by now the greatest virtuoso of all rock 'n' roll cameramen. Though the kinetic montages of Ziggy, the Spiders, and the audience involve editorial interventions alternating among the views provided by the three main cameras, almost all the camerawork is handheld, producing long takes among which Pennebaker's own are especially brilliant. His dance with the music and the musicians transforms the limitations of the handheld cameras, the use of available light, and adherence to chronological continuity into a visual language whose sophistication elaborates the stripped intensity and complexity of Ziggy's music.

Unlike Alice Cooper's earlier elaborate productions and Bowie's own later concert tours, the Ziggy shows took place on a bare stage with little illumination, mostly spotlights on him or band members interacting with him. Working under these constrained conditions, with a very small crew, and no control over the stage or other lighting, Pennebaker concentrated on Ziggy himself. The three and a half minutes of "Ziggy Stardust," for example, the second song, are covered in just seven shots (Figure 18.6). It begins with a wide-shot from stage front with a tiny Ziggy in center frame, his arms held high for assistants to take the satin cloak and reveal his next costume, a white dress. As the rhythm section joins Ronson's guitar, he walks forward and the camera zooms in to meet him. Exactly as he begins to sing, Pennebaker cuts to his own low-angled close-up on the side of Ziggy's face. Held for almost a minute, the shot follows his movements, constantly adjusting framing and focus to maximize his visual presence. An almost imperceptible cut introduces a fresh perspective on his face, but immediately the camera zooms back, placing Ziggy in the bottom right-hand corner of the frame in a forty-second

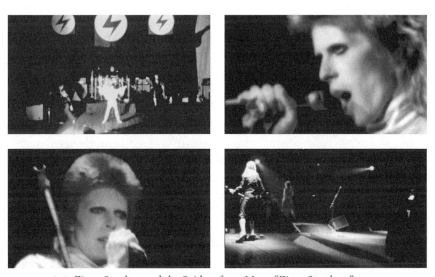

FIGURE 18.6 Ziggy Stardust and the Spiders from Mars, *"Ziggy Stardust."*

wide shot that also allows the strobes momentarily to reveal the stage. Three short shots give a rear view of Ziggy, a view from the audience, and a view of the musicians, before Pennebaker picks up his own close-up for the conclusion of the song. The coverage of other songs is not always as precisely orchestrated to the music and the visual field as this, but the alternation of long takes from two or three cameras is the dominant stylistic feature. Pennebaker's commitment to a record of an immediate apprehension of Bowie's stage show nevertheless allowed him to create visual analogues to the tensions in the Ziggy persona and his music's dramatizations of them. The cameramen and the editors amplify Ziggy's audio-visual spectacle as if they were visual musicians recruited to the Spiders from Mars.

Enacted within a dystopia of artifice, Ziggy's performance is, like the earlier countercultural spectaculars it invokes, the basis of a utopian commonality created imaginatively, musically, and filmicly both within and beyond the alienation of commodity relationships, a transcendant moment celebrated jointly by David Jones, Bowie, Ziggy, the Spiders, the fans, and Pennebaker's crew (Figure 18.6). As Ziggy brings all these together for the last time—until the film is seen—the summary performance of the continually enacted suicidal redemption occurs twice: once immediately before the intermission, when in the last stanza of "My Death," after the line "for in front of that door, there is . .," one audience member after another calls out "Me!" and Bowie smiles slightly and says, "Thank You." And again just before the final song, he makes the astonishing announcement, "Not only is this the last show of the tour, but it's the last show that we'll ever do," and terminates Ziggy's career.[18] Although the Hammersmith concert ended with Ziggy's "Rock 'n' Roll Suicide" and with David Bowie's unexpected suiciding of Ziggy and the Spiders, the final song still affirmed a commonality of love and redemption among the singer, his alter-ego, and their fans. Even though "All the knives seem to lacerate your brain," still the final strophe affirms community:

> Let's turn on and be not alone—wonderful
> Gimme your hands cause you're wonderful—wonderful
> Gimme your hands cause you're wonderful—wonderful
> Oh gimme your hands.

A generation of alienated teenagers imaginatively transform themselves into a conspiracy of aliens, a company of the ecstatic damned.

Half a decade earlier at Monterey, Pennebaker had made Otis Redding's announcement of the "love generation" the pivot of the first great counterculture rock film; at Hammersmith, he transcended its collapse, transcended the murders and deaths with which *Gimme Shelter*, *Lady Sings the Blues*, and *Nashville* culminated, and turned a commercial advertising assignment into a euphoric celebration. Direct Cinema had been among the casualties of *Gimme Shelter*, but in *Ziggy*, Pennebaker triumphantly reasserted cinema's power to

reproduce and disseminate popular music, to create a rock 'n' roll visuality, and to dance with rock 'n' roll. Though it took him thirty years to bring his film to light, hardly a greater cinematic gift to rock 'n' roll could be imagined.

But Bowie's insistence on "Changes" and his warning in the song of that name to "you rock 'n' rollers" to look out and "turn and face the strange" referenced profound transitions in the musical era that had begun in the mid-fifties. Even the Rolling Stones on the title track to their 1974 album, *It's Only Rock 'n' Roll* recognized that rock 'n' roll demanded the spectacle of self-annihilation when (with Bowie singing backup) Jagger offered his fans a consummation like Ziggy's: "If I could stick a knife in my heart/Suicide right on stage/Would it be enough for your teenage lust/Would it help to ease the pain?" Though Bowie never performed live again as Ziggy, his next album, *Diamond Dogs*, recorded during the winter of 1973–1974, continued the glam post-apocalyptic vision, constructing it loosely on George Orwell's *1984*, though the objection of the Orwell estate prevented him from turning it into a stage show. The following summer, he returned to the United States, to Philadelphia where Bill Haley had first made his mark exactly twenty years before, and with funk musicians Carlos Alomar and Luther Vandross on the album *Young Americans* (1974) he constructed another biracial music. But terming it "plastic soul," he affirmed the artifice, not the sincerity, of a Londoner making black American music.

As autonomous white and black music revolutions emerged in the mid-seventies in punk and hip-hop, Bowie himself turned to new forms of music and to new forms of audio-visual music. He made extensive but unrealized preparations for a *Diamond Dogs* film, and continued to appear in other features: he reincarnated Ziggy in 1976 as Newton in Nicolas Roeg's *The Man Who Fell to Earth*, had a turn as a three-hundred-year-old vampire in *The Hunger* (Tony Scott, 1983), and later revisited the birth of modern English working-class musical subcultures in Julian Temple's *Absolute Beginners* (1986). But fundamentally more important were his own music videos. One shot by Mick Rock of him performing "Space Oddity" was used to promote the record's re-release in the United States, and in late 1972 Rock shot a promotional video for "The Jean Genie," condensing Pennebaker's alternating long takes into the rapid montages that quickly came to characterize the new form. At the end of the decade, the Buggles had the first MTV hit with a song from their 1980 album *The Age of Plastic*, "Video Killed the Radio Star." And in August 1980, dressed in the Pierrot costume he had invoked earlier in the decade and which Kenneth Anger had used in *Rabbit's Moon*, Bowie resuscitated Major Tom for the iconic video for "Ashes to Ashes." It revealed his mastery of what subsequently became the most comprehensive mode of rock 'n' roll visuality and the form in which the moving image everywhere engaged its dance with popular music.

{ NOTES }

Chapter 1

1. Béla Bartók believed *Le Sacre du Printemps* (*The Rite of Spring*) to be "one of the best examples of the intensive permeation of art music by genuine peasant music"; "The Relation of Folk Song to the Development of the Art Music of Our Time" (1921) in Benjamin Suchoff, ed., *Béla Bartók: Essays* (New York: St. Martin's Press, 1978), p. 325. In Elvis's second film, *Loving You*, his manager invoked the riots that greeted *The Rite of Spring* in defending him against censorious town elders. In 2005, Augusta Read Thomas received a commission from the Memphis Symphony Orchestra and the Music Library Association for an eight-minute work for orchestra, *Shakin': Homage to Elvis Presley and Igor Stravinsky*.

2. Quoted in Peter Guralnick, *Careless Love: The Unmaking of Elvis Presley* (Boston: Little, Brown, 1999), p. 350.

3. "The Camp Meeting Jubilee" appears on the Document Records' album, *The Earliest Negro Vocal Quartets (1894–1928)*. The film *Transatlantic Merry-Go-Round* (Benjamin Stoloff, 1934) included a song called "Rock and Roll," which invoked the earlier nautical use of the phrase; see William H. Young and Nancy K. Young, eds., *The Great Depression in America: A Cultural Encyclopedia* (Westport, CT: Greenwood Press, 2007), p. 506.

4. Of the many histories of rock 'n' roll, I have found Jim Curtis's *Rock Eras: Interpretations of Music and Society, 1954–1984* (Bowling Green, OH: Bowling Green State University Popular Press, 1987) the most useful. For African American popular music from the late 1950s to the early 1970s, Brian Ward's *Just My Soul Responding: Rhythm and Blues, Black Consciousness, and Race Relations* (Berkeley: University of California Press, 1998) is indispensable. Though distinct and mutually exclusive "black" and "white" musical elements cannot be defined, still functional historically specific generalizations do allow distinctions between the more assertive and complex rhythmic tendencies of African and African American music and the harmonically richer European music. Though rock 'n' roll is properly characterized as fundamentally a white assimilation of black musical styles, US and UK popular music from the mid-1950s to the end of the 1960s was characterized by especially open interchanges in both directions. For the theoretical justification of the use of the concepts of black and white music in this period, see Ward, *Just My Soul Responding*, pp. 7–8.

5. According to David Halberstam, by early 1956 the thirteen million US teenagers had a total income of seven billion dollars, 26% more than three years earlier; see *The Fifties* (New York: Villard Books, 1993), p. 473. Jon Savage has traced the history of teenagers from the late nineteenth century British and US hooligan and the Parisian Apache gangs, through the flappers and the French Zazous and German Pirates based on swing music, to their emergence as a distinct social and marketing demographic in the United States at the end World War II. First appearing in print in 1941, the term "teenager" had

become accepted by 1944, when *Seventeen*, a magazine for girls, was launched, and in January 1945 the *New York Times* published "A Teen-Age Bill of Rights"; see Jon Savage, *Teenage: The Creation of Youth Culture* (London: Chatto & Windus, 2007). The term "youth culture" was coined by Talcott Parsons in an essay, "Age and Sex in the Social Structure of the United States," *American Sociological Review* 7 (1942): 604–616. Parsons proposed that at the offset of adolescence, "a set of patterns and behavior phenomena which involve a highly complex combination of age grading and sex role elements" (p. 606) emerges, different from the kind of responsibility displayed by adult males; this "specifically irresponsible" culture with a "particularly strong emphasis on social activities in company with the opposite sex" (pp. 606–607) was characterized by "a strong tendency to develop in directions which are either on the borderline of parental approval or beyond the pale, in such maters as sex behavior, drinking and various forms of frivolous and irresponsible behavior" (608).

6. See Richard A. Peterson and David G. Berger, "Cycles in Symbol Production: The Case of Popular Music" in Simon Frith and Andrew Goodwin, eds., *On Record: Rock, Pop, and the Written Word* (New York: Pantheon Books, 1990).

7. *Life* 38.16 (April 18, 1955): 166–68.

8. "Rock-and-Roll Called 'Communicable Disease,'" *New York Times*, March 28, 1956, p. 33.

9. "White Council vs. Rock and Roll," *Newsweek*, April 23, 1956, p. 32. On the same page, the magazine also reported that members of the Citizens Council had assaulted Nat King Cole during a performance in his hometown of Montgomery in retaliation for his singing with white women. For extended details of racist attacks on black musicians, see Ward, *Just My Soul Responding*, pp. 95–109.

10. Davis was quoted in Steve Chapple and Reebee Garofalo, *Rock 'n' Roll Is Here to Pay: The History and Politics of the Music Industry* (Chicago: Nelson-Hall, 1977), p. 47; Sinatra was quoted in Gertrude Samuels, "Why They Rock 'n Roll—And Should They?" *New York Times Magazine*, January 12, 1958, p. 18. Linda Martin and Kerry Segrave provide a comprehensive history of what they term "rock-bashing" from the mid-1950s to the mid-1980s in *Anti-Rock: The Opposition to Rock 'n' Roll* (Hamden, CT: Archon Books, 1988).

11. The sociology of classical music had been developed and codified early in the twentieth century, most notably by Max Weber in *Die rationalen und soziologischen Grundlagen der Musik* (1921) (tr. *The Rational and Social Foundations of Music* [Carbondale: Southern Illinois University Press, 1958]), but significant attention to popular music and the culture industries generally began with Theodor Adorno and Max Horkheimer. Though based on the standardization and pseudo-repetition he found in 1930s commercial light music, Adorno's analysis of the social function of distraction remains fundamental to the understanding of capitalist entertainment generally, including much popular music: "Distraction is bound to the present mode of production, to the rationalized and mechanized process of labor to which, directly or indirectly, masses are subject. This mode of production, which engenders fears and anxiety about unemployment, loss of income, war, has its 'nonproductive' correlate in entertainment; that is, relaxation which does not involve the effort of concentration at all. People want to have fun." "On Popular Music," rpt. in Frith and Goodwin, eds., *On Record: Rock, Pop, and the Written Word*, p. 310. Despite Adorno being made a *bête noire* in 1990s affirmative cultural studies, nothing in his analysis of 1930s light music, which lacked rock 'n' roll's social transgressiveness,

could be reconstructed as a putative Adornian critique of the later music. In fact, he specifically excepted "youngsters who invest popular music with their own feelings" (p. 314, n. 3) from the processes of distraction. David Riesman understood the immediate antecedents of rock 'n' roll similarly in his 1950 essay "Listening to Popular Music," in which he differentiated between majority and minority attitudes among teenage popular music fans; whereas the former are indiscriminate consumers, the latter group "comprises the more active listeners, who are less interested in melody and tune than in arrangement or technical virtuosity. It has developed elaborate, even overelaborate, standards of music listening." "Listening to Popular Music," in Frith and Goodwin, eds., *On Record*, p. 9. Somewhat later, Stuart Hall and Paddy Whannel formulated distinctions among "folk art," "popular art," and "mass culture," arguing for a continuity between pre-industrial folk art and popular artists such as Charlie Chaplin or Miles Davis, yet for a categorical break between them and mass art where "the formula is everything—an escape from, rather than a means to, originality. . . . Mass art uses the stereotypes and formulae to simplify the experience, to mobilize stock feelings and to 'get them going.'" Stuart Hall and Paddy Whannel, *The Popular Arts* (New York: Pantheon Books, 1965), p. 69.

12. Chester Anderson, "Rock and the Counterculture," *San Francisco Oracle* 1 (1967): 2, 23; in Theo Cateforis, ed., *The Rock History Reader* (New York: Routledge, 2013), p. 96.

13. Ralph J. Gleason, "Like a Rolling Stone," *The American Scholar* 36.4 (Autumn 1967): 555.

14. Jann Wenner, "Musicians Reject New Political Exploiters," *Rolling Stone* 1.10 (May 11, 1965): 22.

15. Wenner, "Musicians Reject New Political Exploiters," p. 1.

16. Eldridge Cleaver, "Convalescence," in *Soul on Ice* (New York: McGraw-Hill, 1968), p. 195.

17. Jerry Rubin, *Do It!* (New York: Ballantine Books, 1970), pp. 17–19.

18. The patterned sounds we know as *music* are generated by and generate psychic, social, and material relations in the minds, bodies, and activities of the people who produce and receive them. Like the *mode of film production* (or *cinema*), any given *mode of musical production* involves the interaction between two apparatuses, the one psychic and somatic and the other institutional and material. The former consists of the physical and mental procedures, skills, and pleasures though which music is created and perceived, and the latter all the agencies and establishments in which the sounds exist and which they bring into existence: musicians, critics, fans, and audiences; performances, concerts and concert halls, musical instruments, records and record players, music schools, radio, and television programs—and films. During the postwar industrialization of popular music, both apparatuses expanded and proliferated exponentially.

19. Cf. "Though all industrial mass production necessarily eventuates in standardization, the production of popular music can be called 'industrial' only in its promotion and distribution, whereas the act of producing a song-hit still remains in a handicraft stage. The production of popular music is highly centralized in its economic organization, but still 'individualistic' in its social mode of production." Adorno, "On Popular Music," p. 306.

20. See Peterson and Berger, "Cycles in Symbol Production," p. 142.

21. Jacques Attali, *Noise: The Political Economy of Music* (Minneapolis: University of Minnesota Press, 1985), p. 140. Written in 1977, Attali's theorization of transformations in

the mode of musical production proposing an emancipatory component in rock 'n' roll at the point of popular production was, however, only one moment in his more comprehensive analysis of its overall industrial recuperation, colonization, sanitization, and banalization, through which it becomes a mechanism of social control: "It creates a system of apolitical, nonconflictual, idealized values. It is here that the child learns his trade as a consumer" (ibid., p. 110). Rick Altman approached similar questions in *The American Film Musical* (Bloomington: Indiana University Press, 1989). He proposed that the ideological accomplishment of the classical film musical narrative reflects the additional social function of the songs, which he calls the musical's "operation role": "the societal practices directly influenced, enabled, or engendered" by a genre (p. 353). Since the songs were deliberately "written for the [unamplified] voice and piano," and also "self-consciously written not to surpass the range and capacities of the average amateur music lover," they provided the basis for various kinds of amateur domestic practice, rather than mere passive consumption. This popular practice was sustained and mediated by the sale of sheet music, so that "for over a quarter-century the musical and the sheet music industry together combined to provide the nation's most powerful defense against mass-mediated passivity" (p. 352). The emergence of "Electronic Reproduction," specifically "the rise of the original-cast recording in the late forties along with the long-playing record" (p. 353) and the mass circulation of recordings, especially of records that were no longer "simply recordings of live performance, but electronically created in studio" (p. 355) ended this period of participatory interchange: "Where once American popular music had provided a liberating impulse working against the very media serving as its vehicle, now that same music fully deserved the criticisms leveled at it by Adorno" (p. 356). For Altman, the decline of the classic musical represented the last stage in the destruction of truly popular music and its commodification. Since the nineteenth century, a growing rift between amateur and professional endangered the previous "situation where composition, listening and performance remain[ed] interchangeable community activities" (p. 348). Altman recognizes that in the 1930s and 1940s, theater and film musicals had enabled and managed a fundamental reciprocity between the production and consumption of music as commodified entertainment and the popular re-creation of the same songs; but, refusing to recognize that rock 'n' roll films also provide the basis for popular practice, he argues that it coincided with and in fact caused the collapse of the formal and structural possibilities of the musicals themselves:

> From the films of Elvis Presley and the teenie-bopper beach blanket shows starring Frankie Avalon and Annette Funicello to the rock concert documentaries of the seventies . . . the musical has slowly destroyed itself by losing its balance between narrative and music, indeed by abandoning the classic syntax whereby narrative is not just an excuse for music, but stands in a particular, structured relationship to that music. This way, in short, lies the musical as illustrated record album. This way lies MTV (p. 121).

22. *Rock Eras*, p. 4.

23. Hall and Whannel, *The Popular Arts*, p. 276.

24. Where earlier sociology attempted to read music's social meaning from its intrinsic formal properties, recent projects modeled on reader-response literary analysis recognize that musical meaning is created in " human-music interaction, "so that "musical

affect is constituted reflexively, in and through the practice of articulating or connecting music with other things"; Tia DeNora, *Music in Everyday Life* (Cambridge: Cambridge University Press, 2000), p. 33.

25. Filmmakers and film theorists have explored the musical structuration of film images almost since the beginning of cinema. Around 1912, the painter Léopold Survage made abstract animations based on musical principles, while in the 1920s French critic Émile Vuillermoz suggested orchestrating images "according to a strictly musical process." The history of abstract visual music derives from these ideas, most notably in the work of Oskar Fischinger, but they have also been important for non-abstract filmmakers, especially Sergei Eisenstein. James Tobias has explored the musicality of these and other filmmakers in *Sync: Stylistics of Hieroglyphic Time* (Philadelphia: Temple University Press, 2010), where the Vuillermoz quote appears (p. 19). His foundational definition of musicality proposes that it "comprises those effects of music as they may be performed or presented in other than auditory media: performances that may only mime or otherwise do not produce audible music, or qualities specific to music presented in visual terms." (p. 19).

26. Though the present account focuses on cinema, television enters its story in many ways, being integral to both rock 'n' roll's development (especially in popularizing it outside urban centers) and to cinematic negotiations with it; filmic depiction of rock 'n' roll television and filmic projects initially conceived for the other medium are two of the most important. Beginning in the early 1950s, teen dance shows with popular stars lip-synching to current hits emerged locally before moving to the networks, most importantly *Bandstand*, renamed *American Bandstand* in 1957 and running for thirty-five years. Rock 'n' roll was also popularized in variety shows including *The Steve Allen Show, The Tonight Show*, and *The Ed Sullivan Show*.

27. As early as 1958, Robert Brustein traced an important genealogy of such variously vulnerable, inarticulate, narcissistic, and rebellious figures from the proletarian heroes of 1930s Group Theatre through Brando, Dean, Paul Newman, and Montgomery Clift to Elvis in *Jailhouse Rock* in "America's New Culture Hero: Feeling Without Words," *Commentary* 25 (Fall 1958): 123–129. Brustein saw Elvis as performing such an inarticulate character, and also as being its "musical counterpart": "Beginning by ignoring language, rock and roll is now dispensing with melodic content and offering only animal sounds and repetitive rhythms. In Elvis Presley, the testament of Stanley Kowalski is being realized," p. 129.

28. Richard Fehr and Frederick G Vogel, *Lullabies of Hollywood: Movie Music and the Movie Musical, 1915–1992* (Jefferson, NC: McFarland, 1993), p. 1.

29. Books about film and rock 'n' roll include David Ehrenstein and Bill Reed, *Rock on Film* (New York: Putnam's, 1982); Rob Burt, *Rock and Roll: The Movies* (Poole, UK: Blandford Press, 1983); Linda J. Sandahl, *Encyclopedia of Rock Music on Film* (Poole, UK: Blandford Press, 1987); R. Serge Denisoff and William Romanowski, *Risky Business: Rock in Film* (New Brunswick, NJ: Transaction, 1991); Marshall Crenshaw, *Hollywood Rock: A Guide to Rock 'n' Roll in the Movies* (New York: Harper-Perennial, 1994); Jonathan Romney and Adrian Wootton, eds., *Celluloid Jukebox: Popular Music and the Movies since the 1950s* (London: British Film Institute, 1995); Kevin Donnelly, *Pop Music in British Cinema* (Berkeley: University of California Press, 2001); Pamela Robertson Wojcik and Arthur Knight, eds., *Soundtrack Available: Essays on Film and Popular Music*

(Durham, NC: Duke University Press, 2002); Ian Inglis, ed., *Popular Music and Film* (New York: Wallflower Press, 2003); John Kenneth Muir, *The Rock & Roll Film Encyclopedia* (New York: Applause Theatre & Cinema Books, 2007); and David Laderman, *Punk Slash! Musicals* (Austin: University of Texas Press, 2010). The last of these, *Punk Slash! Musicals*, is a unique consideration of a specific musical form and the moving image culture associated with it. Journalistic overviews of films about rock 'n' roll include Richard Staehling, "The Truth about Teen Movies," *Rolling Stone* 49 (December 29, 1969), 34–47; Thomas Weiner, "The Rise and Fall of the Rock Film," *American Film* 1.2 (November 1975): 25–29 and 1.3 (December 1975): 58–63; Greil Marcus, "Rock Films" in Jim Miller, ed., *The Rolling Stone Illustrated History of Rock & Roll* (New York: Random House, 1976), pp. 390–400; Dave Marsh, "Schlock Around the Clock," *Film Comment* 14 (August 18, 1978): 7–13; Carrie Rickey, "Rockfilm, Rollfilm" in Anthony DeCurtis and James Henke, eds., *The Rolling Stone Illustrated History of Rock & Roll: The Definitive History of the Most Important Artists and Their Music* (New York: Random House, 1992), pp. 111–120; and Howard Hampton, "Scorpio Descending: In Search of Rock Cinema," *Film Comment* 33.2 (March–April 1997): 36–42; Hans J. Wulff, "Rockumentaries. Eine Arbeitsbibliographie," *Kieler Beiträge zur Filmmusikforschung* 5.1 (2010): 158–167; www.filmmusik.uni-kiel.de/KB5/KB5.1-Biblio. pdf (accessed 9/25/2010) is a bibliography of writings on rock 'n' roll and cinema.

30. Altman, *The American Film Musical*, p. 92.

31. A remake of *Ninotchka* and one the last of Arthur Freed's great MGM musicals, *Silk Stockings* culminates, not in a duet between the two stars, Astaire and Cyd Charisse, but in Astaire's own "The Ritz Roll and Rock." With his trademark top hat and tails, his dance appears to be an appropriation of elements of rock 'n' roll into the more sophisticated form of the musical proper, even though it is not entirely clear whether Cole Porter's lyrics indict or celebrate its appropriation by the "smart set." Astaire sings of how, finding it "much too tame," "they jazzed it up and changed its name"; now "all they do around the clock is the Ritz Roll and Rock," "dowagers and diplomats behave like alley cats," and "fancy fops and fillies . . . make those hick hillbillies look like squares." Astaire's own skills and his position within the "smart set" appears to signal the superiority of the genre he had served so beautifully, and it wins him Ninotchka.

32. On the rock 'n' roll films and classic musicals, see Barry K. Grant, "The Classic Hollywood Musical and the 'Problem' of Rock 'n' roll," *Journal of Popular Film & Television* 13.4 (Winter 1986): 195–205. Grant notes the importance of rock 'n' roll's rising popularity and industry convergence in producing conglomerates dealing in both films and records whose interests were served by the promotion of the new music, but argues that rock 'n' roll films often forced the music to fit earlier conventions, with the result that in them "rock 'n' roll changed more than did the musical film" (p. 199). Two important precursors to rock 'n' roll feature films were Soundies and Scopitones. Made in the United States between 1940 and 1946, Soundies were short films of popular music and dance performance that played on Panoram visual jukeboxes in bars and restaurants. Originating in France in 1958 and flourishing for a decade, Scopitones were similar short films for jukeboxes; they too featured many forms of popular music, but little rock 'n' roll.

33. The integrated form is best exemplified by Vincente Minnelli's work for the Freed unit at MGM, beginning with *Meet Me in St. Louis* (1944) and culminating in *An American in Paris* (1951) and *The Band Wagon* (1953). But the distinction between musicals in which diegetically and stylistically autonomous discrete numbers interrupt the narrative in the

manner of Berkeley's 1930s films and those in which the songs, dance, and other elements are all integrated into it, organically emerging from it and furthering its progress, is not entirely categorical. The many interim degrees of integration have been schematized as follows: (1) those that "are completely irrelevant to the plot" (as when the characters watch an arbitrary nightclub performance); (2) those that "contribute to the spirit or theme"; (3) those "whose existence is relevant to the plot, but whose content is not" (as in show business musicals in which important characters are themselves performers); (4) those that "enrich the plot, but do not advance it, by establishing a situation or atmosphere or displaying character, but that could be removed without causing noticeable continuity gaps (love duets, for example); (5) those that "advance the plot, but not by their content" (as with a successful audition performance); and (6) those that "advance the plot by their content." See John Mueller, "Fred Astaire and the Integrated Musical," *Cinema Journal* 24.1 (Fall 1984): 28–40 (quotes pp. 28–31). Minnelli excelled in numbers in the last category. "Dancing in the Dark," for example, from *The Band Wagon*, in which the discovery that the Astaire and Cyd Charisse characters can in fact dance together transforms their relation with each other and the possibilities of the plot. Mueller also notes that though musicals featuring numbers of the third category are usually designated as unintegrated, if the story concerns the process of putting on a show, then the accumulation of such numbers does integrate them into the plot. This is the case with most rock 'n' roll musicals.

34. Rick Altman developed the notion of the "dual focus" in his magisterial *The American Film Musical*, to which I am fundamentally indebted, here especially to pp. 16–27. For Altman the gendered dual focus is feature of all musicals, and he curtly summarizes: "No couple, no musical" (p. 103).

35. Astaire cited in John Mueller, *Astaire Dancing—The Musical Films* (London: Hamish Hamilton, 1986), p. 26.

36. Ironically, the big band music instanced by Whiteman is precisely the kind of music against which rock 'n' roll would react, specifically in the first extended rock 'n' roll narrative film, *Rock Around the Clock* (1956). *Strike Up the Band* especially resembles another early rock 'n' roll film, *Rock, Pretty Baby!* (Richard Bartlett, 1956): its hero, also called Jimmy, also comes from a middle-class family, and against his father's wishes aspires to being a musician rather than a doctor, and it too culminates in a contest for high-school bands, though in this case it is broadcast on television rather than radio.

37. "The Self-reflective Musical and the Myth of Entertainment," *Quarterly Review of Film Studies* 2.3 (August 1977): 313–326; rpt., Rick Altman, ed., *Genre: The Musical* (London: Routledge and Kegan Paul, 1981), pp. 159–174, and subsequently elaborated in the book, *The Hollywood Musical*, 2nd ed. (Bloomington: Indiana University Press, 1993). Feuer does not use the term "commodity relations." Altman's term for "backstage" musicals is "show" musicals and he distinguishes them from "folk" musicals in terms similar to Feuer's: see *American Film Musical*, pp. 200–270. Like Feuer, he argues that the folk musical attempts to conceal the commodity relations it involves: "In short, the folk musical preaches a gospel of folk values to an age of mass media. It creates a myth to dissemble the break between production and consumption, between capital and labor, between past and present. Yet paradoxically this folk message, this attempt to reconstitute a national folk, must be carried by the very mass media which represents its avowed enemy" (*American Film Musical*, p. 322).

38. Feuer, "The Self-reflective Musical," in Altman, *Genre: The Musical*, p. 160.

39. Hall and Whannel, *The Popular Arts.*

40. Feuer, *The Hollywood Musical*, p. 3.

41. Feuer, *The Hollywood Musical*, p. 16.

42. An important Hollywood subset of this genre couples the rise of an actress with the corresponding decline of the actor who discovers her. The best known is *A Star Is Born* (William A. Wellman, 1937), remade by George Cukor with Judy Garland in 1954 and adapted to popular musicians in Frank Perry's 1976 version starring Barbra Streisand and Kris Kristofferson.

43. Biopics about jazz musicians continued after the emergence of rock 'n' roll with, for example, *The Gene Krupa Story* (Don Weis, 1959), *The Five Pennies* (Melville Shavelson, 1959) (about Red Nichols), *Lady Sings the Blues* (Sidney J. Furie, 1972) about Billie Holliday, *Bird* (Clint Eastwood, 1988), and *Round Midnight* (Bertrand Tavernier, 1986), a fictionalized composite of Bud Powell and Lester Young. Of the many biopics about rock 'n' roll musicians and tributary forms of music, the most interesting include *Your Cheatin' Heart* (Gene Nelson, 1964), about Hank Williams; *Leadbelly* (Gordon Parks, 1976); *The Buddy Holly Story* (Steve Rash, 1978); *The Rose* (Mark Rydell, 1979), based on Janis Joplin; *Coal Miner's Daughter* (Michael Apted, 1980), about Loretta Lynn; *Sid and Nancy* (Alex Cox, 1986), about Sid Vicious; *La Bamba* (Luis Valdez, 1987), about Richie Valens; *Great Balls of Fire!* (Jim McBride, 1989), about Jerry Lee Lewis; *The Doors* (Oliver Stone, 1991) focusing on Jim Morrison; *What's Love Got to Do with It* (Brian Gibson, 1993), about Tina Turner; *Ray* (Taylor Hackford, 2004), about Ray Charles; *Control* (Anton Corbijn, 2007), about Joy Division's Ian Curtis; *Walk the Line* (James Mangold, 2005), about Johnny Cash; and *Get On Up* (Tate Taylor, 2014) about James Brown.

44. Frank Zappa, "The Oracle Has It All Psyched Out," *Life*, June 29, 1968, p. 85.

45. Again, Frank Zappa: "To deny rock music its place in the society was to deny sexuality. Any parent who tried to keep his child from listening to, or participating in this musical ritual was, in the eyes of the child, trying to castrate him." "The Oracle Has It All Psyched Out," p. 86. The psychoanalysis of visual pleasures has been extensively theorized: pleasure in looking at other people in cinema is supposed to be a variable combination of identification with and symbolic possession of the visible object in processes that are specifically gendered. In general, heterosexual men derive pleasure from visual identification with male ego ideals and visual consumption of female erotic objects, while women are divided by more complex patterns of identification and desire; these scopic regimes are constantly in flux, and any given film may shift and destabilize the dominant patterns of identification. In the absence of any similarly developed psychoanalysis of musical pleasure, it may be assumed that listening and especially listening to music involve similar libidinal transactions operating at an interface between biological sensuality and cultural coding. The production and apprehension of sonic patterns organized in respect to pitch, rhythm, duration, color, and so on and—especially in the case of singing, the timbre or grain of the human voice—create circuits where the drive to hear may, if not realize its object, still circle around it in ongoing pleasure. These processes may be especially rich, realized consciously as well as unconsciously, in the case of popular song, which is so commonly erotically invested, if not so specifically gendered as are scopic relations among people. Religious music, opera, *lieder*, and modern pop are all fundamentally concerned with the pleasures and pains of love, and no less than other music, popular songs typically offer a spectrum of opportunities for identification that multiply

across gender roles, especially with the sliding signification of pronouns in the lyrics. In Freud's theory of human sexuality, *drives* (*Triebe*) are fundamental. Unlike instincts, which reflect purely biological needs, drives are simultaneously somatic and psychic, and hence cultural and symbolic. Jacques Lacan's elaboration of the nature of drives in *The Four Fundamental Concepts of Psycho-Analysis* (New York: Norton, 1978) maintains the distinction, but adds that they can never be satisfied and in fact do not aim at completing a relationship with an object, but rather circle around it, the repetitive movement itself being the source of pleasure. (His phrase, *la pulsion en fait le tour*, contains a pun according to which the drive both tours and tricks the object [p. 168]). These drives are always partial (this reiterating Freud's phrase, "partial drives") in that sexuality participates in psychic life "in a way that must conform to the gap-like structure of the unconscious" (p. 176). The four partial drives are the oral (to suck, located at the lips), the anal (to defecate, located at the anus), the scopic (to see, located at the eyes), and the invocatory (to hear, located at the ears). Though it may be entailed in various forms of attention to the buttocks, the anal drive is not prominent in rock 'n' roll, a conspicuous exception being punk rocker G. G. Allin, as documented in *Hated: G G. Allin and the Murder Junkies* (Todd Phillips, 1994). But the scopic and invocatory desire are. An unusually lucid explicator of Lacan notes that a drive "originates in an erogenous zone, circles round the object, and then returns to the erogenous zone," all in a circuit "structured by three grammatical voices": active (for example, to see), reflexive (to see oneself), and passive (to be seen); see Dylan Evans, *An Introductory Dictionary of Lacanian Psychoanalysis* (London; New York: Routledge, 1996), pp. 46–48. These scopic and invocatory circuits are fundamental to the phenomenology of concert attendance and of musical cinema.

46. These issues have been addressed by Michel Chion in *Audio-Vision: Sound on Screen*, ed. and trans. Claudia Gorbman (New York: Columbia University Press, 1994). Despite proposing that film should be understood as a combined audio-visual mode of perception (which would appear to imply a union of sight and sound, simultaneously apprehended in both modes), Chion consistently presents sound as subordinate and supplementary; it is an "added value" (p. 5) to the image, and "most cinema" is defined as "'a place of images, plus sounds'" (p. 68). Rick Altman more acutely notes that the "reversal of the image/sound hierarchy lies at the very center of the musical genre" and cites the Busby Berkeley production number as the point at which "*Everything—even the image—is now subordinated to the music*" (italics in original); *The American Film Musical*, p. 71. Astaire's contrary priorities—"Either the camera will dance, or I will"—privileged the single shot, with a virtually stationary camera that kept the singers and dancers in full view through the entire sequence. Berkeley and Astaire exemplify, respectively, what may be thought of as the "Eisensteinian" and the "Bazinian" models of audio-visual musical composition. Between them lies the issue of whether the relation between the image and the music should be one of similarity or contrast, parallelism or counterpoint. Addressing this question in 1944, Theodor Adorno and Hanns Eisler attacked parallelism: "Why should one and the same thing be reproduced by two different media? The effect achieved by such a repetition would be weaker rather than stronger." *Composing for the Films* (rpt. London: Continuum, 2007), pp. 44–45. In Berkeley's sequences, both camera and dancers danced, the sequences were fragmented and kaleidoscopically rearranged in the editing and elaborated with non-diegetic metaphors; but the music directed the visuals' structure. In the earliest rock 'n' roll films, parallelism dominated because it

was easier and cheaper, but as the rock 'n' roll film grew in importance, more complex audio-visual images were created and the advent of music videos launched unprecedentedly sophisticated compositions derived from experimental film.

47. Carrie Rickey first raised the possibility that a film could embody rock 'n' roll's aesthetic qualities. In her attempt "to identify the distinctive features of the rock-movie genre, the qualities that make rock roll," she excluded all the obvious candidates—films that represent music, including concert movies such as *The T.A.M.I. Show* (Steve Binder, 1964), cinéma-vérité chronicles such as *Gimme Shelter*, and authorized documentaries, such as Madonna: *Truth or Dare* (Alex Keshishian, 1991)—and instead nominated films that mobilize values equivalent to those that she sees as defining rock 'n' roll's cultural ethos: "Movies about youthful charisma, narcissism and sex appeal all dressed up (or down, if you prefer) in death-defying, sometimes death-embracing, attitude," which she dates from *Knock on Any Door* (1949), Nicholas Ray's melodrama about a juvenile delinquent. Her canon begins with *Blackboard Jungle*, whose delinquents first manifested a youth culture separate from that of adults, before it divides into "Sexwatch" and "Deathwatch" subgenres. The former was inaugurated with Elvis's sex drive and rebelliousness in *Jailhouse Rock* (Richard Thorpe, 1957) and continued through the Beatles' more blithe sexuality in *A Hard Day's Night* (Richard Lester, 1964); the latter, in which the protagonist is redeemed in death, began with *The Harder They Come* (Perry Henzell, 1973) and continued in similar martyr biopics from *The Buddy Holly Story* (1978) to *The Doors* (Oliver Stone, 1991) that, like *Knock on Any Door*, feature fast-living young men who die young (see "Rockfilm, Rollfilm," quotations from pp. 113 and 114). *Knock on Any Door* does, in fact, make some association between juvenile delinquents and hot jazz—the rock 'n' roll of the time—but it rather looks back to the gangster films of the 1930s, such as *Angels with Dirty Faces* (Michael Curtiz, 1938) in that its celebration of delinquency is more ambivalent than equivalent films of the sixties and after. David Laderman's *Punk Slash! Musicals* is an exemplary investigation of the way films about punk formally internalize musical properties.

48. Cinema studies has an advantage over musicology in possessing a terminological distinction between "film"—the strip of celluloid imprinted with visual and aural information that is communicated to the spectator—and "cinema"—the ensemble of institutions and processes, of psychic and material apparatuses within which films are produced and consumed, and which they reciprocally sustain, the film's mode of production.

49. A schematization of this field would be bounded by the following limit-case examples: industrial films about industrial musical production, such as *A Hard Day's Night*; industrial films about amateur musical production, such as *The Commitments* (Alan Parker, 1991); amateur or avant-garde films about industrial musical production, such as *Scorpio Rising* (Kenneth Anger, 1964); or *Superstar: The Karen Carpenter Story* (Todd Haynes, 1987); amateur or avant-garde films about amateur musical production, by definition not well known, but *The Blank Generation* (Amos Poe and Ivan Kral, 1976) and *The Punk Rock Movie* (Don Letts, 1978), home movies of early punk in New York and London, respectively, approximate them.

50. Between 1963 and 1969, for "the first time record sales surpassed the gross revenues of all other forms of entertainment"; see Richard A. Peterson and David G. Berger, "Cycles in Symbol Production: The Case of Popular Music," Simon and Goodwin, eds., *On Record: Rock, Pop, and the Written Word*, pp. 152.

51. Although it unaccountably omits substantial reference to popular music, Paul Young's study of competition among the media industries, *The Cinema Dreams Its Rivals: Media Fantasy Films from Radio to the Internet* (Minneapolis: University of Minnesota Press, 2006), appropriately asserts the absoluteness of Hollywood's stake in confronting any new media: "the maintenance of the Hollywood cinema as an *institution* that is and will remain distinct from competing media institutions" (p. xxii).

Chapter 2

1. Evan Hunter, *The Blackboard Jungle; A Novel* (New York: Simon & Schuster, 1954). Born Salvatore Albert Lombino, Hunter later turned to crime fiction, becoming famous as Ed McBain. Brooks was himself a notable contributor to noir novels of the period, having written *The Brick Foxhole* (1947) on which the movie *Crossfire* (Edward Dmytryk, 1947) was based. For production details and analysis of contemporary critical responses to *Blackboard Jungle*, see R. Serge Denisoff and William Romanowski, *Risky Business: Rock in Film* (New Brunswick, NJ: Transaction, 1991), pp. 6–20.

2. Aram Goudsouzian situates *Blackboard Jungle* in Poitier's career in *Sidney Poitier: Man, Actor, Icon* (Chapel Hill: University of North Carolina Press, 2004), especially pp. 100–112.

3. Though it considerably tones down the novel's sex and violence, the film is otherwise a faithful adaptation, except in one main respect: in the novel, Dadier's main antagonist is Miller, rather than West, who, even though he is a delinquent and is sent to reform school, is relatively incidental. The enlargement of West's role makes the film dramatically and thematically simpler, emphasizing white delinquency in place of the novel's complex and sometimes erotically charged focus on racial difference. A decade later, in *To Sir, with Love* (James Clavell, 1967), one of the numerous films about teachers in problem schools inspired by *Blackboard Jungle*, Poitier's role was reversed as he played the teacher in an inner-city London school.

4. Haley had been recording amalgamations of rhythm and blues and country music several years before Elvis, beginning with a country-styled version of Ike Turner's "Rocket '88" in 1951. The basic motif of "Rock Around the Clock" has been traced to an early conjunction of the words "rock" and "roll" in the title of a song, "My Man Rocks Me (With One Steady Roll)," recorded by Trixie Smith in 1922, a version of which, "Round the Clock," was recorded by Wynonie Harris in 1945. Another version, "(We're Gonna) Rock Around the Clock," written by Max C. Freedman, was recorded in Philadelphia in 1953 by a white combo, Sonny Dae and His Knights. Haley regularly performed his cover of this, and recorded it himself, along with "Thirteen Women (and Only One Man in Town)" for Decca in New York on April 12, 1954, a week after the release of Hank Ballard's "Work with Me, Annie" and the same day that Big Joe Turner released "Shake, Rattle and Roll"; see Jim Dawson, *Rock Around the Clock: The Record That Started the Rock Revolution!* (San Francisco: Backbeat Books, 2005), pp. 9–24. The two takes of "Rock Around the Clock" Haley made were edited together for the 2 minute 8 second record, which was released on May 20, 1954, with "Rock Around the Clock," designated as a "fox trot," as the B side. But it proved more popular than "Thirteen Women" and became a regional hit, though initially—before the film—it was nowhere nearly as successful as his previous recording, "Crazy Man, Crazy," or his next, a million-selling cover of Turner's "Shake, Rattle

and Roll" that also crossed over, reaching number 1 on the pop singles charts and 4 on rhythm and blues charts. An orchestral version of "Shake, Rattle and Roll" appeared in *How to Be Very, Very Popular* (Nunnally Johnson, 1955), released some four months after *Blackboard Jungle*. Hayley's performance of "Rock Around the Clock" on the Ed Sullivan Show in August 1955 after *Blackboard Jungle*'s release is believed to have been the first time rock 'n'roll appeared on national television, and later re-releases returned the record to the charts several times in both the United States and Britain, most notably in 1974 after its use in *American Graffiti* (George Lucas, 1973). Dawson notes that "Crazy Man, Crazy," a hit written and recorded by Haley, was featured in a television play starring James Dean as a juvenile delinquent: *Rock Around the Clock*, p. 54.

5. See Dawson, *Rock Around the Clock*, pp. 113–117. Paul N. Reinsch has examined the issues involved in Brooks's inclusion of Haley's song and hence rock 'n'roll in the film in "Music over Words and Sound over Image: 'Rock Around the Clock' and the Centrality of Music in Post-Classic Film Narration," *Music and the Moving Image*, 6.3 (Fall 2013), 3–22. After consulting Brooks's handwritten annotation to the script, Reinsch details the growth of the director's determination to make rock 'n'roll "paramount to the impact" of the film (p. 9).

6. John Sinclair, *Guitar Army; Street Writings/Prison Writings* (New York: Douglas Book, 1972), 13.

7. Hy Hollinger, "Controversial Pic Backfire," *Variety*, September 14, 1956, p. 5, cited in Thomas Doherty, *Teenagers and Teenpics: The Juvenilization of American Movies in the 1950s* (Philadelpia: Temple University Press, 2002), p. 223.

8. In the novel, the only music associated with the teenagers is by Perry Como and Tony Bennett, crooners whom they invoke in preference to the earlier jazz musicians on Edwards's records; Miller and his friends sing European Christmas carols; and Dadier finally captivates his students by telling them a story rather than showing them a film.

9. For information on the production of this revue, see http://www.weirdwildrealm. com/f-rockrollreview.html (accessed July 6, 2010). The version of *Rock 'n'Roll Revue* discussed here is a combination of an earlier one that had a limited release in April 1955, and *Harlem Variety Revue*, released in May. Produced by Louis D. Snader in Hollywood, Snader Telescriptions were, along with Soundies and Scopitones, among the most important precursors to music videos. Some of these numbers, and similar ones from *Rhythm 'n' Blues Revue* and *Basin Street Revue*, were repackaged for a series of thirteen half-hour television shorts, "Show Time at the Apollo" (1955). Next year's *Rockin' the Blues* (Arthur Rosenblum, 1956) was another all-black revue.

Chapter 3

1. "Rock 'n' Roll: A Frenzied Teen-Age Music Kicks Up a Big Fuss," *Life* 38, no. 16 (April 18, 1955), pp. 166–68.

2. See Thomas Doherty's *Teenagers and Teenpics: The Juvenilization of American Movies in the 1950s* (Philadelphia: Temple University Press, 2002), pp. 60–62. Specifically referencing *Teenagers from Outer Space* (Tom Graeff, 1959), Bangs's comment appears in *Psychotic Reactions and Carburetor Dung* (New York: Knopf, 1981), p. 116.

3. The most useful short guide to this and other jukebox musicals below is Mark Thomas McGee, *The Rock and Roll Movie Encyclopedia of the 1950s* (Jefferson, NC: McFarland,

1990). For additional production details, record film tie-ins, and extensive analysis of contemporary critical responses, see R. Serge Denisoff and William Romanowski's *Risky Business: Rock in Film* (New Brunswick, NJ: Transaction, 1991).

4. The scene echoed the occasion when the then-fifteen-year-old Bill Haley discovered his vocation while performing popular songs in the idiom of Gene Autry at a local farmer's market. With his band, the Saddlemen, he had developed what he called "a mixture of western swing, Dixieland, and hard-edge blues" that had become popular as dance music among teenagers in the Philadelphia area; see Jim Dawson, *Rock Around the Clock: The Record That Started the Rock Revolution!* (San Francisco: Backbeat Books, 2005), p. 39. The film thus sets him back in the cultural environment from which he had migrated in developing rock 'n' roll.

5. Formed in Philadelphia in 1951, the white group was, along with Haley, one of the first to cover rhythm and blues hits. Elvis recorded Big Mama Thornton's "Hound Dog" after seeing them perform it in Las Vegas.

6. *Day at the Races* (Sam Wood, 1937), *Manhattan Merry-Go-Round* (Charles F. Reisner, 1937) *Hellzapoppin'* (H. C. Potter, 1941), and *Killer Diller* (Josh Binney, 1948) are among the most remarkable of these, all featuring black dancers, with *Malcolm X* (Spike Lee, 1992) a recent instance. Arthur Murray's 1954 edition of *How to Become a Good Dancer* included four pages of instruction for Swing: the Basic Lindy Step, the Double Lindy Hop, the Triple Lindy Hop, the Sugar Foot Walk, and the Tuck-In Turn. See Ralph G. Giordano, *Social Dancing in America: A History and Reference*, Vol. 2, *Lindy Hop to Hip Hop, 1901–2000* (Westport, CT: Greenwood Press, 2007).

7. In its invitation to dance, rock 'n' roll films form another "body genre," in which, according to Linda Williams's seminal argument, "the body of the spectator is caught up in an almost involuntary mimicry of the emotion or sensation of the body on the screen." See "Film Bodies: Gender, Genre, and Excess," in Leo Braudy et al., eds., *Film Theory and Criticism* (Oxford: Oxford University Press, 2009), p. 605.

8. McGee, *The Rock and Roll Movie Encyclopedia of the 1950s*, pp. 151–152.

9. McGee, *The Rock and Roll Movie Encyclopedia of the 1950s*, p. 127.

10. Rob Burt, *Rock and Roll: The Movies* (Poole, UK: Blandford Press, 1983), p. 7.

11. Thomas P. Ronan, "British Rattled by Rock 'n' Roll," *New York Times*, September 12, 1956, p. 40. See Denisoff and Romanowski, *Risky Business*, pp. 34–35, for its UK reception; they also provide excellent summaries of the popular press's and the trade papers' response to rock 'n' roll and rock 'n' roll films, especially pp. 21–40. Doherty's argument that *Rock Around the Clock* was "the first hugely successful film marketed *to teenagers to the pointed exclusion of their elders....* [and that it] "pushed motion picture strategy toward the teenpic" (*Teenagers and Teenpics*, p. 74, emphasis in original) overstates the degree to which subsequent rock 'n' roll films created an independent teenage cultural sphere, especially since jukebox musical narratives so regularly attempt to disprove the music's social threat, an issue of concern to adults alone. Hollywood's attempt to bridge the generation gap in a double address is nicely summarized in a poster for *Mister Rock and Roll* that advises; "Young People: Show Your Adults How Terrific Your Music Is! Take Them to See This Picture That Explains All About the New Exciting Rhythm. They'll Love It as Much as You Do!" (see Figure 3.5).

12. Though it was not officially released until January 1957, *Don't Knock the Rock* in fact premiered on December 12, 1956, in Los Angeles.

13. *Rock Baby—Rock It* was an exception, with many of its numbers performed live by local amateur and semi-amateur Dallas musicians.

14. One case of this interpenetration is especially interesting. *Don't Knock the Rock*, starring Alan Freed and several of the artists he programmed, had its New York premiere as an item in Freed's Manhattan stage show. During the film, the mayor of a small town attacks rock 'n' roll, causing "screams of derision and boos" to be directed at his image by the theater audience: Denisoff and Romanowski, *Risky Business*, p. 57.

15. A spectacular television finale also concludes *Shake, Rattle, & Rock!*, *The Girl Can't Help It*, *Rock, Pretty Baby*, *Mister Rock and Roll*, and *Loving You*.

16. Freed's career began in July 1951 when Cleveland record store owner Leo Mintz persuaded him to host a show on WJW radio playing rhythm and blues for black listeners. His show "The Moondog House" proved enormously popular and on the strength of it, in March 1952 he sponsored a "Moondog Coronation Ball" at the Cleveland Arena that had to be aborted when between six and twenty-five thousand, mostly black, young people turned out. He continued to promote concerts featuring black artists for mostly black audiences, even as his radio show began to attract more white listeners, and doo-wop and rhythm and blues increasingly crossed over with the Orioles' cover of a country song, "Crying in the Chapel," topping the rhythm and blues and also reaching number eleven on the pop charts in 1953. As his fame spread, he organized a concert in Newark in May 1954 that drew ten thousand fans, some 20 percent of them white. Later that year, he took his radio show to WINS in New York City at an astounding salary of seventy-five thousand dollars a year, but when a legal challenge deprived him of the right to the name "Moondog," he renamed it "The Rock 'n' Roll Party," cementing his association with the term. His concerts at the Paramount Theater in Brooklyn, and later at locations in Manhattan, and his related touring shows became spectacularly popular and profitable. His biographer has summarized his empire in the spring of 1956: "Freed had to his credit not only his local WINS 'Rock 'n' Roll Party' and his nationally syndicated 'Camel Rock and Roll Party' but also a new international audience via Radio Luxembourg, a starring role in a worldwide-distributed rock 'n' roll movie [*Rock Around the Clock*], and successive record-breaking grosses at his live stage shows. What is more, the deejay presided over more than two thousand fan clubs and he regularly received over fifteen thousand supportive letters, cards, and other messages each week"; John A. Jackson, *Big Beat Heat: Alan Freed and the Early Years of Rock & Roll* (New York: Schirmer Books, 1991), p. 135. As Elvis's ascendancy brought more white performers into rock 'n' roll, Freed began to feature them in his enterprises, especially on his television show, "Alan Freed's Big Beat," begun in July 1957. But opponents of rock 'n' roll found disc jockeys to be easy targets and increasingly focused on him; after an episode of his television show in which Frankie Lymon danced with a white girl, causing it to be canceled, his decline began. Indicted following a riot at his 1958 touring show in Boston, he lost his radio show, and became a central figure in the House subcommittee investigations of payola, itself a front for an attack on rock 'n' roll. The prosecution dragged on until December 1962, when he received a six-month suspended jail term after pleading guilty to accepting gifts for playing records. The IRS sued him for unpaid taxes, and in 1965 he died a broken man. (All information on Freed derived from Jackson, *Big Beat Heat*.) The film *American Hot Wax* (Floyd Mutrux, 1978) was loosely based on his life; and he appeared as a character in *La Bamba* (Luis Valdez,

1987), *Great Balls of Fire!* (Jim McBride, 1989), *Ray* (Taylor Hackford, 2004), and *Who Do You Love* (Jerry Zaks, 2000). *Mr. Rock 'n' Roll: The Alan Freed Story* (Andy Wolk, 1999) is a recent television biopic.

17. *Don't Knock the Rock* was filmed before *Rock, Rock, Rock!*, which was rushed into production, completed in two weeks, and released in advance of the other film.

18. Wyman records that when he saw the sequence, "The hair stood up on the back of my head, and I got shivers all over. I'd never been affected like that. I think Keith saw that movie about sixteen times!" cit. Ethan A. Russell, *Let It Bleed: The Rolling Stones, Altamont, and the End of the Sixties* (New York: Springboard Press, 2009), p. xiv.

19. The first part of Clanton's career could well have itself supplied the plot for a jukebox musical. A white singer from Louisiana with a feel for rhythm and blues, he formed a band while in high school, and an appearance on a local radio show led to a contract with Ace Records in 1957. His recording, "Just a Dream," sold over a million copies and he appeared on *American Bandstand*. He had several more hits and starred as a singer in another rock 'n' roll film, *The Teenage Millionaire* (Lawrence Doheny, 1961), before being drafted in 1961.

20. In order of the decreasing proportion of musical performance, other films featuring rock 'n' roll include:

Jamboree (1957): Intrigues among two ingénue singers and their respective managers wind through the Brill building, various recording studios, and visits to DJs and radio stations, culminating in a telethon for a "dreaded disease," MC'd by Dick Clark, that segues into a convention supper for jukebox distributers. Along the way, more than twenty DJs from all over the United States, Germany, and the United Kingdom present their ostensibly local talent, along with appearances by Carl Perkins, Fats Domino, Count Basie's Orchestra with Big Joe Williams, Jerry Lee Lewis, Frankie Avalon, Buddy Knox, Slim Whitman, Jimmy Bowen, and Charlie Gracie, plus half a dozen lesser-known acts.

Rock Baby—Rock It (1957): Produced by a legendary, garlic-chewing promoter, J. G. Tiger, it features local Dallas high-school kids putting on a "Giant Rock 'n' Roll Benefit Show" to make the rent for their own rock 'n' roll hang-out, the Texas Hot Rock club. The club is about to be taken over by a local crime boss on behalf of the Detroit mob, but the kids discover enough evidence to incriminate the mobsters (all played by moonlighting wrestlers), and the happy ending is marked an astonishing dance performance of "Rockin' Bop," by Kay Wheeler, the founder of the nation's first Elvis fan club. The plot, however, only occasionally bubbles through cracks in what is essentially a revue of stellar though forgotten doo-wop, rhythm and blues, rockabilly, and even Dixieland bands of the time, including Rosco Gordon and the Red Tops, whose performance of "Chicken in the Rough" is graced by a live chicken atop Gordon's piano.

Shake Rattle & Rock! (1956): The producer of a television rock 'n' roll show creates a club that brings previously delinquent youth together around rock 'n' roll and puts them on the path to respectability. The club is threatened by an unscrupulous landlord and mobsters, and by the local fogies who form an organization, SPRACAY, "Society for the Prevention of Rock and Roll

Corruption of American Youth," and campaign to abolish rock 'n' roll. In order to buy a permanent building and defeat the fogies, they put on a show of their own performances that augments appearances by Fats Domino and Big Joe Turner from the television program.

Let's Rock (1958): A simian balladeer with Sinatraesque voicing and raincoat who has made a success with "nice pretty strong ballads" finds himself abandoned by the kids. A disastrous appearance on Wink Martindale's Rock 'n' Roll Party, along with encounters with priceless performances by Roy Hamilton, the Royal Teens ("Short Shorts"), Danny and Juniors, and Della Reese, along with a visit to one of Freed's shows at the Brooklyn Paramount, persuade him to switch to rock 'n' roll and win the girl.

Rock, Pretty Baby! (1956): Supported by their middle-class families and girlfriends, a struggling high-school band that includes Sal Mineo and John Saxon enter a televised competition, and though they don't win, they do get a summer camp gig when they graduate. Rod McKuen appears and Henry Mancini wrote much of the music. The band's story is continued in *Summer Love* (Charles F. Haas, 1958) at the summer camp in Lake Tahoe, but by this point the band's fortunes are only a background for romantic intrigues and minor familiar conflicts, the sunshine flipside of the noir delinquency films.

Sing Boy Sing (Henry Ephron, 1958): Not a jukebox musical so much as an abbreviated biopic about a singer torn between religious and secular music. The role of the singer, Virgil Walker, had been written for and offered to Elvis, but his manager, Tom Parker turned it down, recommending instead that it be given to Tommy Sands.

Exploitation films released in the 1950s with incidental guest appearances by rock 'n' roll singers include *Untamed Youth* (Howard W. Koch, 1957) with Eddie Cochran and also a rock 'n' roll song by Mamie Van Doren; *The Big Beat* (William J. Cowen, 1957) with Fats Domino; *Carnival Rock* (Roger Corman, 1957) with the Platters; *Rock All Night* (Roger Corman, 1957) with the Platters and the Blockbusters' excellent rockabilly guitar; *Hot Rod Gang* (Lew Landers, 1958) with Gene Vincent; *Girls Town* (Charles Haas, 1959) with Bobby Darin; *Juke Box Rhythm* (Arthur Dreifuss, 1959) with Johnny Otis and the Treniers. Other instances tacked a performance onto a narrative in which the singer has no role. In *High School Confidential* (Jack Arnold, 1958), for example, Russ Tamblyn goes undercover as a juvenile delinquent in order to bust a high-school dope scene while also avoiding Mamie Van Doren's clutches. The film opens with Jerry Lee Lewis singing the title song on a flatbed truck to promote a high-school hop; though the song is subsequently played as both underscore and source music, he is never seen again. The use of Lewis's music to publicize the hop and the film is especially ironic, since for most of the narrative Tamblyn associates himself with delinquent teen culture in order to rise in its hierarchy—posing as a drug supplier, dressing for the part, adopting the argot ("I'm looking to graze on some grass. . . . I heard you and Mary Jane were going steady") and participating in hot-rod races—but after succeeding in exposing the real dealers, he rejects it. Films about delinquents in which rock 'n' roll is even more incidental, many of them American International Pictures (AIP) productions featuring hot rods and drag racing, include *Hot Rod Gang*'s sequel, *The Ghost of Dragstrip Hollow* (William J. Hole, Jr., 1959); *The Delinquents* (Robert Altman, 1957), which has Julia Lee performing "The Dirty

Rock Boogie"; *Blue Denim* (Philip Dunne, 1957); and *Unwed Mother* (Walter Doniger, 1958), the last two both being about teenage pregnancy and including rock 'n' roll songs. Similar exploitation films continued in the 1960s both in the AIP beach party films from 1963's *Beach Party* (William Asher, 1963) to *The Ghost in the Invisible Bikini* (Don Weiss, 1966) and in low-budget films about hippie delinquents, including *Riot on Sunset Strip* (Arthus Dreifuss, 1967), and exploitation producer David F. Friedman's *Bummer* (William Allen Castleman, 1973), advertised as a "A Far Out Trip Thru a Hard Rock Tunnel" in which three groupies' involvement with a rock 'n' roll band leads to mayhem and murder. Katzman continued to produce pop music films with *Calypso Heat Wave* (Fred F. Sears, 1957), *Juke Box Rhythm* (Arthur Dreifuss, 1959), *Hootenanny Hoot* (Gene Nelson, 1963), *Twist Around the Clock* (Oscar Rudolph, 1961), *Don't Knock the Twist* (Oscar Rudolph, 1962), the Hank Williams biopic, *Your Cheatin' Heart* (Gene Nelson, 1964), two Elvis vehicles, *Kissin' Cousins* (Gene Nelson, 1964) and *Harum Scarum* (Gene Nelson, 1965), and *The Fastest Guitar Alive* (Michael D. Moore, 1967) starring Roy Orbison in his only film appearance. *Twist Around the Clock* is a scene by scene remake of *Rock Around the Clock*, with the twist emerging to replace rock 'n' roll that has become as obsolete as had swing in the earlier film. *Don't Knock the Twist* is a looser imitation of its namesake, with the twist itself threatened by the Mashed Potato and other new dances. Chubby Checker stars in both and has minor roles in the plot.

Chapter 4

1. Kenneth Anger, *Hollywood Babylon* (Phoenix: Associated Professional Services, 1965), p. 271.

2. Anger, *Hollywood Babylon*, p. 270.

3. R. Serge Denisoff and William Romanowski designate it "the best overall rock picture until *A Hard Day's Night*." *Risky Business: Rock in Film* (New Brunswick, NJ: Transaction, 1991), p. 49. On its release, an extremely favorable review in *Variety* greeted it as "the first de luxe version" of the several rock and roll features in release at the time and, praising all the main actors, the script, the direction, and the music, correctly predicted its box-office success; see "The Girl Can't Help It," *Variety* 205. 34 (December 19, 1956): 7.

4. Cochran's appearance was his first on national media, but in the record deal he secured on the strength of it, "Twenty Flight Rock" became the b-side to "Sittin in the Balcony"; see Denisoff and Romanowski, *Risky Business*, p. 51.

5. Quoted in Rob Burt, *Rock and Roll: The Movies* (Poole and New York: New Orchard Editions, 1986), p. 21.

6. David Ehrenstein and Bill Reed, *Rock on Film* (New York: Delilah Books, 1982), p. 18.

7. The single, "As The Clouds Drift By" b/w "Suey" (London HL 80065), was recorded in 1965 and released in 1967 a few weeks after her death. See Steven Roby, *Black Gold: The Lost Archives of Jimi Hendrix* (New York: Billboard Books, 2002). Roby reports that Hendrix played the bass part as she sang, then added the guitar lead, and that in 1967 in Bolton, England, Jayne caught the Experience at a theater where two days later she was to perform. The idea of studio chemistry between Jayne and Jimi tops even her missed encounter with Little Richard (of whose band, Hendrix was a veteran).

8. For Mansfield's biography, see Martha Saxton, *Jayne Mansfield and the American Fifties* (Boston: Houghton Mifflin, 1975).

9. As Ehrenstein and Reed phrase it, "Neither adult, nor child, Mansfield's bubbly enthusiasm and total lack of self-pretense complemented the spirit of rock and roll to a tee." *Rock on Film*, p. 17.

10. "Defense of Jayne Mansfield," *Film Culture* 32 (Spring 1964): 24–27. For McClure, "Dark lambs" like her were innocents who unconsciously bore an immense love that had been "driven undercover into their bodies or souls and spirits" and as such they were "carriers of a lost and necessary health that is desired by those they attract." With a cover photo of Kenneth Anger on the set of *Scorpio Rising*, articles on his and Warhol's films, and an interview with Jack Smith, this issue of *Film Culture* was replete with "black lambs." Compare Ehrenstein and Reed's view that Mansfield was "a succulent A-bomb just waiting to explode (with rock music as the detonator)" and that her aura "exuded works in perfect complement to the hit-and-run 2.32 sec. foreplay-to-orgasm viscerality of the (then) 'new sound'": see Ehrenstein and Reed, *Rock On Film*, p. 162.

11. The complete sequence of records used in *Rabbit's Moon* is "There's a Moon Out Tonight" (The Capris, 1958), "Oh, What a Night" (The Dells, 1956), "Bye Bye Baby" (Mary Wells, 1960), "I Only Have Eyes for You" (The Flamingos, 1959), and "Tears on My Pillow" (The El Dorados, 1957).

12. Jonathan Cott, "Anger Rising," *Sunday Ramparts*, May 17, 1970; cited in Robert A. Haller, *Kenneth Anger* (Minneapolis: Walker Art Center, 1980), p. 8.

13. Anger's notes to the film in *Magick Lantern Cycle* (New York: Film-Makers Cinematheque, 1966), selections rpt. P. Adams Sitney, *Visionary Film: The American Avant-Garde, 1943–2000*, 3rd ed. (Oxford and New York: Oxford University Press, 2002), p. 103. The headings for the four-part division below are quoted from the same notes.

14. Carolee Schneemann, "Kenneth Anger's 'Scorpio Rising,'" *Film Culture* 32 (Spring 1964): 9–10.

15. Anger's (in)consistent subversion of rigid ethical systems reflects Crowley's philosophy of Thelema, whose fundamental principle was, "Do what thou Wilt shall be the whole of the Law." In this religion, Lucifer is not the Devil, but the god of beauty and light, and as such has a special importance for cinema.

16. Carrie Rickey, "Rockfilm, Rollfilm," in Anthony DeCurtis and James Heneke, eds., *The Rolling Stone Illustrated History of Rock & Roll: The Definitive History of the Most Important Artists and Their Music* (New York: Random House, 1992), p. 114.

17. From a prospectus for the project, cit. Sitney, *Visionary Film*, p. 110.

18. After *Rabbit's Moon*, Anger continued his involvement with sixties' youth cultures and their music, first in San Francisco and then in London, especially in relation to the Rolling Stones and Jimmy Page.

19. Before *Easy Rider*, the soundtrack for *The Graduate* (Mike Nichols, 1967) used primarily original folk-rock songs. On compilation scores, see especially Jeff Smith, *The Sounds of Commerce: Marketing Popular Film Music* (New York: Columbia University Press, 1988), pp. 154–185.

20. Scorsese reported that seeing *Scorpio Rising* as a student "gave me the idea to use whatever music I really needed." Peter Decherney, *Hollywood's Copyright Wars: From Edison to the Internet* (Chichester: Columbia University Press, 2012), p. 188.

21. Scorsese's chronology is less precise than Lucas's, and though the ambience is late 1950s–early 1960s, the rock songs it includes range from 1954 (Johnny Ace, "Pledging My Love") to 1968 (Rolling Stones, "Jumpin' Jack Flash"). 1973 also saw the US release of *The Harder They Come* (Perry Henzell), which redeployed early rock 'n' roll's associations

with delinquency in the world of Jamaican reggae. The use of rock 'n' roll on soundtracks continued to grow in the later 1970s, though by then the ubiquity of pop music made it moot whether any contemporary film could *not* be about it. By the 1980s, films such as *The Big Chill* (Lawrence Kasdan, 1984) and *Goodfellas* (Martin Scorsese, 1990) typified the use of rock both for thematic commentary and as a potent marketing tool. In the new millennium, such a doubled utility extended to films set in even the remote past, in *A Knight's Tale* (Brian Helgeland, 2001) and *Marie Antoinette* (Sofia Coppola, 2006), for example.

Chapter 5

1. The evening is recounted in Peter Guralnick's *Last Train to Memphis: The Rise of Elvis Presley* (Boston: Little, Brown, 1994), p. 330. Biographical information on Elvis is derived primarily from this and from Guralnick's sequel *Careless Love: The Unmaking of Elvis Presley* (Boston: Little, Brown, 1999); Dave Marsh, *Elvis* (New York: Thunder's Mouth Press, 1997); and Charles L. Ponce de Leon, *Fortunate Son: The Life of Elvis Presley* (New York: Hill and Wang, 2007). Alanna Nash's The *Colonel: The Extraordinary Story of Colonel Tom Parker and Elvis Presley* (New York: Simon and Schuster, 2003) covers Elvis's relationship with his manager.

2. Quoted in Guralnick, *Careless Love*, p. 350.

3. An exception to the dearth of musicological comment on Elvis's vocal abilities is Gregory Sandow, "Elvis Presley: Rhythm and Ooze," *Village Voice*, August 16, 1987, pp. 71, 74–76. Describing his great abilities in the terms of classical musicology, Sandow notes his "perfect rhythm," his mastery of "the seductive phrasing" of operatic tenors, and his remarkable vocal range: "Elvis was very nearly all at once a tenor, baritone, and bass."

4. Respectively, Eldridge Cleaver, *Soul on Ice* (New York: McGraw-Hill, 1968), p. 194, and Leonard Bernstein cited in David Halberstam, *The Fifties* (New York: Fawcett Columbine, 1994), pp. 456–457.

5. Cited in Marsh, *Elvis*, p. 121. Marsh understands the poverty of Elvis's background as "the entire secret of his seeming passivity about his own career."

6. Robert Johnson, "Thru the Patience of Sam Phillips Suddenly Singing Elvis Presley Zooms into Recording Stardom," *Memphis Press-Scimitar*, February 5, 1955, Second Section, p. 9.

7. Marion Keisker, Phillips's secretary who first brought Elvis to his attention, recalled him saying, "If I could find a white man who had the Negro sound and the Negro feel, I could make a billion dollars." Though he denied saying this, Phillips's own commitment to black music was unequivocal and he did claim that his recordings of African American artists and of Elvis had "knocked the shit out of the color line." Cited in Guralnick, *Last Train to Memphis*, p. 134.

8. In his autobiography, Berry recalled that when he took "Maybellene" to Chess, he "couldn't believe that a country tune (he called it a 'hillbilly song') could be written and sung by a black guy"; Chuck Berry, *Chuck Berry: The Autobiography* (New York: Harmony Books, 1987), p. 100. The film, *Cadillac Records* (Darnell Martin, 2008), depicts Leonard Chess's recording of Berry and other influential blues and rhythm and blues artists.

9. For Elvis's interest in gospel music, see Charles Wolfe, "Presley and the Gospel Tradition," in *Elvis: Images and Fancies*, ed., Jac L. Tharpe, special issue of *Southern Quarterly* 18, no. 1 (Jackson: University Press of Mississippi, 1979), pp. 135–161. Introduced

on his first RCA recording session, the Jordanaires backed Elvis from 1956 to 1967; they were followed by the Imperials (1969–1971) and the Stamps Quartet (1972–1977). Elvis sometimes recognized his music's debt to his religion (see, for example, Guralnick, *Last Train to Memphis,* p. 432) but was also sometimes defensive about it (p. 320).

10. Cited in Marsh, *Elvis*, p. 9.

11. Cited in Guralnick, *Last Train to Memphis,* p. 331.

12. Though made in respect to Elvis's earliest musical involvements, Peter Guralnick's observations that gospel music "combined the spiritual force that he felt in all music with the sense of physical release and exaltation" and that "quartet music was the center of his musical universe" (*Last Train to Memphis,* p. 47) are no less true of the Elvis's late work, the *Comeback Special* and subsequent live performances.

13. Quoted in Guralnick, *Careless Love,* p. 174. Guralnick details Elvis's extensive religious quests; see especially pp. 173–193. When he died in the bathroom on August 16, 1977, the book he had with him was a study of the Shroud of Turin.

14. Different sources give different numbers; these are from Guralnick, *Last Train to Memphis,* p. 262; after *Loving You*, these were very quickly and considerably raised.

15. Elvis had previously appeared in *The Pied Piper of Cleveland: A Day in the Life of a Famous Disc Jockey* (1955), a documentary directed by Arthur Cohen for Universal about a disc jockey, Bill Randle. Also including Pat Boone and Bill Haley, it was shot when he was on tour in Cleveland, but it has never been released. On Elvis's films, see Gerry McLafftey, *Elvis Presley in Hollywood: Celluloid Sell Out* (London: Robert Hale, 1989), and Peter Guttmacher, *Elvis! Elvis! Elvis!: The King and His Movies* (New York: MetroBooks, 1997). Douglas Brode, *Elvis Cinema and Popular Culture* (Jefferson, NC: McFarland, 2006) is an often insightful revisionist account of the oblique or allegorical social, biographical, and psychological content in the Elvis's films, and of the persona's development; summarily, "Throughout the Elvis [film] oeuvre, his characters are victims of identity crisis, reflecting the performer who played them" (p. 238).

16. "Mr. Wallis asked me what kind of part I'd like to play, and I told him one more like myself, so I wouldn't have to do any excess acting" (Guralnick, *Last Train to Memphis,* p. 261).

17. Jim Curtis, *Rock Eras: Interpretations of Music and Society, 1954–1984* (Bowling Green, OH: Bowling Green State University Popular Press, 1987), p. 22. Attacks in the press included that by Bosley Crowther, who opined that the "picture itself was a slight case of horse opera with the heaves," with Elvis's performance "turgid, juicy and flamboyant, pretty much as he sings" ("The Screen: Culture Takes a Holiday: Elvis Presley Appears in 'Love Me Tender,'" *New York Times*, November 16, 1956, p. 22) and Henry Hart in *Films in Review*, who was even less judicious: "The weak mouth seems to sneer even in repose, and the large, heavily-lidded eyes seem open only to be on the lookout for opportunities for self-indulgence. . . . How a society as dynamic as ours throws up such a monstrosity is beyond the scope of this review": cited in Guttmacher, *Elvis! Elvis! Elvis!*, p. 18.

18. Howard Thompson, "Actor with Guitar," *New York Times*, July 4, 1958, p. 13.

19. Elvis would have recognized several similarities with his own life: Virgil becomes a singer by secularizing the music he learns in revival meetings; Virgil's manager, Mr. Sharkey (played by Edmond O'Brien, *The Girl Can't Help It*'s Fats Murdoch) is relentless in his exploitation of his discovery; and there is a character who stands in for Elvis's Memphis stooges.

Chapter 6

1. Graceland press conference, March 7, 1960, quoted in Douglas Brode, *Elvis Cinema and Popular Culture* (Jefferson, NC: McFarland, 2006), p. 75.

2. Hal B. Wallis and Charles Higham, *Starmaker: The Autobiography of Hal B. Wallis* (New York: Macmillan, 1980), p. 149.

3. *"Blue Hawaii,"* *Variety*, November 29, 1961, p. 6.

4. Though preceded by *Gidget* (Paul Wendkos, 1959) with Sandra Dee and James Darren, the beach movie subgenre was effectively inaugurated by *Beach Party* (William Asher, 1963), with Frankie Avalon and Annette Funicello. Six more films from American International Pictures (AIP) followed, ending with *The Ghost in the Invisible Bikini* (Don Weis, 1966). In addition to Avalon and Funicello, many featured musical guests. Other producers made more, and Elvis returned to the beach with *Girl Happy* and *Paradise Hawaiian Style*. Thomas Lisanti provides a comprehensive overview of the subgenre in *Hollywood Surf and Beach Movies: The First Wave, 1959–1969* (Jefferson, NC: McFarland, 2005).

5. Quoted in Guralnick, *Careless Love*, p. 170.

6. This typology draws from Vladimir Propp, *Morphology of the Folktale* (Austin: University of Texas Press, 1968). Propp's proto-structuralist analysis of Russian *volsebnaja skazka*, or fairy tales, proposed that while the number of characters and activities in the corpus was immense, they revealed a common and invariable organizational form when subjected to a deep analysis focused on the "function," that is, on the "*act of a character, defined from the point of view of its significance for the course of the action*" (p. 21; italics in original). He found that, though they could be performed by different protagonists, only thirty-one such "functions" (now often known as narratemes) underlay all *skazka*, and though they were not all present in all of them, if they did occur they were always performed in the same sequence. The *skazka* Propp investigated were both more complex and condensed than most Elvis movies, whose functions do not always occur in the same order. Nevertheless, they are sufficiently standardized that, like the *skazka*, all Elvis movies are fundamentally "of one type in regard to their structure" (p. 23), and in fact the most pivotal of Propp's functions recur in the Elvis movie, including, No. 11, Hero leaves home; No. 12, Hero is tested; No. 26, Task is resolved; No. 28, False hero or villain is exposed; and No. 31, Hero marries and ascends the throne (is rewarded/promoted). This further justifies the suggestion developed below of their operation as a folk narrative. Scotty Moore's remark about Elvis's "science fiction name" is cited in David Halberstam, *The Fifties* (New York: Villard Books, 1993), p. 459. In *Kissin' Cousins*, the King plays both himself and his cousin, doubling his role: in one he is good-natured and without family, and in the other, the opposite. The narrative is set in the past in only five instances: four in the nineteenth century—*Love Me Tender, Flaming Star, Charro!*, and *Frankie and Johnny*—and *Trouble with Girls*, set in 1927. *Stay Away, Joe* makes reference to the socioeconomic problems of Native Americans and to problems of identity, both for those who stay on the reservation and those who leave. Labor and unionization issues occur in *Trouble with Girls*.

7. Elvis's collaboration with Hollywood to refuse the King any social mobility and keep him of, though not in, the working class is illuminated by the career of the only artist with a remotely similar command over American culture since the mid-twentieth century, Andy Warhol. Warhol recognized him in his 1963 silkscreens of his role in *Flaming*

Star, and titled one of his own films *Lonesome Cowboys* (1968) after Elvis's melodramatic song. Both were social upstarts of boundless ambition who made transformative interventions in their respective mediums, and though they broke through the class barriers in their respective art worlds, they were never entirely comfortable there and were sustained socially by an entourage of sycophants and fellow speed freaks. Their radical innovations ruined previous aesthetic hierarchies and distinctions, and both became involved full-time in cinema after previous successful careers in a different medium. Both distanced themselves from their most radical early work, and as a consequence both their careers are commonly divided into good periods and bad ones, in which they became brand names attached to inferior products, until they both died prematurely because, though tremendously wealthy, they received inadequate medical care.

8. In *Risky Business: Rock in Film* (New Brunswick, NJ: Transaction, 1991), R. Serge Denisoff and William Romanowski entirely omit discussion of Elvis's films, and not even *King Creole* is mentioned in the index. Commonly, only an ironic celebration of their awfulness gives them a place in any canon. Jeffrey Sconce, for example, includes "Elvis flicks"—not "Elvis movies" or "Elvis films"—in his list of "trash cinema," "the most critically disreputable films in cinematic history": " 'badfilm,' splatterpunk, 'mondo' films, sword-and-sandal epics, Elvis flicks, government hygiene films, Japanese monster movies, beach-party musicals, and just about every other historical manifestation of exploitation cinema"; "Trashing the Academy: Taste, Excess, and an Emerging Politics of Cinematic Style," *Screen* 36.4 (Winter 1995): 372. Music critics are even more dismissive: Greil Marcus attacks "the seamless boredom of the movies and the hackneyed music of the soundtrack albums," though he does hazard that "[s]omeday, French film critics will discover these pictures and hail them as a unique example of *cinema discrepant*; there will be retrospectives at the *Cinematheque*"; *Mystery Train; Images of America in Rock 'n' Roll Music* (New York: Dutton, 1976), p. 143. Dave Marsh argues that "the movie period is the black hole of Elvis's career" in which he became "an expendable dummy who could be cloned and turned into whatever sort of dim-witted goon his masters demanded"; *Elvis* (New York: Thunder's Mouth Press, 1997), pp. 12 and 122. Historians of the film musical are kinder. Rick Altman discusses only *Blue Hawaii* in any detail, but he still affirms that despite being "poorly made in every way," "the films of Elvis Presley stand out like a beacon within the production of the late fifties and sixties" and that he "dominated a decade of musical filmmaking because of his understanding of the sexuality of song"; *The American Film Musical* (Bloomington: Indiana University Press, 1989), pp. 92 and 194–196.

9. *Roustabout* begins in a roadhouse where, as Charlie Rogers, he antagonizes a party of fraternity boys by flirting with their girls and singing a song, "Poison Ivy League," that ridicules their wealth and privilege. They pick a fight with him, but his karate chop breaks the arm one of them, and so he is jailed for the night and then is kicked out of town by the police. No sooner is he on his motorbike than he tries to pick up another girl, Cathy (Joan Freeman, who three years later co-starred with Roy Orbison in *The Fastest Guitar Alive* [Michael D. Moore, 1967]), a passenger in a jeep driven by her father, Joe, and stepmother, Maggie, the owner of an almost bankrupt carnival. Seeing a "young punk" who should be taught a lesson, Joe runs Charlie off the road, and he winds up working for the carnival while his bike is being repaired. Harboring a bitterness attributed to his lack of parents, Charlie displays a conflicted and unpredictable mix of arrogant belligerence and innocent kindliness reminiscent of youth protagonists of the 1950s. Joe's comment—"the

kid is nothing but trouble"—and Maggie's—"cruel boy; you must have been hurt pretty badly"—are two of several animadversions on his complicated personality. Though he attempts to seduce every woman who crosses his path, as well as callously pressuring Cathy to have sex with him, he falls in love with her. When the carnival is threatened with foreclosure, his singing attracts so many teenagers that it appears he may save it, but Joe's hostility drives him away to sing in a rival carnival's girly show. Only a last-minute change of heart brings out his better side, and he returns to Cathy and saves the carnival. Charlie's testaceous promiscuity and violence are visually figured by his motorcycle, blue jeans, and leather jacket that mark him as a fifties rock 'n' roll hoodlum. The tension between this character and the carefree buoyance of his main sixties persona recurs in the songs: though many of them are what was by now the usual cheery schmaltz, his hostile unruliness erupts in the lyrics of "Roustabout" itself ("I'll go the way I want/Driftin' just like the sand/Doin' what job I can"), in the aggressive rhythm of the two main rockers, "Wheels on My Heels" and "Hard Knocks," and again in the latter's lyrics: "Some kids born as rich as a king/But I was born without a doggone thing/Hard knocks, all I ever knew was hard knocks."

10. The one exception to his working-class positioning is *Clambake*, in which the King is a college-trained chemical engineer and the son of a Texas oil tycoon. But he affirms the order of the Elvis movie by switching roles with a poor water ski instructor and switching his own custom sports car for the other's motorcycle so as to assume a working-class identity. Thus disguised, he plays a poor boy in competition with a rich guy for Shelly Fabares, herself playing against type as a poor girl trying to land a millionaire husband.

11. The prevalence of hypergamic romance is pinpointed in *Spinout*, where a wealthy tycoon attempts to recruit the King to drive in his race team and tricks him into singing at his daughter's birthday party, but warns him not to get any ideas about her; the King defiantly rejects the implication that he may be good enough to drive for the man, but not to marry his daughter. The most common underlying narrative schema thus subtends a fundamentally contradictory fable of sexual and class mobility: although a King, he never sheds his working-class characteristics and only rarely evidences any sensitivity about them, yet the narratives provide him the hypergamy narratively more common for females.

12. The sentiment is often repeated, for example, in *Paradise Hawaiian Style*, "I'm not going back to work for somebody else, Danny," or in *Clambake*, when his (apparently) wealthier rival tells him that in entering a boat race against him, he is "stepping a little out of line," the King replies, "You mean I should stay where I belong." Uniquely, the King is management in *The Trouble with Girls*; his antagonist tells him that, with his cigar, he is a "caricature of a capitalist."

13. The only significant exception is, again, *Stay Away, Joe*, but there the elements of the King's and his family's class consciousness are subsumed within the politics of ethnicity; only by playing a person of color can the King be among equals, and even then he must be categorically more equal than all others.

14. The exceptions where African Americans and/or black people do appear are extremely minor: a young lawyer in *Wild in the Country*, a doo-wop group in *Viva Las Vegas*, a fairground worker in *Roustabout*, a slave in *Harum Scarum*, a boy who accompanies Elvis's blues song on his harmonica in *Frankie and Johnny*, a couple in a nightclub in *Easy Come, Easy Go* (Robert Goodstein and John Rich, 1967), and a boy in *The Trouble with*

Girls (who is partnered with a little white girl, much to the consternation of some of the townsfolk). The King courts a Mexican woman in *Fun in Acapulco*.

15. The distinction between the show musical and the folk musical derives from Jane Feuer and Rick Altman in, respectively, *The Hollywood Musical*, 2nd ed. (Bloomington: Indiana University Press, 1993) and *The American Film Musical*. I use it here to distinguish between films that present the King earning his living as a professional musician and those in which, having some other occupation, he performs more or less as an amateur. For Altman, "The show musical involves the spectator in the creation of a work of art . . . [while] the folk musical projects the audience into a mythicized version of the cultural past" (*The American Film Musical*, p. 272). Only in *Frankie and Johnny* and *The Trouble with Girls* (plus *Love Me Tender* and *Flaming Star*) are Elvis's folk musicals set in the past, but in the others, the present is so devoid of any historical specificity that it is essentially mythicized.

16. Joshua Gamson, *Claims to Fame: Celebrity in Contemporary America* (Berkeley: University of California Press, 1994), reports a press agent on her manufacture as a star, "We felt there was a need in The Industry for a female Elvis Presley. We mounted her on a billboard on Sunset Strip with her legs round a motorcycle" (p. 46). The previous year, she had starred in *Bye Bye Birdie*, the film version of a Broadway play about a pop singer based on Elvis who is drafted into the army. For the off-screen relations between Elvis and Ann-Margret, see Guralnick, *Careless Love*, pp. 147–154.

17. Howard Thompson, "Elvis Presley Teams with Ann-Margret," *New York Times*, May 21, 1964, p. 42.

18. *Spinout* is one of the few films not brought to a romantic closure by Elvis uniting with his leading girl; he does marry the three women who chase him, but he "marries" them to other men, while himself remaining single.

19. Guralnick, *Careless Love*, p. 100. Compare Gerald Mast, "Paramount Recycled Crosby as Elvis Presley," in *Can't Help Singin': The American Musical on Stage and Screen* (Woodstock, NY: Overlook Press, 1987), p. 225.

20. The term "producer's game" is Rick Altman's; see his *Film/Genre* (London: BFI Publishing, 1999), p. 38.

21. Hal Wallis, "Following No Formula: Interview with David Austen," *Films and Filming* 13.3 (December 1969): 8. By this time, Wallis and Paramount had not made a film with Elvis for three years, the last having been *Easy Come, Easy Go* (1966).

22. Guralnick, *Careless Love*, p. 75.

23. Ibid., pp. 137, 147, and 189.

24. Guralnick, *Last Train to Memphis*, p. 260.

25. For anecdotal evidence of Elvis's scorn for his sixties movies, see Guralnick, *Careless Love*, pp. 86–87, 106, 159, and 171. Priscilla also recorded Elvis's unhappiness with them: "He loathed their stock plots and short shooting schedules, but whenever he complained to the Colonel, Colonel reminded him that they were making him millions"; *Elvis and Me* (New York: Putnam's, 1985) p. 188.

26. Guralnick, *Careless Love*, p. 322.

27. For an account of the production of the show, see Guralnick, *Careless Love*, pp. 293–317; Finkel claimed that Elvis wanted "to depart completely from the pattern of his motion pictures and from everything else he has done"; cited in Guralnick, *Careless Love*, p. 293. Binder's plans for the show directly addressed racial issues: "I wanted to let the

world know that here was a guy was not [racially] prejudiced, who was raised in the heart of prejudice, but who was really above all that"; Guralnick, *Careless Love*, p. 298.

28. Described here is the ninety-minute version that Binder submitted to NBC that included the extensive sections of Elvis's more or less spontaneous improvisation. In the initial show, most of this was cut, as was the bordello sequence in the "Guitar Man" section. First broadcast in the television special hosted by Ann-Margret just after Elvis died, the full ninety-minute version has since become accepted as standard.

29. With leader singer Darlene (Wright) Love, the Blossoms were one of the most accomplished and versatile "girl groups" of the 1960s. They appeared regularly on *Shindig*, and the many hits they made for Phil Spector, which he released under the name of the Crystals, included "He's a Rebel," which features prominently in *Scorpio Rising* (Kenneth Anger, 1963). They toured with Elvis in the 1970s.

30. *Mystery Train*, p. 145. In his review, Peter Guralnick wrote, "It was like nothing I had ever seen on television before, other than Howlin' Wolf's appearance on *Shindig*, both a revelation *and* a vindication"; Guralnick, *Careless Love*, p. 323.

31. Of the thirty songs sung entirely or in the medleys, only five were from the sixties movies, "Can't Help Falling in Love" from *Blue Hawaii*, "Little Egypt" from *Roustabout*, "Big Boss Man" and "Guitar Man" from *Clambake*, and "Let Yourself Go" from *Speedway*.

32. Though in three of these he was involved in the entertainment industry, in none of these did he play a professional musician: a motorboat racer (*Clambake*), a Native American roustabout (*Stay Away, Joe*), a racecar driver (*Speedway*), and a pin-up photographer (*Live a Little, Love a Little*). In *Clambake* he comes from a wealthy bourgeois family and only pretends to be poor, and instead of sampling several girls, he pursues only one. In *Stay Away, Joe* he again has a family, but it is Native American, not Caucasian, and though he pursues both Caucasian and non-Caucasian girls, the film ends without his commitment to any. In *Speedway*, he pursues and wins only one girl: Nancy Sinatra as an IRS agent! *Live a Little, Love a Little*, one of his strangest movies, plunges him into a psychedelic miasma populated by *Playboy* types and a schizophrenic kook who slips him a "hallucinogenic drug," after which he sleeps with her, the first and only such an event in his movies.

33. Guralnick, *Careless Love*, p. 351.

34. Judith Sims, "At Last—The First Elvis Presley Movie," *Rolling Stone*, 121 (November 9, 1972), p. 8.

35. Elvis's thirty-third and last movie was followed by *Elvis: Aloha from Hawaii*, a concert at the Honolulu Convention Center in January 1973 that was broadcast globally on television by satellite and supposedly watched by a billion people, a quarter of the world's population. After his divorce in October and the rapid deterioration of his health, he continued to record and perform until, increasingly drug dependent, he descended into rock 'n' roll suicide. In the most interesting independent Elvis documentary, *Der Elvis* (1987), punk musician Jon Moritsugu exploited Elvis's degeneration as a metaphor for the decline of popular music overall, while his film's confrontationally amateur production and extreme bad taste manifests punk's putatively renovative aesthetic. Jonas Mekas's short *Elvis & Wien* (2001) includes footage of Elvis performing at Madison Square Garden in 1972.

But in film as in life, even when dead, Elvis appeared. Elvis impersonation films had begun as early as 1963 with *Bye Bye Birdie* (George Sidney), based on a 1960 stage musical

set in 1958 just before Elvis's departure for Germany. About to be drafted, Conway Birdie is a louche, beer-swigging, pelvis-thrusting teenage sensation who visits a randomly chosen fan for one last kiss on behalf of girls everywhere. He is eventually decked on the *Ed Sullivan Show* by the boyfriend of the chosen girl, played by Ann-Margret, whose performance of the title song and overall vitality made the role a breakout for her, and led to her part in *Viva Las Vegas* (also directed by George Sidney) the next year. A generation after his death, films featuring Elvis or Elvis impersonators as characters proliferated, including *Finding Graceland* (David Winkler, 1998), *3000 Miles to Graceland* (Demian Lichtenstein, 2001), *Bubba Ho-tep* (Don Coscarelli, 2002), and *Elvis Has Left the Building* (Joel Zwick, 2004). The only one of any interest is *Bubba Ho-tep*, in which Elvis reappears in an old folks' home, disabled by a broken hip suffered in a stage fall and by what he believes is phallic cancer. In the early 1970s, he had made a deal to escape the prison of his fame by switching places with an Elvis impersonator, whose death then stranded him in his self-impersonation. Resting before a battle with a mummy who is sucking the life out of the other invalids, he turns on the television, only to encounter a "Twenty Four Hour Elvis Movie Marathon" in which the King will out-strum, out-race, and out-fight the bad guys while slaying the girls. "Shitty pictures, man, every single one," he ungenerously remarks.

Chapter 7

1. The Beatles' only meeting with Elvis was less than rewarding, and in the height of his paranoia he turned against them, observing to President Nixon that they had been "a focal point for anti-Americanism." Peter Guralnick describes both meetings in *Careless Love: The Unmaking of Elvis Presley* [Boston: Little, Brown, 1999], pp. 210–212 and pp. 420–421. Elvis never made music as significant as his earliest and he retrieved his career by returning to it, while the Beatles dramatically raised the stakes with almost every new album. And of course, while Elvis was isolated from the counterculture, the Beatles were its ringmasters.

2. A film version of the program was made featuring Donegan and others, *6.5 Special* (Alfred Shaughnessy, 1958).

3. Opened in 1956 in a Soho basement, the 2i's Coffee Bar was for several years the heart of the British skiffle and later rock 'n' roll culture. The many stars discovered there included Tommy Steele, Cliff Richard, Terry Dene, and Adam Faith. According to Faith's recollections when his group, Terry Denver and the Worried Men, were the house band, performances ran from seven to eleven, six nights a week, with audiences in the two to three hundred range: see *Acts of Faith: The Autobiography* (New York: Bantam Press, 1996). Coffee bars are linked to teenage music in five of the films discussed below—*The Tommy Steele Story, Serious Charge, Expresso Bongo, Beat Girl* and *It's Trad, Dad!*—and posters for the 2i's appear in *Beat Girl*.

4. Tommy Steele, *Bermondsey Boy: Memories of a Forgotten World* (London; New York: Michael Joseph, 2006), p. 256.

5. Music continued to be important in the British New Wave cinema of the early sixties. The use of jazz and other forms of music and other media as thematic markers in a story about delinquent youth in *The Loneliness of the Long Distance Runner* (Tony Richardson, 1962) recalls, though is much superior to, parallel taxonomies in *Blackboard Jungle*. Of

other films, *All Night Long* (Basil Dearden, 1962) is especially interesting. Co-scripted by the blacklisted Paul Jarrico with a plot based on *Othello*, it depicted intrigues among musicians and music promoters, all taking place in a jazz club in a refurbished warehouse; it features several mixed-race couples and marijuana smoking, along with performances by Charles Mingus, Dave Brubeck, Johnny Dankworth, and others. But all the characters are cosmopolitan adults rather than working-class youth. British thrillers referencing youth music include *Face The Music* (aka *The Black Glove*, Terence Fisher, 1954) with music by Kenny Ball, and *Violent Playground* (Basil Dearden, 1958) which explicitly connects rock 'n' roll and juvenile delinquency.

6. Garth Bardsley, *Stop the World: The Biography of Anthony Newley* (London: Oberon Books, 2003), p. 38.

7. With record sales estimated at 250 million, Richards had number one hits in the UK in each of the six consecutive decades following the 1950s but, despite appearing on the *Ed Sullivan Show* in 1960, he failed to make an impact in the US until the 1980s.

8. When the Beatles eclipsed his singing, Faith turned to acting in roles that were unrelated to rock 'n' roll, though in the next decade, he returned to play an unscrupulous manager in a retrospective examination of 1960s British music, *Stardust* (Michael Apted, 1974).

9. Fury's second film, *I've Gotta Horse* (Kenneth Hume, 1965), included half a dozen songs, but focused on his love of animals. Marty Wilde appeared in *Jet Storm* (aka *Killing Urge*, Cy Enfield, 1959), *What a Crazy World* (Michael Carreras, 1963), and later *Stardust* (Michael Apted, 1974).

Chapter 8

1. The Beatles also appeared on the show in September 1965 and later, when they limited their live appearances, subsequently sent promotional films, including ones for "Rain," "Penny Lane," and "Strawberry Fields Forever."

2. Stephen Mamber, *Cinema Verite in America: Studies in Uncontrolled Documentary* (Cambridge, MA: MIT Press, 1974), p. 146.

3. The first British television broadcast was a 40-minute version, *Yeah! Yeah! Yeah! The Beatles in New York*, on February 12 and 13, 1964—before the tour was finished—with a 50-minute version titled *The Beatles in America* broadcast in the United States on November 13. But *What's Happening! The Beatles in the USA* was not broadcast complete or released theatrically in either the United States or Britain. The Maysles made their own, 74-minute, cut that had some theatrical screenings in the mid-1960s as *What's Happening! The Beatles in the USA*, and Apple released a 52-minute theatrical version in 1991 as *The Beatles: The First US Visit* and an 81-minute DVD also including the Washington concert and the three *Ed Sullivan Show* performances under the same title in 2003. All details from Joe McElhaney, *Albert Maysles* (Urbana: University of Illinois Press, 2009), pp. 65–66. McElhaney's analysis focuses on the Maysles own cut, but he provides a scene-by-scene comparison between *What's Happening! The Beatles in the USA* and *The Beatles: The First US Visit* (pp. 175–179).

4. Subotsky also wrote several of the songs, including "Ring-a-Ding," which generated the film's US title, *Ring-a-Ding Rhythm!*

5. Andrew Yule, *The Man Who "Framed" the Beatles: A Biography of Richard Lester* (New York: D. I. Fine, 1994), p. 68.

6. Lester's achievement was recognized in the popular and quality British press; the *Evening Standard* noted its "disproportionate inspiration" and the *Observer* found it "extraordinarily inventive, one of the most imaginative British movies of the decade"; in the United States, *Variety* wrote that Lester's direction was the "most interesting aspect of this bright little picture." The film was the second biggest grosser of the year in the United Kingdom, taking in £300,000 for its £60,000 investment. Yule, *The Man Who "Framed" the Beatles,* pp. 71–72.

7. On *A Hard Day's Night* specifically, see Richard Lester, *The Beatles in Richard Lester's A Hard Day's Night: A Complete Pictorial Record of the Movie* (New York: Chelsea House Publishers, 1977), Stephen Glynn, *A Hard Day's Night* (London: I. B. Tauris, 2005), and Donnelly, *British Film Music and Film Musicals* (London: Palgrave Macmillian, 2007), pp. 151–165.

8. Quoted in Roy Carr, *Beatles: At the Movies* (New York: Harper Perennial, 1996), p. 25.

9. As Bob Spitz observes, "The Beatles would play Beatles and do what Beatles normally did—minus the smoking, drinking, swearing, and sex." *The Beatles: The Biography* (New York: Little, Brown, 2005), p. 491.

10. These earlier Beatles releases and the finale's previously released "She Loves You" were not included on the soundtrack album.

11. A cameraman since 1930, Gilbert Taylor had also shot a Tommy Steele film, *Tommy the Toreador* (John Paddy Carstairs, 1959) and *Dr. Strangelove or: How I Learned to Stop Worrying and Love the Bomb* (Stanley Kubrick, 1964); later he worked with distinction for Roman Polanski on *Repulsion* (1965) and *Cul-de-sac* (1966), and many other films including *Ferry Cross the Mersey* (Jeremy Summers, 1965), featuring Gerry and the Pacemakers.

12. Robert B. Ray has argued that if it would be hard to exaggerate the Beatles' effect on US teenagers of the 1960s, "[i]t would be harder still to exaggerate the impact that *A Hard Day's Night* had on the American film industry. . . . By convulsing the British 'kitchen sink realist' tradition with Mélièsian tricks, Lester also showed Hollywood a way of spoofing established modes . . . [that] finally made available to the American audience the stylistic innovations of the French New Wave." *A Certain Tendency of the Hollywood Cinema, 1930–1980* (Princeton, NJ: Princeton University Press, 1985), pp. 270–72.

13. Crowther's review "Screen: The Four Beatles in 'A Hard Days Night'" appeared in the *New York Times,* August 12, 1964, p. 41. Sarris's comments (from his August 27, 1964 review) were reprinted slightly modified in Lester, *The Beatles in Richard Lester's A Hard Day's Night,* p. xiii.

14. Figures variously from R. Serge Denisoff and William D Romanowski, *Risky Business: Rock in Film* (New Brunswick, NJ: Transaction Publishers, 1991), pp. 137–138, and Jeff Smith, *The Sounds of Commerce: Marketing Popular Film Music* (New York: Columbia University Press, 1988), p. 55.

Chapter 9

1. Under the title, "Singers Romp Through Comic Adventures," Bosley Crowther's review in the *New York Times* continued tongue-in-cheek that since *A Hard Day's Night* was as serious and sensible as the Beatles could be, in *Help!* they decided "to go for the utterly absurd." August 24, 1965, p. 25.

2. Neaverson, *The Beatles Movies* (London: Cassell, 1997), p. 48.

3. Richard Lester argued, "What the Beatles should do is make this glorious, world's most expensive home movie. They should make it themselves." Cited in Susan Lydon, "New Thing For Beatles: Magical Mystery Tour," *Rolling Stone* 1, no. 3 (December 14, 1967): 1. In the United States, the chief exponent and theorist of amateur filmmaking was Yoko Ono's friend Jonas Mekas. Lennon met Ono almost a year before shooting for *Magical Mystery Tour* began, and he appeared in several of Mekas's diary films, including (much later) *Happy Birthday to John* (1995). By 1966, McCartney had completed two experimental films, *The Defeat of the Dog* and *The Next Spring Then; Punch* remarked that "they were not like ordinary people's home movies." See Barry Miles, *Paul McCartney: Many Years from Now* (New York: Holt, 1998), p. 297.

4. On the Beatles' films, see Bob Neaverson, *The Beatles Movies*, and Roy Carr, *Beatles: At the Movies* (New York: Harper Perennial, 1996). Carr is especially useful for information on the various feature and other film projects the Beatles considered but rejected, including *The Yellow Teddybears* (a teenage exploitation film), an adaptation of Tolkien's *The Lord of the Rings*, and *A Talent for Loving* (a western); films in which individual Beatles had bit parts in dramatic and/or non-singing roles; and films for which individual Beatles wrote music, including Paul's for *The Family Way* (Roy Boulting, 1966) and George's for *Wonderwall* (Joe Massot, 1968). Richie Unterberger, *The Unreleased Beatles: Music and Film* (San Francisco: Backbeat Books, 2006) lists all the television performances, promotional films, and other moving image material. Often involving music and humor, Ringo's acting career was the most extensive, with parts in *Candy* (Christian Marquand, 1968); *The Magic Christian* (Joseph McGrath, 1969), playing opposite Peter Sellers and his fellow Goon, Spike Milligan; Frank Zappa's *200 Motels* (Tony Palmer, 1971); *That'll Be the Day* (Claude Whatham, 1973). and many others. He also directed and appeared in a T-Rex documentary *Born to Boogie* (Ringo Starr, 1972). Two years after *Help!* John played a soldier in Richard Lester's *How I Won the War* (1967) and in the late 1960s, he collaborated with Yoko Ono on several experimental films, including *Smile, Rape, Honeymoon, Self Portrait*, and *Erection*. George had a small part in *All You Need Is Cash* (Eric Idle and Gary Weis, 1978), and cofounded a production company, HandMade Films, in order to finance the Monty Python film *Life of Brian* (Terry Jones, 1979), in which he had a brief, uncredited appearance, and the company made several subsequent films. And Paul, along with his wife, Linda Eastman, and Ringo, starred in a vanity production, *Give My Regards to Broad Street* (Peter Webb, 1984); a day-in-the-life of a musician somewhat reminiscent of *Magical Mystery Tour*, it was very poorly received.

5. For production details, see Bob Spitz, *The Beatles: The Biography* (New York: Little, Brown, 2005), pp. 720–724, 732–735.

6. McCartney's schema was a circle with eight segments designated as: "1. Commercial introduction. Get on the coach. Courier introduces. 2. Coach people meet each other/ (Song, "Fool on the Hill?"). 3. marathon-laboratory sequence. 4. smiling face. LUNCH. mangoes, tropical (magician). 5. and 6. Dreams. 7. Stripper & band. 8. Song. END." Spitz, *The Beatles*, pp. 720–721.

7. Susan Lydon, "New Thing For Beatles: Magical Mystery Tour," *Rolling Stone* 1, no. 3 (December 14, 1967): p. 4.

8. Abbie Hoffman (under the pseudonym "Free"), *Revolution for the Hell of It* (New York: Dial Press, 1968), p. 67.

9. Typical UK press reviews were "worse than terrible," "rubbish, piffle, chaotic, flop, tasteless, nonsense, emptiness, and appalling," and "rubbish . . . piffle . . . nonsense!"; for more obloquy, see Spitz, *The Beatles*, p. 734. Though *Rolling Stone*'s reviewer thought such comments were "bitter, ignorant, and demented," he correctly noted its debt to the avant-garde, arguing that "the Beatles haven't developed their editing ideas in the ways that Stan Brakhage and Bruce Conner have." Paul agreed that the project was a mistake, but only "because we thought people would understand that it was 'magical' and a 'mystery tour.'" Both quotes from Jonathan Cott, "'We Thought People Would Understand'- Paul," *Rolling Stone* 1, no. 5 (February 10, 1968): 22.

10. Giannalberto Bendazzi, for example, argues that "[a] complex, almost redundant film, *Yellow Submarine* is an example of the balance between artistic creation and marketing. . . Rather than being the banner of the protest generation, this film is its commercial symbol"; *Cartoons: One Hundred Years of Cinema Animation* (Bloomington: Indiana University Press, 1994), p. 281.

11. Jerry Hopkins, "The Trouble with the Beatles," *Rolling Stone*, no. 62 (July 9, 1970): 12. Lindsay-Hogg, director of the important mid-1960s UK pop music television show, "Ready Steady Go," had been chosen for the project on account of his previous work on the Beatles' "Hey Jude" and "Revolution" promo films.

12. Michael Goodwin, "Let It Be," *Rolling Stone*, no. 61 (June 25, 1970): 52. A much longer, more appreciative, account of the film appeared in the next issue: Jonathan Cott and David Dalton, "Daddy Has Gone Away Now: Let It Be," *Rolling Stone*, no. 62 (July 9, 1970): 20–23.

13. Among the more interesting are *I Wanna Hold Your Hand* (Robert Zemeckis, 1978), about the escapades of three girls trying to make contact with the Beatles and get into the *Ed Sullivan Show* on the occasion of their first appearance; containing both documentary footage of the show and incidents imitated from *What's Happening! The Beatles in the USA*, it showed the fans' point of view of the show, as against *A Hard Day's Night* fictionalized version. With Peter Frampton and various Bee Gees, *Sgt. Pepper's Lonely Hearts Club Band* (Michael Schultz, 1978) restaged the Sgt. Pepper myth along with elements from *Yellow Submarine* in *Heartland, USA*. *The Hours and Times* (Christopher Munch, 1991) dramatized John's vacation in Spain with Brian Epstein in 1963, and *Nowhere Boy* (Sam Taylor-Wood, 2009) his adolescence and relations with his aunt Mimi. *Backbeat* (Iain Softley, 1994) returned to the pre-fame days in Hamburg, foregrounding Stuart Sutcliffe's love for Astrid Kirchherr.

14. Other mid-sixties British rock'n' roll features include two directed by Lance Comfort, *Live It Up!* (US title, *Sing and Swing*, 1963) with Gene Vincent, and its sequel, *Be My Guest* (1965), both starring David Hemmings, who forms a rock'n' roll group with his pals, including Steve Mariott, later of the Small Faces; *It's All Over Town* (Douglas Hickox, 1963), set in Soho in and around the London Palladium, with the Hollies, the Springfields, and the trad jazz band, Acker Bilk; *What a Crazy World* (Michael Carreras, 1963) with Freddie and the Dreamers and Joe Brown; *Just for Fun* (Gordon Flemyng, 1963) with cameos by more than a dozen acts; *Saturday Night Out* (Robert Hartford-Davis, 1964), an exploitation film also set in the dives of Soho showcasing the Merseybeat group, the Searchers; *Gonks Go Beat* (Robert Hartford-Davis, 1965), a science-fiction comedy about a conflict on Earth between Beatland and Ballad Isle; and *Seaside Swingers* (aka *Every Day's a Holiday*, James Hill, 1965) with John Leyton, Freddie and the Dreamers, and cinematography by Nicolas Roeg. Freddie and the

Dreamers also appeared in *Just for You* (US title, *Disk-O-Tek Holiday*, Douglas Hickox and Vince Scarza, 1966) with the Merseybeats, and *The Cuckoo Patrol* (Duncan Wood, 1967). Herman's Hermits appeared in the US films *When the Boys Meet the Girls* (Alvin Ganzer 1965), *Hold On!* (Arthur Lubin, 1966), and *Mrs. Brown You've Got a Lovely Daughter* (Saul Swimmer, 1968). *Beat City* (Daniel Farson, 1963), a documentary short made for television, examined the Merseybeat scene and featured performances by Gerry and the Pacemakers, Billy J. Kramer and the Dakotas, Rory Storm and the Hurricanes, and other local bands. *Go Go Mania* (UK title, *Pop Gear*, Frederic Goode, 1965) was a US-made compilation of lip-synced performances by mostly British Invasion acts.

15. As the first satirical rock documentary, *All You Need Is Cash* anticipated the *faux* heavy metal movie, *This Is Spinal Tap* (Rob Reiner, 1984) and other "mockmentaries." A follow-up, Eric Idles's own *The Rutles 2: Can't Buy Me Lunch* (2002), had only limited release.

16. Eric Lefcowitz, *The Monkees Tale* (San Francisco: Last Gasp, 1985), 7.

17. Ibid, p. 12.

Chapter 10

1. Later, Charles and Ike and Tina Turner appeared in *The Big T.N.T. Show* (Larry Peerce, 1966), discussed below, but Hollywood did not tell their stories until the biopics *What's Love Got to Do with It* (Brian Gibson, 1993) about Tina Turner and *Ray* (Taylor Hackford, 2004) about Charles.

2. Bob Dylan, *Chronicles: Volume One* (New York: Simon & Schuster, 2005), p. 5.

3. For example, Richie Unterberger suggests that folk musicians found the "counterculture ethos" mirrored by even the early Beatles. He quotes David Freiberg of the Quicksilver Messenger Service saying that *A Hard Day's Night* "pictured them as being a very communal thing" and "kind of the way all of us were actually living." Jerry Yester, a member of the Modern Folk Quartet, recalled that in summer 1964 everybody would go to an "all-night theater in Hollywood, *every night*, to see *A Hard Day's Night*. It was like this instantly formed tradition." *Turn! Turn! Turn!: The '60s Folk-Rock Revolution* (San Francisco: Backbeat Books, 2002), p. 81.

4. Robbie Lieberman, *"My Song Is My Weapon": People's Songs, American Communism, and the Politics of Culture, 1930–1950* (Urbana: University of Illinois Press, 1989), p. 66.

5. Among these, Ochs and Baez most strongly maintained the links between folk music and political activism. There are two documentary films about Ochs, *Chords of Fame* (Michael Korolenko, 1984) and *Phil Ochs: There But for Fortune* (Kenneth Bowser, 2010); the latter poignantly reveals the tension between his commitment to topical protest songs and the desire for rock 'n' roll stardom that consumed him.

6. Two years later, in 1967, the folk song "Alice's Restaurant Massacree" by Woody Guthrie's son, Arlo, became a hit record and was used as the basis for a successful feature film, *Alice's Restaurant* (Arthur Penn, 1969) that was released a few days after his performance of the song at Woodstock.

7. The audience's hostility at this event has been exaggerated; for a comprehensive account, see Richie Unterberger, *Turn! Turn! Turn!*, pp. 1–21. The "Maggie's Farm" performance appeared in *Festival!* (1967), Murray Lerner's documentary about the 1963–1966 Newport Folk Festivals, and the entire set in his *The Other Side of the Mirror: Bob Dylan*

at the Newport Folk Festival (2007), which contains Dylan's appearances in 1963, 1964, and 1965.

8. Cited in Bob Spitz, *The Beatles: The Biography* (New York: Little, Brown, 2005), p. 533.

9. Cited in Clinton Heylin, *Bob Dylan: Behind the Shades Revisited* (New York: William Morrow, 2001), p. 148.

10. *The T.A.M.I. Show* used the technology and practices of live music television to make a theatrical film; *Dont Look Back* broke the interaction, being conceived and completed as a film; and, though planned for television, *Monterey Pop* was shot on film and theatrically released. Finally, at least according to its associate producer, Dale Bell, *Woodstock* was designed "so that it would never be seen on television"; see Dale W. Bell, *Woodstock: An Inside Look at the Movie That Shook Up the World and Defined a Generation* (Studio City, CA: Michael Wiese Productions, 1999), p. 253.

11. Jonas Mekas, "The First Statement of the New American Cinema Group," *Film Culture* 22–23 (Summer 1961): 130–133.

12. Richard Leacock, "For an Uncontrolled Cinema," *Film Culture* 22–23 (Summer 1961): 23–26.

13. P. Adams Sitney, ed., "The Independent Film Award," in *Film Culture Reader* (New York: Cooper Square Press, 2000), p. 425.

14. Jonathan Kahana and Dave Saunders have traced the counterculture's influence on documentary filmmaking; see, respectively, *Intelligence Work: The Politics of American Documentary* (New York: Columbia University Press, 2008) and *Direct Cinema: Observational Documentary and the Politics of the Sixties* (London: Wallflower Press, 2007).

15. *Sweet Toronto* was later retitled as *John Lennon & The Plastic Ono Band: Live in Toronto '69*. First with Leacock and later with Chris Hegedus and other collaborators, Pennebaker made other documentaries about music, including *Keep On Rockin'* (1969), featuring Little Richard, Chuck Berry, and Bo Diddley; *Ziggy Stardust and the Spiders from Mars* (1973), a performance film with David Bowie; *Depeche Mode 101* (1989) about the Brit Pop group; *Branford Marsalis—The Music Tells You* (1992), about the jazz musician; *Down from the Mountain* (2001), about traditional US music; and *Only the Strong Survive* (2002), with several surviving soul singers of the sixties.

16. Of other pop music documentaries of the period, especially important is *Lonely Boy* (Roman Kroitor and Wolf Koenig, 1962), about Paul Anka, a ballad singer prominent in the period between Elvis and the Beatles. Sponsored by the National Film Board of Canada, it has some elements in common with early Direct Cinema, including candid shots of hysterical girls, car journeys between engagements, and off-stage scenes. But many of these are staged, and edited with direct address interviews, rapid montages, and expository voice-overs that, from outside the milieu, explore "the astonishing transformation of an entertainer into an idol." Its overall constructedness was quite alien to Direct Cinema, as indeed was Anka's Sinatraesque lounge music to contemporary folk and rock 'n' roll.

17. *Life* (New York: Back Bay Books, 2010), p. 112. Richards declared it "a hugely important film for aspiring rock musicians at the time," primarily because Chuck Berry triumphed over attempts by drummer Jo Jones and his other jazz accompanists to undermine his performance. Stanley Booth reports that Richards saw it fourteen times; see *The True Adventures of the Rolling Stones* (New York: Vintage, 1984), p. 44.

18. After its brief theatrical run, *The T.A.M.I. Show* was occasionally broadcast on television (though with the Beach Boys sequence omitted for legal reasons), on KCET in Los Angeles, for example, and also on the ABC network, where Dick Clark inserted commercial breaks between segments (personal correspondence from Steve Binder, August 1, 2011). Thereafter it circulated only on poor-quality video bootlegs until it was restored and released on DVD in 2010.

19. Winters himself appeared in *Rock, Rock, Rock!* and both the Broadway and film production of *West Side Story*. His many important rock 'n' roll commissions include work on the television shows *Shindig!, Hullabaloo,* and *The Monkees,* and he worked with Elvis on *Viva Las Vegas, Easy Come, Easy Go, Girl Happy,* and *Tickle Me*. Basil also crisscrossed the history of rock 'n' roll cinema, choreographing and appearing in *Viva Las Vegas* and *Head* and later working with many important musicians, including David Bowie, David Byrne, and Tina Turner. She danced for Bruce Conner's short *Breakaway* (1966), which was cut to her hit single of the same, and in 1982 she had a bigger hit with "Mickey."

20. James Brown considered it one of his best-ever performances, later recalling "I don't think I ever danced so hard in my life, and I don't think they'd ever seen a man move that fast. . . . It was one of those performances when you don't even know how you're doing it." James Brown with Bruce Tucker, *James Brown: The Godfather of Soul* (New York: Macmillan, 1986), p. 153. Brown appeared shortly after in a mutant surf film, *Ski Party* (Alan Rafkin, 1965).

21. Selected acts from *The T.A.M.I. Show* and *The Big T.N.T. Show* were compiled as a single feature, *That Was Rock* (Steve Binder and Larry Peerce, 1965).

Chapter 11

1. "Third Independent Film Award," *Film Culture* 22–23 (Summer 1961): 10.

2. *Dont Look Back* was a Leacock Pennebaker production. Pennebaker also made an unreleased film about Bob Dylan shot in 1966, *Something Is Happening,* and published a transcript of *Dont Look Back: Bob Dylan, Dont Look Back* (New York: Ballantine Books, 1968). In 2007 he released *65 Revisited,* a new film made from footage shot for but not used in *Dont Look Back*. Dylan hired Pennebaker to film his next UK tour in 1966, but his own edit of the footage titled *Eat the Document* was rejected by ABC television who had commissioned it, and has never been publicly released. In the next decade Dylan's interest in acting led him to take a small part in *Pat Garrett and Billy the Kid* (Sam Peckinpah, 1973); he wrote, starred in, and directed the four-hour *Renaldo and Clara* (1978), which intersperses the 1975–1976 Rolling Thunder Revue tour with role-playing by Dylan himself, his ex-wife Sara, Joan Baez, and others. He subsequently played versions of himself in several features.

3. In *Direct Cinema: Observational Documentary and the Politics of the Sixties* (London: Wallflower Press, 2007), Dave Saunders highlights the counterculture's influence on Direct Cinema filmmakers. The idea that the most significant documentaries depicted the rise and fall of the counterculture was probably first suggested by William Rothman: "The arrival of the counterculture that Dylan prophesied and helped goad into existence was announced in Pennebaker's landmark *Monterey Pop,* released in 1968; the counterculture's mythical high-water mark was registered in Michael Wadleigh's *Woodstock* (1970); its violent death was prematurely reported in *Gimme Shelter* . . . its early

retirement was mourned in Martin Scorsese's elegiac *The Last Waltz* ... and its surprising continual survival ... was celebrated in Pennebaker's and Chris Hegedus's remarkable 1989 film *Depeche Mode 101*"; *Documentary Film Classics* (New York: Cambridge University Press, 1997), p. 145. The present account contrarily proposes that, rather than observationally documenting this history of the counterculture, the films themselves substantially created and disseminated this narrative, and that Direct Cinema's engagement with the counterculture caused the collapse of its own original axioms.

4. Quoted in Stephen Mamber, *Cinema Verite in America: Studies in Uncontrolled Documentary* (Cambridge, MA: MIT Press, 1974), p. 91.

5.*Playboy,* February 1966, http://www.interferenza.com/bcs/interw/66-jan.htm (accessed October 17, 2012).

6. Before the final concert, Dylan is filmed singing parts of the following songs: "Don't Think Twice, It's All Right" (from *The Freewheelin' Bob Dylan*, 1963) "The Times They Are a-Changin'," and "The Lonesome Death of Hattie Carroll" (from *The Times They Are a-Changin'*, 1964), and "All I Really Want To Do" and "To Ramona" (from *Another Side of Bob Dylan*, 1964). At the Albert Hall he sings "The Times They Are a-Changin'" and "Talkin' World War III Blues" (from *The Freewheelin' Bob Dylan*), and then three songs, "It's Alright, Ma (I'm Only Bleeding)," "The Gates of Eden," and "Love Minus Zero/No Limit." In a hotel room jam he sings "It's All Over Now, Baby Blue," from *Bringing It All Back Home*. Earlier, in his hotel room, Joan Baez sings his "Percy's Song, " an out-take from *The Times They Are a-Changin'*, and "Love Is Just a Four-Letter Word."

7. Pennebaker, *Bob Dylan, Dont Look Back*, n.p.

8. Faithfull gives an account of this event and of the homage paid to Dylan by the Beatles and Rolling Stones in London in *Faithfull: An Autobiography* (New York: Little, Brown, 1994), pp. 40–56.

9. Information on the festival is derived from "Pop Powwow," *Newsweek*, July 3, 1967; Michael Goldberg, "Monterey Pop: The Dawning of an Age," *Rolling Stone*, issue 501 (June 4, 1987): 116–120; Joel Selvin, *Monterey Pop* (San Francisco: Chronicle Books, 1992); Michael Lydon, "Monterey Pops! An International Pop Festival," reprinted in *The Sound and the Fury: A Rock's Backpages Reader. 40 Years of Classic Rock Journalism*, ed. Barney Hoskyns (New York: Bloomsbury, 2003); and Marley Brant, *Join Together: Forty Years of the Rock Music Festival* (New York: Backbeat, 2008). Writing for *Newsweek*, Michael Lydon was initially unsure whether the festival was "a nightmare and something beautiful existing side by side or a nightmare and many beautiful things existing side by side," but concluded that "if not perfect the festival was as good as it could have been" (Lydon, "Monterey Pops!," p. 255). He was critical of some acts, recognizing that the Who's instrument destruction had a "dramatic intensity. And no meaning. No meaning whatever" (p. 265), but generally was sympathetic, insightful, and even eloquent: "The Dead built a driving, unshakeable rhythm that acted not just as rhythm but a wall of noise on which the solos were etched ... like fine scrolls on granite" (p. 266). And though he thought "the heavy erotic feeling of [Hendrix's] act was absurd," he nevertheless found the climax to be an extension of Elvis's gyrations "to infinity, an orgy of noise so wound up that I felt that the dynamo that powered it would fail and fission into its primordial atomic state" pp. 267–268.

10. Simon Frith notes correctly: "Unlike the traditional pop package show, put together *for* the fans out there, the rock festival—in its length, its size, its setting, its reference to a

folk tradition—was an attempt to provide materially the experience of community that the music expressed symbolically. This put a new burden on the stars; they had to make themselves 'known' to their audiences directly": "Rock and the Politics of Memory," in *The 60s Without Apology*, eds. Sohnya Sayres, Anders Stephanson, Stanley Aronowitz, and Fredric Jameson (Minneapolis: University of Minnesota Press, 1984), p. 66.

11. The Association, the Paupers, Beverly, Johnny Rivers, and Laura Nyro, the Group With No Name, and Scott McKenzie also performed, though they are not seen in the film.

12. From "Monterey," a song celebrating the festival written and recorded by Eric Burdon and the Animals.

13. Not included in *Monterey Pop*, Hendrix's comments appear in *Jimi Plays Monterey* (Chris Hegedus and D. A. Pennebaker, 1986) just before "Wild Thing": "I'm not losing my mind. This is for everybody here. . . . So we're gonna do the English and American combined anthem together, OK?"

14. "Pop Powwow," p. 80.

15. Lydon, "Monterey Pops!," p. 253.

16. "Transcriptions from Tape," *Monterey Pop Symposium* (Monterey Art and History Association; Monterey, California, June 15, 16, 17, 2001), cited in Mayes, *It Happened in Monterey*, p. 45.

17. Though the actual lyrics of the song address a woman and otherwise refer only to the Avalon Ballroom, composer Sam Andrew claimed that the "theme was the combining of so many seeming opposites, north and south, east and west, man and woman, mainstream and counterculture, vision and reality. Monterey was the place where these extremes melted together for one magic moment." In Elaine Mayes, *It Happened in Monterey: Modern Rock's Defining Moment* (Culver City, California: Britannia Press, 2002), p. 47.

18. Information on cameramen was supplied by D. A. Pennebaker, personal correspondence, September 3, 2014.

19. Cited in Charles White, *The Life and Times of Little Richard* (New York: Da Capo Press, 1994), p. 226.

20. In addition to *Woodstock*, other films featuring Jimi Hendrix include *Band of Gypsys: Live at the Fillmore East* (aka *Jimi Hendrix: Band of Gypsys—Live at the Fillmore East*) (no director, 1970); *Jimi Plays Berkeley* (Peter Pilafian, 1971); *Jimi Hendrix* (aka *A Film about Jimi Hendrix*, Joe Boyd, John Head, and Gary Weis, 1973), which contains concert footage and interviews with many contemporary musicians; *Jimi Plays Monterey* (Chris Hegedus and D. A. Pennebaker, 1986), with his entire Monterey performance; and *Jimi Hendrix—Live at the Isle of Wight* (Murray Lerner, 1991). His last filmed concert was in *Rainbow Bridge* (Chuck Wein, 1971).

21. Though the major studios' engagement with rock 'n' roll in the 1960s was limited to the Elvis films, API and other minors continued to exploit musical trends, initially with the surf party films and later more sensationalistic low-budget features in which rock 'n' roll was incriminated in hippie depredations. Sam Katzman sparked the genre with *Get Yourself a College Girl* (Sidney Miller, 1964) about a songwriter at a conservative girls' school featuring the Dave Clark Five, and the Animals. *Riot on Sunset Strip* (Arthur Dreifuss, 1967) about Los Angeles hippies, was quickly followed by *The Love Ins* (Arthur Dreifuss, 1967) about San Francisco acid-heads, both with the Chocolate Watch Band and other psychedelic music. Another hippie exploitation film, *Psych-Out* (Richard Rush,

1968), featured the Strawberry Alarm Clock. A comedy staring Sonny and Cher, *Good Times* (William Friedkin, 1967), was something of an anomaly, but the summa of the genre appeared the next year with *Wild in the Streets* (Barry Shear, 1968), in which a singer joins with Max and his band of rock 'n' roll revolutionaries to demand that the voting age be lowered to fourteen. Eventually Max becomes president, sends all those over thirty-five to re-education camps for LSD therapy, and establishes a purely hedonist order, only to face a revolt by ten-year-olds. In *Beyond the Valley of the Dolls* (Russ Meyer, 1970), a racially integrated all-girl rock 'n' roll band comes to grief in the Sunset Strip hyper-surreal drug culture. Exploitation producer David F. Friedman's *Bummer* (William Allen Castleman, 1973), advertised as a "A Far Out Trip Thru a Hard Rock Tunnel" in which three groupies' involvement with a rock 'n' roll band leads to mayhem and murder, was an epilogue. *The Cool Ones* (Gene Nelson, 1967), choreographed by Toni Basil, features an out-of-control go-go television girl who invents "the Tantrum," which Bruce Conner dances at the Whisky a Go Go.

22. To this end a Monterey International Pop Festival Foundation was established to distribute funds to charities, and the film's titles indicate that though it was produced by Adler and Phillips, it was "presented" by "The Foundation," a "California non-profit Organization." Ticket prices ranged from $3 to $6.50, but costs ($290,233) exceeded income ($211,451), and only the (ultimately aborted) sale of the television rights to ABC prevented a net loss. Apparently book-keeping was less than coherent, and various accounts suggest that some money was given to the Haight-Ashbury Free Clinic and that someone absconded with $50,000, but the overall disposition of what profits there were is not reported. The film is supposed to have grossed $2 million (thereby providing the incentive for the film of the Woodstock festival), but full details are not available. See Michael Lydon, "The High Cost of Music and Love: Where's the Money from Monterey?," *Rolling Stone* 1.1 (November 9, 1967): 1, 7; and Goldberg, "Monterey Pop: The Dawning of an Age," and Gina Arnold, "Pop Perfect," http://www.metroactive.com/papers/metro/06.14.01/montereypop-0124.html (accessed September 5, 2011).

Chapter 12

1. Abbie Hoffman (under the pseudonym "Free"), *Revolution for the Hell of It* (New York: The Dial Press, 1968), p. 67. Internal evidence suggests that this was written in the spring of 1968.

2. Reprinted in Abbie Hoffman, *Woodstock Nation: A Talk-Rock Album* (New York: Random House, 1969), pp. 75–77.

3. Hoffman, *Woodstock Nation*, p. 4.

4. Federal Judiciary Center, http://www.fjc.gov/history/chicago7.nsf/autoframe?open Form&header = /history/chicago7.nsf/page/header&nav = /history/chicago7.nsf/page/ nav_documents&content = /history/chicago7.nsf/page/hoffman_testimony (accessed October 19, 2011).

5. John Sinclair, *Guitar Army; Street Writings/Prison Writings* (New York: Douglas Book Corp., 1972), quotations respectively from pp. 14, 10, 13, 20, 31, and 28. Born in 1941 in Flint, Michigan, John Sinclair was involved in the mid-sixties underground press, poetry, and jazz communities of Detroit. He managed the band MC5 from 1966 to 1969, during which time they performed at the anti-war rally at the Chicago Democratic convention

that the police attacked. In 1968 he cofounded the White Panther Party in solidarity with the Black Panther Party, and collaborated with it and other civil rights groups in Fred Hampton's Rainbow Coalition. His prison sentence prompted John Lennon's song, "John Sinclair."

6. Sinclair, *Guitar Army*, p. 20.

7. Ibid, p. 28.

8. Michael Lydon, "Rock for Sale," *Ramparts*, June 1969, pp. 19–24. The following month, Robert Christgau proposed a similarly dour, if less cogently argued, assessment in the *Village Voice*. His "Rock'n'Revolution" began with a rhetorical question, "Why is rock like the revolution?" and he answered it in Monterey's terms, "Because they're both groovy"; subsequently he argued that since the festival, the idea of revolution had evolved "from an illusion of humorless politniks to a hip password that, like everything hip, was promulgated free (both vitiated and made more dangerous) by magazines, networks, and even advertising agencies." "Rock'n'Revolution." Reprinted in Robert Christgau, *Any Old Way You Choose It; Rock and Other Pop Music, 1967–1973* (Baltimore, MD: Penguin Books, 1973), p. 97.

9. Lydon, "Rock for Sale," p. 21.

10. Ibid., p. 24.

11. See Keith Richards, "We found out . . . that all the bread we made for Decca was going into making little black boxes that go into American Air Force bombers to bomb fucking North Vietnam." Quoted in Steve Chapple and Renee Garofalo, *Rock 'n' Roll Is Here to Play: The History and Politics of the Music Industry* (Chicago: Nelson-Hall, 1977), p. 86.

12. On the Woodstock festival, see especially Robert Stephen Spitz, *Barefoot in Babylon: The Creation of the Woodstock Music Festival, 1969* (New York: Viking Press, 1979); Joel Makower, *Woodstock: The Oral History*, 40th anniv. ed. (Albany: State University of New York Press, 2009); and James E. Perone, *Woodstock: An Encyclopedia of the Music and Art Fair* (Westport, CT: Greenwood Press, 2005).

13. Quoted in Dale W. Bell, *Woodstock: An Inside Look at the Movie That Shook Up the World and Defined a Generation* (Studio City, CA: Michael Wiese Productions, 1999), p. 52.

14. On *Woodstock*, see especially Bell, *Woodstock*. Details of the filming and editing below were compiled from the sources assembled by Bell, and from Spitz, *Barefoot in Babylon*, p. 488, and Makower, *Woodstock*, pp. 303–317.

15. The entire arsenal is listed in Bell, *Woodstock*, pp. 72–74.

16. Quoted in ibid., p. 80.

17. Maurice was credited as producer and Wadleigh as director. Along with Maurice, credited cameramen include Malcolm Hart, Don Lenzer, Michael Margetts, David Myers, Richard Pearce, and Al Wertheimer. Hart, Lenzer, Margetts, and Wertheimer were neophytes, but both Myers and Pierce were experienced; films they later (separately) photographed include *Mad Dogs & Englishmen* (Pierre Adidge, 1971), *Wattstax* (Mel Stuart, 1972), *Let the Good Times Roll* (Robert Abel and Sidney Levin, 1973), *The Grateful Dead Movie* (Leon Gast and Jerry Garcia, 1977), *Renaldo and Clara* (Bob Dylan, 1978), *Rust Never Sleeps* (Neil Young, 1979), *Baby Snakes* (Frank Zappa, 1979), and many other rock films. Schoonmaker's editing was nominated for an Academy Award Film, along with the Best Sound nomination. A 228-minute director's cut with added performances, also called *Woodstock, 3 Days of Peace & Music*, was released in August 1994; in 1999, archival footage

was used for *Jimi Hendrix: Live at Woodstock* (with directors' credit going to editors, Chris Hegedus and Erez Laufer), and in June 2009, a "40th Anniversary edition," remastered to accord with the director's cut, was released on Blu-Ray and DVD.

18. Compare Rick Altman's comment on *The Great Caruso* (Richard Thorpe, 1951): "Music is no longer just a job or talent, it is an artistic consecration of the marriage vows": *The American Film Musical* (Bloomington: Indiana University Press, 1987), p. 236. *Woodstock* is the only rock 'n' roll documentary that Altman accepts as a musical; he argues that it may be read as a narrative ("the rural romance with flower children: motivated by love for music and peace, half-a-million youths overcome local resistance and eventually demonstrated love for the land") and also as a dual-focus narrative, not because of the fusion of musicians and audience, but because it "establishes a parallel between male-female coupling and the romance between the wandering hippies and the stable populace." Ibid., p. 103.

19. William Blake, *Milton*, plate 28.

20. Less than half of the acts that performed were included in the film, and though Havens did open and Hendrix did close the festival, the chronology is otherwise freely rearranged. For example, the fences were broken before the festival began, not in response to Havens's song, "Freedom"; Sha Na Na appeared just before Jimi Hendrix rather than on "Saturday," Santana and Sly and the Family Stone both appeared on Saturday rather than "Sunday," and so on.

21. Originally formulated by Gustav Freytag in 1863, this notion of a five-act structure has been widely used in the analysis of classical drama. See Gustav Freytag, *Technique of the Drama*, trans. Elias J. MacEwan (Chicago: Griggs, 1896).

22. Not included in the initial release but restored in the Director's Cut is an extraordinary seven and a half minute uninterrupted take of Canned Heat performing "A Change Is Gonna Come." As usual, Wadleigh's close-ups weave among the performers, often following from one soloist to another, with his wide lens creating dynamically skewed images of faces and guitars.

23. Warnow discusses the editing in Bell, *Woodstock*, pp. 173–176.

24. Quoted in Bell, *Woodstock*, p. 154.

25. Split screens had been recently used in two feature films, *The Thomas Crown Affair* (Norman Jewison) and *The Boston Strangler* (Richard Fleischer), both in 1968. Underground filmmakers had sometimes used side-by-side projection to create parallel effects, Kenneth Anger in the 1958 version of *Inauguration of the Pleasure Dome*, for example, and Andy Warhol in *Chelsea Girls*, but they had more commonly relied on multiple superimpositions to generate contrastive layering. *A Hard Day's Night* simulated multi-screens in the side-by-side television monitors.

26. See John Binder, location unit supervisor for the film: "As it wasn't directed—as I said, it was a segmented thing where people worked on their own with their own ingenuity and were just experienced enough to co-ordinate what they were doing with each other, and you got a coherent film out of it—in that sense, I think Michael [Wadleigh] took too much credit. But I will say something else. I don't think that there was another person around that would have kept the film together." Quoted in Makower, *Woodstock: The Oral History*, p. 317.

27. " Cinema: Hold onto Your Neighbor," April 13, 1970, p. 100. The industry press was similarly positive: *Variety*, for example, found it "a milestone in artistic collation of raw

footage into a multi-panel, variable-frame, dazzling montage," and "an absolute triumph in the marriage of cinematic technology to reality" "Woodstock," April 1, 1970, p. 14.

28. Mike Goodwin, "Woodstock," *Rolling Stone* 57 (April 30, 1970): 48.

29. Figures are from R. Serge Denisoff and William Romanowski, *Risky Business: Rock in Film* (New Brunswick, NJ: Transaction, 1991), pp. 714–715. Other estimates include John Roberts's own that its revenues exceeded $100 million worldwide, with the soundtrack albums selling over 6 million units to gross more than $100 million. Quoted in Bell, *Woodstock*, p. 53. Dennisoff and Romanowski report that the ticket price caused *Film Quarterly* to refuse to review it until it could be "seen at less outrageous prices" (*Risky Business*, p. 714).

30. "The Hard Rain's Already Fallin', " in *Revolution for the Hell of It*, p. 162. In pre-festival negotiations, Hoffman had agreed that the Yippies would endorse the festival in return for space to distribute leaflets, but his further attempts to politicize it along the lines of "The Hard Rain's Already Fallin'" were not generally successful. He had to be dissuaded from liberating an expensive lens from the equipment trailer and Pete Townshend hit him on the head with his guitar—not that this indicated any political sophistication in Townshend, who also kicked Wadleigh's camera into his face. And after attending the premiere, Hoffman complained, "I immediately noticed that there was a kind of conscientious effort to take out the politics. I don't mean just scenes of the hospital tents. . . . I mean leaflets and . . . the more political discussions were removed." Quoted in Makower, *Woodstock*, p. 318. But he was mistaken in blaming Warners for editorial decisions made by the filmmakers.

31. *The Hollywood Musical*, 2nd ed. (Bloomington: Indiana University Press, 1993), p. 3. In respect to *Woodstock* specifically, Feuer further notes, "The contradiction between the actual audience in the film and mass distribution was revealed to the author when spectators in Bloomington, Indiana, picketed the theater, refusing to pay admission to *Woodstock because they were in it*" (p. 111).

32. Details from personal correspondence with Yalkut, March 5, 2012.

33. "A Call for a New Generation of Film Makers,": *Film Culture* 19 (1959): 3.

34. Other important underground films about rock concerts and the musical elements of the counterculture include Ronald Nameth's *Andy Warhol's Exploding Plastic Inevitable* (1966) and Andy Warhol's *The Velvet Underground in Boston* (1967); Ben Van Meter's *S.F. Trips Festival, An Opening* (1966), a documentation of a three-night San Francisco acid test; Peter Ungerleider's *Under My Thumb* (1969) about the Rolling Stones' Hyde Park concert after Brian Jones's death; Ira Schneider's video documentaries, *The Woodstock Festival* (1969) and *The Rolling Stones Free Concert* (1969), the latter being about the Altamont concert also featured in *Gimme Shelter*; Thom Andersen and Malcolm Brodwick's *The Rock 'n' Roll Movie*, 1967, a metrical montage of fragments of rock 'n' roll records from Bill Haley to the Rolling Stones, disjunctively juxtaposed to a miscellany of shots of bands performing, record shops, pressing and mailing records, the Sunset Strip, cruising cop cars, and other elements of the Los Angeles rock scene. Beginning as a flicker of very short shorts (2:4:2:5:3:5:3:6 frames), the film gradually extends their length and finishes with a shot several seconds long of Mick Jagger dancing, apparently to the accompaniment of the Penguins' "Earth Angel"; and *The Hog Farm Movie* (David Lebrun, 1970), a documentary about the 1968 cross-country trip staging rock 'n' roll lightshows made by the commune that later supplied security at Woodstock. Several short films were made about the Doors,

including *Feast of Friends* (Paul Ferrara, 1969), a forty-minute documentary nominally directed by a UCLA friend of Jim Morrison, containing concert footage and scenes of police manhandling fans. Though screened locally, it was never officially released. See Jerry Hopkins, "Door's Movie Is a Feast for Friends," *Rolling Stone* 37 (July 12, 1969), p. 8.

35. A partial list through the mid-1970s would include *Elvis: That's the Way It Is* (Denis Sanders, 1970); *Gimme Shelter* (Albert and David Maysles and Charlotte Zwerin, 1970); *A Night at the Family Dog* (Robert N. Zagone, 1970); *Mad Dogs & Englishmen* (Pierre Adidge, 1971); *Ten for Two: The John Sinclair Freedom Rally* (Steve Gebhardt, 1971); *200 Motels* (Tony Palmer and Frank Zappa, 1971); *Medicine Ball Caravan* (François Reichenbach, 1971); *Celebration at Big Sur* (Baird Bryant and Johanna Demetrakas, 1971); *The Concert for Bangladesh* (Saul Swimmer, 1972); *Journey Through the Past* (Neil Young, 1972); *Glastonbury Fayre* (Nicolas Roeg and Peter Neal, 1972); *Sweet Toronto* aka *Sweet Toronto Peace Festival* (D. A. Pennebaker , 1972); *The Concert for Bangladesh* (Saul Swimmer, 1972); *Fillmore* (Richard T. Heffron, 1972); *Born to Boogie* (Ringo Starr, 1972); *Pink Floyd—Live at Pompeii* (Adrian Maben, 1972); *Elvis on Tour* (Robert Abel and Pierre Adidge, 1972); *Cocksucker Blues* (Robert Frank, 1972); *Ziggy Stardust and the Spiders from Mars* (D. A. Pennebaker, 1973); *Ladies and Gentlemen: The Rolling Stones* (Robin Binzer, 1974); *Janis* aka *Janis: The Way It Was* (Howard Alk and Seaton Findlay, 1974); *Good To See You Again, Alice Cooper* (Joe Gannon, 1974); *The Song Remains the Same* (Peter Clifton and Joe Massot, 1976); and *The Grateful Dead Movie* (Jerry Garcia, 1977).

36. Lerner also released other material from the festival in various compilations, including *Blue Wild Angel: Jimi Hendrix at the Isle of Wight* (2002), *Miles Electric: A Different Kind of Blue* (2004), *Jethro Tull: Nothing Is Easy—Live at the Isle of Wight 1970* (2005), and *Emerson, Lake & Palmer: The Birth of a Band—Live at the Isle of Wight 1970* (2006).

37. Sets by Chicago, Gilberto Gil, Sly and the Family Stone, and a choir of schoolchildren, the Voices of East Harlem, were especially impressive and well received, but were not featured in the film.

38. See "Isle of Wight Festival 1970: Planning Difficulties," http://www.blurbwire.com/topics/Isle_of_Wight_Festival_1970::sub::Planning_Difficulties (accessed December 12, 2011).

39. "Lerner had already screened *Woodstock* and didn't like what he'd seen. 'That's what impelled me to want to do this film,' says Lerner by phone from his Manhattan offices. 'I thought [*Woodstock*] glossed over too many things. I wouldn't have said it then, but I'll say it now. I felt, 'No, this isn't right. I gotta do the other.' I felt that behind the scenes, there were similar things to what I show in my film. But why should they be impelled to show it? Well, it isn't that they *have* to, but they were making the point that everything was hunky-dory—peace & love obviously. And I don't believe it.'" "*Message to Love*: Isle of Wight Festival," http://www.filmvault.com/filmvault/austin/m/messagetolovethei1.html (accessed December 8, 2011). In an interview on the DVD release, he characterized his film as "a clear and unrelenting look at money and the power of money in the business, and the contradiction between the message of the music and the commercialism of the music business." In addition to the pivotal role of the fence and overall structure, the many parallels between the two films include a direct repeat of the marijuana-smoking montage, and a parody of the Port-O-San man sequence. The editors included Stan Warnow, who did stellar work on *Woodstock*, and Howard Alk, assistant director of *Dont*

Look Back and variously director and cinematographer on *Eat the Document, Janis*, and *Renaldo and Clara*.

Chapter 13

1. Richards, *Life* (New York: Little, Brown, 2010), p. 237.

2. *Life* 38.16 (April 18, 1955): 168.

3. Quoted in Tony Sanchez, *Up and Down with the Rolling Stones* (New York: William Morrow, 1979), pp. 44–45.

4. Richards's remark is quoted in Philip Norman, *Symphony for the Devil: The Rolling Stones Story* (New York: Simon and Schuster, 1984), p. 227.

5. Robert Fraser Gallery gave early shows to some of the best US artists of the 1960s, including Jim Dine, Andy Warhol, and Bruce Conner, as well as influential British artists. Fraser's social milieu is documented in Harriet Vyner, *Groovy Bob: The Life and Times of Robert Fraser* (London: Faber and Faber, 2002), which includes comments on him by Jagger, Richards, and Kenneth Anger.

6. William Rees-Mogg, "Who Breaks a Butterfly on a Wheel?" *Times*, July 1, 1967, p. 11.

7. Quoted in Stephen Davis, *Old Gods Almost Dead: The 40-Year Odyssey of the Rolling Stones* (New York: Broadway Books, 2001), p. 83. Davis describes the ongoing saga of continued riots, pp. 84–85, 96–98, 101, 124, and so on. The spring 1967 European tour saw especially violent clashes between youth and police, even behind the Iron Curtain in Warsaw. Jagger attributed it to political frustration; see Sanchez, *Up and Down with the Rolling Stones*, pp. 60–61.

8. Discussed here is the original version of the film, not the re-edited version, *Charlie Is My Darling: Ireland 1965* (Mick Gochanour and Peter Whitehead, 2012).

9. Quoted Victor Coelho, "Through the Lens, Darkly: Peter Whitehead and The Rolling Stones," *Framework: The Journal of Cinema and Media* 52.1 (Spring 2011): 179.

10. Whitehead also made promos for "Lady Jane," "Let's Spend the Night Together," "Dandelion," and "Ruby Tuesday" for the Rolling Stones, and others for Nico, the Shadows, the Dubliners, Eric Burdon and the Animals, the Small Faces, and Jimi Hendrix. He also edited silent footage shot for a television montage sequence of the Beach Boys, eventually releasing it on DVD as *The Beach Boys—In London 1966* (2006), half an hour of footage of the Pink Floyd at Sound Techniques Studio in Chelsea, released on DVD as *Pink Floyd: London 1966-67* in 2005, and a hundred minutes of Led Zeppelin recorded in concert at the Royal Albert Hall, released, along with other footage, as a double DVD, *Led Zeppelin: Live at Royal Albert Hall* in 2003. Whitehead always considered his documentaries as a means of entry into feature filmmaking, and envisioned several with the Rolling Stones. He wrote two treatments for them about the organization of teenagers into fascist revolutionary armies; the first, for example, concerned a megalomaniac manager of a financially successful pop group who uses "their image and rebellious nature to attract the country's youth [and forms] a secret army of under 25s channeling their dissatisfaction against current morality/religion/politics/big business, etc., into a coherent religion of revolution." See Peter Whitehead, "Two Film Treatments: 'Proposal' and *Mein Kampf*," *Framework: The Journal of Cinema and Media* 52.1 (Spring 2011): 209–216, quotation on p. 210. In the event, Peter Watkins's *Privilege* (1967) preempted these. He also

wrote a treatment for *Orpheus Inc.*, a satire on a media-controlled dystopia that was to have starred Jagger and Faithfull.

11. By the end of the decade, the subgenre of Hollywood and British "Swinging London" films included *Darling* (John Schlesinger, 1965), *The Knack . . . and How to Get It* (Richard Lester, 1965), *Alfie* (Lewis Gilbert, 1966), *Blowup* (Michelangelo Antonioni, 1966), *Morgan: A Suitable Case for Treatment* (Karel Reisz, 1966), *Arabesque* (Stanley Donen, 1966), *Georgy Girl* (Silvio Narizzano, 1966), *Modesty Blaise* (Joseph Losey, 1966), *I'll Never Forget What's'isname* (Michael Winner, 1967), *Poor Cow* (Ken Loach, 1967), *Smashing Time* (Desmond Davis, 1967), *Bedazzled* (Stanley Donen, 1967), *Up the Junction* (Peter Collinson, 1968), *The Touchables* (Robert Freeman, 1968), *Wonderwall* (Joe Massot, 1968), *Salt and Pepper* (Richard Donner, 1968), *Joanna* (Mike Sarne, 1968) and *Performance* (Donald Cammell and Nicolas Roeg, 1970). Though replete with mod motifs, only *Blowup, Smashing Time, Bedazzled,* and *Performance* had substantial address to the music culture at heart of the phenomenon. In *Blowup*, the photographer protagonist modeled on David Bailey visits a nightclub where the Yardbirds are performing; the set concludes with a guitar being smashed in imitation of Pete Townshend, the Who having declined to appear in the film. In *Bedazzled*, Peter Cook as the devil grants Dudley Moore's wish to become a pop star, and he is seen on a television show set resembling *Ready Steady Go!* performing a melodramatic ballad, "Love Me," only to be upstaged by the Devil. George Harrison composed the soundtrack for *Wonderwall*. The soundtrack to *Poor Cow*, Ken Loach's neo-realist study of a young working-class woman, contains several songs by Donovan. The title song for *Georgy Girl* was a global hit for the Seekers, and the film also contains a performance by a rock 'n' roll band. *Salt and Pepper* was an unfortunate Ratpack cum James Bond spy caper featuring Sammy Davis and Peter Lawford as owners of a Soho nightclub where Davis performs as a rock 'n' roll singer and guitarist. *Alfie*'s jazz soundtrack was by Sonny Rollins, but Cher performed the title song in the US single release. The protagonist of *If . . .* (Lindsay Anderson, 1968), the best British film about youth rebellion, was inspired, not by rock 'n' roll, but by the "Sanctus" from Guido Haazen's *Missa Luba*.

12. Quoted in Paul Cronin, "The Ceremony Of Innocence," *Sight and Sound* 17.3 (March 2007): p. 23. The Congress of the Dialectics of Liberation was a political meeting in London in 1967, featuring mostly Marxist intellectuals and others, including R. D. Laing and Stokely Carmichael.

13. Details on Godard's activities in this period are taken from Richard Brody, *Everything Is Cinema: The Working Life of Jean-Luc Godard* (New York: Metropolitan Books, 2008), and Jonathan Cott, "Jean-Luc Godard," *He Dreams What Is Going On Inside His Head* (San Francisco: Straight Arrow Books, 1973), pp. 27–43. Godard commented extensively on *One Plus One* in the latter.

14. Jonathan Cott, "Mick Jagger," in *He Dreams What Is Going On Inside His Head*, p. 96.

15. Interview in the *Sunday Times*, June 23, 1968, cited in Brody, *Everything Is Cinema*, p. 338.

16. Bill Wyman, *Stone Alone: The Story of a Rock 'n' Roll Band* (New York: Viking, 1990), pp. 490–491.

17. All are between 9½ and 11½ minutes long, save the last, which is only 7. *One Plus One*'s cinematographer was Tony Richmond, who went on to shoot several important rock 'n' roll films, including *Let It Be, The Rolling Stones Rock and Roll Circus, Stardust, The Man Who Fell to Earth,* and *The Kids Are Alright*.

18. After Godard had completed *One Plus One*, the producers re-edited the ending, bridging the final scene in the studio and the conclusion on the beach with the more

than six-minute take of the completed version of "Sympathy for the Devil" that Godard had shot but decided not to use. It is played in its entirety though not continuously, being interrupted halfway through by short extracts of the voice-over novel and the Stones' jamming. Godard objected to the inclusion of the completed song, and at the London Film Festival premier on November 29 of the producer's cut, now titled *Sympathy for the Devil*, he punched Quarrier and told the audience to demand their money back and leave the theater to watch his version that was screened outside on the building wall. When the film was released in the United States in April 1970, the two versions were shown on alternate days, but subsequently *Sympathy for the Devil* became the standard.

19. Despite its recent neglect, *One Plus One* was generally well received by critics, probably because of the prestige of Godard's immediately previous films, *La Chinoise* and *Weekend* (both 1967). In *Newsweek*, Joseph Morgenstern expressed reservations about its political radicalism, yet also announced that the film is "revolutionary in its own right because it makes us see and hear and eventually understand the synthesis [between the two main montage elements] without telling us any stories about it"; "Coming Together," March 30, 1970, p. 88. Though *Time*, in a review in an issue focusing on "Protest!," found its attempt to blend aesthetics and revolutionary politics unsuccessful; nevertheless its images "are crazily beautiful, and the photography is impeccable" and "it displays the incontestable energy and stylistic daring that have made Godard the cinema's foremost pop essayist"; "Cinema: Collision of Ideas," May 18, 1970, p. 98. Arguing that it "contemplates rather than advocates revolution," Roger Greenspun in the *New York Times* noted especially the precision of its movement between the two stands of the montage; "Screen: 'Sympathy for the Devil' [1 + 1]" April 27, 1970, p. 42. Less judiciously and reflecting the counterculture's predispositions, the *Los Angeles Free Press* proposed it as "the most novel, exhilarating and poetic work this great filmmaker has thus far produced, more violent and innocent, more flamboyant and provocative in its visual rhetoric of revolution yet at the same time so optimistic as almost to resemble a hymn in praise of life as it might yet be lived"; Michael Ross, "Godard Dreams the Devil's Art," vol. 7, no. 16 (April 17, 1970): p: 34. But subsequently, like the Dziga Vertov Group's films generally, if noticed at all, it is usually maligned. The Stones themselves, though, were never very charitable: Jagger concluded that Godard was a "fucking twat" (quoted in Peter Doggett, *There's a Riot Going On* [Edinburgh and New York: Cannongate, 2007], p. 211) and Richards thought "[t]he film was a total load of crap," continuing, "He had no coherent plan at all except to get out of France and score a bit of the London scene. . . I think somebody slipped him some acid and he went into that phony year of ideological overdrive"; *Life*, p. 252.

20. "I had given [Mick] Mikhail Bulgakov's *The Master and Margarita* to read—he devoured it in one night and spit out 'Sympathy for the Devil.'" Marianne Faithfull, *Faithfull* (Boston: Little, Brown, 1994), p. 186.

21. This correlation was made by Michael Chaiken, cited in Brody, *Cinema Is Everything*, p. 340.

22. Jonathan Cott, "Jean-Luc Godard," *He Dreams What Is Going On Inside His Head*, p. 37.

23. Quoted in ibid., p. 37. When Godard toured the United States in the spring of 1968 with *La Chinoise*, his 1967 film about the contradictions in the French student movement that anticipated the May 1968 strikes, he became acquainted with the US resistance to the invasion of Viet Nam, the Black Panthers, the student movement, and rock 'n' roll. He made an agreement with D. A. Pennebaker and Richard Leacock to produce a television

documentary about these and shot it in November 1968, but abandoned the project, leaving Pennebaker to complete the film himself. Released in 1971, what was begun as *1 AM* (*One American Movie*) became *1 PM—One Parallel Movie*, or *One Pennebaker Movie*. As well as footage of Eldridge Cleaver, LeRoi Jones, Tom Hayden, and Leacock, Godard, and Wiazemski, it included an extended sequence of the Jefferson Airplane performing on the rooftop of Manhattan's Schuyler Hotel on December 7, 1968. Marty Balin shouts "New York, Wake up, you fuckers," and announces, "Free love and free music." As the band launches into their surrealistic, "House at Pooneil Corners," Godard is seen filming from the window of the Leacock-Pennebaker office. His footage constantly zooms and pans, emphasizing Balin and Grace Slick swapping choruses, and is intercut with images of people on the street and in the surrounding buildings apparently enjoying the music. But after about seven minutes the police arrive, one of them shouting, "Make sure that they stop the music. If they continue the music, lock them up," and another covering the camera lens with his hand to end the sequence and the insurrection.

Chapter 14

1. "Return of Satan's Jesters," *Time*, May 17, 1971, p. 60.

2. "Magick" was one of Crowley's alternative terms for term for Thelema, his occult religion of self-realization through a Luciferian liberation from Christian repression, its core principle being, "Do what thou wilt shall be the whole of the Law." As a disciple of Crowley, Anger understood his own life's work in cinema as a parallel project, sustained by the fact that in European Christianity, Lucifer is both the bringer of light and, to all intents and purposes, interchangeable with Satan, the Devil, the Edenic serpent, and the anti-Christ. Anger understood his art as Luciferian Magick, a practice of bringing light and urging disobedience to repressive cultural forms, including especially contemporary Hollywood cinema. Some terminological contradictions can appear in the difference between Crowley's theories and others that in some respects have similar ends, especially Nietzsche's opposition of Dionysius and his associated musical ecstasy against Apollo, the god of light.

3. "An Interview with Kenneth Anger: Conducted by Spider Magazine," *Film Culture* 40 (Spring 1966): 70.

4. "Aleister Crowley and Merlin Magic," *Friends* 14 (18 September 18, 1970): 16; cited in Robert A. Haller, *Kenneth Anger* (Minneapolis: Walker Art Center, 1980), p. 8.

5. The concert was filmed by Granada Television and *The Stones in the Park* (Leslie Woodhead, 1969) was broadcast occasionally before being released on DVD in 2007. The US independent filmmaker Peter Ungerleider shot parts of it in 8 mm, later blowing it up to 16 mm to make the thirty-minute, silent *Under My Thumb* (1969). Ungerleider evidently had access to the Stones' party, and the first third of the film finds them in their hotel room and follows them to the park, with the final two-thirds comprising long takes of the concert shot from on stage, mostly focusing on Jagger. In a version of the film titled *The Rolling Stones*, held at the Harvard University Film Archives, the footage is accompanied by non-synchronous sound of the Stones talking before the concert, with Jagger discussing "Adonais." After seeing the original 8-mm version, Jonas Mekas devoted his December 11, 1969, *Village Voice* column to the Stones, noting that Ungerleider had

photographed them with "great sensitivity, with almost religiousness." *Movie Journal: The Rise of the New American Cinema, 1959–1971* (New York: Collier, 1972), p. 361.

6. Rebekah Wood, "Interview [with Kenneth Anger]," in *Into The Pleasure Dome: The Films of Kenneth Anger*, edited by Jayne Pilling and Mike O'Pray (London: British Film Institute, 1989), p. 51.

7. See Carrie Rickey, "Rockfilm, Rollfilm," in *The Rolling Stone Illustrated History of Rock & Roll: The Definitive History of the Most Important Artists and Their Music*, edited by Anthony DeCurtis and James Henke (New York: Random House, 1992), p. 113.

8. Cited in Jonas Mekas, "Movie Journal," *Village Voice*, August 21, 1969, reprinted in Jonas Mekas, *Movie Journal* (New York: Macmillan, 1972), pp. 354–357. The notes indicate that last sentence is a quotation from Crowley's book, *Magick*.

9. In 1969, Anger received *Film Culture*'s Tenth Independent Film Award for "his film, *Invocation of My Demon Brother* specifically, and for his entire creative work in general"; "Tenth Independent Film Award," *Film Culture* 48–49 (Winter and Spring 1970): 1. After marrying Bianca Macias, Jagger ended his relationship with Anger, though others of his circle continued to collaborate with him, including his brother Chris, Faithfull, Cammell, and Page, all of whom had roles in his magnum opus, the finally completed version of *Lucifer Rising* (1972), for which Beausoleil wrote the music while in prison.

10. Anger's "an attack on the sensorium" is quoted by Deborah Allison, "Magick in Theory and Practice: Ritual Use of Colour in Kenneth Anger's Invocation of My Demon Brother," *Senses of Cinema*, February 2005: http://sensesofcinema.com/2005/feature-articles/invocation_demon_brother (accessed June 20, 2015). Carel Rowe earlier explained, "all of his films have been evocations or invocations, attempting to conjure primal forces which, once visually released, are designed to have the effect of 'casting a spell' on the audience. The Magick *in* the film is related to the Magickal effect of the film *on* the audience." "Illuminating Lucifer," *Film Quarterly* 27.4 (Summer 1974): 24–33, quote on p. 26. Jonas Mekas reported, "Even without knowing the meanings [of the magick], I can feel the tremendous energies of the film, energies that are being released by the images, by the movements, by the symbols, by the situations." "Three Notes on 'Invocation of My Demon Brother,'" *Film Culture* 48–49 (Winter and Spring 1970): 2.

11. Of the extensive commentary on *Performance*, see especially Peter Wollen, "Possession," *Sight and Sound* 9.5 (September 1995): 20–23, and Marianne Faithfull, *Faithfull: An Autobiography* (New York: Little, Brown, 1994). Colin MacCabe's *Performance* (London: British Film Institute, 1998) has details of the production history. For Cammell's career as a whole, see Rebecca and Sam Umland, *Donald Cammell: A Life on the Wild Side* (Godalming, UK: FAB Press, 2006). On the film's music, see K. J. Donnelly, "*Performance* and the Composite Film Score," in *Film Music: Critical Approaches*, edited by Kevin Donnelly (New York: Continuum, 2001), pp. 152–166.

12. Jagger wrote "Memo from Turner" alone because Richards was suspicious that his sex scenes with Pallenberg were not simulated; hostile to the whole project, he refused to collaborate on the music, though he did finally consent to play on the song. He later designated Cammell as "the most destructive little turd I've ever met"; *Life* (New York: Little, Brown, 2010), p. 253. Created by Jack Nitzsche, the original score prominently featured Ry Cooder's slide guitar.

13. Richards, *Life*, p. 237.

14. Faithfull, *Faithfull*, p. 154.

15. Ibid., pp. 154–155.

16. Quoted in Stephen Davis, *Old Gods Almost Dead: The 40-Year Odyssey of the Rolling Stones* (New York: Broadway Books, 2001), p. 300.

17. The *New York Times* reviewed it at least three times: on the first occasion, Roger Greenspun claimed that "with its sadism, masochism, decorative decadence, and languid omnisexuality, 'Performance' turns out to be the kind of all-round fun that in the movies oft is tried but rarely so well achieved"; a week later, Peter Schjeldahl found its texture to be "as hypnotic in its density and intricacy as a Tantric mandala"; John Simon's reply a week later concluded that it was the genre's "foulest flowering," an "indescribably sleazy, self-indulgent and meretricious film"; respectively, "Screen: 'Performance,'" August 4, 1970, p. 21; "One Emerges a Little Scorched, But ," August 16, 1970, p. D1; and "The Most Loathsome Film of All?," August 23, 1970, p. D5. Warner Bros. capitalized on the dispute by printing the Simon and Schjeldahl reviews side by side in its advertisements. The trades were similarly split: Larry Cohen in *The Hollywood Reporter* found it "the most compelling, mesmerizing visual experience of the year," while for Murf in *Daily Variety* it was "a crime meller, laced with needless, boring sadism and dull, turning-off sex angles"; respectively, "'Performance' Brilliant, Disturbing Work of Art," August 3, 1970, p. 3, and "Performance," August 5, 1970, p. 20. *Time* and *Life* were, however, in agreement: for the former it "alternates between incomprehensible chi-chi and flatulent boredom," and Richard Schickel in the latter wrote that it was "the most disgusting, the most completely worthless film I have seen since I began reviewing": respectively, "Mick's Duet," August 24, 1970, p. 61, and "A Completely Worthless Film," October 2, 1970, p. 6. The London *Guardian*, on the other hand, found it "cracker—richly original, resourceful, and imaginative: a real live movie, in fact, just when we were beginning to think that maybe it wasn't possible anymore from home-grown talent." Derek Malcolm, "Performing Right and Wrong," *The Guardian*, December 31, 1970, p. 8.

Chapter 15

1. "Stones Concert Ends It," quoted in David Caute, *The Year of the Barricades: A Journey Through 1968* (New York: Harper & Row, 1988), p. 448.

2. "Altamont: Pearl Harbor to the Woodstock Nation," *Scanlan's Monthly*, March 1970, reprinted by the editors of *Ramparts* in *Conversations with the New Reality: Readings in the Cultural Revolution* (San Francisco: Canfield Press, 1971), pp. 61 and 62.

3. Stanley Booth's *The True Adventures of The Rolling Stones* (Chicago: A Capella, 1984) is the classic account of the 1969 US tour that culminated at Altamont, and Robert Greenfield's *S.T.P.: A Journey Through America with the Rolling Stones* (New York: Da Capo Press, 2002) that of the 1972 US tour.

4. On the Altamont concert, see Michael Lydon's account of the entire 1969 tour, "The Rolling Stones Discover America," in his *Flashbacks: Eyewitness Accounts of the Rock Revolution, 1964–1974* (New York: Routledge, 2003), pp. 123–184; it incorporates his initial report on the concert, "The Rolling Stones—At Play in the Apocalypse," first published in *Ramparts Magazine* in March 1970. Albert and David Maysles gave their account of the filming and the equipment used in "*Gimme Shelter*: Production Notes," *Filmmakers Newsletter* 5.2 (December 1971): 28–31.

5. The stabber, Alan Passaro, was eventually tried for the murder but was acquitted on the evidence of *Gimme Shelter*. Sam Green made a short documentary about Hunter titled after his gravesite, *Lot 63, Grave C* (2006).

6. Sonny Barger, *Hell's Angel: The Life and Times of Sonny Barger and the Hell's Angels Motorcycle Club* (New York: William Morrow, 2001), p. 168.

7. *Rolling Stone*, January 21, 1970, pp. 16–36. Eleven writers and some fifty photographers contributed. On the inaccuracies in this essay and their effects on subsequent commentary, see especially Michael Sragow, "Gimme Shelter: The True Story," *Salon*, August 10, 2000, http://www.salon.com/2000/08/10/gimme_shelter_2/ (accessed March 30, 2012). Having interviewed many of the people at Altamont and involved in the movie, he concludes, "The legend of Altamont as apocalypse was largely based on that *Rolling Stone* cover story."

8. "Let It Bleed," p. 30.

9. According to *Rolling Stone*, Wexler had wanted to do "something with a little more craft and depth than, say, a movie like *Monterey Pop*. He was interested in doing a behind-the-scenes chronicle of the tour," but negotiations fell through because, Wexler believed, the Stones were dissatisfied with Godard's *Sympathy for the Devil*. "Let It Bleed," p. 26.

10. Albert Maysles later re-edited the unused Madison Square Garden footage with additional backstage and other material, releasing it in 2009 as *Get Yer Ya-Ya's Out*, a half-hour long DVD.

11. Richard Leacock, "For an Uncontrolled Cinema," *Film Culture* 22–23 (Summer 1961): 23–26.

12. Quoted in Dale W. Bell, *Woodstock: An Inside Look at the Movie That Shook Up the World and Defined a Generation* (Studio City, CA: Michael Wiese Productions, 1999), p. 255.

13. By contrast, the only other film—actually a video—of Altamont, Ira Schneider's *The Rolling Stones Free Concert* (1969), shows no signs of violence. Recorded with a hand-held portapak on ground level amid the crowd, it alludes to (via added intertitles) the low stage and the hiring of the Angels; but its eighteen minutes are mostly composed of close-up shots of freaks dancing, drinking wine, and gaily disregarding Cutler's pleas for them to move back. Several bands are seen from a distance, but Schneider approaches the stage for the Stones' set, showing Jagger singing surrounded by the Angels, but no untoward events.

14. Among the negative reviews of the film uncritically based on the article, Pauline Kael's was the most egregiously mendacious. Likening reviewing the film to "reviewing the footage of President Kennedy's assassination or of Lee Harvey Oswald's murder," she scurrilous asserted that the festival and its lighting had been deliberated staged for the film and implied that the director had deliberately "excite[d] people to commit violent acts on camera" so as to provide free publicity for the film; "The Current Cinema: Beyond Pirandello," *The New Yorker*, December 19, 1970, pp. 112–115. The directors rightfully objected to such totally unwarranted assertions in their reply to Vincent Canby's negative *New York Times* review that had been editorially titled "Making Murder Pay" in their "But the Killing Happened," *New York Times*, December 27, 1970, p. 77. Other reviews include Joel Haycock's attack in "*Gimme Shelter*," *Film Quarterly* 24.4 (Summer 1971): 56–60, and David Sadkin's analysis of the film's formal innovations, "*Gimme Shelter*: 'A Corkscrew

or a Cathedral?'" *Filmmakers Newsletter* 5.2 (December 1971): 20–27. Ralph Gleason blamed the eruption of the violence that he found latent in all the Stones' music on the tension between the idea of a free concert and the greed that he implied was the films' motive: "Perspectives: Altamont Revisited on Film," *Rolling Stone*, April 1, 1971, p. 31.

15. Jack Kerouac, "Introduction," to Robert Frank, *The Americans* (New York: Grove Press, 1958), p. vi. Jagger describes his introduction to Frank in the documentary *Stones in Exile* (Stephen Kijak, 2010).

16. Details from personal correspondence with John Van Hamersveld, October 5, 2012.

17. "Second Independent Film Award," April 26, 1960, reprinted in P. Adams Sitney, ed., *Film Culture Reader* (New York: Praeger, 1970), p. 424.

18. Accounts of the film all claim that it is unedited, but the abrupt location shifts between Los Angeles and New York, and visible tape splices reveal many cuts.

19. See Stefan Grissemann's excellent phenomenology of viewing Frank's films in "Vérité Vaudeville: Passage Through Robert Frank's Audiovisual Work" in Brigitta Burger-Utzer and Stefan Grissemann, eds., *Frank Films: The Film and Video Work of Robert Frank* (Zurich and New York: Scalo, 2003), pp. 21–67. For example, "These films aim to be present only for a moment . . . to then immediately 'retreat' from conscious-ness once again, as though they had never been there, like dreams you can't really piece together when you wake up. These films are not interested in leaving behind tracks, they remain pale, ungraspable, are more 'atmospheric' than 'pictorial,'" p. 24. Other produc-tion details derived from Greenfield, *S.T.P*, http://www.guardian.co.uk/film/2004/oct/09/popandrock; and Jon Wilde, "Sex, Songs and the Stones: An Interview With Marshall Chess, Part 2," http://www.sabotagetimes.com/music/sex-songs-and-the-stones-an-inter-view-with-marshall-chess-part-2 (accessed May 7, 2102).

20. The term "*Baudelairian Cinema*" was coined by Jonas Mekas in a *Village Voice* article in May 1963 to describe the cinematic "poetry which is at once beautiful and terrible, good and evil, dirty and delicate" he found in Jack Smith's *Flaming Creatures* and other films; see Mekas, *Movie Journal the Rise of a New American Cinema, 1959–1971* (New York: Collier Books, 1972), pp. 85–86. Susan Sontag's description of *Flaming Creatures* could just as well refer to *Cocksucker Blues*: "One can easily doubt that a certain piece of footage was intended to be overexposed. Of no sequence is one convinced that it had to last this long, and not longer or shorter. Shots aren't framed in the traditional way; heads are cut off; extraneous figures sometimes appear on the margin of the screen"; "Jack Smith's *Flaming Creatures*" in her *Against Interpretation and Other Essays* (New York: Dell, 1966), p. 231. In a section of Don DeLillo's novel, *Underworld*, called "Cocksucker Blues," one of his characters attends a clandestine screening of the film in New York in 1974. He writes, "She loved the washed blue light of the film, a kind of crepuscular light, a tunnel light that suggested . . . a subversive reality maybe, corruptive and ruinous, a beautiful tunnel blue" (New York: Scribner, 1997), pp. 382–383.

21. Jagger was quoted in Allen Ginsberg, "Robert Frank to 1985—A Man" in Anne Wilkes Tucker, ed., *Robert Frank: New York To Nova Scotia* (Boston: Little, Brown, 1986), p. 76. The settlement is not a matter of public record and accounts of its details vary.

22. Frank himself commented, "I have been on trips with extraordinary people, but nothing that so totally excludes the outside world." Quoted in Greenfield, *S.T.P*, p. 198.

23. Frank exploited groupies more callously than the previous year's *Groupies* (Ron Dorfman and Peter Nevard, 1970) that at least allowed them a voice of their own.

Also essentially a backstage musical, *Groupies* alternates between club performances by Alvin Lee, Joe Cocker, Terry Reid, and other musicians and scenes in which female fans gossip among themselves or recount their adventures and aspirations. Their desire to have sex with pretty rock stars is sometimes a win-win situation for both parties, even when, as with one veteran of Jimmy Page, it involves consensual whipping. The grounds on which the groupies construct their self-esteem may be precarious, and some of them have become disillusioned and others, especially one of several male gay groupies, have been damaged. But their moxie and youthful beauty gives them a degree of power and satisfaction of which other fans can only dream.

24. Marshall Chess reported that Frank "did not like The Stones. He didn't like the way they treated people. He disliked the aura around the band. The tour turned him off completely"; Jon Wilde, "Sex, Songs and the Stones: An Interview with Marshall Chess, Part 2," http://www.sabotagetimes.com/music/sex-songs-and-the-stones-an-interview-with-marshall-chess-part-2 (accessed May 7, 2102). Robert Greenfield similarly affirms that while Frank started the tour with "a great affection for Jagger," by the end he was "fed up and disgusted with this rock and roll sickness that makes everybody who gets near it crazy"; *S.T.P.*, pp. 49 and 247, respectively.

25. The footage was shot by Bob Fries and Steve Gebhardt (who also photographed the benefit concert produced by John Lennon, *Ten for Two: The John Sinclair Freedom Rally* [Steve Gebhardt, 1971]), with some accounts claiming that it was originally designed for inclusion in *Cocksucker Blues*. When it became clear that Frank's film would never find wide distribution, Fries and Steve Gebhardt cut an autonomous film, but the footage was turned over to Binzer, a maker of television commercials. See Vicki Hodgetts, "Ladies & Gentlemen: The Rolling Stones," *Rolling Stone* 160 (May 9, 1974), p. 15.

26. Hodgetts, "Ladies & Gentlemen: The Rolling Stones," p. 15.

27. Rino, "Ladies and Gentlemen, The Rolling Stones," *Variety*, April 17, 1974, p. 6. Emphasizing Jagger's ambisexuality, the reviewer noted that his "whirling dervish abandon is updated Weimar cabaret—a species of campy evil" (ibid.). The *Hollywood Reporter* similarly found it a "canned concert"; see John H. Dorr, "Ladies and Gentlemen . . . The Rolling Stones," August 1, 1974, p. 3. The film generally received mixed to poor reviews. The exclusion of the fans had been anticipated in *Pink Floyd: Live at Pompeii* (Adrian Maben, 1972), featuring Pink Floyd performing in a Roman amphitheater in Pompeii. The band plays a complete live set without any audience being present.

28. Hodgetts, "Ladies and Gentlemen: The Rolling Stones," p. 15.

29. After its initial release and apart from video bootlegs, the film was generally unavailable until the Stones reacquired rights to it. A digitally remastered version was released theatrically in 2010 and subsequently on DVD.

30. Frank Zappa, "The Oracle Has It All Psyched Out," *Life*, June 29, 1968, p. 85.

31. Some examples: the 1981 US tour to promote the album *Tattoo You* produced *Let's Spend the Night Together* (Hal Ashby, 1983), as well the live album *"Still Life" (American Concert 1981)*; the 1990 European "Urban Jungle" tour to promote *Steel Wheels* produced the IMAX film, *At the Max* (Noel Archambault, David Douglas, Julien Temple, and others, 1991); the 1994 tour to promote *Voodoo Lounge* produced *The Rolling Stones: Voodoo Lounge Live* (David Mallet, 1995); the US tour to promote *Bridges to Babylon* produced *The Rolling Stones: Bridges to Babylon Tour '97–98* (Bruce Gowers, 1997); and the 2005–2006 legs of the "A Bigger Bang Tour" produced the four-DVD set, *Rolling Stones: The Biggest Bang*

(Hamish Hamilton, 2007), with the two-concert detour at the Beacon Theater in Boston producing *Shine a Light* (Martin Scorsese, 2008) and the album, *Shine a Light—O.S.T.* Only much later did footage shot of the 1978 tour to promote *Some Girls* produce *The Rolling Stones: Some Girls Live in Texas '78* (Lynn Lenau Calmes, 2011).

32. James Brown with Bruce Tucker, *James Brown: The Godfather of Soul* (New York: Macmillan, 1986), p. 224.

Chapter 16

1. "The National Black Political Agenda," in Komozi Woodard, Randolph Boehm, Daniel Lewis, eds., *The Black Power Movement, Part 1: Amiri Baraka from Black Arts to Black Radicalism* (Bethesda, MD: University Publications of America, 2000), microfilm, reel 3, http://www.blackpast.org/?q = primary/gary-declaration-national-black-political-convention-1972 (accessed October 5, 2012).

2. On the politicization of black music, see Brian Ward, *Just My Soul Responding: Rhythm and Blues, Black Consciousness, and Race Relations* (Berkeley: University of California Press, 1998) and Craig Hansen Werner, *A Change Is Gonna Come: Music, Race & the Soul of America* (Minneapolis: University of Michigan Press, 2006).

3. Of these two songs, he recalled, "You can hear the band and me start to move in a whole other direction rhythmically. The horns, the guitar, the vocals, everything was starting to be used to establish all kinds of rhythms at once"; James Brown with Bruce Tucker, *James Brown: The Godfather of Soul* (New York: Macmillan, 1986), p. 149.

4. See Ward, *Just My Soul Responding*, pp. 339–417, for details of this politicization.

5. Vincent Canby reviewed these genres and placed both blaxploitation and *Lady Sings the Blues* in their context: "All But 'Super Fly' Fall Down," *New York Times Film Reviews*, November 16, 1972, pp. 332–333. Parallel innovations in television sitcoms and popular music shows oriented to African Americans followed, most notably *Soul Train*: a black version of *Bandstand* and similar teenage shows developed in the early 1950s, it premiered in Chicago in August 1970, went on to national syndication a year later, and lasted until 2008.

6. The major exception was *Sweet Sweetback's Baadasssss Song* (Melvin Van Peebles, April 1971). Black music was much more fundamentally internalized as a model for film language in *Bush Mama* (Haile Gerima, 1976), *Passing Through* (Larry Clark, 1977), and many of the other films made at the University of California at Los Angeles during the "Los Angeles Rebellion."

7. Josiah Howard provides an overview of blaxploitation in *Blaxploitation Cinema: The Essential Reference Guide* (Godalming, UK: FAB Press, 2008), pp. 7–19. See also Gerald Martinez, Diana Martinez, and Andres Chavez, *What It Is . . . What It Was!: The Black Film Explosion of the '70s in Words and Pictures* (New York: Hyperion, 1998).

8. As early as August 1972, Junius Griffin, president of the Beverly Hills-Hollywood chapter of the National Association for the Advancement of Colored People, called for protests against what he described as "the power exploitation of the black condition in America by the white owned, white controlled, and white financed motion picture and film industry." He condemned the "continued warping of our black children's minds with the filth, violence, and cultural lies that are all pervasive" and accused the films of "representing black males as pimps, dope pushers, gangsters, and super males brimming with

sexual prowess, but lacking any other discernible skills." See "NACCP Takes Militant Stand on Black Exploitation Films," *The Hollywood Reporter*, August 10, 1972, pp. 1 and 10.

9. Hayes also acted in *Three Tough Guys* and starred in *Truck Turner*, and his extradiegetic singing is integrated into the latter's narrative, for example when he is heard singing "You're In My Arms Again" as he meets his lover.

10. A significant exception is *The Mack* (Michael Campus, 1973), which dramatizes the tensions between the exploitation of the community and efforts to renew it in the relationship between two brothers, Goldie, a drug pusher turned pimp, and Olinga, a black nationalist who is trying to build a "Black America Within but Without White America." Goldie's initial success in seducing, schooling, and punishing his women is lovingly and sometimes surreally detailed, especially in sequences at a Player's Ball, where he receives the "Pimp of the Year" award. Disgusted by his brother, Olinga nevertheless comes to his aid when other pimps, white gangsters, and corrupt cops attempt to destroy him and murder their saintly mother. Though finally Goldie gives up the life, as is typical the indictment of crime in the narrative is much more ambiguous than in the soundtrack lyrics, in particular Willie Hutch's hit single, "Brother's Gonna Work It Out": "Stop the pimps, the hustler, and the pusher man as fast you can./Open your ears and eyes to the fact /Of what's truly holding you back."

11. Newton quotations are from *To Die for the People* (New York: Random House, 1972), pp. 113 and 139.

12. More specifically, "The steady mid-tempo soul jazz instrumental never changes key or varies except to expand parts by accumulation. But unlike War's guitar driven sound, the Van Peebles rendition by an emergent Earth, Wind & Fire emphasizes accidentals in the melody in a manner more commonly associated with Charles Mingus, John Coltrane, or the Art Ensemble of Chicago, lending the minimal and carefree west coast feel an undertow of both menace and comedy, landing oddly on the flat-fifth at cadence points of the main theme." Dean Wilson, personal communication, December 16, 2012.

13. Rob Bowman, *Soulsville: The Story of Stax Records* (New York: Simon and Schuster, 1997), p. 222.

14. Figures from http://www.the-numbers.com/movies/1971/0ASSS.php (accessed April 12, 2013).

15. See "Melvin Van Peebles," in Martinez at al., *What It Is . . . What It Was!*, p. 35.

16. Only implied in the film, this is specifically articulated in the novel upon which it was based: "You're a black man. . . . But you're also part a white man. . . . And you smart enough to go back and forth between black and white man"; Ernest Tidyman, *Shaft* (New York: Macmillan, 1971), p. 51.

17. On Hayes's music for *Shaft*, see Bowman, *Soulsville, U.S.A.*, pp. 229–233.

18. Craig Werner, *Higher Ground: Stevie Wonder, Aretha Franklin, Curtis Mayfield and the Rise and Fall of American Soul* (New York: Crown Publishers, 2004), p. 161.

19. According to one source, *Sweetback*'s domestic gross was $15 million on $150,000 estimated production costs; *Shaft* grossed a total of $23 million on $1,200,000 costs and saved M.G.M. from bankruptcy; and *Super Fly* grossed $19 million on $150,000 costs; Martinez et al., *What It Is . . . What It Was!*, p. 58. These figures are not reliable, and other sources halve the grosses of *Shaft* and *Super Fly*.

20. Billie Holiday with William Dufty, *Lady Sings the Blues* (New York: Doubleday, 1956; rpt. New York: Penguin, 1992). Of Holiday biographies, Robert O'Meally's *Lady*

Day: The Many Faces of Billie Holiday (New York: Little, Brown, 1991) valuably emphasizes Holiday's artistry.

21. The Funk Brothers' accomplishment was later documented in *Standing in the Shadows of Motown* (Paul Justman, 2002).

22. The Supremes starred alongside the Rolling Stones in *The T.A.M.I. Show* (Steve Binder, 1964), and thereafter were the subject of several semi-fictional treatments. Their early career was referenced in the film *Sparkle* (Sam O'Steen, 1976); Aretha Franklin's recording of Curtis Mayfield's soundtrack reached number one on the Billboard Rhythm and Blues album charts and was certified gold. O'Steen also directed a remake of *Sparkle* in 2012. A 1981 Broadway musical *Dreamgirls* was based on the Supremes and other black groups, with a 2006 film adaptation, also called *Dreamgirls*, directed by Bill Condon.

23. The Beatles' covers were the Marvelettes' "Please Mr. Postman," Smokey Robinson's "You Really Got a Hold on Me," and Barrett Strong's "Money (That's What I Want)." Dylan's remark has no authoritative source, but it occurs in, for example, Bob Gulla, *Icons of R & B and Soul* (Westport, CT: Greenwood Press, 2007), p. 258.

24. Most production details for *Lady Sings the Blues* are derived from J. Randy Taraborrelli, *Call Her Miss Ross: The Unauthorized Biography of Diana Ross* (New York: Birch Lane Press, 1989).

25. Quoted in Taraborrelli, *Call Her Miss Ross*, p. 258.

26. Gleason was astonished at Ross's performance: "In this film the face and the figure and the sound of Diana Ross have become Billie Holiday. I do not know how it was possible for her to get the kind of feeling she did into her singing"; "Perspectives: Diana Ross Is Billie Holiday," *Rolling Stone*, November 23, 1972, p. 22.

27. "Billie's Blues: Truth Takes a Holiday," *Los Angeles Times*, October 29, 1972, p. 51.

28. Quoted in Wendell Hutson, "Berry Gordy Jr. Honored at Chicago Gala," http://www.examiner.com/article/berry-gordy-jr-honored-at-chicago-gala (accessed June 24, 2015).

29. See, for example, *Round Midnight* (Bertrand Tavernier, 1986), *Bird* (Clint Eastwood, 1988), *Thelonious Monk: Straight, No Chaser* (Charlotte Zwerin, 1988), *Ray* (Taylor Hackford, 2004). *What's Love Got to Do With It* (Brian Gibson, 1993) only appears to be an exception, for though Tina is not addicted to drugs, she is addicted to Ike—who is addicted to cocaine.

30. In 1973, Ross was nominated for two Golden Globes awards, "Best Motion Picture Actress" and "Most Promising Newcomer - Female," wining the later. She lost the Oscar to Liza Minnelli.

31. Holiday with Dufty, *Lady Sings the Blues*, p. 9.

32. Holliday's creative interaction with her instrumentalists is also clear in the several songs in which she is paired with Louis Armstrong in *New Orleans* (Arthur Lubin, 1947) where, much to her disgust, she played a maid; her account of the filming appears in Holiday with Dufty, *Lady Sings the Blues*, pp. 119–122. Her only other film appearance was in a short, *Symphony in Black: A Rhapsody of Negro Life* (Fred Waller, 1935), in which Duke Ellington is seen composing music based on vignettes of African American life; already playing a spurned lover, she sings "Saddest Tale."

33. James Baldwin, *The Devil Finds Work: An Essay* (1976) (New York: Vintage, 2011), pp. 114–115. In the same essay, Baldwin did, however, apologize that his cynicism about Ross's casting "could not have possibly been more wrong" (p. 106).

34. Taraborrelli, *Call Her Miss Ross*, p. 261.

35. *Hollywood Film, 1963–76* (Malden, MA: Wiley-Blackwell, 2011), p. 268.

36. Wally Heider recorded sound. The film was not well received and failed to repay production costs. It was restored and released on DVD in 2004 with commentary tracks by several of the performers, together with a booklet essay by Rob Bowman from which many of the details below were obtained. Sanders had recently completed *Elvis: That's the Way It Is* (1970), a documentary of Elvis's Summer Festival in August 1970 in Las Vegas.

37. James Brown did later perform for a concert documentary in Africa. *Soul Power* (Jeff Levy-Hinte, 2008) was assembled from footage shot at a concert in Zaire (now Democratic Republic of the Congo), planned to accompany the "Rumble in the Jungle" boxing match between Muhammad Ali and George Foreman in October 1974. Though an injury to Foreman caused the bout to be postponed, the concert took place, and the film features Brown, B. B. King, the Spinners, and Bill Withers, along with Celia Cruz, Miriam Makeba, and Manu Dibango. *When We Were Kings* (Leon Gast, 1996) documented the rescheduled bout and also included brief appearances by many of the same artists.

38. Though featured in the film's original release, at her own request, Flack was omitted from the later DVD.

39. "Wattstax '72' Film Shot by 90% Black Crews; 250 G Budget for Docu," *Variety*, September 27, 1972, p. 61.

40. On *Wattstax*, see Rob Bowman, *Soulsville: The Story of Stax Records* (New York: Simon and Schuster, 1997), especially pp. 267–271 and 290–295.

41. "Wattstax '72' Film Shot by 90% Black Crews; 250 G Budget for Docu," p. 1.

42. Quoted in Bowman, *Soulsville*, p. 268.

43. After the premier film, MGM threatened suit over Hayes's "Theme from Shaft" and "Soulsville," both of which had appeared in *Shaft*, and they were replaced by a different song, shot on a soundstage with a background designed to resemble the concert. Long believed to be lost, the originals were found and restored, and the soundtrack was remastered for the film's thirtieth anniversary, and the whole released as *Wattstax—The Special Edition*.

44. Jane Feuer, *The Hollywood Musical*, 2nd ed. (Bloomington: Indiana University Press, 1993), p. 3.

45. "Big Rental Films of 1973," *Variety*, January 9, 1974, pp. 19 and 60. Priced at $6.98, the album, *Wattstax—the Living Word*, sold "no better than respectably: 225,000" but still went gold: Arthur Kempton, *Boogaloo: The Quintessence of American Music* (Ann Arbor: University of Michigan Press, 2005), p. 284.

Chapter 17

1. On the history of country music, see especially Bill C. Malone, *Country Music, U.S.A.* (Austin: University of Texas Press, 2002). On the social and institutional construction of country through the 1950s, see Richard A. Peterson, *Creating Country Music: Fabricating Authenticity* (Chicago: University of Chicago Press, 1997).

2. On the "singing cowboy" films, see Douglas B. Green, *Singing in the Saddle: The History of the Singing Cowboy* (Nashville: Country Music Foundation Press & Vanderbilt University Press, 2002). Willie Smyth has argued that in the years 1933–1953, some seven hundred films were released containing an average of four or five hillbilly songs each, to

make a total of three thousand songs recorded audio-visually; see "A Preliminary Index of Country Music Artists and Songs in Commercial Motion Pictures," *JEMF Quarterly* 20.73 (Spring–Summer 1984): 103. While recognizing that cowboy songs predominated, Smyth asserts there were "also a great many hillbilly, western swing, and novelty songs in feature films, shorts, and Soundies" in the same period" (p. 104). See also, Wade Austin, "Hollywood Barn Dance: A Brief Survey of Country Music in Films," *The Southern Quarterly* 22.3 (Spring 1984): 111–123.

3. For example, a western suit given to Elvis generates a crucial incident in the plot of *Loving You* (Hal Kanter, 1957). Nudie, or Nudie-inspired, clothes were worn by almost every important country music personage after the early 1950s, and also by many rock 'n' roll musicians, including Elvis—for whom Nudie made the gold *lamé* suit—and groups, including America, ZZ Top, and the Flying Burrito Brothers.

4. Chuck Berry, *Chuck Berry: The Autobiography* (New York: Harmony Books, 1987), p. 14. Most of these details are taken from this account. The film *Cadillac Records* (Darnell Martin, 2008) depicts Leonard Chess recording Berry and other influential rhythm and blues artists.

5. Ray Charles and David Ritz, *Brother Ray: Ray Charles' Own Story* (New York: Dial Press, 1978), p. 222.

6. The incorporation of country music into folk rock and rock was regularly noted in the later sixties; see, for example, Jon Landau's review of albums by the Band, the Buffalo Springfield, and the Byrds, "Country and Rock," *Rolling Stone*, September 28, 1968, p. 24. With a cover featuring the Band, *Time* magazine introduced "The New Sound of Country Rock" in January 1970.

7. On the "Nashville Sound," see Bill C. Malone, *Country Music, U.S.A.*, pp. 256–262, and Bill Ivey "Commercialization and Tradition in the Nashville Sound," in William R. Ferris and Mary Hart, eds., *Folk Music and Modern Sound* (Jackson: University Press of Mississippi, 1982), pp. 129–141.

8. The CMA Awards were first given in 1967, and beginning in 1969 were televised live. Ironically, the 1970 film *The Nashville Sound* features more than forty performers, but most of them are those that the "Nashville Sound" was sidelining, including Roy Acuff, Hank Snow, Lester Flatt, Earl Scruggs, Loretta Lynn, and Porter Wagoner. Tensions between the more commercial Nashville sound and the harder, traditional sounds continued through the sixties, both on records and in the series of popular television shows from the *Porter Wagoner Show* (1960–1981) through three that debuted in 1969, the *Glen Campbell Good Time Hour*, the *Johnny Cash Show*, and *Hee Haw*, a hillbilly parody show, which though full of grotesque comedy, still had fine music. But the sixties also saw a revival of honky-tonk by George Jones and others; the development of alternative centers, especially Bakersfield, where Buck Owens and Merle Haggard revived a harder country sound; and the creation of "outlaw country," by Nashville veterans including Waylon Jennings, Willie Nelson, and Kris Kristofferson.

9. Structurally similar, *The Nashville Sound* visited the city in November 1969 when a convention for visiting disc jockeys coincided with the forty-fourth anniversary celebration of the first *Grand Ole Opry* radio show. Its extended finale takes place at the Opry where, along with the cutting of a birthday cake, a sequence of stellar artists perform for live broadcast over station WSM. The editing produces a metonymic history of country music, progressing from stars who began their careers in the 1930s, though

bluegrass, and culminating with contemporary artists who link with black music and rock 'n' roll. Released four years after *Music City U.S.A.*, *The Nashville Sound* is technically much more sophisticated, and evidently influenced by the late sixties rock documentaries. Cameraman and director Robert Elfstrom (who would soon shoot parts of *Gimme Shelter*) photographed the performances with agile, handheld cameras, at least one of them on stage, fluidly panning and zooming to allow the editor to mix short takes of close-ups and wide-shots in sync with the song structures.

10. Jane Feuer, "The Self-Reflective Musical and the Myth of Entertainment," *Quarterly Review of Film Studies* 2.3 (August 1977): 313–326. Reprinted in Rick Altman, ed., *Genre: The Musical* (London: Routledge and Kegan Paul, 1981), p. 168.

11. *Country Music Holiday* was distributed by Paramount, *That Tennessee Beat* by Twentieth Century Fox, *Nashville Rebel* by American International Pictures, and *The Road to Nashville* by Crown International Pictures.

12. Quoted in Allison Graham, *Framing the South: Hollywood, Television, and Race During the Civil Rights Struggle* (Baltimore, MD: Johns Hopkins, 2001), p. 98.

13. A country music remake of *Wild Guitar* (Ray Dennis Steckler, 1962), *Nashville Rebel* was something of a bridge between the two kinds of film about country music. It starred Waylon Jennings as Arlin Grove, a returning soldier who is beaten and robbed by drunken hooligans and dumped on the roadside near a country hamlet. Rescued by Molly (future television star Mary Frann in her feature debut), he reveals himself as a singer/songwriter, who wants to make his mark in life with his music. Displaying his talent at a rural hootenanny, he is spotted by Wesley Lang, an unscrupulous promoter who sees in him, as Parker did in Elvis, a million dollar's worth of talent. After giving Arlin and Molly the generic tour of Nashville—Ernest Tubbs's record shop, Roy Acuff's museum, and the Parthenon, where Faron Young is seen performing—Lang signs him, and thereafter the narrative becomes a struggle between Molly's desire to return to country simplicity and Lang's intention of exploiting his property to the fullest. Arlin becomes a star, but when, after weeks on the road, he chooses to appear at the Grand Ole Opry rather than celebrate Molly's pregnancy, she returns home and Arlin sinks further into Lang's diabolical schemes and alcoholism. But at the end, his musical success assured, he returns home to Molly and Arlin Junior. Though Jennings did not write the songs, his performances of them are superb; but his wooden acting, the schematic narrative, and the one-dimensional characterization deflate the film's conflicted premise that, while the music itself is authentic and pure, at least one player in its commercial promotion is heinous. *Moonshine Mountain* (Hershell Gordon Lewis, 1964) was a similarly eccentric contribution. A follow-up to Lewis's splatter film *Two Thousand Maniacs!* it also satirized Southern rednecks' treatment of visiting Yankees. This time it appears that the victim will be Doug Martin, a television folk singer who comes to a hamlet in the South Carolina hills to gather material from the "real folk." But despite some initial hostility, his picking skills earn him acceptance, and an early high point is a barn party, featuring several local amateur musical performers and a square dance. Though Lewis restrained the gore, the second half degenerates into murderous farce in which the demented town sheriff makes moonshine, and kills Martin's New York girlfriend and a series of "federals" sent to investigate, dumping their bodies into his still. Motifs from the jukebox musical recur in Martin's romance with a country girl and his concluding appearance on television, where he sings, "If I Had a Hammer," but the narrative of the sheriff's depravity usurps

the musical. Not dissimilar contradictions appear in three other narrative films, *That Tennessee Beat* (Richard Brill, 1966), *The Gold Guitar* (J. Hunter Todd, 1966), and *What Am I Bid?* (Gene Nash, 1967).

14. Produced by Elia Kazan, *A Face in the Crowd* was distributed by Warner Bros. and produced by Sam Katzman for Four-Leaf Productions, who also produced two of Elvis films; *Your Cheatin' Heart* was distributed by MGM; *Payday* was produced by Fantasy Films and distributed by Cinerama Releasing Corporation, a national distributor; and *Nashville* was produced and distributed by Paramount.

15. *Payday*'s score was by Shel Silverstein, who had written hits for Johnny Cash, Loretta Lynn, and many other country singers, and also the music for *Ned Kelley* (Tony Richardson, 1970).

16. Altman later recalled how impressed he had been hearing Carradine singing two songs he had written, "It Don't Worry Me" and "I'm Easy," at a party during the shooting of his *Thieves Like Us* (1974): "When I heard them I knew I wanted to base a whole movie around them, a movie that would simply give me an excuse to put them in." Quoted in Jan Stuart, *The Nashville Chronicles: The Making of Robert Altman's Masterpiece* (New York: Simon and Schuster, 2000), p. 37.

17. While researching her role, Anspach spent considerable time among country musicians, remarking, "I felt great love and compassion for them and couldn't mock or spoof them or deal with Altman's condescending attitude"; Stuart, *Nashville Chronicles*, p. 86. Gifted as both an actress and musician, Blakely later toured with Bob Dylan's *Rolling Thunder Revue* and appeared as Mrs. Dylan in *Renaldo and Clara* (1978).

18. Renowned for both his secular and gospel music, Acuff had been a recording star since the mid-1930s and with his band, the Smokey Mountain Boys, had joined the Grand Ole Opry in 1938. Formed with the songwriter Fred Rose, his Acuff-Rose Music became the most important publisher of country music. Acuff also appeared in several films in the 1940s, most notably *Grand Ole Opry* (Frank McDonald, 1940), a forerunner of the sixties country music films. When *Nashville* was made, he had recorded almost fifty albums.

19. The response of Nashville musicians when the film belatedly opened there was described by George Vecsey, "Nashville Has Mixed Feeling on 'Nashville,'" *New York Times*, August 10, 1975, p. 41. Further responses were catalogued in Stuart, *Nashville Chronicles*, pp. 292–294; they include Lynn Anderson's, "The producer, writer, and director obviously had a preconceived notion that Nashville and all it stood for was trash," and Minnie Pearl's even more telling comment on the representation of the fans: "The music was terrible. I *know* they did a bad job with the Opry. There was a plastic look about the fans. . . Also, they left out the most important part of Nashville: the fellowship and love that exists between country singers and their fans" (both p. 292). When Altman died, the *Nashville Post* revisited the controversy, summarizing, "It depicted the Music City as Bumpkin Central Station, a sort of Peyton Place-meets-Appalachia." See E. Thomas Wood, "Nashville Director Altman dead at 81," http://nashvillepost.com/news/2006/11/21/ inashvillei_director_altman_dead_at_81 (accessed July 2, 2013). Greil Marcus, one of the few commentators to object to Altman's treatment of the musicians and fans, correctly notes, "The most chilling scene in 'Nashville'—the vicious, heartless reaction of the crowd to Barbara Jean's onstage breakdown—cannot possible be a metaphor for anything save the director's cynicism and disinterest in his ostensible subject, since no country audience anywhere in America would respond to the crisis of a singer as well-loved as Barbara Jean

is supposed to be with anything less than sympathy, compassion, and fear"; "Ragtime and Nashville: Failure of America Fad," *Village Voice*, August 4, 1975, p. 96. Altman's disregard for country music may be contrasted with his hiring of Joshua Redman and other accomplished musicians to play in the style of the jazz giants of the period in *Kansas City* (1996). Similarly, when he did at last satirize Hollywood directly in *The Player* (1992), his ironically affectionate portrait was peopled by a galaxy of stars.

20. Quoted in Paul Gardner, "Altman Surveys 'Nashville' and Sees 'Instant' America," *New York Times*, June 13, 1975, p. 26.

21. Appalled by what she heard about *Nashville*, Loretta Lynn extended the narrative of her 1970 chart-topping single, "Coal Miner's Daughter" into an autobiography. Directed by Michael Apted, *Coal Miner's Daughter* (1980) gained Sissy Spacek an Academy Award for Best Actress, as well as being nominated for six others. It anticipated a series of major studio feature films that more sympathetically approached the by-then fully corporatized country music industry. These included *Honeysuckle Rose* (aka *On the Road Again*) (Jerry Schatzberg, 1980), a romantic drama starring Willie Nelson; *Urban Cowboy* (James Bridges, 1980) in which John Travolta publicized country as he had disco in *Saturday Night Fever* (John Badham, 1977); *The Night the Lights Went Out in Georgia* (Ronald F. Maxwell, 1981); *Tender Mercies* (Bruce Beresford, 1983), a critical if not commercial success that won Best Actor award for Robert Duvall; the Patsy Cline biopic *Sweet Dreams* (Karel Reisz, 1985); the unsuccessful *Falling from Grace* (John Mellencamp, 1992) that also starred Mellencamp; and *Pure Country* (Christopher Cain, 1992) with country superstar George Strait. The independently produced county music revue was revived at least once in the 1970s in *That's Country* (Clarke Da Prato, 1977), which featured fifteen acts, including Chet Atkins, June Carter Cash, Ferlin Husky, Bill Monroe, Minnie Pearl, Marty Robbins, and Kitty Wells.

Chapter 18

1. The first attempt to link rock 'n' roll songs into a narrative is usually credited to "A Quick One, While He's Away," a nine-minute sequence written by Pete Townshend that appeared on the album, *A Quick One* (1966). The Pretty Things' *S.F. Sorrow* (1968) is usually recognized as the first significant rock 'n' roll concept album, one in which each song has a role in an overarching conceptual matrix, in this case, the biography of Sebastian Sorrow from birth to old age. The Kinks' *Arthur (Or the Decline and Fall of the British Empire)* (1969) followed, along with the first composition specifically designated as a rock opera, *Tommy*. Written mostly by Pete Townshend and released as an album by the Who in 1969, it subsequently appeared as a concert, a film, and a theatrical production. Other early concept albums include David Bowie's echo of the Kinks in *The Rise and Fall of Ziggy Stardust and the Spiders from Mars* (1972), the Who's *Quadrophenia* (1973), Lou Reed's *Berlin* (1973), and Genesis' *The Lamb Lies Down on Broadway* (1974). *Hair*, "The American Tribal Love-Rock Musical," was first staged off-Broadway in 1967 before moving to Broadway in 1968, with the very successful cast recording released the same year. Deriving from the stage rather than rock 'n' roll musicians, *Jesus Christ Superstar* first appeared as an album in 1970, then as a Broadway musical, where it was termed a "rock musical." Some of these subsequently appeared as films, including *Ziggy Stardust and the Spiders from Mars* (D. A. Pennebaker, 1973), *Jesus Christ Superstar* (Norman Jewison, 1973), *Tommy* (Ken Russell, 1975), *Quadrophenia* (Franc Roddam, 1979), and *Hair* (Miloš Forman, 1979).

2. In some ways resembling glam rock theatricality, Alice Cooper's performances were also the subject of several US documentary films, notably *Good to See You Again, Alice Cooper* (Joe Gannon, 1974) and *Welcome to My Nightmare* (David Winters, 1976). Films about music business corruption followed somewhat later in the United States with, for example, *That's the Way of the World* (Sig Shore, 1975).

3. Actor Terence Stamp's original idea for "a film of a pop singer who thought he was Jesus Christ" was the basis for British television writer John Speight's story, from which Norman Bogner, later a successful US novelist, produced the script and Watkins himself revised it. One of thirteen low-budget films financed by Universal between 1967 and 1970, it was Watkins's first to be shot in 35 mm: see Joseph A. Gomez, *Peter Watkins* (Boston: Twayne, 1979), p. 71. Peter Suschitzky, its cinematographer, worked again with Watkins on his next project, *Gladiators* (1969), and on other English music films, including *That'll Be the Day* (Claude Whatham, 1973) and *The Rocky Horror Picture Show* (Jim Sharman 1975).

4. Jones later starred in another surreal dystopian film, *The Committee* (Peter Sykes, 1968), with music by Pink Floyd and a performance by the Crazy World of Arthur Brown.

5. Herbert Marcuse, *One-Dimensional Man: Studies in the Ideology of Advanced Industrial Society* (Boston: Beacon Press, 1964). Debord's *La Société du spectacle* was first published in French in 1967, while Max Horkheimer and Theodor W. Adorno's *Dialektik der Aufklärung* (1944) (Dialectic of Enlightenment) was not translated into English until 1972.

6. A selection of reviews are reproduced in Gomez, *Peter Watkins*, pp. 73–74.

7. After a previous career in advertising and as a photographic agent, Puttnam became one of the most successful British producers of the seventies, whose productions included Ken Russell's musical films *Mahler* (1974) and *Lisztomania (1975)*.

8. Figures from Alexander Walker, *National Heroes: British Cinema in the Seventies and Eighties* (London: Harrap, 1985), p. 79.

9. *Flame*'s screenplay was written by Andrew Birkin, who had assisted the Beatles on *Magical Mystery Tour* in 1967. The film was followed by a successful novel, *Slade in Flame* (St. Albans, UK: Panther Books, 1975) written by John Pidgeon and based on the screenplay.

10. Abbie Hoffman (under the pseudonym "Free"), *Revolution for the Hell of It* (New York: Dial Press, 1968), p. 67.

11. Henry Edwards and Tony Zanetta, *Stardust: The David Bowie Story*, (New York: McGraw Hill, 1986), p. 13.

12. Mark Paytress notes the discovery of a 1968 manuscript, *Ernie Johnson*, detailing Bowie's plans for a musical film that concludes with the hero staging a party where he commits suicide; *The Rise and Fall of Ziggy Stardust and the Spiders from Mars* (New York: Schirmer Books, 1998), p. 24. Bowie's obsession with alternative personae who die is often linked biographically to his elder brother, Terry Burns, a schizophrenic, who later committed suicide.

13. John Mendelsohn, "David Bowie: Pantomime Rock?" *Rolling Stone*, April 1, 1971, p. 16.

14. From a January 1972 US radio interview, quoted in Paytress, *Ziggy Stardust*. p. 78. The account given to Burroughs concludes, "Ziggy is advised in a dream by the Infinites to write the coming of a starman, so he writes 'Starman,' which is the first news of hope

that people have heard. . . . When the Infinites arrive, they take bits of Ziggy to make themselves real because in their original state they are anti-matter and cannot exist in our world. And they tear him to pieces on stage during the song 'Rock and Roll Suicide'" (ellipses added); Sylvère Lotringer, ed., *Burroughs Live: The Collected Interviews of William S. Burroughs, 1960–1997* (Cambridge, MA: Semiotext[e], 2001), p. 231.

15. Jean Baudrillard, "Simulacra and Simulations" in Mark Poster, ed., *Jean Baudrillard, Selected Writings* (Stanford, CA: Stanford University Press, 1988), p. 170.

16. After the concert, Pennebaker returned to New York and completed the half-hour video for RCA, but he continued to work on the feature-length film. Difficulties in mixing the sixteen-track audio down to four for a Dolby film track postponed completion, and after the early college and television screenings, a one-hour version appeared on ABC television in 1974 with a stereo track broadcast simultaneously on FM radio, and a cut was screened at the Edinburgh Film Festival in 1979. After the 1983 video release, it appeared on laser disc in Japan in 1985. The 2003 theatrical version was also released on DVD with voice-overs by Pennebaker and Visconti. The cameramen were Pennebaker at stage right, Nick Doob at stage left, and Jim Desmond in front, with additional footage by Mike Davis and Randy Franken. Released in October 1983, a soundtrack album, *Ziggy Stardust: The Motion Picture*, reached the UK top twenty.

17. Carrie Rickey defined the Deathwatch film as one in which "the hero's untimely death at the end validated and/or redeemed him"; "Rockfilm, Rollfilm" in Anthony DeCurtis and James Henke, eds., *The Rolling Stone Illustrated History of Rock & Roll: The Definitive History of the Most Important Artists and Their Music* (New York: Random House, 1992), p. 117.

18. The first three songs announce the presence of the band: "You're the blessed, we're the Spiders from Mars" ("Hang On To Yourself"), the overall persona of Ziggy and his annihilation: "When the kids had killed the man/I had to break up the band" ("Ziggy Stardust"); the chaos he causes ("Watch That Man"). The next three emphasize the star's identification with the fans: "Wild Eyed Boy from Freecloud" is terminated at the stanza, "It's so hard for us to really be/Really You/And really Me"; "we're juvenile delinquent wrecks" ("All the Young Dudes"); and the dismay their flexible sexuality causes their parents: "Don't you know you're driving your/Mamas and papas insane/ . . /You gotta make way for the homo superior ("Oh! You Pretty Things"). "Moonage Daydream" puts the fans in contact with the extraterrestrial singer: "Keep your 'lectric eye on me babe/Put your ray gun to my head/Press your space face close to mine, love" and "Changes" explores the impermanence in which they are caught and the abuse they suffer: "And these children that you spit on/As they try to change their worlds." The two remaining songs before the intermission confront death, Major Tom impotently floating around his tin can "Far above the Moon" in "Space Oddity" and Bowie/Ziggy going to meet "My Death." Less tightly linked, the songs after the intermission are initially more macabre: Ziggy is reintroduced as the "Cracked Actor," turning tricks in his decline; "Time" portrays him and his fans as time's helpless tricks; and in "The Width of a Circle," the narrator realizes that he is a monster and has sex with a devil. "Let's Spend the Night Together" continues with a once-scandalous sexuality, and if the hard rock 'n' roll of "Suffragette City" seems outside the Ziggy narrative, the Velvet Underground's "White Heat/White Light" glimpses a deathly ecstasy, perhaps a drug overdose. After Ziggy's spoken farewell, he sings his last song, "Rock 'n' Roll Suicide"

{ INDEX }

Film (both short and feature length) and record album titles are in italics, with song titles in quotation marks. Names following film titles are directors, and names following song titles are performers.